Arts Management

Arts Management is designed as an upper division undergraduate and graduate level text that covers the principles of arts management. It is the most comprehensive, up-to-date, and technologically advanced textbook on arts management on the market.

While the book does include the background necessary for understanding the global arts marketplace, it assumes that cultural fine arts come to fruition through entrepreneurial processes, and that cultural fine arts organizations have to be entre-preneurial to thrive. Many cases and examples of successful arts organizations from the United States and abroad appear in every chapter.

A singular strength of *Arts Management* is the author's skillful use of in-text tools to facilitate reader interest and engagement. These include learning objectives, chapter summaries, discussion questions and exercises, case studies, and numerous examples and cultural spotlights.

Carla Walter is an Associate Professor of marketing at California Lutheran University, USA.

Arts Management

An Entrepreneurial Approach

CARLA STALLING WALTER

Routledge
Taylor & Francis Group

NEW YORK AND LONDON

First published 2015
by Routledge
711 Third Avenue, New York, NY 10017

and by Routledge
2 Park Square, Milton Park, Abingdon, Oxon, OX14 4RN

Routledge is an imprint of the Taylor & Francis Group, an informa business

© 2015 Taylor & Francis

Library of Congress Cataloging-in-Publication Data
CIP data has been applied for

ISBN: 978-1-138-88611-7 (hbk)
ISBN: 978-0-7656-4154-0 (pbk)
ISBN: 978-1-315-71388-5 (ebk)

Typeset in Times New Roman
by Apex CoVantage, LLC

Contents

Foreword

Russell Belk

All artists and art organizations—whether public or private, profit or nonprofit, sub-sidized or unfunded—need income to survive and flourish. This is a most basic fact of life in the arts as it is in virtually all fields. Yet, as Carla Stalling Walter puts it in the first chapter of this book, "Until recently . . . one was in either the universe of art or the universe of money, and the twain never met." This dying, though not completely dead dichotomy is based on two mythic stereotypes: the starving artist in a garret dedicated to art above all else, and the greedy and philistine businessperson out to maximize profits at any cost. Both stereotypes are greatly exaggerated. Yet, like most stereotypes, they contain a grain of truth. The production of art and the production of revenues are strange bedfellows. That is precisely the conundrum that this book seeks to resolve. Individual artists, companies of artists, or arts organiza-tions can both produce great art and yet be successful in earning a living, growing, and even prospering. This book can serve as a basic text for just how to accomplish such a reconciliation of art and business. It recognizes that experiencing art can be a transcendent, quasi-religious experience at the same time that it shows how to provide such experience to the right target audience in a way that meets and exceeds audience expectations while also exceeding the break-even point of costs versus revenues.

Just as Walter brings together art and business, she also brings together a multi-disciplinary set of perspectives that includes philosophy, economics, anthropology, political science, marketing, management, and psychology. The reader is the richer for it. Walter notes that art audiences can vary in terms of their engagement and involvement with an arts offering. This book, however, strives to maintain a maxi-mum level of reader engagement and involvement with a mix of text, video links, cases, and vignettes. While the book focuses on both performance art and fine art, it also includes intriguing contexts such as theme parks, circuses, sports, and Robert Pirsig's *Zen and the Art of Motorcycle Maintenance*. It draws on drama not only as a performance art but also as a metaphor for understanding art audience experiences. It covers a range of phenomena in arts marketing, including price/quality inferences, art auctions, class struggle for cultural capital, and other seemingly counterintuitive

or irrational phenomena, and makes perfect sense of them. And it deals with both the mechanics of demographic and psychographic market segmentation and the more ethereal phenomena of creating audience awe, ecstasy, and collective engagement. It offers both practical advice for the "culturepreneur" and analyses of ritual, countercultures, and perceived authenticity in the arts.

The book is largely focused on Western medium- and large-sized arts organizations. Yet the same principles should apply elsewhere in the world and to such diverse phenomena as producing videos for YouTube, working as a street busker, selling art through online vehicles such as Etsy and eBay, selling downloadable seasons of television series for binge watching, and cross-marketing with the latest Disney movie or the hottest haute couture. The discussion of intellectual property rights and the fair use doctrine is quite helpful in wading through a complex and changing body of law. The text also raises ethical issues that call attention to triple bottom-line considerations in assessing the full impact of marketing and management decisions.

Walter's book also raises important public policy issues with regard to the arts. Whether we consider the arts as a market good or a merit good makes a great deal of difference in how they are funded. Crowdfunding sources like Kickstarter offer an example of how changing technologies of the Internet impact the arts. Tie-ins between museums like the Victoria and Albert, the Metropolitan, and the Hong Kong Art Museum and commercial brands like Ferragamo, Ralph Lauren Polo, and Louis Vuitton offer new models for corporate sponsorship while also raising basic questions about the function of the museum in a contemporary age. So too does the pervasive influence of the Internet in allowing people to access art without a visit to the museum. The very nature and function of such art institutions is challenged in the process.

To end where I began, with Carla Stalling Walter's observation that art and commerce make strange but necessary bedfellows, I am reminded of my colleague Don Thompson's book *The $12 Million Stuffed Shark: The Curious Economics of Contemporary Art*. The title refers to Charles Saatchi's purchase of a Damien Hirst work of art for the price noted in the title, only to find that the shark was improperly preserved, had begun to decay, and needed to be replaced by the artist. Not only do this and other cases in Thompson's book force us to see how passion plays a role in pricing as well as art appreciation, but also they raise interesting questions about the definition of art, its authenticity, its stratospheric prices, and the role of celebrity in the contemporary art market. What can we say except that art is fascinating and its appeal is sometimes overwhelming? *Arts Management: An Entrepreneurial Approach* goes far in helping us to appreciate such cases and the amazing intersection of art and business. It is fascinating without overwhelming the reader with esoteric details. It is itself a work of art.

Foreword

François Colbert

The cultural sector experiences a continuous influx of new ventures. These new ventures are initiated either by experienced managers or by young artists freshly out of art school. Human beings are very creative and, especially in our modern and wealthy societies, anyone can have a fair try in offering a new cultural product to the market. However, if the entry barriers are low in the arts, what we call an exit barrier is high since artists often choose to live poorly instead of selecting another sector to earn a living. Even if our market for arts and culture is densely crowded, new companies and new products join every year the already present competitors. To save its place under the sun, cultural entrepreneurs must approach the market with essential pieces of knowledge and a well-thought-out plan.

This book by Carla Stalling Walter certainly represents pertinent material for those who would like to maximize their chances of success. Even if readers are not familiar with management principles and rules, this textbook will be easy to read. Principles, concepts, and their application are logically presented so readers will receive a plan for building their business strategy.

Several topics are important to master for someone wanting to become a cultural entrepreneur. Management relies on three basic areas: to sell, to produce, and to measure. For an organization to survive selling is the first key component; for any product one must find a market, a niche to serve and generate income. Then, the company must produce what has been sold; thus in the arts, the artist has the say on the product development; the entrepreneur must find the right audience for the right work of art. Finally, financial reports must be prepared in order to verify if revenues cover costs; there is no way to survive if the books are not in order. Marketing, production, and financial management are the three pillars of management and the three essential aspects of knowledge to master.

Other areas are supporting the organization along with those three pillars. Human resources management, information technology systems, legal matters, economics of the sector, cultural policies—all those disciplines contribute to the well-being of the organization and must be studied. This book covers all those sectors and disciplines. In addition, readers will find resources and practical information such as how

to do market research and how to build a business plan. Case studies help readers grasp the complexity of managing in the arts. Finally, the book offers the reader reflection on what is an entrepreneur.

Arts management is a young discipline. The author cites several scientific articles that have been published in the last forty years. Surprisingly, we in fact know little about many aspects of managing in the arts. It is academic research that fuels knowledge on essential aspects such as consumer behavior and business strategy. Our discipline is young but still, in this book, the reader will find many references to important pieces of research. Reading some of those references will complete the tool kit of the cultural entrepreneur.

This book will be a companion to any new or established entrepreneur since, even if you have been in this business for many years, it is always interesting to confront its practices and knowledge with new material that represents food for thought. Our world is getting more complex because of six elements in the environment: (1) the world is becoming global, in the arts as well as in other sectors of the economy; (2) in order to differentiate from the competition, good customer service will become extremely important, especially in large cities where people have a vast choice of experiences; (3) technology is changing many facets of arts organizations, in marketing as well as production; (4) the cultural market is oversaturated, so the consumer faces tremendous choices for leisure activities while companies struggle to survive; (5) baby boomers are retiring and a young generation is growing up with tastes different from those of the older segment of the population; and (6) governments in many countries are cutting their cultural spending due to money shortages. To successfully face those challenges, cultural entrepreneurs cannot be too informed. Carla Walter's book will give cultural entrepreneurs the information they need to face those challenges.

Introduction

Welcome to *Arts Management: An Entrepreneurial Approach*!

As I was finishing my doctoral dissertation on the economics of three major international ballet companies, I envisioned publishing a text that would gather together many pieces of information that would guide the successful launching and leading of arts organizations, and doing so in a frame that embraced entrepreneurship. I believed then, and still do, that artists are in some part entrepreneurial and that, with the changes in the economic and technological landscapes, there was going to be a need to articulate for-profit and hybrid structures to produce art and cultivate arts consumers. These new structures would work alongside of and in tandem with the historical supply model given through nonprofit organizations. Indeed, today we see this approach to arts production and consumption being staged frequently in the United States.

Therefore, my purpose in writing this book was to provide a university upper-division undergraduate- and graduate-level text that covers the principles of arts management and entrepreneurship. Its audiences are students who are not business majors and practitioners seeking to increase their knowledge of contemporary arts management and entrepreneurship. The aim of the book is to be the industry standard textbook for fulfilling the prerequisite survey course in graduate arts management and entrepreneurship or the capstone undergraduate course. In such programs, students can choose a concentration or focus such as media, entertainment, theater, dance, design, and so on.

While the book does include the background necessary for understanding the global arts marketplace, it assumes that cultural fine arts come to fruition through entrepreneurial processes and that cultural fine arts organizations have to be entrepreneurial to thrive. With this premise in mind, the supply and demand of arts has to be linked to arts consumers and their demands, with an eye toward utilizing technology in systems and processes as well as arts distribution and creation.

The text is situated within the intersections of a theoretical framework, with practical applications and experiential exercises. One of the aspects of this textbook that I hope you really appreciate is its use of movies as pedagogy, and applying the ephemeral nature of services, which is very appropriate to arts consumption. At the

end of each chapter, discussion questions are provided. Using the book, students will be able to formulate and design an arts or creative company. In this way, the book accommodates the practitioner and the novice in terms of learning outcomes.

Part I. Understanding the Cultural Fine Arts

Chapter 1. The Business of the Arts and Culture

This chapter provides the reader with a background of arts and culture from a historical perspective. Its purpose is to inform the reader of the long history of arts management and entrepreneurship and to contextualize the current environment.

Chapter 2. Studies in Culture

Many arts entrepreneurs come to the field with a high degree of specialization in their own or a particular cultural fine art. However, in order to be well-rounded, it is necessary to have an understanding of multiple art forms and how they relate to culture. This chapter gives this overview.

Chapter 3. The Anthropology and Spirituality of Consumption

Arts consumption does not occur in a vacuum. It is tied to human ritual and spirituality. This chapter focuses on the need for humans to consume art and what it means to have a cultural consumption experience. The purpose is to provide the arts entrepreneur and leader with a sense of urgency in providing services and products in arts that connect to the human condition.

Chapter 4. The Economics of Tangible and Intangible Fine Arts

Unlike the economics of tangible products or known service goods, the economics of arts and culture has its own supply and demand functions. The reader is given the background necessary to understand the economics of arts and culture and how pricing correctly is critical for the market. In addition, when formulating a consumer experience, packaging the experience is an art in itself. Therefore, the purpose of this chapter is to show the importance of getting these issues right by placing the financial aspects of the company in the context of an appropriate economic structure.

Part II. Entrepreneurial Development

Chapter 5. The Cultural Fine Arts in Entrepreneurial Process

Entrepreneurship is covered in this chapter. The purpose is to teach readers what it means to be a successful entrepreneur who can develop creativity, identify the market and trends, and avoid pitfalls.

CHAPTER 6. CONSUMER BEHAVIOR IN THE CULTURAL FINE ARTS

Entrepreneurs provide services and products that fill an unmet need or provide those services and products in new ways. This chapter gives readers the necessary tools to understand consumers and their behaviors when it comes to arts experiences. It draws on the background given in Part I.

CHAPTER 7. MARKETING RESEARCH IN THE CULTURAL FINE ARTS

Products and services, as well as evaluation of consumer experiences, rely heavily on marketing research. This chapter covers the methods and practices of marketing research that an entrepreneur or arts manager will need in identifying consumer trends and making course corrections or generating new products and services. The chapter is user-friendly, touching on statistical approaches in ways that are easily understood and adapted.

PART III. MANAGEMENT AND PROCESSES

CHAPTER 8. THE CULTURAL FINE ARTS ORGANIZATION AS A SERVICE

Providing arts to the market requires that the organization or the entrepreneur delivers excellence in customer service and quality. This chapter provides that framework by explaining methods and processes that readers can implement in their company.

CHAPTER 9. CULTURAL FINE ARTS ORGANIZATIONS AND THEIR MANAGEMENT

This chapter provides an overview of organizational behavior and management so that the reader understands culture, leadership, employee management, and cultivation of an entrepreneurial environment. Its purpose is to teach nimbleness and flexibility so that the entrepreneurial organization adapts to changes in the environment.

CHAPTER 10. COPYRIGHTS, INTELLECTUAL PROPERTY, CULTURAL POLICY, AND LEGALITY IN CULTURAL FINE ARTS ORGANIZATIONS

Simply, this chapter gives the reader an idea of the critical nature of cultural policy and legality in intellectual products and services. The purpose is to emphasize the need to pay attention to laws in order to protect a company's ideas, products, and services from being infringed upon.

CHAPTER 11. TECHNOLOGY AND THE CULTUREPRENEURIAL ORGANIZATION

The current environment that the cultural arts firm finds itself in now requires attention to the technical aspects of running the organization as well as the need to connect with fine arts consumers. The purpose of this chapter is to provide an overview

of the mechanisms that constitute the management information system for a cultural arts organization.

PART IV. GROWTH AND SUCCESSION

CHAPTER 12. FUND-RAISING AND DEVELOPMENT FOR THE CULTUREPRENEURIAL ORGANIZATION

Profit and nonprofit organizations both need to understand methods and strategies for fund-raising. This chapter helps readers develop strategies for their firm, product, and/or service.

CHAPTER 13. FINANCIAL MANAGEMENT AND INVESTING IN THE CULTURAL FINE ARTS ORGANIZATION

It is not enough to have earned and unearned income. In running an arts organization, often one needs advances in capital for projects or other expenses. Moreover, it is important to be able to read and understand financial statements. Readers come away with this knowledge after covering this chapter, which like Chapter 7 on marketing research, is presented in a user-friendly manner.

CHAPTER 14. SUCCESSION PLANNING FOR THE CULTURAL FINE ARTS ORGANIZATION

The firm has grown and is successful; however, the most successful firms have plans to transfer them to other individuals. Sometimes the transition is unexpected, and therefore this chapter gives readers a map to follow so their firms may continue in their absence.

After working through this book, you will have a broad understanding of aspects of excellence that are required for starting and subsequently leading a cultural fine arts organization. Importantly, you will be able to draw on the history of this field and connect with current individuals who are enthusiastically forging new pathways in providing the cultural fine arts.

ACKNOWLEDGMENTS

Every book produced requires the efforts of many people, including editors, publishers, friends, loved ones, and family. For me, first and foremost I thank my family for their support and encouragement. Friends, loved ones, and colleagues are important to me as well, and I would like to let them know how much I appreciate the kind and gentle suggestions they gave me along the way regarding producing this textbook. In particular, Charles Maxey, PhD, Dean of the School of Management at California Lutheran University played an integral and supportive role in my moving forward

with writing and publishing this book, and therefore I extend a very special thanks to him.

I would like to thank reviewers of the prospectus for their thoughtful comments that helped to shape this text, and early readers of the textbook who provided feedback. In particular, I am indebted to Russell Belk, professor of marketing and Kraft Foods Canada Chair in Marketing of York University in Toronto, Canada; François Colbert, Carmelle and Rémi Marcoux Chair in Arts Management and UNESCO Chair in Cultural Management at HEC Montreal, Canada; and Ruth Rentschler, chair and professor of arts and entertainment management, Faculty of Business and Law at Deakin University in Melbourne, Australia.

Next, I extend my sincere appreciation to the Santa Fe Opera, in particular Cindy Layman; Steven Roth, president of the Pricing Institute; Lori Reese, who represents the work of artists Christo and Jeanne Claude; the City of New York Staff at 311; Patricia Breman of Strategic Business Insights; Jenifer Thom, public affairs and communications specialist at the San Francisco Foundation; Jo Mueller, executive director at Spiva Center for the Arts; Momoko Vanna at IEEE Computer Society; and Regina Starr Ridley, publishing director at *Stanford Social Innovation Review*.

Part I

Understanding the Cultural Fine Arts

The Business of the Arts and Culture

LEARNING OBJECTIVES

After reading this chapter, you will be able to do the following:

1. Define creative and cultural arts industry; cultural arts management; cultural clusters; and the culturepreneur.
2. Understand the current scope of the cultural industries.
3. Give an overview of "for-profit/not-for-profit" organizational structures.
4. Recognize the economic context for managing the arts.
5. Situate demand for the arts historically.

6. Explain generally how public policy considerations are related to historical cultural arts economic contexts.
7. Comprehend why understanding consumers and managing the demand for the arts is important.

WHAT'S ON?

David Shirgley
"An important message about the arts"—an animated video by David Shirgley
YouTube, September 9, 2010
www.youtube.com/watch?v=T6rYDaORe3k

SPOTLIGHT: *THE GATES*, CENTRAL PARK, NEW YORK CITY, 1979–2005

When *The Gates* arts project was proposed in 1979, Commissioner Gordon Davis rejected the idea, primarily because Central Park was being revitalized and could not support a project as large and popular as a Christo and Jeanne-Claude work of art. Over time, however, the plan evolved, and it finally consisted of 7,500 "gates" made of saffron-colored, lightweight vinyl fabric. *The Gates* were to stand at about sixteen feet high and be placed throughout the park.

Exhibit 1.1 *The Gates*, Central Park, New York City, 1979–2005

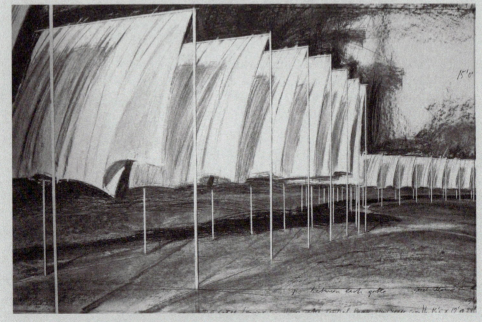

(*Photograph courtesy of Christo and Jeanne-Claude*)

Christo and Jeanne-Claude agreed to finance all costs without sponsorship, including planning, design fabrication, delivery, installation, information, security, auxiliary ambulances, insurance, full site restoration, and cleanup. In addition to generating money for the city parks and recreation department, *The Gates* had an enormous positive impact on the city's culture and economy. The mayor's office anticipated and realized benefits to the city in excess of $135 million. *The Gates* also created more than 1,000 temporary jobs, as the project required workers to construct, install, and monitor the exhibit.

After twenty-five years of resistance and confusion, *The Gates* was finally installed in Central Park between February 12 and February 27, 2005. The saffron-colored fabric panels were suspended from the top of each gate and hung down to seven feet above the ground, stationed about twelve feet apart. The luminous, billowing material accented the organic and serpentine design of the meandering footpaths, while the rectangular poles were reminiscent of the grid pattern of the city blocks around the park.

Central Park remained open to the public during *The Gates* installation for the people of New York continued to use the park as usual. For those who walked through *The Gates*, the saffron-colored fabric became a golden ceiling creating warm shadows. When seen from the buildings surrounding Central Park, however, it seemed like a golden river appearing and disappearing through the bare branches of the trees and highlighting the shape of the meandering footpaths.

IMPACTS OF THE CREATIVE AND CULTURAL ARTS INDUSTRY

It is estimated that the U.S.-based nonprofit arts and culture industry generated $166.2 billion in economic activity in 2005, which was nearly a 25 percent increase over 2000. In real dollars, that translates to an 11 percent increase. That rate is close to the growth of the gross domestic product (GDP), by comparison, which had a growth rate of about 12.5 percent in real dollars.

At the same time, spending by nonprofit arts and culture organizations grew 18.6 percent between 2000 and 2005, from $53.2 billion to $63.1 billion (a 4 percent increase when adjusted for inflation). Event-related demand by audiences increased 28 percent during the same period, from $80.8 billion to $103.1 billion, or 15 percent when adjusted for inflation. Of the billions of dollars the creative and cultural industry generated, it supports 5.7 million full-time jobs that remain local and not off-shored to international locations. Moreover, estimates suggest that the cultural and creative industry generates nearly $30 billion in revenue to local, state, and federal governments every year.

Arts and culture organizations influence event-related spending by audiences at restaurants, hotels, retail stores, and other local businesses. When patrons attend a performing arts event, for example, they may park their car in a toll garage, purchase

dinner at a restaurant, and eat dessert after the show. The typical attendee spends about $30 per event, after buying an admission ticket. Importantly, cultural tourists spend twice as much as local consumers in buying tickets and related services and goods.

Right now, international cities are competing to attract new businesses as well as the brightest professionals. The winners will be communities that offer a plethora of arts and culture opportunities. As the arts flourish, so will creativity and innovation—the fuel that drives the global economy. Arts and culture also support productivity in the workforce as a whole. Engagement with arts and culture helps to develop critical thinking, creative problem-solving skills, and effective expression and communication ability. These skills improve intellectual ability and well-being, enabling greater success in daily living. As a whole, arts and culture education supports improvements in the effectiveness and flexibility of national workforces, with positive impacts on productivity, long-term health, and reduced crime.

It is estimated that by 2018, the U.S. labor force will increase by 10 percent, or 15.3 million people. Professional and related service occupations are expected to provide more than half of these new jobs. The professional-and-related-occupations category, which includes artists, is projected to increase by nearly 11 percent. At 11 percent, the projected growth rate for artists is similar to the rate projected for overall labor force growth. However, the artist-employment growth rate lags behind the professional-and-related-occupations category by about 6 percent.

Of the artist occupations, museum technicians and conservators are projected to increase the most between 2008 and 2018 (by 26 percent), followed by curators (23 percent). The occupations within the artist categories that are likely to increase at the average rate of the labor force are fine artists, such as painters, sculptors, and illustrators (12 percent); music directors and composers (10 percent); producers and directors (10 percent); and commercial and industrial designers (9 percent).

Around the globe the growth trend is seen as well. In the United Kingdom, the creative and culture industry is rapidly growing and providing economic impacts as well. There, the arts and cultural sector accounts for approximately 0.4 percent of the nation's GDP. The industry is estimated to support an aggregate approaching 300,000 full-time jobs or 1.1 percent of total UK employment. The arts and culture industry salaries are nearly 5 percent more than the country's median salary of £26,095. Furthermore, for every £1 of salary paid by the arts and culture industry, an additional £2.01 is generated in the wider economy through indirect and induced multiplier impacts. The role that arts and culture play in supporting commercial creative industries is estimated at close to 5 percent of UK employment, 10 percent of UK GDP, and 11 percent of the UK's service exports. Arts and culture play a significant role in supporting these industries.

The phrase "creative and cultural industry" captures a variety of different but related industries, as shown in Exhibit 1.2. It includes not just "cultural" industries but also "creative" industries that encapsulate types of software industry growth, such as publishing software, software consultancy and supply, and new media and

computer games. These are industries that are defined by their creative working and by the intellectual property they create. In Europe, it is an aggregate group of industries consisting of a total of 6,576,558 persons or 2.71 percent of the European labor market.

There has been considerable debate over the idea that the industries that constitute the creative and cultural industry can in fact be aggregated. Despite many similarities and interdependencies, the activities of creative and cultural industries need to be understood as separate industries in their own rights. The knowledge requirements, working methods, business and organizational forms, and consumer interfaces that define competitiveness in computer games are, for instance, very different from those that shape competitiveness in the classical fine arts.

THE CULTURAL AND CREATIVE INDUSTRIES: SOME DEFINITIONS AND DISTINCTIONS

Cultural arts management and entrepreneurship resides within an area sometimes referred to as the *creative and cultural arts industry*,[1] a thriving and ever-expanding global and local business sector. It is estimated that in the global marketplace, the impact of this industry exceeded US$1.3 trillion as of 2005,[2] and in many countries the contribution to GDP is considerable, ranging from about 7 percent in the United Kingdom and the United States to nearly 3 percent in Asian countries.[3] Along with its economic contributions, the creative and cultural arts industry also functions as a measure of social and individual well-being and is considered part of the knowledge economy critical to innovation and technology.[4]

Recently, partly as a result of its expansion, there has been a debate about exactly what comprises the "creative" and the "cultural" makeup of this industry. Part of this debate arises from a change in the definition of creativity in this milieu, and how that creativity informs and generates innovation, intellectual property, and economic growth through a knowledge economy. The focus of the *creative industry* is on "those industries which have their origin in individual creativity, skill and talent and which have a potential for wealth and job creation through the generation and exploitation of intellectual property."[5] Given this definition, the cultural arts constitute a subset within the creative and cultural industry as they have been subsumed into it due to overarching creative and cultural policies.[6] However, the cultural arts can often be distinctly identified because they are approached and managed quite differently than the creative industry. The creative industry finds most of its enterprises, which can include nearly any company from advertising to physics, seeking profit or investment oriented under a capitalist-informed umbrella.

The cultural industry encompasses organizations that combine the creativity and intellectual property aspects required in the definition of the creative enterprise, yet produces goods and services differently than the creative enterprise does. The works of *cultural industry organizations* embody and generate symbolic meaning

and use value associated with production.[7] The cultural industry comprises creative arts, music, dance, theater, literature, visual arts, crafts, and new forms of video art and multimedia. The principal purpose of these arts is to generate and "communicate meaning about the intellectual, moral and/or spiritual behavior of the individual and/or the beliefs, values, norms and other expressions of groups in society."[8]

Scanning panoptically and historically around the world, one perceives that the arts that constitute this industry have historically informed societies and played varying roles within their respective cities and organizations, as they do now.[9] In the cultural industry, artists have been the leaders in generating artistic forms while, until recently, relying on patrons or other arrangements for their incomes. Artists were characteristically people who danced, painted, wrote prose and poetry, sculpted, wrote or played music, or otherwise created works that others considered useful. These broad areas slowly grew into organizational taxonomies we know of today as the performing and fine arts, categorized by aesthetic ideology, points which will be addressed in detail later.

One of the issues that we face today, driven by the difficulty of fully comprehending and defining it, is the scope of creative and cultural arts, the conglomeration of the production of creative and cultural arts under measurable categories, and the organizational structures of the creative and cultural arts concern. Part of the problem arises from the ways in which different countries' policies and resource allocation strategies inform creative and cultural arts practices, and the fragmented ways in which they are handled. Questions as to what to include in the category of creative and cultural arts also arise from issues related to aesthetics.[10] Moreover, the creative and cultural industries have been characterized as a conglomeration of *creative clusters* by evaluating the creative and cultural arts enterprises economically in geographic areas. In defining a *creative cluster*, which is helpful for our purposes of identifying precisely how to situate the cultural and creative enterprise, Sparks and Waits suggest that the "creative cluster includes not only the traditional visual artists, cultural performances, and nonprofit institutions, but also large economic sectors such as entertainment, fashion, publishing, and broadcasting, which are among the fastest-growing and most export-oriented sectors of the American economy."[11]

At this writing, the *creative and cultural arts industry* includes a variety of practices, from visual arts to entertainment media, and knowledge sectors, as well as their supporting firms' practices that they influence, and there is a wide range of consideration given to this latter point, which I return to in the next chapter. Admittedly, what constitutes "the arts" has a long controversial history, a story that will unfold as we move forward. However, the boundary of the focus in this book will be the fine, contemporary, and classical performing arts and the ways in which they are distributed and consumed. The creative and cultural arts industry, whether examined in clusters or in larger frameworks, is comprised of goods and services that involve creativity in their production, embody intellectual property, and also convey symbolic meaning, as shown in Exhibit 1.2.

Exhibit 1.2 **An Illustration of the Creative and Cultural Arts Industry**

Multipliers of the Core
Advertising, Fashion, Tourism,
Architecture

**Carriers of Arts Goods and
Services**
Magazines, Display Spaces,
Performance Spaces, Books,
Television, Radio, Film

Ancillary/Supporting Industries
Collectors, Designers, Composers,
Retailers, Promoters, Agents, Publishers,
Record Companies, Distributors,
Suppliers

The Creative Industry Core
Music, Dance, Theater, Literature,
Visual Arts, Crafts, Performance Art,
Video Art, Computer/Multimedia Art

Creative Industry Ideology

In today's economy, all players at the economic table are recognizing that a competitive edge and a creative edge go hand in hand to support economic prosperity:

- Creative and new media industries are growing in number and playing increasingly prominent economic and social roles.
- The market value of products is increasingly determined by a product's uniqueness, performance, and aesthetic appeal, making creativity a critical competitive advantage to a wide array of industries.
- The most desirable high-wage jobs require employees, such as dancers and musicians, with both creativity and high-order problem-solving and communications skills.
- Business location decisions are influenced by factors such as the ready availability of a creative workforce and the quality of life available to employees.

In this environment, arts and cultural resources can be economic assets:

- The arts and cultural industries provide jobs, attract investments, and stimulate local economies through tourism, consumer purchases, and tax revenue.
- Perhaps more significantly, they also prepare workers to participate in the contemporary workforce, create communities with high appeal to residents, businesses, and tourists, and contribute to the economic success of other sectors.

Sources: David Throsby, *Economics and Culture* (New York: Cambridge University Press, 2001); Pierre Bourdieu, *The Field of Cultural Production*, ed. R. Johnson (New York: Columbia University Press, 1993); Chris Hayter and Stephanie Casey Pierce, *Arts & the Economy: Using Arts and Culture to Stimulate State Economic Development* (Washington, DC: NGA Center for Best Practices, January 14, 2009), www.nga.org/files/live/sites/NGA/files/pdf/0901ARTSANDECONOMY.PDF.

Irrespective of debate about the contents and growth of the creative and cultural arts industry, many universities and colleges have formed programs to serve a growing demand for educated arts managers and entrepreneurs. As a result, this textbook is meant to provide methods and information for you to launch, grow, or manage cultural organizations.

THE CULTUREPRENEUR PRODUCER OF THE ARTS

At present, it is important to have a definition of what an arts entrepreneur—sometimes called a *cultural arts entrepreneur* or *culturepreneur*—is and does. According to Hisrich, Peters, and Shepherd, an *entrepreneur* is a person who takes the initiative, bundles resources in innovative ways, and is willing to bear the risk and uncertainty of action, with an eye toward creating value for a product or service.[12] Simply stated, then, for the purposes of this textbook, *culturepreneurs* are "artists undertaking business activities within one of the four traditional sectors of the arts who discover and evaluate opportunities in the arts and leisure markets and create a business to pursue them."[13] However, along with creating art, these creative individuals have the task of managing, marketing, and administering their work. Culturepreneurs may do these kinds of activities themselves, or they may work with others to complete aspects of the *entrepreneurial process*. In order to effectively manage, or get work done through others or oneself, culturepreneurs also engage in planning, organizing, leading, and controlling within the organization.[14] Taken together, these activities will be understood to constitute the broad field of arts management or arts administration or cultural organization management, within an entrepreneurial spectrum. Until somewhat recently, management of firms within the cultural *industry*—which is defined as a group of firms that offer a product or class of products and services that are similar and are close substitutes of each other[15]—has been left unaddressed or handled in ways that have minimized its importance.[16] The point to grasp is that the cultural industries contribute significantly to economic impacts and growth for countries, cities, and nations, and this economic impact is provided through culturepreneurs.

What is also important to note, though, is that the cultural arts have historically been informed by the manifestation of politics, economics, spirituality, and the explicit discussion of these through individual expression. Often, behind the production and consumption of arts are drivers of resistance and complicity. What is meant by this is that today the culturepreneur has emerged onto a new forefront driven by changes in the global economy—reductions of spending by governments, a consumer culture, and new forms of nonprofit and private enterprises. These kinds of changes are the result of a variety of causes, including, for example, the meltdown of the financial markets in 2007 and, at the same time, increases in technology associated with capital flows, electronic arts, and many industry restructurings. However, if we study other points in time and other centers of leading economic growth—that is, geographic locations at which poignant change occurred—we can witness similar flows. It is almost as if it is at these ruptures that art production and consumption capture and deliver humanity.

For example, in France during the pre- and postrevolutionary period of 1848, these kinds of changes were apparent. In Flaubert's *Sentimental Education: The Story of a Young Man*, published in 1869, the reader is shown the vicissitudes of arts management from the points of view of the artists, the managers, and the financial supporter, as well as the political puppetry that artists' works were subjected to. In *The Rules of Art: Genesis and Structure of the Literary Field*, Pierre Bourdieu provides an analysis of arts management in Flaubert's novel. His writing on this subject deserves attention for at least two reasons. First, it provides a historical understanding of the ways in which the macro forces of the industry at the time controlled the micro-level development of arts management and cultural entrepreneurship. Second, it sets forth a historic context through which both arts managers and cultural entrepreneurs may gain clarity regarding their roles and define and redefine them as necessary. In the case when the two constitute separate individuals or entities, digesting this knowledge stresses the need for wisdom to understand the forces guiding the market for creative work, and the tensions, if any, between markets' and artists' points of view. In the case of the culturepreneur coming to or participating in the market, this contextualization additionally provides a framework for positioning and gathering resources to support producing and selling creative work.

A CONTEXTUAL RELATIONSHIP: ARTISTS VERSUS MANAGERS

It is not easy to characterize the friction between artists and their managers. Until recently, and this remains true in some circles, there were two universes—the arts and cultural management—and the choice of which to work in was clear. At the time of the French revolution referred to earlier, one was in either the universe of art or the universe of money, and the twain never met. The artist was not supposed to care about money; that is, a particular level of "disinterest" was a prerequisite for being considered an artist, and in fact the displaying of concern for money disqualified a person from being a true artist. At the time, there was a recasting of what had been an understood mechanism between aristocracy, cultural production, and the artist thanks to the rise of the bourgeoisie, and its tastes and preferences, along with evolving technology. More extensive details on this history will be covered in Chapter 2, under the discussion of fine art. For now, suffice it to say that where there once was a particular vetting process that sanctioned art as well as underwrote it, it was being replaced by market forces and public policy, yielding what Pierre Bourdieu terms "Bohemia and the invention of an art of living."[17] Here, "art for art's sake" forms one pole, seeking to get rid of any market for art[18] and to develop symbolic profits for those artists who are condoned and supported by the wealthy classes; that is, "bourgeois consecration"[19] emerges at the other pole, creating an arts market for commercial art products. To put it more clearly, the popular artists who produced for the market through dealers and managers, rather than bohemians who produced for symbolic disinterested profits unsupported by wealth, were the ones who succeeded financially and reputationally. Bourdieu writes, "One is in fact in an economic world inverted: the artist cannot triumph on the symbolic terrain except by losing on the economic terrain [in the short run], and vice versa [in the long run]. . . . the probable effects of

the properties attached to agents—whether in an objective state, such as economic capital securities, or in an incorporated state, such as dispositions constitutive of the habitus—depend on the state of production."[20]

Moreover, the "development of the press is one index among others of an unprecedented expansion of the market for cultural goods," and, as is the case in many sectors of today's society, the expansion of the printing press afforded many students who were of the bourgeois class the ability to complete their educations without the prospect for career positions. "These newcomers, nourished in the humanities and in rhetoric but deprived of the financial means and the social protection indispensable for taking advantage of their degrees," invented a new society of artists, where "scribblers and daubers predominate" but fascinating shifts were occurring, and aesthetics was being redefined. At the time, the market drove artistic and management success and molded the popular ideal of art, creating yet another schism between those who chose to remain disinterested and those who acquiesced to the art dealers, political positions, and the economics of arts during this period of rupture.[21]

However, it is an audience that consumes and the artist who produces for it that determines any market for art, along with the political environment the arrangement is found in. How an audience is defined can range from patron to consumer, and the market is the mechanism through which art is exchanged. Bourdieu reminds us that it is "in effect the social quality of the audience (measured principally by its volume) and the symbolic profit it assures which determine the specific hierarchy established . . . with it closely corresponding to the social hierarchy of the respective audiences."[22] In discussing the inverse market for symbolic goods such as art, Bourdieu identifies the choices for audience acquisition and artistic production: merchandise that is intended to yield monetary profit arising from supply and demand of nonpure art, *or* signification—that is, the symbolic profit arising from producing "pure" art. Bourdieu concludes that the "principle of differentiation is none other than the objective and subjective distance of enterprises of cultural production with respect to the market and to expressed or tacit demand, with producers' strategies distributing themselves between two extremes that are never, in fact, attained."[23] However, the relationships between these extremes have been historically antagonistic, at least since the middle Renaissance period. Today, though, this kind of tension is giving way, but not quickly because there are arguments about what art is and who decides its aesthetic and economic value.

Yet this is the crumbling and culturally inherited arena in which we find philosophies held by arts managers and cultural entrepreneurs being redefined. The point of introducing it here is to provide a horizon for articulating a direction. One must know where one stands and what choices one is making in these universes. The divides are deeply ingrained and often cross macro-geopolitical spaces, inform political parties, function as sites of memory, and determine financial allocations. Aside from understanding the deeply held points of view of the artist, producers, distributors, and consumers, one must understand which production function is at work given the creative product in question. This makes arts management and cultural entrepreneurship similar yet unique relative to other markets for service products and entertainment. We can refer to these as production cycles that work with existing

demand or production cycles that are created through targeted and selective demand. There are at least four demand factions for the cultural arts: governments, consumers, patrons, and conglomerations of these last three, with each being coupled with supply functions. Moreover, the organizational structure that long held that the arts should be housed under the nonprofit frame is not completely accepted any more. I will turn to a discussion of the choice later in the chapter; this is covered extensively in Chapter 9.

The key for now is to notice that Bourdieu refers to this relationship between the artist and the market as a game in which one must understand the playing field and the rules. The idea is that the general field never changes, but the players and the stakes do. For example, historically an external dealer, such as an agent, has been needed to "consecrate" an artist, whether she or he is seeking symbolic or monetary profit. That set of rules, which existed for a very long time, began to deteriorate with the installation of technology that allowed nearly anyone artistic access to the audience, where demand could be developed. Apple Inc., as an example, is often credited with shifting an entire domain when it leveraged the music industry's mechanism for distribution and purchase of songs and the royalty structure used to compensate

Exhibit 1.3 **Kensington Palace**

(Photograph courtesy of Carla Stalling Walter)

Spotlight: The Royal Ballet of England

The Royal Ballet is an internationally renowned classical ballet company, based at the Royal Opera House in Covent Garden in London. The Royal Ballet was founded on the vision of Dame Ninette de Valois, dancer, choreographer, and entrepreneur. In 1931, she moved her school and company into the Sadler's Wells Theatre in North London. Before then, her dancers had performed at the Old Vic Theatre, so her company was known as the Vic-Wells Ballet. Dame Ninette and her company remained at Sadler's Wells Theatre until 1939 and spent the war years touring widely in Great Britain and, to a lesser extent, in Europe, performing for the Allied troops.

After armistice, in the winter of 1946, her company moved to the Royal Opera House, premiering a new, full-length production of *The Sleeping Beauty*, and reopened Covent Garden as a lyric theater after its war period closure. In 1956, the company was renamed the Royal Ballet as granted by royal charter.

The largest of the four major ballet companies in Great Britain, the Royal Ballet continues to be one of the world's most famous ballet companies. The company employs about 100 dancers and has built facilities within the Royal Opera House. The company structure includes creative directors and staff. In December 2006, Wayne McGregor was appointed the Royal Ballet's resident choreographer. In April 2007, Barry Wordsworth was reappointed music director. Monica Mason became director of the Royal Ballet in December 2002 and was succeeded by Kevin O'Hare in 2012.

The Royal Opera House and Manchester City Council are planning a new development known as Royal Opera House, Manchester. The proposal is for the Palace Theatre in Manchester to receive an £80 million renovation, creating a first-class theater capable of staging productions by both the Royal Ballet and the Royal Opera. The Royal Opera House would take residence of the theater for an annual eighteen-week season, staging sixteen performances by the Royal Opera, twenty-eight performances by the Royal Ballet, and other small-scale productions. The proposals would establish the Palace Theatre as a designated base for the Royal Opera House companies in the north of England, as a producing house for new ballet and opera, and as a training center for all aspects of theater production. It is expected that this effort will create 700 jobs for local people.

Dame Ninette regularly expressed the hope that the dancers she trained at Covent Garden would go out later, like seeds, and create new companies on the same model around the world. However, there is fierce competition at the major dance establishments for excellent dancers. Recently, the Royal Ballet needed to attract an impressive dancer with the ability to be a shining star. It had lost a succession of leading names, including the sudden departure of Sergei Polunin and the loss of two principal dancers, Tamara Rojo and Alina Cojocaru, to the Coliseum. Principal Johan Kobborg, Cojocaru's dance partner, also left

Covent Garden for Bucharest. One of the company's potential star performers, Dawid Trzensimiech, walked out, and then the company's dancing backbone, members of the corps de ballet, called in union representatives, pointing to the heavy daily workloads and difficult working conditions.[24]

As some companies, including the Royal Ballet, try to sell more tickets, directors have chosen to offer familiar, nonrisky, profitable productions such as *The Nutcracker* and *Sleeping Beauty*. But these are not necessarily the exciting new premieres and challenging works that dance artists want to perform. Ballet dancers, unlike opera singers, cannot demand vast salaries, but within a company they gain security, holiday pay, and a pension. However, like opera singers, they work under great pressure and public scrutiny. The most cherished positions, however, become an issue of supply and demand. World-class dancers are few and far between; they can afford to pick and choose where they go and what they will command at the box office.[25]

artists. The popularity of the dissemination dictated the consecration, and it is a long shot to categorize Apple as an arts management company—though according to the definition given above, it is situated within the creative industry. However, although Apple changed the face of music distribution and production forever, it is not the pioneer in this kind of restructuring of the game. Print technology had the same impact when it was spreading across the globe. Moreover, with the increase in technology, there has become an expanding field that encompasses cultural production that seeks to establish it as an attractive marketplace and market space for managers and artists. Here in the twenty-first century, the pure artist is no longer one who aspires to bohemian identity; through their own devices or through an arts management professional, artists are expected to be able to manage their market, their production function, and their technology.

THE CULTURAL ENTERPRISE FRAMEWORK

Another premise that informs the culture industry is the normative belief that government should fund the arts, in the vein of the art-for-art's-sake mentality carried over from the nineteenth century into the present. It is important for artists, arts managers, public policy makers, marketers, or cultural entrepreneurs to engage with leading an arts organization without an assumption that they *should* be funded by a government purse. Government support for the culture industry exists to the extent that it represents "government's demand" for them. In other words, governments that establish cultural premises giving priority to funding the arts are integral to having them underwritten. Importantly, though, the choice is not necessarily a prerequisite for leading successful arts organizations, nor for producing art. Given this premise, we can actually lay aside assumptions of normative and positive economics as a rationality in funding, a discussion to which we will pass in a few moments.

For now, instead of assuming that government is supposed to fund cultural organizations, take it as given that arts are produced and managed in a dynamic environment, regardless of what underlying political and economic structure supports them. An exigent movement from this mind-set of a natural relationship between the arts and government support is needed to fully engage in producing, understanding, and leading successful arts practice and organizations—regardless of whether they are structured as a not-for-profit entity. But where did the notion of government funding for the arts come from? We often hear that many countries fund the arts, and in fact some of them do. How the cultural arts are funded depends on a great deal, and it manifests differently from country to country and wanes and ebbs depending on the situation.

The model of the arts as funded by government has not been a given over time, nor have artists expected government to underwrite them. Our current ideal of a government-funding model for the arts here in the United States stems from England and those who interpreted John Maynard Keynes's economic policies.[26]

In Europe, we find a central figure in England influencing and shaping the cultural industry funding model as we have come know it. At the time when England formed the Arts Council of Great Britain, ballet mistress Ninette de Valois, the head of the Royal Ballet and a savvy culturepreneur in her own right, though she may not have called herself that, espoused that it was a foregone conclusion that government should fund the arts.[27] One key individual who was a part of that Arts Council, a patron, and a consumer of arts was economist John Maynard Keynes. Since that time, many governments small and large have followed England's lead in implementing cultural policy. Britain's Arts Council model, with the help of a terribly long and protracted economic depression in the 1930s, has become the benchmark for advocating government support of cultural organizations.

As such, understanding the cultural sector from a broad view of the terrain requires understanding of (1) a firm's structure, (2) economic theory, (3) public policy, and (4) consumer behavior theories, as these four areas are applied to the arts. These categories are especially important as the techno-globalization of culturepreneurship is rapid. Therefore, public policy, economic theory, and consumer behavior theory frame the stage that an arts producer, manager, and cultural entrepreneur act upon. In the ensuing sections, each of these areas is described in order to situate an arts organization as it functions in today's world.

THE FIRM'S STRUCTURE

The typical reason for setting up a nonprofit structure in the United States is to allow for tax-deductible donations, contributions, and sponsors, along with state and federal tax-exempt status if applied for. Because of the restrictions on not-for-profit organizations, such as the disposition of funds remaining after paying expenses, some organizations elect to establish for-profit arms or separate enterprises for particular practices that are ancillary or complementary to the art itself. Making contributions and receiving matched funds from other granting organizations can also motivate selection of a not-for-profit structure. Plus, the idea of not

paying taxes on profits is also attractive. Leaders of nonprofit organizations, who are shielded from liability as another benefit, must be able to show how they spent the company income. The other aspect of deciding upon a not-for-profit structure is perception. Many people perceive that this structure is not self- or investor-focused; and the output of the firm is not driven by a profit motive. Rather, by definition, the mission is driven by a cause of some sort. However, make no mistake: a not-for-profit firm may deal with billions of dollars, and the stakeholders may be compensated well. In addition, there may be many layers of federal, state, and local compliance measures required to maintain the not-for-profit tax-exempt status. And there is a good deal of procedure required in order to establish this kind of organization.

As opposed to a nonprofit organization, one can elect to establish a for-profit entity, choosing from many alternative structures ranging from simple to complex—a sole proprietorship, a limited partnership, or a corporation with variations on the last two. Such an entity supports certain types of arts entrepreneurs and artistic companies, such as art galleries and studios. For example, culturepreneurs can establish a low-profit limited liability company (L3C), a benefit corporation, or a flexible purpose corporation (FPC). The choice of firm structure will depend on the arts organization's goals, objectives, and mission, and whether its owner/founder seeks to operate in a for-profit, not-for-profit, or blended financial environment. A full discussion of the choices available is included in Chapter 9 of this volume.

CULTURAL ECONOMIC THEORY

The culture industry finds itself married to economics. Four areas of economics inform the production of the cultural arts: determining if the arts output is produced within a "failed market" and deciding if it is a merit good, a public good, or a social welfare good—or all three. Our discussion begins with John Maynard Keynes. One of Keynes's biographers, D.E. Moggridge, devotes an entire chapter to Keynes's involvement and interest in the arts. We learn that Keynes's leadership was instrumental in the establishment of the Arts Council of Great Britain, and he influenced a state-funded ballet in England, the Royal Ballet. He sat on the board of trustees at Covent Garden, where the Sadler's Wells Ballet was housed, and he was the treasurer of the artistic group known as the Camargo Society.[28]

Aside from his involvement with the Arts Council of Great Britain, Keynes is credited in the economic literature with challenging prevailing views of classical economics, or what is referred to as the *laissez-faire* policy of the 1930s that contributed to the Great Depression.[29] The Keynesian solution to the so-called imperfect markets that caused unemployment and the economic depression it generated required specific macro-level spending. In the main, it meant that government revenues and expenditures, or fiscal and monetary policies, were needed to increase aggregate demand and investment. Application of such changes would turn the economy around.[30] Debates about Keynes's assertions abounded at the time of his publication of *The General Theory of Employment, Interest and Money* in 1936 and continue today.

In the 1936 publication, the culture industry was not directly named as a beneficiary of this type of solution for its market failure—that entrepreneurs would not produce the cultural arts because of the fact that they do not typically generate sufficient profits. However, savvy artistic directors and proponents of the art form quickly adopted Keynesian solutions. Huntington has argued that artistic directors and professional ballerinas were influential in shaping Keynesian economic theory due to their direct experience with "market failures" in England.[31] Governments in the United States and Canada remained aloof from such applications of Keynesianism and couched relevant expansion spending within broader schema of national identity. Keynes theorized that aggregate demand stimulation via government intervention, consumer spending, and investment could reduce rampant involuntary unemployment. He further argued that this solution would provide investors with favorable incentives and a measure of security.

Keynes's theories have received a great deal of interpretation from economists, but there was a growing tendency in the 1970s through the 1980s to abandon Keynesian economic theory in explaining what was occurring in the general economy at the time—for example, unemployment, inflation, extreme and precarious business cycles.[32] Aside from the criticisms leveled against the applicability of his ideas over time, it is important to realize that Keynes's General Theory did not explicitly posit that government demand for the arts was necessary. Still, culturepreneurs who looked to Keynesian principles to support their arguments for funding relied upon a government demand structure that was not initially established for the purpose of aiding the arts industry.

In regard to the silence of the Keynesian economic literature on the subject, Mary Clarke, in a statement describing Keynes's relationship to Ninette de Valois and the Arts Council of Great Britain, quotes de Valois as saying, "Keynes . . . was very largely responsible for the subsequent extension of the now accepted principle of the need for Government support for the arts."[33]

As an equivalent of Great Britain's Arts Council, the National Endowment for the Arts (NEA) was established in the United States as part of the National Foundation on the Arts and the Humanities Act of 1965.[34] The NEA's grant-making ability is dependent on congressional appropriations and private donations, and the founding legislation sees the responsibility for funding the arts as a matter for private expenditure but also a federal matter in terms of American nationalism, and hence the language is in line with nationalist and social criticism externalities. It is not statutorily mandated that funds be given to arts organizations as in the case of Canada or Germany, for example. While the overall trend in the United States between 1963 and 1976 had been to increase funding of the cultural arts, this trend reversed and declined beginning in 1990.[35]

What should be noted is that the arts councils were founded first on the grounds of a particular felt need in nationalist movements and social criticism and that the councils were characterized as positive externalities which benefit the government, not arts organizations. That arts organizations benefited from these federal efforts is secondary. The creation of arts councils and public support for the arts grew out of a "felt need" for national identity during the post-World War II era, but this felt need

had not sufficiently transferred into a felt need of the consumer—not, at least, until recently with the emergence of the creative industries.

With this knowledge of Keynesian scholarship, one could say it dances through arts management history beginning in the 1930s. Keynes mentions nothing of his involvement with the arts and he does not make mention of the applicability of his theories to them, but his actions, documented by his biographer and others even if in passing statements, do. Economists writing about Keynes's demand theory discuss the theory's strengths and weaknesses related to government spending but do not apply the theory to the economics of arts.

Keynes's failure to speak directly about government funding of the arts has had some serious consequences. People have *assumed* he believed that government should fund the arts, and this has become a conventional wisdom of sorts. This assumption is open to interpretation. While many arts organizations are structured in a not-for-profit system, financing the arts can come through several sources. Government funding is an option, not a right, nor a natural law of cultural economics.

Certain arts have not only been described as market failures, but also as *merit goods*; that is, goods that require governmental financial assistance to be produced because society members do not generate sufficient demand to support the industry in a market economy. Viewed differently, such an argument forms the basis for imposing preferences or tastes of one group (e.g., government) on others (e.g., the community) as opposed to having tastes arise from market or nonmarket demand.[36] In many countries, including Canada and the United States, this argument was used to pay for cultural products couched in a national identity framework to establish public subvention.[37] The other viewpoint espoused under the auspices of support for merit goods—government support of the arts—is a "normative" one resting on a value judgment that art is good for us. Either way, merit goods arguments are problematic in the marketplace because they perpetuate oversupply inasmuch as merit goods are provided because governments think constituents should consume them.[38]

As an alternative, *social welfare economics* developed during the interwar period between 1919 and 1939, during which time unemployment and economic depression were rampant. Welfare economics refers to the study of improving the economic welfare of a given society as a whole.[39] Public funding programs for arts fall under the broad heading of welfare economics, as do economic behaviors that generate negative externalities, such as less than favorable impacts to the environment resulting from capitalist production. However, positive externalities that the government promotes, such as arts and education, exist as well.[40] Since the market generally will not provide them due to the lack of accumulated profit to be had, governments adopt them into their social welfare policies.

The fact is that many culture organizations have been characterized, assumed *a priori*, as residing in an industry comprised of companies that cannot cover costs from receipts alone. On the other hand, to completely require that the arts assume economic responsibility for viability would be an example of jeopardizing a positive externality, an overarching benefit to society, and this is the argument that is often used to perpetuate government funding.[41] Of course, not all cultural economists agree with this point. Throsby and Withers systematically refute all positive

externality arguments as being an insufficient basis from which to build support for the notion of public funding. The only argument in favor of the positive externality effect that they support is that of national identity and social inquiry. They write:

> We can recognize, using the conventional economic criteria provided by economic analysis, that the major area in which there may be some *a priori* basis for justifying resort to public assistance for the . . . arts is that of collective social benefits, particularly in the areas of national feeling and social inquiry. Such assistance would be independent of, and not justified by, any cost-revenue financial squeeze facing arts firms.[42]

In the United States, support for the arts has been historically given in a not-for-profit frame, while in other countries the picture is different. One of the reasons given for providing government support is that, without it, no business entity would supply support because the profits are too small. And if there were no businesses to bring the arts to the market, society would suffer. In other words, a society without the arts is not what is desired. This leads us directly to the discussion of public policy and the arts.

PUBLIC POLICY AND THE CULTURAL INDUSTRY

To examine aspects of funding the arts with respect to government directives and private patronage in the United States, one looks to public policy. Before proceeding, it is worth discussing the notion of patronage here. *Patronage* will be defined as quantifiable, tangible money or liquid or semi-liquid assets given to not-for-profit or blended arts corporations for expenditure or use for an artistic or administrative function. Moreover, what is given can be counted in some way against federal tax liability. This definition of patronage focuses on contributed revenues, either from individuals or corporations. Patronage includes sponsorships from companies who contribute money in exchange for publicity and advertising space, companies that contribute money through a foundation subsidiary that they own wholly or in part, and individuals (including artistic directors who donate cash, board members who "pay dues," and all manner of cash donors), families, and/or their family foundations that contribute to cultural organizations either through direct cash donations, granting procedures, or endowment funding.

Patronage in the United States as it affects arts organizations can find its origins with the Ford Foundation, founded in 1936.[43] Henry Ford and his son Edsel Ford bequeathed stock to the foundation in their wills, and Edsel Ford gave $25,000 to the foundation that could be used while he was alive. At the time of their deaths in 1947 and 1943, family controlled foundation assets were estimated at approximately $417 million.[44] More will be said about patronage in Chapter 12.

Cultural public policy scholarship addresses the cultural economics that informs the cultural arts. It is from within writings on public policy scholarship that the arts continue to be positioned as a nonprofit venture. In describing public policy for the arts, Lowry writes:

> Public policy in the arts is the sum of private and governmental interests (of which individual patrons, corporations, and national and local arts councils are examples) with particular or general values in mind. Advocacy [of public support] is any argument, action, publication or coalition promoting increased contributed income for the arts.[45]

While Lowry explains why public subsidy applies intrinsically to the arts, Hendon clarifies how it is determined that arts organizations continue to receive public subsidy. In this regard, he refers to "market failure" as the source of such determination:[46]

> For public monies to be used for arts subsidies, we must be able to show either that the public interest will be served directly or at least that the special interests served are widely accepted as desirable social objectives. "Market failure" applied to the arts is really [saying that] demand for (certain) arts ought to be greater, or supply ought to be greater or better in certain markets. Actually, in some instances, the market is not failing; rather it is simply not providing the market solutions desired by those who tout the widespread merit of the arts.[47]

What is important is Hendon's suggestion that the issue is not with continuing to provide public subsidy but rather that the market—lack of demand—is the problem with the arts and this is why the arts continue to receive public subsidy. The viewpoint is that the existing policy translates into a continued subsidy and is crippling for other needs that also require funding. Demand management from consumers and patrons could substitute for the lack of government demand, thus eliminating the need for continued subsidy.

Policy issues come into play when defining the creative and cultural industries. As was mentioned at the beginning of the chapter, the funding mechanism for the creative industries tends to reside in a for-profit structure, with firms that produce many different types of creative products that in turn produce intellectual property. Governments are keen on adapting growth of the creative sectors because they contribute significantly to economic growth. Importantly, the innovation and intellectual property they generate can be counted as investment and used to develop competitive advantages within nations. With the march forward of globalization and technological changes, creativity is key to growth, and countries develop creative and cultural industry policy that dictates what kinds of resources are allocated to them.

In any event, in each area, the creative and the cultural industries, there has been a turn toward a focus on the consumer. This is due to the fact that supply does not make its own demand, so being able to understand consumers or develop them for your goods, services, and ideas becomes paramount.

CONSUMER BEHAVIOR

With the focus having rested for so long on public support and the economics of supplying the arts, the consumer was neglected. Some of this lack of focus was due to the underlying tension between arts and money, and the art-for-art's-sake mentality

that railed against advertising and marketing the arts to consumers. Advertising in the United States has been in existence as an industry since the early nineteenth century. It is a primary competitive weapon used to protect and expand market shares and to establish and maintain customer brand loyalty.[48] In the arts, a change in advertising and consumer behavior was motivated in part by the dwindling audiences and the need to expand them, reduced government subsidy, and policy changes when there was little in the way of information to guide arts managers in advertising to attract consumers to the arts.[49] Tibor Scitovsky, an economist who is critical of the U.S. structure of demand for arts, wrote "What's Wrong with the Arts Is What's Wrong with Society" in *The Economics of the Arts* in 1976. He said:

> Economists . . . know almost nothing about the motivation of consumers. . . . Probing into consumer behavior should give economists a better understanding of what harmony between consumption and production really signifies.[50]

He concludes that while economists are astute in modeling income and prices related to consumer choice, the economists' view of the consumer is really unsatisfactory,[51] because they take consumer tastes as given. Since the economists offered no real satisfactory effort in defining or assessing consumer behavior, one was forced to look to other disciplines for answers. As a result, over the last thirty years, a vast body of research and literature regarding consumer behavior and the cultural industry has developed.

One discipline that does research and attempts to understand consumer behavior is anthropology. Anthropologists Berry and Kunkel propose a marketing theory methodology that could be used to analyze consumer behavior. They begin by arguing that consumer theory has to do with behavioral consequences and relationships between people and their activities, along with analysis of demographic data and cognitive learning responses. Their point is that studying the behavioral aspects of people can provide an understanding of consumer tastes. Moreover, they argue that arriving at an understanding of consumer behavior—and therefore tastes from a marketing standpoint—requires that the level of analysis be with the individual consumer.[52]

In order to both understand and develop this kind of theory of consumer behavior, three bases are needed. First, a model of a consumer needs to be developed, then an understanding of that consumer's relationship to her social context must be determined, and, finally, the method that will lead to an ability to predict a given individual's behavior has to materialize.

Approaching the subject of consumer behavior a bit differently, the anthropologist and economist scholarly team of Douglas and Isherwood reviews theories wherein consumption behavior becomes an end product of one's useful work or the result of creating a supply.[53] In other words, consumers are looked upon as the producer's puppets to increase available goods for mere living or as automatons who work merely in order to consume and contribute to corporate profits. No contextual social meanings materialize according to this definition. Therefore, the authors establish a model wherein consumption is linked to culture. In the end, they believe

that consumption decisions are moral judgments about how people should behave in given social arrangements. Chapter 3 will return to this topic in an in-depth discussion of the anthropology of consumption.

With this model of consumption in mind, Douglas and Isherwood propose that goods are not acquired for subsistence or show or as ends in themselves. Rather, goods make culture visible and stable while they massage social relationships. Consumption of goods carries meanings when considered as part of a total social framework, and all goods, whether they serve physical needs or admit one to a ballet performance, perform this type of work. Goods, moreover, identify these meanings through what Douglas and Isherwood define as marking services that carry value through social contracts between consumers.[54] We need to get closer to the conditions for getting and giving marking services to be able to analyze changing tastes in economic terms. Marking services provide clues to onlookers about one's social position and relationships within a society or group. Goods purchased support that position and those relationships, and this is where the focus on the consumer of the arts should rest.

That was not the conventional wisdom, as economist John Kenneth Galbraith was known to say. In his classic *The Affluent Society*, published in 1958, he reflects upon, among other things, criticisms about economics. His comments are couched in a frontal attack on conventional wisdom in capitalist societies which he characterizes as relying on ways of thinking that do not allow for clarity or new ideas. Moreover, ideas are adhered to because of vested interests in them. He writes:

> But perhaps most important of all, people approve most of what they best understand. As just noted, economic and social behavior are complex, and to comprehend their character is mentally tiring. Therefore we adhere, as though to a raft, to those ideas which represent our understanding. This is a prime manifestation of vested interest.[55]

What is important for this discussion is that Galbraith identifies Keynes as a rebellious thinker who devoted significant intellectual consideration to the concept of demand. He notes that Keynes defined demand as falling in two categories: those needs that we feel no matter what our situation, and those that are used to make us feel superior to our fellows. Although Keynes's demand theory, Galbraith asserts, was able to attack and perhaps solve the problem of cyclical economic depression and its resultant unemployment through government spending, he has not been heard on the issue of two types of human needs:

> Keynes observed that the needs of human beings "fall into two classes—those needs which are absolute in the sense that we feel them whatever the situation of our fellow human beings may be, and those which make us feel superior to our fellows." However, on this conclusion, Keynes made no headway. In contending with the conventional wisdom, he, no less than others, needed the support of circumstances. And in contrast to his remedy for depressions, this he did not yet have.[56]

Galbraith further suggests that consumer demand in the arts has conventionally been reserved for those consumers who feel superior to others in social contexts and marking opportunities. He goes on to state that advertising and salesmanship are the chief methods of want creation—the manufacture of demand especially for wants that did not previously exist. In order to manufacture demand, the path for expansion of consumer demand must be accompanied by expansion in a given industry's advertising budget. Not insignificantly, he notes that

> advertising is not a simple phenomenon. It is also important in competitive strategy and want creation is, ordinarily, a complementary result of efforts to shift the demand curve . . . or to change its shape by increasing the degree of product differentiation. . . . It should be noted . . . that the competitive manipulation of consumer desire is only possible . . . when such need is not strongly felt.[57]

In this vein, Andreasen notes that there was not a strongly felt need in the arts, and Galbraith provides strong opinion about the ability of marketing and advertising to affect demand positively when there is no strongly felt need. Today, as the expanding cultural industry attests, a positive shift in consumer demand for the arts has occurred. Marketing and advertising can further develop such needs as research undertaken specifically for understanding consumer preferences and tastes, as Galbraith asserts, and such needs are linked to consumer behavior. Consumer behavior and marketing research, as aspects of managing an arts organization and assessing "felt need," will be covered in depth in Chapters 6 and 7.

CHAPTER SUMMARY

This chapter has defined the creative and cultural arts industries and given an overview of the relative growth of the sector. Within this discussion, the scope of the textbook was defined, with the focus on the cultural arts as they have historically been defined and guided by culturepreneurs and arts managers. Importantly, a brief history of the tensions between artists and managers was touched upon. Today, the artist and the arts manager have been given space to work together in managing the company. In today's world, a cultural organization can exist in a for-profit, not-for-profit, or blended arrangement of the two, using newly created forms of corporations. Economic policy arenas in which the cultural enterprise operates in the United States was explained, noting the Keynesian history that forms its backdrop. In contrast to the government demand supported by these historical frames, the need to understand consumers and their behaviors was introduced.

The next chapter will explore the notion of aesthetics, culture, and meaning. A historical brush of the fine and performing arts is given, with the eye toward defining these fluid concepts and giving the arts manager and artist alike an overview of the cultural arts. The next chapter also discusses and frames the notion of contemporary visual, popular culture, and electronic arts, while setting the stage for presenting festivals.

DISCUSSION QUESTIONS

1. Explain, in detail, the differences between the cultural and creative industries. Do you think there is a need to distinguish between them in organizing and running the arts organization? Why or why not? Support your answer with examples.
2. Explain the economic context in which today's cultural enterprise resides. How does this contrast with an art-for-art's-sake positionality? Is there ever a time when an art should be produced without regard for demand? Supply several examples that support your response while refuting the belief that government should fund the arts.
3. Is it necessary to cultivate consumer demand for the cultural arts? Why? What are your viewpoints on this?
4. What are the three critical ways to distinguish a cultural good or service from a creative one? Please list three distinct firms that produce cultural goods, and three distinct firms that produce creative ones (six firms total). Can you point to a firm that produces both?
5. Is Apple Inc. a creative or cultural firm? Explain.

NOTES

1. David Throsby, "The production and consumption of the arts: A view of cultural economics," *Journal of Economic Literature* 32, no. 1 (March 1994), 1–29; Colette Henry (ed.), *Entrepreneurship in the Creative Industries: An International Perspective* (Northampton, MA: Edward Elgar, 2007); Susan Galloway and Stewart Dunlop, "A critique of definitions of the cultural and creative industries in public policy," *International Journal of Cultural Policy* 13, no. 1 (2007), 17–31; Ruth Towse, "Managing copyrights in the cultural industries," paper presented at the Eighth International Conference on Arts and Culture Management, Montreal, Canada, July 3–6, 2005.
2. Henry, *Entrepreneurship in the Creative Industries*.
3. Ibid.; Centre for Economics and Business Research (CEBR), *The Contribution of the Arts and Culture to the National Economy*, Report for Arts Council England and the National Museum Directors' Council (London: CEBR, May 2013).
4. Erin Sparks and Mary Jo Waits, *New Engines of Growth: Five Roles for Arts, Culture, and Design* (Washington, DC: NGA Center for Best Practices, 2012), www.nga.org/files/live/sites/NGA/files/pdf/1204NEWENGINESOFGROWTH.PDF.
5. Galloway and Dunlop, "Critique of definitions," 20.
6. Ibid.; Nicolas Garnham, "From cultural to creative industries: An analysis of the implications of the 'creative industries' approach to arts and media policy making in the United Kingdom," *International Journal of Cultural Policy* 11, no. 1 (2005), 15–29; Andy C. Pratt, "Cultural industries and public policy: An oxymoron?" *International Journal of Cultural Policy* 11, no. 1 (2005), 31–44; Stuart Cunningham, "The creative industries after cultural policy: A genealogy and some possible preferred futures," *International Journal of Cultural Studies* 7, no. 1 (2004), 105–115.
7. David Throsby, *Economics and Culture* (New York: Cambridge University Press, 2001).
8. Galloway and Dunlop, "Critique of definitions."

9. James Elkins (ed.), *Art History versus Aesthetics* (New York: Routledge, 2006); Pierre Bourdieu, *The Rules of Art: Genesis and Structure of the Literary Field*, trans. Susan Emanuel (Cambridge: Polity Press, 1996); National Endowment for the Arts (NEA), *How Art Works: The National Endowment for the Arts' Five-Year Research Agenda, with a System Map and Measurement Model* (Washington, DC: NEA, September 2012).

10. Simon Roodhouse, "Creative industries: The business of definition and cultural management practice," *International Journal of Arts Management* 11, no. 1 (Fall 2008), 16–27.

11. Sparks and Waits, *New Engines of Growth*, 7. The idea of clustering is taken from Michael E. Porter's *The Competitive Advantage of Nations* (New York: Free Press, 1990). See also Mercedes Delgado, Michael E. Porter, and Scott Stern, "Clusters and entrepreneurship," *Journal of Economic Geography* 10, no. 4 (2010), 1–24.

12. Robert D. Hisrich, Michael P. Peters, and Dean A. Shepherd, *Entrepreneurship*, 8th ed. (New York: McGraw-Hill/Irwin, 2010), 6.

13. Andrea Hausmann, "German artists between bohemian idealism and entrepreneurial dynamics: Reflections on cultural entrepreneurship and the need for start-up management," *International Journal of Arts Management* 12, no. 2 (Winter 2010), 17–29.

14. Chuck Williams, *Management*, 7th ed. (Mason, OH: South-Western Cengage Learning, 2013).

15. Orville C. Walker Jr. and John W. Mullins, *Marketing Strategy: A Decision-Focused Approach*, 6th ed. (New York: McGraw-Hill/Irwin, 2008), 85.

16. David Cray, Loretta Inglis, and Susan Freeman, "Managing the arts: Leadership and decision making under dual rationalities," *Journal of Arts Management, Law, and Society* 36, no. 4 (2007), 295–313.

17. Bourdieu, *Rules of Art*, 54.

18. Ibid., 81.

19. Ibid., 72.

20. Ibid., 83.

21. Ibid., 54, 55.

22. Ibid., 115.

23. Ibid., 142.

24. Vanessa Thorpe, "Royal Ballet vs. English National Ballet: Who will win battle of ballet superstars?" *The Observer (The Guardian)*, February 1, 2014.

25. Ibid.

26. Throsby, "Production and consumption of the arts"; John Kenneth Galbraith, *The Liberal Hour* (London: Hamish Hamilton, 1960).

27. Mary Clarke, *The Sadler's Wells Ballet: A History and an Appreciation* (London: A. and C. Black, 1956); Ninette de Valois, *Step by Step* (London: W.H. Allen, 1977).

28. D.E. Moggridge, *John Maynard Keynes: An Economist's Biography* (London: Routledge, 1992), 577–579. See also Clarke, *Sadler's Wells Ballet*, and Kathrine Sorley Walker, "The Camargo Society," *Dance Chronicle* 18, no. 1 (1995), 1–114, for example.

29. Gregory N. Mankiw, *Macroeconomics*, 4th ed. (New York: Worth, 2000); Michael Howlett, Alex Netherton, and M. Ramesh, *The Political Economy of Canada: An Introduction*, 2nd ed. (Don Mill: Oxford University Press, 1999), 24.

30. Howlett, Netherton, and Ramesh, *Political Economy of Canada*, 23.

31. Huntington, Carla Stalling. "Ninette de Valois, Lydia Lopokova and John Maynard Keynes, III; Economics and Ballet in London 1932–1942," Society of Dance History Scholars: *Proceedings of the Society of Dance History Scholars*, Summer 2003, 55–59.

32. Alain Barrere (ed.), *The Foundation of Keynesian Analysis* (New York: Macmillan Press, 1988); Bradley W. Bateman and John B. Davis (eds.), *Keynes and Philosophy: Essays on the Origin of Keynes's Thought* (Aldershot: Edward Elgar, 1991); Omar F. Hamouda and John N. Smithin (eds.), *Keynes and Public Policy After Fifty Years*, Vol. I: *Economics and Policy* (New York: New York University Press, 1988); Robert W. Dimand, "The development of Keynes's theory of unemployment," in *Keynes and Public Policy After Fifty Years*, Vol. 1: *Economics and Policy*, ed. Omar F. Hamouda and John N. Smithin (New York: New York University Press, 1988); Étienne Mantoux, *The Carthaginian Peace, or The Economic Consequences of Mr. Keynes* (London: Oxford University Press, 1946); and Moggridge, *John Maynard Keynes*, provide only a small listing.

33. Clarke, *Sadler's Wells Ballet*, 196.

34. C. David Throsby and Glenn A. Withers, *The Economics of the Performing Arts* (New York: St. Martin's Press, 1979), 209.

35. Ibid., 150, 209, 210, 211.

36. Ibid., 192.

37. Ibid.; Robert Bothwell, *Canada and Québec: One Country Two Histories* (Vancouver: University of British Columbia Press, 1999); Robert Bothwell, Ian Drummond, and John English, *Canada Since 1945: Power, Politics, and Provincialism* (Toronto: University of Toronto Press, 1981).

38. Throsby and Withers, *Economics of the Performing Arts*, 195, 196.

39. Howlett, Netherton, and Ramesh, *Political Economy of Canada*, 21.

40. Ibid., 23.

41. Bruno S. Frey, *Arts and Economics: Analysis and Cultural Policy* (Berlin: Springer-Verlag, 2000).

42. Throsby and Withers, *Economics of the Performing Arts*, 175, 179.

43. Anne Barclay Bennett, *The Management of Philanthropic Funding for Institutional Stabilization: A History of Ford Foundation and New York City Ballet Activities* (New York: Garland, 1993), 84.

44. Ibid.

45. W. McNeil Lowry (ed.), *The Arts and Public Policy in the United States* (Englewood Cliffs, NJ: Prentice-Hall, 1984), 21–22.

46. Quoted in Joseph E. Stiglitz, *Economics of the Public Sector*, 3d ed. (New York: W.W. Norton, 2000).

47. William S. Hendon, "Introduction," in *Economic Policy for the Arts*, ed. William S. Hendon, James L. Shanahan, and Alice J. MacDonald (Cambridge: ABT Books, 1980), 21.

48. Inger L. Stole, "Advertising," in *Culture Works: The Political Economy of Culture*, ed. Richard Maxwell (Minneapolis: University of Minnesota Press, 2001), 83–106.

49. Alan R. Andreasen, *Expanding the Audience for the Performing Arts* (Santa Ana, CA: Seven Locks Press, 1992), 1.

50. Tibor Scitovsky, "What's wrong with the arts is what's wrong with society," in *The Economics of the Arts*, ed. Mark Blaug (London: M. Robertson, 1976), 6.

51. Andreasen, *Expanding the Audience for the Performing Arts*, 11.

52. Leonard L. Berry and John H. Kunkel, "In pursuit of consumer theory," in *Consumer Behaviour Analysis: Critical Perspectives on Business and Management*, Vol. 1: *The Behavioural Basis of Consumer Choice*, ed. G.R. Foxall (New York: Routledge, 2002), 35–49.

53. This discussion draws from Mary Douglas and Baron Isherwood, *The World of Goods: Towards an Anthropology of Consumption*, rev. ed. (New York: Routledge, 1996), 8, 12, 37–39, 49, 51, 73.

54. Ibid., xxi.

55. John Kenneth Galbraith, *The Affluent Society* (Boston: Houghton Mifflin, 1998), 7.

56. Ibid., 123.

57. Ibid., 127, note 4.

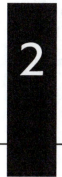

2 Studies in Culture

CHAPTER OUTLINE

LEARNING OBJECTIVES

After reading through the text, and doing the exercises, you will be able to do the following:

1. Define and contextualize aesthetics as a cultural phenomenon.
2. Understand the ways culture and meaning are shaped.
3. Grasp the scope of the classical fine (tangible and intangible) arts to be covered in this text.
4. Understand contemporary visual art.
5. Have a working knowledge of festivals.

6. Recognize the iterative nature of the different platforms on which the fine and performing arts manifest themselves (i.e., in contemporary, popular culture, and electronic arts).
7. Utilize the understanding of studies in culture in framing entrepreneurial approaches to arts and cultural management and production.
8. Comprehend the broad notion of different types of nonfinancial value relative to the arts.

WHAT'S ON?

PillowTV
Jacob's Pillow Dance Festival
YouTube, March 22, 2013
www.youtube.com/watch?v=HXSH3UR3Ec4

SPOTLIGHT: SPIVA CENTER FOR THE ARTS, JOPLIN, MISSOURI, 1939–PRESENT

Exhibit 2.1 **Spiva Center for the Arts**

(Courtesy of Spiva Center for the Arts, Joplin, Missouri)

Originally incorporated as the Ozark Artists Guild, the Spiva Center for the Arts has presented visual arts experiences in Missouri since 1947. George A. Spiva—businessman, philanthropist, and lover of the arts—helped establish Joplin's first art center in 1958. First located in the Zelleken House built in 1893 by Edward Zelleken, the Ozark Artists Guild opened an art center there in 1958. Now, the Spiva Center makes its home in the historic Cosgrove Building in downtown Joplin, Missouri. Founded on the belief that opportunities in the arts should be available to all, the Spiva Center for the Arts flourishes through the generosity of members and friends who share that vision.

The mission of the Spiva Center for the Arts is to celebrate the creative experience by

- promoting the arts and awarding talent in several competitive categories
- showcasing visual, literary, and performing arts
- nurturing creative expression
- offering a myriad of classes and programs to excite and involve students of all ages
- stimulating and educating diverse audiences in the Joplin, Missouri, region
- featuring exhibits in three galleries year-round, including PhotoSpiva
- providing fund-raising and development opportunities

Spiva Center for the Arts provides exhibit and purchase opportunities for the fine arts and enjoys the benefits of a gallery store that supports local artists. The organization itself is structured as a nonprofit, headed by Executive Director Jo Mueller, operated by several staff members, and guided by a board of directors. Some of its funding comes from the Missouri Arts Council, the Community Foundation, Freeman Hospital, and local corporate sponsors. At the same time, the store is arranged as a for-profit entity. You can learn more about the Spiva Center for the Arts at www.spivaarts.org.

SPOTLIGHT: BUYING THE *"TITANIC* VIOLIN" AT AN ART AUCTION

A violin[1] thought to be the one played by Wallace Henry Hartley, the bandleader of the *Titanic*, as the ship sank has been declared genuine following a CT scan at a hospital. Radiographers at BMI Ridgeway Hospital in Wiltshire in the

United Kingdom scanned the violin to examine it from the inside. The resulting three-dimensional digital image was used to validate the violin's authenticity. The instrument was found in a leather luggage case monogrammed "W.H.H." along with a silver cigarette case, a signet ring, and a letter written by the violin teacher who had given the objects to the current owner's mother. On the tailpiece of the violin is a silver plate inscribed "For Wallace on the occasion of our engagement from Maria." Wallace Hartley's fiancée Maria Robinson gave him a violin when they got engaged in 1910, and he took it with him on the *Titanic*. Hartley became part of the ship's legend by leading his fellow musicians in playing as the vessel sank. They are famously said to have played the hymn "Nearer My God to Thee." In the freezing North Atlantic waters, 1,517 people died. Hartley's body was recovered from the water about ten days after the ship sank on April 15, 1912, the violin was strapped to him and therefore was not easily discovered. From a diary entry of Maria Robinson, experts considered it was retrieved from the water in 1912 and returned to her. Then, after her death in 1939, the violin was given to a local Salvation Army and later given to the owner's mother in the early 1940s.

In 2006, auctioneers who specialize in *Titanic* artifacts were approached by the violin's owner, who wanted to find a way to prove the violin authentic in order to sell it. According to Andrew Aldridge of Henry Aldridge & Son, the firm of auctioneers, the CT procedure clarified that the instrument was authentic by allowing examination of the interior and the glue that held the violin together. It is thought that the instrument was in a very heavy leather bag that would have protected it from saltwater damage. And the animal glue that apparently held it together is not affected by cold. Also, the silver plate on the violin indicates its authenticity. The auctioneers spent seven years gathering information that would give them confidence that the violin was Hartley's; they then gave the violin its certificate of authenticity. Auctioneer Alan Aldridge says the violin was the "rarest and most iconic" piece of *Titanic* memorabilia.

However, maritime historian Daniel Allen Butler argues that the violin could not possibly have been recovered from the doomed ship's wreckage. The genuine article would have fallen apart after exposure to the waters of the North Atlantic, he says, and the wood would soon have lost its shine and shape. Other people also doubt whether the violin is the genuine article, believing it could not have survived being submerged in the sea.

Yet the auction in Wiltshire resulted in a sale at a record price of more than £900,000 in just ten minutes. Mr. Aldridge opened the bidding for the violin at £50; the bids soon passed £100,000. It eventually sold for £900,000 ($1,454,000) hammer price, £1.1 million ($1,778,000) including buyer's premium and taxes. The BBC's Duncan Kennedy says the buyer was a British collector of *Titanic* artifacts who has, of course, chosen to remain anonymous.

Despite many remaining doubts as to how any wooden instrument could have survived intact the sinking of the *Titanic* and the subsequent week and a half in the water, somebody was willing to bet $1.78 million on the chance of

its being the real deal. Even so, an elaborate hoax seems at least as possible as its being Hartley's violin. In any case, the circumstances of its life trajectory seem more like a fictional drama than reality.

QUESTIONS

What are your thoughts? Would you have bid for the violin? Why? Are there ethical considerations that need to be evaluated here?

AESTHETICS, CULTURE, AND MEANING

Individuals arrive at providing products and services for, or producing for, the cultural industry from a variety of perspectives and walks of life. Many artists come to the field of arts management with a high degree of specialization in their own art, while some entrepreneurs enter the field without much background in the arts. However, in order to be well-rounded in managing the arts, it is prudent to have an understanding of the history of multiple art forms and how they relate to culture. While many individuals may wind up with a specialization in managing one of the fine or classical performing arts, our rapidly changing approaches to and understandings of the vastly changing variety of arts calls for a broad knowledge base. Therefore, this chapter provides an overview of the historical aspects of fine and classical performing arts.

The discussion begins with aesthetics, culture, and meaning. Next the text turns to framing the fine and classical performing arts in historical context. The focus of this chapter is not to provide in-depth art historical coverage but to give you a brief synopsis of the fine and classical performing arts so that the contextual nature of these in your relationships with customers, dealers, patrons, distributors, and so on will be immediate to your frame of reference. With this orientation you will have a working knowledge of the scope of the arts in a broad frame, and you will be able to be conversant with interested individuals with whom you may work or interact.

Once this historical positioning is given, the next section of the chapter turns to contemporary visual, popular culture, and electronic arts. The chapter concludes with a discussion of festivals, because, as you will see, all of these various arts are subjects ripe for presentations at celebrations that festivals so often bring to light.

DEFINING AESTHETICS

DEFINITIONS

Dictionary.com

aes·thet·ics [es-thet-iks or, esp. British, ees-] noun (used with a singular verb)

1. the branch of philosophy dealing with notions such as the beautiful, the ugly, the sublime, the comic, etc., as applicable to the fine arts, with a view

to establishing the meaning and validity of critical judgments concerning works of art, and the principles underlying or justifying such judgments.
2. the study of the mind and emotions in relation to the sense of beauty.[2]

Merriam-Webster Online

1. a branch of philosophy dealing with the nature of beauty, art, and taste and with the creation and appreciation of beauty
2. a particular theory or conception of beauty or art: a particular taste for or approach to what is pleasing to the senses and especially sight [as in] "modernist aesthetics"; "staging new ballets which reflected the aesthetic of the new nation"—Mary Clarke & Clement Crisp
3. a pleasing appearance or effect: beauty [as in] "appreciated the aesthetics of the gemstones"[3]

Routledge Encyclopedia of Philosophy

1. the philosophy of art

Aesthetics owes its name to Alexander Baumgarten who derived it from the Greek *aisthanomai*, which means perception by means of the senses. . . . As the subject is now understood, it consists of two parts: the philosophy of art, and the philosophy of the aesthetic experience and character of objects or phenomena that are not art. Non-art items include both artifacts that possess aspects susceptible of aesthetic appreciation, and phenomena that lack any traces of human design in virtue of being products of nature, not humanity. . . . The great German philosopher Immanuel Kant presented a conception of an aesthetic judgment as a judgment that must be founded on a feeling of pleasure or displeasure; he insisted that a pure aesthetic judgment about an object is one that is unaffected by any concepts under which the object might be seen; and he tried to show that the implicit claim of such a judgment to be valid for everyone is justified.[4]

Internet Encyclopedia of Philosophy

Aesthetics may be defined narrowly as the theory of beauty, or more broadly as that together with the philosophy of art.[5]

Aesthetics is the subject matter concerning, as a paradigm, fine art, but also the special, art-like status sometimes given to applied arts like architecture or industrial design or to objects in nature.[6]

WHAT IS AESTHETICS?

As may be evident after reading these definitions, when talking about aesthetics, you must keep many aspects of the subject in mind. Coming to an agreement about what

aesthetics is can be difficult. Is it beauty or philosophy? What objects are constituted as aesthetic? How do you know something is aesthetically pleasing? To whom? And who decides? These are just a few of the questions that beg to be answered, and by the end of this section, you will be able to formulate answers to them. Keep in mind that centuries of arguments and theory underpin the field of aesthetics, courses are taught in this subject area, and academic degrees can be attained just in this field.[7] Therefore, the task here is to introduce the subject in a way that makes your role as culturepreneur or arts manager easier.

We start by being aware of the *aesthetic attitude*, that is, a way of seeing with what is known as *disinterest*. Disinterest requires that the individual not receive any personal benefit or goal-directed outcome, with the caveat that engagement with the art occurs for the sake of the art itself. *Aesthetic distance* requires that there is no eroticism, or sensual or moral judgment in one's reaction, and that one has some sense of artistic history. If one adopts an aesthetic attitude toward something, one focuses on the areas that provide an *aesthetic experience*, including revulsion or ugliness, and if this can be done, then whether it is an artistic or nonartistic piece, it becomes an *aesthetic object*. In short, the aesthetic attitude requires leaving aside value judgments and desires for financial or other gain, and being open to receiving aesthetic experiences. If this concept seems a bit frustrating, it has had the same impact on other *aesthetic theorists*, such as George Dickie and Gary Kemp, who were critical of it, noting that the supposed ease of evoking such an attitude is unrealistic.[8] The main point is to be aware of the concepts of aesthetic attitudes and experiences so that they can be woven into your dealings as an arts manager or entrepreneurial art producer.

Aesthetics can be approached from many directions, including philosophy, cultural studies, or anthropology, yet it is often predicated upon different geographic locations and different points in time. In certain spheres, aesthetics is associated with tastes, that aspect of economic choice that is taken as given, as noted in the previous chapter. *Tastes* have to do with likes and dislikes, why people consume what they do, and how they—the consumers and their purchased services and products—fit within society. In still other circles, aesthetics has to do with an appreciation for beauty, or emotion. Each of these aspects of aesthetics and tastes emanate from and span centuries before and after the Common Era. As such, it is best to treat the concept of aesthetics broadly, with an eye toward what the consumers you deal with will think or how an aesthetic attitude about something can be molded. For example, one person may find that occupying an aesthetic attitude is easy when looking at an original Renoir painting but may have difficulty seeing the aesthetics of contemporary art. The idea of the aesthetic attitude suggests that one should be able to suspend judgment while looking at either type of aesthetic object. Failing that, the very idea that one finds one or the other emotionally challenging suggests that this is an aesthetic experience. These kinds of analyses can apply to varying art forms.

Where did these notions of aesthetics come from? Aesthetics is a learned cultural behavior, a categorical way of interpreting art, and this current behavioral analysis has been applied in a retrospective manner to arts from historical civilizations. What we find when we examine the cultural construction of art is that art and its appreciation as a separate entity away from use is relatively new. Thus, when we talk about aesthetics prior to the Romantic period, it is a bit like imagining we can use the

concept of a mobile phone to imagine how individuals felt and perceived each other when they communicated in ancient civilizations. That kind of communication, to our knowledge, did not exist. The point is that when we talk about aesthetics we are talking about how cultures, and subcultures, appreciate and value artistic forms, and for individuals, what their aesthetic attitudes are.

The results of these kinds of defining treatments are productions or stabilizations of social class and the determination of culture.[9] The issue today can be stated thus: who determines taste and aesthetic value? Much discussion has centered around the notion that *aesthetic value* is created by a male, Eurocentric point of view and that aesthetics is very much a social construction reflective of the culture's dominant discourse.[10]

In discussions of the arts, there nearly always circulates, either explicitly or implicitly, a polarization of high and low culture which in turn dominates how the arts are perceived and conceived.[11] The high arts are those consumed because they are defined by learned and acquired taste, religion, or nature, and the low arts are driven by pleasure. This dichotomy can be traced back to the Enlightenment and forward through the notion of Romanticism. At its core, the basis for distinctions between high and low artistic forms resides in political structures and power moves; the authority to judge or arbitrate taste comes through the dominant power. This is one reason for the development of a feminist aesthetics, which argues that different vantage points would give rise to different value systems, which in turn support different aspects of political and power structures. Mary Wollstonecraft is said to have been among the first feminist writers on aesthetics. For her, aesthetics was found in all of nature, combined with the working classes, daily activities, and simplistic living, and she stood against constructions of taste relative to social class and power.[12]

Nevertheless, Romanticism was a period, again like the one we witnessed during 2007, that coincided with tremendous restructuring of work and finance in the industrial period. Since then, this distinction between low and high culture has been entrenched in such a way that it mimics the distance between a civilized society and a primitive one. If one was cultured, one was considered elite and of a certain socio-geo-politico-economic standing. The idea of this kind of culture was to reflect the best of civilized life, the best elements available to see, hear, taste, and live in—a profound experience. In contrast, one could be considered a being of nature, living outside the awareness of or access to these kinds of experiences. The concept of elite culture, attributed to Matthew Arnold,[13] has held the attention of many scholars from diverse disciplines since the idea was introduced. Over time, some have argued that high and low culture simply suggests dominant discourses that are lorded over subordinate groups. Besides this polarizing argument, other writers attempt to parcel humanity into similar cultures, trying to find ways in which we are all similar, as opposed to social engineers who suggest that there is a way to see culture as a separator.[14]

It has been concluded that the distinction is merely found in highbrow and low-brow definitions of culture,[15] or within social class. Some also argue that there is a blurring of the line between the two. I will leave it up to you to assess your beliefs;

however, as an arts manager or an artist, you are certain to blunder if you do not know what you are producing and what your audience is looking for, its tastes, its notions of aesthetics, and how to produce an aesthetic experience, without buying into cultural judgments.

With this in mind, we can say that aesthetics is a cultural phenomenon. And culture can be found everywhere and within it resides meaning. In fact, this meaning is often applicable to a given culture. You may think you have just been walked around a circle. Not at all. Take, for example, the meanings attributed to a holiday dinner and an everyday dinner. In some cultures, the daily dinner means family focus, taking time to prepare foods from scratch, and spending time together. In other cultures, this dinner can mean grabbing take-out on the way home and eating it on the subway, alone in the midst of others, or ordering dinner over the phone, having it delivered, and eating it while watching television or reading social media. For many people, to do anything other than these on a weeknight would be unheard of. At the same time, holiday dinners can vary depending on the culture; for example, the daily fasting of Ramadan can lead to a daily dinner that looks very much like an annual feast. Of course, a holiday dinner for the Fourth of July differs from that of Thanksgiving, and in each of these there is more variation still among subcultural groups. The point is that culture often defines likes and dislikes and dictates behaviors. Culture is a learned phenomenon that is shared by groups and subgroups of people. Culture spans a wide range of topics, from cooking to architecture and from language to fashion and the cultural arts.

CULTURE AND MEANING

Culture is everywhere around us, and something we talk about it in abstract terms. Anthropologists, sociologists, historians, and others talk about culture within their fields of study, and people generally talk about culture as well. You may have heard people say that they want to check out the culture of the organization or that the culture of New York is different from that of Miami. Culture has broad inferences and meanings depending on the context in which it is being used. It has been used to explain the spiritual and intellectual development of civilization in societies and nations over a historic period of time.[16] In this book, however, *culture* in an abstract form will be seen through an anthropological and social lens, to point to attitudes, beliefs, behaviors, and values that are shared among a group of people. In applying this kind of lens to the activities around goods and services in the *production and consumption of culture*, we include those that deal with intellectual, moral, creative, and artistic aspects that generate symbolic meaning, value, and intellectual property, as explained in Chapter 1. With this definition we can describe succinctly, then, cultural goods, cultural industries, cultural institutions, and cultural artists, relating these to an overarching cultural economy, as shown in Chapter 1.

In some sense, it does not matter whether there is a separation between high and low culture because what is important is the meaning people derive from their cultural exposures to art and the experiences they gain from them. By *meaning* I rely on what some have referred to as the notion of signs and what they signify in an

object, or the personal experiences taken from an interaction.[17] Attending a gallery opening of contemporary art, the world premiere of a newly reconstructed ballet, or exposure to digital visual arts can have profound spiritual and personal importance for the viewer.[18] Such experiences can shape attendance at these types of events for lifetimes and generations because the activities provide cultural meaning to the participants and reflect back to them their personal value. Because of this, the arts manager's sensitivity to these kinds of aesthetic experiences and the ability to create, expand, and repeat them are paramount. While artists may be disinterested producers of artistic goods and services, the arts manager cannot be. It is your role to provide movement of the artistic goods and services to buyers and to teach, when necessary, how to consume them. And while it is true that this motive underlies your activities, consumers do not want to have it revealed to them directly. But consumers need to have this aesthetic experience, a sense of emotion and provocation, or sometimes the spiritual experience that art allows.[19]

It has been suggested that consumers receive connection and derive meanings based on tastes and that these tastes are learned predispositions.[20] As was argued in the first chapter, this is the area that economists historically partitioned away from evaluative elements. It boils down to this in all cases, however, that tastes drive many, if not all, decisions and choices around art.[21]

Therefore, for the purposes of the culturepreneur, or arts manager, this discussion has been included here because you should know, on deeply historical levels, from what point you are operating. If you are the artist or arts manager, you ask, "To whom am I presenting my work? Where am I presenting it? Why? What is the historical situation the art emerges from?" The answers to these questions are paramount to a successful enterprise. And in every case, it is true that all artwork deserves respect and appreciation. All artistic forms have value for a given perceiver. Even more poignant is the fact that the answers to these questions need to be clearly answered before staging or hosting any event or performance or establishing an arts-related entity, for that matter. Should you find yourself involved with an organization that does not have answers to these questions, you will want to strategically formulate them in tandem with other stakeholders. Luckily you will learn how as you work through this textbook. That said, it is particularly useful to understand these age-old historical positions circulating around aesthetics and culture, so that you can be knowledgeable, like knowing the family histories of Romeo and Juliet before inviting both fathers to dinner! Because while we do live in a world of technology that is developing and evolving to include more arts through shifting centers of financial leadership and artistic development, culture underlies all of it.

With this understanding of aesthetics, culture, and meaning in mind then, the next section discusses fine, performing, and contemporary arts. Included in the discussion are visual, popular culture, and electronic arts. As with the above discussion of aesthetics, keep in mind that this is an overview, because much of this subject matter lives within a rich and extensive body of literature and analysis. The purpose of providing it here is to give you an overview of these areas of the arts. Many arts managers, and some artists as well, have extensive expertise in one field, but perhaps not another.

THE FINE ARTS

TANGIBLE FINE ART

According to Dictionary.com, *fine art* is "a visual art considered to have been created primarily for aesthetic purposes and judged for its beauty and meaningfulness, specifically, painting, sculpture, drawing, watercolor, graphics, and architecture."[22] Noted economics of the arts authors Heilbrun and Gray suggest that the scope of the fine arts includes painting, sculpture, and "the associated institutions of art museums, galleries, and dealers."[23] The definition of fine art is as fluid as defining culture. In general for our purposes, fine art comprises an aesthetic, not an applied or practical, utilitarian function. Fine art is developed, consumed, and appreciated for beauty and intellectual purposes.

Who creates fine art? The U.S. Bureau of Labor Statistics identifies *fine artists* as those who paint, sculpt, and illustrate.[24]

However, the concept of fine art in our current discourse, the role of the fine artist, and their related distributive institutions have been discussed in many locations that identify them as cultural constructions.[25] In other words, the ideas or the concepts of art, the artist, and the cultural industry as stable categories have not always existed, and at some points in times past, there was no word or phrase for them as we understand them today.

Scholars argue that during the classical Greek era of Plato and Aristotle, the period from about 500 BCE to early 300 BCE,[26] there was no categorical subject area such as art as we know it. The idea of a *disinterested artist* who produced aesthetic creations was disseminated broadly after the Renaissance, in an art-for-art's-sake or nearly religious or at least moral belief system. Before the Hellenistic period there was no such conception as art for art's sake.[27] Rather, an artist was someone who was skilled at a craft and typically commissioned by a patron. That craft could range from sculpting to horse-breaking. The exceptions were poets and speakers, who were not considered artists. The separation between an artist and an artisan did not exist. And at the same time, the notion of separation of the aesthetic from the functional was not conceptual either. Art was built into one's work or service being performed or administered, whether it was religious or civic. Artistry was included and understood as an integral part of life, not set aside for viewing or consuming in isolation. Because of these points of view, there was no need for an art market nor were there collectors. Artists were simply suppliers of goods and services that provided functions for life.[28] They were not set apart from other people as spiritually unique and exceptional, but they were expected to use their imagination,[29] intelligence, and innovation to produce their wares, and these talents were honored as part of their commission.

In the Hellenistic period, that is, between the fall of Alexander the Great (323 BCE) and the rise of ancient Rome (approximately 30 BCE),[30] we have documented what are referred to as the liberal and vulgar arts, also known as free and servile arts. The latter involved payment, while the former were associated with education. Free or

liberal arts were "grammar, rhetoric, . . . mathematical arts of arithmetic, geometry, astronomy and music," while visual arts were considered servile.[31] Nevertheless, the modern system of fine art and aesthetics that we know and reference conventionally today did not come into existence until more than a millennium later. However, before that occurred, the categories of liberal and servile arts would continue to shift and redefine themselves more than once. For example, in the Middle Ages, liberal arts were subdivided into the *trivium* (grammar, rhetoric, and logic) and the *quadrivium* (the "mathematical arts" listed above). Under the mechanical arts, adapted now to be derived from the words "vulgar" or "servile," one could lump nearly all other aspects of human production, including weaving, hunting, medicine, and theatrics, including dance, acrobatics, singing, and music played for wages.[32] Moreover, those participating in the mechanical arts were defined as "artificers," who were commissioned and considered laborers, not "creators," a term that was reserved for God but that would come to identify artists later in history. Both men and women were included in these guild arrangements and were expected to label their work. During this time, aesthetics was not associated with goods and services, but rather its associations relative to enabling functions, religions, or understanding an object's beauty found in nature. The point is that how we perceive aesthetics today in relation to how we define fine art versus crafts does not apply to times past, in the old art, or artificer, system.

We now enter into the Renaissance, from about 1350 to 1600. It is here that we begin to see glimpses of the modern system of fine art that we know in the West. But it will take a tremendous shift for this change from the old system to the modern one to occur. During this time, painting, sculpture, and architecture found a distinguished position, while poetry and musical playing continued to be excluded from this formation. The mechanical and the liberal arts categories remained as they were established in the Middle Ages, with the exception that logic was replaced by poetry in the *trivium* category, and to it history and philosophy were added. You can begin to see how we have come to categorize "liberal arts" in our current society and can probably see that we have entered a period when the liberal arts are coming under revision and question.[33] Be that as it may, during the Renaissance, as in periods before it, there were no cultural classifications or definitions of fine arts. And our modern image of artists who have something deeply imbedded in their spirit or psyche that drives them to "create" did not yet exist either. Artificers generally worked in groups with other artificers, hired by people who paid them under a negotiated contract.

However, during the 1400s, another period of economic expansion when architects flourished,[34] the concept of the artist as one who is deeply inspired arose, thanks to self-reflexivity and the rise of individuality on the part of a small group of Renaissance court artificers, who positioned themselves outside the guilds in terms of wages and rules in order to work freely in the noble courts. Still, however, artificers were payroll employees, or contracted and compensated consultants, who received room and board in exchange for production of goods and services.[35] In general, the idea of an individual creator of art as we know it today was still not common.

However, the Renaissance saw the beginning of a shift in gendered acceptance of the artificer, as men's and women's roles were separated, pushing women to focus on home and children.

The classical fine arts as we adapt them in current parlance were stabilized in France, between 1746 and 1751, and included music, poetry, painting, sculpture, architecture, and dance, with a clear separation from mechanical arts.[36] The concept of an artist as a creator with a divine calling or inspiration and an ascetic, disinterested point of view is located in the nineteenth century and related to the French revolution of the late 1800s. The spiritually motivated artist was a response to rapid economic changes. However, to be spiritually motivated was only one aspect of the caricature of the artist. Artists also had to have above-average intelligence, be perfectionist rebels in seeking freedom of expression, and exercise imagination in delivery. Being disinterested meant that they paid no attention to earnings. "The artist" had been created, and with the march of industrialization, the artisan would succumb to the production market, introducing a protracted arbitrary difference between the two groups. And in this moment, architecture as a fine art was to experience, and in some circles still experiences, a deep conflict between an aesthetic view and a functional practice. Space prevents an in-depth analysis of architecture; however, it is included in many design schools and in specialty fields that comprise it in artistic or entrepreneurial discussion.

The purpose of this section of the chapter was to give an overview of the evolution of what we call the *tangible classical fine arts*. For the remainder of the textbook, these tangible fine arts will be understood to include painting, drawing, watercolor, sculpture, and architecture that provide an aesthetic experience and are outside of contemporary ideas or representations. The reader should be forewarned, however, that tangible "fine art" is an evolving category: nearly anything may be classified as tangible fine art, and anyone can create it.

The next section of this chapter turns to the intangible classical fine arts—theater, dance, symphony orchestra—that is, the classical performing arts, which are different from the tangible classical fine arts, even though at one point in time they were all subsumed into one arts category. Separating the intangible classical arts from the tangible fine arts is sometimes based on the way they are produced and distributed. While the classical fine arts are tangible, shown in galleries and museums or, in the case of architecture, standing as monuments, and can be valued financially with balance sheets, the classical performing arts, in and of themselves, are intangible and generally constitute a performance within a proscenium stage. As shown in Exhibits 2.2 and 2.3, this makes for a very clear dividing line for demarcating them and for delivering, staging, and distributing them as well. The other intangible and tangible fine arts we find in contemporary culture, such as photography, digital animation, and jazz concerts, are discussed later in the section dealing with contemporary visual, electronic, and popular culture arts. However, in this textbook, the intangible classical arts will include those traditionally covered in classical performing arts.

Exhibit 2.2 **Continuum of Fine Arts: Tangible and Intangible**

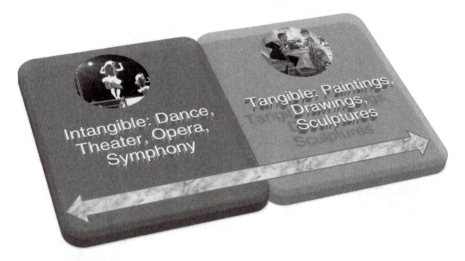

Source: Simona Botti, "What role for marketing in the arts? An analysis of art consumption and artistic value," *International Journal of Arts Management* 2, no. 3 (2000), 14–27.

(*Photographs courtesy of Carla Stalling Walter*)

Exhibit 2.3 **Arts Classification**

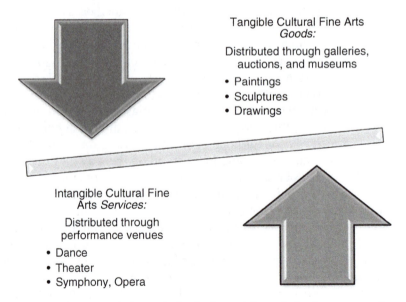

Source: Simona Botti, "What role for marketing in the arts? An analysis of art consumption and artistic value," *International Journal of Arts Management* 2, no. 3 (2000), 14–27.

Classical and Intangible Fine Art

In this text, the *classical intangible fine arts* are defined as theater, opera, choreographed classical and contemporary dance, including modern, interpretive, and ballet, and symphony delivered in a live concert setting; these will be referred to interchangeably as the *classical performing arts* in this text.[37] These arts were categorically created and developed aesthetically in similar fashion as the tangible fine arts. They are evident in locations around the world and follow a similar trajectory of development, arising during the point in time known as the Renaissance, when literature included plays, or operas, and plays included music and dance. Once again, there is the tension between the cultural constructions of tastes for audiences who prefer classical intangible fine arts. For centuries, dance was seen as arousing passions, and in many countries, especially religious ones, dance was forbidden. The classical intangible arts were often used to deliver political messages and dictate behavior, and attendance was determined by social class. Elite performances were distinct from folk or peasant rituals and celebration, and the same high and low dichotomies of taste polarized society. The artists who create classical intangible performing arts are singers, musicians, conductors, dancers, choreographers, actors, and writers.[38]

The classical performing arts rely on the same notions of aesthetic experience, aesthetic attitude, aesthetic distance, and aesthetic disinterest that were described earlier. They also rely on learned *aesthetic behavior* that facilitates a *spiritual aesthetic experience*.[39] Many people have been to a symphony or artistic concert and witnessed applause at the wrong moment. The notion of waiting until the end of a section of music or even the end of the entire concert before applauding originated in 1803, in Weimar, and spread to other learned societies around the world.[40] This convention is currently practiced everywhere. Similarly, who, at a concert dance, has not secretly given a smirk in the direction of an audience member who whistles and shouts at the dancers? The behavior of watching the performance quietly and reverently, then applauding and standing at the end, had to be taught.

In the West, theater, opera, symphony music, and dance gradually became stand-alone intangible classical fine arts, based on tastes and social classes, over a period of time beginning with the introduction of a proscenium stage. One notes carefully that the intangible fine arts have been attended to by humans from at least 2000 BCE, in Africa, Egypt, the Middle East, China, Asia, India, and, in more recent history, what we know to be Europe.

Differently than the evolution of the artist discussed in the last section, it was similar for a time. That is, the work was commissioned and funded by a patron or other sponsor. The way that the classical performing arts were embraced economically varied, however, and the funding models used to fund classical performing arts were stipulated by the governments where they originated or by markets supporting them. Think about Shakespeare's plays and the way in which they were funded. The process was not assumed to be government-supported, and plays were not performed if

they were not funded. In the United States, moreover, a commercial theater is often structured differently from a nonprofit one.

The differences between the intangible and tangible fine arts are many, but one that has been particularly interesting for the classical performing arts is that they were not typically subject to technological economies of scale, and there was no recognizable exchange system available for them. Later in this chapter, a discussion of value will touch on the tangible fine arts and also on the value society places on owning and collecting fine art. But here it is important, from an arts management point of view, to grasp the history of how classical performing arts companies have been characterized economically and to understand performances as an ephemeral and evanescent display: while they can be video-recorded and replayed, one cannot capture the lived experience, by its very nature.

You will learn in more detail later in the text that John Maynard Keynes's idea of deficit spending was introduced, and within it notions of the inherency of wrapping funding of classical intangible fine arts were teased out by arts managers who were eager to find ways to fund them. Why? Because at the time, these kinds of organizations were classified as "deficit-generating" companies: companies that would not generate profits. Operating in the red or grasping constantly for income, their cost structure seemed as if expenses would continue to increase, while economies of scale so valued in industry were considered impossible. Such companies are by definition labor dependent, because even though we have a great deal of technology available to us now and some appreciate it, the "holographic" musician, dancer, or actor did not arouse consumer tastes of the times! Baumol and Bowen coined a term for this problem: *The Cost Disease*.[41] The solution was informed by the wisdom coming from the Arts Council of Great Britain at the time, which supposed that the arts would cease to exist if the government did not fund them. It was predicted that problems facing the classical intangible fine arts would not only persist but get worse and that they would apply universally to all performing arts groups in capitalist, affluent countries, if government did not increase its subsidies.

Baumol and Bowen compared classical performing arts to manufacturing concerns by noting productivity gains in the United States in the twentieth century, based on increases in man-hours. They stated that increases in productivity and efficiencies have allowed a doubling of output every twenty-nine years for manufacturing, but not for the classical performing arts. Baumol and Bowen pointed out ways in which manufacturers were able to generate products by applying capital expenditures, rather than human labor, to increase supply at decreasing costs. Advantages in lowering costs to produce the same or higher quantities of goods resulted from applications of technological advances, and wage and price configurations that would allow for increasing profits. Output was not labor-intensive, but rather capital-intensive. Also, Baumol and Bowen asserted that classical performing arts organizations were labor-intensive, produced a product that was itself laborious, and therefore would never be able to have revenue cover costs, let alone accumulate surplus profits or capital. Baumol and Bowen's study further proposed that the amount of time required to create and stage certain live performances had not changed since

antiquity and that it would never be possible to reduce the time it takes to do so. As they said,

> Whereas the amount of labor necessary to produce a typical manufactured product has constantly declined since the beginning of the industrial revolution, it requires about as many minutes for Richard II to tell his "sad stories of the death of Kings" as it did on the stage of the Globe Theater. Human ingenuity has devised ways to reduce the labor necessary to produce an automobile but no one has yet succeeded in decreasing the human effort expended at live performance.[42]

Moreover, the study stated that as a capitalist society became more affluent— a result of increased technological advances and application of capital rather than human labor—the increase of affluence in the general economy would attract away those who might have been interested in careers in the performing arts in pursuit of higher incomes and quality of life. For all these reasons, Baumol and Bowen argued that rising deficits in the performing arts would be inevitable and that therefore significant and continuing government support was necessary if performing arts were to survive as an industry in capitalist countries.

Baumol and Bowen's 1966 work seemingly sealed the fate of classical performing arts organizations. The authors' findings and hypotheses were accepted nearly without question or objection for a long time. There was such a general acceptance of the cost disease for classical performing arts organizations that this assumption virtually went unchallenged, absorbed into the conventional wisdom and accepted as a natural phenomenon.

Certainly Baumol and Bowen's research was seen as groundbreaking and comprehensive at the time of publication and was instrumental in forming and finalizing the National Endowment for the Arts and Humanities. Simply said, the study stated that classical performing arts companies had to receive increased government funding *because* they generate deficits, as artists operated in an art-for-art's-sake world. Increased government expenditure, therefore, was the only solution considered.

However, Baumol and Bowen's conclusion had several limitations. For one, the study precluded any deficit reduction arising from increased demand by consumers, and it did not anticipate the degree to which technology and different modes of distribution can provide economies of scale and at the same time heighten or reproduce consumers' aesthetic experiences when watching from remote locations.

Scholars later theorized that there were two other means of closing income gaps and reducing deficits that Baumol and Bowen did not consider.[43] One involved increasing government, consumer, and patron demand. The other approach lay in managing the supply of performances. As to the first means, support for it was found in the work of noted scholars C.D. Throsby and G.A. Withers. In *The Economics of the Performing Arts*, they made the following criticisms regarding the analysis of the demand and supply functions:

> This conclusion [the cost disease] has been the prevailing proposition in economic analysis of the performing arts ever since it was developed by Baumol

and Bowen. And the model must be accepted as a useful starting point for examining the cost side of live performing arts actively over time. But the Baumol-Bowen model contains no real analysis of the demand or revenue aspects of live performance and, indeed, there is a direct failure in the argument to recognize certain demand implications of the model's own structural assumptions.[44]

Such an analysis, if undertaken at the time, might have significantly altered Baumol and Bowen's theory.[45]

Baumol and Bowen's silence about increased revenue generation from demand strategies likely rested upon the political desire for a national arts endowment in the United States, but also upon economic theory's reluctance to explore consumer demand generated by consumer tastes.[46] Tastes, as economic theory argues, should be taken as given. Moreover, say economists, consumer demand is merely motivated by price and income changes, while the more of a good that individuals consume, the less they demand.[47] Certainly it is curious that economists have been able to sustain consumer demand theory based on ignoring why consumers demand what they do.[48] In order to serve arts managers and cultural entrepreneurs and provide them with a well-grounded industry platform, it is useful to know this history and then focus on demand behaviors on the one hand, and supply and cost management on the other. Thus, there is no need to continue to accept a notion of a cost disease as a structural given. In today's world, the classical intangible fine arts do not need to fall prey to skyrocketing deficits when arts management strategy and tactics are actively provided.

In other countries, the classical intangible fine arts are funded through government support, yet the professional organization is held accountable to budgetary constraints. The market for these arts varies by country, just as their development varied over time and place and was associated with rituals such as death, religious practices in worship, and seasonal changes and celebrations. In other instances, performances were held to entertain royalty and to please civic leaders. Like tangible fine arts, performances were part of the larger functioning society, integrated into daily life. The artists were paid wages or were commissioned to perform. However, today, while classical performing companies may have mastered being viable, artists in this field are still very oversupplied and often face stiff competition as too many artists seek too few classical performing arts opportunities at a living wage.

We can classify the fine arts then, as tangible or intangible, keeping in mind that tangible products can arise from intangible fine arts, as when a symphony orchestra produces its recorded music for sale or a dance company makes its production available for purchase on DVD. When talking about the tangible fine arts, the image evoked is to rest with paintings, sculptures, and so on, created by humans and is similar for the intangible arts. However, the actual artistic content of the intangible classical fine arts is staged in order to be recorded.

You can see how the definition can quickly get out of hand. What about the talented individual who can create classical performing arts out of digital resources without having a performance staged in reality? As the digital world evolves, there

may be a solution for that kind of display, and in such a case, you can imagine that there are economies of scale available! Rather than trying to answer every case, keep in mind the definition given earlier about the fine arts, whether tangible or not, and the definition of cultural industry provided in Chapter 1. Using these two tests is the key to determining whether a work is a creative enterprise or a cultural one.

CONTEMPORARY VISUAL, ELECTRONIC, AND POPULAR CULTURE ARTS

From the previous section, it is probably evident that getting our arms around the classical intangible fine arts is elusive. The categories of classical dance, theater, opera, and music seem almost impossible to define, especially in the technological world we live in today, where someone with a digital device can produce a musical score and not know how to play an instrument or read music! Two areas that can encompass these kinds of nebulous arts are contemporary and performance arts.

Contemporary art, by definition, is "sculpture, painting, and other cultural works that are from the current time, or since World War II," or since the beginning of what some refer to as postmodernism. The nature of contemporary art is to stand against the defining structures of social class and the determination of taste. In the same way, *performance art* is defined as a "multimedia art form originating in the 1970s in which performance is the dominant mode of expression. Performance art may incorporate such elements as instrumental or electronic music, song, dance, television, film, sculpture, spoken dialogue, and storytelling."[49] Performance art does not require a formal stage, can be live or virtual, and can be planned or spontaneous. Within contemporary and performance art, popular culture arts and electronic arts are included. *Popular culture arts*, sometimes referred to as pop arts, are those arts that are displayed in media, such as advertising, and have everything to do with mass production, communication, and consumption. Pop art is considered its own art form. Consider Andy Warhol's work in producing advertisements for products that appeal to consumers' sensibilities, or comic books, fashions, or anything that is associated with consumer culture. Electronic art is produced with electronic media, such as a computer or notebook, or by technological means. Pixar is an example of a company that produces electronic art in the form of animated films; people writing songs with their iPads or using a software program that has sounds that mimic an instrument are also producing electronic art.

In these categories of contemporary and performance arts, which sometimes morph into a category of "visual arts," nearly everything that was excluded from the classical fine arts can be included. From photography to architecture, visual arts are everywhere and evolving. This leads us to further evidence we can look to in our own lifetimes that demonstrates that the concepts of art, the artist, and aesthetics are not stable and that they have everything to do with social manifestations, technological advances and uses, and power structures. Contemporary and performance arts arise in many cases as reactions or responses to the world the artists live in, providing commentary about what is being experienced. It is not insignificant that artists find their way into displays of popular culture, including television, movies, advertisements, mixed and multimedia presentations, and electronic arts and games.

While this textbook focuses on the classical tangible and intangible arts as outlined above, it is the conglomeration of these arts and the producers' and managers' abilities, however, that underpin the growing cultural industry.

FESTIVALS

Festivals abound in art and religion. Arts managers close off the streets or block off a specific time and place, usually once each year, to hold celebratory events. Rousseau called them public spectacles, where the people attending were the object of the art, a spontaneous manifestation that allowed art to flourish outside the concepts of taste and disinterest, but more importantly allowed for an escape from the constraints of daily life.[50] People danced in the streets, sang, drank, and laughed. In short, festivals were an outcry for a need for social justice, a point that Mary Wollstonecraft made quite clear in her feminist work against social taste and disinterested art.[51] Festivals evolved in France as part of the Revolution in 1789, in part drawing on Rousseau's ideals, to help stem the tide of gruesome scenes that dominated riots and revolts. Solidarity through marching, dancing, and singing accompanied the resistance that was the Revolution, and these arts were offered as a way forward. After such mass demonstrations, small festivals were encouraged so that in the neighborhoods the feeling of freedom and allegiance to the revolution was carried through the country. The point is that Rousseau's idea had been used to further political aims and therefore turned the notion of festival into yet another artistic and aesthetic communication vehicle for political ends. The festival would come to be nationalized and juxtaposed to high art, eventually diminishing in the face of the desire for taste and luxury. National festivals would give way to commercial ones in France.

Today, arts festivals generally hold annual events, building on themes derived from celebrations such as the Ojai Music Festival (see Exhibit 2.4), the Monterey Jazz Festivals, the Cannes Film Festival, Jacob's Pillow Dance Festival, the Kansas City Arts Walk, the International Poetry Festival of Medellin, and the Annecy Animated Film Festival. One such festival is covered below, and another is the Jacob's Pillow Dance Festival featured in What's On?

There are thousands of festivals for all classical fine and performing arts; most are structured as a nonprofit organization, on a local, national, or international scale. Festivals can have a major tourist impact on the arts economy. Which one sparks your interest? As an arts manager, your role centers around planning, organizing, and delivery of the festival each year, in both changing or nonchanging outdoor or indoor locations. But you will see quickly that it is not just the celebratory staging of art and crafts that brings audiences. Many festivals incorporate not only an artistic focus, but also include dining and excursions, merchandising, and participation. Festivals do not have the same expenses as a touring company or a company that is in residence. This makes them an attractive form for many culturepreneurs, as staffing and event spaces can be expanded and contracted for the festival delivery and in the quiet, preparatory parts of the year. Festival staff members spend the

Exhibit 2.4 **Ojai Music Festival, Ojai, California**

Attendance at cultural fine arts festivals is increasing rapidly around the world, and the Ojai Music Festival is a leader in this trend. At its inception in 1947, under the guidance of founder John Bauer and conductor Thor Johnson, the Ojai Music Festival featured a balance of classics and more contemporary fare. By the time Lawrence Morton took over as artistic director in 1954, the emphasis had shifted to new music and Ojai soon became the showcase for many, including Elliott Carter, Aaron Copland, Lou Harrison, and Igor Stravinsky.

It was Morton who established the tradition of rotating music directors, and with this innovation each festival became the reflection of its director. Ojai's music directors have invited distinguished soloists, first-rate chamber ensembles, and world-class orchestras to join them in exploring the intersection between new music and everything from jazz, electronics, and computers; dance, theater, and experimental staging of social and political issues; to repertory that might go back to the Middle Ages or reach across the globe.

Today, the Ojai Music Festival is dually led by the artistic and executive directors, managed by its staff, and guided by their board of directors. They successfully renovated their outdoor auditorium by strategically engaging the community, donors, sponsors, and grant funders.

In addition, answering the desire of those who want to experience the music but could not get to Ojai, in 2011 the organization innovated and expanded its arts offerings to stretch northward to Ojai North, in partnership with Cal Performances in Berkeley. Immediately after the festival is concluded in Ojai, reprises are given in Berkeley, as well as joint commissions and co-productions. More than just a sharing of resources, Ojai North represents a combining of artistic ideals and aspirations. The combined efforts forward artists' synergies and culturepreneurial innovations. One such innovation is a profitable retail experience providing festival goers the opportunity to purchase music and memorabilia.

However, the Ojai Music Festival boasts more than music. It is an experience hundreds enjoy, covering an annual weekend complete with lectures, films, nature experiences, yoga, and fine gourmet dining. Of course, music is available at different locations from dawn to midnight. This kind of culturepreneurial innovation provides the economic impacts discussed in Chapter 1, created by the artists at the core of the cultural fine arts. Tickets are available in a series so that attendance at particular events can be at the discretion of the arts consumer, and, of course, they sell out very quickly! Visit www.ojaifestival.org for more information.

time between their events preparing for the next one. Some festivals are held in one location, while others are touring festivals. The decision to be a festival company will have implications, such as whether one looks upon them as providing value as would be had in a gallery or a dedicated staging location. This brings us to the next section of this chapter, where the discussion turns to creating value and what that means.

VALUE

What does it mean for something to have value? How does one decide that a work of art is good or bad, right or wrong? According to Graeber,[52] theories of value have centered around three main areas: sociological, that is, conceptions of what is ultimately good, proper, or desirable in human life; economic, or the degree to which objects are desired, particularly as measured by how much others are willing to give up to get them; and linguistic, relative to structural linguistics,[53] that seeks to find "meaningful difference" in arbitrary associations. However, these three areas have left aside the notion of the anthropological theory of value, which is "the way in which actions become meaningful to the actor by being incorporated in some larger,

Exhibit 2.5 **Relationships of Cultural Fine Arts Value Creation**

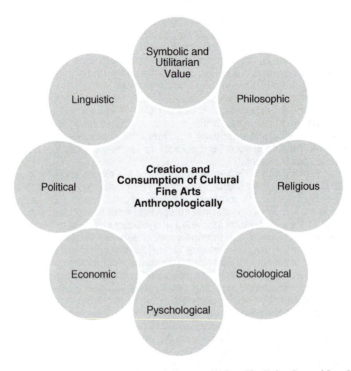

Source: David Graeber, *Toward an Anthropological Theory of Value: The False Coin of Our Own Dreams* (New York: Palgrave, 2001), xii.

social totality—even if in many cases the totality in question exists primarily in the actor's imagination."[54]

Many ideas inform "value" when it comes to aesthetics and the arts intangible and tangible, fine and contemporary. Please refer to Exhibit 2.5 for an illustrative view.[55] Scholars in the fields of philosophy, sociology, religion, psychology, anthropology, and economics have weighed in on this topic. Indeed, in Chapter 4, economic value and the supply and demand of art, and in Chapter 8, arts formulated as "service product" experiences will be presented. However, here the immediate goal is to review value as it relates broadly to the following questions: For whom is the aesthetic experience valuable, and who determines what is valuable aesthetically? How is this related to our broad understanding of culture?

Because we are talking about ultimately providing consumable experiences in the arts arena, it is necessary to look to the disciplines that circulate around aesthetic value. Of course, again, the scope of this book is not to pursue an exhaustive study of the discourses that constitute and form the entire field of aesthetic value. Ultimately, the goal of the culturepreneur is to provide aesthetic experiences and objects for people. This outcome, then, informs considerations of aesthetic value from the perspectives of utilitarian, cultural or symbolic, and experiential reference

points. Thus the discussion of value and art, for our purpose, must reside within an anthropological system.[56]

DETERMINANTS OF AESTHETIC VALUE

Utilitarian value refers to something's value as determined by its use or function. In this perspective, an object has *utilitarian value* to the extent that consumers find it useful to accomplish a goal they might have and the consumer's endeavors are motivated by this extrinsic goal.[57] *Symbolic value* refers to the ability of a consumption object to carry cultural and personal meanings beyond the tangible, physical characteristics of the material object while the underlying object functions as a social tool, serving as a means of communication.[58] Symbolic value is not directly obtained from the physical attributes of the object, but rather is related to cultural meaning and/or social symbols.[59] *Experiential value* is connected to emotion and is often contrasted with utilitarian consumption.[60] The major value proposition is that experiential consumption is pleasing in itself within the confines of the emotion generated by the experience itself. Therefore, experiential value is provided from an object's attributes, which in turn generates emotional arousal.[61] In many instances, the ability to provide this transformational nature through consumption or interaction with the product or service becomes the basis of *cultural value* in the consumptive process.[62]

In determining *aesthetic value*, we couple the transformational desire with a return to the problem of taste[63] and Immanuel Kant's aesthetic theory.[64] Kant's perspective suggests that the aesthetic judgment is made when a subject reports an experience of delight in viewing a certain object, based on a "free interplay" between the stimuli of information perceived in the object and the conceptual representation of this information in memory.[65] Aesthetic liking is the liking associated with this interplay. The satisfaction or feeling produced in the aesthetic judgment is disinterested—that is, it does not produce a desire or interest in possession.[66] That means that in making an aesthetic judgment, the subject takes no interest in the functioning of the object, neither as she believes others perceive it, nor as she perceives it herself.[67] Unlike utilitarian and experiential value, but like symbolic value, aesthetic value is found in the construed attributes of an object and makes the aesthetic value a type of gestalt. Gestalts concern properties that are intrinsically determined as being part of a whole or a system, rather than being extrinsically determined.[68]

As Pierre Bourdieu explains, aesthetic value lies in the perception of perceiver and in the producer of the artistic object, which again occurs within a cultural context, or what may be referred to as the complex playing field of cultural production on which artists and perceivers find themselves.[69] Therefore, the value derivations for aesthetics are agreed upon by the myriad of players within a certain arena. In this way, aesthetic value can be seen or imagined as a circular process because it is within one's field that aesthetic value has meaning. In today's culturepreneurial world, nearly anything can be identified as art, especially as

the lines between fine and contemporary, performing and performance blur or at least get redrawn with shifts in the cultural, social, political, and economic landscapes.[70] There are those who will continue to press the notion that aesthetic value has to do with discernment of traditional fine arts and beauty, such as classical ballet and paintings, certain types of architecture, and poetry. Nonetheless, at the end of the day, "the audience at the opera or the visitors to an exhibition apply their own meanings to the work or works of art they are witnessing, based on the emotions that spark them."[71] A connection between the viewers' interpretations and the artists' intention is developed, and the value arises in the viewers' emotional experiences and symbolic meaning associated with the artistic object. And these emotional experiences are not stable; that is, different responses can be had at different times in consuming the same artistic experience. Therefore, "aesthetic responses are primarily emotional or feeling responses" that are very personal and subjective.[72]

Within the context of aesthetics, areas informing value that will be of interest to the culturepreneur are spiritual, social, historical, symbolic, and authentic.[73] These categories can be combined to formulate goods and services relative to the arts. Because of this, as has been argued elsewhere,[74] the idea of high and low arts has no place in the arts management function. Creating value, then, is a matter of knowing who your consumers are, what they are seeking, and how to fulfill their needs.

CHAPTER SUMMARY

This chapter has explained the tangible and intangible classical fine arts, including the associated institutions of art museums, galleries, and dealers in the former category, and in the latter, theater, opera, choreographed classical and contemporary dance, including modern, interpretive, and ballet, and symphony delivered in a live concert setting. Other arts fall within a contemporary or popular arts perspective. Though the scope of this textbook is the classical fine and performing arts, aspects of performance, electronic, and popular arts were defined. The purpose of doing so was to provide an understanding of the differences between the two art forms. While it is true that popular culture art is not always considered within the artistic arena historically, nevertheless, the creative industry is a location for artistic outlet for many artists. The conglomeration of the arts has been bifurcated into high and low art forms historically, yet the lines between them are blurry.

Culture and meaning were described in the context of aesthetics and their creation in learned environments. The concept of aesthetics as a learned behavior was defined and discussed in the context of understanding how to approach aesthetics as an arts manager or culturepreneur. Aesthetic value was described and explained, particularly as it functions within an anthropological framework. We conclude that beauty is in the eye of the beholder and that arts managers or culturepreneurs have to be aware of what that is for the respective arts consumer they serve. The culturepreneur has to seize the moment to develop exceptional experiences and do so

nonjudgmentally. The chapter included a brief coverage of festivals in the classical fine arts, and examples of them were given.

DISCUSSION QUESTIONS

1. Explain aesthetics. Develop a working definition of aesthetics.
2. Find examples of fine art that you would characterize as fitting into your definition, and explain why.
3. What is the genesis of the idea of the artist? Have we always held the artist in mind as we do today? Explain.
4. What is culture? How do people find meaning in works of art? How can you differentiate between culture and meaning? List three reasons why you will need to understand these concepts as an arts manager.
5. Compare and contrast your particular art form or practice (or your favorite one if you are not a practicing culturepreneur) against three others. How are they different? Similar? Where can you find a location to integrate your work with at least two other fine arts?
6. Define the cost disease. Assuming you are an arts manager or culturepreneur for a classical performing arts company (not a festival), list three ways you will actively seek to provide full-length performances and at the same time not fall victim to the cost disease.

EXPERIENTIAL EXERCISES

1. Attend one major and one minor museum and gallery of fine art and contemporary art; take virtual tours of these online. Compare and contrast.
2. Attend classical performing art performances live, and watch a prerecorded one. Compare and contrast them.
3. Attend a festival of fine arts and of performing arts at a community event, and compare these with the online and housed-in-a-building events. What are your observations?
4. Discuss at least three types of aesthetic value created within each of the preceding three exercises.
5. Make note of outside art placements such as train stations, buses, business offices, and parks. Explain their aesthetic value. Distinguish between fine and contemporary arts.
6. Interview five artists, five gallery owners, and if possible several performing arts managers at a local performing arts venue. Ask them their impressions of value creating in the arts. What common themes emerge? How are the responses different?
7. Actively distinguish developing/making art for pay and developing/making art for play; start with determining/locating Kantian definitions that separate fine versus craft art. Push yourself to find the difference and to identify the spiritual/moral in the distinction between play and pay.
8. Have students work with developing and differentiating aesthetic attitudes and experiences.

9. Refer to the following links and discuss architecture as art—or not.
 - Borson, Bob. "What is art?" *Life of an Architect*, August 17, 2010. www. lifeofanarchitect.com/what-is-art/.
 - Rackard, Nicky. "Video: Vito Acconci: Is architecture art?" *ArchDaily*, March 22, 2013. www.archdaily.com/349031/video-vito-acconci-is-architecture-art/.
10. In light of the cost disease, follow the link below. After watching and reflecting on the premises of the cost disease, what are your thoughts on this Ted Talk?
 - Cameron, Ben. "The true power of the performing arts (video)." TED, February 2010. www.ted.com/talks/ben_cameron_tedxyyc.

FURTHER READING

Adorno, Theodor W. *Aesthetic Theory*, ed. Gretel Adorno and Rolf Tiedemann; trans. Robert Hullot-Kentor. Minneapolis: University of Minnesota Press, 1997.

American Society for Aesthetics. Aesthetics Web Sites. www.aesthetics-online.org/net/.

Cox, Kenyon (ed.). *The Fine Arts*. Boston: Hall and Locke, 1911.

Heilbrun, James, and Charles M. Gray. *The Economics of Art and Culture*. 2nd ed. New York: Cambridge University Press, 2001.

Hogarth, William. *The Analysis of Beauty*, ed. Ronald Paulson. New Haven, CT: Yale University Press, 1997 [1753].

Kant, Immanuel. *Critique of Judgment*, trans. J.H. Bernard. New York: Hafner Press, 1951 [1790].

King, Alexandra. The Aesthetic Attitude. In *Internet Encyclopedia of Philosophy*, ed. James Fieser and Bradley Dowden. www.iep.utm.edu/aesth-at/.

McCracken, Grant. "Culture and consumption: A theoretical account of the structure and movement of the cultural meaning of consumer goods." *Journal of Consumer Research* 13, no. 1 (1986), 71–84.

Wreen, Michael J., and Donald M. Callen (eds.). *The Aesthetic Point of View: Selected Essays*. Ithaca, NY: Cornell University Press, 1982.

NOTES

1. Duncan Kennedy, "Titanic violin could fetch record price at auction," *BBC News*, October 16, 2013, www.bbc.co.uk/news/uk-24560046.
2. Dictionary.com, "Aesthetics," http://dictionary.reference.com/browse/aesthetics.
3. Merriam-Webster Online, "Aesthetic," www.merriam-webster.com/dictionary/aesthetic.
4. Malcolm Budd, "Aesthetics," in *Routledge Encyclopedia of Philosophy*, ed. E. Craig (London: Routledge, 1998), www.rep.routledge.com/article/M046.
5. Barry Hartley Slater, "Aesthetics," in *Internet Encyclopedia of Philosophy*, ed. J. Fieser and B. Dowden, www.iep.utm.edu/aestheti/.
6. Alexandra King, "The aesthetic attitude," in *Internet Encyclopedia of Philosophy*, ed. J. Fieser and B. Dowden, www.iep.utm.edu/aesth-at/.
7. Dominic McIver Lopes, Aesthetics in the Academy: Survey results in brief, Aesthetics online, 1998, www.aesthetics-online.org/academy/survey-results.php.
8. George Dickie, "The Myth of the Aesthetic Attitude," *American Philosophical Quarterly*, 1, 1, 1964, 56–65; Gary Kemp, "The aesthetic attitude," *British Journal of Aesthetics* 39 (1999), 392–399.

9. Pierre Bourdieu, *Distinction: A Social Critique of the Judgment of Taste*, trans. Richard Nice (Cambridge, MA: Harvard University Press, 1984).

10. Pierre Bourdieu, *The Field of Cultural Production*, ed. R. Johnson (New York: Columbia University Press, 1993).

11. William Hogarth, *The Analysis of Beauty*, ed. Ronald Paulson (New Haven, CT: Yale University Press, 1997 [1753]); Jean-Jacques Rousseau, *The Social Contract and Other Later Political Writings*, ed. and trans. V. Gourevitch (New York: Cambridge University Press, 1997 [1761]).

12. Mary Wollstonecraft, *A Vindication of the Rights of Woman*, ed. C.H. Poston (New York: Norton, 1989 [1792]).

13. Matthew Arnold, *Culture and Anarchy*, ed. Jane Garnett (New York: Oxford UP, 1960–1977/1965 [1869]).

14. Raymond Williams, *Culture and Society: 1780–1950* (New York: Columbia University Press, 1983); James Clifford, *The Predicament of Culture: Twentieth-Century Ethnography, Literature, and Art* (Cambridge, MA: Harvard University Press, 1988).

15. Lawrence Levine, *Highbrow/Lowbrow: The Emergence of Cultural Hierarchy in America* (Cambridge, MA: Harvard University Press, 1988).

16. David Throsby, *Economics and Culture* (New York: Cambridge University Press, 2001).

17. Jean Baudrillard, *For a Critique of the Political Economy of the Sign*, trans. Charles Levin (St. Louis, MO: Telos Press, 1981); Grant David McCracken, *Transformations: Identity Construction in Contemporary Culture* (Bloomington: Indiana University Press, 2008).

18. Arthur Schopenhauer, *The World as Will and Representation* (Vol. 1), trans. E.F.J. Payne (New York: Dover, 1969); Friedrich Nietzsche, *The Will to Power*, ed. W. Kaufmann, trans. W. Kaufmann and R.J. Hollingdale (New York: Random House, 1968).

19. F. David Martin, *Art and the Religious Experience: The "Language" of the Sacred* (Lewisburg, PA: Bucknell University Press, 1972).

20. Larry Shiner, *The Invention of Art: A Cultural History* (Chicago: University of Chicago Press, 2001); Mary Anne Staniszewski, *Believing Is Seeing: Creating the Culture of Art* (New York: Penguin Books, 1995); Bourdieu, *Field of Cultural Production*; Monroe C. Beardsley, *The Aesthetic Point of View* (Ithaca, NY: Cornell University Press, 1982).

21. Bourdieu, *Distinction*.

22. Dictionary.com, "Fine art," http://dictionary.reference.com/browse/fine+art.

23. James Heilbrun and Charles Gray, *The Economics of Art and Culture*, 2nd ed. (New York: Cambridge University Press, 2001), 4.

24. U.S. Bureau of Labor Statistics, "Occupational employment and wages, May 2013: 27–1013 Fine artists, including painters, sculptors, and illustrators," 2013, www.bls.gov/oes/current/oes271013.htm.

25. Staniszewski, *Believing Is Seeing*.

26. Thomas R. Martin, *Ancient Greece: From Prehistoric to Hellenistic Times* (New Haven, CT: Yale University Press, 1996), 94.

27. John Boardman, *Greek Art*, 4th ed. (New York: Thames & Hudson, 1996), 16, quoted in Shiner, *Invention of Art*, 26.

28. Robin Barber, "The Greeks and their sculpture," in *Owls to Athens: Essays on Classical Subjects Presented to Sir Kenneth Dover*, ed. E.M. Craik (Oxford: Clarendon Press, 1990); Nigel Spivy, *Understanding Greek Sculpture: Ancient Meanings, Modern Readings* (London: Thames & Hudson, 1996).

29. David Graeber, *Toward an Anthropological Theory of Value: The False Coin of Our Own Dreams* (New York: Palgrave, 2001).

30. Peter Green, *Alexander to Actium: The Historical Evolution of the Hellenistic Age* (Berkeley: University of California Press, 1993).

31. Shiner, *Invention of Art*, 22.

32. Ibid., 30.

33. Annette Gordon-Reed, "Critics of the liberal arts are wrong: Yes, science and tech are important, but a new report shows that employers prize a more broadly-based education," *Time*, June 19, 2013, http://ideas.time.com/2013/06/19/our-economy-can-still-support-liberal-arts-majors/.

34. Shiner, *Invention of Art*, 43.

35. Kemp, "Aesthetic attitude," 392–399.

36. Staniszewski, *Believing Is Seeing*, 115; Shiner, *Invention of Art*.

37. Heilbrun and Gray, *Economics of Art and Culture*; William J. Baumol and William G. Bowen, *Performing Arts: The Economic Dilemma* (Cambridge, MA: MIT Press, 1966).

38. Paul Solman, "Performing artists compete, move, adapt in tough economy," *PBS Newshour*, June 27, 2013, www.pbs.org/newshour/bb/business-jan-june13-artists_06-27/.

39. Levine, *Highbrow/Lowbrow*.

40. Peter Gay, *The Bourgeois Experience: Victoria to Freud*, Vol. 4: *The Naked Heart* (New York: Oxford University Press, 1995).

41. Baumol and Bowen, *Performing Arts*.

42. Ibid., 164.

43. Carla Stalling Huntington, "Moving beyond the Baumol and Bowen cost disease in professional ballet: A 21st century pas de deux (dance) of new economic assumptions and dance history perspectives," PhD dissertation, University of California, Riverside, 2004; David Throsby and Glenn A. Withers, *The Economics of the Performing Arts* (New York: St. Martin's Press, 1979).

44. Throsby and Withers, *Economics of the Performing Arts*, 51.

45. Ibid., 52.

46. According to the economist and anthropologist research team of Douglas and Isherwood, no one knows why people want goods. Economists avoid the question so that tastes are treated as given. It is the unexplainable factor of demand that is held constant, which allows economists the ability to provide explanations in changes in demand. Mary Douglas and Baron Isherwood, *The World of Goods: Towards an Anthropology of Consumption*, rev. ed. (New York: Routledge, 1996), 3.

47. Ibid., 5.

48. Douglas and Isherwood further believe the economists' practice of resting a large part of their theory of choice on differences in tastes to be curious and puzzling. Ibid., 7.

49. YourDictionary.com, "Contemporary art," LoveToKnow Corp., www.yourdictionary.com/contemporary-art.

50. Rousseau, *Social Contract*.

51. Wollstonecraft, *Vindication of the Rights of Woman*.

52. Graeber, *Toward an Anthropological Theory of Value*.

53. Ferdinand de Saussure, *Course in General Linguistics*, trans. W. Baskin (New York: McGraw-Hill, 1966 [1916]).

54. Graeber, *Toward an Anthropological Theory of Value*; Baudrillard, *For a Critique of the Political Economy of the Sign*; Grant David McCracken, *The Long Interview* (Thousand Oaks, CA: Sage, 1988).

55. Simona Botti, "What role for marketing in the arts? An analysis of art consumption and artistic value," *International Journal of Arts Management* 2, no. 3 (2000), 14–27.

56. James R. Bettman, *An Information Processing Theory of Consumer Choice* (Reading, MA: Addison-Wesley, 1979); Brian T. Ratchford, "The new economic theory of consumer behavior: An interpretative essay," *Journal of Consumer Research* 2, no. 2 (September 1975), 65–75.

57. Douglas B. Holt, "How consumers consume: A typology of consumption practices," *Journal of Consumer Research* 22, no. 1 (1995), 1–16; Sidney J. Levy, "Symbols for sale," *Harvard Business Review* 37 (July–August 1959), 163–176; M. Joseph Sirgy, "Self-concept in consumer behavior: A critical review," *Journal of Consumer Research* 9, no. 3 (December 1982), 287–300.

58. Edward L. Grubb and Harrison L. Grathwohl, "Consumer self-concept, symbolism and marketing behavior: A theoretical approach," *Journal of Marketing* 31 (1967), 22–27.

59. Grant David McCracken, "Culture and consumption: A theoretical account of the structure and movement of the cultural meaning of consumer goods," *Journal of Consumer Research* 13, no. 1 (1986), 71–84; Baudrillard, *For a Critique of the Political Economy of the Sign.*

60. Elizabeth C. Hirschman and Morris B. Holbrook, "Hedonic consumption: Emerging concepts, methods, and propositions," *Journal of Marketing* 46, no. 3 (1982), 92–101; Morris B. Holbrook and Elizabeth C. Hirschman, "The experiential aspects of consumption: Consumer fantasies, feelings, and fun," *Journal of Consumer Research* 9, no. 2 (September 1982), 132–140; Haim Mano and Richard L. Oliver, "Assessing the dimensionality and structure of the consumption experience: Evaluation, feeling, and satisfaction," *Journal of Consumer Research* 20, no. 3 (December 1993), 451–466; Erica Mina Okada, "Justification effects on consumer choice of hedonic and utilitarian goods," *Journal of Marketing Research* 42, no. 1 (2005), 43–53.

61. Rajeev Batra and Olli T. Ahtola, "Measuring the hedonic and utilitarian sources of consumer attitudes," *Marketing Letters* 2 (April 1990), 159–170; Holt, "How consumers consume"; Mano and Oliver, "Assessing the dimensionality and structure of the consumption experience."

62. McCracken, *Transformations.*

63. Monroe C. Beardsley, *Aesthetics from Classical Greece to the Present: A Short History* (New York: Palgrave Macmillan, 1966).

64. Immanuel Kant, *Critique of Judgment*, trans. J.H. Bernard (New York: Hafner Press, 1951 [1790]).

65. Henry E. Allison, *Kant's Theory of Taste: A Reading of the Critique of Aesthetic Judgment* (Cambridge: Cambridge University Press, 2001); Donald W. Crawford, *Kant's Aesthetic Theory* (Madison: University of Wisconsin Press, 1974); Eckart Förster, *Kant's Final Synthesis: An Essay on the Opus Postumum* (Cambridge, MA: Harvard University Press, 2000).

66. Kant, *Critique of Judgment.*

67. Beardsley, *Aesthetics from Classical Greece to the Present.*

68. David Katz, *Gestalt Psychology*, trans. R. Tyson (New York: Ronald Press, 1950); Kurt Koffka, *Principles of Gestalt Psychology* (New York: Harcourt, Brace, 1935); Wolfgang Köhler, *Gestalt Psychology: An Introduction to New Concepts in Modern Psychology* (New York: Liveright, 1929); Max Wertheimer, "Gestalt theory," in *A Source Book of Gestalt Psychology*, ed. Willis D. Ellis (London: Kegan Paul, 1938), 1–11.

69. Bourdieu, *Field of Cultural Production.*

70. Grant David McCracken, *Culture and Consumption II: Markets, Meaning, and Brand Management* (Bloomington: Indiana University Press, 2005).
71. Botti, "What role for marketing in the arts?" 34.
72. Ibid., 36, quoting Elizabeth C. Hirschman, "Aesthetics, ideologies and the limits of the marketing concept," *Journal of Marketing* 47, no. 3 (Summer 1983), 51.
73. Throsby, *Economics and Culture*.
74. Botti, "What role for marketing in the arts?"; Carla Stalling Huntington, *Black Social Dance in Television Advertising: An Analytical History* (Jefferson, NC: McFarland, 2011).

3 The Anthropology and Spirituality of Consumption

CHAPTER OUTLINE

LEARNING OBJECTIVES

After reading this chapter, you should be able to do the following:

1. Understand consumption broadly in an anthropological framework.
2. Relate consumption anthropologically to the arts.
3. Be conversant about contemporary rituals and their relation to consumption, and understand the arts as a ritual practice.
4. Know three different approaches to understanding consumer wants within an anthropological context.
5. See how consumption of arts can be viewed as fulfilling spiritual aspects of humanity.

6. Be conversant in the ways that arts goods, ideas, and services when consumed reflect the self.
7. Come to understand the idea of the arts consumptive experience that arts managers attempt to create for their consumers.

ASSESSING AND CREATING THE IMPACT ECHO

It is five minutes before curtain as Joe and his wife Laura settle into their seats. The small theater is packed. Next to them in row M, Aisha and her friends talk about their plans for the weekend. Aisha has never been to this theater before and came tonight, rushing directly from work, because one of her friends bought tickets. Joe and Laura, on the other hand, purchased their tickets months ago as part of a subscription package. The couple attended the preperformance talk with the director an hour earlier, and Joe also went online the day before to read the local paper's review of the production and the director's commentary on the theater's website. The curtain ascends and the performance begins. The attendees laugh when they are expected to, hold their breath when they are expected to, and clap at the end. Aisha is moved to give a standing ovation, one of only a few people in the theater to do so. Joe and Laura hurry out, concerned about parking and traffic on the way home. Aisha and her friends linger

Exhibit 3.1 **The Impact Echo**

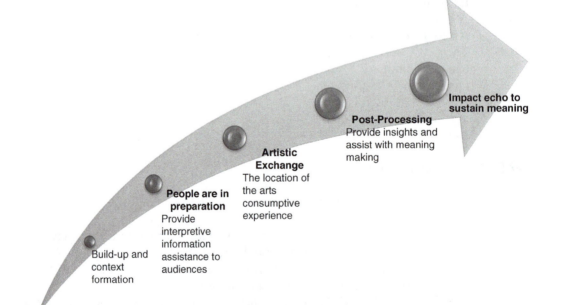

People are in preparation
Provide interpretive information assistance to audiences

Build-up and context formation

Artistic Exchange
The location of the arts consumptive experience

Post-Processing
Provide insights and assist with meaning making

Impact echo to sustain meaning

Source: Alan S. Brown and Rebecca Ratzkin, *Making Sense of Audience Engagement*, Vol. 1: *A Critical Assessment of Efforts by Nonprofit Arts Organizations to Engage Audiences and Visitors in Deeper and More Impactful Arts Experiences* (San Francisco: San Francisco Foundation, 2011).

in the lobby, talking intensely before heading out for drinks. One month later, Aisha finds herself recalling scenes and lines from the performance. She has already told other friends about the play and posted a link to the theater's website on her Facebook page. Meanwhile, the performance has completely slipped out of Joe's mind. He has moved on to other things and, if asked, would only be able to remember the name of the play but little else.

Aisha and Joe can be seen as prototypes on a spectrum of arts consumers. In this story, they attended the same play, but their preparation efforts and postperformance "meaning-making" activities were vastly different. While Joe made a greater effort to gain context on the work he was about to see, Aisha knew little about the play before the curtain rose. Afterward, Aisha and her friends dove into an animated conversation about the play, while Joe did not. Both walked away with personally valuable experiences.

The sequence of events and activities leading up to and extending after a performing arts event is different for every member of the audience. Although they share a common artistic experience, every audience member also has a unique experience. In the case of museums and gallery exhibitions, every visitor might take a somewhat different pathway through the museum and spend different amounts of time and energy with different exhibitions and works of art. In this case, the "artistic exchange" (i.e., the transference of emotion and meaning between the artist and the public) is different for every visitor. While performing arts organizations are generally able to remain in contact with ticket buyers after a performance, the same is not true of most museums. Their ability to engage visitors before and after the visit is more limited. These are just some of the complexities that arts groups face in negotiating the terrain of audience engagement. While every participant has a unique trajectory or "arc of engagement" in relation to a specific work of art, much can be done to define pathways through the work that lead to deeper and more meaningful experiences. Every audience member has a unique arc of engagement based on his or her appetite for, and approach to, engaging. Research on engagement preferences suggests six general typologies of audience members:

- *Readers* are "light engagers" who do little except for reading program notes, wall texts, and an occasional article.
- *Critical reviewers* pay attention to critics' reviews and other independent sources of information before deciding to attend.
- *Casual talkers* process art by talking about it informally with friends and family members.
- *Technology-based processors* are facile with blogs, social media, and other digital venues for engagement.
- *Insight seekers* seek an intellectual experience and like to absorb a lot of information before and after arts programs.
- *Active learners* want to get personally involved in shaping their own experience.

Arts groups typically find some blend of these people in their audience and should think carefully about which typologies are served by the current programs, which are underserved, and which of the many types of engagement activities will best suit them. Providing a diverse offering of programs and activities—social and solitary, active and passive, peer-based and expert-led, community-based and

audience-focused—is a must. Many engagement programs, especially those that activate conversation between audience members, are very cost-effective. Much remains to be discovered about how audiences engage and the many opportunities for drawing them more deeply into the arts. Several arts organizations across the country have had success in developing audiences by using the impact echo, including museums, dance companies, theaters, and opera companies.

MANIPULATING CULTURAL FINE ARTS CONSUMERS?

> The joy of music should never be interrupted by a commercial.
>
> —Leonard Bernstein

Although the intention of marketing seems quite idealistic and totally good in its abstract sense, it becomes doubtful sometimes whether it remains good while it is being implemented. Does the intention to satisfy arts customers involve at some point manipulating them? Is it even about satisfying the cultural fine arts customer, or does it also involve totally materialistic objectives? A conclusive or definitive answer to these questions is best seen as a gray area, and individuals are likely to have their own opinions.

To be focused on the cultural fine arts consumer is part of the essence that brings success to the culturepreneurial organization; it is the underlying culture that enables an organization to grow, simply because marketing is the glue that sticks the arts consumer to the company and its offerings. Targeting cultural fine arts consumers and then influencing them to engage and be loyal to the organization is not an easy job, but it is the main reason the culturepreneurial company exists. In this frame, marketing is simply a set of tools available to the organization. Without using them in some form, fashion, or combination, the organization collapses. And without knowing what cultural fine arts consumers want and delivering that to them, the company may witness declines in engagement. Knowing what the cultural fine arts consumer needs is what marketing is all about.

However, is marketing really good? Does the marketing function manipulate cultural fine arts consumers negatively? Making people need something that they might not have thought about before being exposed to a promotion, just to make money and profits, can be considered unethical.

An important question to be answered is to what extent situational and organizational variables influence marketing practitioners in interacting with cultural fine arts constituents. Some practitioners believe that they make decisions in an organizational environment that is less ethical than their own system of values and beliefs. Therefore, marketing practitioners who work for cultural fine arts organizations may be faced with conflict in structuring how to think and act ethically toward cultural fine arts constituents.

Because the importance of ethical decision making in marketing is becoming more evident, it is recommended that culturepreneurial organizations adopt organizational and strategic mechanisms for establishing and maintaining cultural fine arts marketing ethics, including codes of marketing ethics, marketing ethics committees, and ethics education modules for marketing managers. By formalizing the beliefs and behavior of the founders and leaders, an ethical frame of reference could

be instilled, especially since cultural fine arts constituents and stakeholders identify their ethical beliefs in relation to the behaviors of the arts organizations' leaders.

THE ANTHROPOLOGY OF CONSUMPTION

In a capitalist macro economy, economists explain that consumption by consumers and their households accounts for most spending and growth,[1] with roughly one-third of spending attributed to businesses of all types in advanced countries.[2] Estimates of the relationship between gross domestic product (GDP) and consumption are shown in Exhibits 3.2 and 3.3.

Exhibit 3.2 **GDP as a Function of Consumption**

Gross domestic product (GDP) is a combined measure of the way an economy is growing. It takes the sum of consumer spending or consumption, adds investments and government spending, plus net exports, as shown:

$$GDP = \Sigma C + I + G + (X - M)$$

where
C	= consumption,
I	= investments,
G	= government spending, and
$(X - M)$	= exports minus imports.

This says that GDP equals consumption, investment, government spending, and exports minus imports (which are subtracted to avoid double-counting). Consumer spending appears to be about 60 to 70 percent of the economy. This ratio is found by dividing consumer spending by GDP.

Exhibit 3.3 **Arts as a Function of GDP**

Consider:

Value added refers to an industry's contribution to the U.S. economy through its labor and capital. It is estimated by using a method similar to that used to calculate the nation's gross domestic product (GDP).

According to Dun & Bradstreet data analyzed by Americans for the Arts, 2.98 million people across America work for 612,095 arts-centric businesses. This represents 2.2 percent and 4.3 percent, respectively, of all U.S. employment and businesses.[1]

The NEA claimed in 2008 that 35 percent of artists were self-employed—more than three times the level of the U.S. labor force. The NEA report found that 45 percent of all artists work full-time jobs.[2]

- Performing arts establishments (NAICS, North American Industry Classification System, 7111) are part of the larger Arts, Entertainment, and Recreation Sector (NAICS 71).
- The U.S. performing arts industry is supported by nearly 8,840 organizations with a total of 127,648 paid workers.
- In its annual estimates of value added, the results for the performing arts, sports, and museums are combined and aggregated to show that those industries contributed $70.9 billion to the U.S. economy.
 - These organizations generate nearly $13.6 billion in annual revenues, according to the most recent estimates, relative to $1.3 trillion for the creative and cultural industry as a whole.
- The motion picture and sound recording industry added $59.8 billion to the U.S. GDP.
- Publishing and software contributed $147.7 billion.

(continued)

Table: Arts as a Function of GDP (in billions of U.S. dollars)

Year	2005	2006	2007	2008	2009	2010	2011	2012
Total for all industries	23,517	24,891	26,157	26,825	24,655	26,097	27,526	28,693
Arts GDP								
Arts, entertainment, recreation, accommodation, food services	846.1	902.4	948.0	969.6	943.1	964.0	1,013.4	1,075.3
Arts, entertainment, and recreation	199.7	219.8	238.9	246.7	243.1	245.2	254.7	268.6
Performing arts, spectator sports, museums, and related	106.0	115.9	126.2	131.8	132.3	132.2	136.5	144.0
Amusements, gambling, and recreation industries	93.7	103.9	112.7	114.8	110.8	113.0	118.2	124.6
Arts Percentage Value Added								
Arts, entertainment, recreation, accommodation, and food services	3.7	3.7	3.7	3.6	3.6	3.6	3.6	3.7
Arts, entertainment, and recreation	0.9	0.9	1.0	1.0	1.0	1.0	1.0	1.0
Performing arts, spectator sports, museums, and related	0.5	0.5	0.5	0.5	0.5	0.5	0.5	0.5
Amusements, gambling, and recreation industries	0.4	0.4	0.4	0.4	0.4	0.4	0.4	0.4

Overall Perspective of For-Profit Performing Arts Companies

	Total	Revenue ($1,000)	Payroll ($1,000)	Employees
Theaters (1,205), including dinner (166), and opera (10)	1,381	3,840,676	961,903	31,044
Dance companies	118	64,510	19,230	844
Symphony orchestras and chamber groups	46	30,945	9,593	464
Other music groups (jazz, rock, and country bands)	3,007	3,165,966	740,541	13,562
Other performing arts companies (includes circuses, magic shows, and ice-skating performances)	347	930,357	250,148	8,278
For-profit performing arts companies	4,899	8,001,509	1,971,822	53,728

Overall Perspective of Nonprofit Performing Arts Companies[3]

	Total	Revenue ($1,000)	Payroll ($1,000)	Employees
Theaters and opera	2,196	3,049,317	1,033,333	38,130
Dance companies	407	532,396	196,006	7,770
Symphony orchestras and chamber groups	799	1,715,102	695,345	23,848
Other music groups (jazz, rock, and country bands)	646	237,142	69,996	3,623
Other performing arts companies (includes circuses, magic shows, and ice-skating performances)	45	38,314	13,285	549
Nonprofit performing arts companies	3,939	5,572,271	2,007,965	73,920

Comparisons: For-profit and nonprofit performing arts

	Total	Revenue ($1,000)	Average Revenues	Payroll ($1,000)	Employees	Revenues/ Employees
For-profit performing arts companies	4,899	8,001,509	163,329	1,971,822	53,728	$14,892
Nonprofit performing arts companies	3,939	5,572,271	141,464	2,007,965	73,920	$7,538

Growth in the Arts

- Artist occupations fall within the BLS category known as "professional and related occupations." This category, which includes health-care practitioners, engineers, computer and mathematical workers, and legal professionals, is slated for faster than average growth—that is, it is expected to grow by nearly 17 percent.
- In 2008, there were 13,000 dancers employed, and this number is expected to increase by 7 percent to 13,900 by 2018.
- In 2008, there were 16,200 choreographers, expected to increase by 5 percent to 17,200 by 2018.
- The number of dancer and choreographer jobs will grow slower than the rate of employment growth.
- The number of musicians, singers, and other workers will grow between 8 and 10 percent, on par with the rate of employment growth, depending on the position, from 240,000 to 259,600, or by 19,600 jobs.
- Between 2008 and 2018, the U.S. labor force is expected to increase by 10 percent, or by 15.3 million people.
- Of the artist occupations, museum technicians and conservators are projected to increase the most between 2008 and 2018 (by 26 percent), followed by curators (23 percent).
- Artist occupations likely to increase at the average rate of the labor force are fine artists— that is, painters, sculptors, and illustrators—(12 percent); and music directors and composers (10 percent).
- Some artist occupations, such as actors, dancers, and singers, are expected to increase in both growth and competition, making it harder to eke out a living.

(continued)

- Between now and 2018, however, no artist occupation is expected to face "good to excellent" competition, in which job openings are more numerous than job-seekers.
- Jobs for dancers and choreographers are expected to grow more slowly than average. In addition, competition is intense; therefore, regular employment is a challenge in this field.[4]

Source: U.S. Bureau of Economic Analysis, "Widespread growth across industries in 2012; revised statistics of gross domestic product by industry for 1997–2012," news release, BEA 14-02, January 23, 2014, www.bea. gov/newsreleases/industry/gdpindustry/2014/gdpind12_rev.htm.

1. Americans for the Arts, "Creative industries," www.americansforthearts.org/by-program/reports-and-data/ research-studies-publications/creative-industries.
2. www.nea.gov/research/ResearchReports.
3. 2007 Economic Census, U.S. Census Bureau.
4. U.S. Bureau of Labor Statistics, *Occupational Outlook Handbook*, 2010–11 ed. (Washington, DC: U.S. Bureau of Labor Statistics, 2010).

Arts consumption does not occur in a vacuum, as it is included in this consumptive arrangement. Indeed, the "creative industry" is a strong economic driver and serves to foster rapid growth. The production from the culture industry is included in this overall analysis, as was pointed out in Chapter 1. More than being just a function of a macroeconomic financial calculation, however, the cultural industry and its produced arts objects are tied to human ritual and spirituality. This chapter focuses on the need for humans to consume art and what it means to have a cultural consumption experience. The purpose is to provide the culturepreneur and arts manager with a sense of what is involved in providing services and products in the arts that connect with their arts enthusiasts in these ways.

We have already seen that tastes are difficult to define and explain and that, for many years, economists writing under the bridge between tastes and consumption provided by utility theory avoided broaching the subject. They instead examined economic behavior while assuming tastes as *given*. Economists approached consumer consumption as stemming from rational behavior, with people making choices based on information. Moreover, rational behavior dictates that consumption would be reduced as people become satisfied or satiated with consumptive acquisitions that met their needs. In addition, economists contended that people will not only spend, but also save or invest, suggesting that these are forms of deferred consumption. As people earn more money, they are not likely to spend all of it, but will put aside some for future consumption.[3]

Furthermore, while economists agreed that people have physical and spiritual needs, they tended to continue to be comfortable explaining how rational consumers engage in order to fulfill them.[4] In a moment we turn to different aspects of needs, assuming that there is no differentiation between a need and a want in the context of this discussion. Granted there are, in certain cultures, areas where subsistence needs often go unmet, for a variety of reasons. Those are beyond the scope of what we are covering in this text. However, leaving aside spiritual or noninstrumental needs, as the economists do, one cannot present a clear picture of why people consume in their culture and, in particular, for our case, in the *core cultural industry*, as was defined in Chapter 1. Groups in societies and the individuals that constitute them have to

be considered not as individual economic actors but as part of a whole overarching anthropological system.

CULTURE AND CONSUMPTION

People use culture to make connections with each other, and works of art (tangible and intangible) signify group affiliation, provide for ease of identity of other members of their group in making commonality, and importantly, therefore, function within an artistic classification system. Taken together, these connections and relationships to cultural products form tastes anthropologically—by leaving people out or counting them in through "sharing of names."[5] Your favorite sports team or event will, perhaps, provide a more familiar example of "name sharing." If you follow soccer, and you strike up a conversation about soccer with someone, and she knows the history of the FIFA World Cup and has bought tickets to each game no matter where it was held, and you have done these things as well, the two of you are immediately connected. However, if she merely watches soccer games on television, that is a connection with less tie strength, and if your new acquaintance does not watch sports at all, then there is no connection. With the connection in the first instance, both of you share a strong link; by name sharing, you show you are part of a group of people in diverse locations around the world who value what soccer provides and probably share a set of experiences and purchases, such as attending soccer games and buying clothing adorned with soccer logos. And immediately you are able to classify the newcomer in terms of her tastes for soccer.

Therefore, in this textbook, *taste* will mean "a form of ritual identification and a means of constructing social relations (and knowing what relationships need not be constructed)."[6] And this definition points clearly to the issue of why economists resist tackling tastes as part of the demand function relative to the arts. Within this definition, tastes become ways in which in-group and out-group members are identified—and in the case of the culture industry, tastes are everywhere and always related to aesthetics and notions of value. These details were covered in Chapter 2.

One way to capture an understanding of consumption is by using an anthropological lens, through which we observe the ideology of ritual as connected to tastes, because arts consumption symbolizes and yields meanings. These symbols and meanings in turn culminate in cultural capital accumulation (i.e., the command of culturally prestigious goods, ideas, and services) that can be utilized as its own system of exchange. Ultimately, people consume to fulfill complex wants on a myriad of levels, and often consumption fulfills several wants simultaneously. For example, an individual may attend a chamber music concert because he wants to be seen by others in his group or make, expand, or reinforce social connections to heighten the possibility of being elected to a board position or meeting a potential mate, while, and at the same time, he may have a goal of enlarging his tolerance for quartets of a particular musical era. Other goals and wants, of course, can also be given as underlying reasons for what is manifested

by arts consumption, such as wanting to experience new adventures or expand intellectual knowledge.

Consumption occurs on the micro level that is often dictated on a more macro level, and these in turn, are situated, always, within an anthropologic frame, to meet needs.[7] Consumption is evaluated anthropologically as a snapshot of time within societies and groups, carried out by individuals to meet wants. In this text, therefore, *consumption* will be understood as people's use of goods, ideas, and services that happens at a point in time and both arises in and is dictated by culture, to meet wants, to communicate, and to explain or stabilize social relationships.[8]

Moreover, consumers go about the anthropological process of acquiring goods, ideas, and services based on their tastes; the activities are done in ritualistic fashion and often with other people—family, friends, colleagues, and so on. *Rituals* become the way people and events are classified—set in social contexts—using these goods, ideas, and services so that they may be evaluated for their similarities and differences (i.e., name-sharing aspects). Rituals help shape the system and it is a matter of applying this process to the notions of high art and popular or low art to make an anthropologic association for the consumption of culture. The reason this clarification and demarcation of consumption, tastes, and ritual is important is because it displaces the *culturepreneur* from the role of having to make judgments about arts consumers. Rather, understanding consumption tastes through an anthropological lens provides a disinterested way of constructing and interpreting the arts consumption function. This helps to produce art within an understanding of social categories and begins to explain why, for instance, people are attracted to different kinds of arts. As Douglas and Isherwood write, "Goods that minister to the physical needs—food, or drink—are no less carriers of meaning than ballet or poetry."[9]

Drawing on the materials set forth in the previous chapters, it is now possible to state emphatically that goods, ideas, and services carry meaning, and this is particularly true of the arts. In this area, people enjoy not only the good or service of the art itself, but also the "sharing of names" and commensurate experiences that they garner: the investment of time, attention, energy, and financial resources in learning about, consuming, or producing artistic products and experiences. Through name sharing within groups, the meaning and cultural significance of art objects are made, providing a marking process to identify individuals who, by agreement within the culture itself, consume similarly. For example, donors name-share by identifying contribution levels to arts organizations, audiences mark each other in special seating arrangements in theaters, and arts consumers discuss the process of participating in an event such as the Ojai Music Festival. These kinds of name-sharing arrangements are further facilitated by usage of social media and other communication modes. A discussion of the use of technology in the arts management process will be given in Chapter 11. Here, though, it is necessary to examine where rituals come from, as they are related to consumption.

RITUALS AND CULTURAL CONSUMPTION

From a panoptic vantage point, we can note that goods move meaning from the over-arching social structure a culture resides in, and further conceptualizes consumption of goods in the "symbolic action" or, more precisely, rituals, in defining name-sharing and marking processes, as depicted in Exhibit 3.4. From this vantage point, a ritual is

> a kind of social action devoted to the manipulation of cultural meaning for pur-poses of collective and individual communication and categorization. Ritual is an opportunity to affirm, evoke, assign, or revise the conventional symbols and meanings of the cultural order. To this extent, ritual is a powerful and versatile tool for the manipulation of cultural meaning.[10]

There are four kinds of rituals—exchange, possession, grooming, and divestment—and each of them is linked to the anthropology of consumption by providing and facili-tating cultural meaning.[11]

EXCHANGE RITUALS

Exchange rituals focus on giving goods, services, and ideas to others or to oneself. As an example, in the United States, it is easy to conceptualize giving a Valentine's Day gift that includes food, a romantic excursion, and personal adornments. Foods include dinners and candies, while romantic excursions can range from a couple's

Exhibit 3.4 **Consumption and the Movement of Goods**

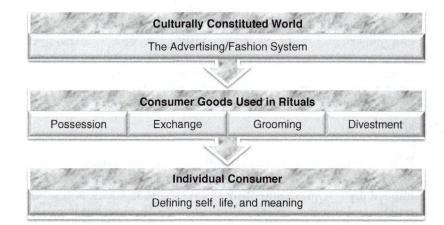

Source: Grant David McCracken, "Culture and consumption: A theoretical account of the structure and movement of the cultural meaning of consumer goods," *Journal of Consumer Research* 13, no. 1 (June 1986), 71–84.

getaway for the weekend to a quiet massage. During the Valentine's Day season, it is typical to exchange gifts of personal adornment, such as jewelry or watches. Other kinds of ritual giving mark many different culture-specific observances, from holidays and birthdays to graduations and christenings. The point is that the gift carries cultural meaning. As such, giving someone tickets to see a performance of the San Francisco Opera means one thing, while giving the person tickets to a community opera entirely another.

POSSESSION RITUALS

In *possession rituals*, goods, ideas, and services are used as markers for the cultural meaning they represent. People take possession of the meaning, in that the goods, ideas, and services they consume have symbolic meaning to them and to others. These symbols point to class, gender, ethnicity, and other kinds of variables that provide group identity within the overall social structure.

GROOMING RITUALS

Grooming rituals are activities performed by people to assure that goods possessed transfer their symbolic meaning. McCracken uses an example of the "going-out ritual" which exemplifies the nature of grooming rituals. "Going out to the symphony" requires, for example, one set of grooming rituals, food preparation perhaps by way of reservations at a restaurant, taking a private form of transportation, and wearing clothing reserved for special events. Differently, "going to a festival" takes on another set of grooming rituals, including wearing appropriate clothing, developing food in picnic form, and arranging for transportation that allows carriage of the picnic. Moreover, if one is attending subcategories of the symphony or the festival kinds of events, the going-out ritual requires yet other kinds of goods. Keep in mind also that grooming rituals can be placed in consumption objects themselves, such as spending resources and time in cultivating the garden of one's home, thereby giving more emotional significance and symbolic meaning to one's residence. Display of a work of art or sculpture etched on a comforter, for example, may place meaning on the home.

DIVESTMENT RITUALS

When *divesting rituals* occur, people go through a process of extracting the meaning they have invested in goods, services, and ideas, removing the symbolism they have imbued them with. In and of themselves, goods, ideas, and services fulfill wants or satisfy goal-directed objectives in ritualistic fashion, but it is *culture* that invests the meaning in them.

The four areas of ritual just discussed should be seen as fluid practices, allowing changes in the overall social structure of culture. Shifting categories of meaning are fulfilled by diverse goods, ideas, and services, and therefore this ideology of

Exhibit 3.5 **Modified Model of Consumers' Appropriation of Countervailing Cultural Meanings**

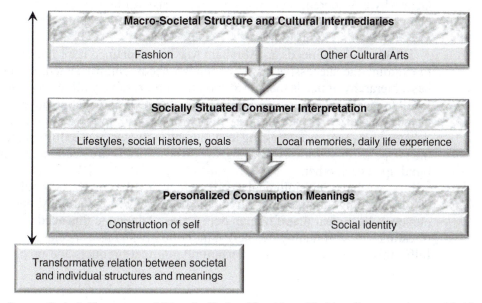

Source: Craig J. Thompson and Diana L. Hayko, "Speaking of fashion: Consumers' uses of fashion discourses and the appropriation of countervailing cultural meanings," *Journal of Consumer Research* 24, no. 1 (June 1997), 15–42.

cultural meaning is not meant to be interpreted as a static one or be considered in any way oppressive, or hegemonic, though it has been criticized as such. As depicted in Exhibit 3.5, the model of the movement of goods, services, and ideas has been examined as a location of counteractivity. While this theoretical argument has proposed a way to understand how consumers can resist the overriding process of cultural construction, the purpose here is to highlight that there is an anthropology of consumption that operates in rituals employing goods, ideas, and services, including cultural and artistic ones, that fulfill human wants and needs.

EXPLAINING CONSUMER WANTS

The preceding section presented consumption as fulfilling needs and wants in an anthropological frame. But what exactly are needs? Are they different from wants? If so, how? For all intents and purposes, wants and needs are equivalent, only because in our society, in Western society, in a society where consumption carries meaning, a want can be manufactured and manipulated through a variety of processes, such as advertising, envy, and other human interactions, and contrived so that it looks like a need. In the following subsections, three models of human needs—hierarchical, functional and symbolic, and systemic—are illustrated to explain the ways we can interpret consumption of arts goods, ideas, and services.[12]

MASLOW'S HIERARCHY OF NEEDS

Generally considered, there are five levels basic to human existence, but there are many goods, ideas, and services that are in use through which these needs can be met, as shown in Exhibit 3.6.

The hierarchy of needs, as Abraham Maslow explained it, provides us with a way to examine the successive levels of human needs. Simply stated, the human being has a hierarchy of needs that, once satisfied, progressively allows a person to look to fulfill higher-level needs. Whether these higher needs are instinctual or whether they have been created as part of the evolution of a consumption culture is an interesting debate;[13] however, as interesting as it may be to pursue, it is unfortunately not within the scope of this work. According to Maslow, needs are sequentially ordered and build upon each other.

First we have physiological needs, which involve the basic bodily instincts of eating, sleeping, taking care of hygienic needs, covering the body, and reproducing ourselves. It is clear that if human beings do not attend to this need level, in the case of eating and reproducing, we perish individually and as a species. Yet many people fulfill this sustenance need by consuming gourmet products and preparing them on

Exhibit 3.6 **The Hierarchy of Needs**

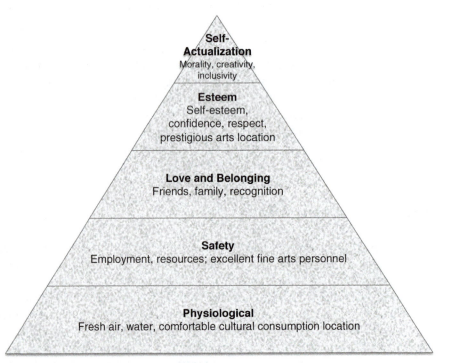

Source: Elizabeth Hill, Catherine O'Sullivan, and Terry O'Sullivan, *Creative Arts Marketing*, 2nd ed. (New York: Butterworth Heinemann, 2003), 125.

high-end appliances, within homes that are developed and furnished by designers—
and importantly, decorated with arts cultural goods. Several movies come to mind—
for example, *Fun with Dick and Jane*, a movie about a couple who has many of the
desired objects that meet these needs. Another movie that depicts the way that needs
are met is *Mr. and Mrs. Smith*, which exposes the home as a repository of upscale
goods to fulfill these kinds of needs. Importantly, movies are vehicles that transfer
information relative to cultural meaning, as explained in the preceding section. As
such, these two movies allow viewers to glimpse how consumers are taught how to
fulfill the lower-level needs in a variety of ways.

Next, we have the safety need: we want to feel that our existence and our pos-
sessions are not threatened. It is easy to see that humans have this need fulfilled by
owning homes that can be locked and possessions that can be kept safe, with human
protection for loved ones insured and assured by police and security systems. At the
same time, some people fulfill this need with computer surveillance systems, insur-
ance, and property protected by award-winning pets.

The third human need is for love and belonging. People have to feel loved, to feel
they belong to a group, and to be in contact with other people, or they risk losing
their minds. This kind of human connectedness needs to be created, established, and
cultivated in order to thrive. Here an interesting illustration of this need comes to
mind from the movie starring Tom Hanks, *Cast Away*. Hanks's character is stranded
on an island without any other humans or contact with any, and his examination of
the island reveals no signs of a current civilization. In order not to be "alone," he
draws a "happy face" onto a soccer ball he finds on the shore, in order to keep him-
self in "human" company while he waits to be rescued. In short, humans need faces
to look at, people to talk to, and, hopefully, people who will respond with love and
affection that makes for belonging.

Next, we have needs for self-esteem and acknowledgement from people outside
of ourselves; for example, praising us for doing good work, providing social sta-
tus feedback and attention, reflecting approval relating to the meaning arising from
what was done. These inputs lead to the internal feelings of satisfaction and pride in
our accomplishments and self-respect, in relation to the community's whole. These
kinds of needs can be met by many activities, including, for examples, attending a
ballet, listening to the right music, or participating appropriately in an art auction—
and having a respectable individual provide a favorable mention or gesture toward
the action.

Finally, the need for self-esteem is followed by the need for self-actualization,
which is where people enjoy peak experiences, contentment, and happiness; it is
the same ideology as spiritual fulfillment or enlightenment—transcendence. Many
people expend enormous energy trying to achieve this state, through many different
consumption objects and mediums, though some people are not aware, consciously,
that this is what they seek. Consider, for example, the arts connoisseur who enjoys
the riveting feeling of winning the acquisition of arts objects in an auction or indi-
viduals who attend symphonies and experience a spiritual situation. The point is that
the highest level of need satisfaction resides in the realm of actualization, trying to
understand existential questions through consumption.[14] These desires are operating

in the background of our consciousness all the time; however, theoretically, when we are distracted by the lower-level needs, our attention turns there and stays there until we are able to feel we have satisfied them. A transcendent experience can also arise from watching a fine arts performance or attending a gallery.[15]

The fact remains that people are seekers of answers to the hard questions about life in all cultures and over the course of history, whether they admit it or not and whether they indulge in purchasing spiritual products and gifts, or if purchasing something else, such as when they call what they buy a peak experience. Such experiences can be induced, such as for many who play online games, participate in competitive sports, travel to witness the wonders of the world, go hang gliding, or attend to the arts. There are two other models of examining needs, and the next one of interest includes looking at functional, symbolic, social, and emotional needs.

FUNCTIONAL, SYMBOLIC, SOCIAL, AND EMOTIONAL NEEDS

What motivates the consumption of art can also be examined by looking at functional or cultural, symbolic, social, and emotional needs, as shown in Exhibit 3.7.

Exhibit 3.7 **Functional, Symbolic, Social, and Emotional Needs for Cultural Fine Arts**

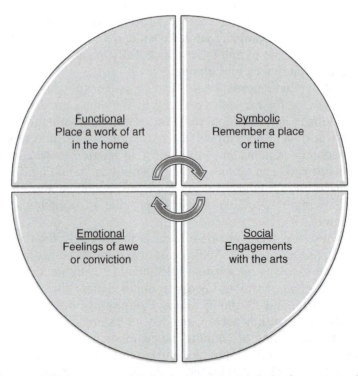

Source: Simona Botti, "What role for marketing in the arts? An analysis of art consumption and artistic value," *International Journal of Arts Management* 2, no. 3 (2000), 14–27.

In terms of *functional needs*, those are needs that are considered when we recognize a problem and go about solving it, or when we face the feeling or reality of lacking something. This kind of need can be physical or intellectual, and therefore cultural art can fulfill these needs. For example, we may want a picture to hang on the wall, or desire more educational knowledge about Chinese art and its history, in order to fill a functional albeit cultural need.

Symbolic needs are those that are related to meaning that a product or service is imbued with on a psychosocial level, and can provide the relative social markers discussed earlier. At the same time, *social needs* are those that arise when finding one's place in the society. These needs can be met with arts by providing the naming points explained above.

And lastly, *emotional needs* have to do with how we find love, feelings of pleasure, enjoyment, relaxation, fun, and a host of other emotions that may or may not be connected to fulfilling other needs. However, these kinds of emotional needs are positioned within an escape function and are connected to the aesthetic experience when talking about consumption.

The emotional need fulfillment is the most important for arts consumption because humans need feelings of awe, wonderment, and flow experiences,[16] and the role that the artist plays in creating works of art is tantamount, such that it becomes a driving force facilitating nonutilitarian, noninstrumental function, even while consumption of arts goods, ideas, and services solves other needs. These kinds of needs—functional, symbolic, social, and emotional—are fulfilled within one's cultural context and therefore allow a broad range of experiences and objects that can be used in service of fulfilling wants.

Many of the needs people have are articulated and met by establishing and achieving goals. The list of goals one has can be long, and the goals themselves can be seen as short-term or long-term in focus. At the same time, goals can be nestled inside each other, such that a short-term goal achievement propels one along toward carrying out a long-term goal. This is recognized easily, for example, when consumers set out to find a place to live, buy a new pair of pants, or find a good doctor. Saving for the children's college education and retirement for some constitutes a long-term focus on goals, as do investing with a certain return expectation and setting aside part of one's estate for an arts organization in a last will and testament. Goals are achieved within the levels and areas of need fulfillment, whether considered hierarchical or functional/symbolic, and as such, goals can include ideas such as realizing a higher level of awareness of ethical or spiritual elements, such as attending the theater, going to museums, or touring the Holy Land.

NEEDS AS A CONSTRUCTION OF CULTURE

However, before we accept the two broad conceptual frameworks characterizing needs evaluation outlined in the two preceding subsections, it is necessary to consider needs from a Baudrillardian perspective. According to this view, there is no meaning in a theory of needs, but instead there is only an ideological concept of need. The basis of this perspective arises from an argument that needs are contrived by a

type of mythology in which needs "need" production and production needs "needs." Given this point of view, consumption allows individuals to interpret their world, or imagine a new one, by the way they fulfill their needs through an exchange function. Importantly, consumption of items serves as a system of codes, yielding objects that point to difference or similarity, since feeling different from or the same as the other person or a group is mainly what consumers seek. Needs, then, are concocted within difference or similarity arising from provisioning of goods, ideas, and services.[17] In other words, needs are a part of the entire anthropological system under which "the soul and body still persist in the subject-object of dialectic of need."[18]

Another way of understanding how needs are constructed and met is to say that human beings have primary and secondary needs, both residing in the material and spiritual conceptions, and having a minimum threshold. In this way, contemplating a progressively animal-to-spiritual continuum of need fulfillment, as shown in the hierarchy of needs, is not viable. Why? Because cultures create "surpluses" regardless of the structure they find themselves in, or where in the industrialization/consumerization process it finds itself, in which the cultural industry participates. That is to say, therefore, that needs are arbitrarily created by the culture one lives in. Difference and inclusion relative to in-group or out-groups are a social fact. Because of the human condition, individuals consuming below a given level of need are described and relegated to purchasing the objects of difference, while those consuming above an arbitrary line of surplus are objects for envy. The "need" then is for the human consumption of signs (objects) that symbolize (mean) one's place in the social strata.

Whether the hierarchical, functional, or systemic model of needs and goal fulfillment is accurate is not the issue. What is important is their applicability to arts management and culturepreneurship. The point is to now think of products and services relative to the arts that can be positioned for consumption dictated by fulfilling needs based on and within cultural contexts. As such, understanding consumption anthropologically provides a mechanism to conceptualize the contextual and reflective nature of how consumption of arts goods, services, and products both sustains and creates the cultural industry. Not only that, arts consumption can serve as a spiritual practice.

ARTS CONSUMPTION AS A SPIRITUAL EXPERIENCE

How can one suggest that arts consumption substitutes, or drives and manifests, as a spiritual practice? Recent literature on the subject points this out. In this section, several aspects will be considered. How is spirituality defined? Why do humans "need" it? And in what ways have they fulfilled it? How does art fit within this model? The discussion begins with spirituality, moves through transcendence, and arrives at transformation. The key for the arts manager or culturepreneur is to be able to connect arts production and delivery with these consumptive experiences that are a part of the arts consumers' demand functions.

In an article titled "The Current Status of Measures of Spirituality: A Critical Review of Scale Development," Afton N. Kapuscinski and Kevin S. Masters[19]

explain the nature of the difficulty of defining spirituality. Central to the problem is the interrelationship between religion historically, and spirituality contemporarily. According to these two authors, religion is understood to include notions of God, systematic rituals, readings, behaviors, faith, a love or form of devotion for God, and having the answer to the difficult questions of existence and death. These, in turn, they argue, are connected to a place of worship and a prescribed set of accepted values and beliefs within a community. This is easy to conceptualize, as we know of Buddhists, Hindus, Sufists, Christians, and other groups that are affiliated with definitional locations. Degrees of religious belief, moreover, can be measured with quantitative attributes and constructs, from a psychological viewpoint. Spirituality, however, Kapuscinski and Masters point out, differs from religion in that it includes a transcendent aspect and does not have a clear structure, since it is interpreted by the experience of the individual. Like the notion of aesthetics, it could very well be that the definition of the spiritual is different for each person. The authors therefore stress the ideology that employing qualitative inquiry will get at the definition of spirituality more succinctly than quantitative methodological practices employed by psychologists and sociologists who look to understand spirituality and religion.[20]

Other writers and scholars provide valuable food for thought along these lines. For example, the article "Spiritual But Not Religious? Evidence for Two Independent Dispositions," written by Gerard Saucier and Katarzyna Skrzypinska,[21] demonstrates that even though researchers have a difficult time defining a distinction between the religious and the spiritual, the "layperson" knows the difference. Moreover, the authors support a notion that spirituality gives rise to churches composed of one congregant, so to speak, consistent with an individualistic consumer society that arises in advanced capitalism. The fact is that "spiritual" and "religious" are difficult to define in the academic literature, both separately and precisely, especially when researched in a quantitative tradition. But this does not mean we do not know what they mean or how to distinguish them.

Stuart Rose, a scholar straddling the consumption, advertising, and religious research worlds, has written "Is the Term 'Spirituality' a Word That Everyone Uses, But Nobody Knows What Anyone Means by It?" While the title of his article can sum up the question, he comes to his conclusion by asking religious leaders from disparate walks questions meant to tease apart definitional distinctions. What he suggests is what people know but is difficult to prove: that religion and spirituality have similar but not the same meaning, and we know the difference. He writes:

> Spirituality can be experienced in the wonder of nature, in joy and the arts, in humanism, football, the funeral of Princess Diana, mutual tolerance for all living things, in acts of complete selflessness, and in service. Overall, membership of, or belief in, a particular religion was not thought to be prerequisite for the experience of the spiritual. . . . The outcome of these questions allows me to assume safely that the two terms describe, in essence, the same or a very similar experience, although the term "spirituality" covers a wider spectrum of activities than the term "religious."[22]

Regardless, he finds that whether one camps with the spiritual or religious, both manifestations need a practice aspect associated with them—a set of things people do in support of their beliefs. In our case, consuming art experiences is such a practice.

Another interesting approach to this question of "Is the spiritual different from the religious?" can be found in William Irwin Thompson's *The Time Falling Bodies Take to Light: Mythology, Sexuality and the Origins of Culture.*[23] In taking on the origins of culture, Thompson theorizes that organized "religion" was not needed when humans were in touch with the Great Mother and the Cosmic Dance. Societies have flocked to places of worship because individuals have lost that internal connection, as if one were looking for breathable air that is already there or a fish seeking the water that surrounds it. Thompson surmises, "Religion is not identical with spirituality; rather, religion is the form spirituality takes in a civilization; it is not so much the opiate of the masses as it is the antidote for the poisons of civilization."[24] He suggests, among other things, that the artist and the mystic redeem us from the poisons of civilization. For Thompson, however, manifestation of religion is the reason that more people attend museums than churches on Sundays nowadays, for example, in postreligious culture in an effort to tap into the precivilized ways of knowing a connection long lost.

One way around getting caught up in the definitional paradox, and what some may conclude is basically a question of semantics, is to use the words "mystic, mystical, mysticism" to help us come to understand more clearly what we mean by the spiritual, and what people seek in consumption of arts experiences. The overall experience is what McCracken, in *Transformations,*[25] explains that consumers long for when they are being transformed. It is one in which people feel in touch with something greater than themselves, in the sense that there is a greater intelligence, meaning, direction, reason for being on earth, and human being. Arts consumers attempt to understand why life is important or propose that there is a known disposition of our beings after death. It is a feeling, an awareness, a connection, a love for people and the world in the unlovable and lovable conditions. Moreover, mystical experiences are themselves nonarticulable in a given moment.[26]

How does this help us in the facets of consumption and eventually lead us to an anthropology and spirituality of consumption for the arts? We might find some insight in Heather Skousgaard's article "A Taxonomy of Spiritual Motivations for Consumption."[27] In her view it is simply that consumption provides that missing yet sorely needed spiritual experience, and consumers consume because it is itself now a spiritual practice. Her research shows that people seek meaning, connection, and emotional transcendence through consumption. In meaning, they want to understand the world they are in, where it is going, and why. For connection, people are looking for mystical relationships, based on caring, with other people and with higher beings. In terms of emotional transcendence, people desire to achieve a sense of calm, peacefulness, and fulfillment. In this last category of emotional transcendence, it is not only tranquility they seek, but safety and security. Reflecting back to the hierarchy of needs, if we believe this position given by Skousgaard's assumptions, we can easily see the relationship between consumption and spirituality, even as

Skousgaard warns us that spirituality is extremely complex and includes both cognitive and affective components. Nevertheless, consumption itself has now become a spiritual practice, and consuming arts goods, ideas, and services stands in as a surrogate for the spiritual but not the religious. It is also here that the arts services product has to fit—a point taken up in detail in Chapter 8, which discusses the arts as a service. Indeed, cultural institutions create or develop deep moral and intellectual stimulations that do not necessarily involve ascetic behavior, and a location for consumption through individual human transformation and social advancement.[28]

Exhibit 3.8 Silicon Valley Creates, San Jose, California

Igniting investment and engagement in arts and creativity in Silicon Valley is the mission of the newly created Silicon Valley Creates (www.svcreates.org), located in San Jose, California. The boards of directors of what were previously two separate organizations, the Arts Council Silicon Valley and 1stACT Silicon Valley, announced a formal merger, resulting in the creation of a regional nonprofit: Silicon Valley Creates. The organization builds on the thirty-year history of support for the arts community through regional grant making and professional development, while it simultaneously benefits from 1stACT Silicon Valley's dynamic role in incubating innovative programs and nurturing partnerships like ArtSpark, which encourages children's participation through the Symphony Silicon Valley. The new organization is committed to raising the visibility and value of the arts, growing investment in arts and creativity, increasing participation in creative outlets, and building the capacity of a cultural ecosystem.

More than ten arts and culture organizations benefit from Silicon Valley Creates, rejuvenating an area of San Jose that had been undervalued into an evolving arts and entertainment district. One of the organizations helping to lead that transformation is Anno Domini, self-described as The Second Coming of Art and Design (www.galleryad.com). The independently run gallery appeals to a very diverse audience, including independent creative types, varied artists, young families, and the more conventional gallery-goers.

Another example of an arts and culture organization participating in and benefiting from Silicon Valley Creates is TheatreWorks (www.theatreworks.org), a musical and drama performance group. Established in Silicon Valley for nearly forty years, it is noted for its willingness to experiment—to give local theatrical audiences brand-new, never-before-seen plays and musicals. It's similar to a pre-pre-Broadway run. The musical *Memphis* debuted at TheatreWorks and moved to (and can still be seen on) Broadway. "We were quite excited to fly to New York to see it, and so proud that we first produced it here," said Phil Santora, managing director of TheatreWorks. "What we are is an incubator for new plays and musicals. We have just finished our fifty-third world premiere on our stage. Our plays then are performed around the country—in La Jolla, Memphis, St. Louis, Seattle, off-Broadway," Santora said. "We are a safe place to create—composers and playwrights come together here and cross-pollinate." It seems as though theatergoers this year are more likely to buy individual tickets rather than subscribe to the entire series. The company finds multiple ways to connect with arts consumers to stabilize revenues and create that impact echo.

ART AS A CONSUMABLE OBJECT AND REFLECTION OF SELF: THE PRACTICE

You may remember that Douglas and Isherwood[29] described the emotion of envy to explain the way that people react when they see someone with something they want and also suggested that people "share names" based on possessions and actions. Nobility were the elite to whom people looked to understand behavior and desires, and within and around the

nobility, people understood what they were to consume or had their desire for consumption created.

Taking an anthropological and consumer behavioral view, in his work on culture and consumption, Grant McCracken exposes a history of consumption behavior that dates back to the 1500s in Europe.[30] Differently from Douglas and Isherwood, though, McCracken describes this as social competition, rather than name sharing, and it is perhaps here where one first notices the implications between high and low culture at this early date. Consumption had become somewhat expansive in the movement of goods internationally. By the eighteenth century, extravagant luxury wants had become necessities.[31] Moving into the nineteenth century, consumption of goods, ideas, and services defined one's self, values, social change, and the world people lived in. People read meanings symbolized in goods, ideas, and services and, attaching them to themselves, allowed objects to define themselves in reflection to society. Consumption became the mirror face to production as the consumer's response to industrialization. When the wealthy exhibited their goods, ideas, and services, from clothing to housing, the notion of conspicuous consumption—that is, showing off wealth by what one consumes—came into play,[32] and with that the idea of trickle-down, of spending power and consumption moving from the upper down into the lower classes, became apparent.[33] While some argue that the process is linguistic, describing arbitrary relationships between objects and meaning transposed onto them, goods, ideas, and services consumed become iconic;[34] that is, the item communicates what it signifies—information on social identity. Not only that, there is a relationship between a person and an object.[35] In other words, what you consume essentially defines you.

Within this understanding of the consumption landscape, arts are part of the picture, and McCracken's argument focuses upon the *symbolic nature* of goods and experiences related to consumption activities—these goods and activities that are representational of culture. As a point of formulaic reference we can draw this analogy: "If I have art/culture, I must have taste, and if I have taste, I must have status," and through this taste, discernment of the "fine" is available.[36] That is, the ability to understand the symbolic meaning associated with a particular artistic form allows space for the importance of consumption of the arts produced for the cultural industry.

But because consumption has grown into a reflexive activity mirroring self and society, the net around art objects has increasingly widened, as the consumer is sought by many different cultural and arts institutions. Popular art producers demonstrated the ability to attract consumers, catering to their tastes and providing what these consumers want. Consumers thus expect to be able to make choices based on their own points of view and not only by what is dictated by the superstructure and flow of goods. Therefore, "anything put before the consumer must be crafted to meet existing needs, wants, and expectations" in his or her negotiations of culture.[37]

One result is that the self and the world are porous, theoretically, for the post-postmodern society formulated around Western consumption. With a little education and mobility, real or imagined, people can move into different spaces and identify with different selves of their choosing by what they practice. And with this comes

the divine "right" to make these choices about who they are based on what they consume, what cultural category they aspire to belong to, and how these attach to self-identity and spirituality. Moreover, consumers have multiple self-identities that are global in nature, requiring identity to be fluid and putting consumption on a transformative trajectory on a variety of levels, culminating in expansionary individualism. And in "a culture of expansionary individualism, it is almost as if anything permitted in art is now *expected* in life."[38]

At this juncture, the point that must be pressed is that consumers' self-definitions are as mobile, fluid, and interchangeable as they can imagine them, and consumption, it is argued, is used to symbolically provide proof of the meaning of a self-concept. Consumption of arts goods, ideas, and services supplies fulfillment of these expansionary needs, in fine arts, contemporary arts, and popular arts frames, and the consumer is free to choose and define and ingest what these objects mean, in rituals, exchanges, gifts, and divestitures. From the pre- to postmodern periods, cultural articulations and their relationship to spiritual or mystical experiences have been active in arts consumption practices.

THE ARTS CONSUMPTIVE EXPERIENCE

Up to this point, the chapter has walked you through the idea of an anthropology of consumption, explained theories of needs, and shown how consumption practice has been described as working in tandem with transcendent and mystical experiences: the practice of consumption is a part of the overall need for spiritual transcendence. The purpose of providing you with this background as an arts manager and culturepreneur is to equip you with an understanding of what consumers expect as "take-aways" from their experiences in the arts. People come to the arts table for a variety of reasons, to fulfill a variety of wants. These can range from the intellectual to the social, with transcendent and mystical desires underpinning some of them.

The *arts consumptive experience* is one in which the consumer is wowed, transformed, allowed a momentary escape, captured in a feeling of flow, or otherwise positively overwhelmed in feeling self-actualized by the offering and the practice of the experience. Once the experience is over, it motivates word of mouth, social media postings, and allegiance to the arts product or service; this "echo effect" is covered in Chapter 8. People want to buy merchandise, sign up for season tickets, participate in functions, and give their money in support.

As we shall see when talking about the arts as a service product, creating this effect is no simple or easy task, yet it is what consumers expect from art. Why? Because we have asked—demanded—that the arts change humans for the better, even while in a consumptive frame, and irrespective of whether the arts experience is in high or low aesthetic contexts. Importantly, as our world experiences more movement in rapidly changing global and local environments where people desire these transformative experiences, where arts products and services are presented and consumed as an anthropological process, we seek that which "strengthens our ability to thrive together in a dynamic and complex social environment."[39] This is ultimately what the culturepreneur or the arts manager must provide—consistently.

CHAPTER SUMMARY

One of the points that this chapter raised was whether there is a difference between wants and needs. In this textbook, they are considered as equivalent. The important point is to know different approaches to understanding arts consumers' desires within their anthropological contexts. Hierarchical, functional/symbolic, and systemic approaches were presented in order to facilitate understanding how the arts can fulfill consumers and provide what they are looking for.

Reading this chapter supports the position that places an understanding of consumption relative to needs and wants broadly in an anthropological framework. To do so, an anthropological approach to consumption was given relative to the arts consumption. The literature makes it evident that this kind of consumption has a long and detailed history. The chapter additionally presented the theoretical ideology of rituals and their relation to consumption. Gifting, possession, grooming, and divesting rituals inform the arts consumptive experience and allow an understanding of arts consumption as a ritual practice.

As with the aspects of ritual behavior, it was proposed that consumption of the arts can be viewed as fulfilling mystical aspects of human beings. A discussion of the differences between the spiritual and the religious was presented, with the goal of determining that arts consumers are seeking transcendent experiences. If such experiences are achieved, then the arts manager and the culturepreneur have succeeded. The transcendent experience additionally includes the idea that arts goods, ideas, and services, when consumed, reflect the self-concept, which is changeable, fluid, and culturally contextual. Taken together, the chapter assists readers to understand the idea of the arts consumptive experience that arts managers and culturepreneurs attempt to create for their consumers.

DISCUSSION QUESTIONS

1. Consider the differences between needs and wants. Make some notes about what they are, and how they are situated within categorical locations hierarchically, functionally, or systemically. Should the arts manager or culturepreneur care about distinguishing between needs and wants? Why?
2. Consider each of the following events: an evening at the opera in Sydney, Australia; a Sotheby's arts auction in Paris; participation at a local arts festival; and attendance at a matinee of *The Nutcracker* performed by the Bolshoi Ballet on tour in New York. Describe the going-out ritual that would be utilized in each of these events. How are they different or the same? Imagine four different goals that could be achieved by attending these events.
3. Using the three theories of needs covered in Question 1, explain what needs are fulfilled by attending and participating in the arts offerings in Question 2. Please clarify which theory of needs your answers apply to.
4. Discuss meaning transfer and self-identity construction through cultural arts consumption. How does this work?

5. Explain the difference between the spiritual and the religious. Why does arts consumption focus on this area?
6. In setting up an arts consumptive experience, what is required based on the view that arts consumers seek transcendence? Do you agree or disagree with the idea that the role of the arts manager or culturepreneur is to provide such experiences? Why?

EXPERIENTIAL EXERCISES

1. The Arts Consumptive Experience Plan

 a. Make some notes about how you will go about making sure you are providing, or are going to provide, the arts consumptive experience in the arts cultural area you work in.
 b. Interview arts managers or culturepreneurs in the fine tangible and intangible arts. Ideally you will select two companies or organizations in each area; if possible, one should be relatively large compared to the other one. Ask questions about how the arts offerings are selected and how the managers expect them to impact their arts consumers. How do your interviewees know if they have succeeded in what they plan to do?
 c. Compare and contrast what you plan to do with what is being done based on your interviews. What key elements surface in regard to planning for the arts consumptive experience?

2. The Arts Consumptive Experience

 a. Interview several arts consumers, and ask them if they have had arts consumptive experiences that they considered underwhelming. Ask them what was missing from their experience. Make notes or record the conversations.
 b. Compare and contrast what the arts consumers had to say with the ideas presented in the chapter relative to the desire for a transcendent experience. What have you uncovered from the conversations with the arts consumers?

3. Merging the Arts Consumptive Experience Plan and Outcome

 a. Take a step backward to consider the points of view expressed by the arts managers and culturepreneurs and by the arts consumers. After thinking about them, what can you say about this process? What would you tell someone who is contemplating being an arts manager or culturepreneur, or those who are already in these roles and who want to grow their organizations? Be as specific as possible, within the context of the points raised in this chapter.

FURTHER READING

Hegel, G.W.F. *On Art, Religion, and the History of Philosophy: Introductory Lectures*, ed. J. Glenn Gray. Indianapolis: Hackett, 1997.

Martin, F. David. *Art and the Religious Experience: The "Language" of the Sacred*. Lewisburg: Bucknell University Press, 1972.

Nagel, Thomas. *Mind and Cosmos: Why the Materialist Neo-Darwinian Conception of Nature Is Almost Certainly False*. New York: Oxford University Press, 2012.

Plate, S. Brent (ed.). *Religion, Art, and Visual Culture: A Cross-Cultural Reader*. New York: Palgrave, 2002.

Rinallo, Diego, Linda Scott, and Pauline Maclaran (eds.). *Consumption and Spirituality*. New York: Routledge, 2012.

Tillich, Paul. *On Art and Architecture*, ed. John Dillenberger; trans. R.P. Scharlemann. New York: Crossroad, 1987.

Wagner, Richard. *Religion and Art*, trans. William Ashton Ellis. Lincoln: University of Nebraska Press, 1994.

NOTES

1. Rick Mathews, "US GDP is 70 percent of personal consumption: Inside the numbers," *PolicyMic*, September 21, 2012, www.policymic.com/articles/15097/us-gdp-is-70-percent-personal-consumption-inside-the-numbers.

2. William R. Emmons, "Don't expect consumer spending to be the engine of economic growth it once was," *Regional Economist*, January 2012, www.stlouisfed.org/publications/re/articles/?id=2201.

3. John Maynard Keynes, *The General Theory of Employment, Interest, and Money* (New York: Harcourt, Brace, 1936).

4. Mary Douglas and Baron Isherwood, *The World of Goods: Towards an Anthropology of Consumption*, rev. ed. (New York: Routledge, 1996), 4.

5. Paul DiMaggio, "Classification in art," *American Sociological Review* 52, no. 4 (1987), 442.

6. Ibid., 443.

7. Douglas and Isherwood, *World of Goods*; Grant David McCracken, "Culture and consumption: A theoretical account of the structure and movement of the cultural meaning of consumer goods," *Journal of Consumer Research* 13, no. 1 (June 1986), 71–84.

8. Douglas and Isherwood, *World of Goods*, 39

9. Ibid., 49.

10. McCracken, "Culture and consumption," 79.

11. Grant David McCracken, *Culture and Consumption: New Approaches to the Symbolic Character of Consumer Goods and Activities* (Bloomington: Indiana University Press, 1990); Craig J. Thompson and Diana L. Hayko, "Speaking of fashion: Consumers' uses of fashion discourses and the appropriation of countervailing cultural meanings," *Journal of Consumer Research* 24, no. 1 (June 1997), 15–42.

12. McCracken, "Culture and consumption"; Douglas and Isherwood, *World of Goods*; David Throsby, *Economics and Culture* (New York: Cambridge University Press, 2001).

13. David Graeber, *Toward an Anthropological Theory of Value: The False Coin of Our Own Dreams* (New York: Palgrave, 2001).

14. Russell W. Belk, Melanie Wallendorf, and John F. Sherry Jr., "The sacred and the profane in consumer behavior: Theodicy on the odyssey," *Journal of Consumer Research* 16 (June 1989), 1–38; Yu Chen, "Possession and access: Consumer desires and value perceptions regarding contemporary art collection and exhibit visits," *Journal of Consumer Research* 35, no. 6 (2009), 925–940; Russell V. Belk, "The sacred in consumer culture," in *Consumption and Spirituality*, ed. Diego Rinallo, Linda Scott, and Pauline Maclaran (New York: Routledge, 2012), 69–80.

15. Jennifer Radbourne, Katya Johanson, Hilary Glow, and Tabitha White, "The audience experience: Measuring quality in the performing arts," *International Journal of Arts Management* 11, no. 3 (2009), 16–29; F. David Martin, *Art and the Religious Experience: The "Language" of the Sacred* (Lewisburg: Bucknell University Press, 1972).

16. Carla Stalling Huntington, *Black Social Dance in Television Advertising: An Analytical History* (Jefferson, NC: McFarland, 2011); Mihaly Csikszentmihalyi, *Beyond Boredom and Anxiety* (San Francisco: Jossey-Bass, 1975).

17. Jean Baudrillard, *For a Critique of the Political Economy of the Sign*, trans. Charles Levin (St. Louis, MO: Telos Press, 1981).

18. Ibid., 79.

19. Afton N. Kapuscinski and Kevin S. Masters, "The current status of measures of spirituality: A critical review of scale development," *Psychology of Religion and Spirituality* 2, no. 4 (2010), 191–205.

20. Katherine Hagedorn, "From this one song alone, I consider him to be a holy man: Ecstatic religion, musical affect, and the global consumer," *Journal for the Scientific Study of Religion* 45, no. 4 (2006), 489–496; Marc Luyckx Ghisi, "Towards a transmodern transformation of our global society: European challenges and opportunities," *Journal of Futures Studies* 15, no. 1 (2010), 39–48; Heather Skousgaard, "A taxonomy of spiritual motivations for consumption," *Advances in Consumer Research* 33 (2005), 294–296.

21. Gerard Saucier and Katarzyna Skrzypinska, "Spiritual But Not Religious? Evidence for Two Independent Dispositions," *Journal of Personality* 74, no. 5 (October 2006), 1257–1292.

22. Stuart Rose, "Is the term 'spirituality' a word that everyone uses, but nobody knows what anyone means by it?" *Journal of Contemporary Religion* 16, no. 2 (2001), 202.

23. William Irwin Thompson, *The Time Falling Bodies Take to Light: Mythology, Sexuality and the Origins of Culture*, 2nd ed. (New York: St. Martin's Griffin, 1996).

24. Ibid., 103.

25. Grant David McCracken, *Transformations: Identity Construction in Contemporary Culture* (Bloomington: Indiana University Press, 2008).

26. Carla Walter, "A womanist transmodern theodancecologic approach to reframing markets and consumption," paper presented at Consumer Culture Theory Conference, Tucson, Arizona, June 13–16, 2013.

27. Skousgaard, "Taxonomy of spiritual motivations for consumption."

28. Grant David McCracken, *The Long Interview* (Thousand Oaks, CA: Sage, 1988).

29. Douglas and Isherwood, *World of Goods.*

30. McCracken, *Long Interview.*

31. Douglas and Isherwood, *World of Goods*; McCracken, *Transformations*; Belk, "Sacred in consumer culture"; Diego Rinallo, Linda Scott, and Pauline Maclaran (eds.), *Consumption and Spirituality* (New York: Routledge, 2013).

32. McCracken, *Long Interview*, quoting Neil McKendrick, "The consumer revolution of eighteenth-century England," in *The Birth of a Consumer Society: The Commercialization of Eighteenth-Century England*, ed. Neil McKendrick, John Brewer, and J.H. Plumb (Bloomington: Indiana University Press, 1982), 9–33.

33. Thorstein Veblen, *The Theory of the Leisure Class: An Economic Study of Institutions* (New York: Macmillan, 1912).

34. Georg Simmel, *The Philosophy of Money* (3rd ed.), ed. David Frisby; trans. Tom Bottomore and David Frisby (New York: Routledge, 1904/2004).

35. Charles S. Peirce, *The Collected Papers of Charles Sanders Peirce*, 8 vols. (Cambridge, MA: Harvard University Press, 1932); Douglas B. Holt, *How Brands Become Icons* (Boston: Harvard Business School Press, 2004).

36. McCracken, *Long Interview*, 71.

37. Grant David McCracken, *Culture and Consumption II: Markets, Meaning, and Brand Management* (Bloomington: Indiana University Press, 2005), 136; ibid., 151.

38. McCracken, *Transformations*, 303; italics in original.

39. The James Irvine Foundation, "Overview," 2011, http://irvine.org/grantmaking/our-programs/arts-program.

4 The Economics of Tangible and Intangible Cultural Fine Arts

CHAPTER OUTLINE

LEARNING OBJECTIVES

After working through this chapter, you will be able to do the following:

1. Understand the overall approach to supply and demand in the fine tangible and intangible arts.
2. Be able to differentiate between demand and supply of the tangible and intangible fine arts.
3. Understand the economics of cultural creativity that underlies the supply of arts goods, ideas, and services.
4. Explain the demand and supply equations underlying the tangible and intangible fine arts.
5. Understand the concepts of services relative to the tangible and intangible fine arts.

6. Have a working conception of pricing and elasticity relative to tangible and intangible fine arts service products.
7. Recognize the process for determining price elasticity of demand.

SPOTLIGHT: THE SANTA FE OPERA

Every July and August since 1957, nearly 85,000 opera enthusiasts have been drawn to northern New Mexico to enjoy productions by the Santa Fe Opera. The adobe theater blends with the high desert landscape—a mix of nature and art that leaves a feeling of splendor. The company grew from an idea stemming from John Crosby, who led this culturepreneurial organization for more than forty years. Then Richard Gaddes took over until he retired, eight years later. Now Charles MacKay serves as the company's leader.

The Santa Fe Opera has positioned itself within an opera festival market. Its mission is to advance the operatic art form by presenting ensemble performances of the highest quality in a unique setting with a varied repertoire of new, rarely performed, and standard works; to ensure the excellence of opera's future through apprentice programs for singers, technicians, and arts administrators; and to foster and enrich an understanding and appreciation of opera among a diverse public. More than 1,600 performances have been given here, including *Lulu*, *The Cunning Little Vixen*, and, in 2005, Thomas Ades's *The Tempest*. The 2008 season included the American premiere of *Adriana Mater* by Kaija Saariaho, while in 2009, *The Letter* by Paul Moravec was performed.

Casts include leading opera singers, such as Patricia Racette, Joyce DiDonato, William Burden, Michelle DeYoung, Kristine Jepson, Susan Graham, and Charles Castronovo. And like many other cultural fine arts organizations, the Santa Fe Opera has become one of New Mexico's cultural and economic leaders. Its reputation attracts thousands of patrons each year, and its impact on New Mexico's economy has been calculated at more than $200 million each year.

The open-air theater has won several design awards and is widely recognized for blending contemporary design with traditional building styles. The architectural firm of James Stewart Polshek and Partners was responsible for the design. Over the years, the theater has evolved from 480 seats to the current theater of more than 2,000 seats, which opened in 1998. Moreover, there is space for 106 standing spectators. Every seat and standing room position has the view of a digital computer screen that translates the operas.

Additionally, in 2001, Stieren Orchestra Hall, also designed by Polshek and Partners, was built. The 12,650-square-foot, three-story space provides rehearsal areas for the orchestra and serves as the venue for the Prelude Talks offered to audience members before most performances. This multiuse space has also become a location for lectures, special events, and recitals,

contributing to the company's revenues. Recently, though, company leaders sought to increase revenues by changing their approach to pricing. Rather than offering the same price for all operas and performances, as had been tradition, with a 5 percent annual price increase, they felt that a more differentiated pricing approach would be beneficial.

The Santa Fe Opera recognized that a successful pricing strategy required much more than just adopting a change in tactics. Leaders made important changes, beginning with increasing prices in areas that seemed unlikely subjects for price increases, such as for the standing-room tickets and lowest-priced single tickets. The concept of yield management pricing was used to offer unsold capacity at discounts and highly sought-after capacity at premiums, with incentive packages as a part of the pricing structure. The pricing changes were applied to all performances. At the end of the season, the Santa Fe Opera sold 9,384 tickets at increased prices and 225 at reduced prices. Top prices rose from $183 to $225 for the most popular performances. The Santa Fe Opera earned more than $130,000 in incremental revenues. Santa Fe adopted a three-tier pricing approach for its 2012 season, anticipating each performance's demand by repertory and previous sales patterns. The focus on pricing strategy drove a new revenue management culture throughout the organization.

You can visit the Santa Fe Opera on Google Maps at http://goo.gl/maps/Y2VMN.

SPOTLIGHT: PRICE FIXING AT THE ART AUCTION HOUSE

In 1993, Sotheby's and Christie's, two renowned art auction houses, entered into an anticompetitive cartel agreement that lasted until early 2000, when the parties began to set prices individually.[1] The purpose of the cartel agreement was to reduce the fierce competition between the two leading auction houses that had developed during the 1980s and early 1990s. The most important aspect of the agreement consisted of an increase in the commission paid by sellers at auction (the vendor's commission). But the collusive agreement also covered other revenue-generating areas, such as advances paid to sellers, guarantees given for auction results, and payment conditions.

Importantly, the highest senior executives of both organizations led the illegal and unethical actions. Alfred Taubman and Anthony Tennant, the chairmen of Sotheby's and Christie's, respectively, had secret discussions at their private homes. These were followed by regular gatherings between the companies' chief executive officers at the time, D.D. Brooks of Sotheby's and Christopher Davidge of Christie's.

When the two companies were found to be engaged in cartel behavior, the European Commission fined Sotheby's €20.4 million (i.e., 6 percent of its worldwide sales), while Christie's was not fined because it provided evidence to prove the existence of the cartel. Based on evidence provided by Christie's to authorities in the United States and Europe, and confirmed by both auction houses during the proceedings, the companies were found to have illegally colluded to fix prices. In 2000, Christie's and Sotheby's agreed to pay $256 million each to compensate clients for the commissions they charged on sales. Taubman spent a little under ten months in jail and paid $156 million of Sotheby's bill; the firm paid the rest. Sotheby's fine was additionally increased by $45 million by the U.S. Department of Justice and $20 million by the European Commission. Christie's did not pay anything to the federal authorities because it cooperated in providing evidence of the cartel arrangement. About 300 employees were dismissed from Sotheby's. Christie's has also cut staff by about 1,900.

Today Taubman controls 22 percent of Sotheby's capital and 63 percent of the voting rights. Sales revenues in 2012 were $768 million, according to the *Wall Street Journal*. Christie's website reported annual sales of more than $6 billion in 2012—the highest total in its history.[2]

QUESTIONS

What are your thoughts on the cartel? Should the fines have been higher? Should Taubman have had jail time at all? Should Taubman be allowed to continue in his role on the board? What about Christie's? Explain your answers.

THE SUPPLY AND DEMAND OF TANGIBLE AND INTANGIBLE FINE ARTS

In many introductory economics courses, students are taught that in a perfect world, supply and demand intersect. A demand curve shows the quantities and at prices that consumers will buy, and the supply curve illustrates the quantities and costs at which suppliers will produce goods, ideas, and services. The theory of perfect competition explains that there is no one firm that can control the market and that consumers have options to buy substitute products and services in that market, so that equilibrium between supply and demand is established. Despite the model of perfect competition, monopolies or oligopolies do exist. To the extent to which there is only one firm that sets the prices and consumers have no choice of substitute products, a monopoly exists. If a few firms have power to set prices, an oligopoly exists; still, there is less competition with an oligopoly than with perfect competition. Looking at an organization regionally, some consider fine arts as existing in an oligopoly structure. However, it is probably more accurate to consider the idea of monopolistic

competition because the fine arts markets are very competitive but contain only a few large sellers. In whatever manner a fine arts market is characterized, keep in mind that these are theoretical notions given for the marketplace, to explain the way markets function in a capitalist economy.

The purpose of this chapter is to review the economics of fine arts. The goal is to provide a sense of what it entails so that you will understand the motivation for cultural arts producers and their consumers in this industry and marketplace. This chapter is not meant to give a complete account of economics, which is a broad field with its own academic courses and degrees granted. We limit our conversation to the arts, leaving aside entertainment goods, ideas, and services as outlined and discussed earlier; that is, we will focus on fine and contemporary tangible and intangible arts goods, ideas, and services in general, as they are situated in the core cultural arts industry.

Unlike the economics of tangible products or service goods, the economics of arts and culture has its own supply and demand functions. The reader is given the background necessary to understand the economics of arts and culture and how pricing correctly is critical for its markets. In addition, when formulating an arts consumptive experience, packaging the experience is an art in and of itself. Therefore, another purpose of this chapter is to demonstrate the importance of getting these issues right, so that the financial aspects of the cultural organization are placed in the context of an appropriate economic structure.

There is a large number of studies about the history of the economics of the cultural arts, drawing its trajectory from the sixteenth century forward.[3] Within this historical treatment of the economics of the cultural arts, people's engagement with the cultural arts was often seen as wasteful, capable of corrupting human morality. On the other hand, from a productive point of view, the cultural arts were considered from the art-for-art's-sake mentality mentioned in Chapter 2. In a sense, the attitude was "Build it and they will come," as we say today about many endeavors. Setting this history aside, however, this part of the textbook starts with the tangible and intangible cultural arts in contemporary culture. In this framework, two assumptions underpin how the economics is considered. First, it is assumed that using technology and cultivating innovation are accessible and desirable for the arts manager and the culturepreneur producing cultural works. Second, it is assumed that some portion of the people in the fine arts consumer market want to engage in a variety of consumptive arts experiences—from watching a traditional Shakespeare play at the Globe Theatre in London to taking a virtual tour of the Boston Museum.

The first chapter of this book touched upon economics and the cultural arts, explaining that, historically, the intangible fine arts were mainly manifested through a nonprofit organization, because according to economic theory, one can consider production of the arts as existing within a failed market, giving rise to positive externalities, and constituting a normative good for society. Indeed, our Western view of the arts production function is founded in the notion that government should fund the arts on some level, and in many countries this kind of demand is seen, with the cultural industry contributing to the creative and cultural industry's economic activity.

As you will quickly realize, though, the economics of each cultural art form will have a distinct supply and demand function, with different policies governing or

informing them, depending on the country or cluster the cultural art resides in. This means that the economic aspect of paintings and sculptures will differ from that of the intangible fine arts, for example, and this will in turn differ from consumption of and dissemination of reproductions in the secondary markets of tangible fine arts. In addition, many consumers have now grown accustomed to a decision model for consumption that includes services marketing experiences—they want to know what they are buying beforehand. Depending on what cultural art you are endeavoring to promote or create, you will therefore need to understand the economics of that market. With these boundaries in mind, several aspects of the economics of fine arts and culture are included in this chapter. The economics of cultural creativity of artists' labor, or, more broadly, the supply of artistic products and services, and the demand, or arts consumers' motivations to consume artistic goods, ideas, and services, are subjects of importance to the culturepreneur and arts manager. We take each in turn.

Supplying Cultural Arts Services, Ideas, and Products
The Economics of Cultural Creativity in the Fine Arts

Innovation has imploded in the arts, and this is something that we understand that occurred over a momentum-gathering historical time period. If we were to film time moving from the sixteenth century to the eighteenth in terms of innovation in the creation and delivery of cultural arts, we would find a process slowly accumulating steam until the increased use of innovation with computers generating heretofore unheard-of ways to produce art and consume it. Creativity may be a result of being spiritually driven, imaginative, and highly intelligent, but much of cultural creativity is the result of a process, and nowadays, that process is often facilitated by technology. You may already have guessed that the innovative process will be different in the tangible and intangible art forms. For example, a new piece of music may be composed without a single instrument; and for the firm or individual who produces (supplies) this music, the way in which it is developed will impact the costs to produce it. For the individual preparing the music on a computer, there will be *fixed costs* (i.e., costs that do not vary with the amount of product being produced) for the hardware and software. In addition, perhaps there are *sunk costs* of a formal education in music or digital arts, which cannot be recouped. For the individual preparing a live symphony, in addition to fixed costs of composition and perhaps the sunk costs of an education, there are *variable costs* that will change with production output, such as for musicians' labor, the purchase of musical instruments and the ancillary costs of those instruments, such as maintenance and storage, and other human costs that impact the production of innovative symphony pieces. At the same time, each composer in these two scenarios may envision production of CDs for sale at a concert event, online, or through an MP3 download. The costs for the CD production may vary between the computer-generated and the human-generated symphony, depending on how the CD is created—that is, from a live performance or a recorded one. In a strictly cost-conscious and economically rational world, the computer-generated symphony would prevail. But this is not the case at all times, and for this

reason, among others covered in Chapter 1, the cultural arts are analyzed within their economic contexts, outside of a perfect market environment.

CULTURAL CREATIVITY AS UTILITY

Some may think of the deranged and obsessed person being driven to produce culturally artistic works—an image that has been molded as a caricature of an artist. In addition, artists are also characterized as being suddenly struck by genius and imagination, which is often motivated by a "muse." While it is not impossible that being driven by some internal source, or studying ideas, traveling, or being inspired by particular individuals comprise muse materials, it is not always the case that inspiration for cultural creativity arises from a particular type of individual or kind of behavior. In the cultural creative process, one moves often in noncircular form, from an idea, then to incubation processes, then on to a developed good, idea, or service, with one or more revisions of the development. In the end, this process manifests finally in creating works of cultural fine art. The culturepreneurial process depends upon this. The well-managed cultural creative process in an arts organization is cultivated with new arts service products being developed consistently, and the decision to bring an arts service product to the marketplace or space may hinge on the research done supporting projected financial and product outcomes. In the cultural art world, there is a sort of myth that artists often produce goods, ideas, and services without a clear market for them and without thought for monetary compensation, but rather with an eye toward developing *cultural value*, as it was defined in Chapter 2, for the world.

That kind of conceptualization of artistic cultural creativity represents a romantic idea of novelty, surprise, and newness, happened upon spontaneously, in isolation from the world, without any sort of structure underlying it.[4] But this fanciful view of cultural creativity has been shown to be incorrect.[5] In reality, cultural creativity takes place within historical contexts and within the confines of a discipline, emerging over time to produce innovative solutions. Sometimes the culturally creative individual produces something of awe or restates the mundane in a new light. However, the culturally creative product comes about through a dynamic process that changes the rules of a given system. As such, a *culturally creative individual* is "one who regularly solves problems, fashions products, and/ or poses new questions in a domain in a way which is initially considered novel but which is ultimately accepted in at least one cultural setting."[6] Moreover, cultural creativity can happen along a continuum, from exploratory to transformative, with the former being the novelty, and the latter being ascribed to something genuinely original. Something genuinely original breaks from the structural rules altogether, and it is these culturally creative goods, services, and ideas that lead to the arts consumptive experience.

Knowing that artistic cultural creativity does not belong to the realms of happenstance, what can be said? Economists argue that artists produce goods, ideas, and services with a certain kind of maximizing utility in mind and within a set of constraints. Remember that tangible and intangible artistic goods, ideas, and services are a subset

of cultural goods imbued with cultural creativity, communicating and generating symbolic meaning, and potentially protectable under intellectual property rules.[7] An artist's utility in producing artistic goods, ideas, and services then becomes measured against both how it contributes to the artist's income and how useful the artist's contribution to a larger repository is. The time an artist spends creating a work will be related to the degree to which he or she finds utility in contributing something of cultural value versus producing something of economic value at the end of the process.

The decision to pursue an artist's career—and it is a decision—is governed by a set of variables that come together and support a set of expectations for output and contribution to cultural value. This decision is itself done in the frame of mind of maximizing this utility, or else the artist would choose to do something else (i.e., spend the time doing activities that would provide for a greater sense of utility). The artist who is considered extremely creative and innovative theoretically produces more cultural value than a less than stellar artist, so that the exchange for cultural value of the art in the creative context rests on the value of labor spent on the creative production itself. You can imagine that one may be willing to pay more for a creative genius's work than for work of cultural art produced by an artist who is not considered extraordinary.

Along with our collective memory of the artist working with a muse and being struck by inspirational genius, there exists the image of the artist as starving and poor. More precisely, today's artists may be working at Trader Joe's or other grocery stores, waiting tables, or carrying out activities that are ancillary to the creation of their artwork because they do not have a patron, they are not receiving extraordinary income from the sale of their work, and they have not won a grant or other tax-free money to support their work. Because of this, the creative process may be exaggerated, taking longer to complete a work of art even though the artist wants to contribute something of cultural value. Yet those individuals are not content with being ascetic in their production and contribution to cultural value. They want to make money. They not only want to find utility in maximizing the cultural contribution; they also want to maximize their income.[8] They are not content to work at menial jobs to make ends meet or to produce and sell small, less spectacular works to tide them over until the larger, more lucrative work is completed. Artists are motivated to create cultural goods, services, and ideas through maximizing their contribution to cultural value *and* their income; the degree to which one or the other prevails will depend on the individual's personal utility. At the other end of the spectrum from those who are maximizing cultural value, there are artists for whom the utility lies in the economic income from the work. While they are interested in producing some cultural value, that is not the leading motivation. With utility theory in mind, one can easily make the leap that cultural creativity does not equal an age-old caricature of the ascetic artist, starving happily, with inspiration from the muse. Exhibit 4.2 illustrates these points and concepts.

In the romantic ideology informing the mythos of what artists were like, they were often characterized as spiritual, possessing genius, an active imagination, and the ability to discern and provide taste, and as a result able to produce artistic works, with or without a muse.[9] While those attributes may well accrue to particular people who produce cultural arts, today we know that what constitutes art is given in a

Exhibit 4.1 **The Santa Fe Opera House**

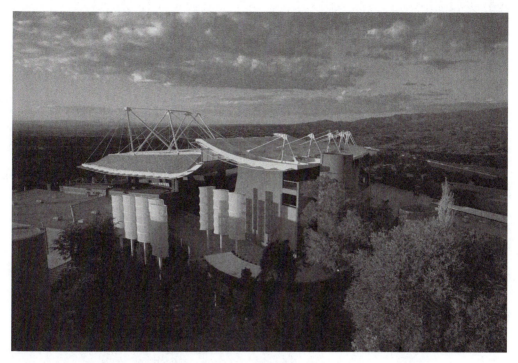

(Photograph by Robert Godwin. Courtesy of the Santa Fe Opera.)

cultural and political context. We acknowledge the fact of a creative process and inspiration that evolve from a myriad of motivations, based on degrees between economic and cultural value. In a sense, both types of value are determined by a market of consumers, who will by their actions infuse a given artistic good or service with each. Both economic and cultural values can change over time. Indeed, some people have the view that art is created without any consideration for the market and its product is simply a form of self-expression. However, this has not been found to be the universal motivation for producing fine art, and artists often approach their work with a desire for personal commercial and financial benefit.

It is probably wise to understand what motivations underlie the supply of art under your management. As you can probably imagine, the approaches to tangible arts production will differ from that for the intangible. Each of these supply functions is produced with some kind of end market in mind, which ranges from the artist production for self-consumption to a production for mass consumption. In the next section we consider the tangible arts. Existing art works would be considered under a particular supply function, whereas newly created works impact the overall supply of tangible arts products. You will note that many tangible works of art function as investments, in highly complex financial markets, and their exchanges command billions of dollars. With this in mind, let us turn to a more expansive discussion of the arts markets.

Exhibit 4.2 **Continuum of Cultural Creative Motivation**

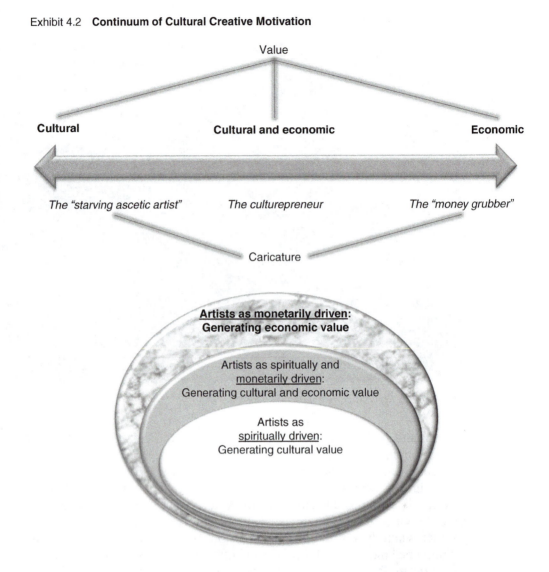

TANGIBLE CULTURAL FINE ARTS MARKETS

There are two types of tangible fine arts markets. The first is the *tangible primary arts market*, in which contemporary original works of art are produced and sold for the first time for a price. In this market artists may be unknown or not well known, and here new works of established artists are also traded. Artists may or may not be *commissioned* to produce work in the tangible primary cultural fine arts market. Sam Kieth is an example of a contemporary commissioned artist (see Exhibit 4.3).[10] Within the tangible primary fine arts market, artwork is typically distributed through artists' studios, galleries, festivals, and other commercial establishments but can include other display locations such as coffee shops, foyers of business establishments, airports, shopping malls, traffic ways,

Exhibit 4.3 **Sam Kieth**

and any number of creative locations, including photos or videos of the work in advertisements.

In the gallery or artist's studio, for examples, prices may often be visible to facilitate purchase. The placement of these kinds of works of art may be developed through an intermediary such as an art dealer, and the price is determined by the

dealer, with or without input from the artist. The price will attempt to capture time and materials spent on the project by the artist, plus a markup for transaction, sunk, and opportunity costs, and profits. Higher production costs may influence the artist's decision to produce the work, in particular if there is no contractual agreement by a buyer at the start. In this instance, the artist bears all the risk in producing the speculative work and bringing it successfully to the market. At the same time, artists producing for this market may choose not to display all of their work, in order to help control the supply and, therefore, the price.

In contrast, in the *tangible secondary fine arts market*, existing known works of tangible fine art are exchanged, often through auctions and dealers. Top-of-mind companies in this market are Sotheby's and Christie's. At times, secondary tangible fine art is exchanged in galleries as well, arranged again by an art dealer. It is in this market that the idea of art as an investment resides, with art being auctioned at times for millions of dollars. See Exhibits 4.4 and 4.5 to visualize the continuum.

To summarize in broad terms, we have tangible speculative or commissioned artwork developed for the primary market.

Exhibit 4.4 Cultural Fine Arts Markets: Primary Tangible

An example of a primary tangible cultural arts painting, offered for sale in a gallery. This is a speculative and/or commissioned market.

(Photograph courtesy of Carla Stalling Walter)

Exhibit 4.5 Cultural Fine Arts Markets: Secondary Tangible

Auguste Rodin sculpture, *Three Shades*, 1881

An example of a secondary tangible cultural fine arts sculpture. Such works of art are found in galleries, and museums, and sold at art auctions.

(Photograph courtesy of Carla Stalling Walter)

INTANGIBLE CULTURAL FINE ARTS MARKETS

The primary market for intangible performances (with commissioned and speculative drivers of production) and the secondary market for intangible arts goods, services, and ideas can be represented in similar fashion, as was done for the tangible fine arts. First, consider the secondary intangible fine arts market, comprised of *existing* classical compositions. So, for example, the play *Macbeth*, the ballet *Swan Lake*, and Mozart's *Concertos*, in whole or in part, would constitute portions of the secondary intangible fine arts markets. As will be discussed in Chapter 10 regarding copyrights, primary intangible fine arts that can be documented may be recorded, and those recordings receive copyright accrual. In some cases, these products, such as recordings that can be purchased, would constitute a revenue stream for each market.

The difficulty with the intangible fine arts arises with the extreme level of labor-intensive expenses and other variable costs that increase with the number of productions and performances, along with considerations for the firm structure—for profit or not for profit.[11] Commercial theaters typically function in the primary and secondary markets but with the goal of the producers clearly being to make profits, while the actors (artists) may be motivated by varying degrees of utility toward income or cultural value creation. However, in the nonprofit intangible fine arts organizations, such as symphony orchestras and dance companies, the cost of labor can exceed the available revenues, and firms look toward earned and unearned income, with earned income derived from ticket sales, merchandise, or ancillary experiences, for example, and unearned income stemming from grants and donations. Patrons can provide commissions for works in the primary intangible fine arts market, as well as in the tangible fine arts market for a nonprofit company or artist. As referenced in Chapter 1, one major issue that nonprofit intangible arts organizations have faced is the ability to utilize innovative techniques to remain free of the cost disease.[12] Many have done so with the use of technology, diversifying the repertoire to include classics and world premieres, using more efficient management techniques, and designing novel ways to display intangible arts to expanded audiences.[13]

For example, while it may be true that it takes just as long as it ever did to produce a full version of *The Nutcracker* and that it cannot be produced necessarily by machinery, which would effectively equate with one type of productivity gain, it could very well be that excerpts of the dances would delight viewers so that shorter performances could be given. Similarly, the work could be delivered in unusual spaces, such as during lunchtimes in the park near or in business communities. Or the venue could be broadened so that more arts consumers are in attendance for a shorter total number of performances. In sum, the intangible fine arts market has to look for improvements in technology, economies of scale, diversification of offerings, best practices in management, and, of course, the best artists who are able to adapt, learn quickly, and display versatility in their skill sets.

The problem is this: the more it costs to pay artists, to utilize costumes, music, and other inputs, and to cover the cost of performance space, the higher the ticket price must be. In general, price is to reflect all the costs of supplying the artistic work, plus some degree of profit. Pricing will be covered in detail later in the chapter, but suffice it to say that this formulation of prices is true whether you are dealing in the primary or

secondary markets in the intangible fine arts, and in the primary tangible fine arts market. A different scenario governs the tangible secondary fine arts prices. "So?" you may ask, "what do I care if only three people in the world can afford a ticket, and they enjoy my or my company's performance?" There are opportunities for this, undoubtedly.

However, besides the fact that intangible fine artists want to display their works before ever-increasing audiences, it is because the arts are considered a public good that it is felt that society is worse off, with ticket prices rising so far out of the most people's reach, than it is when people are able to consume intangible arts.[14] Therefore, in determining the supply of your intangible arts products and services in managing costs, it will be well for you to design a plan that includes the primary, world premieres and risk-associated productions along with a season that reflects the secondary classics. In the nonprofit world, of course, grants and patrons should be cultivated, while in the for-profit commercial sector, advertisers and other sponsors can be approached to close income gaps between earned revenue and costs.

Yet it is not only labor issues that drive costs upward. For each newly created primary work, there are "one-off" development costs. That is to say, for each new work of art, the cost of creating it is sunk, including trademark and copyright expenses, along with revisions of the work. In addition, the marketing costs to bring the work to the *awareness* of arts consumers, those consumers who are not necessarily convinced of the value of the arts consumptive experience, cannot be recovered directly. The ticket price can usually cover only a portion of the costs, but it can be manageable if the total costs are "amortized," so to speak, over a period of years. In the secondary intangible fine arts market, the costs can be recouped if the marketing materials are "reused" in subsequent seasons.[15]

The other issue with the intangible fine arts is that the "inventory"—that is, the repertoire of the art work—has to do with copyrighted materials, but the inventory of seats is immediately perishable at the close of the performance. This points to a clear path that engages with managing and stimulating demand as a way to mitigate the cost disease.[16] We will return to this idea of *perishability* in the discussion of the arts as a service product in Chapter 8.

To recap, the fine cultural arts market is comprised of tangible and intangible fine art works, which circulate in primary and secondary markets. Tangible fine art in secondary markets act as investments and/or financial vehicles, while intangible fine art in nonprofit primary and secondary markets must be monitored closely to control costs and supply, and find innovative means to close income gaps. Consulting an accountant will enable you to determine if the copyrighted collection you hold can be considered an investment or an asset.[17]

DEMAND FOR TANGIBLE AND INTANGIBLE FINE ARTS

Generally and broadly speaking, the *determinants of consumer demand for the arts* are a function of the good or service quality[18] relative to its price, price of its substitutes, consumer income, and consumer tastes.[19] In this section, consumer demand is going to be explained by bifurcating demand for intangible and tangible fine arts goods, ideas, and services in consideration of these determinants.

As was the case in describing artists' motivations in producing and creating culturally artistic products and services, utility is also a way to talk about the motivation and desirability arising from consuming a fine arts cultural offering. And just like artists, consumers are trying to maximize their expected utility, or satisfaction, in spending time and money on artistic goods, ideas, and services. It could be that consuming intangible arts constitutes choices among an array that can be categorized as leisure, while tangible arts can be associated with consumption utility. This kind of distinction is dangerous, however, because one can both find utility and fulfill leisure time in consuming the arts. However, leisure and utility are the underlying factors that contribute to demand for the arts.

This discussion begins with the intangible fine arts, which will be considered as a choice selected from an array of entertainment possibilities for fulfilling of leisure time and the desire for the arts consumptive experience. Why leisure time? Data indicate an upward trend from 1990 to 2005 of people expending more of their income on leisure—that is, deriving more utility from it, with increases in spending for intangible fine arts more than doubling.[20] However, the expenditure for a ticket to the intangible fine arts is often overshadowed and subordinated by the expected utility of the time commitment required.[21]

It has been said that time waits for no one. In current contexts, the time spent attending an arts presentation is traded for something else, and this limited time is allocated based on perceptions of utility. Will arts consumers gain more benefits from attending an arts offering or from watching the recorded version of it? Will the artistic consumptive experience be as good if they do a virtual tour of a museum in their city rather than physically go see it? Answers to these questions depend on the way arts consumers feel about their time and the resources at their disposal. While leisure time has not appreciably increased in aggregate in Western society, the options about where and how to spend it have.[22] The intangible arts constitute a subset of options of the ways that arts consumers can spend their time.[23] Therefore, using leisure time and monetary expenditures on the intangible fine arts as a way to consider arts consumers' utility of artistic experiences has been established.

The concept of *leisure time* refers to free time to enjoy rest and relaxation, with the underlying contribution to spiritual renewal and recreation of body, soul, and mind. This approach is consistent with our discussion about the consumption of arts in the anthropological frame. Obviously, this kind of leisure time can be spent doing many different pleasurable activities, from gardening to skydiving. Consumers must thus consider many competing activities and practices in allocating their finite leisure time, because nearly everyone has to spend time doing something outside of leisure. Most economists think of these activities as working, eating, sleeping, and other time-consuming behaviors.[24] But you can easily leap to the idea that, in returning to hierarchical categories of wants, one can enjoy a leisurely French dinner or sleeping in an exotic environment, and that many people do not feel as if they work if they are pursuing their passion. For our discussion, we will assume that leisure time is the time left over after working and providing for subsistence. That means consumers have choices about what to do with this "leftover" time. In an affluent society, more leisure time is theoretically available, and again this affluence points to

the distinction between tastes for different artistic goods, ideas, and services. There-fore, in terms of the arts, consumers are looking to fill their leisure time with activi-ties that produce emotional, spiritual, and transformative experiences of some sort, based on the anthropological frame sketched in Chapter 3.

DEMAND FOR THE INTANGIBLE FINE ARTS

For the intangible fine arts, it has been shown that increases in income track closely with increased expenditures for them; that is, income and expenditure on the intan-gible fine arts are directly proportional. We have already talked in earlier chapters about taste being something economists had taken for granted in determining the demand function. However, tastes for the intangible arts can be seen as drivers of its demand, arising from an accumulation of experiences over time, being directly proportional to income and education.[25]

Moreover, the more one acquires this cultural competence, the more one wants, which may be positive for consumption in the cultural arts industry as a whole, not just the intangible fine arts; however, the concept of rational addiction is sometimes a problem for supporting the idea of marginal utility,[26] which states that people will consume less of something after they have derived the satisfaction of having con-sumed the first unit. Next, consumers must consider prices for substitutes, which for our purposes for the intangible arts can range over a number of possibilities. For example, if the symphony is being staged, its prices will compete with those for the theater, the ballet, the opera, and other entertainment that consumers perceive as substitutes. If a consumer, however, has not developed an accumulation of experi-ences for anything other than ballet, the price of substitutes competes only on the supply of the ballet, which can be had at a live performance, but also via a purchase of a recorded event. Hidden costs, sometimes referred to as complementary costs, also affect the consumption of the intangible arts. These hidden costs include many items depending on the consumer, such as transportation, babysitting, buying a new outfit to attend the event, and ancillary meals. If these hidden costs exceed a certain point, then demand for the intangible arts decreases.

A generalized demand function is used to develop a demand curve, and within the function itself prices are manipulated, as shown in Exhibit 4.6.

DEMAND FOR THE TANGIBLE FINE ARTS

Differing from the intangible fine arts and leisure time expenditure utility, the tangi-ble fine arts are comprised of utility derived from the desire of individuals and firms to possess such works. In many cases, the consumption of a tangible fine arts object can be likened to a purchase, but tangible fine art also functions as an investment or savings item. In this view, then, we look upon demand through a theory of asset demand, which for fine art includes five considerations: wealth, return on invest-ment, risk and uncertainty, the degree of liquidity desired, and, of course, tastes, the desire for the arts consumptive experience, and preferences.[27]

Exhibit 4.6 **The Demand Function for the Intangible Cultural Fine Arts**

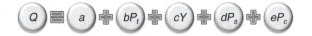

such that the variables have the following definitions:
Q = quantity of tickets demanded per time period
P_t = price of the tickets
Y = average annual per capita income
P_s = weighted average price of substitutes, such as movies, concerts, and other alternatives
P_c = composite price of complementary goods, such as dinner, cost of child care, and transportation to the venue
a = a constant value that will change with taste
b = elasticity of demand for tickets
c = spending change with per capita income
d = sales revenues change with price of substitutes
e = sales revenues change with price of complementary goods

Coefficients measure change in value of the dependent variable, Q, per unit of change in the independent variable, and this is why some are negative in value. Here is an example:

	Case 1	Case 2		Case 1	Case 2
Independent variables			Calculate quantity demanded		
P_t	20.00	25.00	a	75,000	75,000
Y	3,800.00	4,300.00	$b \times P_t$	(60,000)	(75,000)
P_s	24.00	24.00	$c \times Y$	228,000	258,000
P_c	25.00	25.00	$d \times P_s$	48,000	48,000
Coefficients			$e \times P_c$	(62,500)	(62,500)
Constant (a)	75,000.00	75,000.00	Quantity of tickets, Q	228,500	243,500
b	(3,000.00)	(3,000.00)			
c	60.00	60.00			
d	2,000.00	2,000.00			
e	(2,500.00)	(2,500.00)			

Source: James Heilbrun and Charles Gray, *The Economics of Art and Culture*, 2nd ed. (New York: Cambridge University Press, 2001), 76–77.

The demand for the tangible fine arts is also determined based on one's position—or goals—as an art dealer, investor, or collector. An art dealer is someone who functions as an intermediary in the marketplace for fine arts, receiving a commission for selling fine arts objects. An investor is someone seeking to earn monetary value from the appreciation of the work. While a collector enjoys owning fine art and likely seeks a reward from appreciation of the work over time, the collector's risk and motivation functions differ. However, all three are seeking a return on their investment, albeit from varying considerations, and all are trying to lower, contain, or quantify their risk of loss should a piece of art depreciate or hold steady during their ownership. Aside from trying to clarify each consumer specifically and for the moment assuming that arts in this view are luxury goods, let it be sufficient to

generally understand that collectors include a factor in their demand function for aesthetic value they will derive by owning the piece, while investors and dealers do not. Exhibits 4.7 and 4.8 present the relationships included in the demand function when determining what will be paid and the expected return.

Exhibit 4.7 **Demand for Tangible Cultural Fine Arts**

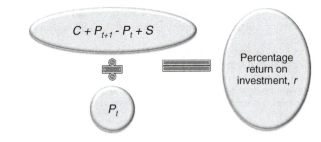

In this equation,
C = the amount of the payment received, for example, when there is an interest payment
P_{t+1} = the expected price in the future period, or the expected change in price
P_t = the actual purchase price of the object
S = the nonfinancial benefit of ownership, such as aesthetics

By way of example, a *collector*, who will not receive payment *C*, is told that a *primary market painting* is selling for P_t of $8,000; that collector thinks the artist's work will appreciate to P_{t+1} of $10,000 in one year and that owning the painting is worth the price in terms of aesthetics, *S,* at $1,000, making the percentage return on investment, *r,* 37.5 percent.

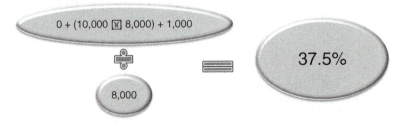

For an *art speculator*, there is a decrease in the percentage return on investment to 25.5 percent when *S* is zero:

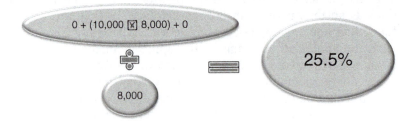

Source: David Throsby, *Economics and Culture* (New York: Cambridge University Press, 2001), 178.

Exhibit 4.8 **Return on Investment and Price Factors**

To determine the highest price that will be paid for a tangible cultural fine art by either a *speculator* or a *collector*, this equation changes to

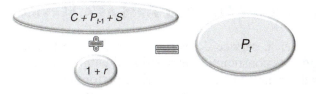

$$\frac{C + P_{t-1} + S}{1 + r} = P_t$$

It is most likely that at an auction, the *collector* will pay more for a painting than the speculator because the collector will have a value for *S*, whereas the *speculator* will not.

Source: David Throsby, *Economics and Culture* (New York: Cambridge University Press, 2001), 178.

Many objects of tangible art are sold at auctions, using a process known as an English auction. Items are placed in an auction with a reserve price in mind set by the seller in consultation with the art dealer or intermediary. Intermediaries are paid commissions or premiums by the sellers and buyers, respectively. Bidding on the pieces is facilitated by information provided ahead of the auction, in the form of a booklet with details on the art and the artist, presale low and high estimates, the history of the sales for the art work, if any, and other salient facts giving instructions for participating in the event. Successful sales are referred to as having a "hammer price," or the finally bidding price that has been "hammered down." Commissions are based on the hammer price, usually around 10 percent, but this percentage can be negotiated. If the reserve price for the piece is not achieved, the work is said to have been either "knocked down," "burned," or "bought-in." Auction houses are in the business of selling art, and they compete with each other in doing so. Moreover, they are successful to the degree that they hold a particular reputation which, as art investors perceive, positions them as able to attract better source materials and to sell the work better than another, not to the degree that they invest over time in them. In other words, the *perceived quality* (a concept related to arts service quality presented in detail in Chapter 8) of the auction establishment is critical. In the end, investors must determine what they will invest for art and bear the risks that the market determines what the collective conscious believes the value of the work is. Alas, we are placed right back in the conundrum of being able to predict tastes. Will consumer taste for a particular piece increase over time or diminish? And, if so, by how much? Unless there is reliable information showing the performance of a piece of art in financial markets, it is difficult indeed to predict, and again this is one reason for distinguishing between primary and secondary arts markets.[28]

Having explained that there are different demand functions for the tangible and intangible fine arts, we next introduce the idea of delivering the arts in a service framework. Products are not alone what is important to arts consumers; the service

they receive in relation to the art also forms an image in their minds. Importantly, it provides them with a memorable feeling. This positive and memorable feeling works in tandem with the arts consumptive experience that arts managers and culturepreneurs must facilitate.

CONCEPTUALIZING THE CULTURAL ARTS AS A SERVICE PRODUCT

In Chapter 8, service delivery in regard to the fine arts is covered in depth. Here, though, arts consumption is positioned within the context of a service, whether it is offered through museums, galleries, performances, festivals, or other experiences. *Arts services* provide intangible benefits to meet arts consumers' wants and needs through the arts consumptive experience, from a consumer's prepurchase contemplation, to purchase, and then on to the consumer's postpurchase evaluation of the experience. You may think of the intangible fine arts as fitting nicely into the arts services category, while imagining that the tangible fine arts are concrete goods that do not include a service aspect. This is mostly true, as goods reside on a continuum, from very concrete to ephemeral. So it is reasonable to think that sculptures and paintings, for example, occupy the concrete end, and fine arts performances reside at the other. However, each experience of consumption of art incorporates areas of services that impact arts consumers and their impressions. Because of this, an arts manager and the culturepreneur have to consider the impact of arts services. The starting point is the consumer purchase process as it relates to services. Next, four aspects of arts services quality dimensions are important to know, and, last, the process of arts services marketing will be instrumental in casting the fine arts in the light of service delivery.

ARTS CONSUMER PURCHASE DECISION PROCESS

In general, consumers go through a five-step purchase decision process. The first step is the separation from one's ideal state, or recognition of a problem of sorts. The second step is looking for ways to solve the problem or return to the ideal state. To do so, consumers gather information, after which they typically move to the third step—developing a set of alternatives to choose from that will solve their problem or place them in the state they would like. Fourth, once the alternatives are identified, the purchase decision is made, and then, the actual purchase of the alternative selected constitutes the fifth step. After this, the consumers are either restored to the state they imagined they would be as a result of the purchase, or not.

One of the key aspects of trying to select an alternative is the degree of uncertainty that circulates around the purchase decision. The higher the level of uncertainty or risk, coupled with lower amounts of useful information, the more involved the decision to purchase is. Of course, this is a generalization, because some purchases, even large ones, are seemingly done on impulse. Nevertheless, purchases that are perceived to be of high risk, such as attending a cultural event, going on vacation, or investing in a painting, require a good deal of information. Of course, our interests here center on the arts. Therefore, if consumers want to buy tickets to an arts event, they will be confident in their purchase to the extent that they have the information

they need to make the purchase decision. If not, they will gather information from their memories or from friends and associates. If that does not give them what they need to decide whether to attend an event or purchase an experience, they will look for outside information to guide the decision. Here is where the critics, reviewers, and experts play a role in determining the perceived value or contribution of the purchase. Once the information is collected, consumers will come to a point where they have an evoked set of brands they will entertain for purchase, and from them they will purchase based on a number of factors, such as price, quality, and perceived anticipated satisfaction derived from the purchase. After the purchase, consumers evaluate the degree to which their satisfaction has been met. If it was met, we say there was no gap in the expected versus the perceived experience. If it was not met, we say there is a gap between expectations and outcomes.

In the arts, the consumption experience is guided by a number of properties that are absent from the general decision to purchase and consume goods or services. For example, while you may be able to get a refund on your ticket, it is not likely, and it is generally not the standard practice to "return" a piece of art work because it does not do what a company said it would. As it is then, people buy based on information they can obtain before purchase, and sometimes buy without any information, only to gain the knowledge of the quality during the experience. How do they know if the newest modern dance touring company will be good? Even the program notes may leave a lot of unanswered questions, and for a small company, marketing materials may be scarce. What kind of audience will be there for name sharing? Here arts consumers can evaluate prior knowledge of the venue if they have it, but if not, they have to rely on information search to position the venue relative to others they know. Even if consumers do enjoy the offering, how do they know it meets with their cultural standards of excellence? You may have heard of the riots in Paris after Diaghilev's Ballets Russes performed Nijinsky's *L'Après-Midi d'un Faune*. People were so unhappy with the production they took to the streets! While we do not expect to see this display of dissatisfaction very often, it is because of these and other difficulties in evaluating the situation in the purchase decision that we say that services, including arts as services, have experience and credence properties, while often lacking search properties that are available with goods. Yet there is plenty that can be done to facilitate an arts consumptive experience when the arts as a service product are effectively managed. In this textbook, the phrase *arts services product* refers to the intangible fine arts when they are experienced, from the first encounter with the arts organization, and the services aspects related to the purchase of the tangible fine arts.

FOUR ASPECTS OF PROVIDING ARTS SERVICES PRODUCTS

Mass production allows people to receive the benefits of standards of reproduction. Each time people purchase items that have been produced this way, they expect them all to be the same. In fact, much effort is expended in quality control to make sure this is the case. Many mass-produced and perishable items can be stored in a physical inventory, packaged for shipping, and saved by the purchaser for later consumption. However, this is not the case in the fine cultural arts that have not been mass-produced.

When talking about services, there are four areas that come into consideration: *intangibility, inseparability, inconsistency* or *heterogeneity*, and *inventory that is perishable*—meaning it cannot be carried over for sale at a later time. By definition, an arts "service product" is intangible, in that it is untouchable. It is also, by its very nature, inseparable from the artist who created it. Services may demonstrate inconsistencies, or what has been considered as heterogeneity, in the final product or the way it is provided, and services are subject to an inventory, which is considered perishable; that is to say, available only at a given time.[29] For example, an artist most likely will not want to produce the exact same piece of work twice. A consumer may attend two showings of a production but it will vary in its consistency depending on the day and the cast, while it may have an overall recognizable theme. A world-renowned choreographer's work will be recognizable to viewers who are familiar with it, even as the dancers modify it for their performance on the stage. Rodin sculptures are recognizable and attributable to Rodin, and if we find a work that he has created that goes against what we know of him, we cannot separate that fact from the work. Moreover, if an auction does not succeed, often we attribute the failure to the auctioneer, being unable to separate the outcome from the facilitator. And if an auction house has an auction in which works are not sold, or a symphony holds a concert wherein seats have no "bums" in them, inventory is lost, and the revenue is not recoupable at all. These aspects of providing arts service products make them particularly interesting in their management. We will cover ways to manage each of these aspects in Chapter 8.

ARTS SERVICE QUALITY DIMENSIONS

Aside from the issues facing the arts discussed in the preceding section, arts services providers have to find ways to provide consumers with quality offerings that ultimately lead to their satisfaction. Five areas are of importance here: *reliability, tangibles, responsiveness, assurance*, and *empathy*. In providing an arts experience, consumers evaluate the quality by assessing how reliable the company or individual offering the service is. While the service itself is intangible, consumers look for tangible signs, such as the physical attributes of the location or other merchandise related to the offering, to help them understand what is being offered and to position it within their minds. Consumers also look for the organization's employees and stakeholders to be responsive, providing assurances that the consumers' needs and questions are legitimate. Finally, if something is not to their liking or a problem occurs, or if they have a suggestion, then consumers look for the company to be empathetic toward them.

ARTS SERVICES MARKETING

Arts managers in the tangible and intangible arts arenas borrow heavily from marketing strategy to provide their goods, ideas, and services. In Chapter 6, consumer behavior relative to marketing, and in Chapter 7, market research will be addressed

in detail. Here we can briefly characterize the *eight Ps* of arts services as the following: product, prices, place, promotion, people, physical environment, process, and productivity.[30] Within this set, the first four items constitute the subset of the four Ps of marketing. The *product* is the service product being offered; *prices* include what people pay and the desire of firms to recoup their costs and investments; *place* means where the consumer acquires the service; and *promotion* includes the numerous factors that make the offering known and attractive to consumers. In terms of the latter four, *people* has to do with the degree of customer orientation the employees have; *physical environment* will facilitate an assessment of the service; the *process* is how the service is delivered and the mechanisms consumers use to access the service; and *productivity* includes how efficiently the service is delivered, and the capacity that can be handled to meet demand.

Exhibit 4.9 **Yield Management Pricing in the Cultural Fine Arts**

Yield management pricing is a pricing method that is used to reflect levels of demand. You are already familiar with this kind of pricing if you have booked airfare, a hotel room, or other kinds of travel services. And, of course, if you have opted to attend an afternoon or weekday show, you may have done so in order to take advantage of low prices.

While it is true that a completely sold event is desirable, from a price elasticity of demand point of view, selling out is only good news if each arts offering, each seat or what have you, has been sold for the maximum amount. If everything sells out months in advance, the price may have been set below an optimal yield.

Setting prices at appropriate levels before tickets go on sale is fundamental to maximizing revenues. But to do this, there has to be enough information to accurately predict demand. The problem is that projections of sales volume may be unsupported by data, and there is often pressure to set prices a year or more in advance of arts offerings and a lot can happen in a year! Yield management pricing offers the opportunity to reset pricing to react to demand or unpredictable changes in the environment.

Many arts organizations use yield management pricing. They seek to increase revenue by using total sales as a trigger to raise prices in measured increments. When a predetermined percentage of total tickets has sold for any given performance, prices are raised. For example, the Pittsburgh Opera uses total percentages of house sales for price changes. When sales reach 60 percent, 70 percent, 80 percent, and 90 percent of total house sold, at each point the price rises 10 to 15 percent across all available sections.

Carolina Performing Arts uses yield management pricing to adjust for demand for performances where revenue projections were underestimated. The company has built dashboards that incorporate sales for a variety of comparable performances. When actual sales begin to differ dramatically from the expected, the company adjusts prices until they align with expectations.

Alvin Ailey Dance Company builds its seating for each season, reserving rows of each price section. After a period of sales reveals trends in demand, these rows are priced according to that demand, either as part of the lower-priced seating block or as part of the adjacent higher-priced section, depending on which price band is selling faster. Using this method returns the highest yields.

In order to take advantage of yield management pricing, promotional materials should include price ranges that arise from the yield management software that is being used and as demand is monitored. As each percentage of sales is reached, prices can be changed as described. The campaign calendar will dictate each of the moments in time when changes in prices are indicated. Each week, the company should schedule sales meetings to review pricing and demand, and adjust accordingly. Sales personnel should be prepared to be transparent about pricing, to explain to patrons that prices are subject to change, and to encourage arts consumers to order without delaying. Most patrons will understand that your price strategy ensures that the art offerings will continue well into the future.

Source: Kara Larson, *Can You Use Dynamic Pricing?* (Portland, ME: Arts Knowledge, n.d.).

PRICING FINE ARTS OFFERINGS

In the previous sections of this chapter, demand and supply were discussed in an attempt to explain the way artists supply and arts consumers demand arts consumptive experiences. Now it is necessary to talk about those prices that inform the demand and supply for the fine arts.

It is likely that you have experienced lowering a price for an intangible fine arts offering, only to find that fewer people attend. At the same time, if you have called for price increases, you may have been met with resistance by board members or associates. In pricing tangible fine arts in the primary market, formulas abound that encompass markups and discount considerations. Clearly, there are several factors at work in setting prices, and based on given prices, arts consumers will draw conclusions about value and perceived quality. In this section of the chapter, several areas relative to setting prices are covered. One of them is elasticity of demand. The other is the price as a signal of value relative to the tangible arts markets. Finally, after these a discussion of pricing methods in the intangible fine arts is presented.

DEFINITION OF PRICE ELASTICITY OF DEMAND FOR INTANGIBLE FINE ARTS

Changing a price has an impact on the quantity demanded. Usually one thinks that if the price of something is lowered, more people will buy, while if a price is raised, fewer people will buy. This is partly true, depending on the type and availability of substitute products and services. If a product or service has many substitutes, then raising the price will have an impact on the quantity demanded, and generally the opposite is true. But what has to also be considered is the impact of raising and lowering prices on quantity demanded and total revenues when relative substitutes or complementary arts offerings are not immediately available. For example, what would be a close substitute for attending an arts offering featuring pianist Emanuel Ax? In addition, how many arts consumers buying tickets would make it successful? Would a private concert for one or two individuals garner the total revenues sought? It may; however, the arts consumptive experience often depends on interactions with others; therefore this kind of concert would most likely be offered with others that would showcase Mr. Ax, and yet, not many substitutes are available.

Price elasticity of demand has to be considered when changing prices. Prices and quantities on the demand curve are inversely related, meaning that they move in opposite directions. What has to be considered is the percentage change in each. When a percentage change in price has no effect on a percentage change of quantity demanded, then we have unitary elasticity. There is no difference in revenue. If the percentage change in price leads to a percentage change in quantity demanded that is greater than 1 percent, then demand is said to be elastic. The increase in price will reduce total revenue. Similarly, if the percentage change in price leads to a percentage change in quantity demanded that is less than 1 percent, then demand is said to be inelastic; that is, increasing prices will increase total revenue while reducing the

Exhibit 4.10 **Price Elasticity of Demand**

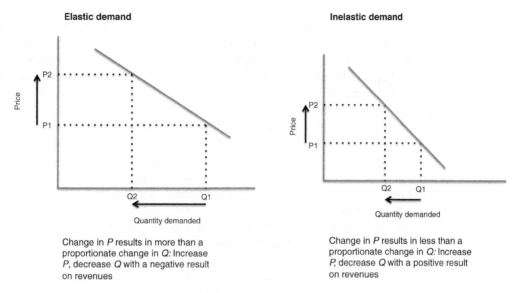

Change in *P* results in more than a
proportionate change in *Q*: Increase
P, decrease *Q* with a negative result
on revenues

Change in *P* results in less than a
proportionate change in *Q*: Increase
P, decrease *Q* with a positive result
on revenues

Source: Elizabeth Hill, Catherine O'Sullivan, and Terry O'Sullivan, *Creative Arts Marketing*, 2nd ed.
(New York: Butterworth Heinemann, 2003), 169.

quantity demanded a bit. At the same time, decreases in prices will reduce total revenues. Intangible fine arts offerings are considered price inelastic. Therefore, considerations of the impact of price decreases need to be carefully studied relative to the quantity demanded. These concepts are depicted in Exhibit 4.10.

CONVENTIONS IN PRICING TANGIBLE FINE ARTS

Differently than establishing prices in the intangible fine arts, pricing in the tangible fine arts has to be considered for the primary and secondary tangible fine arts markets. In the primary tangible fine arts market, pricing is based on the following aspects:

- knowledge or a feel for what the market trends are
- trial and error
- how well known the artist is
- comparable sales
- the minimum reserve price an artist wants to garner

As was mentioned earlier, an artist may choose not to supply the market with too many arts offerings in order to exercise some control over prices. If the artist is working with an art dealer, that individual may influence the price setting process, particularly if the artist is somewhat unknown. Generally speaking, one considers the costs involved in producing the work, or what is referred to as the *reserve price*—fixed costs, labor hours, and relative proportions of sunk costs, plus some

consideration for profit—and doubles it to arrive at the *optimal price*. Therefore, the artist must keep track of the time spent in creating the work and determine an hourly rate for working. All expenses need to be tracked and recorded for a given art work, and the determination of how sunk costs will be spread across art works needs to be made ahead of time. For example, will the costs of a course of study be divided by five, to reflect the number of years over which the costs will be spread, and then further divided by the quantity of expected arts offerings in a given year? Or will the sunk costs be recovered over a longer or shorter period of time?

The price can be determined this way; however, it remains up to the arts consumers in the market to decide if the stated price will be paid. Therefore, knowing all the components of the costs and the desired profits allows for formulating the price, yet finding a buyer for the art work at that price may take time. The process of decision making to purchase in this market is considered risky, and therefore the information available may not allow for an understanding of the level of post-purchase dissonance that may occur. Therefore, prices for tangible fine arts in the primary market are often garnered between the artist's reserve price and the optimal one.

In the secondary tangible fine arts market, existing works of art are bought and sold at an auction. Here price is determined by bidding, which usually comprises a market without substitute art works, for a limited numbers of buyers. Therefore, the demand curve will be vertical, reflecting one quantity demanded, at different prices. As mentioned earlier, the process derives from the English auction where the price is raised until only one buyer prevails, or no sale is made. The beginning bid is given by a reserve price, which will comprise the costs of using the auction intermediary and the costs of production. If the work sells above the reserve price, it is called the hammer price. If it does not sell above the reserve price, at a hammer price, then the work is essentially "bought in" or retained by the seller at the stated reserve price. Prices in the secondary market reflect the degree to which there are arts consumers with preferences and tastes for the tangible fine arts, plus the appreciation, return on investment expected, and value imbued in the work. The buyer's willingness to pay a given price also includes the individual's thrill in the acquisition process and the emotional motivations to possess tangible fine arts.[31]

PRICE AS A SIGNAL OF VALUE AND PRICING METHODS IN THE INTANGIBLE FINE ARTS

As has been stated already, price signals value for the arts consumer. In the intangible fine arts, it is known that prices are typically inelastic, with an increase in the price yielding a small percentage change in quantity demanded. Value is related to perceived quality, and quality can be derived from a number of aspects of service dimensions. How then does an arts manager or culturepreneur determine the price of attending an intangible arts event? There are two overarching considerations for pricing strategically. They are based on costs or based on demand. After this, one has

to consider how the pricing strategy is implemented—that is, how venue locations will garner a price per seat in a yield management framework.

Several concepts and equations will be helpful.

Total Revenue

Total revenue (*TR*) is calculated by multiplying *price* (*P*) by *quantity* demanded (*Q*), or $TR = P \times Q$. It is here that price elasticity of demand may be calculated, by varying *P* and *Q* to evaluate the effect on *TR*. Inelastic demand will reveal an increase in *TR* when *P* is increased, with a slight decrease in *Q*.

Total Costs

Total costs (*TC*) are calculated by adding *fixed costs* (*FC*) to *unit variable costs* (*UVC*) multiplied by *quantity* produced: $TC = FC + (Q \times UVC)$.

Fixed costs are costs that do not change with the number of productions and performances, while variable costs do change with production and performances. Examples of fixed costs are rents, mortgages, long-term debt payments, salaries of management and staff, prepaid insurance costs, storage costs, costs to produce new works or acquire assets, and overhead costs, such as information technology infrastructure. *Variable costs*, or direct costs, include labor costs, supplies, materials that are used only in conjunction with the production, and so forth. The point is to quantify all of the costs incurred in conducting the intangible fine arts.

The Break-Even Point

The *break-even point* (*BEP*), where *total costs* (*TC*) equal *total revenues* (*TR*), is calculated by computing fixed costs and then dividing them by the difference between the unit price (*UP*) less unit variable costs (*UVC*): $BEP = FC/(UP - UVC)$. Knowing the *BEP* will be useful for understanding how costs are operating, what costs can be covered with unearned income, and which may be attributed to earned income.

Note that these price relationships hold for merchandise as well; you will want to include them in your analysis.

Should you price for demand or for cost? This will depend on the organizational objectives relative to growth and mission accomplishment, and the constraints faced in the competitive environment. Objectives can include profit maximization for the for-profit enterprise, or providing the arts service product to a maximum number of arts consumers, or bringing new arts consumptive experiences to the marketplace. The pricing strategy will also take into consideration the unearned income received from donors, patrons, sponsors, and grant-making institutions. Therefore, the overall financial position of the organization will need to be considered when setting objectives.

As such, pricing for the intangible fine arts offering usually has to be done within a competitive market. Understanding the prices of competitors' arts services products

can both serve as a guide as well as dictate prices. The manager of a dance company needs to consider the prices for tickets to the opera, symphony, theater, and other dance productions in the area. If there are no competitors, it may mean that there is no established market, and therefore evaluating the arts consumer segments and their demographics may serve to get a feel for prices.

A price strategy that focuses on cost will attempt to recover all the costs incurred relative to the offering. Having completed an analysis of what costs can be covered by donors, patrons, sponsors, or grants in a not-for-profit organization may facilitate the decision on pricing to cover the remaining costs. Alternatively, the price strategy used to focus on demand will have an eye toward the arts consumers in the market for the arts service product and what that market is willing to bear.[32] Factors to consider are the location of the venue, the quality of the artists delivering the artistic offering, the time of year and the level of risk in the arts consumptive decision process relative to the offer. Yet if the decision to price for demand is made, it is still prudent to understand the costs involved in bringing the offering to the market. Revenues received over and above the costs can be invested in the organization and will signal donors and grants makers, and possible investors should the organizational structure allow for them, about the financial health of the organization.

Once a pricing strategy is determined, implementation of it will be required. How do you go about this? In setting a price for a seat within a venue, you must consider its geographic location (e.g., San Francisco versus Santa Fe, New Mexico), the time of the year, the day of the week, the hour of the performance, and the internal locations of the seats relative to the line of vision of and the proximity to the venue's stage. Ticket prices for season subscriptions will vary from individual purchases of different performances. Ideally, you would use yield management pricing software to determine the prices of each seat under different scenarios so that the price inelasticity of demand is maximized. Calculating the revenue in aggregate for the entire time frame under consideration, such as a three-year window of time, should be compared to the total costs projected over the same time period. It is here that you will be able to determine any deficits and arrange for needed unearned income or investments.[33]

CHAPTER SUMMARY

This chapter has covered a great deal of ground. It began with the supply and demand of the tangible and intangible fine arts. Here the discussion included the way that creativity is addressed in the cultural arts, seeing the decision to become a producer of fine art as a function of utility, with the utility ranging from economic to cultural value. Next the chapter covered the demand side of the two categories of the fine arts. In addition, the presentation of the arts as a service product was explained, along with the aspects of quality and the characterization of services. Nestled within this framework, the arts consumer purchase process was covered, noting that risk is a driver for purchase decisions. The remainder of the chapter focused on pricing, including determining elasticity and pricing strategies. Factors that determine price for fine arts were covered, including fixed and variable costs, and calculations of break-even points.

You should now understand the overall approach to supply and demand in the fine tangible and intangible arts and be able to differentiate between demand and supply functions of the tangible and intangible fine arts. Importantly, you should understand the economics of cultural creativity that underlies the supply of arts goods, ideas, and services and be able to explain the demand and supply equations underlying the tangible and intangible fine arts. You should be able to recognize and develop a process for determining price elasticity of demand for the intangible fine arts offering and to set prices in the tangible fine arts market.

DISCUSSION QUESTIONS

1. Consider the arts as a service product. What are the aspects of quality that are important to this rendering of the fine arts?
2. Explain the differences in demand for the fine tangible and intangible arts.
3. What is price elasticity of demand? Why is it important for the intangible arts? Does this concept apply to the tangible fine arts? Explain.
4. How would you price a painting by an emerging tangible fine arts professional in the primary market? Does pricing differ in that case from that for an established individual in the primary tangible arts market? Make an accounting of the costs that would constitute the reserve price for each, assuming that there is an art dealer facilitating the work but no identified arts consumer.
5. Outline the purchase decision process for the tangible and intangible arts consumer. How does information availability impact this process in the tangible and intangible arts marketplaces?

EXPERIENTIAL EXERCISES

1. What are the fixed costs of your organization and the variable costs of offering an intangible fine arts service product? Calculate the break-event point.
2. Go to the websites of two major intangible fine arts organizations and download their annual reports. What are the fixed costs? Variable costs? Identify earned and unearned revenues.
3. Explore three different providers of yield management software for the intangible fine arts. Compare and contrast them. Would you employ one or more of them? Why?
4. Examine three websites of art auction houses. Evaluate upcoming auctions and gather information about the work, identifying the reserve prices for each. Then, participate in an online arts auction or, if the auction is near your location, participate in person. What are your observations? Can you determine the hammer price? Was anything "bought in?"

FURTHER READING

Baker Richards Consulting. Revenue Management and Dynamic Pricing. The Pricing Institute. www.thinkaboutpricing.com/left-navigation/revenue-management.html.

Barclays. *Profit or Pleasure? Exploring the Motivations Behind Treasure Trends*. Wealth Insights, vol. 15. London: Barclays, 2012. www.ledburyresearch.com/media/document/barclays-wealth-insight-volume-15.pdf.

Grampp, William D. *Pricing the Priceless: Art, Artists, and Economics*. New York: Basic Books, 1989.

Heilbrun, James, and Charles Gray. *The Economics of Art and Culture*. 2nd ed. New York: Cambridge University Press, 2001.

Hill, Elizabeth, Catherine O'Sullivan, and Terry O'Sullivan. *Creative Arts Marketing*. 2nd ed. New York: Butterworth Heinemann, 2003.

Throsby, David. *The Economics of Cultural Policy*. Cambridge: Cambridge University Press, 2010.

NOTES

1. "Just the two of us: The duopoly in fine-art auctions is weakened but very much alive," *The Economist*, February 27, 2003, www.economist.com/node/1612774.

2. Christie's. "Christie's attracts new collectors as global appeal for art continues to grow in 2012," press release, January 17, 2013, www.christies.com/about/press-center/releases/pressrelease.aspx?pressreleaseid=6125.

3. Victor A. Ginsburgh and David Throsby, eds., *Handbook of the Economics of Art and Culture* (Amsterdam: Elsevier North-Holland, 2006).

4. Noam Chomsky, *Language and Mind* (New York: Harcourt Brace Jovanovich, 1972).

5. Roger McCain, "Defining cultural and artistic goods," in *Handbook of the Economics of Art and Culture*, ed. Victor A. Ginsburgh and David Throsby (Amsterdam: Elsevier North-Holland, 2006), 147–167.

6. Howard Gardner, "Seven creators of the modern era," in *Creativity*, ed. J. Brockman (New York: Simon & Schuster, 1993).

7. McCain, "Defining cultural and artistic goods"; David Throsby, *Economics and Culture* (New York: Cambridge University Press, 2001).

8. Economic game theory (Roberto Cellini and Tiziana Cuccia, "Incomplete information and experimentation in the arts: A game theory approach," *Economia Politica* 20, no. 1 [2003], 21–34) is available to model the way in which artists work in relation to the creative process, which involves a series of steps, which will be covered in more detail in ensuing chapters. In this chapter, the concept of an artist working through a utility function to supply the arts is tantamount to the discussion. There is also an argument that creativity is something that can be learned as opposed to something that is inherent—that is, there is a difference between creativity and talent.

9. Throsby, *Economics and Culture*.

10. James Heilbrun and Charles Gray, *The Economics of Art and Culture*, 2nd ed. (New York: Cambridge University Press, 2001).

11. The production function (inputs and outputs) for the nonprofit intangible arts has mainly focused on labor costs, leaving the entrepreneurial, capital, land, and investment aspects under-theorized. One problem also arises as nonprofits have objectives that vary from maximizing audiences to maximizing creative works, different from the profit motive of for-profit firms. Therefore, the decision about what is being maximized drives the production function. Along with focusing on managing and stimulating demand and approaching the nonprofit arts organization entrepreneurially, these aspects of the production function need

to be considered and constitute the topics of later chapters in this volume, save for details of economic modeling. Several authors have contributed to such modeling of the intangible arts, and the reader is encouraged to see Arthur C. Brooks, "Nonprofit firms in the performing arts," in *Handbook of the Economics of Art and Culture*, ed. V.A. Ginsburgh and D. Throsby (Amsterdam: Elsevier North-Holland, 2006), 473–506, for a starting point.

12. William J. Baumol and William G. Bowen, *Performing Arts: The Economic Dilemma* (Cambridge, MA: MIT Press, 1966).

13. Paul Dimaggio, "Nonprofit organizations and the intersectoral division of labor in the arts," in *The Nonprofit Sector: A Research Handbook*, 2nd ed., ed. Walter W. Powell and Richard Steinberg (New Haven, CT: Yale University Press, 2006), 432–461.

14. A public good is one that can be enjoyed by a person without depleting the supply available for others. It is thought that for something to be a public good, it cannot exclude anyone from enjoying it, along with having a very low marginal cost to provide an additional increment of it to a consumer. Think of public radio, for example, to which everyone can listen but not everyone contributes financially to make it available. The public goods argument includes several types of values to society because the intangible arts exist. Existence, option, education, prestige, and bequest values are included as ways that society is better off with the intangible arts. See Brooks, "Nonprofit firms in the performing arts," or Howard Vogel, *Entertainment Industry Economics: A Guide for Financial Analysis*, 7th ed. (New York: Cambridge University Press, 2007), for an expanded discussion.

15. William J. Baumol, "The arts in the 'new economy,'" in *Handbook of the Economics of Art and Culture*, ed. V.A. Ginsburgh and D. Throsby (Amsterdam: Elsevier North-Holland, 2006), 339–358.

16. Brooks, "Nonprofit firms in the performing arts"; Carla Stalling Huntington, "Moving beyond the Baumol and Bowen cost disease in professional ballet: A 21st century pas de deux (dance) of new economic assumptions and dance history perspectives," PhD dissertation, University of California, Riverside, 2004.

17. See Internal Revenue Service, "14. Sale of Property," in Publication 17 (2013), Your Federal Income Tax (Washington, DC: IRS, 2013), www.irs.gov/publications/p17/ch14.html#en_US_2012_publink1000172315, and consult with your tax adviser for more information.

18. Quality issues include the performance repertoire itself, standards of performance, the level of talent of the performers, the venue, standards of seating and comforts afforded to attendees, sound, lighting, design, and so on. Louis Levy-Garboua and Claude Montmarquette, "Demand," in *A Handbook of Cultural Economics*, ed. Ruth Towse (Cheltenham: Edward Elgar, 2003), 201–213. See also Throsby, *Economics and Culture*.

19. Heilbrun and Gray, *Economics of Art and Culture*, 2nd ed.

20. Vogel, *Entertainment Industry Economics*, 20, Table 1.4.

21. Throsby, *Economics and Culture*, 116.

22. Leisure time is a function of the income and substitution effects and is given by a backward-bending labor supply curve. People will work for more hours and earn more income up to a point, after which they will prefer to spend their time on leisure activities. Vogel, *Entertainment Industry Economics*, 11, Figure 1.6.

23. Throsby, *Economics and Culture*; Vogel, *Entertainment Industry Economics*.

24. Vogel, *Entertainment Industry Economics*.

25. Levy-Garboua and Montmarquette, "Demand."

26. The reader should be aware of the theory of rational addiction, consumption of the arts as habit-forming, and learning by consuming, which suggests that people maximize utility and

can explain their tastes for the arts by comparing it to engaging in demand behavior based on a large accumulation of favorable past consumption experiences. Some have proposed this theory to explain arts demand and price elasticities to explain tastes. For more details, see Bruce A. Seaman, "Empirical studies of demand for the performing arts," in *Handbook of the Economics of Art and Culture*, ed. V.A. Ginsburgh and D. Throsby (Amsterdam: Elsevier North-Holland, 2006), 415–474; Gary S. Becker, *Accounting for Tastes* (Cambridge, MA: Harvard University Press, 1996); and Gary S. Becker and Kevin M. Murphy, "A theory of rational addiction," *Journal of Political Economy* 96, no. 4 (August 1988), 675–700.

27. Throsby, *Economics and Culture*.

28. The literature is rich with studies on art as an investment and setting prices for art objects at auctions, under a theory of private value auctions. It has been shown that investing over time in the arts market can be likened to investing in the stock market, since returns on art are similar to the returns on common stock. Orley Ashenfelter and Katheryn Graddy, "Art Auctions," in *Handbook of the Economics of Art and Culture*, ed. Victor A. Ginsburgh and David Throsby, 909–945 (Amsterdam: Elsevier North-Holland, 2006). Arts indices exist for different pieces of artwork in differing locales. The scope of this textbook limits covering these topics in detail, unfortunately.

29. Elizabeth Hill, Catherine O'Sullivan, and Terry O'Sullivan, in *Creative Arts Marketing*, 2nd ed. (New York: Butterworth Heinemann, 2003), use the terms "heterogeneous" in place of "inconsistent," and "perishability" in place of "inventory." In this textbook the terms will be used interchangeably.

30. Valarie A. Zeithaml, Mary Jo Bitner, and Dwayne D. Gremler, *Services Marketing: Integrating Customer Focus Across the Firm*, 6th ed. (New York: McGraw-Hill Irwin, 2013); Roger Kerin, Steven Hartley, and William Rudelius, *Marketing*, 10th ed. (New York: McGraw-Hill/Irwin, 2010); Christopher H. Lovelock and Jochen Wirtz, *Services Marketing: People, Technology, Strategy*, 7th ed. (Upper Saddle River, NJ: Prentice Hall, 2010); Valarie A. Zeithaml, Mary Jo Bitner, and Dwayne D. Gremler, *Services Marketing: Integrating Customer Focus Across the Firm*, 4th ed. (New York: McGraw-Hill Irwin, 2006).

31. Judith H. Dobrzynski, "The art of the hunt," *New York Times*, April 28, 2013; Blake Gopnik, "Why is art so damned expensive?" *Newsweek*, December 5, 2011, http://mag.newsweek.com/2011/12/04/why-is-art-so-damned-expensive.html; S.T. Basel, "The art market: Why buy art?" *The Economist*, June 22, 2012, www.economist.com/blogs/prospero/2012/06/art-market; Barclays, *Profit or Pleasure? Exploring the Motivations Behind Treasure Trends*, Wealth Insights, vol. 15 (London: Barclays, 2012), www.ledburyresearch.com/media/document/barclays-wealth-insight-volume-15.pdf.

32. Philippe Ravanas and Paula Colletti, "What price is right for looking glass?" *International Journal of Arts Management* 12, no. 3 (Spring 2010), 3.

33. Firms in the marketplace provide yield management pricing software for the arts. See Baker Richards Consulting, "Revenue Management and Dynamic Pricing," The Pricing Institute, www.thinkaboutpricing.com/left-navigation/revenue-management.html. At the same time, you may want to develop your own pricing software using tools and resources provided by spreadsheets or other financial instruments.

Part II
Entrepreneurial Development

5 | The Cultural Fine Arts in Entrepreneurial Process

CHAPTER OUTLINE

LEARNING OBJECTIVES

After reading this chapter, you will be able to do the following:

1. Understand the culturepreneurial creative process.
2. Explore ways to increase idea generation.
3. Know the relationship between the creative process of the artist and that of the culturepreneur.
4. Easily articulate how to define an opportunity and whether to pursue it.
5. Have an overview of a business plan to enable you to develop one for the arts.
6. Comprehend positioning.

7. Generate attributes that facilitate perceptual maps.
8. Follow a systematic set of steps to generate a position in the market.
9. Differentiate between the business strategy of a pioneer or a follower into a market.
10. Recognize the product or service life cycle and the need to manage it.
11. Establish a process of evaluating whether you have achieved your goals in deciding to pursue an opportunity.
12. Have the tools needed to begin developing a business plan.

What's On?

Harvard i-lab
"Artist as Entrepreneur: A Conversation with Wynton Marsalis"
YouTube, February 15, 2012
www.youtube.com/watch?v=JzFPHSbv73I

Finding Money for Culturepreneurial Ventures in the Cloud[1]

All artists are entrepreneurs. All entrepreneurs are artists. It is a challenge to find ways to invest in the business of the arts. Yet with start-ups like Kickstarter, Eventbrite, and Artsicle, many now take their business of making art into their own hands.

For centuries, artists have relied on themselves, individual patrons, or institutions to market their work. To hold individual presentations, artists would have to find a reputable gallery that would carry their work. Gaining that kind of access was not easy. Some artists were enabled with their own financing. In that case, artists could pay a mediocre gallery to show their work, a luxury that very few artists could afford.

Now, new technologies are disrupting the art world, allowing artists to fund, promote, and create their own displays. For example, Erick Sanchez had excellent representation in New York City at the William Bennett Gallery in Soho. After the firm's demise, however, it was difficult to find another gallery of the caliber he wanted. He needed space to create, materials, and supplies, not to mention representation. So he turned to Kickstarter, a start-up that lets individuals leverage social networks to fund projects. After he created the Kickstarter page, he marketed and promoted the project using WordPress, email, and Facebook. That enabled him to successfully fund his out-of-pocket costs. The next step was to market and promote his show. Sanchez created printed invitations on InDesign, a skill that can be self-taught using YouTube, and digital invitations on Eventbrite. Social media and blogs, such as Artefuse, were the avenues that he used to generate awareness and attendance at his show.

Sanchez is a pioneer in the artists' community, but he is not the only one disrupting the industry. Many culturepreneurs strive to embrace their own destinies and outcomes by making their art available through cloud-based networks. Welcome to a new art world.

Exhibit 5.1 **Juxtaposition Arts**

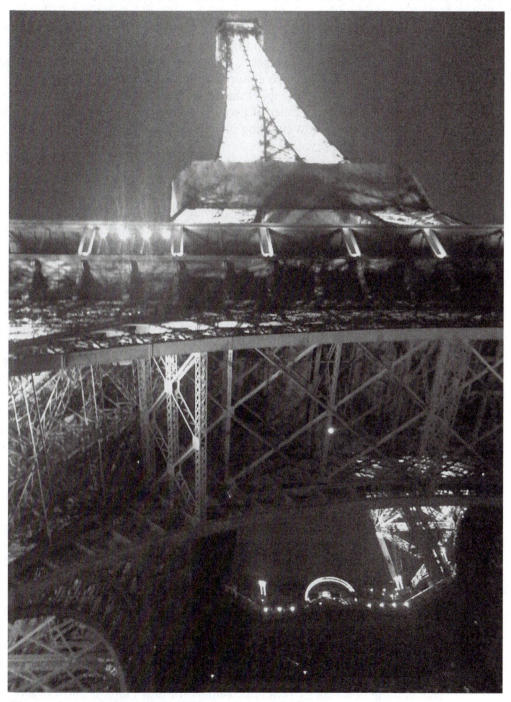

(Photograph courtesy of Carla Stalling Walter)

PLAYING DOWN THE PROFIT MOTIVE IN CROWDFUNDING

Crowdfunding is the process of raising money from numerous small financial contributions that provide start-up funding for your cultural fine art venture. Crowdfunding depends on the online presence of the culturepreneurial venture and interaction through social networks. The culturepreneur must display the project in a fashion that gathers interest and engages "the crowd" in order to attract funding in sufficient amounts from a large number of people. Derived from the concept of cooperatives and crowdsourcing, crowdfunding is your social network, through which the Internet plays a key and pivotal role.

To an extent, crowdfunding has been around for a long time in the form of raising funds for a cause or for a nonprofit motive. But due to the advent of the Internet and platforms like crowdcube.com, kickstarter.com, and rockethub.com, business crowdfunding, or crowdfunding for private ventures, gained attention. These websites provide a platform for culturepreneurs to crowdfund their projects or new initiatives.

Crowdfunding is an economic model that retains key attributes of the capitalist economy, such as a profit motive and private ownership, but introduces new characteristics. Although profit is an objective and companies are privately owned, the financial means of production are not privately owned; they have been socialized. The socialization of the supply of productive wealth is the defining feature of crowdfunding.

Is crowdfunding cultural fine arts a revolutionary new use of technology for the social good? Or is it something else? New technologies sometimes simply facilitate exploitation. New technologies like crowdfunding can and do alter the existing conditions of cultural production. At the same time, the dominant forces in cultural production have tremendous power to use and shape these new technologies. The true significance of crowdfunding shifts mind-sets and realities around organizational possibility, potentially reinforcing and extending, or even transforming, the traditional organization of cultural fine arts production.

Crowdfunding can also create opportunities for exploitation. Crowdfunding, like some types of competitions, can encourage fantastic wins for a few, while requiring others to create on speculation, ultimately gaining nothing for their efforts. Importantly, while more and more people can afford consumer-grade production tools, and while some amateur productions are successful, consumer-grade production tools can only go so far. Although the Internet provides innumerable opportunities for the free distribution of creations, some artists lack the up-front capital required to move to the next level of professional-grade productions and therefore to take advantage of digital distribution tools on a professional basis.

Small entrepreneurs without access to venture capital have traditionally relied on the "three *F*s": friends, family, and fools, or bootstrap financing. Crowdfunding provides one alternative, if the funding is provided up front. If so, it lends itself to encouraging new voices, providing outlets for new cultural fine arts producers, and providing up-front capital. At the same time, it can facilitate work on speculation for little or possibly no return, with a significant up-front investment required on

the part of creators for a project that may or may not ultimately receive funding. *Ex poste* crowdfunding requires up-front work, providing funding when the project is complete. This kind of crowdfunding offers little help to artists who do not have the required up-front capital to produce a project.

Ex ante crowdfunding makes funding available up-front, removing some of the risk to creators by providing a mechanism that ensures the production is popular and is therefore likely to be a success. *Ex ante* crowdfunding ensures that culturepreneurs produce cultural fine art with value to others along the way. On the other hand, crowdfunding can reproduce the worst inequalities of the star system, encouraging large wins for a few, while leaving the rest to gain little if any recognition or financial reward for their efforts. However, some models of *ex ante* funding can provide true opportunities to new and upcoming creators, while at the same time being associated with risks that are absorbed by individual funders, rather than by traditional sources of funding such as government or corporations. Crowdfunding creates new opportunity and start-up funding, but also creates risks.[2]

CULTUREPRENEURS AND THE CULTURAL CREATIVE PROCESS

Entrepreneurship is alluring and many aspire to reap its promises of financial and artistic freedom, cultural change, fame, and ultimate control over one's destiny. As an entrepreneur, you might imagine being your own boss, leading a group of people, perhaps establishing and growing a going concern that can become a family-based organization that lasts through generations.[3] Alternatively, the dream may be that a company is started from scratch in the garage or at the kitchen table, and it grows and attracts investors, with the triumph of an initial public offering or a lucrative acquisition. We hear of such cases all the time, and we are hearing more news like this in cultural arts organizations. As importantly, entrepreneurs generate wealth, economic stimuli, careers, and support gross domestic product (GDP) with imports and exports as well.

Yet the decision to be an entrepreneur has many aspects that need to be considered. The main consideration is the risk. *Risk* is assessed based on the magnitude and probability of business success balanced against the extent of possible business failure and loss that could result in bankruptcy.[4] Many start-ups fail, and most fail in the first five years. Those that do survive often experience growing pains, since the entrepreneur may be great at idea generation but lack management stamina. Some individuals believe there is no need for a business plan, and they dismiss or underestimate the amount of working or investment capital needed to carry them through the period from start-up to sustained solvency. Often the degree of management expertise that is needed is unexpected as well. Therefore, while the notion of being an entrepreneur is very alluring, succeeding at it requires planning and self-evaluation.

In addition, when coupling the entrepreneurial process with the creative aspects of the production and supply of fine cultural arts goods, ideas, and services talked about in Chapter 4, it is evident that proceeding with caution is definitely good advice. This then is the reason for this chapter on culturepreneurship. It provides an in-depth review of what it requires to be a culturepreneur, developing business plans,

and identifying the market and trends. The purpose is to reveal the steps required to become a successful culturepreneur and to aid in avoiding pitfalls. Yet sometimes even the best plans and designs will be met with outcomes that are not expected or wanted. This chapter discusses these issues as well.

WHAT IS A CULTUREPRENEUR?

Just as the concepts of culture, aesthetics, and art can be approached from many different viewpoints, so can the definition of entrepreneur. An economist will see entrepreneurs one way, an occupational therapist will characterize them another way, and small business owners and employees will maybe understand entrepreneurs differently as well. Some parents may think of an entrepreneur as a gambler, while others will expect their children to become an entrepreneur or to follow the family expectation of taking over a family business some day. The point of bringing these views to bear at the outset is to explain right away that the word "entrepreneur" has meanings but also connotations. Here we will consider the economic framing of, and the psychological characteristics that define, an entrepreneur.

In Chapter 1 an *entrepreneur* was defined as a person who takes the initiative, bundles resources in innovative ways, and is willing to bear the risk and uncertainty of action, with an eye toward creating value for a product or service.[5] There we also said that *culturepreneurs* are "artists undertaking business activities within one of the four traditional sectors of the arts who discover and evaluate opportunities in the arts and leisure markets and create a business to pursue them."[6] *Entrepreneurship* involves creating something new or devising an innovation that is valuable to others, with the entrepreneur devoting time and resources to the innovation which will ultimately result in financial rewards and personal satisfaction. Similarly, *culturepreneurship* involves conceiving or leading a cultural arts organization, producing for a cultural arts audience, and being committed to culturally creative endeavors, based on the cultural value that the culturepreneur desires to create. You can imagine this point of reference with the artist who desires to produce something of beauty or value, being driven to do it, and gaining a reward of some type. Now if we refer back to the idea of the cultural creative process of the artist as fulfilling a utility function, as discussed in Chapter 4, this is an easy kind of connection to make. The utility is balanced between creating cultural value and financial return, depending on the type of art and the artist. In a culturepreneurial frame, though, the satisfaction of providing the innovation is connected with being willing to bear the risk, with personal satisfaction, and with the monetary return. It is the potential for a high level of return and satisfaction that may be available from being one's own boss and meeting a new demand or creating one that drives the entrepreneurial process in the capitalist economy. And in order to realize this kind of anticipated return, the culturepreneur has to bear the risk, which often requires putting personal assets on the line in exchange for the promise of the anticipated return.

Does this kind of drive and initiative set the entrepreneur apart from others? Do entrepreneurs have a different mind-set from those who are not driven to be innovative, create value, and assume risk for a promise of reward? It seems that

culturepreneurs engage in a thinking process that may be characteristic of a group of people likely to go in this direction.[7] While some people follow a decision process that is stepwise and linear, focused on an outcome with limitations, and they are comfortable thinking this way, culturepreneurs often operate in a different way. As was defined in Chapter 4, during the cultural creative process, artists proceed, often in noncircular form, from an idea, then to incubation processes, then on to a developed good, idea, or service, with one or more revisions of the development. In the end, this process manifests finally in creating works of cultural fine art. Culturepreneurs tend to be able to use their emotions, unconsciousness in incubation, resources, senses, and hunches to carry them toward their vision. This has been called an effectuation process. Such a thinking process allows creativity and actions in a highly uncertain environment. This kind of thinking is referred to in this textbook as the *culturepreneurial mind-set*.

CULTUREPRENEURIAL CHARACTERISTICS

Because the environment is constantly in motion, entrepreneurs must be flexible, have access to resources they need, and be both self-reliant and able to acknowledge where they need support. In addition, they have to be able to see multiple outcomes at the same time in the risks they are taking. So this means that along with the effectuation abilities, culturepreneurs also have to be able to adapt and cognitively process situations quickly. Such cognitive adaptability can be honed in all of us, should there exist a desire to do it. These behaviors have to also be coupled with the cognitive aspects of thinking and self-reflection that allow for assessment of the environment and development of strategies to be able to realize cultural and economic value creation.

Despite the culturepreneur's effort to harness these abilities and processes that lead to belief in the idea or innovation that the culturepreneur envisions, there is a great deal of failure in culturepreneurial ventures. When the phrase "business failure" is used, basically it means there is not enough money to pay debts, not enough value or potential value to attract adequate investment, and therefore the business cannot continue to operate. *Failure* is often seen as part of the culturepreneurial process—a way to learn. True, we would prefer to have success when we launch a new venture, but it does not always happen this way. What is important, though, after a failed venture is to evaluate it and not let it deter the development of a more successful one. After an unsuccessful attempt, some culturepreneurs may focus too much on the business termination due to failure, which may in turn lead to a downward spiral or negativity in culturepreneurial thinking and acting. This is not to imply that culturepreneurs should take their ventures lightly and cast all doubts aside, but rather to point out that failure is part of learning how to be successful; dwelling on the failure is likely to beget more failure. These two polar views are termed loss- and restoration-orientation, respectively. Having a restoration-orientation is the optimal point of view. In reality, after a loss there will probably be some movement between these two poles. The point is to learn, feel, revise your plans, and keep moving forward.

To summarize, then, culturepreneurial characteristics include adaptability, flexibility, and the ability to process and use information quickly. Additional important

attributes are the ability to face potential financial loss and, should such an end materialize, the fortitude to recover from such a loss. During each point along the way, the culturepreneur also has to be self-reflective while creating arts offerings that provide cultural and economic value.

THE CULTUREPRENEURIAL CREATIVE PROCESS

While there is no absolute way of approaching it, the next aspect of the process needing to be analyzed is the *culturepreneurial creative process*. This entails coming up with viable new cultural fine arts ideas, goods, and services *systematically*. One has to glean processes and ideas in what exists, or what does not, and be able to imagine something different that will be of cultural value for an audience. In both the intangible and tangible primary cultural arts, creative individuals maximize utility in providing cultural value or seeking financial returns; placing this goal within a cultural arts creative process involves bringing new light to the old, or formulating something entirely new. In Chapter 8 the systematic cultivation of new arts service products and ideas is discussed as an organizational manifestation. Here, though, we realize that, because creativity apparently declines with age and experience, it is important to "exercise" and cultivate the creative muscles. One major way to do this is to imagine how something might be done better or how you might do something completely differently from how you are doing it. This is how many innovations occur. Ask yourself, "If I had a magic wand, how could I do this better? Faster? Slower?" The idea is to come to the table without limitations, to see and think without the current filters people generally carry around. You are looking for an opportunity to fill a need that may or may not exist. In the latter case, your idea may create a need that is filled by you! This is done by systematically applying your cognitive and affective capabilities, combined with your experience and education, to evaluate the environment and generate opportunities.

How does one generate creative ideas? Virtually every part of your day can be used in idea generation, by paying attention to the environment. When talking about environment, the factors include looking at changes in the environment and critically evaluating trends. What will be the next new technology, or how will the existing technology change to meet needs? What kinds of social trends are happening with health, well-being, community, family, and relationships? What do you perceive are governmental changes that may affect the way we do things? Where is the economy heading? How will these different areas take shape in your neighborhood, your country, and ultimately over the globe? An assessment of the environment can be local or global, and it should actually entail both.

Ideas can also come from asking questions, having conversations, reading the news, or seeing someone else's creation. Talking to children is a great way to get new ideas. They are not limited by conditioned responses, so asking them how they would make a mural or design an online art exhibit may generate ideas out of this world, but those ideas can be boiled down to something that is going to provide the return needed for the amount of risk undertaken to fulfill the need you are creating, or the need that exists for your audience. Talking to newly hired employees or new

board members can also provide a long list of new ideas because these individuals have a clear perspective that is not encumbered by the organizational culture. Aside from asking questions and seeking to study trends in the environment, going to events, listening to lectures and talks, attending conferences, and reading materials that are inspirational are also ways to generate ideas. In short, idea generation is a practice, and it should become systematic in your daily life as an entrepreneur. While it may seem that this aspect of the entrepreneurial creative process is looking for the "big idea," it does not necessarily have to be because finding ways to address smaller changes in the environment can be entrepreneurial as well.

Now that you have creative ideas, what is next? That is where opportunity assessment begins. And if the opportunity seems to signal a green light, then you move into full-on evaluation. If the decision is to move forward with implementing the opportunity, then funding the enterprise and leading its growth come into play. Ideally, you will have an inventory of viable ideas, so that you can systematically implement them over time. As can be seen in Exhibit 5.2, there is a systematic approach to follow in determining whether you will move forward. We will start with searching for the opportunity, assessing entry into the market, asking how economic and cultural value are added, and developing strategies that will underlie the entry by sketching

Exhibit 5.2 **SAAS for Opportunities in the Culturepreneurial Process**

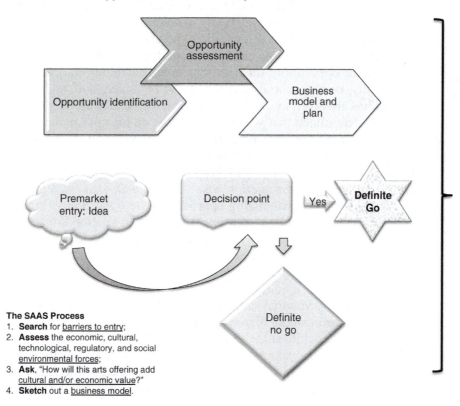

The SAAS Process
1. **Search** for barriers to entry;
2. **Assess** the economic, cultural, technological, regulatory, and social environmental forces;
3. **Ask**, "How will this arts offering add cultural and/or economic value?"
4. **Sketch** out a business model.

a business model. Combining this assessment process with a desire to create cultural and economic value can lead to thriving and rewarding culturepreneurship.

DEFINING AND ASSESSING OPPORTUNITY AND CREATING THE BUSINESS PLAN

WHAT IS AN OPPORTUNITY?

An *opportunity* is a situation in which culturepreneurs bring their skills and resources to bear on a set of ideas that will provide cultural and economic value for the market. In this volume, it is defined as a financially feasible, potential venture that provides an innovative new cultural arts service product, improves on an existing cultural arts offering, or imitates a profitable cultural arts service product in a fine arts market.[8] Opportunities are evaluated for both profit-seeking firms and not-for-profit organizations.

The way that an opportunity is articulated will be based on what audience the culturepreneur is targeting for need fulfillment, how long the opportunity is thought to be viable with the resources available, and whether the culturepreneur's makeup and skills can be effectively applied in seizing it. The culturepreneur has to believe in the opportunity and exhibit the desire and willingness to do what it will take to make it happen. With this drive in place, then, the main goal of defining and assessing the opportunity is to see if it is viable and whether or not there are resources available to take advantage of it. An *opportunity assessment* evaluates, before full-on business plan development and implementation, the viability of the opportunity based on the above characteristics of the culturepreneur, the industry, and the market.

Define the opportunity succinctly by conceptualizing it. Ask questions about the opportunity, be clear about how it came to be understood, and identify what kinds of reactions are given in feedback when the idea is discussed. For example, suppose you have determined that you want to assess an idea of opening a new arts auction house. Where did the idea come from? Why do you think it is viable? What is motivating you to want to do this? In order to conceptualize it, writing it down or recording it in some way will be useful. For example, writing *An opportunity exists to open a new type of global arts auction house that is conducted entirely electronically* may be a framing or contextualizing approach to the opportunity. You may have come up with this idea based on your experiences with auction houses and the environment they reside in, or the way that you have heard secondary tangible arts investors imply new needs for the process, or through reading biographies of art dealers. After the concept is clear, then a systematic plan to assess the opportunity itself should be followed. Being a culturepreneur, you will find this process useful in each and every opportunity you may engage with, and completing this process before actually moving into the business planning stage is very important. It helps to identify mere wishful thinking while at the same time avoiding being overly cautious.

How will the *business model* unfold? This term refers to the actual process that the organization follows in exchanging its arts service products for price consideration that leads to revenue streams that generate income over time. In a for-profit

frame, if an online arts auction is based on selling to the highest bidder, then the business model is set up this way. If, however, you are assessing an opportunity for a not-for-profit organization, the business model will need to include the exchanges for earned income, such as arts offering prices and merchandise, and the process for garnering unearned income from grants, donors, and patrons.

After the business model is determined, asking the question "What audience or market will want this cultural arts offering?" is the first critical assessment that has to be determined. In other words, what is the *market* for the opportunity and what *industry* does it reside in? Earlier in the textbook we discussed the cultural arts industry in terms of supply, which is where your opportunity will lie, within the core concentric circle of cultural arts given in Chapter 1. In terms of researching markets and defining targets, more detail will be given in Chapters 6 and 7, but for the moment it is necessary to understand that a *market* is the set of arts consumers, patrons, and/or businesses that will buy your cultural arts offering. In this volume, the term "market" will often be used interchangeably with the term "audience." In any event, trying to get your arms around the size and characteristics of the audience is necessary here. While it may seem like an easy assessment, it is not sufficient to say that wealthy consumers of secondary tangible arts will want this. Using the example about developing a virtual cultural arts auction house, it would be more helpful to explicitly state that the audience will be those with a certain affinity for cultural arts expenditures online who have resources to participate, and to give the number of people this may entail and the projected revenue, income, and profit.

For example, one way to state it would be as follows: "Our potential 4,000 clients in the cultural arts market are men and women who are technologically savvy with net worth exceeding US$10 million, who seek anonymity and privacy in their acquisitions, who have participated in cultural arts auctions over the last five years. On average, the revenue generated from one online auction will exceed $2 million and we expect to provide twenty such auctions per year, with 40 percent profit." As you can see, this statement tells a great deal about the cultural arts consumer who will be interested in your arts offering.

Next, the question of *competition* has to be addressed. Who are the competitors in this industry? Where are they? Are they international in scope? What are the barriers that make it difficult to enter the industry? Will it take a great deal of financial or other resources to prevent delving into the industry? Are patents or copyrights needed? Does entry into the industry require a long lead time that will eclipse the window of the opportunity you are assessing? These can all be considered sources of *barriers to entry* and should be carefully evaluated in the decision to move forward with the opportunity.

Taken together, in the overarching context of the previous set of questions, you must also determine if you need to conduct a large-scale marketing research project to delve into the industry and the market. What kinds of *market research* information are you going to need? Is there enough *secondary* information available from other sources for you to fully develop a picture of the market and industry to use in the business plan? Or will you need to conduct *primary* research that is specific to your arts offering as well? What are the overall business objectives, and what type of

marketing strategy will need to be employed to achieve them? Finally, ask yourself if you have the skills, access to resources, networks, and support necessary to take on this opportunity.

In summary, opportunity assessment has the following general components. After defining the opportunity and conceptualizing it, the preliminary answers to a defined set of questions may be generated in this order or approached in a fluid process. What is important is that you gather enough information about the opportunity after conceptualizing it to make an informed decision to move forward with it or not.

1. First, define the opportunity succinctly by conceptualizing and articulating it. Writing it down or documenting it somehow is a best practice, and then add the following:
2. Explain the business model. How will you make money?
3. Sketch what you expect the arts audience or market will want from the cultural arts offering. Is this project viable?
4. Identify the industry competitors and resist the urge to ignore this step. Are the barriers to entry surmountable?
5. Understand the degree of primary market research that is needed. Can you use secondary research materials or will you need to expend resources on primary research to achieve the business objectives?
6. List the skills, resources, and experiences you possess to carry out this opportunity. Do you have what it takes to stick with this? Who are the individuals or organizations you can turn to when you need assistance?
7. Finally, is it possible to seize this opportunity within the relative time frame that exists?

If the answers to these questions are satisfactory, then it is likely that moving forward to the next step is warranted. In that event, you will take the information gathered in the opportunity assessment phase into full business planning.

THE BUSINESS PLAN: AN OVERVIEW OF THE CONTENT

Every company, regardless of its size, needs to have a business plan because this is the road map you will follow to achieve the ends you expect in going forward with your opportunity. Your business plan explains your business strategy. It sets forth the pro forma *financial statements* explaining the business model relationships between the expense of the arts offering and the income it will generate; it describes the *markets and industries*; it outlines the *organizational structure*; and it clearly articulates the *environment* that the business operates in. Importantly, the document will inform investors and donors or sponsors regarding capital and cash flow requirements to launch and sustain the business, and what their roles will be. A key point that needs to be included in the business plan is what the culturepreneur brings to the table. Does the plan demonstrate the culturepreneur has the resources (1) materially (i.e., networks, family, friends, cash, experience, enthusiasm); (2) emotionally (i.e., demonstrates culturepreneurial thinking); and (3) cognitively

(i.e., experience, knowledge, education, leadership capacity) to successfully drive execution of the plan? As you can imagine, the organizational structure is going to be a critical driver.

In addition, allocation of surpluses in a profit-seeking financial forecast in for-profit mode will differ from income generation and surplus management in a mission-driven concern. The latter will look to explicitly state profits and losses over time and seek to establish a return on investment either for the culturepreneur, or the investors, or both. In this structure, the percentage of ownership is also a consideration since some investors may expect to exchange an ownership interest for their funding. In a fully not-for-profit structure, profit maximization is not the stated goal, and so you will need to demonstrate the way your financial expenditures are to be balanced against your earned and unearned income. As investors look for profit in relative percentages in for-profit firms, contributors look for a bottom line that operates in the black, the ability to reinvest within the organization, and a balance between operating and direct expenses. We will cover financial statements in detail in Chapters 12 and 13, but the point of establishing the contents of a business plan is to understand that these are crucial and central elements of it.

To summarize, the *business plan* includes all of the following elements:

1. The *business vision, mission, objectives*, and *development plans*.
2. An overview of the *organizational structure* in which the cultural arts offering will be provided, including a formal or advisory board, profit structure, and investor and/or donor requirements.
3. An *environmental analysis* of the current cultural arts industry trends and expectations that will impinge upon the venture, including the competitive, regulatory, economic, social, and technological environments.
4. *Financial pro forma projections* that set forth the relative risk/return expected from the venture based on costs and pricing for arts service products, as covered in Chapter 4; this financial projection and analysis will be based on earned (sales) and unearned income (grants and donations) and the costs of providing the arts service products. Also, the business plan includes pro forma balance sheets that indicate the ownership assets, such as capital improvements, investments, and endowments, and the liabilities of the firm.
5. A *market strategy, analysis*, and *plan* situated within the context of the business mission, goals, and objectives.
6. The *management structure* that will be utilized that incorporates the strengths and weaknesses of the culturepreneur in seizing the opportunity.
7. An *executive summary* that succinctly explains the business model on one page, and appendices that set forth assumptions and in-depth details that provide reference materials for interested readers.

A business plan can range from a few to many pages, depending on the detail and the nature of the arts offering. The key is to remember that many investors or donors will want to see an overview and be able to refer to details if they have questions. A

good deal of detail can be placed in an appendix if necessary. Now that the opportunity has been assessed and the business plan has been prepared, the next section looks at positioning the offering within the market.

THE MARKETING STRATEGY AND POSITIONING

The marketing strategy is an important and integral component of the overall business plan, and positioning is the most important aspect of marketing. Everything else flows from there. *Positioning* is actively managing where your cultural arts offering resides in the arts consumers' minds, relative to similar arts service products. To clarify positioning, we can use an example from consumer goods. For example, consider soft drinks as a consumer product. Each soft drink constitutes a point on a graph relative to other soft drinks that consumers make comparisons against to determine attributes associated with that soft drink. Every product or service has this *positioning map*, or *perceptual map*, as it is often referred to as. Cars, shoes, houses, computers, phones, arts auction houses, festivals, artists, performing arts companies—all cultural arts service products—have such a map that is formulated in the consumers' mind. A representation of a positioning map is shown in Exhibit 5.3.

Many positioning maps are based on the relative relationships between price and quality. Price is generally a signal of value, though there is the caveat that the buyer

Exhibit 5.3 **Positioning Map of Arts Auction Houses**

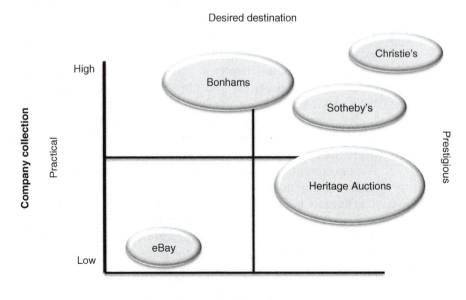

Source: Elizabeth Hill, Catherine O'Sullivan, and Terry O'Sullivan, *Creative Arts Marketing*, 2nd ed. (New York: Butterworth Heinemann, 2003).

needs to beware. However, price and quality are not the singular axes that we can measure and compare arts service products with. The criteria could be trustworthiness and innovation, or transcendent fulfillment and quality, or capturing cultural value and price. Not only are arts service products subject to this kind of mapping, but companies in an industry are as well. Relative examples of companies are hospitals, surgery centers, universities, department stores, computer companies, restaurants, and performing arts venues. Every product or service provider that exists resides within one or more perceptual maps. And the cultural fine arts offerings can be based on the artists, the venue, the company's reputation, the donors, the patina of the art itself, and any number of other considerations. Moreover, it is relatively straightforward to gain access to this kind of comparative information when talking about the arts with consumers.

In general, perceptual and positioning maps are developed from data—qualitative and quantitative, primary and secondary—gathered from surveying or interviewing consumers. The same process can be followed in the cultural fine arts. Ideally, your arts service products will be systematically positioned in the perceptual map during your initial launch and plan. Because of changes in firm strategy or environmental forces, it may be necessary to *reposition* the offering. This entails moving the arts offerings and/or the cultural arts firm or organization from one point to another within the perceptual map.

Where you position depends on the degree to which you expect to differentiate your arts service products relative to the competitors. For example, suppose your arts auction house is being positioned relative to all the arts auction houses in the industry, with quality and prestige as the two measures of arts consumers' perceptions. If you select a location exactly the same as that identified by another company, you will select head-to-head competition. However, if you locate close to one of the firms or in a different location, you will be selecting a differentiation strategy. We will assume that the arts auction houses each constitute a niche of their own, because they are not in any way handling mass-produced goods or services. In this way, you will decide how you will let arts consumers know where you want them to locate your firm, and your arts offerings, relative to others in the industry and other arts service products.

As is evident from the preceding discussion, the decision about where to position your cultural arts offering or how to align your company relative to others has competitive implications. The main point is to be able to differentiate yourself from your competitors in a manner that arts consumers can recognize, based on attributes that will provide a value proposition for them and a competitive advantage for your firm or organization. Of course, this brings up the issue of scale and where in the industry you will fall. In your business mission and plan, you will state clearly if your mission encompasses being a local, national, or international arts organization. In turn, of course, these defining factors will have implications as well. If you continue along the lines of opening a new arts auction house that will necessarily involve an international audience, the expectation is to compete with Sotheby's and Christie's. And what features and benefits that are different from those of existing art auction houses do you anticipate offering to your customers? How can they be quantitatively

and qualitatively explained to an arts consumer? The culturepreneur has to be able to articulate these differences, and arts consumers have to be able to recognize them. This is an integral part of the business plan and often underpins the ultimate success of the venture.

Now that positioning has been determined for your company and your arts offerings, what marketing strategy will you follow to achieve the goals and objectives stated in your business plan? In other words, how will you allocate resources to building, growing, and sustaining your competitive advantage or place in the industry? Will you be interested in growing the client base? Increasing the size of or cultivating the arts audiences for your cultural arts goods and services? Maintaining costs? Producing a certain number of world premieres or newly developed arts service products? Growing the merchandise aspects or the donor and endowment bases? How will you accomplish these ends? Over what period of time? However, the long-term marketing strategy will be concerned with how the external trends will support or impact the market and industry over a period of time, while the internal strengths and weaknesses of the firm are leveraged to position the firm in the market. In general, the use of "the eight *Ps*" of the arts offering—the product, prices, place, promotion, people, physical environment, process, and productivity, as described in Chapter 4—is part of the focus of the process in marketing planning. Know that each of the eight *Ps* will command a portion of your revenues or capital infusions, and the way the resources are allocated toward them should effectively move the company toward realizing the goals and objectives it selects. The objectives and goals that you set in the marketing strategy flow from the business plan, and these then become the guiding lights for pursuing marketing objectives and goals.

MARKET SCOPE AND ENTRY STRATEGIES

What is the best way to enter the market based on the business plan, marketing strategy, and the position you want your firm to occupy in the industry and your products in the market? What is the best way to achieve the marketing goals and objectives that drive the business model? Is your cultural arts offering new? That is, does it represent an innovation that audiences will see as new? Or is it a modification of an existing cultural arts offering that has something different to offer?

A *new entry* means offering a new cultural arts offering to an existing market or providing something new to an untapped market and establishing a firm to take advantage of the new entry over a period of time, with a competitive advantage. In general, arts service products are offered to existing markets or to newly created markets, and you can be the first to the market, following a *first mover* or *pioneer strategy*, or a latecomer to the market, following what is referred to as a *follower strategy*. Pioneers, or first movers, as they are sometimes called, gain an advantage by offering something unique or innovative that has difficulty being reproduced and that is offered often to new markets, in a very particular position within the competitive landscape that offers value to the consumer. The advantages of being a pioneer to a market include being able to define and choose the arts consumer that will be targeted and setting the ground rules for other firms that will enter the

market after you. Successful pioneers expose themselves to the greatest amount of risk, yet at the same time, they take control of the market and establish attractive revenues, income, and profits from arts consumer bases that intrigue or allure other competitors to follow them.

However, being a follower into the market should not be dismissed out of hand because the pioneer paves the way and provides illumination for the pitfalls and mistakes that the follower can capitalize on. With a follower strategy, the culturepreneur enters the market after the product or service has shown promise in pioneering firms or after a failure of a pioneer, demonstrating the potential for the follower to take advantage of marketing opportunities.

Before deciding the entry strategy, it may be useful to look at the scope of your endeavor first. The *scope* of your offering will be related to the risk you are managing, and there are three general ways to control this. You enter the market with either a narrow or a broad range of the market in mind, or you enter with an imitation strategy. All three options have the goal of managing risk, but they do so in different ways.

A narrow scope offers arts service products to a small market, while the broad scope is indicative of working with a large number of markets and with a range of arts offerings to meet wants. The *narrow scope* hopes to limit the arts offerings or mix of arts offerings to a small number and thereby reduce the exposure of risk and rapid competitor attraction. The *broad scope* attempts to diversify the risk across a broad array of arts offerings, with the less stellar arts offerings able to be divested or restructured, while the more attractive and viable offerings can be cultivated.

When implementing an imitation strategy, often referred to as a *me-too* strategy, risk is reduced as well because the business model duplicates an existing one. A familiar type of imitation strategy is a *franchise*, such as Arthur Murray Dance Studio; ceramic arts studios whose customers paint and decorate precrafted "sculpture" utilize a formulaic method of reproducing something already being done in the market. Of course you are familiar with food and consumer goods franchises. Nevertheless, these are ways to conceptualize your approach to entering the market, and they are not meant to be mutually exhaustive, because there may be one aspect of your business plan that would thrive with a narrow scope while other aspects would work well with a broad scope.

You may have in mind the idea of being able to franchise the business at a later date, which will impact your actions. If your business plan anticipates buying a franchise, it may be good for you to understand the scope it will bring with it. A culturepreneur has to be able to be nimble, change with the environment or cause environmental change, and identify the scope as it supports the goals and objectives of the business strategy, even while they are subject to environmental forces. This is why the business plan is so very important, including the ability to access the resources and leverage the skills needed to bring the venture to fruition. It will entail setting out the metrics that define success, allowing culturepreneurs to know when they have met, exceeded, or fallen short of their vision and goals.

Marketing strategy and positioning together form two aspects of the marketing strategy used in the business plan. In order to be clear about the strategy,

culturepreneurs have to understand the product or service life cycle their arts offering is situated in, how those products and services relate to growth and market share, and the stage of adoption that the arts consumers who constitute the organization's target markets are in. In other words, each of the firm's arts offerings has to be evaluated based on the goals of the organization for that arts service product and the resources available to seize upon the marketing objectives. Tools available to conduct these kinds of analyses are given by the Boston Consulting Group Matrix and the Industry Attractiveness Business Position Matrix. Therefore, the next section of the textbook turns to the arts service product life cycle and then to the way to evaluate the organization's arts offerings through market share and growth.

THE ARTS SERVICE PRODUCT LIFE CYCLE

The product or service life cycle explains where an arts offering is in time.[9] The general format of an arts service product life cycle (ASPLC) includes five stages: introduction, growth, shakeout, maturity, and decline. Unless the ASPLC is actively managed over time, products and services are thought to eventually decline. If they do decline, they need to be actively harvested and then exited from the market. This means that in a culturepreneurial organization there needs to be a structured and frequent review of the location of its arts service products relative to the ASPLC, and a strategic assessment of them with respect to market share and market growth.

As shown in Exhibit 5.4, the stages are as follows:

1. In the introduction phase, the new or innovative arts service product is presented to the market when there are few competitors and few arts consumers.

Exhibit 5.4 **A Generalized Arts Service Product Life Cycle**

	Stages of the arts service product life cycle				
	1	2	3	4	5
	Introduction	Growth	Shakeout	Maturity	Decline
Market growth rate	Moderate	High	Level	Insignificant	Negative
Changes in innovation	High	Moderate	Limited	Limited	Limited
Market segments	Few	Few to many	Many to few	Many to few	Few
Competitive intruders	Few	Many	Decreasing	Limited	Few
Revenues and profits	Negative or little	High	Receding	Low to high	Low
Organization's objectives	Stimulate demand	Build share	Build share	Retain share	Harvest
Arts service product	Improve quality	Improve quality	Determine value	Use for future growth	Innovate
Pricing strategies	Test price-skimming or penetration	Yield management	Yield management	Hold prices steady	Reduce with innovation of new arts offerings
Promotion strategies	Selective coverage	Intensive coverage	Intensive coverage	Intensive coverage	Selective coverage
Attention to the remaining 8 *P*s	High	High	High	High to medium	Reduced

Stages of the product life cycle

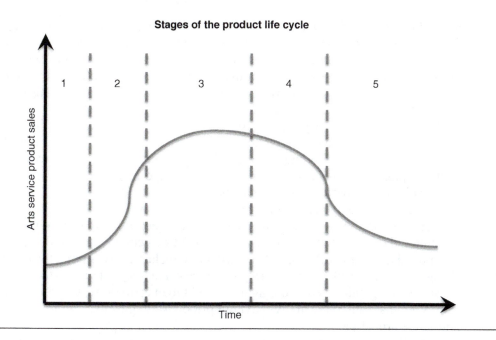

The growth rate and market share are both relatively low. The goal is to create demand and establish the desired position by demonstrating the cultural value of the arts offer and how it will fulfill an arts consumer's want or need.

2. The growth phase sees increases in both the demand for the arts service product and the relative market share for it. Arts consumers have shown interest, and multiple followers may have entered the market, increasing competition for the arts consumer's attention. Culturepreneurial firms are seeking to build their share of the market and keep the arts audiences they have garnered.

3. A shakeout phase occurs as some competitors exit the market because they cannot sustain the revenues needed to continue operations. There is slower expansion of market share, yet the culturepreneur can increase it by offering something unique to existing arts consumers or something that will attract new segments of arts consumers.

4. The maturity stage sees little growth of the market and few new market segments, and only the successful arts organizations remain, retaining the majority of the arts consumers for the arts offering.

5. In decline, the market share begins to evaporate and interest in the arts service product significantly diminishes to the point of needing to be abandoned.

Regarding the decision to take an entry strategy of pioneer or follower, pioneers are able to capitalize on their ability to move into the market, and in doing so they set the rules by which other competitors may enter the market as followers. Pioneers can take advantage of patents and copyrights, pricing strategies, experience

in production and distribution, as well as establishing connections with suppliers. The culmination of these advantages can result in significant barriers to entry for followers, with the added benefit for the pioneer of being extremely successful in the venture. With success, of course, the culturepreneurial firm will attract competitors, as will be shown as it moves into the growth, shakeout, and maturity phases of the ASPLC.

However, all is not rosy with a first mover strategy because essentially the culturepreneur is paving the way while others watch and learn from your mistakes, or learn better ways of providing the arts offering. As such, followers enter the market after the pioneers with less risk and take advantage of the first mover pathways. Many culturepreneurs who anticipate success often see themselves as first movers, but a follower strategy can be extremely lucrative as well.

In each of the phases of the ASPLC, pricing is a factor that must be considered. In Chapter 4, the topic of price elasticity of demand was covered. From that discussion we know that the arts offering is typically price inelastic. Over time, the decision to change prices from the initial offering has to be considered relative to the arts market segments being cultivated. Here again, a yield management software program will help. With that said, there are two overall pricing strategies that can focus the direction of the arts offer.

Price skimming is setting the price high for an arts market that is willing to buy the new arts service product. These are the arts consumers who are typically innovators in a given product or service class. The opposite strategy, *penetration pricing*, is setting prices low, in order to gain market share and attract a large number of arts consumers. This kind of pricing allows the culturepreneur to gather customers, develop their loyalty over time, and pose a barrier for new entrants who follow. Using yield management software will help identify the ways in which the pricing should be applied.

ARTS SERVICE PRODUCT MARKET SHARE AND RELATIVE GROWTH

Up to now, the phrase "market share" has been used to allude to the size of the market an arts organization controls. Simply stated, a firm's market share is the percentage of the overall market that it holds, which can be stated in terms of revenues or numbers of consumers using the product or service. Over time, the pioneer theoretically gains an advantage by garnering half of the market share, with followers gathering 30 percent and late entrants taking the remaining 20 percent. This is depicted graphically in Exhibit 5.5.

To determine the relationships between the relative growth of the market and the relative share the arts organization holds for a given arts offering, the Boston Consulting Group Matrix can be utilized, along with or separately from the Industry Attractiveness Business Position Matrix. In looking at arts consumers and their willingness to adopt a new arts service product, we utilize the diffusion of innovations model.[10] Our discussion will begin with the arts consumer and then move into the analysis of arts service products.

Exhibit 5.5 **Relative Market Share and the ASPLC**

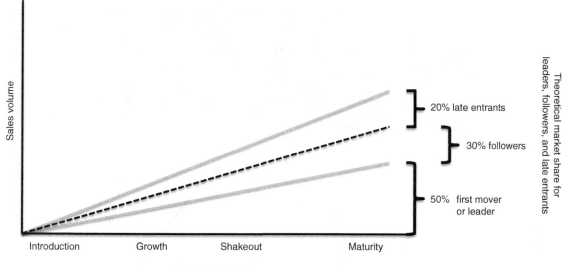

Source: Orville C. Walker Jr. and John W. Mullins, *Marketing Strategy: A Decision-Focused Approach*, 6th ed. (New York: McGraw-Hill/Irwin, 2008).

Diffusion of Innovation

In general, a new arts service product moves through a diffusion process, whereby a new arts offering is adopted by arts consumers. The *diffusion of innovation* process, as it is called, quantifies arts consumers relative to their willingness to be first or last to adopt a product or service; each adopter group has particular characteristics. As Exhibit 5.6 shows, it is clear that assuming the total market available is 100 percent, the model suggests that the market is composed of the following:

- 2.5 percent are innovators
- 13.5 percent are early adopters
- 34 percent are early majority
- 34 percent are late majority
- 16 percent are laggards

The diffusion of innovation process follows the general shape of the ASPLC: the innovators, early adopters, and early majority fall into the introduction, growth, and shakeout phases of the ASPLC, while the late majority comprises the decline phase and the laggards occupy the divesting and harvesting phase. The diffusion model helps the culturepreneur identify the characteristics and behaviors of the arts consumer and can aid in quantifying how many arts consumers are available for the arts offering

Exhibit 5.6 **Diffusion of Innovations Model**

- Innovators are the first individuals to adopt an innovation. Innovators are willing to take risks, have the highest social class, have great financial liquidity, are very social, and have closest contact with scientific sources and interaction with other innovators.
- Early adopters have the highest degree of opinion leadership of the adopter categories. Early adopters have a higher social status, more financial liquidity, and more advanced education and are more socially forward than late adopters.
- Early majority folks adopt an innovation after a significantly longer time than the innovators and early adopters. Members of the early majority tend to be slower in the adoption process, have above-average social status, lack contact with early adopters, and seldom hold positions of opinion leadership in a system.

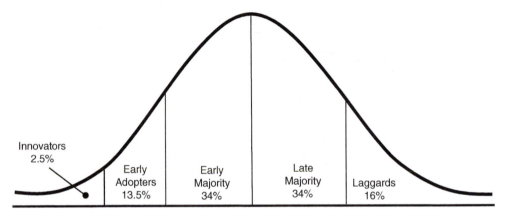

Source: Everett M. Rogers, *Diffusion of Innovations*, 5th ed. (New York: Free Press, 2003).

- Late majority individuals approach an innovation with a high degree of skepticism and adopt it only after most other people have already done so. Members of the late majority have below-average social status, very little financial liquidity, are in contact with others in the late majority and early majority, and have very little opinion leadership.
- Laggards are the last to adopt an innovation. Members in this category show little to no opinion leadership and sometimes have an aversion to change. Laggards tend to be focused on "tradition," to have the lowest social status and the lowest financial liquidity of all adopters, to be the oldest, and to be in contact with only family and close friends.

depending on the location it occupies in the ASPLC. Moreover, the location that arts consumers occupy relative to the diffusion process also implicates them in their willingness to engage in price skimming versus penetration pricing. However, there is one very important issue that needs to be kept in mind in utilizing this analysis to estimate market share. Arts consumers follow an *arts adoption process* that effectively begins by defining the overall market available to culturepreneurs as those who have some exposure and interest in cultural arts consumption. Therefore, it is important to understand that as arts consumers move through this diffusion process, the numbers of individuals in each of the adopter categories has to be measured against their overall exposure to the cultural arts. It is possible to develop new target markets for the cultural arts offering outside of this frame, but doing so may require more resources. Chapter 6 provides a full discussion of arts consumers and the arts adoption process.

Having quantified the market and market share, the next analysis involves examining the relative growth of the market size, the relative growth of the arts organization's share of it, and how you will allocate resources to the arts service products within them. In this textbook, we cover two methods of determining resource allocation in managing the portfolio of arts service products you offer. The first is the Boston Consulting Group Growth Share Matrix, and the second is the Industry Attractiveness Business Position Matrix.

BOSTON CONSULTING GROUP GROWTH SHARE MATRIX

The Boston Consulting Group Growth Share Matrix (BCG Matrix) evaluates the arts organization's offerings by evaluating the rate of the overall growth of the market and the market share that the firm commands. It is divided into four quadrants, with market growth comprising the vertical axis (y) and the relative market share covering the horizontal axis (x). Each quadrant is numbered, beginning with quadrant one in the upper right corner, moving to quadrant two in the upper left, then to quadrant three in the lower left, and finally into quadrant four in the lower right corner. Each of the quadrants houses aspects of the portfolio or business units. Quadrant one comprises Question Marks; the second quadrant houses Stars; the third quadrant contains Cash Cows; and the last quadrant hosts Dogs. Each of the firm's arts service products is placed in its respective quadrant in a numbered circle that indicates the size of the market share the firm holds by the size of the circle; there may be overlap as the arts service product grows. This is shown in Exhibit 5.7. Each numbered circle represents a hypothetical arts offering, and the size of the circle is meant to approximate the sales revenues relative to the other arts offerings of a culturepreneurial organization. It is also possible to relate these to their locations on the ASPLC and the revenue potential related to the diffusion of innovations.

Resources are allocated to the arts service products that are projected to provide the most growth in market share and in the overall market growth rate. As such, Question Marks typically require a lot of cash to push them forward through the introduction phase. Question Marks have not yet proven they will provide the income they promise and so they need cultivation. Stars are arts offerings that are growing market share and within a growing overall marketplace. Resources are needed to keep them moving, but typically they will require relatively less than those in the Question Mark stage. Cash Cows are dreams come true, so it seems. These arts offerings do not require as much resource expenditure to continue to bring in revenues in a stable market. Dogs are arts service products that are in decline, so investing resources in them would make little sense. They are not increasing in market share and the market is no longer growing.

The culturepreneur often begins with an arts offering that can be categorized in a particular way. For example, let us theorize a set of arts offerings in the tangible fine arts primary market, such as sculpture. A culturepreneur can create several types of offerings, such as miniatures, busts, and life-size statues, using a variety of applicable materials. By assessing the market growth and estimating the arts firm's market share for each of these

Exhibit 5.7 **BCG Matrix**

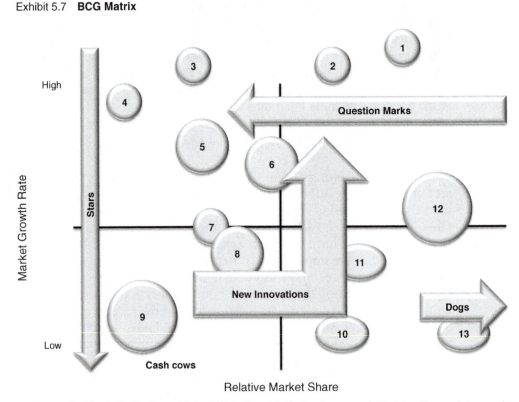

Source: Orville C. Walker Jr. and John W. Mullins, *Marketing Strategy: A Decision-Focused Approach,* 6th ed. (New York: McGraw-Hill Irwin, 2008), 45.

types of arts offerings, the culturepreneur can establish the positions for Stars, Question Marks, Cash Cows, and Dogs. The same process can be used for other cultural fine arts offerings from the firm, depending on its focus (i.e., tangible or intangible).

INDUSTRY ATTRACTIVENESS BUSINESS POSITION MATRIX

Not everyone agrees that the BCG Matrix is the best way to assess the portfolio one holds nor to use it for allocation of resources because the matrix involves a level of subjectivity and environmental analysis that would be too onerous to engage in that would yield measurable decision variables about where to move arts services and products in the marketplace. Another way to go about this chore is to use an Industry Attractiveness Business Position Matrix. The advantage of using this model is that the culturepreneur is allowed the freedom to define factors that are important to the specific market and to determine more specific variables that impact the attractiveness of the industry relative to the cultural fine arts organization's competitive position.[11] The result is an analysis of the firm's ability to compete within attractive industries.

Factors that are available for consideration within the firm include assessing the firm's strengths in several areas. The holding of copyrights, the firm's expertise in

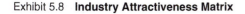

Exhibit 5.8 **Industry Attractiveness Matrix**

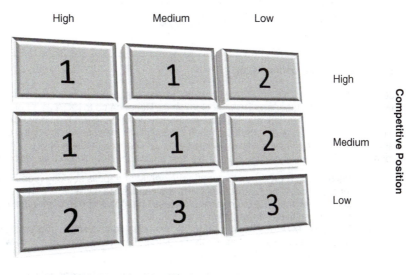

Industry Attractiveness

	High	Medium	Low	
High	1	1	2	
Medium	1	1	2	
Low	2	3	3	

Competitive Position

Factors that are considered as important to:
Competitive Position
- Size, arts consumer base, relative market share, margins, marketing, patents, copyrights, and others

Industry Attractiveness
- Size, growth, barriers to entry, environmental forces, demand, funding, and others

Source: Orville C. Walker Jr. and John W. Mullins, *Marketing Strategy: A Decision-Focused Approach,* 6th ed. (New York: McGraw-Hill Irwin, 2008), 47.

the use of technology, patents, its growth rate, and its arts consumer base can be considered as examples of attributes. Given the selected attributes that the culture-preneur uses to describe the arts firm, the next important step is to ask which of them demonstrates the firm's greatest strength. Ranking them in this way, and also selecting the attributes that the culturepreneur deems as having the most importance and weighting, should be delineated. Using these factors, rankings, and ratings, the culturepreneur next examines how each arts offering in the portfolio compares to the behavior in its industry. The result is a matrix of nine boxes that reflects the arts organization's competitive position relative to the attractiveness of the industry. Arts offerings that are ranked 1 indicate that resources should be allocated; a ranking of 2 suggests that limited investment is needed to maintain the current position, and a 3 indicates that the arts offering should be divested (see Exhibit 5.8).

The model is useful for getting one's arms around the relationship between one's actual arts offerings and the arts industry. Of course, it has to be used as a tool and not a crystal ball because of the way the cultural arts function in the economy and the way that unearned income functions.

As you can see, neither market attractiveness model is perfect, and each has its limits. However, it is prudent to use one or both portfolio models to assess arts offerings and systematically apply resource allocation to their growth and maintenance. The goal is to invest in arts service product offerings that will yield the results that are envisioned in the marketing strategy.

Exhibit 5.9 **Juxtaposition Arts**

Juxtaposition Arts, known as JXTA, is a youth arts education program in Minneapolis, founded and led by culturepreneurs Roger and DeAnna Cummings. Roger came to JXTA as a Loeb Fellow at Harvard's Graduate School of Design, and DeAnna as a graduate of Harvard's Kennedy School of Government. However, perhaps more important than their credentials is their connection to the community. Both Roger and DeAnna know from personal experience how art changes the lives of young people; that is why they founded JXTA. What they envision and how they are guided is shown in their vision and mission:

- Vision—JXTA prepares the youth of North Minneapolis seeking creative work as dynamic innovators and problem solvers with the confidence, skills, and connections they need to accomplish their educational and professional goals and to contribute to the revitalization of the communities where they live and work.
- Mission—JXTA develops community by engaging and employing young urban artists in hands-on education initiatives that create pathways to self-sufficiency while actualizing creative power.

The organization combines design education and youth empowerment with a social-enterprise business model. Students begin with visual-arts literacy training and then take advantage of employment while learning professional design, production, and marketing skills in one of five social-enterprise studios that produce high-quality design products and services for sale to local and national customers.

JXTA leaders and their board of directors believe that integrative problem-solving abilities learned through the hands-on creative process of idea generation, production, and marketing are exactly the skills young people need to succeed in cultural fine arts. Importantly, the founders believe that sustained participation in community-focused creative expression powerfully advances the development of individuals, communities, and places.

The underlying motivations of JXTA include engaging students, and all arts constituents, in the following:

- Affirming the creative potential of each human being
- Emphasizing the importance of discipline, study, and practice
- Respecting the contributions of those who went before us
- Including diverse individuals and groups in relevant ways
- Modeling integrity in individual and organizational leadership
- Demonstrating successful and ethical business practices

JXTA provides an array of artistic entrepreneurial opportunities. One of them is built on the core of the apprentices' training in primary tangible arts production. JXTA's Contemporary Arts Studio produces original canvas paintings and mixed-media works for large and small businesses and individual collectors. Large businesses use the work in offices and work spaces, while supporting the community. The Painting and Drawing Studio is a significant source of innovative art. In addition, the company has relationships with local galleries and art dealers. This more traditional distribution mechanism provides a needed structure for the work of an artist team in the studio rather than relying on work commissioned or requested by a customer.

Importantly, artists from any of the JXTA lab studios facilitate art creation for events. This encompasses a broad range of activities, from hands-on opportunities for the public to artists' demonstrations at fund-raisers. A short film about Juxtaposition Arts is available on YouTube ("Genius Loci: Part 1," YouTube, December 23, 2013, www.youtube.com/watch?v=cgnN8X6RRQ4).

Source: Juxtaposition Arts, "Our vision," http://juxtapositionarts.org/about/our-vision/.

CHAPTER SUMMARY

The culturepreneurial process involves creativity and idea generation, but also it involves assessing opportunities. For those that seem viable, a full-on business plan needs to be developed that charts the strategy, the course, the goals and objectives, defines the product or service succinctly, and points out the market in which the culturepreneur will operate. Here you determine if you are a first mover or a follower, whether the product or service is being introduced, growing, or mature, and exactly how you can bring your skills to bear on the offering of value. A method for measuring success and making adjustments is therefore needed, and it is as pertinent as all other elements of working through the culturepreneurial process.

Knowing ahead of time what the market entry strategy will be is crucial. This gives you a full picture of what the process of offering your product or service will entail. It also requires that you understand the industry and market that you are entering, where the product will be positioned, and its location in the arts service product life cycle. Importantly, by having these clearly determined and supported by a set of financial pro forma financial statements, you will be able to evaluate your progress toward the goals and objectives set out in the business plan. Because very few experiences yield perfection and because everyone has an individual vision of success, using the business plan as a guide as well as a benchmark toward progress is crucial.

If your venture is wildly successful beyond your imagination that will suggest one set of adjustments you will need to make. If your venture does not proceed as planned, then other kinds of changes will be needed. At every point along the way, it is necessary to reassess your skills and experience, so that when course corrections or redirections are warranted, they are easily addressed. Keep in mind as well that the skills needed to launch a product or service through the introduction stage in the product life cycle are usually different from those needed to sustain a product in maturity. Having a strong organizational structure and excellent leadership and delegation skills will be necessary.

DISCUSSION QUESTIONS

1. Explain succinctly the difference between culturepreneurs and entrepreneurs. Define the culturpreneurial creative process. How is that related to the cultural creative process?
2. What is an opportunity? How does one go about assessing an opportunity?
3. Explain the elements of a business plan. How is the business plan different from the opportunity assessment?
4. Is positioning the most important aspect of marketing? Why?
5. Explain the relationship between the arts product service life cycle, the diffusion of innovations, and the BCG Matrix. What information is available to the culturepreneur or arts manager using these tools to evaluate the market relative to the arts organization's offerings?

EXPERIENTIAL EXERCISES

1. Sketch out a business plan for an institute of fine arts. Part of the firm will be for profit and another part will be set up in a nonprofit structure. Make sure you first do an opportunity assessment. Then, set up the business plan and marketing strategy, the goals and objectives, and the scope of the market. Explain who your arts consumers are in detail.

2. Develop a perceptual map for the symphonies in the international market, as well as a perceptual map for art galleries in your city. Use the price and quality relationship to establish the axes to position each of the firms. Suppose you enter the industry of international symphonies within the city you reside in. What kind of market entry strategy would you use? Why? Do the same kind analysis for art galleries in your city.

FURTHER READING

Entrepreneur Media. Starting a business. Entrepreneur.com. www.entrepreneur.com/starting-abusiness/index.html.

Inc. www.inc.com.

Schilling, Mary Kaye. "Get busy: Pharrell's productivity secrets." *Fast Company* 181 (December 2013/January 2014). www.fastcompany.com/magazine/181/december-2013-january-2014.

Undercofler, James. "Defining entrepreneurship in the arts." *State of the Art*, July 11, 2012. www.artsjournal.com/state/2012/07/defining-entrepreneurship-in-the-arts/.

NOTES

1. Veronika Sonsev, "The artist entrepreneur: How technology is transforming the art world," *Forbes*, October 22, 2012.

2. Sara Bannerman, "Crowdfunding culture," *Journal of Mobile Media* 7, no. 1 (2013), 1–30.

3. Jim Hart, "What if . . . artists were trained as entrepreneurs?" *TCG Circle*, www.tcgcircle.org/2011/05/what-if-artists-were-trained-as-entrepreneurs/.

4. Robert D. Hisrich, Michael P. Peters, and Dean A. Shepherd, *Entrepreneurship*, 8th ed. (New York: McGraw-Hill/Irwin, 2010).

5. Ibid., 6.

6. Andrea Hausmann, "German artists between bohemian idealism and entrepreneurial dynamics: Reflections on cultural entrepreneurship and the need for start-up management," *International Journal of Arts Management* 12, no. 2 (2010), 17–29.

7. Michael Haynie and Dean Shepherd, "A measure of adaptive cognition for entrepreneurship research," *Entrepreneurship Theory and Practice* 33, no. 3 (2009), 695–714; Frieda Fayena-Tawil, Aaron Kozbelt, and Lemonia Sitaras, "Think global, act local: A protocol analysis comparison of artists' and nonartists' cognitions, metacognitions, and evaluations while drawing," *Psychology of Aesthetics, Creativity, and the Arts* 5, no. 2 (2011), 135–145; Ap Dijksterhuis and Teun Meurs, "Where creativity resides: The generative power of unconscious thought," *Consciousness and Cognition* 15, no. 1 (2005), 135–146.

8. This definition is adapted from R.P. Singh, "A comment on developing the field of entre-preneurship through the study of opportunity recognition and exploitation," *Academy of Management Review* 26, no. 1 (2001), 10–12.

9. Orville C. Walker Jr. and John W. Mullins, *Marketing Strategy: A Decision-Focused Approach*, 6th ed. (New York: McGraw-Hill Irwin, 2008), 175. Elizabeth Hill, Catherine O'Sullivan, and Terry O'Sullivan, *Creative Arts Marketing*, 2nd ed. (New York: Butterworth Heinemann, 2003), 139, mention the product life cycle as applicable to the arts.

10. Ibid.; Walker and Mullins, *Marketing Strategy*.

11. Walker and Mullins, *Marketing Strategy*, 47.

6 Consumer Behavior in the Cultural Fine Arts

CHAPTER OUTLINE

LEARNING OBJECTIVES

After reading this chapter, you will be able to do the following:

1. Define markets, market segments, and target markets.
2. Identify segmentation strategies for arts markets.
3. Explain important complexities related to consumer behavior influences.
4. Identify the difference between high and low involvement and the impact of motivation on the arts consumptive decision process.
5. Grasp the relationship between the consumptive hierarchy of effects, the diffusion of innovations model, and the adaptations models relative to the arts consumer.
6. Utilize the arts adoption process.
7. Articulate and apply the purchase process in arts products and services.
8. Establish a basis for understanding arts consumer satisfaction.

THE TREASURE HUNT FOR THE WEALTHY

A desire for tangibility and familiarity, coupled with concerns about broader markets, is encouraging more investors to increase the proportion of their wealth that is allocated to art objects that are considered "treasures." Classic cars, precious jewelry, fine art, and antiques fall into this category. Currently, wealthy individuals hold an average of between 10 and 20 percent of their total net worth in treasure assets.

Owners of cultural fine art will seek an average of 62 percent appreciation of value in the year after first owning before they consider selling.[1] This is an example of the endowment effect, whereby individuals will require a price that is much higher when selling an art object than they would be willing to pay for it.

Relatively few wealthy individuals own treasure solely for its financial characteristics. No cultural fine art object, including those considered treasures, is held entirely for financial or emotional reasons, though a good deal of the motivation is emotion. Yet the emotional motivations for wealthy individuals to own treasure are complex. Even so, these can be broadly grouped into three main categories: enjoyment, social, and heritage. The motivations are not mutually exclusive and an arts consumer may own a single item for one, two, or all three categories of motivation. The most important motivation for owning treasure is enjoyment; wealthy arts consumers acquire treasure because of the feelings of pleasure they enjoy. This supports a view that treasure should be regarded as part of an individual's personal holdings (assets that are owned to support lifestyle or enjoyment purposes), rather than as a separate asset class in the investment portfolio. In this categorization, owning treasure supports the social activity of sharing or showing the art to others.

At the same time, some individuals may acquire treasure for its heritage value. These individuals want their heirs to enjoy their treasures for a lifetime as well. Moreover, wealthy arts consumers who acquire treasure theoretically perform a role in society when they lend their works to museums. On the other hand, there is a debate that holding treasure removes capital from productive investment and hurts the overall economy. By investing directly in businesses, it can be argued, wealthy individuals contribute more to society than those with large holdings of valuable treasures.

Regardless of the outcome of the debate about the disposition of capital, when an individual invests in any financial asset, doing so entails both financial and emotional motivations and risks. Someone considering the potential financial returns from investing in a hedge fund may also envision the status that being a sophisticated investor brings, while considering an investment in bonds may provide comfort from their perceived safety. Treasure investments are evaluated similarly, with a bit of a difference: while some individuals may acquire financial investments primarily for financial reasons, a greater proportion of the benefits from treasure investments can be derived from the emotional aspects.

The fact that treasure has such a large emotional component to it means that collectors can be particularly susceptible to behavior biases and heuristics—simplification rules for making decisions. In the art market, a great amount of emotional value is involved. For example, the availability bias is a mental shortcut that consumers use

to draw conclusions from information and examples that are easily accessible, yet doing this can skew decision making, especially in the cultural fine arts. Because reports on art sales focus on returns and hammer prices, arts consumers may get incorrect information and develop beliefs that these are representative of broader trends in the market. Emotional attachment to an object can exacerbate this phenomenon, causing what is known as the affect bias. If you are in a good mood and your attitude toward the art is favorable, you tend to pay more and feel less risk. The previous price paid for a similar item can also have an impact on price expectations in a bias known as anchoring. What this means is that arts consumers "anchor" their estimate of the value of an art work on the previous sale information, or base it on the anchor estimate supported by the auctioneer at the time of sale.

For most wealthy arts consumers, the emotional motivations for holding treasure outweigh the financial. Because it can be enjoyed, shared, and transferred, it confers status. Moreover, it can be an object of respect that defines an individual and a family. With any high-involvement purchase such as treasure, there are biases that influence decision making. However, whenever there is a significant emotional pull, influences can be pronounced. Being aware of these is a critical step in the arts consumer's purchase decision process.

DRAWING LINES AROUND AUDIENCE DEVELOPMENT?

The term "audiences" is meant to encompass all the people who might come into contact with your cultural fine arts offering. This includes your current users and visitors and people attending events and taking part in activities. Importantly, though, the term also includes people who *could* become visitors, attendees, and users in the future. This makes the potential audience extremely large, and therefore it necessarily has to be subject to first segmenting and then targeting groups of people based on numerous criteria.

Development refers to the process of moving the potential audience into particular phases of an arts consumptive category. Audience development encompasses aspects of marketing, education, outreach, and community development, and it often works best when different approaches come together to engage people in different groups. Developing audiences often requires that culturepreneurs and arts managers try new things. It needs everyone's support and buy-in—really from all arts constituents. This is central to the audience development process. Key to any audience development approach, though, is knowing your audience and the value your cultural fine arts service product brings to the audience, and understanding how the two will mesh.

This means not just marketing a finished arts offering but involving audiences, communities, and users in the creative process; understanding fears, attitudes, and preconceived ideas; and presenting opportunities for dialogue and engagement. To invite this kind of participation is best conducted with an ethical communications strategy that builds trust between your cultural fine arts organization and the target markets you hope to engage. The point of using such a strategy allows understanding of diverse audience needs and suggests that cultural fine arts organizations

seek to get involved in consumers' lives and to promote a greater understanding of the world.

Such movement toward audience development has to consider target markets, culturepreneurial objectives, and the notion of embracing diversity and inclusion—at many different levels and within many contexts. At the same time, sensitivity is required, as there can be unintended perceptions about who is included or excluded from particular audiences. Moreover, producing an impression that can be read as stereotypical can be problematic as well. These aims may appear to be in conflict; however, understanding the nuances of audiences is crucial. Careful attention to audience development provides needed longevity and stability for a cultural fine arts organization. Within the process there exist many opportunities for building relationships with the community, serving the larger social good, and providing innovative cultural fine art offerings.

MARKETS, MARKET SEGMENTS, AND TARGET MARKETS

Chapter 5 explained that culturepreneurs provide cultural arts service products that fill an unmet need, or provide them in new ways in order to pursue the fruits perceived in an opportunity supported by a business plan. In this chapter the attention turns to focus on arts consumers. It gives you the necessary tools to understand markets, market segments, and target markets that are comprised of arts consumers. Simultaneously, the behavior of arts consumers when it comes to arts experiences is explained so that marketing to them becomes a process linked to the goals and objectives of the business venture. This chapter relies on the background information provided in Part I of the textbook, as well as on the information given in Chapter 5 in regard to positioning, arts service product life cycles, and management of the arts products and services within the firm. We begin with markets, market segments, and target markets.

MARKETS AND MARKET SEGMENTS

A *market* is comprised of people and firms who are willing, able, and have the desire to buy a product or service to satisfy a need within a relative product or service category. For example, there is a market composed of people who imagine completing a graduate degree. This universe of people that constitutes the market for graduate degrees is probably extremely large. A subset of them may be willing, able, and have the desire to complete a degree. Yet the market is somewhat heterogeneous when examined at this broad level. Therefore, it is necessary to *segment the market* into smaller groups first before expending resources to attract them to your university. Having delineated the market segments that will respond to your offering favorably, the *target market* is comprised of people who exhibit specified characteristics and are likely to seek enrollment within the near future so that the objectives and goals of the university are met. For instance, one market segment could comprise parents of newborns who are themselves holders of graduate degrees. Those young parents will have a different set of criteria and motivations for approaching university graduate school than prospective students in the market segment who are thinking about

continuing or expanding their education. The latter may be the target market of primary concern, while the former may constitute a secondary target market.

There are markets for cultural fine arts, popular art, performing art, festivals, and museums, for example, and markets for more specifically combined presentations of these and other bundled arts services and products. For the tangible fine arts, markets include those for painting and sculpture, and for the intangible fine arts, they include musical offerings, dance, and theater productions. In many cases, the market can be viewed from an international perspective on the one hand and through a very local lens on the other. The main issue with a market is reaching the consumers, those who constitute the market. To achieve this we *segment the market*, which is a process that allows the provider of the goods and service to group the buyers into segments that have similar characteristics. While there is some controversy about who is excluded in the process of market segmentation, and care must be taken when selecting communication for various market segments, the process is meant in an overarching manner, to bring your product or service to a group of consumers so that they decide to try it, experience it, favorably tell people about it, and remain loyal to your arts company, as demonstrated by their repeat engagements with your arts offerings.

TARGET MARKETS

After the market segments have been defined, the next step is to determine the target markets. The way to this end is to estimate the relative size and successful outcome anticipated in each segment. These estimates will be based on the business goals identified in the business plan. Once each market segment has a quantifiable basis, then each is prioritized. Continuing with our example about university graduate education, it may be that the segment of parents with toddlers will provide a large influx of students, but not for a number of years, while the adults who are looking to supplement their education will yield less revenue and profit now, but will lead to achieving the strategic direction. These two segments will be prioritized, with the toddlers' parents comprising a *secondary market* and the adults returning to university graduate school being *primary markets*. They both will be target markets, however; *target markets* are the quantifiable groups of consumers that you are going to focus resource allocation on, providing one or more of your goods and services to, at a certain industry and market position, within a given time horizon. Target markets are developed with the strategic directions in mind and based on the ASPLC, the diffusion of innovations model, and the relative growth expected, as was covered in Chapter 5. To illustrate, we can continue with the example of graduate school. A primary graduate school target market may be very responsive to enrolling in a master's or doctoral degree program in fashion design, arts management, or creative writing, but may be less so in a program in information technology. Therefore, within a primary target market, further refinement and prioritizing may be warranted. The resource allocation will be based on the likelihood of reaching that target market and having it favorably respond to your message and purchase your offering. This does not mean that the toddler market is forgotten; it means that the primary target markets are clear, more homogeneous in terms of responsiveness

Exhibit 6.1 **Market Segment and Target Market Matrix**

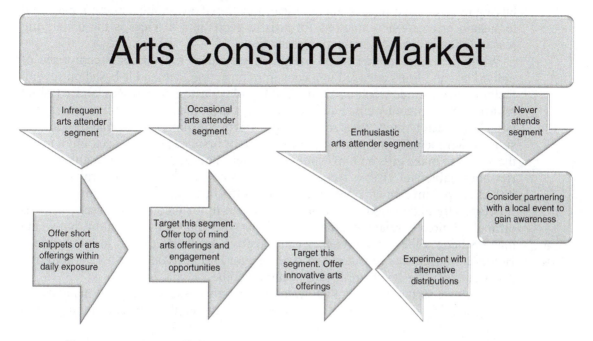

to the offering, with the secondary target market directions mapped out and relative resource allocations made.

A market segment and target market matrix is helpful in visualizing the market segments you will target and the offerings you will provide in the way of arts products and services. Exhibit 6.1 illustrates the primary and secondary markets.

Now that the distinctions between markets, market segments, and target markets are clear, we turn to an examination of some of the strategies used for segmenting arts markets. In the next section, demographic, psychographic, geographic, and other market segmentations methods are discussed and illustrated.

SEGMENTATION STRATEGIES FOR ARTS MARKETS

Previously, in Chapter 4, it was noted that artists have different motivations for producing their work, ranging from economic to cultural value or, more likely, a combination of the two. In proportion, their motivation is guided by a certain type of utility they derive from working in their chosen artistic fields. As a culturepreneur, we noted that artists are motivated by bringing together a series of talents and skills in an innovative way to create cultural value, which is demonstrated by arts consumers' willingness to buy the arts service product. At the same time, it was pointed out that the demand function for the tangible cultural fine arts differed from that of the intangible cultural fine arts. Therefore, this section does not attempt commentary or judgment on whether or not an artist is making products and designing artistic services for a market because it is the arts consumer who ultimately purchases what the

artist develops. Understanding why consumers buy and how to manage to keep them buying to fulfill their needs—hierarchical, functional, symbolic, or emotional—and to sustain or create new markets for artistic goods and services is the underlying reason for employing segmentation strategies.

While the target market for primary and secondary art objects is comprised of individuals and firms engaged in a consumption action, demand is based on several factors. They include wealth, risk, desired liquidity, tastes, preferences, and a desired return on investment by either an individual or a firm. Indeed, these kinds of acquisitions have been termed "treasure holdings."[2] Arts consumers in the market for treasure, which includes the primary and secondary fine arts objects, seek enjoyment, the ability to make gifts and investments for their family, and making wealth categories both stable and visible. Acquisition therefore has much more intertwined with it than simple investment. While it is often difficult to quantify the term "wealth," it is typically understood as having a large quantity of income and assets, yet it is difficult to directly relate income to social classes.[3] Bill Gates is wealthy, but so are many Silicon Valley entrepreneurs with positive net worth (assets less liabilities). However, individuals in Gates's income category outpace others who are entrepreneurs or executive-level employees of high income.

Therefore, suffice it to say that "wealthy" means possessing a great many assets and generating one's income from investments rather than by exchanging one's labor for pay.

The treasure market for these kinds of fine cultural art objects, therefore, is not only derived and defined by treasure hunting, but also based on the theory of asset demand. One of the main demographic variables for segmenting this market depends upon social class as well as wealth, because the target market has to have the willingness, ability, and desire to consume your arts offering. Later in the chapter, demographics and psychographics explain these terms more precisely; however, it is probably fair to heed caution when approaching the topic of treasure hunters. The communications expectations are highly sensitive.

In any event, with the arts consumer's needs in mind, there are many ways to segment and create target markets of art audiences and consumers. Indeed, according to the U.S. Bureau of Economic Analysis, in 2009, U.S. consumers spent nearly $15 million on performing arts and another $6 million for museums and library attendance.[4] Moreover, between 2000 and 2005, spending by U.S. audiences increased 15 percent, from $80.8 billion to $103.1 billion when adjusted for inflation.[5] This trend also is seen in the United Kingdom,[6] Southeast Asia, and other developed countries.[7] While there was a downturn in arts audience participation as a result of the 2007 economic crisis and the use of electronic distribution during this period of time,[8] these data demonstrate that the arts market trend in noncrisis economic times is very much both international and local, as well as lucrative and growing.

As such, it is important to segment markets. Markets can be segmented according to demographic, geographic, or psychographic data or according to behavior and occasion, and also by combinations of these methods, or mixed strategies, as depicted in Exhibit 6.2. Once the segments are identified, then, as stated earlier, each can be targeted, based on the goals and objectives of the arts organization. Each strategy will be covered in the following subsections.

Exhibit 6.2 **Segmentation Variables**

Nature of segmentation	Segmentation variables	Example
Demographic	Gender, age, race, ethnicity, household size, marital status, income, education, occupation	Male, 29, Native American, married, with no children, software engineer, college graduate
Geographic	Region, city, state, zip code, metropolitan statistical area	Southeastern New Mexico, census tract number, urban
Psychographic	Personality, VALS, lifestyle	Innovator, extroverted
Behavioral	Virtual user, user frequency, user status	Prefers online interaction, enthusiastic and loyal arts consumer

Source: Roger Kerin, Steven Hartley, and William Rudelius, *Marketing*, 10th ed. (New York: McGraw-Hill/Irwin, 2010).

DEMOGRAPHICS IN SEGMENTING THE ARTS AUDIENCES

One method used to target audiences is by working with selected *demographic variables*, such as gender, age, income, education, occupation, and marital status. It is easier to target those who have been exposed to the arts or who have a clear set of preferences and tastes for the cultural arts, as it has been argued that influencing trial later in life is a bit daunting and requires a good deal of resource allocation within the marketing function.[9] Leaving this point about converting consumers into arts audiences later in life aside for the moment, consider the demographic variables of arts audiences. In general, across the United States, Canada, Australia, and Europe, women are generally more frequent attenders of fine arts events, as are people who are between thirty and sixty-five years old, who are educated with some college (those who have completed university education beyond college attending more), who are in professional occupations with incomes ranging between $75,000 and $100,000 per year, and who are married. Nearly 70 percent of the attenders are Caucasian and non-Hispanic.[10] In terms of cultural arts participation in electronic form, the overall trend shows a decline in participation in arts events that are media-driven for all demographic groups: although "rates of arts participation through live attendance remained relatively stable between the 1982 and 2002 SPPA [Surveys of Public Participation in the Arts] while rates of arts participation through electronic media declined substantially. This trend was observed despite the increase in accessibility of electronic media between 1982 and 2002."[11] The exact demographic segmentation variables used will depend on the goals of your marketing strategy and the resources available for this purpose.

GEOGRAPHIC SEGMENTING

Geographic segmenting looks at consumers in their physical locations of work and home. Here we look at the local area to assess those who are likely to be attenders. In addition, a geographic area can help define tourist-based target audiences that may travel to the area for a variety of reasons and would like to experience the arts. There are several ways to explore and evaluate a geographic area.

In the United States, begin by looking at your metropolitan statistical area (MSA) as defined by the U.S. Census Bureau. You can thus gather information on the shifts and changes that are occurring in the population within the area, including race, age, and gender information.[12] Based on the people you want to target, this kind of segmenting can be a valuable asset in quantifying the audience you serve, providing secondary data in the estimated size of the arts consumer population, and identifying the possible effect of tourism on the area. Another way to examine geographic areas is by determining the type of area being served, as, for example, city size and type. Is the area urban or rural? Suburban? Industrial? The answers to these kinds of questions will guide your segmenting. For example, if an area is industrial, it means that people are working there who may enjoy an arts event during a business meeting or on a company retreat. While the arts attenders targeted here may live outside the area, they may constitute a unique and very motivated audience. It is also possible that with exposure to your arts offering in a unique fashion, they will utilize word of mouth to increase the arts organization's visibility and reach.

The geographic segmentation variables suggests the concept of a designated market area (DMA) that is reachable through media channels such as television, print, Internet, and outdoor distribution. Often, information about audience behavior in these DMAs is available from Nielsen Media Research. Although these are macro-level approaches to segmenting markets, one can drill down and segment within a region, statistical area, or DMA, for example, by zip code.

PSYCHOGRAPHIC SEGMENTATION

Looking at the market at demographic and geographic levels provides a categorical method for grouping audiences based on tactile kinds of assessments—where they live, what their occupations are, and what their income, gender, and marital status is. Combining such categories with information about how arts consumers within them think and act forms yet another way to approach and refine segmentation. It is thought that individuals who live and work in an area or who have other characteristics in common will be of similar lifestyles. What is a lifestyle? It is the way in which a person or a group lives. More specifically, it is "the habits, attitudes, tastes, moral standards, economic level, etc., that together constitute the mode of living of an individual or group."[13] Psychographic segmentation is developed by study of people's interests, activities, and opinions—called IAO. In addition, we look at personality in this kind of analysis. Because of the kind of understanding it yields, psychographics can be instrumental in segmenting cultural arts markets because of its ability to develop a profile of the arts consumer in different categories of arts object acquisition and interest.

One very dynamic approach to psychographic segmenting is through values, attitudes, and lifestyles, or what is called VALS™. The system, developed by SRI International, is currently owned and operated by Strategic Business Insights. VALS includes two broad consumer characteristics: (1) the motivation to consume products and services, and (2) the consumer's available resources. These two overarching dimensions form the basis for the underlying eight segments that then range

from Innovators to Survivors. Within each of three primary motivations of ideals, achievements, and self-expression, there is a high resource and low resource group. These consumer groups, which are shown in Exhibits 6.3 and 6.4, can also be accessed at the VALS website.[14]

Behavior- and Occasion-Based Segmentation

This kind of segmentation includes product and service features, as well as the way and the rate at which the product or service is consumed. Different features and consumption rates will be given for different arts offerings. You can imagine that there will be a different behavioral segmentation for an annual performance of *The Nutcracker*

Exhibit 6.3 **U.S. VALS™ Framework**

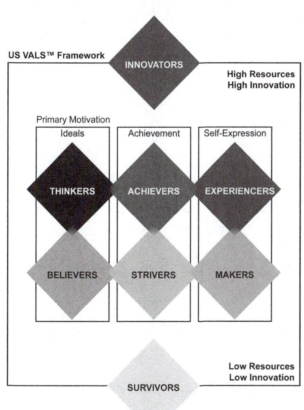

Source: Strategic Business Insights, "US Framework and VALS™ Types," www.strategicbusinessinsights.com/vals/ustypes.shtml. Copyright © 2013 by Strategic Business Insights. All rights reserved.

Exhibit 6.4 **U.S. VALS™ Table: Demographic and Behavior Snapshots Highlighting the Vibrancy of Using VALS™**

Primary Motivation	Innovators	Ideals		Achievement		Self-expression		Survivors
Psychological Descriptors	Sophisticated In charge Curious Percent of innovators	Thinkers Informed Reflective Content Percent of thinkers	Believers Literal Loyal Moralistic Percent of believers	Achievers Goal-oriented Brand conscious Conventional Percent of achievers	Strivers Contemporary Imitative Style conscious Percent of strivers	Experiencers Trend-seeking Impulsive Variety-seeking Percent of experiencers	Makers Responsible Practical Self-sufficient Percent of makers	Nostalgic Constrained Cautious Percent of survivors
Total U.S.	**10**	**11.3**	**16.5**	**14**	**11.5**	**12.7**	**11.8**	**12**
Median age	47	58	53	41	30	24	48	69
Married	62	73	62	70	32	20	64	45
Work full-time	67	52	40	65	45	42	56	13
Own a tablet or e-reader	36	25	9	19	6	14	7	4
Contributed to environmental organization in past year	20	11	2	4	2	3	4	1
Own a dog	39	40	43	52	44	41	57	38
Bought new or different automobile insurance policy in past year	17	16	16	18	15	16	22	14
Buy food labeled natural or organic	24	15	8	10	4	9	8	4
Used hair color at home to cover gray	7	11	15	9	2	1	9	11
Media trusted the most:								
TV	11	25	43	26	38	24	33	54
Radio	15	11	7	7	7	6	12	11
Internet	42	30	21	35	32	48	26	4
Magazines	10	9	7	7	4	3	7	5
Newspapers	23	25	23	24	18	19	22	24

Source: VALS™/Gfk MRI Spring 2012; from Strategic Business Insights, "US Framework and VALS™ Types," www.strategicbusinessinsights.com/vals/ustypes.shtml.

versus a contemporary ballet that is newly choreographed by an unknown choreographer. In the first example, most consumers will expect a holiday performance and familiar music, and in the second, a new ballet during a different time of the year. Another example is a "pops" concert versus a symphony orchestra's presentation of a concert containing only Romantic period music. A pops concert is sometimes associated with spring and summer holidays or memorials and is often held in a less formal location than a concert hall, such as an open-air venue, while the symphony orchestra presentation of Romantic period music will likely be given in a theater or performing arts center. This, of course, is not a definitive rule, but a way to understand the differences in the features and the frequency of intangible art performances. Other arts events and objects can be consumed for different occasions, such as celebrations and social markers, such as romantic dates, or for galas, fund-raisers, and so on.

MIXED SEGMENTATION STRATEGIES IN ARTS MARKETS

In the previous subsections, various segmentation strategies were presented. However, caution should be exercised in drawing clear lines and boundaries around segmentation bases and variables. In reality, segmenting in order to formulate target markets comprises several of the methods presented, to yield a mixed segmentation strategy. The reason is that segmentation is a way to group individuals who have enough in common so that when products and services are provided, consumers will respond favorably toward them and be able to engage with and then act on communications. It may well be that the target audience for a particular arts object will be Strivers who live in a MSA and who are unmarried men, while another target—for the same or a different arts object or offer provided by your organization—may be Experiencers in the same MSA who are in committed relationships. The point is that the tools available allow for a very refined segmentation strategy to precisely target markets. After having determined your cultural arts products and services and identifying market segments, positioning your offer, and then arranging to target the most relevant ones, you will then be able to consider an approach to communicating what you offer and how what you offer fulfills the target markets' needs. But how do consumers decide to purchase? What motivates them? How do they make choices and determine the risks associated with consumption of an arts object or offering? Selecting target markets is only part of the process. One must understand consumers and their behaviors as well.

KNOWING AND UNDERSTANDING THE ARTS CONSUMER

Consumers are complex, and the decision to purchase a product or service can be made through an array of painstaking evaluations or based on an impulse. Indeed, consumer behavior has been the source of study for many researchers. With this view of the vastness of consumer behavior research in mind, we will discuss six broad categories that underlie an understanding of consumers. Of course, this is not an exhaustive list, and like many of the subject materials covered in arts management, extensive study is available in the field of consumer behavior. However, it is important to understand aspects of it so that the presentation of the arts service

product will meet the needs of the target audience. Here, our coverage includes consumer (1) attitudes; (2) involvement; (3) motivation, ability, and opportunity; (4) the hierarchy of arts consumption; (5) central and peripheral routes to persuasion; and (6) early outreach. The point is to allow for an understanding of arts consumers, to formulate both arts offerings and objects, and eventually to develop a basis for communication with respective target audiences, to meet business and marketing strategies and objectives.[15]

ATTITUDES

Attitudes can be formed for nearly anything. From brands to advertisements to venue locations and artists, consumers form attitudes about them. Simply stated, *attitudes* are predispositions to think about or respond to something in a certain way; they include feelings and evaluations about objects, and they are learned and reinforced by exposure and experience. As you can imagine, attitudes can be enduring and difficult to change, and this is one reason that early outreach in targeting arts audiences is important so that positive attitudes can be formed at an early age. Some attitudes are positive and some are negative, and generally it is desirable to have consumers have a positive attitude toward your company, brand, offering, and position in the market. A positive attitude can be related to loyalty, purchase, and favorable word-of-mouth discussions about an offering.

Importantly, attitudes can be measured, quantified, and changed. This is accomplished by examining arts consumers' beliefs and the influences others have on their beliefs. One way to assess attitudes includes an application of a *multi-attribute model* developed by Martin Fishbein and Icek Ajzen,[16] adapted for this purpose. Using such a model allows an understanding of consumers' beliefs and attitudes toward particular attributes relative to an object. The model quantifies attitude toward an object, *A*, as the sum of beliefs, *B*, on a set of specifically measured attributes (*n*), multiplied by the consumer's evaluation of the importance of the salient attributes, *I*. The equation is given in Exhibit 6.5.

There is another attitude model designated as an *expectancy-value approach* that incorporates these measures but also includes a factor to take into consideration what others will think, a relationship to attitudes and behavior called a subjective norm. This model has been called the *theory of reasoned action*[17] because trying to

Exhibit 6.5 **Multi-Attribute Measures of Attitudes**

$$A_{(Object)} = \sum_{(i...n)} \left\{ (B_i)(E_i) \right\}$$

where

$A_{(object)}$	represents the attitude object
n	= number of attributes being evaluated
B	= the consumer's beliefs about the attributes
E	= the importance of the attribute to the consumer

Source: Wayne D. Hoyer and Deborah J. MacInnis, *Consumer Behavior*, 5th ed. (Mason, OH: Cengage Learning, 2010), 129–130.

Exhibit 6.6 **Theory of Reasoned Action and Planned Behavior**

Theory of Reasoned Action

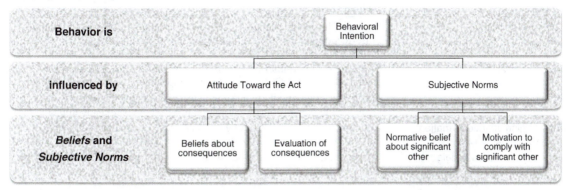

Theory of Planned Behavior

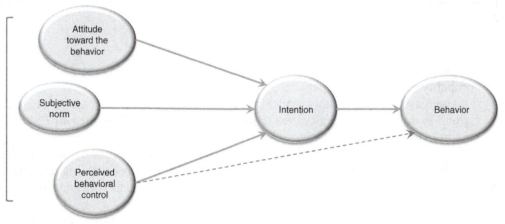

Sources: Icek Ajzen, "The theory of planned behavior," *Organizational Behavior and Human Decision Processes* 50 (1991), 179–211; Wayne D. Hoyer and Deborah J. MacInnis, *Consumer Behavior*, 5th ed. (Mason, OH: Cengage Learning, 2010).

predict what a consumer would do as well as assessing the consumer's attitude is important in targeting the audience. These relationships are shown in Exhibit 6.6.

From this model, we see that a person's attitude toward an action as well as subjective norms comes from the person's beliefs and evaluations of the consequences of taking the action, as well as beliefs about what people who are significant to the consumer think and the desire to comply with the influential person. For example, suppose an arts consumer has a positive attitude about attending the opera. At the same time, perhaps, her relationship partner dislikes the opera and believes that people who attend the opera are wasting time. The opera aficionado may have some motivation to comply with her relationship partner, and if that motivation is strong, it will exert a considerable influence on her behavioral intention and actual behavior.

Exhibit 6.7 **Attitude Change Strategies**

Focus on:	So that:
Changing beliefs	Change what consumers associate with the consequences of acquiring or participating in a cultural fine arts offering, by increasing the positive consequences and decreasing the belief in negative consequences
Changing evaluations	Change how consumers evaluate the consequences of acquiring or participating in a cultural fine arts offering
Adding new beliefs	Add a new belief about an attribute of the arts offering that will positively influence the overall consumer attitude toward the cultural fine arts offering
Encouraging attitude formation based on imagination	Change consumers' attitudes by engaging them in visualizing the impact that the cultural fine arts offering will have on them in positive consequences
Targeting normative beliefs	Change negative beliefs about what significant others will think about the arts consumer

Source: Wayne D. Hoyer and Deborah J. MacInnis, *Consumer Behavior*, 5th ed. (Mason, OH: Cengage Learning, 2010), 129–130.

If it weighs more heavily than the attitude component, then the opera aficionado will probably not attend the opera.

The reason we utilize this model in measuring attitudes is not only to gauge them, which is done through calculations using scaled questions applied in Exhibit 6.5, but also to find ways to change them. Attitude change strategies include changing the aspects of the model which drive the structure of attitudes themselves. There are five ways to do this and they center on changing beliefs or adding and changing attributes that are more important to influence behavior and to understand behavioral intent. These are given in Exhibit 6.7.

Attitude change strategies focus on changing beliefs, evaluations, and experiences relative to the attributes consumers determine are salient. With regard to changing beliefs, it is important to focus on consequences that target audiences believe will result from consuming an arts object or experience. This can be approached by minimizing consequences of attending or purchasing or maximizing the negative consequences of *not* attending or purchasing—in other words, lowering the social risk and the perceived consequences or heightening the benefit received from consuming. Another alternative is to add a new belief about existing or new attributes that will offset or realign the consumer's individual and normative beliefs regarding the consequences. Either simultaneously or differently, focusing on how significant others will think about the consumer can be addressed by showing it is not important or by demonstrating that the significant other will be more favorable toward the consumer should he purchase an arts object or attend an arts event. It is also possible to change how consumers compare arts objects relative to others. For example, the non-opera aficionado may rate opera lower than symphony orchestra performances of popular and classical music. If that consumer can be convinced that opera is at least on a par with a pops concert, then this negative attitude about opera is likely to change.

INVOLVEMENT

Attitudes alone do not explain the whole of consumers and their behaviors. Involvement plays a key role as well. When consumers are involved, it means they are mentally engaged with the decision process; this can be called *high involvement*. On the other hand, *low involvement* does not require as much cognitive processing in formulating a decision, relying more on emotion.

Levels of involvement are related to areas of perceived risk; the higher the risk, typically the higher the involvement one has in the purchase and decision process. Risks are varied, and they are related to each consumer situation and to the actual purchase. Risks are associated with uncertainty; therefore, consumers facing high risk are likely to engage in more research and information gathering before a purchase.

There are five kinds of perceived risks—financial and economic, social, psychological, functional, and time-related—which contribute to the degree of involvement for a consumer.

Of the five main types of risk, most would agree that the first type, *financial* and *economic* risk, causes consumers to become more involved. It is easier to purchase a relatively inexpensive ticket to an afternoon tour of local art galleries than to purchase an expensive ticket to an international travel arts tour without gathering significant information. This is not to say that someone would not do the latter, but rather it is not typical. In the arts, the financial and economic risk also spreads to patrons and philanthropists, grants funders, and other investors, who as individuals have to weigh the economic risk associated with placing resources in a given arts context. These situations of purchasing expensive arts experiences and contributing sizable funds for the cultural arts constitute high-involvement decisions.

A second type of risk includes what is known as *social risk*—that is, what other people will conclude about the consumer who makes a particular purchase. This is somewhat related to the subjective norm aspect of behavioral intention in the theory of reasoned action. The higher the risk that the action will cause social embarrassment, the lower the likelihood that the purchase will be made by the consumer. If you have concluded that this risk is closely associated with consumption that will be visible by others, that is correct. Social risk is particularly important in the event that people will see the purchase and associate it with the consumer. At the same time, the action of consuming an arts object can be seen as socially valuable and distinguishing, for example, if the motivation to consume is based on social hierarchy, as will be discussed in the next section.

Psychological risk is yet another aspect to consider in high-involvement purchase decisions because it affects the consumer's self-perception. What will be the effect on consumers should they attend an arts event or consume an arts object? Some would be offended by depictions of nudity, grotesqueness, or historical renditions of pain. Others would be unhappy with religious or savage images. Psychological risk comes from consumers' belief about how they will relate personally to the arts event or object, and most will attempt to reduce this kind of risk and therefore exhibit higher levels of involvement prior to purchase.

Another type of risk to consider is *functional*. Here the risk is related to the way the product or service fulfills its intended purpose or meets the consumer's expectations. In a services frame, considerable work is done by organizations to reduce this gap between what consumers expect and what they actually receive, by providing information about the arts object or event before consumption. Critical review, word of mouth, press coverage, snippets of showings, and so on can help reduce functional risk.

The final risk that must be considered in the arts frame is that of *time*. How much time will it take to travel to and from the arts event or receive the arts object? For the intangible arts, consumers may be concerned with the length of the performance. If buying tickets, how long will it take to receive them by post or pick them up at the box office Will Call Window? Because of the time risk, consumers will try to gather information to minimize their risk of not having enough time for the purchase.

To summarize, the five kinds of perceived risks all contribute to the degree of involvement for a consumer. The risk varies depending on the particular situation of each arts consumer. However, consideration for risks in connection with involvement is only one aspect of consumer behavior. Motivation, ability, and opportunity, as well as the hierarchy of arts consumption, also play a significant role in involvement.

MOTIVATION, ABILITY, AND OPPORTUNITY

How driven are consumers to take an action? What goals do they expect to achieve, or which need will be met if they make a given purchase? How willing are they to learn about the arts offering? What are the consequences of taking or not taking an action? These kinds of questions underlie the notion of *motivation*, which can be thought of as the degree to which a consumer is driven to solve a problem or achieve a goal in fulfillment of a need. Motivation is connected to the level of involvement the arts consumer has in the purchase process, in terms of buying, acquiring, disposing of, or participating in arts-related activities, products, and services. High-involvement purchases are usually related to a higher level of motivation than the opposite situation, and this is why risks, costs, and benefits have to be taken into consideration. When risks are high, motivation to understand if the offering will meet a need or fulfill a goal is strong, and therefore consumers are more involved in gathering information before purchase. On the other hand, when risk is low, there is less attention given to the information-gathering aspect, and there is generally less pressure to be certain that the consumption action will meet the needs being considered.

Risk associated with high involvement can be mitigated not only with information but with experience. What may be a high-involvement situation, with extreme motivation for one arts consumer, may constitute low involvement and low motivation processes for another. Take, for example, an individual who has experience with purchasing art at an auction, and one who has no experience with the process. The veteran collector will have motivation with experience, so that the degree of involvement may not be as high as for the novice collector, who has an accumulation of social, financial and economic, and psychological risks—or uncertainty. Therefore, novices will be highly motivated to engage in the consumption process to achieve their goals and meet their needs, which could range from making a good financial investment to

creating or reinforcing someone else's perception of their social standing. With this in mind, we can say that arts consumers are motivated when they understand the situation as having *personal relevance* to them and when the decision is in line with their values, attitudes, and lifestyles. Therefore, it is very important—crucial—to understand what motivates the arts consumer into purchase decisions.

Assuming the consumer has the motivation to act, the next important aspect of consumption is considered to be ability, and with it, two dominating aspects. First, what resources are available to the consumer and to what degree? Second, how is the consumer poised to cognitively process information? Does she have experience with the kinds of purchases and outcomes likely in this situation that provides her with a background from which to operate? As such, when talking about *ability*, the discussion centers on the consumer's overall picture to actually purchase an arts product or service. To develop such a picture of the target audience, it is wise to take an assessment based on segmentation variables, such as psychographic and geographic characterizations. Based on the way the arts consumer has been defined, it will be instrumental to then assess the level of experience with arts objects and services that consumers have. A good way to do this is by using a hierarchy of arts consumption experience, which categorizes consumers as arts adopters over a continuum from inexperienced to experienced. This is depicted in Exhibit 6.8 and discussed in the next section.

Exhibit 6.8 **Phases in the Arts Adoption Process**

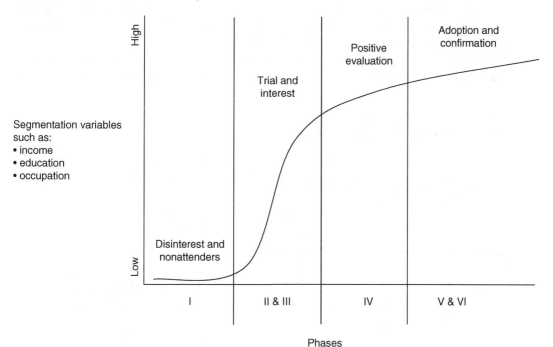

Source: Carla Stalling Huntington, "Reevaluating segmentation practices and public policy in classical performing arts marketing: A macro approach," *Journal of Arts Management, Law, and Society* 37, no. 2 (2007), 127–141.

Hierarchy of Arts Consumption

In order to understand the hierarchy of arts consumption, it is necessary to understand a broader framework of (1) the hierarchy of effects, and (2) the diffusion and adoption process that was covered in Chapter 5. Under the hierarchy of effects, the concern is with understanding the stages a consumer passes through to fully adopt a product or service. The term "adopt" refers to the action of a consumer who has tried the product or service, is experienced, and has become a loyal repeat purchaser. However, to arrive at that level of comfort with a product or service, especially one that is new, and depending on the level of involvement, consumers have to be made aware of the offer. After that, they have to be motivated to evaluate the product or service to determine if it will meet their needs, goals, and self-concept. If consumers determine this to be the case, they try the product or service, and if it meets their needs and expectations, they will adopt it. The key is knowing where the consumer is within this process so that when the market is targeted, the response to your messages and communications will be effective. The hierarchy of effects model for both low- and high-involvement scenarios is shown in Exhibit 6.9.

Diffusion of Innovation

What motivates a consumer to try a new product or service? According to the diffusion of innovation concept presented in Chapter 5, the rate of adoption of a product or service is based on a set of behaviors falling within a range of particular adopter classifications.[18] As was depicted in Exhibit 5.6, broad classifications include innovators, early adopters, early majority, late majority, and laggards.

In addition, the relative percentages of individuals are quantified for each category of adopter over the period of time the innovation moves through the marketplace. The

Exhibit 6.9 **The Hierarchy of Effects Model**

High involvement requires more information and research before attitude formation

| Awareness | Information/Research | Attitude Formation | Trial | Adoption |

Low involvement requires trial before attitude formation

| Awareness | Trial | Attitude Formation | Adoption |

Sources: Roger Kerin, Steven Hartley, and William Rudelius, *Marketing*, 10th ed. (New York: McGraw-Hill/Irwin, 2010); Wayne D. Hoyer and Deborah J. MacInnis, *Consumer Behavior*, 5th ed. (Mason, OH: Cengage Learning, 2010).

usefulness of this tool is to explain that some consumers are eager and quick to enter the market when a product or service is made available, while some are slower to enter. The rate of entry into a market by these kinds of consumers affects not only the target market but the positioning and pricing strategy the organization would follow.

How are the hierarchy of effects and the adoption of innovations related to the arts consumption process? Arts consumption is a result of a behavioral change demarcated by stages of an adoption process, which combines the diffusion of innovations model and the hierarchy of effects. The *arts adoption process* (AAP) includes the following progressive phases:

1. Disinterest (the consumer has no interest in attending an arts event)
2. Interest (has not attended in the last year but is interested)
3. Trial (has attended one arts event in the last year but does not wish to attend more frequently)
4. Positive evaluation (has attended one arts event in the last year and does wish to attend more frequently)
5. Adoption (has attended two or more arts events in the last year but does not want to attend more often)
6. Confirmation (has attended two or more arts events in the last year and wants to attend more often)[19]

Different types of consumers are at different states in the AAP, and target audiences can be moved through each of the stages of the process based on the rate of diffusion and the hierarchy of effects. However, moving individuals through the adoption process is easier if they are *interested*. Those who have been determined to be disinterested will require expenditure of a good deal of the arts organization's resources if they have been determined to constitute a primary target market.

Now that the notions of motivation and ability are clear, let's turn to the discussion of *opportunity*—the set of circumstances that allow the possibility of consuming or accessing a particular arts situation. Supposing the consumer set in the target audience has the motivation and the ability to consume the arts object or event. However, even the most motivated, confirmed, and able arts consumers with the strongest of favorable attitudes toward an arts offering will have difficulty in seizing arts offering opportunities if they face insurmountable time constraints. Assuming that target audiences are beyond *interest* in their location on the AAP, they may not have the time to spare either to attend the event or to evaluate the arts offer itself beforehand. Therefore, it is important for culturepreneurs and arts managers to make sure the arts offering will fit with the target audience's time allocations, which can be borne out by evaluating the psychographics, demographics, and other segmentation variables.

First, consumers need time to evaluate arts offerings. Without the right information provided in a form that is digestible and based on the level of motivation, ability, and opportunity, or without experience about the arts offering, arts consumers might not dedicate the time needed to evaluate the arts offering. Therefore, it is imperative that the arts organization provides information in multiple formats with enough

detail to allow consumers to formulate reasonable expectations about the arts offering. The culturepreneur's understanding of the target market's time constraints can be demonstrated in these evaluative communications.

Second, to reassure consumers who believe they do not have time to attend arts performances, arts organizations can provide arts offerings in different formats. One good strategy is to offer arts events in shortened snippets—for example, during lunch times—or provide truncated performances during certain times and in particular venues. Here, too, it could be beneficial to provide an electronic medium or recorded events that consumers can access at their convenience.

Motivation, ability, and opportunity play key roles with arts consumers and their engagement with an arts experience. Understanding these aspects of their behaviors will facilitate a culturepreneur's position in the marketplace. When providing information and taking the arts consumer's point of view into consideration, communications with the target audiences can be approached from a thought-based direction or a feeling, or affective, direction. As such, the discussion will next broach central and peripheral route processing.

CENTRAL AND PERIPHERAL ROUTES TO PERSUASION

An earlier section of this chapter pointed out that attitude change and formation can occur through changing beliefs about salient attributes or adding attributes, and through changing the desire to comply or the imagined consequences of attending an arts event or purchasing an arts object. Yet attitude change and behavior also depend on a consumer's motivation, abilities, and perceived opportunities to invest in an arts offering. To these ends, processing information is critical. Information processing relative to attitude change and formation occurs through two primary, yet overlapping means. Central and peripheral routes to information processing, addressing cognitive and emotive aspects of attitudes, are defined as *elaboration*. Central routes are accessed via thinking and beliefs, while peripheral routes are addressed through images, sensory contacts, and behaviors. In a central route frame, the consumer thinks and, as a result of cognitive processing, changes his attitude toward an object. Through the peripheral route, a consumer feels or behaves and, as a result, may have his attitudes changed.[20]

It should be kept in mind that these two processes are integrated, and utilization of both aspects of cognitive processing is important for reaching arts consumers. The line between the two processes provides a categorization; however, we find that emotions play a large role in decisions and that cognitions, in turn, impact the emotions.

The underlying theory of central and peripheral route processing comes from hemispheric lateralization, or left- and right-brain theory. The left side of the brain is considered the rational area where cognitions occur, while the right side of the brain is home to feelings and visual stimuli. Determining which approach is best regarding attitude change and formation will depend on the existing attitudes of arts consumers toward the arts object, their behavioral intentions, and their motivation, ability, and opportunity regarding the consumption task. Importantly, considerations for the approach to central or peripheral route processing contribute heavily when, after selecting the target markets, the culturepreneur delivers communications.

Exhibit 6.10 **Models of the Response Process**

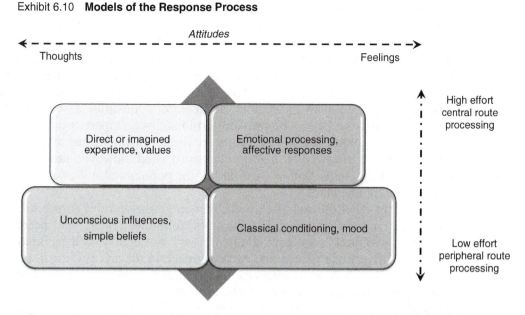

Sources: George E. Belch and Michael A. Belch, *Advertising and Promotion: An Integrated Marketing Communications Perspective*, 8th ed. (New York: McGraw-Hill/Irwin, 2012); Wayne D. Hoyer and Deborah J. MacInnis, *Consumer Behavior*, 5th ed. (Mason, OH: Cengage Learning, 2010).

Refer back to the hierarchy of effects and the diffusion of innovations model presented earlier. The idea with central or peripheral route processing of information is to influence arts consumers. Those who are highly involved may be approached through the central route process to get them to act. The process involves moving through their cognitive, affective, and then behavioral stage, where they are confirmed arts experience consumers and repeat purchasers. However, when arts consumers have low involvement or are not highly motivated, the process used to get them to act may be experiential, following the peripheral route of information processing, with behavior, or action, influencing feelings that lead to confirmation—that is, adoption or change of an attitude *after* the act. Exhibit 6.10 depicts the central route versus the peripheral route processes to behavior and attitudes.

Understanding consumers' internal motivations and attitude formations goes hand in hand with a larger picture that encompasses other influences on behaviors. Other factors to consider are those arising from the sociocultural, early outreach, and marketing mix influences.

SOCIOCULTURAL INFLUENCES ON CONSUMER BEHAVIOR

Social class, reference groups, and culture influence consumer behavior. These influences can be considered normative, and both positive and negative. Social class is an indicator of lifestyle, which may be associated with the method of wealth creation or

classification. For example, upper-class "one percenters" may be entrepreneurs who succeed at bootstrapping, building, and growing a successful firm, as compared to an individual whose family has a lineage of wealth. These two roads to social class distinction through wealth are classified as earned or inherited, respectively. At the same time, education and occupation can be indicators of social class, even though the level of financial success is different. Auction house executives, successful artists, executive and artistic directors, and curators constitute a social class standing differently from those who provide administrative support or janitorial services. Therefore, the middle and lower classes are further distinguished by income. It may be with a bit of unease that this topic is approached; however, nearly all societies have class distinctions, with a good part of the population in Western societies falling into the middle class.

No matter what the social class, reference groups exhibit strong influences on consumers and the arts. Family, educators, religious leaders, and peers are good examples. Children and young adults are very susceptible to these kinds of influences, and this is one reason that early outreach in the arts is critical. Later in life, consumers' business acquaintances, social circles, and group affiliations provide consumption influences. For example, an honor society may dictate behaviors, an appointment to a board may signal other kinds of donor behaviors, a particular position or profession may influence consumption, and at the same time, family and culture continue to do so as well. Holidays and celebrations, mealtimes, and other kinds of rituals formulate consumption needs. And while social class may dictate the level of expenditure, the feeling of belonging and love, and the self-actualization aspects of need fulfillment, should be remembered. It is also wise to note that some influences can shift, but the needs may remain. Therefore, the influences of culture, social class, and reference groups provide access to the consumer in multiple ways.

EARLY OUTREACH

McDonald's creates longtime customers by attracting children when they're very young. Similarly, one way to develop loyal and lifetime audiences who keep coming back to the arts is to reach children and expose them to the arts, since this kind of early childhood experience seems to be correlated with arts consumption in adulthood, provided the child is exposed before about age 17.[21] This kind of exposure by *outreach* is consistent with cultural fine arts consumption across tangible and intangible arts. Playing an instrument, dancing, attending arts festivals, going to the museum, taking art classes, and other kinds of exposure with the family and via school programs are important for this kind of long-term audience development. These individuals will be more likely to be "innovators" in the diffusion of innovation process covered in Chapter 5. Introduction to and participation in the arts to create a consumer base has been found to be consistent across countries and within diverse populations.[22] At this point in time, many individuals have been exposed to the arts thanks to schoolteachers, early outreach programs, the confirmed desire by governing bodies and organizations to offer the arts as a public good, and the educational systems of arts organizations. Many arts organizations demonstrate cultural

fine arts in schools, artistic directors lead community programs for children, and teachers advocate for arts programming and field trips. While these kinds of outreach efforts may not necessarily yield earned income at the point of distribution, they pay dividends later. This kind of outreach, as you can imagine, has to be continuous in order to keep the pipeline of interested individuals for the arts open and flowing.

THE ARTS EXPERIENCE MARKETING MIX

Many have heard of the four *P*s of marketing: product, price, place, and promotion. These elements constitute what is called the *marketing mix* for tangible products in a for-profit environment. For the *intangible services marketing mix*, we add four additional areas—people, physical environment, process, and productivity—and extend the product element to include cultural arts experiences. The intangible services marketing mix can be utilized in both for-profit and not-for-profit organizations. Therefore, the *arts experience marketing mix* encompasses eight *P*s as follows.[23]

1. *Product*. The product is a tangible arts object or intangible arts experience.

2. *Price*. A price is what is charged for purchasing the arts object or intangible arts experience.

3. *Place*. Either the venue or the location constitutes the place where the arts object or experience is consumed or purchased.

4. *Promotion*. Promotion includes how the strategic, goal-oriented communications channels are employed, such as mass or social media, print, electronic, word of mouth, and incentive-based promotions.

5. *People*. When arts consumers come in contact with your company, they will meet people who represent the organization—employees, volunteers, stakeholders, other consumers, and the artists themselves. Based on the interactions that consumers have with people in and around your organization, they judge the quality of the arts offering and theorize what they expect to experience—that is, formulate beliefs that reinforce attitudes. Therefore, it is important to understand the way consumers are accustomed to being treated and set a very enticing bar for people in the organization who are providing high levels of consumer satisfaction.

6. *Physical Environment*. A carefully managed physical environment that portrays the positioning and meaning intended for the point of distribution is also a critical aspect of arts experience marketing. What message does the physical environment convey? How is the area around the building maintained? What does the landscaping portray? Do consumers have immediate access to adequate and well-run restrooms? Will the lobby allow for mingling and refreshments during intermission? What caterer will service the event and what is the caterer's reputation for the quality of the edibles and the wine? For that matter, is wine allowed on the premises? Do you need a coat check? Of course, this is not an exhaustive list; however, these are the kinds of details that add up to formulating the appropriate physical environment for the arts offering. The details will vary depending on the arts experience being distributed.

7. *Process*. Process is defined as the system a consumer experiences from the point of initial contact with your organization to postpurchase satisfaction. Processes conceived of with the consumer, not the organization, in mind are the most successful. Is it easy for consumers to purchase tickets or reserve a space for an arts offering? Is it easy for them to place an order for an arts object? Is the payment procedure complicated? Does it allow for multiple forms of payment, including wire transfers and credit cards, as well as regular mail? Can consumers get their questions answered without being ignored or placed on hold or having limited access to web-based solutions?

8. *Productivity*. How is capacity managed? This is what is meant by productivity for the intangible arts. Are you unable to accommodate consumers' demand because the house is sold out at some performances, openings, or auctions, while you have empty seats or less than optimal attendance at others? Strategies to offer different prices at different times may mitigate capacity problems for some areas, but at no point should prices be changed without conducting a price elasticity of demand analysis, as was mentioned earlier in the text. For a performance hall, each area will command a price based on its location relative to the stage, and the day and time of the performance. Of course, pricing will also be based on the arts offering itself. For a gallery showing or salon exhibition, the location of the art itself will command a price from the artist, and the type of gallery invitation will dictate the price that should help to manage capacity. Private showings will be different from public openings and displays, for example.

The eight *P*s have an influence on consumers and their behaviors in the arts experience. Each of these areas needs to be systematically and purposefully addressed to be in line with the mission and goals of the organization and to reinforce the overall favorable attributes of the offering. Having explained some of the ways that arts consumers are influenced in their behaviors, it is now pertinent to turn to the actual purchase process that arts consumers undergo. The next section of this chapter examines this process.

THE CULTURAL ARTS CONSUMER PURCHASE PROCESS

In this section, an overview of the consumer purchase and decision-making process is explained and applied to the consumption of art. The process comprises five steps, which are clearly defined and delineated. However, consumers do not necessarily pass directly and simply through each of the steps. Rather, they sometimes make decisions out of habit or out of satisficing—giving in to alternatives because it is the best choice that can be made with the information and time available. The five steps of the consumer purchase decision process are problem recognition; information search; alternatives; decision and selection; and postdecision evaluation.

PROBLEM RECOGNITION

Separation from one's ideal state, based on a need that is unfulfilled, is the definition of *problem recognition*. When consumers realize they are hungry or thirsty or need companionship or self-actualized accomplishments, among other kinds of needs,

consumers seek to act to fulfill those needs in order to return to a new or imagined ideal state of being. From this definition, then, it is easy to see that many needs can be generated from a variety of sources, including marketing influences originating in the organization or competitive organizations. From an arts consumption experience point of view, consumers may recognize separation from their ideal state if, for example, they want to buy a tangible arts object, invest or donate to an arts organization, or attend an intangible arts offering. As was discussed earlier, consumers will have different levels of motivation regarding these needs, but nevertheless, after acknowledging the existence of the problem, they engage in information search.

INFORMATION SEARCH

In general, consumers first look inside their memories for information regarding ways to return them to their ideal state of being. They may have had experience with the problem in the past and know how to solve it. Subscribing to a season of performing arts at a particular theater or knowing what gallery to frequent for a particular kind of art object, for example, requires little internal information search. At the same time, companies want their products to be "top of mind" for consumers so that when they are in the position of having to search, a noted solution is readily available in their mind. However, when the internal search for information does not turn up a set of alternatives to fulfill the recognized or unrecognized need, consumers begin looking externally for information. As such, information search is comprised of at least two components—internal and external.

External search is really a process of gathering information to support a decision that begins with the people closest to the consumer and extends outward. In many cases, consumers will ask family, friends, associates, and others in the consumer's environment for information relative to a particular problem. If consumers determine that further information is needed or that the information they have received needs validation, they turn to other impartial sources, such as reviews, rankings, and other consumer satisfaction publications that are available to help them with the decision.

ALTERNATIVES

Once consumers move through gathering information from internal and external sources, as the case may warrant, they develop a set of three to five alternatives, or what is sometimes referred to as an evoked set or a consideration set. This represents the set of brands and alternatives that consumers will choose from to restore them to their ideal state. For example, the symphony orchestra attender may consider classical performances of a given period, led by a particular conductor or featuring a particular musician. Alternatively, an intangible arts consumer may select to attend only particular avant-garde productions of music in certain geographic locations. The same kind of consideration or evoked sets can be formed for collectors of arts objects, based on a variety of criteria, such as the artist, the history of the object, and the display orientation.

DECISION AND SELECTION

Once an evoked set has been determined, how do consumers decide what alternative to choose? Some have forwarded the theory that decisions are rational and that humans will make choices by determining the pros and cons. However, emotions play a role in consumer choice, often providing the driving force underlying them. Even so, in some cases, consumers conduct extensive decision processes, while in others, they follow heuristics, and in others, satisfice. These decision strategies form around the integration of information about the decision based on the consumer's attitudes, feelings, beliefs, social structures, and other influences. In short, coming to a decision is multifaceted, often complex, and based on a variety of factors.

Consumer researchers have theorized that consumers make decisions based on effort, on ranking and weighting of decision factors, and by processes of elimination. Moreover, to help make the decision, consumers develop heuristics, which are somewhat routine, based on prior information searches and knowledge.

Decisions with High Involvement

Cognitive processing models in decision making are based on attributes—aspects of the product or service that the consumer finds important. These models rely on the rational approach many are familiar with, weighing and balancing pros and cons—what is often referred to as a "costs versus benefits" analysis. As such, under the cognitive processing model, the attributes are spelled out, ranked, and weighted. In this *compensatory model*, consumers compare the contents of their evoked set on the attributes they find important, such as company, brand, dates, artist, price, geographic location, venue, time of year; the consumers then multiply the various attributes' weights and tally them. The choice that has the best overall score is the winner. Differently, consumers may reject a choice based on one or two salient attributes, such as artist, type of arts offering, geographic location, or time. In this kind of *noncompensatory model*, consumer choices are eliminated that fall outside of these tests. Basically, the decision process is simplified in noncompensatory decisions because it is simpler to eliminate choices based on specific criteria. The decision models are shown in Exhibit 6.11.

Affective decision processing in high-involvement situations is based on the feelings consumers have, derived from their real or imagined experiences, and often follows a choice that is contraindicated based on their feelings after exhausting their cognitive decision-making processes. Affective decisions in this vein can be explained through appraisal theory, which explains emotions being derived by the way a person remembers the feelings of an experience or imagines how she will feel after an experience directly or indirectly related to the decision task at hand. Importantly, then, feelings are motivators for decisions when they involve aesthetic or symbolic attributes. Because consumers who make emotional choices feel more satisfied than those who make consumption decisions based purely on cognitive indicators, it is important to understand how the arts consumer feels about an arts offering.

Exhibit 6.11 **Compensatory and Noncompensatory Decision Models**

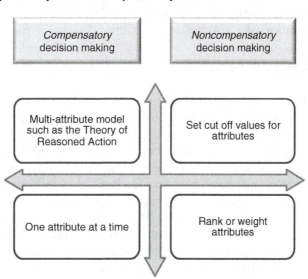

Source: Wayne D. Hoyer and Deborah J. MacInnis, *Consumer Behavior*, 5th ed. (Mason, OH: Cengage Learning, 2010).

Decisions with Low Involvement

For consumers with low motivation, decisions are made under low involvement using heuristics, or rules of thumb, and satisficing. *Heuristics* simplify the decision process, whereby consumers locate the decision close to a *prototype*, or rely on past memory and feelings about the decision. A prototype is a reference point to which arts consumers relate experiences, such as Lincoln Center in New York or the Cleveland Symphony Orchestra conductor. If an arts consumer is faced with the decision to purchase tickets for an event at a little-known venue that was designed by the same architects as Lincoln Center, or to attend a symphony conducted by the same conductor, a heuristic may guide the decision as the consumer places the event close to the prototype. Similarly, if a new arts auction house opens its doors, arts consumers may decide not to participate because the new establishment is located outside of a prototypical understanding of and relation to the tried and true ones. These are called *representational heuristics*, and they differ from *availability heuristics*, which are based on recollections of past experiences. What this means is that, in a low-involvement frame, an arts consumer may, in the examples given, base the decision to attend the unknown arts event or to participate in an auction at the new auction house on the available memory from the outcomes of similar events or on recall of what other people have to say about them.

Satisficing is another simplifying strategy for making a determination of what to choose, a process whereby consumers acknowledge that a choice is "good enough" because they do not want to engage in further efforts to vet the decision. In addition,

people consume out of habit, such as attending the local pops concert, festivals, openings, and annual arts events and galas. Price and branding also form bases for simplification of consumption decisions.

POSTDECISION EVALUATION

Was the arts consumer satisfied with the choice? That is the key question that begs to be answered because that, in turn, drives the next choice when consumers are experiencing separation from their ideal state. Satisfied consumers are willing to keep a neutral frame of mind, and they may make positive remarks about the experience to reference group members. Unsatisfied consumers are, of course, problematic because they may have negative feedback that influences their circle of friends or drive them to provide survey results that influence a larger audience. At the very least, an unsatisfied consumer will remember the feeling of being dissatisfied, which may affect their attitude and motivation in the future. With these consumers, then, it is clear that the goal is to exceed consumer satisfaction levels and minimize dissonance. We can take a look at the differences between satisfaction and dissatisfaction through the *disconfirmation paradigm* and through an *experiential learning hypothesis paradigm*, shown in Exhibits 6.12 and 6.13, respectively.

Exhibit 6.12 **The Disconfirmation Paradigm**

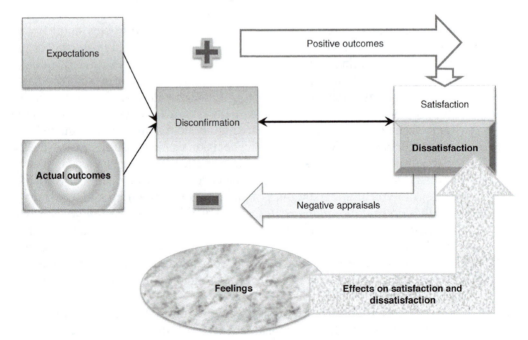

Source: Wayne D. Hoyer and Deborah J. MacInnis, *Consumer Behavior*, 5th ed. (Mason, OH: Cengage Learning, 2010), 281.

Exhibit 6.13 **An Experiential Learning Hypothesis Paradigm**

Source: Wayne D. Hoyer and Deborah J. MacInnis, *Consumer Behavior*, 5th ed. (Mason, OH: Cengage Learning, 2010), 276.

Exhibit 6.14 **Art Basel**

Visit Art Basel (www.artbasel.com)!

Read

Nick Paumgarten, "Dealer's hand: Why are so many people paying so much money for art? Ask David Zwirner," *The New Yorker*, December 2, 2013, www.newyorker.com/reporting/2013/12/02/131202fa_fact_paumgarten?currentPage=all.

And Read

Kelly Crow, "In Miami, Crowds and Confidence," *Wall Street Journal*, December 5, 2013, http://online.wsj.com/news/articles/SB10001424052702303997604579240493758072908.

The five steps of the cultural arts consumer's purchase decision process are problem recognition; information search; alternatives; decision and selection; and post-decision evaluation. The process is not linear, though we use a linear framework to explain it. The purpose of understanding how arts consumers move through the arts experience is important, as will be more evident in Chapter 8. There, the cultural arts are positioned as service products, and the culturepreneur aims the arts consumer toward the arts experience and an impact echo based on measures of subjective and functional arts service product quality.

CHAPTER SUMMARY

This chapter, Consumer Behavior in the Cultural Fine Arts, explained the differences between markets, market segments, and target markets. After presenting these aspects of markets, segmentation strategies for cultural arts markets were presented, including demographic, geographic, psychographic, behavior- and occasion-based, and finally, mixed segmentation strategies. The discussion then turned to knowing and understanding the arts consumer: attitudes, involvement, motivation, ability and opportunity, and the ways in which information processing occurs. Ways to approach the consumer through early outreach, sociocultural influences, the hierarchy of effects, and the adoption process were explained. From that point, the marketing mix, comprised of the eight *P*s, was explained in relation to the arts consumptive experience. Finally, the chapter covered the arts consumer's purchase decision process. The goal of understanding the purchase process is to be able to manage the arts experience and to set the stage for understanding the arts consumption process in relation to the arts as a service product, a topic to be covered in Chapter 8.

DISCUSSION QUESTIONS

1. Explain the differences between market segments and target markets.
2. Design a segmentation matrix using different segmentation variables for three different intangible and three different tangible primary and secondary cultural arts offerings. Include the appropriate segmentation variables for each offering and defend your choices.
3. What is the multi-attribute model of attitudes? How does it work and why is it used? What are its strengths and weaknesses?
4. Is the theory of reasoned action and planned behavior different from the multi-attribute model of attitudes? Explain.

EXPERIENTIAL EXERCISES

1. Explain the attitude change strategies. Using each of the strategies, sketch out a plan to change the attitudes of consumers who have no exposure to the intangible fine arts. Is it possible to use attitude change strategies for tangible fine arts markets? Why?
2. Using the work completed in Question 1, explain the stages in the arts adoption process. Does this model apply to the tangible arts? Why?
3. Does the hierarchy of effects differ from the stages of the arts adoption process? Compare and contrast them.
4. Design (1) a central route and (2) a peripheral route attitude change strategy for an arts consumer in the tangible arts market who has no knowledge of the cultural fine arts but exhibits the sociocultural experiences, motivation, ability, and opportunity to participate. How are the two strategies different? What decision process will they follow? Explain.

FURTHER READING

Ajzen, Icek, and Martin Fishbein. *Understanding Attitudes and Predicting Social Behavior*. Englewood Cliffs, NJ: Prentice-Hall, 1980.

Arts Marketing: An International Journal. Emerald Insight. www.emeraldinsight.com/journals. htm?issn=2044-2084. ISSN: 2044–2084 (online).

Colbert, François. *Marketing Culture and the Arts*. 4th ed. Montreal: HEC Montréal, 2012.

Fishbein, Martin, and Icek Ajzen. *Belief, Attitude, Intention, and Behavior: An Introduction to Theory and Research*. Reading, MA: Addison-Wesley, 1975.

International Journal of Arts Management. HEC Montréal. www.gestiondesarts.com/en/publications/ ijam/. ISSN: 1480–8986.

The Journal of Arts Management, Law, and Society. Taylor & Francis Online. www.tandfonline. com/loi/vjam20#.U3I_BIFdU-A. ISSN 1063–2921 (print), 1930–7799 (online).

NOTES

1. Barclays, *Profit or Pleasure? Exploring the Motivations Behind Treasure Trends*, Wealth Insights, vol. 15 (London: Barclays, 2012), www.ledburyresearch.com/media/document/ barclays-wealth-insight-volume-15.pdf.
2. Ibid.
3. Wayne D. Hoyer and Deborah J. MacInnis, *Consumer Behavior*, 5th ed. (Mason, OH: Cengage Learning, 2010).
4. National Endowment for the Arts (NEA), *Time and Money: Using Federal Data to Measure the Value of Performing Arts Activities*, NEA Research Note #102, April 2011.
5. Americans for the Arts, *Arts & Economic Prosperity III: The Economic Impact of Nonprofit Arts and Culture Organizations and Their Audiences* (Washington, DC: Americans for the Arts, 2007).
6. Centre for Economics and Business Research (CEBR), *The Contribution of the Arts and Culture to the National Economy*, Report for Arts Council England and the National Museum Directors' Council (London: CEBR, May 2013).
7. Colette Henry (ed.), *Entrepreneurship in the Creative Industries: An International Perspective* (Northampton: Edward Elgar, 2007).
8. National Endowment for the Arts (NEA), *Audience 2.0: How Technology Influences Arts Participation* (Washington, DC: NEA, June 2010).
9. Alan R. Andreasen, *Expanding the Audience for the Performing Arts* (Santa Ana, CA: Seven Locks Press, 1992).
10. National Endowment for the Arts (NEA), *2008 Survey of Public Participation in the Arts*, Research Report #49 (Washington, DC: NEA, November 2009).
11. NEA, *Audience 2.0*, 117.
12. See Steven G. Wilson, David A. Plane, Paul J. Mackun, Thomas R. Fischetti, and Justyna Goworowska, *Patterns of Metropolitan and Micropolitan Population Change: 2000 to 2010*, 2010 Census Special Report, C2010SR-01 (Washington, DC: U.S. Census Bureau, September 2012), www.census.gov/prod/cen2010/reports/c2010sr-01.pdf.
13. Dictionary.com, "Lifestyle," http://dictionary.reference.com/browse/lifestyle.
14. Visit the Strategic Business Insights website at "US Framework and VALS™ Types," www. strategicbusinessinsights.com/vals/ustypes.shtml.

15. Hoyer and MacInnis, *Consumer Behavior*.

16. Martin Fishbein and Icek Ajzen, *Belief, Attitude, Intention, and Behavior: An Introduction to Theory and Research* (Reading, MA: Addison-Wesley, 1975); Icek Ajzen and Martin Fishbein, *Understanding Attitudes and Predicting Social Behavior* (Englewood Cliffs, NJ: Prentice-Hall, 1980).

17. Icek Ajzen and Thomas J. Madden, "Prediction of goal-directed behavior: Attitudes, intentions, and perceived behavioral control," *Journal of Experimental Social Psychology* 22, no. 5 (1986), 453–474; Blair H. Sheppard, Jon Hartwick, and Paul R. Warshaw, "The theory of reasoned action: A meta-analysis of past research with recommendations for modifications and future research," *Journal of Consumer Research* 15, no. 3 (1988), 325–343.

18. Everett M. Rogers, *Diffusion of Innovations*, 5th ed. (New York: Free Press, 2003).

19. Andreasen, *Expanding the Audience for the Performing Arts*, 3–4, 8.

20. George E. Belch and Michael A. Belch, *Advertising and Promotion: An Integrated Marketing Communications Perspective*, 8th ed. (New York: McGraw-Hill/Irwin, 2012); Hoyer and MacInnis, *Consumer Behavior*.

21. Robert M. Schindler and Morris B. Holbrook, "Nostalgia for early experience as a determinant of consumer preferences," *Psychology & Marketing* 20, no. 4 (2003), 275–302; François Colbert, *Marketing Culture and the Arts*, 4th ed. (Montreal: HEC Montréal, 2012).

22. James Heilbrun and Charles Gray, *The Economics of Art and Culture*, 2nd ed. (New York: Cambridge University Press, 2001).

23. Valarie A. Zeithaml, Mary Jo Bitner, and Dwayne D. Gremler, *Services Marketing: Integrating Customer Focus Across the Firm*, 4th ed. (New York: McGraw-Hill/Irwin, 2006); Elizabeth Hill, Catherine O'Sullivan, and Terry O'Sullivan, *Creative Arts Marketing*, 2nd ed. (New York: Butterworth Heinemann, 2003).

7 Marketing Research in the Cultural Fine Arts

CHAPTER OUTLINE

Learning Objectives
SPOTLIGHT: The Irvine Foundation
Marketing Research in the Cultural Fine Arts
Defining Marketing Research
The Marketing Research Process
Designing Marketing Research Studies
The Marketing Research Report and Recommendations
Chapter Summary
Discussion Questions
Experiential Exercises
Further Reading
Research Tools
Notes

LEARNING OBJECTIVES

After reading this chapter, you will be able to do the following:

1. Understand the definition of marketing research.
2. Realize the importance of marketing research for solving problems and answering questions relative to the arts organization's objectives.
3. Understand three different approaches to marketing research—exploratory, descriptive, and causal.
4. Describe the marketing research process.
5. Have confidence explaining the differences between primary and secondary research methods, and know when they are needed.
6. Know where to begin looking for secondary marketing research data.
7. Comprehend the types of errors found in marketing research.

8. Conduct focus groups and in-depth interviews, and formulate case and observation studies.
9. Be conversant in the types of survey instruments available.
10. Utilize different survey scales.
11. Know the difference between probability and nonprobability sampling.
12. Write and present a marketing research report.

SPOTLIGHT: THE IRVINE FOUNDATION

The kind of information that can be gleaned from conducting marketing research ranges from developing new programs for new audiences to understanding the behaviors of arts consumers in diverse locations. Many organizations take on such cultural fine arts market research, as has been shown already in the discussion of treasure. In California, the Irvine Foundation is a very key resource for research into the cultural fine arts at the macro and micro participatory levels. In partnership with other economic researchers and foundations, the Irvine Foundation provides secondary research that is readily available online.

For example, in a 2011 report, the Irvine Foundation found that arts and culture play a significant role in the lives of people who live in California. Importantly, California's geographic distributions of people reflect distinctive populations, participation rates, types of cultural fine arts organizations, and levels of arts funding. In addition, the report found that 52 percent of Californians over the age of eighteen attended at least one arts event compared to 46 percent in other states. But that does not mean that the participation rates are uniform. The San Francisco Bay Area had the highest rate, while Riverside and San Bernardino Counties and the San Joaquin Valley had the lowest rate, below the 46 percent level recorded for other states.

Where did the data for these results come from? The results draw from secondary sources, such as the National Center for Charitable Statistics, the California Cultural Data Project, the Survey of Public Participation in the Arts, the American Community Survey, and the Impact Analysis for Planning input-output modeling system. In addition, supplemental secondary data from the 2000 census, the California Department of Finance, and the California Consumer Price Index were utilized. Thirty-six primary research interviews with leaders of organizations underrepresented in the California Cultural Data Project were also conducted. Visit the Irvine Foundation Publications for the Arts and explore more regional marketing research into the cultural fine arts. Or type "cultural fine arts marketing research" into your browser and see what comes up!

MARKETING RESEARCH IN THE CULTURAL FINE ARTS

As François Colbert indicated in his foreword to this textbook, research on arts management and entrepreneurship is a newly emerging field. Nevertheless, marketing research has been engaged in and continues to command attention by culture-preneurs and arts managers. Marketing research has to be undertaken in an ethical environment based on moral standards and codes. In addition, culturepreneurs often need guidance about what to do when faced with an ethical dilemma. In any event, the cultural fine arts consumer, the cultural fine arts researcher, and the sponsoring entity, if there is one, have to be aware of rights and obligations. In general, the focus of ethical responsibility will be on the researcher and extend to the sponsoring organization, and care must be taken to protect arts consumers participating in any research. Doing so will thus typically translate into protecting the cultural fine arts organization.

There are rights and obligations that accrue to both the researcher and the cultural arts consumer participating in a research process. For cultural arts consumers, the right to privacy and the right to be informed must be honored, while they are expected to conform to the principle of being honest. Children as participants of cultural fine arts marketing have additional rights of protection because of their ages, and their parents' or guardians' wishes have to be respected, under the Children's Online Privacy Act in the United States and other laws here and abroad.

The cultural arts market researcher has the obligation to adhere to a code of ethics, such as those set forth by marketing research associations; some arts advocacy groups have adopted their own. While more specific standards are still needed for the cultural fine arts, there are a number of underlying similarities in establishing a system of ethical protections to safeguard the rights of arts consumers.

For example, the principle of voluntary participation requires that arts consumers cannot be coerced into participating in research. Closely related to the notion of voluntary participation is the requirement of informed consent. Essentially, this means that participants in cultural fine arts marketing research must be fully informed about the procedures and risks involved and must give their consent to participate. Ethical standards also require that researchers cannot put participants in a situation where they might be at risk of harm, either physical or psychological, as a result of their participation. As important, there is the aspect of privacy.

There are two standards that are applied to protect the privacy of research participants. Almost all research guarantees the participants confidentiality so that their identity is not compromised. An additional standard is the principle of anonymity. Here the definition is that the participant remains anonymous throughout the study. Clearly, the latter standard is sometimes more difficult to accomplish.

However, even when clear ethical standards and principles exist, there will be times when the need to do accurate research conflicts with the rights of participants. Furthermore, there needs to be a procedure that ensures that researchers will consider all relevant ethical issues in designing and implementing cultural fine arts

marketing research. To address such needs, most organizations have formulated a subcommittee or a board that reviews marketing research designs for their ethical implications and conformity to accepted standards; the board then decides whether additional actions need to be taken to ensure the safety and rights of participants. By implementing this kind of a process, the board also protects both the culturepreneur and the organization against potential legal implications of neglecting to address important ethical issues.

DEFINING MARKETING RESEARCH

Up to this point in the textbook, concepts such as the arts product life cycle, the structure of arts markets and methods to segment them, positioning the arts service product, and the behavioral aspects of arts consumers have been set forth. Within the business plan the market entry strategy is determined, and ways to allocate resources are made explicit based on the business portfolio of cultural arts offerings and ancillaries. It may seem in this discussion that arts offerings are intuitive and that the creative culturepreneur has little connection to the consumption and marketing process. However, make no mistake. Determining which cultural arts products and services to offer, as well as evaluating the experiences of consumers relative to their decision processes and their expectations, relies heavily on marketing research. The dual processes of collecting information and evaluating consumer responses to the cultural arts offering have likely been in practice for hundreds of years, though phrased differently. However, in today's market, consumers have expectations about their cultural arts experiences, and companies generally go to the trouble of producing what consumers want from a market orientation. The culturepreneur and the cultural arts manager alike have to understand the consumer and their market. This chapter therefore covers several methods and practices of marketing research that an entrepreneur or cultural arts manager will need to utilize when identifying consumer trends, making course corrections, or generating new products and services.

According to the American Marketing Association (AMA), marketing is the "activity, set of institutions, and processes for creating, communicating, delivering, and exchanging offerings that have value for customers, clients, partners, and society at large."[1] The process of doing *marketing research* is to systematically gather information on a particular situation, analyze it, and, based on the results of the analysis, make decisions regarding what actions to take about a market or to address a market-related issue. The AMA states:

> Marketing research is the function that links the consumer, customer, and public to the marketer through information—information used to identify and define marketing opportunities and problems; generate, refine, and evaluate marketing actions; monitor marketing performance; and improve understanding of marketing as a process. Marketing research specifies the information required to address these issues, designs the method for collecting information, manages and implements the data collection process, analyzes the results, and communicates the findings and their implications.[2]

As *Entrepreneur* magazine explains,

> Market research provides relevant data to help solve marketing challenges that a business will most likely face—an integral part of the business planning process. In fact, strategies such as market segmentation (identifying specific groups within a market) and product differentiation (creating an identity for a product or service that separates it from those of the competitors) are impossible to develop without market research.[3]

Each of these definitions incorporates the precision of gathering information regarding a particular decision situation with the firm's strategic marketing and business directions in mind. For example, suppose someone in your sphere of influence suggests that ticket prices should be decreased or increased. In many cases, this kind of decision can boil down to a "gut feeling," but without the appropriate information resulting from systematic marketing research to make a wise decision, it could wind up being a disaster. As was pointed out in Chapter 4, pricing decisions should be made based on data that will support them and should include marketing research into price elasticity of demand by consumers. Or suppose you want to offer a particular new kind of cultural arts experience and you are convinced that there is a sizable primary target market out there to support the costs and expenses, a market that will enhance the strategic direction of the firm in providing the new cultural arts experience. Or you believe a cultural arts offering is going to expand and grow beyond belief based on an environmental social trend, and you want to be able to explain this growth to investors so that they will invest or continue to do so. In each of these examples, however, you have little to go on to support and drive the decision direction—until you do the research. In order to move in directions that will bring the organization closer to fulfilling its goals without making costly mistakes, it is best to undertake marketing research before delving in too deeply.

There is a process to follow in engaging in marketing research, with two overarching areas to keep in mind. First, there is an *external, macro-level analysis* of a market that looks at trends and attempts to analyze the environmental situation the firm faces, such as its market share, the projected sales of products or services, the way the industry image is perceived, and where the technological changes may be. These elements can be related to research based on the external environment—that is, cultural, regulatory, economic, social, and technological external factors that may impact how those macro trends will affect the overall market. Secondly, there is an *internal, micro-level analysis* of the market directly related to the firm's ability to manage the eight *P*s. For example, if macro-level research points to trends about online auction house attendance increasing, then that data may impact the firm's decision to increase or decrease the frequency of art auctions or to modify the way that cultural arts consumers and dealers take advantage of the distribution network relative to the auctions. Both kinds of research can be done in a cultural arts firm.

The marketing research process is a systematic approach to answering a question or solving a problem. The process can involve primary and/or secondary research. Qualitative, interpretive, or quantitative empirical marketing research frameworks

can be utilized. There are three basic types of marketing research—exploratory, descriptive, and causal—and a mixed-method type. Exploratory research is undertaken in order to understand a problem or question, to gain some insight or awareness about a marketing phenomenon. Descriptive research attempts to explain the details of the phenomenon, while causal research seeks to understand what relationships exist between variables. Marketing research designs are based on theoretical frameworks and methods relative to them. One caveat is in order, as was the case in previous chapters. Marketing research is a very expansive field of study, and extensive literature exists regarding its use for a myriad of marketing problems and decisions. The point of including the chapter in this textbook is to provide an overview of the process for the culturepreneur and arts manager. With this in mind, the next section works through the marketing research process and explains the use of each type of research method. The chapter then turns to designing research studies and collecting and analyzing data. In closing the chapter, an overview of a marketing research report and recommendations are given. By the end of the chapter, you should have a working knowledge of marketing research and its importance to the cultural arts offering and the culturepreneurial organization. As you can imagine, some marketing researchers conduct studies that are purely theoretical; that vein of research is critical for academic study and in many cases can be adapted to the firm. However, this textbook addresses marketing research of an applied nature, intended to analyze problems and offer solutions that support the strategic orientation of the arts organization as a going culturepreneurial concern.

THE MARKETING RESEARCH PROCESS

Many marketing research problems and questions can be solved or answered without a full-blown marketing research process. Maybe the information you need can be found in your organization's in-house data or is accessible from other trusted secondary sources. For example, information on trends in the cultural arts can be found on many organizations' websites, in countries around the globe. Accessing that information can be valuable if you are under resource allocation constraints in supporting data-driven marketing decisions. However, if the information you need to systematically solve a problem is not readily available, then it may make sense to move forward more formally. Even so, a first review of existing information from secondary sources is always warranted. In any event, generally speaking, the *marketing research process* utilizes a set of ten systematic steps to address a marketing research question or problem:

1. Explain the problem that the research will solve.
2. Determine the objectives of the research in the appropriate theoretical framework.
3. Establish a research design.
4. Determine the sample that will be used.
5. Establish the analysis method(s) for the data.
6. Develop the data-gathering apparatus.

7. Gather the data.
8. Synthesize and analyze the data.
9. Formulate conclusions from the analysis and prepare a report.
10. Make recommendations or take the marketing actions relative to the objectives of the marketing research based on the data.

Every marketing research project is formed around theoretical underpinnings, which are addressed by using interpretive (qualitative) and/or empirical (quantitative) approaches. In the qualitative or interpretive realm, problems being addressed fall under descriptive or exploratory research methods, using mainly interpretive analysis, or descriptive statistical methods, for understanding the data. In the quantitative or empirical arena, problems are solved and questions answered in correlative or causal frameworks, using more advanced statistical methods in analysis. Each approach will be addressed in turn.

QUALITATIVE APPROACHES

Qualitative (interpretive) research is employed to assess or describe a problem, and the results or findings from qualitative research can often be the basis for continued research in the causal frame. In this textbook, four theoretical marketing research approaches in the qualitative framework are of interest for the cultural arts. Ethnographic and observation approaches arise from cultural anthropology; existential and hermeneutical approaches come from constructs within phenomenology; inductive, researcher-based approaches are derived from a Socratic method resulting in grounded theory; and case studies with thematic emphases arise from historical methods.

Data used in qualitative research include transcripts from in-depth interviews, focus groups, and conversations; notes and field work gathered from ethnographic participant observer experiences and observations; historical writings and documents such as program notes, newspaper clippings, and annual reports; advertisements; and many other pieces of information. Some qualitative research designs also employ survey data in order to formulate descriptive understandings of a marketing research problem or question.

How the data are used and interpreted depends upon the problem or question addressed and upon the researcher. These relationships are summarized in Exhibit 7.1.

The kinds of questions and problems a cultural arts manager or culturepreneur may seek to answer or solve using qualitative research designs are nearly unlimited. Here are some examples:

- How do our cultural arts offerings impact, support, or relate to repeat attendance or purchase?
- Are there any trends that indicate attitude shifts relative to the cultural arts experience?
- Which communications and promotional strategies are the best ones to use to effectively reach our target audiences and get them to act?
- What is the optimal performance length our target audiences will enjoy?

Exhibit 7.1 **Selected Qualitative Research Theoretical Designs**

Instrument type	Description	Disadvantage	Advantage	Theoretical aspect
Focus groups	Facilitated discussion by a skilled leader	Nongeneralizable results, expensive, use for comfortable discussions	Fast and flexible, provides a quick read of a situation	Ethnography and case study
Depth interviews	One-on-one probing interview between a respondent and a researcher	Nongeneralizable results, very expensive and time-consuming	Insights come from details from individuals and the ability to get in-depth understanding of behaviors	Ethnography, grounded theory, and case study
Observations	Recording notes and describing events	Can be very expensive, especially if it takes place over time or with considerable investment in technology	Shows or gets very close to actual behavior rather than intended behaviors	Ethnography, grounded theory, and case study
Conversations	Unstructured dialogues recorded by a researcher	May lead to tangential conversations, interpretations are researcher-specific	Gain insight, get at difficult or embarrassing topics, less expensive	Phenomenology and grounded theory

Source: William G. Zikmund and Barry J. Babin, *Essentials of Marketing Research*, 4th ed. (Independence, KY: South-Western Cengage Learning, 2012).

- In what ways can we structure our fund-raising efforts for maximum return?
- Relative to others, what is our standing on the cultural arts consumer's perceptual map? Do we need to reposition our arts offerings and, if so, by what strategy?
- To what extent do normative beliefs impact the arts consumer's intent to purchase tickets to performances?
- Are we charging the correct prices for tickets?
- Should we offer new cultural arts experience products?
- Are there gaps in the expected and perceived quality of our arts offerings?

As you can see, there are nearly unlimited qualitative research questions that may be addressed under the marketing research process umbrella.

QUANTITATIVE APPROACHES

Differing from qualitative approaches, but often used to support them, quantitative (empirical) research can be employed to assess descriptive research questions as well, when you seek a broad understanding of the who, what, where, when, and why of a situation. Here the market researcher relies heavily on surveys and observational methods. Importantly, causal experimental research designs seek to confirm or disconfirm hypotheses and to find causality between dependent and independent variables. Again, changes in prices and revenues could constitute a marketing

research approach in an empirical design, with price being the independent variable and revenues being the dependent variable. Inferences and generalizations are often sought with quantitative marketing research, yet the degree to which a causal or other quantitative research design is generalizable depends on the size of the sample and the certainty of gaining a cross-section of that sample, as well as the errors that are controllable and those that are not. In any event, it is a good idea to use a marketing research instrument that is reliable and valid so that errors are avoided and, in an experimental design, to check if the variable being manipulated is causing the change you are looking for.

We begin the discussion with surveys because they are a very useful and often a rapid way to get information regarding a marketing research problem or question, and then we discuss observation and, finally, experimental designs.

Surveys

Surveys are deployed within two broad sample frames—probability and nonprobability—and contain a variety of question types. A *sample* can be considered a representation of a group being studied. To the degree that the results of the research need to be representative, accurate, and reliable, that will dictate the sample size. A sample is a subset of a larger population. For example, in order to ascertain information relative to a marketing research question about cultural arts consumption in the United States, it would be impossible to survey, interview, or contact every cultural arts consumer. However, if a group of consumers are contacted and a certain number of them reply or participate in the research, we have engaged a sample. Is that sample likely to be representative of all cultural arts consumers? In other words, can the results of the research be relied upon to apply to the population of cultural arts consumers in the United States? Yes, if there is a known and predeterminable probability that everyone in the U.S. cultural arts consumer population will be contacted. There are a number of ways to engage in *probability sampling*. How do we know we have a large enough sample? We base the size of the population on the relative variances or the similarities between the members and the question we are asking, how much assurance or confidence we want to enjoy with our results, and the degree to which we think there may be errors introduced in the research. If there is a large estimation of the differences in the population elements and other factors, a larger sample will be called for. In general, the larger the sample, the more accurate the results, but only to a point and with larger samples returning more accurate results at a diminishing rate.

Simple random sampling is a process that allows for possible inclusion of each population element in the sample. A *population element* is simply a member of the population being studied, and in our example it would be a member of the U.S. population of cultural arts consumers. The random sampling can be based on computer selection or random generation of numbers that are assigned to members of the population. *Systematic sampling* is another way to develop a probability sample, by determining ahead of time to select the *n*th number of the sample until the end is reached and the size of the sample is sufficient. *Cluster* and *stratified* sampling are also ways to get at probability samples. In a cluster probability sample, selection

of the *n*th population element in a given set of geographic clusters is the method, with the desire to have equal distributions coming from the selected clusters. In our example of cultural arts consumers, the clusters could be established relative to cultural arts experiences in cities, or at universities, at festivals, or any other physical location that can be clearly delineated. Stratified sampling is based on grouping the sampling units by a particular known measure about them, such as income or education. Here again, the distribution from each stratum needs to be balanced.

Nonprobability sampling is also employed in a survey approach to marketing research. However, the samples are not systematically drawn in order to represent a population. Instead, samples are comprised based on availability of respondents. Often these are called *convenience samples*. As you probably guessed, the results of these kinds of samples are not generalizable to a larger population. However, they can be very useful. For example, if you wanted to survey consumers or donors in your database to get a feel for how they would respond to new cultural arts offerings, you could approach some of them. Nonprobability samples are also formed by selecting a particular number of people out of a group from a larger convenience sample. So, for example, if you wanted to survey donors at different levels of contributions or consumers who have attended or participated in your cultural arts events over the last three years, you could. *Quota sampling* can be effective and so can *snowball sampling*, in which selected individuals provide the names of additional respondents in a continuous process. Continuing with our example, you might ask patrons to provide names of individuals that you may contact; those individuals in turn are asked for the names of still other individuals who will be contacted, and so on; the total number of respondents thus *snowballs*, ramping up to a particular size. Sometimes a convenience sample is developed by expert opinion or what is known as a *judgment sample*, based on someone's expertise or experience.

Nonprobability samples are typically less expensive and easier to administer relative to probability samples. The decision to use one or the other will be based on the time and resources available and the particular marketing research question being addressed.

Observation

Today's world is riddled with video cameras recording information, directly observing activities of people from the streets to the grocery stores, from the automatic tellers at banks to the art gallery and museum, and in systematic marketing research there is a plethora of video recording and other direct observation documentation that captures nonverbal elements. Physical observation is done through a process whereby individuals and their behaviors are systematically observed by a researcher. Often the behavior is recorded by a device, which can be operated with or without consumers' knowledge. When people do not know they are being observed, the researcher can get their unscripted nonverbal behavior; when people do know they are being observed, the knowledge may introduce a bias by causing them to act differently. The other point to note is that, often, people behave differently from what they say. Sometimes observation is *contrived*, or staged, so that the subjects in the

situation are unaware that their behavior is being recorded. This kind of observation happens with mystery shoppers or people who evaluate others without their knowledge. At the same time, subjects can be observed in laboratory environments such as when they are invited to a preview of a particular cultural arts event. These subjects may or may not be aware that they are being recorded or observed. In some laboratory situations, though, it is clear that observation is taking place and that subjects are participating for that purpose.

Behavior is also observed and recorded when retailers and others collect information about consumers' buying activity. This information, which can be analyzed to see buying trends and patterns, serves the purpose of tracking actual versus intended behavior. As you probably know, online activity is also observable, measured by click-through rates on websites, social media, and text message response rates.

Neurological and biofeedback observations are other techniques available for research in marketing. Typically these are done with apparatuses that monitor a subject's bodily responses to stimuli. Importantly, as was mentioned earlier, observation is useful in exploratory, descriptive, and experimental research designs and therefore can be used in both qualitative and quantitative projects.

How can the cultural arts manager utilize observational methods and take advantage of the information they provide? Many opportunities exist that can be tied to marketing research questions. For example, perhaps you want to understand why merchandise sales are declining or showing lackluster performance. You wonder if the price might be an issue or if the quality of the merchandise may be suspect. Perhaps the culprit is lack of time before a performance, during intermission, or after the performance, or lack of availability online. Or perhaps customer service needs to be strengthened, and this can be determined by doing contrived observation of staff or volunteers. Of course, if resources allow, you could expose a selected target audience to a preview of your art work while they are connected to a neurological or other kind of biofeedback mechanism that measures the body's response to different pieces or displays. These data would provide a wealth of information for marketing research purposes, if the data drives a decision function.

Of course, it is necessary to take care not to violate the consumer's privacy when using observational techniques. Some situations require disclosing the use of observational devices while others do not. Many companies opt to state that surveillance is taking place and therefore make the subjects aware of the possibility of being watched or recorded, which does not require their consent. In today's world, it is often a best practice to err on the side of caution by informing potential consumers of this possibility.

Experimental Designs

In these kinds of research designs, market researchers look for relationships between cause and effect. Whereas in survey research the goal is to measure responses to questions, in an experiment the marketing researcher manipulates one or more variables to see what happens to other variables. There is no doubt that more than one independent or dependent variable can be evaluated in experimental research

designs, and they can be evaluated in the same experiment. However, the detailed scope of experiments is beyond the subject matter covered in this textbook. Still, it is important to know how to use experiments in research designs for answering certain kinds of marketing research questions. Therefore, the topic is covered in a manner that allows for an overview of the process.

Suppose you wanted to determine if a sculpture you are creating (the dependent variable, reflecting what happens as a result of something else) should be priced high or low (price is the independent variable because it is the one you can change). Or suppose you wanted to find out if patrons respond favorably (dependent variable that is acted upon) when you set smaller donation recognition targets (independent variable that can be manipulated) in exchange for an emblem or other token of appreciation. Furthermore, you hypothesize that cultural arts consumers will be willing to pay a high price for the sculptures, while you also hypothesize that patrons will not like smaller donation recognition levels. You could conduct an experiment to evaluate each of these marketing actions, thus testing your hypotheses for decision purposes.

If you determine that an experiment is needed because you want to hypothesize the cause and effect of a marketing action, such as what happens when one of the eight *P*s of price, promotion, physical environment, and so forth is manipulated, then you will need a control group and an experimental group. The *control group* does not receive the "treatment" while the *experimental group* does. This pattern is analogous to medical research in which one group is given a placebo while the other group gets the actual medication. So in our hypothetical cases, the control groups would not be given different prices for the sculpture or different donation levels, but the experimental groups would. One point that is very important is that the two groups be similar in order to isolate the effects of the independent variable on the dependent variable. The reason for using control groups is to measure or expose sources of error that could happen in the experiment.

Unfortunately, there are many sources of error in marketing research overall, and they stem from either the researcher's errors or the respondents' errors. In an experiment it is important to be able to isolate the errors to show that they do not impact the change in the dependent variable. In the above hypothetical examples, you are concluding that in the first case, increased prices for sculptures cause increased purchases; in the second example, that lower donation categories cause fewer donations. If you see the same effect regarding prices in the control group as you see in the experimental group, you will know there is something amiss. However, many errors can be ferreted out in the *manipulation check*, where you do a trial run of the experiment with a small group of subjects to make sure you are getting the cause-and-effect relationship sought. At this stage, changes and adjustments can be made. Knowing what dependent variable to measure relative to an independent one, as you can see, becomes critical in problem recognition. If the experiment supports your hypothesis, then you accept it, and if the experiment does not support the hypothesis, you say the hypothesis was not supported, or reject it.

Who is going to participate in the experiment? *Subjects*, who are a part of the larger sample you are working with, such as the target audience, are also referred to as your *test units*. And once again, you will determine the research sample based on the problem or question you are addressing and the degree to which you want to generalize the findings to a larger population.

DESIGNING MARKETING RESEARCH STUDIES

Research design depends on the question you are asking or the problem you are trying to solve. In *primary research*, wherein the marketing research question needs to be answered with research for your specific problem, the decision is whether there is a need for exploratory, descriptive, and/or causal research. Are you trying to understand an emerging situation or gather details about a phenomenon? Then exploratory research can be used. Here you can draw on interviews, focus groups, conversations, observations, survey data, and secondary resources, a topic covered later in the chapter, to begin to understand what is happening. If you are seeking to describe the situation, surveys can be utilized; secondary data describing trends associated with markets or segments, information from your existing research and data bases, observation, ethnographic research, and online behavior research from social media and other sources can provide rich data for describing what is happening or uncovering consumer viewpoints. Finally, you can design an experiment to get at causal relationships once the exploratory, descriptive research has been done. Of course, there could be a need to use mixed methods of marketing research, or all three to answer the question or generate answers to hypotheses. In any event, you want to clearly state the research design you will embark upon before moving forward so that it will guide your steps and help frame the analysis. Very common research instruments already mentioned include surveys, focus groups, in-depth interviews, ethnographic techniques, experiments, and observation. How do you design these instruments, collect the data, and then analyze the data? It is always good to begin with the end in mind.

PRIMARY DATA

Qualitative Data Collection

Qualitative data gathered from focus groups, interviews, conversations, ethnographic work, and other text-based data will need to be analyzed by interpreting the content of the work. Therefore it is important to understand how this data will be accessed before you begin collecting it. Interviews, conversations, focus groups, and observations are typically recorded by video and audio. Who is going to *transcribe* the data from the electronic media? Imagine the quantity of information in five or six forty-five-minute focus groups with six or eight respondents in each, assuming that the data are stored in audio-visual format. It takes twice the time to transcribe the data as is given in the time sequence, so that equates to about ninety minutes per focus group.

There are companies that will do this chore for you, provided your data are given to them in a precise format. So if you are expecting to outsource the raw data collection materials, you will want to contact vendors who are willing to do this, find out how much they charge, how long the job will take, and in what format you will receive the *transcripts*. There is an advantage to outsourcing and it is basically saving time, with a hope for lower frustration in the transcription process. However, transcribing data as the researcher or with in-house researchers working together can allow for a close connection to the data and the respondents' views. If there is to be no outsourcing, data should be transcribed as close to the research collection point as possible. Of course, an ethnographic approach will require writing up field notes, which probably should not be considered for outsourcing. This kind of forward thinking will help you with planning the duration of the research as well.

Knowing the data collection and analysis process you will embark upon will help with setting up the instruments and guides for collecting data. For interviewing and focus groups, the researcher will need a formatted outline or guide. If using content analysis or getting feedback about future cultural arts events, advertising, or free associations between pictures or other materials, these will need to be prepared for each research encounter. The point is that you will want to be organized before you begin so that you can adhere to a systematic process in data collection. Another important aspect of data collection is determining who will participate. Where will you get respondents from, and, importantly, what will you offer them as an appreciation for their effort? Respondents who participate in a focus group or interview will spend at least an hour with you. Will you interview them in a particular location or will you conduct interviews with them via a virtual meeting? This needs to be set up ahead of time as well (see Exhibit 7.2).

Once collected and transcribed, the textual data will need to be coded and sorted for themes expressed by the respondents. Coded and thematic data are then interpreted for their meanings, and inferences drawn based on them. In some cases, computer programs are available for lexicographic analysis; if this job is done by humans, it will be beneficial if more than one researcher interprets the same data in order to equalize different biases or points of view and to confirm the interpretations.

Quantitative Data Collection

Quantitative data gathered from surveys require different methods of analysis. Survey data analysis will typically be done by computer, and therefore if it is possible to capture the respondents' survey answers by the computer initially, that will eliminate having to enter data from paper or other survey instruments into a computer, which, in turn, reduces a level of error in administering the survey. At the same time, you want to make sure you are getting answers to questions that will address your particular research problem, without having to re-create the wheel each time. For this reason, it is often useful to rely on surveys that have been developed by other researchers and have subsequently been shown to be valid and reliable. Marketing surveys are readily available from a variety of sources and they can be adapted to

Exhibit 7.2 **Focus Groups and In-Depth Interview Guides**

Start with broad questions set in your outline

- Have a guide book to follow that explains who is participating, and the goals of the research
- Give introductory information
- Allow a relaxing atmosphere to develop

Ask more specific questions related to the goals of the research

- Seek understanding and details
- Provide moderating and facilitating to allow all to participate
- Delve in; ask "What do you mean," or "Can you provide more...?"

Gather respondents' examples and insights

- Be nonjudgmental and listen; take notes and record with audiovisual media
- Provide a debriefing for closure
- Thank the members of the group and provide their incentive or compensation

Remember...

- As soon after the interviews as possible, have or cause to have the tapes transcribed
- Make sure responses are interpreted within the contextual frames of references being used
- Note particular themes and words, nonverbal communications you recall from the interactions
- Interpret the qualitative data as much as possible without bias and with the highest ethical standards
- Importantly, remember that no qualitative data can be generalized to a large population

Source: Nedra Kline Weinrich, *Hands-on Social Marketing: A Step-by-Step Guide to Designing Change for Good,* 2nd ed. (Thousand Oaks, CA: Sage, 2011).

your case. Aside from the survey instrument, there are decisions about who will be asked to participate, how many participants will suffice, where the data will be collected, such as online or by text message, how much demographic data to collect, how to structure the question flows, and what kinds of questions to ask. The main problem is getting the information you need, and enough of it for a meaningful analysis, without exhausting your respondents.

Several types of question scales are available, including dichotomous; semantic differential; closed-ended with multiple choices in checking all that apply; check-only-one, Likert format labeled "Strongly agree" to "Strongly disagree"; nested questions using "If so, then fill in . . . "; and open-ended questions. Questions can be formatted in a logical flow to move respondents through the survey and if online require them to answer each question before the survey will advance. Every question has to be coded. For example, a closed-ended question asking for respondents' gender could include at least these choices: Female, Male, Decline to state, or Neither. The researcher would code these answers with numbers 1 through 4 to be able to quantify the self-identification of the respondents. Survey questions using

Likert scales and semantic differentiation allow for analysis of data in terms of basic descriptive and complex statistical methods. Therefore, understanding the direction of the scale is important at the outset. For a Likert scale with seven choices ranging from "Strongly agree" to "Strongly disagree," will the number 1 be set for "Strongly agree" or "Strongly disagree"? Will negative questions, such as "I never attend a festival," be used and, if so, will your scale be inverted? It will make a difference later when computing the described and complex statistical analyses and will help to keep the scales clearly understood, and it may make a difference to the respondents, who are graciously participating freely or for a small level of compensation in your research. Questions and types of scales are presented in Exhibit 7.3.

Exhibit 7.3 **Research Question Types and Scales**

1. **Open-Ended Questions**
 Respondents are free to write their own responses.
 - Tell me about how your family attended . . .
 - What would your opinion about the use of costumes be if . . .
 - At what level would you determine the price was . . .

 Transcribe these and interpret responses. If there are similar themes, they can be grouped.

2. **Geodemographic, VALS, Other Self-Defining Questions**
 Respondents answer a series of questions related to their geodemographic situation, their VALS, use, or other kinds of questions.
 Please select the income level that best describes you:
 - Over $100,000
 - Less than $100,000

 Please tell us your gender:
 - Male
 - Female
 - Other

 Code the questions for ease of analysis, using 0, 1, and/or 2.

3. **Closed-End or Fixed-Alternative Questions**
 Respondents are given a set of alternatives from which to select:
 Please click the button that best answers the following:
 "I go out to dinner at a fancy restaurant _____."
 - ☐ three times a month
 - ☐ twice a month
 - ☐ less than twice a month
 - ☐ we never go out to dinner

 Code the question for ease of analysis from 0 to 3.

4. **Dichotomous Questions**
 These give the respondent an opportunity to answer yes or no.
 Have you been to one of our Galas in the past five years?
 - Yes
 - No

 Code the question for ease of analysis, using 0 and 1.

5. **Likert Scale Questions**
 Respondents are asked to rate the degree to which they agree or disagree with a statement.
 The experience I had this evening was the best yet:
 - Strongly Agree
 - Agree
 - Neutral
 - Disagree
 - Strongly Disagree

 Code the question for ease of analysis using 1 through 5.

6. **Semantic Differential Scale Questions**
 Respondents rate the degree to which they feel or perceive certain descriptions of events or occurrences.
 How would you rate the innovative experience you have had tonight? Please mark the space that approximates your feeling:

 Innovative Excellent _ _ _ _ _ _ _ _ _ _ _ Poor

 Code the question for ease of analysis, for example using numerals 1 through 10, with 10 equaling "Excellent."

 Sources: Roger Kerin, Steven Hartley, and William Rudelius, *Marketing*, 10th ed. (New York: McGraw-Hill/Irwin, 2010); Nedra Kline Weinrich, *Hands-On Social Marketing: A Step-by-Step Guide to Designing Change for Good*, 2nd ed. (Thousand Oaks, CA: Sage, 2011).

If your research design will include visual observational techniques, you will need to utilize recording and monitoring devices and a researcher to collect the observational data. Other kinds of devices may be necessary depending on the level of observation sought. Neurological and physiological devices that measure changes in bodily responses will need to be used at a specialized location and monitored by trained professionals. Once completed, the data from these measures will require an analysis, again by professionals, that can distinguish between neurophysiological effects. In any event, knowing what the end will look like helps drive the process of data collection.

As you can imagine, collecting and analyzing primary data in qualitative or quantitative marketing research can be expensive and time-consuming. Therefore, before embarking on a research design, it is always prudent to see what is already available. That is known as secondary research, which is covered in the next section.

SOURCES OF SECONDARY DATA AND INFORMATION

Though its name sounds the opposite, secondary data collection should be done before embarking on primary data collection. Examining secondary data first could reveal that there is little if any primary data collection needed to answer the marketing research question being addressed. Secondary data collection requires searching for information that already exists or research that has been done for other purposes

that, perhaps, you can use to your benefit. Data sets, focus group transcripts and findings, interview material, internal database information, company sales records, attendance records, and results of experiments or reports on a wide variety of topics are a few of the kinds of secondary data that you could access. For example, the National Endowment for the Arts, the Bureau of Labor Statistics, and cultural arts councils produce and hold a plethora of data and reports. Nielsen and JD Powers and Associates are also sources of information.

Journal articles, association websites, and newsletters relative to the cultural arts and culture also contain helpful, up-to-date secondary data. Local chambers of commerce and convention and visitors bureaus, universities, and libraries are also places where information can be accessed. In addition, much of this data can be accessed online. While you may have to pay a fee for the data, that fee is often less that the costs of performing primary research, which include paying for the researcher's time, laboratory time and experiment equipment fees, data crunchers, and respondent compensation.

Secondary data collection, while useful in the right context, receives some criticism. Researchers may shy away from it because the data were collected for different purposes than the exact research question at hand. The data may perhaps be old or stale, and finally, the data sets are in units or forms that are difficult to manipulate. However, for culturepreneurs in the business of using data for decision making, the way around these problems is to couch the results of the research and state the limitations, if any, which arise because of the data. The point is that secondary marketing research data can be useful to support directions of growth or contraction, ways to improve the firm, and the consumer experience. Marketing research is a tool to assist with that job, and therefore, if the data are available, you can save time and invest your resources elsewhere.

THE MARKETING RESEARCH REPORT AND RECOMMENDATIONS

After the research has been completed, a report is prepared. The degree of formality that the report exhibits depends on the audience and the purpose. However, it is wise to prepare the report so that it can be referred to later if the need should arise, even if the findings lead to a decision that is controversial. In general, the report formulates conclusions from the analysis and contains recommendations for the indicated marketing actions with regard to an arts offering, relative to the objectives of the arts organization and the question or problem being evaluated.

The contents of the marketing research report should be presented in simple language so that it is understandable. An assumption to make is that someone reading it will have limited time and will want to understand the bottom line of the recommendations in broad brushstrokes. Because of this, the report should include an executive summary that summarizes in a few pages what the questions were, the approaches used in data analysis, the findings, and at least two recommendations. It is important that the recommendations be included and that the reader does not have

to guess what the report supports from your point of view. The executive summary should be written last, so that summary charts, tables, and illustrations are included. While it is important for the reader to be able to visualize quickly what the marketing research is saying, at the same time, interested individuals will want to be able to delve deeper into the data and rationale; therefore, appendices with detailed information are to be included. Here the marketing research design, the survey instrument, the background of the research problem, assumptions, spreadsheets, transcripts, statistical data analysis protocols, interpretive methods, and any financial analyses that are necessary can be included.

The main document of the report will be the challenge. What do you include and what do you leave out? How much detail should there be? Include enough information to clearly introduce the marketing research problem or question, and give the context. Talk about the objectives of the marketing research project at hand, and explain the methodology, the results, and where the marketing research boundaries are. Next, discuss conclusions and recommendations. Include visual aids for conceptual displays. The length will vary depending on the question and the scope of the marketing research project. Keep in mind that the intended audience may distribute the report to others; therefore, use of professional formal language is prudent. Using the third person singular may be the best choice in writing style, but first person may be appropriate.

It may be that your report is prepared only in an electronic format and that you will present it before a group of people, such as the board of advisers or investors, employees, or other stakeholders. In that case, consider using not only a portable document file (PDF), but also presentation software such as Prezi (www.prezi.com) to make the marketing research report attractive and easy to flow through.

In summary, the marketing research report consists of the following elements:

1. Executive summary.
2. Introduction, including the rationale, purpose, and context of the marketing research.
3. Marketing research question or problem and its importance in the arts organization.
4. The marketing research design, including primary, secondary approaches and the theoretical background supporting qualitative, quantitative, exploratory, descriptive, causal, or mixed designs.
5. Data collection techniques, including experimental designs.
6. Data analysis and methods.
7. Findings and limitations.
8. Implications and conclusions.
9. Recommendations—at least two—clearly explained and rationalized based on the data analysis, findings, and the marketing research question.
10. Appendices with samples of surveys, transcripts, thematic interpretive methodology, statistical data, and other supporting documentation.

Exhibit 7.4 **The Pricing Institute**

Steven Roth, president of the Pricing Institute, says that "using a decision support system as part of the marketing research process in real time is key in pricing, and that system is based on arts consumers and their behaviors. Pricing is best approached by observing what arts consumers do, in terms of accessing an arts offering, rather than what we think they will do. Companies can realize substantial increases in revenues following such an approach. The best thing to do is price for value, and differentiate arts offerings and prices, and do so based on data" recovered from the arts constituent relationship management system.

The important aspect here is to realize that value is all in the mind of the arts consumer.

Consumers are constantly making subconscious calculations about the relative value of the innumerable options presented to them—choices about leisure activities, cars, clothes, and computers. This is what drives their perceptions of "value for money."

In the case of purchasing an airline seat, the need to be satisfied is simple—to get from A to B—and the means of satisfying it is clear, along with all the attendant features, such as seat size, location, and leg room. There is something objective about a seat on an airplane at a specific time to a specific destination, but when it comes to a seat in a theater at a specific time for a specific show, the experience gained is almost entirely subjective. Data from marketing research helps to quantify that subjectivity and forward pricing decisions.

The value gained from attending an arts event is entirely a function of perception. People exchange money for arts experiences only if they believe they are getting value in return.

Attending an arts event is almost always like buying a brand-new product, which the arts consumer may have never experienced. So what we are selling is the expectation of value to be received. In effect, arts consumers are buying a promise, which is why the communication of value offered by an arts offering is so fundamental. Knowing those arts consumers and being able to observe them or track them will provide much information that can be captured for decision making.

And often we do not communicate the true value (i.e., the art, the experience, the uniqueness). The better we communicate the true value of the arts offer—value as defined by arts consumers—the more we increase that value and the more likely they will become loyal. Information used in the ACRMS can lead exactly down this path, provided data are collected.

Ultimately, people do pay more for arts offerings that are in high demand. Some arts marketers take advantage of this situation by tinkering with supply. Others may artificially make supply look scarce by keeping seats off line and then releasing them at higher prices. This may be effective in raising revenue, but what is the impact on the arts consumer? How does that affect our longer-term relationship with our arts constituents?

Infrequent attenders, unfamiliar with an auditorium and lacking knowledge about an offering, seem to use price as a proxy for value and as such exhibit irrational behavior in relation to price. Frequent attenders, on the other hand, may have been attending a venue for years—opera-goers sometimes know the repertoire and artists better than the management, and classical music subscribers have an intimate knowledge of the auditorium that allows them to be extremely fussy about seat choice on the basis of acoustics. In these cases, capturing the data by observing their behaviors, we get a much greater sense of informed customers making well-informed and rational choices.

Behavioral economics is about how irrationality alters the demand curve—not for all customers and not all of the time, but enough for us to consider how it applies. So our pricing strategies need to identify which segments of the audiences are behaving more or less irrationally. We can do this through marketing research.

Source: Adapted from Steven Roth, "Pricing the arts," unpublished article. Used by permission.

CHAPTER SUMMARY

In this chapter, marketing and marketing research were defined. The purpose of the chapter was to explain the need to use marketing research in decision making. The marketing research process encompasses qualitative and quantitative approaches, based on theoretical designs. In the qualitative arena, anthropology, phenomenology, grounded theoretical methods, and case study methods were introduced. The kinds

of qualitative data collected can arise from transcripts of in-depth interviews, focus groups, observations, and selected survey data. In the quantitative area, empirical research and experimental designs were explained. Data arising from this kind of research is typically statistically analyzed for correlations and causality.

In order to conduct research that will be generalizable, probability sampling is needed, and the chapter explained the differences between it and nonprobability sampling. Moreover, when designing marketing research, it will probably be necessary to conduct secondary research first, before embarking on primary research. There is a plethora of secondary research available, and the first place to investigate is your own organization. From there, examination of government and marketing research company websites can provide information in a broad range of categories, including demographic and geographic segmentation variables. Several websites are presented under Research Tools, after the Further Reading section for the chapter. Once the marketing research is completed, a marketing research report should be written so that the results and recommendations arising from the research can be documented.

DISCUSSION QUESTIONS

1. Compare and contrast depth interviews, focus groups, conversations, observation, ethnography, and case study.
2. Describe the differences between the theoretical approaches to marketing research.
3. What is a probability sample? When is it used? How is it designed?
4. Give three examples of secondary data that can be accessed without cost. What are the limitations of using such data? Is it possible to conduct a marketing research project using only secondary data? How?
5. What kind of data is observational data? Where does it come from and how is it used? What are the advantages and disadvantages of using this kind of data?
6. How do interpretive themes arise in qualitative research?
7. Explain the differences between independent and dependent variables. Give two examples of these kinds of variables (outside of price and revenue) that would be applicable to an arts organization in an experimental design.

EXPERIENTIAL EXERCISES

1. Explain three market- or industry-related problems or questions that a cultural arts firm may face—for example, whether to delete an arts offering, add an arts offering, or modify an existing arts offering. Alternatively, questions and problems can be related to technology and capital improvements, such as spending for new computer systems or building new facilities. Keep in mind that the goal is to move the arts organization closer to its strategic goal. If you work in an arts organization, you may want to note your mission statement.
2. Design a marketing research approach to one of the problems or questions you raised in Question 1.
3. Select the secondary and primary research approaches and respective tools you will use and explain why you selected them.

4. Outline the questions and, where appropriate, the scales that are appropriate for surveys you will use in each tool identified in Question 3.
5. Explain how you will code qualitative data, and how you will transcribe and interpret transcripts.
6. Go to the websites listed under Research Tools at the end of this chapter, sign up for free accounts, and gather as much data from them as you can, specifically geared toward your question.
7. Using the framework presented in the textbook, write a marketing research report to record the findings from your research.
8. Make notes of your observations of this process and keep them for your future reference.

FURTHER READING

Marketing Research Association (MRA). MRA code of marketing research standards. October 15, 2013. www.marketingresearch.org/code.

McNulty, Tom. *Art Market Research: A Guide to Methods and Sources.* 2nd ed. Jefferson, NC: McFarland, 2014.

Zikmund, William G., and Barry J. Babin. *Essentials of Marketing Research.* 4th ed. Independence, KY: South-Western Cengage Learning, 2012.

RESEARCH TOOLS

The following information is presented for reference and ease. These website links were active at the time of publication of this textbook, yet websites change from time to time, so, if you cannot locate a page, search for the name of the organization in your search engine. These links are provided as an aid to marketing research in the fine arts; they are not by any means an exhaustive list. The marketing research firms listed below are provided for information purposes only; this is not an endorsement. Please vet and conduct proper due diligence with any firm that will be engaged with your organization.

SECONDARY DATA SOURCES

Americans for the Arts. Research reports. www.americansforthearts.org/by-program/reports-and-data/research-studies-publications/americans-for-the-arts-publications/research-reports.

National Endowment for the Arts (NEA). Publications. http://arts.gov/publications.

U.S. Bureau of Labor Statistics. Performing arts, spectator sports, and related industries: NAICS 711. www.bls.gov/iag/tgs/iag711.htm.

ONLINE RESEARCH DESIGN FIRMS

These firms provide research materials and other related services.

Qualtrics. Marketing research process: 9 stages to marketing research success. *Q-Insights,* November 5, 2012. www.qualtrics.com/blog/marketing-research-process/.

Survey Monkey. www.surveymonkey.com.
Survey Sampling International (SSI). www.surveysampling.com.

Marketing Research Firms

Art Market Research. About AMR indexes. www.artmarketresearch.com/amr_fr.html.
ArtTactic. www.arttactic.com.
Audience Research & Analysis. www.audienceresearch.com.
International Foundation for Art Research. IFAR Collectors' Corner. www.ifar.org/collectors_corner.php.
WolfBrown. IntrinsicImpact.org: Measure what matters. dashboard.intrinsicimpact.org/about.

Notes

1. American Marketing Association (AMA), "About AMA: Marketing," July 2013, www.ama.org/AboutAMA/Pages/Definition-of-Marketing.aspx.
2. American Marketing Association (AMA), "About AMA: Marketing research," October 2004, www.ama.org/AboutAMA/Pages/Definition-of-Marketing.aspx.
3. Entrepreneur Media, "Market research," Entrepreneur.com, www.entrepreneur.com/encyclopedia/market-research.

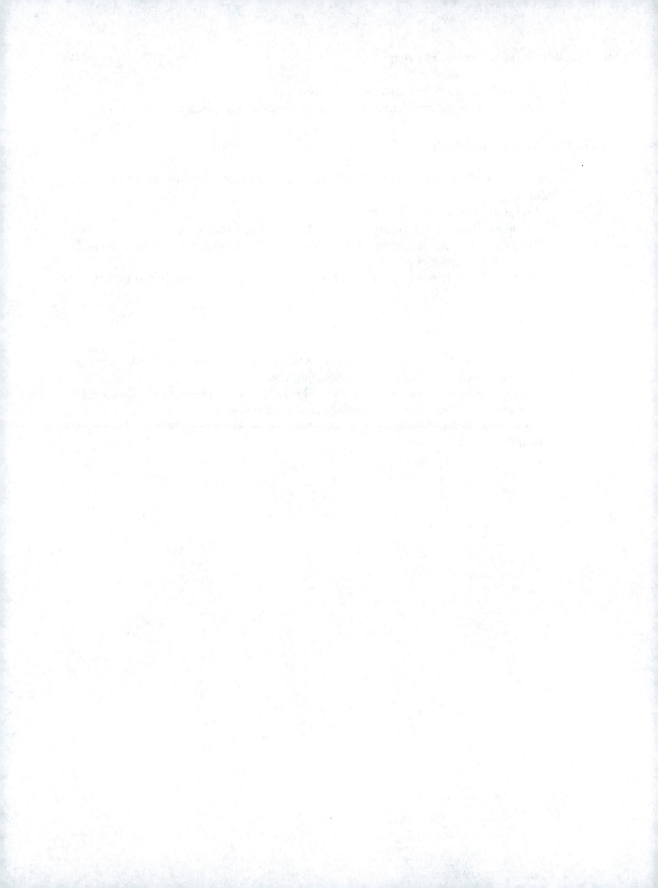

Part III

Management and Processes

8 The Cultural Fine Arts Organization as a Service

LEARNING OBJECTIVES

After reading this chapter, you will be able to do the following:

1. Define cultural arts service product quality.
2. Understand the cultural arts audience experience index.
3. Assign cultural arts consumers to typologies of engagement.
4. Relate the process of engagement to the cultural arts consumption purchase decision process.
5. Explain why metaphors matter in designing cultural arts service quality delivery.
6. Differentiate between functional and subjective cultural arts service product quality in cultural arts organizations.
7. Identify gaps in cultural arts service product quality.
8. Explain why gaps between consumers' expected and perceived cultural arts service quality need to be closed.

9. Develop blueprints and maps for functional and subjective cultural arts service product quality offerings.
10. Utilize tools to measure both types of cultural arts service product quality.

SPOTLIGHT: WALTON ARTS CENTER AND POSTPERFORMANCE POST-IT NOTES

The Walton Arts Center in Fayetteville, Arkansas, initiated an arts service product quality initiative, which included postperformance parties with artists and shared comment "exercises," to reduce the anxiety that audience members feel about contemporary dance and other art forms. The "Post-it® note" component provided an easy, fun, and anonymous forum for audience feedback and sharing.[1] The program is simple enough: a Post-it note is affixed to the cover of each printed program for a certain set of performances. The note prompts audience members with a question about the performance or how it affected them. Signs in the lobby and a precurtain announcement encourage the audience to participate. After the performance, audience members congregate in the lobby for the postevent party. Cocktail tables with extra Post-it notes and pens further urge response. Audience members who write comments are instructed to stick them to the front window in the lobby for everyone to see. Most comments are posted anonymously. Although the notes are displayed only during the postevent party, they are compiled and transcribed for future use in marketing promotions and online content development.

Walton's Post-it note program encourages audience members to write "what they long for" and other feedback on cards and post them in the lobby after the show. Staff take pictures of the cards and post highlights to the company's Facebook page. Additionally, a Secret Desires online forum was set up for both audience members and others to join the conversation. Walton plans to continue to utilize Post-it notes to generate and disseminate audience feedback. Its vision is to have a visual artist work with the comments to create a digital art piece for the arts center's lobby that would continually incorporate new comments as they are collected.

Minimal staff time is required to craft appropriate questions or prompts that elicit feedback; hard materials, like index cards and Post-it notes, are relatively inexpensive; and open forums allow for a dynamic and unpredictable conversation.

Implementing a process like this to aid with assessing arts service product quality is relatively straightforward and can be done with some foresight and planning. Think about what type of feedback you want to elicit: reactions to the artistic production, or more topical responses related to a theme or issue arising from the work. When feedback is anonymous, more personal and interesting responses are possible. Gathering feedback both on-site and on social media is key to disseminating audience reactions and encouraging audience dialogue.

The online component prolongs the conversation and can serve to magnify the impact of the experience. Overall, low-cost, postevent engagement processes like this are great vehicles for audiences to provide and share feedback. Provocative questions encourage deeper reflection on the experience and themes related to the artwork specifically. The resulting torrent of user-generated content can be repackaged for marketing purposes and leveraged through social media to benefit a wider audience.

Walton's Post-it note program was highly successful on multiple levels. Not only did it encourage audience members to provide feedback in general, but it also allowed them to share thoughts with others in a nonthreatening environment because the notes were mostly anonymous. Comments were also useful to staff in that they provided input to future marketing. Artists, who read comments at postevent parties, were highly affected by the notes, which provided them with direct and often personal feedback on their work.

Overall, these types of engagement activities have the possibility of being useful to foster conversation between the organization and the audience, as well as among audience members themselves. One of the keys to scaling up audience conversation is to disseminate comments online. The comments and feedback that audiences provide are valuable content for any form of communication with other audience and community members.

ESTABLISHING SERVICE QUALITY METAPHORS FOR ARTS ORGANIZATIONS

In Chapter 4, the concept of the cultural arts as a service product was introduced. Providing cultural arts experiences to the marketplace or space requires that the cultural arts organization leaders or the culturepreneur deliver excellence in customer service and quality in both tangible and intangible offerings.[2] And while we have already defined services as intangible, there are aspects of the servicescape and delivery that are important to tangible cultural arts as well, because it is often the service aspects of product sales that influence consumers and their attitudes. Today, every touch point with a consumer by anyone or any system representing the company is considered a function of the service aspects of the delivery of the service product. *Touch points* are those locations where the consumer comes into contact with some aspect of the organization.[3] They include the full range of contacts that can be had with the company, such as information and branding about the company, its critical reviews, marketing and virtual dialogues, consumer to consumer interactions, and the actual consumption at the point of the cultural arts offer. Each encounter with the organization is a touch point with the consumer or the patron, members of the board, internal employees and volunteers, granting organizations, bankers—in short, all stakeholders will formulate an impression based on the quality of the service encounter they experience.

In Chapter 5, market entry strategies were introduced, as applied to cultural arts organizations as services or producers of goods, and Chapter 6 moved into understanding cultural arts consumers. This chapter begins to provide a framework to conceptualize that level of service and quality that is intended to purposely provide a more than satisfied customer that incorporates value management. The purpose of doing this is to contribute to the cultural value, revenue, and profit growth of the company sustainably, in a systematic manner. As such, specifically the chapter provides designs, methods, and processes to understand the way cultural arts organizational service delivery processes flow, and choices regarding their implementation in a cultural arts company. Leaving these important mechanisms to chance can lead to frustration on the part of all concerned.

There is an "experience" every time a service is delivered. Sometimes these experiences are very short in duration (e.g., ordering tickets online), while other experiences can be quite lengthy (e.g., a weekend-long cultural arts festival). Every experience ultimately becomes a memory for cultural arts consumers, impacting their attitudes and influencing their postpurchase evaluations. The recognition that all cultural arts are experiences or processes has significant implications for understanding consumer behavior and for management strategy related to the cultural arts. The importance of this recognition cannot be overstated. In the cultural arts, consumer "experience management" is particularly relevant, and knowing how to provide that experience through service quality is the purpose of this chapter.

To begin, it is useful to imagine the layout or the overarching system that will define the cultural arts service experience. One way to do this is by thinking about the structure of the company metaphorically and understanding its touch points. There are two mind-sets regarding approaching cultural arts service products relative to these touch points. One is an experiential orientation and the other is considered production-oriented. Are you focusing on a cultural arts service production process or a cultural arts experiential process?

Service production processes are established for efficiencies, while service experiences are conceptualized as a theater. Within this dichotomy, note that the choice of the arts service product quality metaphor is likely to impact the arts organizational culture. The conversation about creating a culturepreneurial organization will be taken up in Chapter 9. For now, we look at each of the two metaphorical processes of production or experience in the next section. After that, we discuss the aspects of *functional* and *subjective* cultural arts service quality, and designing an experience from the cultural arts consumers' perspective. Last, we raise the issue of dealing with *gaps* in what cultural arts consumers *expected* to receive and what they *perceived* about the experience—that is, where it measured up and where it fell short.

METAPHOR OF SERVICES PRODUCTION: FOCUSING ON PROCESSES

When entering a medical office in the United States, typically a newcomer is greeted with either a staffed or inadequately staffed reception window, given instructions, and then directed to wait until called. Someone, usually a nurse, eventually calls names standing at a door, beckoning the patient to come forward. Once behind the

door, vital signs are taken, and the patient is directed to sit in an exam room to wait for the doctor. After consulting with the doctor, patients are whisked out of the room and around to the other side of the office, where they are given further instruction or directions about their health situation and then directed to the exit. The same kind of service production process confronts consumers when they call a phone number, for example, to order cable service, and are given a nested menu of items to choose from before being asked to wait several minutes until finally a human being is free to talk to them on the phone. In some cases, the caller has no need or desire to speak with someone, and therefore the service is conducted entirely by an automated attendant or on the Internet. These examples may evoke personal experiences in the reader's mind, where waiting was frustrating or incorrect information was provided at each of these touch points. Theoretically, the service as a production metaphor is meant to process consumers, called patients, students, clients, and so forth, in an efficient way. A diagrammatic example is given in Exhibit 8.1.

In the cultural arts organization, some of the processes can be geared toward production in terms of efficient service management. Buying art works via online auction, making a contribution to a charitable drive via telephone or Internet, and buying tickets online are examples of arts service delivery that could benefit from use of the production metaphor in designing touch points. The goal is to provide the service efficiently and, in many cases, cost-effectively. What is important to realize is that overlapping processes are occurring, generally simultaneously.[4] There is the *services marketing area* of the eight *P*s covered in Chapter 6, which encompasses a promotional mix such as advertising, press releases, promotional specials, reviews and criticisms, and social media content; there is the *service delivery area*, comprised of people and technology, that interacts with the cultural arts consumer and is part of the direct experience of the cultural arts offering purchase; and behind the promotional mix and supporting the service delivery are the *operational activities* that make the service encounter possible. All three of these areas impact the

Exhibit 8.1 **Service as a Production Metaphor**

purchase and consumption experience. By categorizing these as a factory production process, it will be clear that the goal is to provide an efficient system that can be scaled for economies for faster, less costly production. The point will be to manage each area, with an eye toward balancing personal service experiences against resource availability.

METAPHOR OF SERVICES AS DRAMATIC THEATER: FOCUSING ON EXPERIENCES

While the metaphor of production attends to the processes that deliver the service, the metaphor of drama concentrates on the experiences consumers take away from interacting with the organization at each touch point. In this metaphor, the actors, sets, backstage functions, audience, and performance make up the overall experience, as depicted in Exhibit 8.2. You might recognize this metaphor if your company is a performing company! However, think of the experience at one of Disney's theme parks or Universal Studios in California, or reenactment locations such as Colonial Williamsburg in Virginia,[5] to facilitate translation of the dramatic experience metaphor to the cultural arts organization. The *actors* are all the people who assume *roles* to influence the arts consumer—not only the individuals who ultimately deliver the cultural arts offering on a stage or in a gallery, but also other staff members who interact with the cultural arts consumer, such as across marketing and virtual contexts. The *audience* is the arts consumer, whose experience is connected with both the actors and other arts consumers as a whole. The overall experiential process takes place during the actual consumption moment and at other times, such as when word-of-mouth discussions occur. When talking about the *setting*, we mean

Exhibit 8.2 **The Arts Experience as a Metaphor of Drama**

Stellar Arts Offerings and Service Provided

Communicated in Arts Organization Marketing

Yields Rave Reviews

Positioning your image purposefully
- There are *roles* for all staff
- *Cast* extends beyond the focus of the arts offering
- Precise *staging* of functional and subjective
- Intense focus on quality

Exceptional Arts Consumer Experiences

Source: Stephen J. Grove and Raymond P. Fisk, "The service experience as theater," in *NA—Advances in Consumer Research* 19 (1992), 455–461.

how the service encounter impacts the arts consumer's senses and attitudes, which also positions the organization through the servicescape. *Backstage* functions will be areas of the organization that consumers are never supposed to see because, if they did, the sight would undermine the experiential aspect of the arts offering, bringing them back to reality. For example, the audience does not want to see performers changing costumes, how the lighting is arranged, or an auctioneer's irritation.

In this kind of understanding of the cultural arts experience metaphor of drama, shown in Exhibit 8.2, there is no point at which the arts consumer is secondary in the thoughts of the arts organization, and all the staff members know their script lines and cues. Additionally, the arts company provides the script lines and cues for the arts audience, perhaps by giving them reading materials, programs, notes, or directions about when to move about the cultural arts offering space.

The determination of which metaphor to emphasize and where within the arts organization to employ it is very important. It will impact every process undertaken in the cultural arts service delivery, ultimately influence the direction the organization will head, and, importantly, the cultural arts consumer's experience relative to the organization's position in the cultural arts industry. The takeaway is to determine the overall metaphor deliberately, without unconscious and haphazard mixing of the two. However, regardless of which metaphor guides the strategic direction of the firm, either efficiency or extraordinary audience experiences, there are two levels of arts service quality: subjective quality and functional, or peripheral, quality. In terms of functional quality, the five dimensions of service quality that underlie the process are reliability, assurance, empathy, responsiveness, and tangibles.[6] The elements of subjective quality in a cultural arts service product include knowledge, risk, authenticity, and collective engagement.[7] The next section of the chapter delves into these two areas of arts service product quality.

QUALITY ARTS SERVICE PRODUCTS AND PERIPHERAL SERVICES

What is quality? Can it be defined? Or is it something that is intuitively known? Robert Pirsig, the author of *Zen and the Art of Motorcycle Maintenance*, suggests that quality cannot be articulated because it is experiential. This idea is taken to apply to the arts offering. The quality of a cultural arts experience is based on individual and personal definitions that arise from one's own subjectivity.[8] Whether you agree with Pirsig's point of view or not, it is true that there has been much research in the realm of service quality and its impact on consumers.[9]

Partly arising out of the discussion of quality is an extensive set of literature and research focused on consumer satisfaction and loyalty.[10] The current view is that consumer satisfaction and consumer loyalty are impacted by perceived service quality. Perceived service quality in the arts offering is comprised of both functional and subjective quality. Moreover, satisfaction is influenced by the consumer behavioral influences on the consumption experience. In other words, a fantastic performance or presentation of exquisite works of art—that is, the *arts service product*—is not in and of itself sufficient to translate into *perceived value*. Perceived value for a cultural arts consumer is comprised of *both* the quality of the arts service product itself and the

quality of *peripheral services*. Attention to the perceived overall value of the service encounter is paramount. Cultural arts consumers do perceive a difference between subjective and functional quality and note that they pay for more than the cultural arts offering: "only true dedicate[d] [cultural arts consumers] put up with" poor functional quality.[11] Simply, there are two areas of concern: the arts service product, such as the performance or the auction, and the peripheral services that act in concert to deliver the arts service product experience. Both need to be accounted for because *both* contribute to perceived value. Rather than focusing on "satisfaction," the level of arts consumer *engagement* is more meaningful in this context. As such, functional quality in the peripheral services of an arts organization together with subjective quality in artistic offerings increases the perceived value; and with increasing levels of service quality the outcome desired is to increase the degree of arts consumer engagement.

Our first focus is on the functional quality, or what we define for the cultural arts organization as *peripheral services*, while the second focus is directed to the technical aspects of the subjective quality that come together to produce the *engaged cultural arts experience*. Underlying this latter point, it needs to be emphasized that it is taken as a given that the actual cultural arts service product you deliver will be aesthetic and in some way demanded by cultural arts consumers to fulfill their self-actualization needs, as discussed in Chapter 3.[12] As such, peripheral service dimensions, including reliability, assurance, empathy, responsiveness, and tangibles, impact value perceptions,[13] while engagement acts on the need fulfillment in the quality cultural arts service product encounter. These two directions of quality are depicted in Exhibit 8.3.

Exhibit 8.3 **Directions of Value in Arts Service Elements of Quality and Peripheral Service Quality Dimensions**

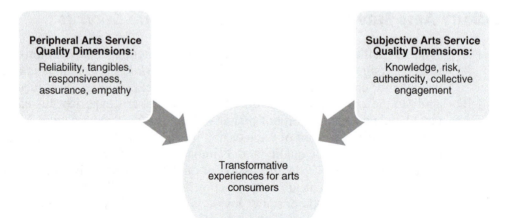

Sources: Jennifer Radbourne, Katya Johanson, Hilary Glow, and Tabitha White, "The audience experience: Measuring quality in the performing arts," *International Journal of Arts Management* 11, no. 3 (2009), 16–29; Valarie A. Zeithaml, Mary Jo Bitner, and Dwayne D. Gremler, *Services Marketing: Integrating Customer Focus Across the Firm*, 4th ed. (New York: McGraw-Hill Irwin, 2006).

PERIPHERAL SERVICE DIMENSIONS

Peripheral, or functional, service quality, as perceived by arts consumers, has come to be analyzed according to five dimensions of cultural arts service encounters, which include any interaction between a cultural arts consumer and your organization, whether physical, electronic, or virtual, whether accidental or planned. These five dimensions are reliability, assurance, empathy, responsiveness, and tangibles. These dimensions are used to evaluate the differences between an *expected* and a *perceived* service, or what is known as the *gaps model of service quality*, which we will turn to later in the chapter.

Reliability is that dimension that evaluates whether the company dependably provides the same, worse, or better levels of service at each encounter and delivers what it promises. A cultural arts consumer who comes to or calls the ticket office, for example, expects to find it open during stated hours and to be greeted by knowledgeable, courteous people who can provide help in a timely manner. Arts consumers who attend an event expect to be exposed to the particular level of service experience that you have promised. Did you promise a fancy event, such as a wine bar or a catered intermission? Or did you promise that the consumer will enjoy an escape from the quotidian aspects of life by attending your event? When these and other kinds of encounters are inconsistent and do not meet your stated promise, the reliability as perceived by the cultural arts consumer is diminished, contributing to a reduction of perceived quality.

Assurance comes to the cultural arts consumer by way of the organization's ability to gain the consumer's trust and confidence. Examples here include providing the service promised for the price; exhibiting ethical stewardship with finances; having adequate funding sources and levels; and providing positive media representations about the organization. In addition, if a cultural arts consumer wants to gather information before an event or offering, the information available would be accurate, timely, and complete, containing any instructions needed to provide information the consumer seeks. Overall, the arts consumer should be confident that the company is led by people who know what they are doing and want to do it.

Though often not directly stated, cultural arts consumers expect the cultural arts service organization's leaders, volunteers, employees, and stakeholders to care about them—personally. No one wants to be treated as a faceless number; arts consumers want to be treated as if they matter. *Empathy* is given through individual attention to cultural arts consumers when they have a question, a problem, or an idea to convey. *Responsiveness* then is expected in the sense that solutions and help are given promptly and ideas are truly considered. The physical appearance and tactile portions of the cultural arts service product—programs, the venue, the location, waiting time, the annual reports, and the types of merchandise—are all contributors to the *tangibles* of the expected service quality.

As you can see, these five dimensions are somewhat intertwined. The expected service in the peripheral areas is very important and contributes to the overall perception of the service product. If a cultural arts consumer experiences a lack in any of these, they note the gaps in service quality that cause a less than optimal

experience. The gaps in service quality in these peripheral areas negatively impact the subjective, or technical, quality of the cultural arts service product itself.[14]

The arts consumer's service encounters with electronic devices are another area in which gaps can occur between what the consumer expects and what is delivered. We cover this topic in more detail in Chapter 11 on technology and the cultural arts, but here, suffice it to say that cultural arts consumers expect the electronic environment to be on par with today's world. Your website or social media pages have to engage arts consumers and also have to be navigated easily so cultural arts consumers can find what they are looking for. Information about the organization, the calendar, reservations, purchase, donations, and samples of the service product need to be readily available. Many consumers would expect a mobile application as well. It goes without saying that an arts organization's commercial website that arts consumers use to enter sensitive personal data must be completely secure. This is an area that falls under the assurance aspect of expected service. If security is not a possibility and you are unable to handle transactions, your website should be only a promotional tool. At the same time, do you promise that you will not sell cultural arts consumers' personal contact information or other data? This is an area of reliability, in which you keep your promise. The website is the face of the organization that reaches around the world, and it often is the first level of service encounter in today's information age. As such, your website should be a pleasing experience for the user as well as providing a valuable function. The peripheral service quality areas within an arts organization constitute one aspect of the perceived value equation. To complete the analysis of arts service quality and perceived value, the chapter takes a close look at the elements of subjective quality.

ELEMENTS OF SUBJECTIVE QUALITY

In the evaluation of quality relative to the subjective aspects of the cultural arts service product, the goal is to incite, through a hedonic response, from the emotions, feelings, imagination, and intellect, an absorbing, transformative, and personally relatable and defined experience in the cultural arts consumer.[15] Here the expectations of arts consumers are not to be taken lightly. The perception of quality rests with a physical reaction, which also engages their memories and fantasies, but importantly provides for mental exercise and development that meets self-actualization needs for connectivity and transformation.[16] A self-actualized experience tends to formulate an intention to repeat the purchase of the cultural arts service product. In addition, as was the case with peripheral service quality, there is a difference between audience satisfaction and engagement. Therefore, in adapting these aspects, especially the transformative connection needed to bridge a self-actualized experience, four areas are important in measuring gaps in subjective arts service quality. They are knowledge, risk, authenticity, and collective engagement.

As was alluded to earlier in the chapter, *knowledge* comes to cultural arts consumers in the form of information to help them understand and set expectations about the cultural arts experience they are going to undertake or participate in. Will

the consumption of the cultural arts offering fulfill needs? Many arts services products are intangible and produced with little name recognition or branding; therefore, without the appropriate prior knowledge, it may be difficult to assess the likelihood that the cultural arts offering will return the cultural arts consumer to a desired ideal state.

Several knowledge points are accessible, for example, in pre-event lectures, photographs, videos, or demonstrations that set forth details about the cultural arts offering, and arts consumer should be encouraged to attend, watch online, or download them. These sources could include biographical sketches of the artists, including their education, upbringing, and trials and tribulations in attaining success. Some information should be made available before the event and also provided during the event. Other information that is ripe for facilitation during the event connects the cultural arts consumer to the event, such as reading, hearing, or visualizing devices that all can partake of passively or by volunteering. Providing these kinds of knowledge interactions via communications can both exceed the cultural arts consumer's expectations and enhance the perceived receipt of the promised cultural arts service product.[17]

One contributor to the subjective quality of cultural arts services vis-à-vis attendance or participation in the cultural event by audiences has to do with *risk*. As mentioned in Chapter 6, risk, which comes in many forms, is based on the idea that there is something at stake that may or may not be recoverable. The types of risks discussed included functional, financial and economic, psychological, time, and social risks. Providing information before an event can alleviate cultural arts consumers' sense of risk and help them determine if a cultural arts offering fits with their values, beliefs, and lifestyles. The lower the risk, then the higher the degree of target audience participation will be. Of course, if the cultural arts consumer is looking for participation in something of a higher risk, the cultural arts offering would emphasize this in its informational messages and pricing. However, in general, lowering the perceived risk of the cultural arts offering along with emphasizing the perceived value is the ultimate goal in this aspect of subjective quality in cultural arts services.

The next aspect of subjective quality in the cultural arts service products centers on *authenticity*. In the tangible cultural arts, the original or authentic art work is highly sought after by the cultural arts market, while in the intangible cultural arts the authentic experience represents a moment of truth, wherein the cultural arts audience perceives the offering as being what was promised.[18] Both types of authentic experiences rest upon the relationship between what is being experienced and the art offering as described in knowledge creation through the information provided about the offering. Importantly, authenticity incorporates a component of believability, based on the cultural arts consumer's perception, and provides an existential moment. This moment evokes a state of being that places the arts consumer outside the mundane, day-to-day, individualized routine of life, providing a sense of awe.[19] At the same time, this existential moment connects the audience or group of cultural arts consumers, binding them together within the authentic experience.[20]

Experiencing awe and the existential moment in relation to the cultural arts offering, reduced risk, and increased knowledge lead to the last piece of the subjective

quality analysis: a notion of collective engagement. The feeling of *collective engagement* is the sense that the individuals within the cultural arts consumptive experience are somehow in tune with similar thoughts and emotions, which may or may not be expressed or articulated at the moment, but which capture the awarenesses generated by the cultural arts experience itself. In other words, this is the construction of meaning generated by the event that can be shared within the context of the existential moment, and it confirms the point that human beings are not alone.

Like the dimensions of service quality discussed in the preceding section, these four areas of subjective quality can be used to assess the value derived from the cultural arts offering, using the *Arts Audience Experience Index*.[21] Each element of subjective quality is measured on a numeric scale from 1 (low) through 5 (high). The index can be used to assess cultural arts consumer experiences and thus to adjust the organization's cultural arts offerings. As you can see, these indexical areas are appropriate for marketing research in order to fine-tune the cultural arts service product mix. Qualitative and quantitative marketing research approaches are both accessible using the index. In Chapter 7, details on conducting marketing research are covered.

Brown and Ratzkin suggest that in addition to the Arts Audience Experience Index, there is an *arc of engagement*.[22] This arc is similar to the cultural arts consumer purchase decision process covered in Chapter 6. Yet the process envisioned by the arc of engagement begins at the point of cultural arts consumption rather than at problem recognition. If the cultural arts consumption experience achieves the level of quality sought, it has a lifelong impact on cultural arts consumers, which will reinforce their consumption intentions.

The arc of experience consists of *build-up* and *contextualization* at the point the cultural arts consumer decides to attend or participate in the event. Next, the cultural arts consumer *participates intensively*, through a variety of interactions developed around or at the cultural arts offering point. Third, there is the *actual cultural artistic exchange*, whereby the arts service product is consumed by the participant. After this, when the cultural artistic exchange is complete, the *post-cultural arts event processing* and *meaning making* occurs. Finally, these four stages culminate in an *impact echo*, whereby cultural arts consumers experience something about the offering that causes them to remember or dismiss it.

Within the arc of experience, cultural arts consumers can be categorized within a typology relative to postengagement and the impact echo. There are six categories: *readers, casual talkers, technology-based processors, insight seekers, critical reviewers*, and *active learners*. *Readers* are people who read information but are not deeply engaged. Next, *casual talkers* look for the socialization provided by the cultural arts consumption event, where they can talk about the experience informally. *Technology-based processors* enjoy online interactions and use the Internet to gather information before attending the cultural arts offering; they then remain connected to the event by reading discussion posts for social and intellectual stimulation. *Insight seekers* explore the meaning created by the art, motivated by the desire to understand the artist's motivations and inspirations toward creativity. This group enjoys the lectures and discussions at the venue. *Critical reviewers* are reliant on professional opinions of cultural arts offerings that stem from trusted sources.

Critical reviewers, moreover, are knowledgeable about the cultural arts yet continue to look for validation from external experts; they enjoy critical dialogue. Finally, the *active learners* can be thought of as those who wish to do the art itself at or before the cultural arts offering.

There are four continuums that each cultural arts consumer typology can be arranged upon: (1) from individual to social participation, (2) from preference for peer-based to expert-led interactions, (3) from active to passive participation in the cultural arts experience, and (4) from consumption of community-based to audience-based cultural arts offerings. Exhibit 8.4 summarizes the concepts covered in this section of the textbook.

Note that if the cultural arts organization conducted the appropriate risk management processes at the outset, allowing cultural arts consumers enough information to make a decision about the experience they are likely to have, their expectations would be in alignment with the kinds of experiences that would reinforce their view

Exhibit 8.4 **Measures for Subjective Quality in the Arts Consumer Purchase Decision Process, the Arts Audience Experience Index, and the Arc of Engagement**

The Arts Consumer Purchase and Decision Process	Experience or Engagement Factor	Scaled (1–5) Subjective Quality Measures
1. Separation from the arts consumer ideal state		
2. Information gathering		Attitude Measures
Internal	*Arts Experience Index*	
External	• Pre-arts offering knowledge	Media and personalized communications
	Arc of Engagement	
	• Gathering information	Notes, prior marketing information
3. Alternative evaluation	*Arts Experience Index*	
	• Risk	Previews, talks, self-actualization exercises
4. Purchase/consumption of the arts offering	*Arc of Engagement*	
	• Build-up	Artistic interviews, social media, audio/videos,
	• Intense preparation	notes programs, lectures, website interactions,
	• Artistic exchange	perceptive emotional interpretive connections
	Arts Experience Index	
	• Authenticity	Believability, promises, performers, relationships
5. Postpurchase processing	*Arts Experience Index*	
	• College engagement	Shared experiences, interactions, discussions
	Arc of Engagement	
	• Meaning and impact echo	Post-arts offering dialogs (immediate and later)

Sources: Alan S. Brown and Rebecca Ratzkin, *Making Sense of Audience Engagement*, Vol. 1: *A Critical Assessment of Efforts by Nonprofit Arts Organizations to Engage Audiences and Visitors in Deeper and More Impactful Arts Experiences* (San Francisco: San Francisco Foundation, 2011); Jennifer Radbourne, Katya Johanson, and Hilary Glow, "Empowering audiences to measure quality," *Participations: Journal of Audience & Reception Studies* 7, no. 2 (2010), 360–379; Jennifer Radbourne, Katya Johanson, and Hilary Glow, "Measuring the intrinsic benefits of arts attendance," *Cultural Trends* 19, no. 4 (2010), 307–324; Roger Kerin, Steven Hartley, and William Rudelius, *Marketing*, 10th ed. (New York: McGraw-Hill/Irwin, 2010).

of need fulfillment and self-actualization. What this means for establishing value from subjective quality is that there are quantifiable measures available for the cultural arts manager and culturepreneur to determine the level of subjective quality the cultural arts consumer desires. Taken together with the functional quality dimensions, these areas can be designed and assessed for the gaps between expectations and actual experiences of cultural arts services products. In the next section, the discussion turns to potential gaps in the quality of cultural arts service products and some methods and processes for analyzing and/or correcting them.

GAPS ANALYSIS IN ARTS SERVICE PRODUCTS AND DELIVERY

Within the earlier portions of this book the phrases "perceived quality" and "cultural arts consumer expectations" were used. These phrases are meaningful because what cultural arts consumers expect from an offering and the perceived quality they ascertain together form an experience gap between the organization and the consumer. Arts consumer expectations are the preconceived ideas that consumers bring to the cultural arts service experience, and the perception is what they glean or take from the engagement. The goal is to have the perceived arts service equal or exceed the expected service so that there is no distance, or gap, between the two. Exhibit 8.5 illustrates this distance. In order to achieve the goal, the cultural arts organization leaders listen carefully to the cultural arts consumer through research and analysis of the dimensions, indices, and continuums described in the previous section. By adjusting the cultural arts offering relative to consumer expectations and the functionality of arts service quality, the organization can therefore meet or exceed cultural arts consumer perceptions across experiences in both functional and subjective service quality areas.

There are four sub-gaps that constitute the overall service quality gap, and these can be applied to the cultural arts as a service organization.[23] The first one addresses the need for the cultural arts organization to properly research cultural arts consumer expectations before making an offering. At the same time, cultural arts organizations must develop and put into place active methods for both retaining cultural arts consumers and addressing service failures. *Service failures* are those points along the arts service product delivery process where consumer expectations are not met.[24] Addressing service failures is essential in order to ensure that the cultural arts

Exhibit 8.5 **The Gap Between the Expected and the Perceived Arts Service Product**

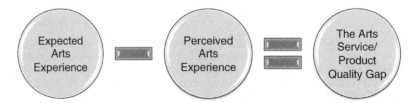

Source: Valarie A. Zeithaml, Mary Jo Bitner, and Dwayne D. Gremler, *Services Marketing: Integrating Customer Focus Across the Firm*, 4th ed. (New York: McGraw-Hill/Irwin, 2006).

consumer is not alienated and left with a perception that undermines the organization and causes the consumer to disengage, while the effort to retain consumers is to keep the cultural arts consumer actively engaged.

The second area for analysis is the cultural arts servicescape design and the cultural arts organization's functional and subjective service quality levels. As was discussed earlier, cultural arts organizations are framed around themes of efficiency or experience. Is the service design following a theater or production metaphor? Is the cultural arts organization concerned with efficiency or experience? Has the cultural arts consumer's voice been accounted for in the design and in the cultural arts offerings? Later in the chapter we turn to a discussion of blueprints and designs for cultural arts organizations, but for the moment it is important to understand that the design and standards of the cultural arts offering impact the quality perceived by the cultural arts consumer.

With the second area for gaps established, the third gap arises when those service designs and levels are not properly implemented. That is, when the cultural arts organization has completed the process of listening and sketching the servicescape design and cultural arts offerings in conjunction with feedback from the cultural arts consumers, systems and processes will need to be implemented to deliver the experiences that cultural arts consumers seek. It is here that the actual cultural arts service product meets the goal of the designs of artistic subjective quality levels that the organization seeks. Areas included for analysis here encompass managing demand and supply of cultural arts offerings, functional service quality levels, peer-to-peer interactions between cultural arts consumers virtually and in reality, and human resource issues.

In addition, when the cultural arts organization makes promises through its promotions, care must be taken to ensure that the messages are consistent and that the promises can be kept. Here is where the advertising and media messages link to aspects of the information and knowledge that the cultural arts consumer will use to make a decision about a cultural arts offering. It is critically important that the messages be relevant and accurate. If there is a disconnect between the promotional mix elements and the expectations they instill in the cultural arts consumer, and the perception of what was experienced, then there arises a fourth gap in service quality. In total, there are four areas that can be sources of differences between expected and perceived quality, which together compose the overall gap in cultural arts service quality. To summarize, the cultural arts organization can match expected to perceived cultural arts service quality by careful attention to the following tasks:

- obtaining details from listening to the cultural arts consumer through marketing research
- establishing designs and standards
- putting processes in place to ensure they are met
- taking care to match promotions with cultural arts service product delivery

Importantly, these gaps can be assessed. Many organizations conduct their research into differences in expected and perceived quality through an instrument known as SERVQUAL.[25] This instrument measures twenty-two service quality

constructs within the five dimensions of functional service quality. In practice, this instrument can be a bit onerous to utilize in the cultural arts organizational context; however, assessing quality is very important and the difficulty in using the instrument suggests that it be adapted or modified, and used at minimum as a starting point. As Hill and colleagues suggest, modification of the SERVQUAL instrument in order to adapt it to a cultural arts organizational context was found to be revealing.[26] Hume and Mort have developed a modified research instrument to separately evaluate functional and subjective quality in the classical performing cultural arts, and this kind of adaptation can be applied in general for the cultural arts organization.[27] Hume and colleagues utilized a service transaction analysis paradigm in conjunction with aspects of SERVQUAL to assess differences between expectations and perceptions, as well as demonstrate the differences between functional and subjective quality outcomes, and their relationship to cultural arts consumers' self-actualization needs. Their findings clearly highlighted that the cultural arts organization leaders believed that if cultural arts consumers were satisfied with the subjective cultural arts experience, they would develop into repeat attenders and participants. However, as noted earlier, cultural arts consumers do perceive a difference between subjective and functional quality and pay for more than the cultural arts offering: "only true dedicate[d] [cultural arts consumers] put up with" poor functional quality.[28] Moreover, cultural arts consumers' perspectives of service quality at both levels differed from those of cultural arts organizational leaders. Stated differently, there are gaps in expected and perceived service quality among cultural arts consumer segments that influence value for the cultural arts consumers and, in turn, ultimately effect the cultural arts organization. As such, it is necessary to know both the cultural arts consumer segments' expectations and perceptions, and to design methods and processes adapted for the cultural arts organization through a SERVQUAL frame that reveals those expectations and perceptions and that positions the cultural arts organization to effectively address and manage them. In Exhibit 8.6, areas for analysis are shown between the subjective and functional quality gaps analysis that can be applied to the cultural arts organization.[29] One way to address these gaps is through appropriate service delivery designs. Therefore, the next section seeks to describe aspects of blueprinting and designing that allow for quality in the delivery of cultural arts service products.

Exhibit 8.6 **Factors Creating Gaps in Arts Service Product Offerings**

Zeithaml et al. have demonstrated the suitability of the analysis of service quality using reliability, assurance, tangibles, empathy, and responsiveness to measure gaps between expected and perceived quality. SERVQUAL consists of twenty-two items that attempt to get at the distances between perceived and expected quality as experienced by the consumer. It has been suggested that the instrument can be used by nearly any service product organization. However, Hill et al. suggest that it may be difficult to actually formulate a modification of SERVQUAL, arguing that there is too much subjectivity in translating subjective data into quantitative measures. They also suggest that the arts attender may have ideas that are simply not possible due to the environmental constraints that an arts organization faces, particularly if it operates in a not-for-profit context. Therefore, they developed

determinants of service quality that could be adapted in the arts, drawing on the work of Zeithaml et al. Hume et al. used service transaction analysis to examine the dimensions of service quality and developed criteria based on the SERVQUAL instrument as well. Their work suggests that there are some arts service product quality measures that are critical to arts consumers. Which is the best approach to use?

Methods of Analyzing Factors Creating Gaps in Arts Service Product Offerings

Zeithaml et al. (2006)	Hill et al. (2003)	Hume et al. (2006)	
SERVQUAL Dimensions	Determinants of Service Quality in the Arts	Critical Factors in Arts Service Transaction Analysis	Sample Arts Service Product Quality Measures
Reliability	Reliability; credibility	Credibility for exceptional emotional performance	Performance is exhilarating; promises are honored in the performance quality; brand consistency; value for the price; skill and knowledge competency demonstrated
Assurance	Competence; communication	Publicity	Publicity reflects the arts offering; critical acclaim is consistent; promotional materials are clear; media chosen are appropriate and timely
Tangibles	Physical environment; access; security	Parking; refreshments; audience flow; ease of payment	Facilities are clean, waiting is absorbed; refreshments are appropriate; restrooms are clean; parking and venue are safe; payment is simple and self-explanatory; map of venue or stage is available
Empathy	Access; courtesy	Service recovery and attention by staff members who care	Service recovery is provided for failed service; performance times are consistent and convenient; staff is polite
Responsiveness	Responsiveness; security	Exceptional personal treatment	Crowd is effectively managed; staff is available to answer questions; staff is knowledgeable, friendly, and courteous

Sources: Valarie A. Zeithaml, Mary Jo Bitner, and Dwayne D. Gremler, *Services Marketing: Integrating Customer Focus Across the Firm*, 4th ed. (New York: McGraw-Hill/Irwin, 2006); Elizabeth Hill, Catherine O'Sullivan, and Terry O'Sullivan, *Creative Arts Marketing*, 2nd ed. (New York: Butterworth Heinemann, 2003); Margee Hume, Gillian Sullivan Mort, Peter W. Liesch, and Hume Winzar, "Understanding service experience in non-profit performing cultural arts: Implications for operations and service management," *Journal of Operations Management* 24 (2006), 304–324.

BLUEPRINTS AND MAPS OF THE ARTS SERVICE ENCOUNTER

Earlier in the chapter, the drama metaphor was presented to describe certain aspects of the cultural arts service quality delivery process. It may also now seem surprising that service industries outside of the cultural arts use theater metaphors or models to establish their flows and processes for existing and new service offerings. We rely on metaphors, as was mentioned earlier, however, in cultural arts management because establishing positive cultural arts service products interactions requires deliberate concentration and management of the desired outcome. In tandem, effective culture-preneurship requires leading your cultural arts consumers to memorable personal

experiences that ultimately contribute to repeat attendance, and portraying quality within the cultural arts offering is key. *Service designs* in the form of *blueprints* and *maps* are visual aids in this process. They are based on whether your organization is focused on efficiency or experience, as presented in the opening of this chapter. As you may imagine, the service design will include the functional quality and subjective quality aspects, along with understanding the relationship between electronic interactions and the cultural arts offering, and the placement of cultural arts consumers and their participation or interaction with the cultural arts organization within this overall context.

Effective service design models (ESDM)[30] include *blueprints* and *maps* that are used to clearly describe the processes and points of possible negative interactions in order to alleviate service failures.[31] The idea is to always foresee areas of service failure and facilitate delivery of an exquisite experience nestled and closely integrated within the functional and subjective service quality framework.[32]

Blueprinting or mapping can occur during the establishment of a cultural arts offering or in revising an existing one. The key is to understand the cultural arts consumer's interaction and experience with the cultural arts organization at each of the touch points as the value drivers. How do cultural arts consumers contact your organization and when? What do they experience during that contact? How do they physically flow through the organization at a cultural arts event? What is important to them? How do you manage the capacity either physically or electronically? These are the kinds of questions that underpin the blueprints and mapping processes. Often, getting the ideas onto paper requires that the cultural arts organization leaders think about the processes, sketch them out in working sessions, and then refine them after going through the experience themselves and gathering qualitative data from cultural arts consumers.

In mapping and blueprinting, one of the first issues to illustrate is the line of demarcation, or the *line of visibility*. There are *front of the house* touch points that are facilitated by *back of the house* efforts. This is illustrated in Exhibit 8.7.

The process of cultural arts service product blueprinting requires that you understand the relationship between the cultural arts consumer and the cultural arts organization, the process the cultural arts consumer follows, the touch points with cultural arts organization personnel, and the physical aspects of the interaction. Begin by understanding the steps that would be followed by a cultural arts consumer who participates in your cultural arts offering; that is, from the cultural arts consumer's perspective, what would be the first touch point? Then what happens between the first touch point and the cultural arts event? What evidence of the cultural arts offering is there for the cultural arts consumer to actually visualize? After the cultural arts offering is concluded, what happens? How are cultural arts consumers moved within the space and what do they do while in it? Here the physical interactions are key, assuming the cultural arts offering is in a physical location. Where are the nodes where functional service quality may be an issue? For example, cultural arts consumers arrive at the door, which is the front of the house, at the line of visibility. How are they greeted? What do they see? Do they have to purchase a ticket or pick up a ticket? Are electronic tickets available? Where are the visitors directed

Exhibit 8.7 **Blueprinting and Mapping an Arts Service Product Consumption Experience**

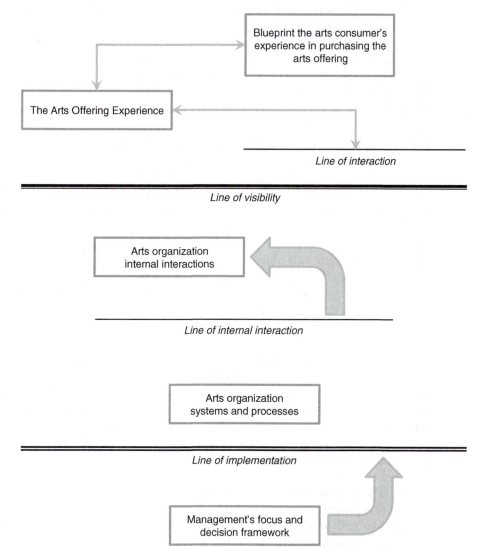

Source: Valarie A. Zeithaml, Mary Jo Bitner, and Dwayne D. Gremler, *Services Marketing: Integrating Customer Focus Across the Firm*, 4th ed. (New York: McGraw-Hill/Irwin, 2006).

and what signs or staff people are posted to clarify what they are to do? If they already have purchased a ticket, what systems are in place if they have lost it? If they have not purchased tickets, what flow are they to follow? What kinds of payment are accepted? How are waiting times managed? Can the cultural arts consumer use self-service to buy tickets in the lobby? Are they on a VIP list? Walking through the process is key to understanding it and necessary to make sure that the experiential aspects of the encounter are clear to those configuring it. All of these kinds of

variations and potential concerns are to be thought out and then blueprinted to show the flow, touch points, and areas for potential service problems so that they can be managed ahead of time.

Blueprinting is difficult to do. It requires that the cultural arts manager think critically about and write out a very complex set of interactions and linkages between the cultural arts service product touch points, processes, physical environment, and the "invisible" organizational processes behind them that impact the cultural arts consumer. The goal of this work is for the cultural arts manager to see it from the cultural arts consumer's perspective and from different segments within the broad overarching definition of cultural arts consumer. The difficulty of creating a blueprint does not eliminate the need for doing it. To simplify the process, start simply with broad processes and then add on complexity. Brainstorm with others, draw pictures, use storyboards and schematics first, and note where the cultural arts consumer will derive value. Then develop a more formalized flow diagram, so to speak. Begin with a schematic that includes

1. how cultural arts consumers become aware of the cultural arts offering
2. how they contact the cultural arts organization
3. how they experience the cultural arts offering, including digital aspects
4. how they enlarge or find meaning from it
5. what they do when and after they exit the experience

Once the cultural arts service product blueprints are formed, cultural arts service product mapping takes place. Mapping requires defining the invisible aspects of the cultural arts service product encounter—that is, the part that the cultural arts consumer does not actually see. Arts service product *mapping* is the process of overlaying the invisible *management and employee functions* that work in tandem with the cultural arts consumers' experience diagrammed in the blueprints. Arts service product maps indicate four clear lines:

1. The *line of interaction* between the cultural arts consumer and the cultural arts organization employees.
2. The *line of visibility* where the cultural arts organization's efforts manifest for the cultural arts consumer.
3. The *line of internal interaction* that indicates the location of front-facing cultural arts organization employees in regard to inward-facing staff, who work outside the cultural arts consumer's view.
4. The *line of implementation*, or the differences between operations support staff and management functions.

An effective arts service design process, then, has two distinct parts that are related and intertwined with the goal of delivering memorable and exceptional cultural arts consumptive experience that fulfill the self-actualization needs of your audiences. First, cultural arts service product blueprints give the cultural arts leaders a sense of what the cultural arts consumer experience is, thus providing the ability to create the

Exhibit 8.8 **The National Endowment for the Arts**

The National Endowment for the Arts (NEA; http://arts.gov) was established in 1965 as an independent agency of the federal government of the United States. To date, the NEA has awarded more than $4 billion to support artistic excellence, creativity, and innovation for the benefit of individuals and communities. The NEA extends its work through partnerships with state arts agencies, local leaders, other federal agencies, and the philanthropic sector.

The NEA is a storehouse and source of cultural fine arts research information and support, and you will find a number of reports that will assist in your research. NEA reports include historical and recent data about arts audiences, providing a rich resource for starting or supporting a cultural fine arts marketing research study. Information and research on environmental trends and the financial behavior of culturepreneurial firms in the cultural fine arts are available. The NEA also engages in research to assess trends in the cultural fine arts, such as technology use, artist employment, and directions of interest in particular types of cultural fine arts. The agency's website provides valuable information about arts education, using arts in learning and assessment, audience development, recently funded grant applicants, and granting opportunities. Many conferences, seminars, webinars, and workshops are convened that introduce and guide the culturepreneur and arts manager to untold resource support. Most reports are downloadable from the web without cost.

memorable experience that consumers seek from the cultural arts offering. Second, cultural arts service product mapping affords the cultural arts manager a visual aid regarding the interactions that take place within the cultural arts organization that will fulfill the cultural arts service product consumption design. The main goal is to examine the locations in order to prevent gaps in expected versus perceived cultural arts service quality.

CHAPTER SUMMARY

In this chapter, the topic of arts service product quality was introduced and covered at length. Part of the discussion centered on determining which metaphor would be the most useful. The metaphor of production or the metaphor of drama, or a combination of them, influences the way the arts organization is run and the organization's culture.

Two areas of arts service product quality were introduced. The first was the functional, or peripheral, service quality that related to the systems and process of the firm. Five aspects of functional service quality in arts organizations were explained. Next, the aspects of subjective quality, that is, the four ways in which the arts consumer engages with the firm, were set out. The Arts Audience Experience Index was shown as a tool to measure subjective arts quality, and SERVQUAL was given coverage to explain using it with the five dimensions of functional service quality. Together, functional quality and subjective quality combine to form perceived value for the art consumer.

When arts consumers' expectations do not meet their perceptions, it is called a gap in arts service product delivery. Gaps have been shown to exist between arts consumers and arts organizations, and gaps analyses can, in many cases, narrow them. Its purpose is to reduce postpurchase dissonance and to produce loyal and more than satisfied arts consumers who will continue to purchase arts offerings.

One way to identify gaps in the arts service encounter is to develop blueprints of who the arts consumer works with throughout the arts organization, and to design maps that indicate how the internal systems interact with that arts consumer. While blueprinting and mapping are a challenging task, the processes are instrumental in identifying touch points and locations of potential service failure.

DISCUSSION QUESTIONS

1. Explain the differences between the metaphor of drama and the metaphor of production. Do they apply to your organization? Why? What other metaphor can you think of to describe your arts concern?
2. Discuss the Arts Experience Index. Explain how you would use the data it provided if you used the index to survey your audiences.
3. Does the arc of engagement make it easier or more difficult to produce arts offerings? Explain.
4. What is your opinion on the discussion of subjective and functional arts service product quality?

EXPERIENTIAL EXERCISES

1. Attend three art galleries in your area, or, if you are an art gallery culturepreneur or arts manager, attend two. Note the ways in which the firms are either production- or drama-oriented. Where are the points of possible service failure? Create a blueprint and map for each gallery.
2. Attend two intangible fine arts events and create a blueprint and map for them. If you are a culturepreneur in the intangible arts with an existing organization, attend one. Note the ways in which the firms are either production- or drama-oriented. Where are the points of possible service failure?
3. What impressions do you have as you compare these experiences?

FURTHER READING

Brown, Alan S., and Rebecca Ratzkin. *Making Sense of Audience Engagement*, Vol. 1: *A Critical Assessment of Efforts by Nonprofit Arts Organizations to Engage Audiences and Visitors in Deeper and More Impactful Arts Experiences*. San Francisco: San Francisco Foundation, 2011.

Radbourne, Jennifer, Hilary Glow, and Katya Johanson (eds.). *The Audience Experience: A Critical Analysis of Audiences in the Performing Arts*. Chicago: University of Chicago Press, 2013.

NOTES

1. Alan S. Brown and Rebecca Ratzkin, *Making Sense of Audience Engagement*, Vol. 1: *A Critical Assessment of Efforts by Nonprofit Arts Organizations to Engage Audiences and Visitors in Deeper and More Impactful Arts Experiences* (San Francisco: San Francisco Foundation, 2011). Used by permission.

2. Orville C. Walker Jr. and John W. Mullins, *Marketing Strategy: A Decision-Focused Approach*, 6th ed. (New York: McGraw-Hill Irwin, 2008).

3. George E. Belch and Michael A. Belch, *Advertising and Promotion: An Integrated Marketing Communications Perspective*, 8th ed. (New York: McGraw-Hill/Irwin, 2012).

4. Christopher H. Lovelock (compiler), *Managing Services: Marketing, Operations, and Human Resources*, 2nd ed. (Englewood Cliffs, NJ: Prentice Hall, 1992).

5. Dan Eggen, "In Williamsburg, the painful reality of slavery," *Washington Post*, July 7, 1999.

6. A. Parasuraman, Valarie A. Zeithaml, and Leonard L. Berry, "A conceptual model of service quality and its implications for future research," *Journal of Marketing* 49, no. 4 (1985), 41–50.

7. Jennifer Radbourne, Katya Johanson, Hilary Glow, and Tabitha White, "The audience experience: Measuring quality in the performing arts," *International Journal of Arts Management* 11, no. 3 (2009), 16–29.

8. Ibid.

9. Parasuraman, Zeithaml, and Berry, "Conceptual model of service quality"; Valarie A. Zeithaml, Mary Jo Bitner, and Dwayne D. Gremler, *Services Marketing: Integrating Customer Focus Across the Firm*, 4th ed. (New York: McGraw-Hill Irwin, 2006).

10. J.J. Cronin, M.K. Brady, and G.T.M. Hult, "Assessing the effects of quality, value, and customer satisfaction on consumer behavioral intentions in service environments," *Journal of Retailing* 76, no. 2 (2000), 193–218.

11. Margee Hume, Gillian Sullivan Mort, Peter W. Liesch, and Hume Winzar, "Understanding service experience in non-profit performing cultural arts: Implications for operations and service management," *Journal of Operations Management* 24 (2006), 304–324.

12. Margee Hume and Gillian Sullivan Mort, "Satisfaction in performing cultural arts: The role of value?" *European Journal of Marketing* 42, nos. 3/4 (2008), 311–326.

13. Margee Hume, "Understanding core and peripheral service quality in customer repurchase of the performing cultural arts," *Managing Service Quality* 18, no. 4 (2008), 349–369; Zuleika Beaven and Chantal Laws, "Service quality in arts events: Operations management strategies for effective delivery," *Event Management* 10, no. 4 (2007), 209–219; J. Charlene Davis and Scott R. Swanson, "The importance of being earnest or committed: Attribute importance and consumer evaluations of the live arts experience," *Journal of Nonprofit & Public Sector Marketing* 21, no. 1 (2009), 56–79; Margee Hume and Gillian Sullivan Mort, "The consequence of appraisal emotion, service quality, perceived value and customer satisfaction on repurchase intent in the performing cultural arts," *Journal of Services Marketing* 24, no. 2 (2010), 170–182; Hume and Mort, "Satisfaction in performing cultural arts"; Arthur C. Brooks and Jan I. Ondrich, "Quality, service level, or empire: Which is the objective of the nonprofit cultural arts firm?" *Journal of Cultural Economics* 31, no. 2 (2007), 129–142; Radbourne et al., "Audience experience."

14. Hume et al., "Understanding service experience."

15. Radbourne et al., "Audience experience."

16. Ibid.

17. Valarie A. Zeithaml, Leonard L. Berry, and A. Parasuraman, "The nature and determinants of customer expectations of service," *Journal of the Academy of Marketing Science* 21, no. 1 (1993), 1–12.

18. Hume et al., "Understanding service experience"; Brown and Ratzkin, *Making Sense of Audience Engagement*.

19. F. David Martin, *Art and the Religious Experience: The "Language" of the Sacred* (Lewisburg, PA: Bucknell University Press, 1972).

20. Ning Wang, "Rethinking authenticity in tourism research," *Annals of Tourism Research* 26, no. 2 (1999), 349–370.

21. Sabine Boerner and Sabine Renz, "Performance measurement in opera companies: Comparing the subjective quality judgments of experts and non-experts," *International Journal of Arts Management* 10, no. 3 (2008), 21–37; Jennifer Radbourne, Katya Johanson, and Hilary Glow, "Empowering audiences to measure quality," *Participations: Journal of Audience & Reception Studies* 7, no. 2 (2010), 360–379; Jennifer Radbourne, Katya Johanson, and Hilary Glow, "Measuring the intrinsic benefits of arts attendance," *Cultural Trends* 19, no. 4 (2010), 307–324.

22. Brown and Ratzkin, *Making Sense of Audience Engagement*.

23. Hume and Mort, "Satisfaction in performing cultural arts"; Hume et al., "Understanding service experience"; Elizabeth Hill, Catherine O'Sullivan, and Terry O'Sullivan, *Creative Arts Marketing*, 2nd ed. (New York: Butterworth Heinemann, 2003).

24. Zeithaml, Bitner, and Gremler, *Services Marketing*.

25. Ibid.; Parasuraman, Zeithaml, and Berry, "A conceptual model of service quality."

26. Hill, O'Sullivan, and O'Sullivan, *Creative Arts Marketing*.

27. Hume and Mort, "Satisfaction in performing cultural arts."

28. Hume et al., "Understanding service experience."

29. Hume, "Understanding core and peripheral service quality"; Zeithaml, Bitner, and Gremler, *Services Marketing*; Hill, O'Sullivan, and O'Sullivan, *Creative Arts Marketing*.

30. Rohit Verma, Gary M. Thompson, William Moore, and Jordan J. Louviere, "Effective design of products/services: An approach based on integration of marketing and operations decisions," *Decision Sciences* 32, no. 1 (2001), 165–194.

31. G. Lynn Shostack, "How to design a service," *European Journal of Marketing* 16, no. 1 (1982), 49–63; G. Lynn Shostack, "Designing services that deliver," *Harvard Business Review* 62, no. 1 (1984), 133–139.

32. Lucy Kimbell, "Designing for service as one way of designing services," *International Journal of Design* 5, no. 2 (2011), 41–52.

9 Cultural Fine Arts Organizations and Their Management

LEARNING OBJECTIVES

After reading this chapter you will be able to do the following:

1. Comprehend the process of modeling an arts culturepreneurial culture.
2. Establish a nonprofit or for-profit cultural arts organization.
3. Understand new mechanisms for using hybrid organizational structures that balance profit motives with mission drivers.
4. Discern differences in leadership strategies in singular- and dual-led cultural arts organizations.

5. Establish a board of advisers or directors with understanding of the legal environment in which the cultural fine arts organization operates.
6. Identify and benefit from executive management teams, work teams, and work groups.
7. Determine an appropriate organizational structure and design the structure primed for growth.
8. Establish a "new" arts service product culture.

WHAT'S ON?

Octarium
"Explaining an Arts NonProfit"
YouTube, December 2, 2010
www.youtube.com/watch?v=T0W59PDwFNM

SPOTLIGHT: DISCOVERY TIMES SQUARE MUSEUM

Discovery Times Square (DTS) is a large-scale exhibition center that displays immersive cultural fine arts offerings. Located in New York City, DTS has offered immersive exhibitions including *Titanic: The Artifact Exhibition, Leonardo Da Vinci's Workshop, King Tut, Pompeii: The Exhibit, Dead Sea Scrolls: The Exhibition,* and *Terracotta Warriors: Defenders of China's First Emperor.* The center's mission: "More than a museum, Discovery Times Square is New York's destination for discovery through unique and immersive exhibits." DTS is a for-profit public company operated by Discovery Communications Inc.

Discovery Times Square Foundation (DTSF) has a different mission: "Our mission is to ignite students' passion for learning by providing them with educational, yet entertaining exhibits that will both teach and inspire them to imagine and explore. By offering specific professional credits for teachers through collaborative curriculum development, DTSF aims to provide tools that will allow teachers to grow and become better educators. DTSF is the committed educational partner of Discovery Times Square." DTSF was formed in 2011 as a nonprofit organization. You can visit it at www.discoverytsx.com/foundation.

CULTUREPRENEURIAL VERSUS MANAGERIAL BEHAVIORS

Are culturepreneurs more ethical than arts managers? Several studies have examined the question of whether there are differences between entrepreneurs and managers and whether their ethical behaviors are influenced by recent events in business practice. Both groups—entrepreneurs and managers—exhibit a high level of ethical awareness and ethical concern, with very few exceptions. According to Frederick G. Crane,[1] entrepreneurs were more likely to perceive certain practices as more

unethical, including taking advantage of company services for personal use; using company time for personal use; exaggerating the performance of a particular offering; and unfairly criticizing competitors' products. Importantly, there was no real difference between this kind of thinking and that of managers. The findings are basically a result of similar cultural and ethical attitudes. Importantly, it seems as if the new movement toward increased entrepreneurial practice that arose out of the financial crisis which began in 2007 will influence ethics in a positive direction.

Crane's findings support and extend to Canadian business ventures the results of an earlier study conducted in 2001 by Branko Bucar and Robert Hisrich,[2] who also found a strong similarity between the entrepreneurs and corporate managers in most of the areas that were explored. In Crane's study, furthermore, like Bucar and Hisrich's study, it appears that similarities in the culture, in legal, regulatory environmental variables, and in the sociodemographic backgrounds of entrepreneurs and managers contributed to the findings. However, and this is consistent with Bucar and Hisrich's findings, Canadian entrepreneurs appeared to hold stronger ethical attitudes regarding some practices compared to their corporate manager counterparts, mainly due to a view that they were owners rather than managers. Thus, mechanisms to increase ownership by managers may contribute to enhancing their ethical behavior. Establishing feelings of or processes toward ownership in a culturepreneurship then becomes critical.

In particular, given the ethical attitudes presented in these two studies, it does seem possible that culturepreneurial organization leaders can set an elevated ethical tone for this new entrepreneurial society. As has been asserted by George G. Brenkert,[3] entrepreneurship is not simply about how one creates a business. It also entails thinking about, managing, organizing, and leading today's society. In the cultural fine arts, these are absolutely as important in as much as they reflect business practices taking shape, including ethical imperatives deeply imbedded in the organization's meaning and mission. It seems that culturepreneurs and arts managers have a central role to play in leading in this area.

MODELING A CULTUREPRENEURIAL ENVIRONMENT

Chapter 1 introduced the issue of the cultural fine arts organizational structure in terms of the choice of a for-profit or not-for-profit entity. There, the concepts of culturepreneurs and the process of being entrepreneurial were explained as well. It is often assumed that a for-profit firm can be entrepreneurial because the leaders are able to take advantage of change and can adjust their processes to meet changes in the environment. Is it possible for a not-for-profit organization to be entrepreneurial? Can the entrepreneurial spirit of the leader of the firm or organization work its way down through the company? The short answers to these questions are both unequivocally yes. Thus, the purpose of this chapter is to explain ways this can be achieved, through active and directed organizational leadership and management. Attention has to be given to these areas in order to shape the direction in which the company is to go. In order to accomplish these ends, culturepreneurs and arts managers must understand entrepreneurial motivations, intentions, and behaviors in order to drive

these behaviors throughout the organization, whether it is structured as a nonprofit, a for-profit, or a hybrid of the two.

As was mentioned in the early chapters of the textbook, entrepreneurs believe in themselves and are self-sufficient. When they have an idea about a product or service, they intentionally bear the risk in bringing it to the market, perceiving that they can add value to an existing product or service or introduce new ones. This is the way that *culturepreneurs* behave as well, as they were defined in Chapter 1. Moreover, culturepreneurs are highly ethical and spend or expend their personal resources carefully and wisely. Culturepreneurial intentions, resource management, and ethical standards and behaviors can be modeled and instilled within an organization's culture. Managers and leaders of the organization are selected, retained, and rewarded based on these behaviors.

A culturepreneurial organization can be developed based on a decision framework that conceptualizes four areas leading to seizing opportunities.[4] It includes, first of all, a strategic orientation that is driven by seeking and evaluating opportunities and making a commitment to seizing short- and long-term initiatives by a systematic and controlled expenditure and allocation of resources. Secondly, the firm's organizational structure remains as flat as possible to support informed, nimble, and optimal decisions. At the same time, individuals are incentivized based on performance and delivery of value creation. Lastly, managed and planned growth is cultivated as a desired outcome of the firm. These four areas constitute the *culturepreneurial organization* that is oriented outward to take advantage of opportunities, with controlled risks and with returns on investments that are at or above stated levels.

To establish such an organization, the *culturepreneurial culture* or the environment within the organization must be systematically molded. It is comprised of eight aspects:

1. Valuing new idea generation—that is, encouraging an environment that brings new ideas for cultural arts service products to the forefront.
2. Utilizing technology—applying technological advancements when warranted.
3. Allowing for failures—giving people room to face challenges, learn, and grow.
4. Approaching and supporting management through teams—avoiding static ways of doing things.
5. Giving visible indications of senior management support in terms of resources and rewards—when good ideas are presented, the organization provides money, material, and people to develop and launch them.
6. Having the ability to establish and maintain the culturepreneurial approaches in the cultural arts service product areas—driving this commitment down through the organization in every aspect of its operations.
7. Developing leaders and champions—recognizing core strengths of people.
8. Having a long-term view of the horizon—taking the time to drive arts quality into every aspect of the firm, balanced with reasonable costs and benefits.

With these ideas in mind, the organization can be built whether structured as a nonprofit entity with or without government ownership of the infrastructure, as a hybrid structure, or as a for-profit firm.

As you can imagine from reading the opening paragraphs, this chapter's discussion explores these organizational formats. Which structure is the most appropriate? All three have advantages and disadvantages, and the choice ultimately rests with the strategic direction sought by the culturepreneur. The organizational structure will crystallize as a result, and the culture infused comes from leadership and management directions. In any case, from these stem the installation of a board of directors or a formal board, as the case may be; the formation of management and other teams and departments; and the systematic addition of new cultural arts service products.

ESTABLISHING A NONPROFIT ORGANIZATION

Many cultural arts organizations are nonprofit in structure,[5] built upon mission-driven goals and beneficial exchanges. Nonprofit cultural arts organizations can be explicitly arranged as such, embedded within another organization, or nonprofit in its identity only. For the most part, when talking about nonprofit cultural arts organizations, the reference is to those "nonprofit organizations that are hegemonic in the fields of art and historic exhibition."[6] These are organizations such as museums, some cooperative art galleries, performing cultural arts groups, and festivals, and discussion here is limited to the tangible and intangible cultural arts covered in this textbook. As was covered in Chapter 4 regarding the economics of cultural arts, formation of the cultural arts organization in a not-for-profit frame has a mythos of being related to an inability to take advantage of economies of scale for the intangible cultural arts, and the inclusion of the cultural arts within the economic and historical model of government-sponsored cultural arts initiatives and tax incentives for those contributing to cultural arts organizations.

Taking this background as their starting point, culturepreneurs of nonprofits are often leaders in establishing and growing these kinds of organizations.[7] Maximizing profits is not the aim; in general, the goals include such directions as deficit minimization, maximizing artistic excellence or critical acclaim, and maximizing audiences or outreach. In each of these categories there can be a plethora of difference. For example, one organization may wish to maximize audience growth in a particular sector or sectors, or develop a reputation for a type of cultural arts offering or offering mix in separate or complementary areas. Visual tangible cultural arts could focus on a broad range of artistic display or be limited to a particular time or geographic location. Importantly, because the not-for-profit organizational structure will be culturepreneurial, it may at some point be necessary for the organization to adjust its specialties or face declining patronage.

Regardless of the overall management goals and what is being maximized, not-for-profit organizations are not evaluated any less rigorously in their handling of or desire for financial growth, capital expansions, wealth and investment accumulation, or in any way considered exempt from any aspects of a competitive culturepreneurial environment. In today's world, the market is extremely competitive; increasing

revenues, minimizing or eliminating deficits, and strengthening the investment pool year over year is paramount. Managing facilities or building new ones constitutes the ends of many capital campaigns, while investment strategies that supply required return on investment streams are expected from the savvy nonprofit leader. The landscape that exists with regard to receiving support from donors and grant makers, artists, and cultural arts consumers requires that attention be given to these areas and others driven by the mission of the organization, as well as other nonprofit maximizing of goals relative to its constituents.

The nonprofit organization enjoys the ability to receive donations and contributions, provided that the company invests its surplus back into the organization and does not distribute profits to investors or stakeholders. Missions for nonprofit organizations do not stress the profit motive, but they drive the creation of service products to change behaviors, attitudes, and outlooks and provide exceptional cultural arts experiences. It is exactly in these organizations where "big hairy audacious goals" form the basis for moving forward.[8] Mission statements define the constituents and stakeholders, identify the needs of the constituents, and couch these within a core set of values that the not-for-profit company believes in. Exhibit 9.1 provides a comparative look at different types of mission statements for cultural arts organizations.

Exchanges are the currency of not-for-profit organizations—that is, what is exchanged in return for something of equal value. Therefore, the not-for-profit organization has to balance what it receives with what it gives. Exchanges require two or more parties, each with a goal and something of value to exchange that benefits the other. A prospective board member may seek a level of prestige in serving on the board, while the organization's goal is to leverage that individual's name recognition. A volunteer may seek to be a docent in return for free tickets to cultural arts offerings, while the organization seeks to reduce its labor costs. Donors may seek to make contributions for naming opportunities and tax relief benefits, while at the same time the organization increases its ability to receive matching grants. Exchange theory is the driving force behind the not-for-profit as it moves forward in achieving its mission.

But exchanges like these assume that nonprofit cultural arts organizations are separate entities and not embedded or captured within other nonprofit cultural arts organizations, such as churches and schools. Many cultural arts organizations do not stand as separate entities or do not file tax returns because they file under a "group return."[9] Actually, many nonprofit cultural arts organizations are small and are based on exchanges through which "the cultural arts organization" exists only for a few hours, such as with a festival.[10]

The nonprofit cultural arts sector is comprised of three different types of organizations. The first is designated by the National Taxonomy of Exempt Entities (NTEE) and incorporated under section 501(c)3 of the Internal Revenue Service (IRS) code. The second one is a cultural arts organization or program "embedded" in 501(c)3 of other nonprofits that fall outside of the NTEE's designations. The third type of nonprofit cultural arts organization includes those unincorporated associations that share both the purposes of the nonprofit and that of a for-profit cultural arts incorporated firm.

Exhibit 9.1 **The What and Why of Mission Statements**

Mission statements provide the *raison d'être* of an organization, explain what is to be accomplished, and serve as a guide for decision making.

Company	Type	Sample mission statement
Tate Modern	Hybrid	"To promote public understanding and enjoyment of British, modern and contemporary art."
Santa Fe Opera	Nonprofit	"To advance the operatic art form by presenting ensemble performances of the highest quality in a unique setting with a varied repertoire of new, rarely performed, and standard works; to ensure the excellence of opera's future through apprentice programs for singers, technicians and arts administrators; and to foster and enrich an understanding and appreciation of opera among a diverse public."
Jacob's Pillow	Nonprofit	"To support dance creation, presentation, education, and preservation; and to engage and deepen public appreciation and support for dance."
Divergent Vocal Theater	Hybrid	"[Divergent] is an ensemble of performer-creators, cultivating our art adventure-to-adventure."
Ojai Music Festival	Nonprofit	"To provide innovative musical programming that defines what is relevant today and to promote music education, guaranteeing that the passion for music is alive and enjoyed for generations to come."
Cirque du Soleil	Private	"To evoke the imagination, invoke the senses and provoke the emotions of people around the world."
Historic Royal Palaces	Nonprofit	"We help everyone explore the story of how monarchs and people have shaped society, in some of the greatest palaces ever built."
Christo and Jeanne-Claude	Private	"All of Christo and Jeanne-Claude's projects come from ideas from their two hearts, and two brains. The artists never create works that come from other people's ideas."
Juxtaposition Arts	Nonprofit	"[T]o develop community by engaging and employing young urban artists in hands-on education initiatives that create pathways to self-sufficiency while actualizing creative power."
Art Basel	Private	"Art Basel stages three premier international art shows, providing a platform for artists and gallerists from all over the globe."
Hearne Southern Auction House	Private	"To bring to the market products that have aesthetic quality as well as investment value."

Note: Please visit each website for details of the mission statements and structure of the organizations.

However, the nonprofit structure is a key factor in attracting donors, sponsors, and patrons. The cultural arts reside within what economists call "failed markets," which means, as explained in Chapter 4, that a for-profit orientation will not work because there is not a price that could be charged to turn a desired profit on the one hand, and economies of scale are elusive on the other. At the same time, people want to engage with the cultural arts offering, and they will subscribe if they are able, and donate as well, if they perceive that the cultural arts organization is stable and trustworthy. This is a key point to consider in demonstrating cultural arts service product quality, as discussed in Chapter 8. Because of this historical leaning, cultural arts organizations adopt the nonprofit structure: constituents have to be assured that company leaders will use contributed, exchanged services and donated funds in

a fiduciary manner.[11] At the same time, a nonprofit structure signals a commitment to subjective quality to the artists, and constituents,[12] of the type discussed, again in Chapter 8. The culturepreneur operating and launching a not-for-profit cultural arts organization, including formation of a board who envisions the goals similarly, is perceived to share these and other quality values over and above the values of a profit-maximizing entrepreneur. Importantly, the government plays a critical role incentivizing culturepreneurs to adopt the nonprofit form for their cultural arts organization venture.[13]

Establishing a federally tax-exempt organization under section 501(c)3 of the IRS requires that specific forms be completed both initially and annually and submitted to the IRS in a timely manner. In order to receive a tax-exempt status from the state in which the cultural arts organization operates in, it is necessary to apply to receive this status from the state's taxing entity. In the process of establishing the tax-exempt status, the number and composition of a board of directors will be identified, along with both writing and adopting articles of incorporation, and bylaws. Therefore, applying for the IRS exemption first will aid in the state application process in some instances. Many do-it-yourself websites can aid in establishing such a corporation. However, using the services of an attorney to form the corporation is advised.

To begin, an exempt public charitable purpose will need to be formulated, which falls into one or more of the following categories:

- religious
- educational
- scientific
- literary
- testing for public safety
- fostering national or international amateur sports competitions
- preventing cruelty to children or animals

According to the IRS website,[14] "charitable is used in its generally accepted legal sense and includes relief of the poor, the distressed, or the underprivileged; advancement of religion; advancement of education or science; erecting or maintaining public buildings, monuments, or works; lessening the burdens of government; lessening neighborhood tensions; eliminating prejudice and discrimination; defending human and civil rights secured by law; and combating community deterioration and juvenile delinquency."

The organization has to be formed either as a trust, a corporation, or an association as defined by the state in which it resides. The IRS website has a link to each state in the United States which assists in this process.[15]

You will also need an employer identification number, which can be applied for online and received immediately,[16] as well as governing documents that set forth the mission, the size and operational aspects of the board of directors, the commitment of any assets to the corporation, and their disposition upon dissolution of the organization. All of this information will need to be completed before applying for federal tax exemption under 501(c)3, including the name of the organization, who

is leading the organization, the mission, purpose, and so forth. Forms are available online and are interactive.

None of this work is necessarily difficult; it is detail-oriented, however. Answering questions incorrectly can jeopardize the receipt of tax-exempt status from the federal government or state taxing entity. For these reasons, it may be beneficial to consult with an attorney to assist with this process. The fees for this kind of service will vary from a few hundred to a few thousand dollars, depending on your location and the complexity of your not-for-profit organization. The IRS also charges fees for some requests for exempt status; these fees must be paid upon submission of forms. If your application is accepted as complete and passes through the determination process, you will receive an Advanced Ruling or "Determination Letter" letting you know that your organization has received tax-exempt status. Advanced Ruling letters are distributed for organizations not yet in operation based on the information provided to the IRS. However, an Adverse Determination Letter may be issued if enough information is not provided or if the information indicates that tax-exempt status is not applicable. In this case, an appeal will have to be filed.

In forming a nonprofit, keep in mind that a limited liability corporation can be a structure that can be used as well. This means that a group of people can form an organization with equal say and limited liability, which we will discuss in the next section.

By any measure, the process of gaining tax-exempt status is worth the effort, particularly if charitable contributions and donations are important and if your mission is driven by maximizing audiences, enhancing artistic quality, or other not-for-profit-maximizing motives. However, if your aim is profit maximization, then forming a company as a for-profit enterprise is required. The next section covers this process.

ESTABLISHING A PROFIT-DRIVEN FIRM

In the preceding section, the aspects of instilling a culture of culturepreneurship were outlined. They also apply to the formation, establishment, and leadership of a profit-driven cultural arts firm. The focus for purposes of this textbook is on those companies that produce tangible and intangible cultural arts service products directly, rather than on cultural arts ancillaries. Cultural arts ancillaries are those firms that supply goods and services to cultural arts organizations and individuals, many of which are for-profit. While most cultural arts offerings that are found under the umbrella of the tangible and intangible cultural arts covered in this textbook are not for-profit, some are for-profit. These include firms, such as for the tangible primary markets, galleries, sculpture spaces, and for the intangible cultural arts, performance spaces, performing companies; and in the secondary tangible cultural arts market, some museums and art auction houses.[17] Here the focus is on the nuts and bolts of setting up a profit-driven firm.

The not-for-profit structure allows an organization to focus on its mission and receive grants and donations; in exchange for using the funds within the organization rather than distributing them to shareholders, the company receives tax-exempt status, with certain caveats. Regulations on tax-exempt nonprofits, such as limitations

on political and lobbying activities, attracting and raising investment capital, in addition to taxes on unrelated business income, can sometimes be onerous.[18] Under a for-profit structure, taxes are paid on profits, donors do not receive a tax deduction for their contributions, and grants are not generally available. So why would one think of adopting the for-profit structure? Many reasons make this attractive. First of all, seeking profits or returns is the driver in many cases for entrepreneurial ventures, and the same can be said for certain types of culturepreneurs.

A for-profit firm can be formed as a sole proprietorship, a partnership using different formats, an S or C corporation in private ownership, or a public corporation.

The *sole proprietorship* is the easiest type of for-profit firm to start. The culturepreneur simply decides to do so. Many culturepreneurs proceed by using part of their home as a studio, for example, and name their place of business after themselves. If a different name is desired, several steps need to be completed, such as filing for a fictitious business name and making sure the name is not being used by another firm so that you are not infringing somebody else's trademark or copyright. For federal tax reporting, your personal Social Security number is all that is needed. If credit is to be extended, you can obtain a Dun and Bradstreet number as this is the way your creditworthiness will be assessed. However, many small business owners who are sole proprietors use their personal credit to pay for supplies and other needs for the business they operate. This is fine to a certain point, if the firm remains small and if there are no employees or other obligations that exceed the revenues of the firm.

One of the main drawbacks of starting a sole proprietorship is that the owner is completely liable for anything and everything that can go wrong, from people being injured on the owner's premises to employment taxes. However, the risk is usually worth the reward, and many people start out this way. In forming the business plan, you will assess all the financial issues and needs. With the business plan and some personal assets, such as real estate or other securities, you can approach the Small Business Administration for loans to help with funding your business. Here again, your credit rating and demonstrated ability to repay will play a role in determining your ability to get a loan.

In the United States, a *limited liability partnership* (LLP) is also a way to form a for-profit organization, and the key phrase is "limited liability." Whereas in the sole proprietor framework the owner is completely liable for everything, in a limited liability partnership the "partners" are only liable to a degree, for their own investment amounts and their own conduct. In other words, two partners in a LLP company—Partner A, who invested $1 million, and Partner B, who invested $200,000—are responsible only for their own actions and can be held accountable only for the amount of investment they made into the company. At the same time, if there is a legal action brought in the conduct of business, it is against the company and not Partners A and B individually. In a general partnership, Partner B and Partner A would both be equally liable should any action be brought against the firm, and both would be equally responsible for debts. As was mentioned earlier, a limited liability corporation (LLC) is also available for use in private firms, and interestingly, this form can be used for both for-profit and not-for-profit organizations.

In a for-profit corporation, the board of directors is responsible and liable for maximizing profits. However, there has been attention paid to the profit motive, and suggestions that perhaps there are other drivers and pure profit incentives need balance against social benefits. The low-profit limited liability company and the benefit corporation can be used as alternative models for establishing a cultural arts concern that allows profits but also seeks other ends.[19]

The low-profit limited liability company (L3C) is an LLC for mission-driven companies. The L3C is ideal for companies that want to blend traditional capital with "philanthropic" capital, such as from foundations. These are open to start-ups in the states of Vermont, Michigan, Wyoming, Utah, Illinois, North Carolina, Louisiana, Maine, and soon in Rhode Island. The L3C offers the same liability protection and pass-through taxation as an LLC; however, it must be in business primarily for a charitable purpose and only secondarily for profit. Different from the traditional nonprofit, an L3C can distribute its profits to owners. The L3C attracts both traditional investment and a very specific type of philanthropic money, called program-related investments (PRI). PRI is capital in the form of equity or debt from a foundation to a for-profit company that is operating in line with the charitable purpose of the foundation.

The benefit corporation, or B-Corp, is for those companies that want to create a measurable positive impact while providing greater transparency to the public. This form of corporation is available in Maryland, Vermont, Virginia, New Jersey, Hawaii, and California. In this arrangement, the purpose of the company is to create public benefit, a broader fiduciary duty, and to be transparent about its overall social and environmental performance and impacts, including the benefit the company brings to its community, environment, employees, and suppliers. By its definition, it has to operate for a material positive impact on society and the environment. Every benefit corporation is required to publish a report that measures its performance on its public benefit, using an independent, third-party assessment tool. A benefit report states how the company performed that year in various social and environmental areas.

Next, the flexible purpose corporation (FPC) is a type of firm that can be formed in California, for companies seeking to do benefit work on their own terms. This structure creates the maximum amount of flexibility for socially or environmentally conscious entrepreneurs. It is designed to pursue profit along with a special purpose of its own designation. For example, a flexible purpose corporation might be a for-profit company such as a real estate development firm that has a special purpose of building a public cultural arts space in each of its geographic areas. Similar to the B-Corp, the FPC has to issue an annual report available to the public with details about the special purpose; the annual objectives that it has set to achieve its special purpose; the metrics used to gauge the success of the special purpose; how it has achieved or fallen short of the stated objectives; and how much money was spent in furtherance of the special purpose.

These types of structures, the L3C, the B-Corp, and the FPC, are attractive because they deliberately seek to mitigate the for-profit driver while taking advantage of investors who, for example, value businesses that are sustainable and committed to

environmental concerns. These structures are available in certain states in the United States, and the federal government categorizes them as for-profit organizations. The type of organizational structure that the culturepreneur seizes will depend on the overall objectives and goals of the venture.

The corporation constitutes another form of for-profit structure available to the culturepreneur. Corporations are treated as separate entities unto themselves, creating a boundary of protection between the owner and potential threats. Any issues that arise financially are limited to the owner's investment, with the exception of particular illegal acts. To set up a corporation, articles of incorporation will need to be registered in the states where business is conducted, according to the applicable states' statutes. Some states are more difficult to incorporate in than others, and therefore getting the advice of legal counsel is recommended in this situation. Corporations are developed through issuance of equity shares, or debt instruments, through the owners or investors.

A corporation's percentage ownership is signaled by the number of outstanding shares of stock one holds. Generally, in a *private corporation* the owner will want to keep control of the company and therefore will command a controlling number of shares, at least 51 percent. If those shares of stock are not traded on a U.S. stock exchange, such as the New York Stock Exchange or other financial market, the corporation is said to be privately held. No financial information is made public. Profits are distributed to owners in the form of dividends (an amount of profit per share) based on the number of shares or the type of shares one holds. If an owner holds all of the shares and pays herself dividends, she will be taxed on those dividends as well as on the remaining profit of her firm.

It is fairly simple for an owner to exit a corporation if there is a desire to sell one's interest and a buyer who wants to acquire it. No partners need to agree, as in the limited liability structure; one simply sells one's share of stock. However, the ease of exit may rest on the articles of incorporation and the distribution of ownership claimed there. It will be prudent to consult legal counsel before making changes.

The S-corporation is a special case of the general corporation, which has to be actively applied for; otherwise, the corporation will be designated as a regular corporation. The choice needs to be an active one because changing the structure from an S to a C corporation will be difficult, if not impossible. However, changing from a C to an S corporation is apparently possible but difficult. An S-corporation offers certain tax benefits. Many think of it as combining the best of the sole proprietorship and the limited liability corporation with the protection of the corporate veil. Dividend income from the venture is taxed as personal, not corporate income, on a pro rata basis of ownership.

Publicly held corporations have stock that is traded and result from an initial public offering (IPO). They are subject to the terms of and disclosure requirements of the IRS and the Securities and Exchange Commission (SEC), and their information is reported publicly. It is not safe to conclude anything about the publicly held corporation. It may be exactly the entity that will suit the aims of the culturepreneurial organization. The size of the firm and other unsubstantiated beliefs should not drive the decision to go for an IPO. Consultation with attorneys well versed

in specialized areas will be necessary, however, in order to move forward in this type of structure.

LEADERSHIP STRATEGIES

Regardless of the type of firm chosen, the leadership of the entity will play a major role in making the vision and mission a reality and driving the culturepreneurial spirit down through the depths of the organization. Before turning to a discussion of leadership strategies, however, it is worth thinking for a moment about the way employees are understood. There are two general theories that guide this kind of analysis. Either employees are self-motivated and trustworthy, or they are not. These opposing ideas are called Theory Y and Theory X.[20] According to Theory Y, employees are self-monitoring and trustworthy; they will not shirk their responsibilities. According to Theory X, they will if they can. This belief causes employees to be treated with suspicion, giving rise to systems and processes that are indicative of distrust and surveillance.

Determining the kinds of beliefs held by the culturepreneur and the arts manager will be an important factor in engaging leadership styles over the followers, and it definitely will be something to consider as the culturepreneurial firm is established and grown. The point of view chosen will impact the formation of teams, work groups, and the corporate culture, and it may impact the organization's ability to achieve its strategic aims. With this now said, we can proceed to the discussion of leadership strategies.

In a textbook about cultural arts management and entrepreneurship, working with concepts as broad as economics and marketing research, service quality, and copyright, you may wonder why leadership strategies are included. Managing the organization you create or work for is based on planning and implementing short-term goals and objectives, organizing the operations and designating resources to bring the plans into reality, and problem solving or controlling the way the firm is run. Some of this work is done through you, as when you manage a group or a team, or by you when you manage yourself and your tasks. Leadership, on the other hand, distinguishes from these tasks to set forth the vision, direction, designs, and change over a long term, while inspiring people and motivating them to act. Because of this, the text devotes this section to a discussion of leadership, its importance, and strategies.[21] Hope and courage delivered through leadership strategies[22] are needed in pervasive form as we move into the next decade and beyond, particularly as the cultural arts attender looks for transformative and self-actualizing experiences through consumption of your service product. Being in the position to lead the organization will be paramount to setting the culture and providing exceptional artistic experiences. People both inside and around the organization look to leaders for their inspiration in fulfilling the mission or directive of the company. A leader provides this.

One aspect that has to be kept in mind when discussing leadership of the cultural arts concern is the notion that sometimes an organization has an artistic director and an executive or managing director—that is, dual directorships. It may be useful to think of these two roles as leading the subjective and the functional aspects of the

cultural arts service product, in order to understand the driving forces behind desired outcomes in these areas, yet they have to be integrated. In any case, there are four styles of leadership accessible in the cultural arts concern. Two of them—charismatic and transformational—are classified as visionary leadership.[23] The other two are transactional and participatory.[24]

Visionary leaders are able to embrace and embody the strategic direction of the firm while also creating a positive picture of the future that motivates people associated with the organization. *Charismatic leaders* are exactly this type, able to inspire others through their way of being. In general, they communicate high performance expectations effectively, exude confidence and high personal moral values, and produce excitement for the future. Charismatic leaders are effective because people who follow them are willing to trust the leader, will expend a great deal of effort and generally perform better because of this, and are committed and happy in their roles.

Transformational leaders are similar to charismatic leaders, with the added abilities of inspiring people to achieve more than they believed they could and providing followers with a sense of being integrally necessary to the organization's objectives and goals. Transformational leaders develop followers intellectually and creatively, provide them with challenges and resulting achievements, and in so doing, develop personal connections with their followers. Many cultural arts organizations are founded, grow, and change under the direction of a charismatic or transformative leader.

Transactional leadership can be classified as goal-oriented and concerned with managing outcomes. For example, transactional leadership is based on exchanges of rewards for completion of tasks and employs SMART objectives and goals.[25] These goals are stated *s*pecifically, *m*easurably, as *a*ttainable, *r*ealistic, and *t*imebound. All goals are to be stated this way, including strategic goals. For example, a SMART goal can be stated as "Our audience base will increase by 2 percent by the end of the fiscal year" or "The culturepreneurial organization offers one gallery opening each month, with each third exhibit comprised of emerging artists." Or "To qualify to be one of our eight board members, individuals will possess ten years of experience in their respective fields, be available to serve as a board member for a three-year term, and will have served on at least one international-level cultural arts board in a significant leadership role." In any event, arts organizations embrace transactional leadership when producing a performance or launching an exhibition, and they can exchange financial or other kinds of rewards to employees, sponsors, and volunteers.

Participatory leadership subscribes to the notion that inclusion of people in the process of making decisions regarding implementation of strategies can positively impact goal achievements. Employees and other constituents have a sense of buy-in with the decision processes. Asking their opinions or advice before implementation of a decision is a leadership approach that can be used in the cultural arts concern, particularly, for example, when developing budgets, expanding staffing, or deciding on venue options. Depending on the degree to which the leaders want to gather input, nearly any decision can be developed through participatory leadership. However, there are a few caveats to keep in mind. It is important to let people know that their input is valuable, but also it is necessary to be careful to state that the final

outcome may be different from what they suggest. At the same time, participatory leadership requires time to meet with people to discuss the directions proposed and therefore can hinder quick decisions and movement. Finally, participatory leadership needs to be genuine; asking people to participate in a perfunctory manner will cause more harm than good because followers will begin to disbelieve the leaders when this behavior happens too often. Therefore it will be necessary to consider carefully when participatory leadership is appropriate and to be aware of the positives and challenges included with this process.

As is apparent from the above considerations in leadership styles, leading is one aspect of driving culturepreneurship. Being effective requires that leaders understand their role in the firm and the concepts covered in Theory X and Y. From the leadership style and the underlying belief system one holds about employees, the conversation now turns to a discussion of teams. There are many different ways to handle and form teams; moreover, the location of the team within the organization will bring behavioral and tasking aspects to bear on their formation. It could be said that all of the groups in an organization can be viewed as teams, from the board to the *corps de ballet*. The point is to develop cohesive and high-functioning working arrangements for given sets of outcomes in the organization.

ESTABLISHING THE BOARD, TEAMS, AND ORGANIZATIONAL STRUCTURE

While the culturepreneurial firm will seem to be the result of an *individual*, there are people working with the culturepreneur, even at the outset, though they may not be immediately visible. The old adage that "no man is an island" is true. Some working relations are informal, while others are formal. Informal relationships include those with friends, family, and close associates who work with the culturepreneurial leader to begin or forward the organization. The task of identifying a *board of advisers* was covered earlier in the textbook. There it was explained that such a board is typically formed for the organization that does not require a formal board, such as in a corporation or sole proprietorship. In those cases, the board functions in an advisory capacity and members are loosely engaged. A formal *board of directors* for a corporation carries more definitive requirements and, in some cases, members are financially responsible for the organizational outcomes. Along with a carefully developed board, teams and groups play a key role in carrying out the goals and objectives of the organization.

THE DEVELOPMENT OF THE BOARD

The responsibility of the board of directors has been increased in recent years partially due to the behavior of corporate leaders and boards of firms in the era of Enron and Arthur Andersen. The *Sarbanes-Oxley Act* (SOX) was passed in 2002 to tighten oversight of public corporations, provide protections for stakeholders, and establish more independence in board function.[26] Enforcement comes through the SEC and covers, in part, senior executives' and board of directors' financial, internal

control, and management liabilities. Criminal activities and civil charges resulting from these liabilities are explicit in the law. While the scope of this textbook is meant to provide an overview of the impact of laws on the culturepreneur, space does not permit complete coverage here. A search online will return many websites with accurate and current information, and a conversation with professionals in the legal and accounting industry can be had. The point is that companies are held to standards that impact the board of directors and the senior management in publicly traded companies, no matter what their size. Private companies are not necessarily impacted by SOX; however, adherence to the spirit of the act would be prudent, and in the event of an IPO the act will certainly be applicable to the organization. Here again, acquiring the services of a qualified attorney is advised.

A board has a very serious part to play in guiding the organization. Its role includes the following responsibilities:

- Designing strategic plans regarding growth and expansion of the organization.
- Resolving conflict between owners and among employees.
- Providing governance and oversight of the company by establishing policies and objectives.
- Selecting, appointing, supporting, and reviewing the performance of the executive directors, chief executive officer, or other executives as defined.
- Ensuring financial solvency and application of resources in a fiduciary manner.
- Establishing, reviewing, and approving operational and capital expenditures and budgets.
- Setting the salaries and compensation of particular personnel.
- Answering to stakeholders for the organization's overall performance.

To set up the board of directors in a corporation, the organization must establish bylaws that explain the board's role, size, qualifications, term limits of seating, voting and selection procedures of members, meeting frequencies, duties, and compensation. Individuals should be able to work with diverse groups of people, be knowledgeable about the cultural industry and the relevant business practices germane to it, bring specific skills in complementary areas for the culturepreneur, and, of course, demonstrate by exemplary ethical behavior. If the culturepreneur determines that a formal board of directors is not necessary, these guidelines can be applied to formation of a board of advisers. A board of advisers does not have the same level of liability considerations and, except for protecting whistleblowers and guarding against deception in document destruction, are not subject to SOX.[27] However, advisory boards are necessary and an expected managerial function of culturepreneurial excellence, and in some instances, particularly in a family business, there can exist both a board of directors and a board of advisers. An advisory board is said to operate at "arm's length" in that advisers are not compensated and only provide advice for the culturepreneur in particular expertise areas.

It is important that people serving on the board in any capacity are knowledgeable about the environment within which a cultural arts organization operates locally, nationally, and globally. These individuals should bring a variety of skills, ideally

those that the culturepreneur can leverage for the firm's growth and development. Bankers, lawyers, technology experts, marketing leaders, and others as dictated by the cultural arts offering mission should be included. Members of the board should also be artistically savvy, have a commitment to the cultural creative aspects of the firm, and should be selected based on a vetting process that systematically evaluates the proposed individual's contributions and past successes or skills. Importantly, the board should be composed of an odd number of people with specified terms, such as three years, so that when any decision is needed, ties or deadlocks or a status quo will be avoided with simple majority agreement.[28]

With or without formal or informal board structure, every successful organization needs an effective management team as well as other teams that function based on the organizational structure. These teams and work groups will need to be adapted to the growing, thriving, nimble culturepreneurial firm.

THE EXECUTIVE MANAGEMENT TEAM

A *team* consists of two or more people who hold themselves mutually and individually accountable for achieving an end or purpose. A team "is a collection of individuals who are interdependent in the tasks, who share responsibility for outcomes, who see themselves and who are seen by others as an intact social entity embedded in one or more larger social systems of the corporations, and who manage their relationships across organizational boundaries."[29] There are many types of teams to which this definition applies, including project, ad hoc, research, engineering, and management teams.[30]

Executive management teams are expected to work with the leader of the organization, in concert with the board, in crafting and implementing mission and strategy, designing plans and metrics, providing direction to other staff members, and managing particular aspects of the firm. The leader of the organization works with the executive management team, ideally, because it is literally impossible to do everything in a firm after a certain point and because, if there are any investors, they will want to see the executive management team free the leader to pursue the larger picture. The executive management team will consist of the key high-level divisional leaders, such as finance/development, marketing, technology, and leaders of each of the mission-driven areas the cultural arts concern is composed of. Care should be taken to ensure the team does not become unwieldy with too many members enrolled. The question that guides bringing someone onto the executive management team is this: How will the person contribute to the synergy of the team, introduce viable ideas, and drive strategic outcomes? The exact composition of the executive management team depends on the organization; importantly, that composition should change as the firm changes.

Each of the executive management team members will be responsible for one or more critical aspects of the firm, and they will provide status reporting and guidance at executive management team meetings. In many firms, a formal, regularly scheduled executive management team meeting provides for consistent structure and sharing of challenges and opportunities that the firm and the culturepreneur face. These

meetings would be best scheduled nearly daily for a new firm and at least weekly, such as each Monday morning, for others.

OTHER TEAMS IN THE ORGANIZATION

Other *work teams* can be formed around management, tasks or projects, events, or functions. As the organization grows, teams can add value to the culturepreneurial firm by increasing productivity, creating a sense of ownership within decision making, and aiding employee development. Teams can be used in conjunction with or separate from departmental organizational structures, a point to which we turn in a moment. There are many kinds of teams available, depending on the degree of autonomy that the culturepreneur wishes to encourage. Some teams are self-directed and self-managing, controlling the outcome of their own work, while others are traditional work groups, given a specific task to complete and closely monitored for outcomes. Between these two extremes, varying levels of autonomy and direction can be imposed, such as for semiautonomous work groups or employee involvement teams. These kinds of teams meet for purposes given to them, such as studying a particular issue, creating new cultural arts service products, or studying cultural arts consumers' needs, and then make recommendations to the management team or the culturepreneur. Teams can be located at a specific geographic location or they can be virtual, depending on the functions and outcomes desired.

People who have participated on teams know that they can be wonderful experiences or can cause disastrous results. There can be problems with team leadership, social loafing by unproductive team members, and difficulty in getting organized and functional within a specific time period. Or some members of a team are not motivated to perform and are problematic. In this kind of situation, the employee will need to be managed. Yet it is possible to enlist excellent team members and still expect some friction. Newly formed teams, or teams with new members added or old members removed, go through four distinct processes of forming, storming, norming, and performing and then, in the case of short-term project or events, through dismantling processes. In the forming stage, the team is understanding its purpose and intended outcome, electing a team leader, and designing team roles. In storming, there is some confusion and perhaps disagreement among team members as to which direction should be followed or what is the best course of action. After storming, the teams engage in norming, where they figure out working processes that allow them to function well, using the team structure efficiently in order to perform their duties and tasks. And when the team's work is complete or that team is no longer necessary, it should document its activities and achievements in a form that can be provided to management, and then be dismantled.

DEPARTMENTAL UNITS

Rather than establishing work teams, organizational departments can be created. These are typically organized around a cultural arts service product or a cultural arts

functional unit. An example of this is, of course, the delineation between a cultural arts service product performance or event, and the executive or functional departments such as ticketing, marketing, finance, development, and merchandising. Or departments can be decentralized, so that all functions adhere to a particular cultural arts service product. For example, a cultural arts offering can have its own accounting, development, human resources, and other departments as if it were a stand-alone organization within the organization. Or the cultural arts offerings can be organized around client type, differentiating between corporate offices offerings, cultural arts festivals, auctions, theatrical displays, and cultural arts in public places. One problem with having decentralized centers such as the ones mentioned is that they can lead to redundancy and poor integration between inside and outside services, encouraging excessive separation. One way to manage this problem is to have an overarching level of culturepreneurial methods and images that are accessible to each decentralized area. For example, in recruiting employees, certain information about the firm should be incorporated into the position posting; when placing an advertisement or displaying social media, a particular branding or logo image should always be incorporated. When selecting artistic personnel, certain criteria should be noted in order to screen the applicants.

These are not all of the ways in which the cultural arts organization can provide a systematic approach to decentralized functions; the exact methods and images used will vary by firm. What is important in selecting either teams or departmental methods of organizing people is that, while the different areas may be responsible for different outcomes, they still work closely together to ensure cultural arts offering service quality levels. The choice will be made depending on the relative appropriateness of the structure as it relates to the goals and outcomes envisioned by the culturepreneur and balanced with the board and executive management team.

ORGANIZATIONAL STRUCTURES

The manner in which the organization is arranged also contributes to the outcomes and supports the culture. What is the best way to organize? The organizational structure is set up to handle the communication and work flow in the best possible way. Obviously, a culturepreneur working alone has only one person to organize, but as the company expands and grows, it must be able to evolve to reflect the needs and culture being created. In cultural arts organizations, it is somewhat usual to have a separation between the creative and the functional areas, with the overall organization being guided by the board and the artistic/creative and executive directors. Bifurcating from there, it is typical to have functional areas reporting to the executive director and the artists and ancillary cultural arts areas reporting to the artistic director. The other consideration is to decide how much distance from the cultural arts consumer and the staff the organizational leaders desire. If there is a desire for a great distance, the firm will be hierarchical in design. If the goal is for closeness to the cultural arts consumer and the staff, the organizational design will be flatter. Examples of organizational designs are given in Exhibit 9.2.

Exhibit 9.2 **Organizational Designs**

<u>Hierarchical organizational structures</u> place outcomes several layers from the board of directors.

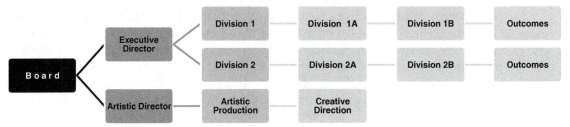

A <u>flat organizational design</u> place the strategic outcomes closer to the organizational founders and the board.

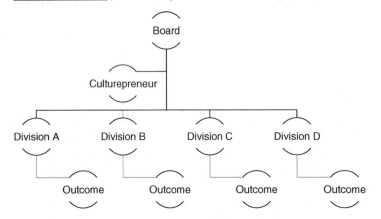

Sources: Robert D. Hisrich, Michael P. Peters, and Dean A. Shepherd, *Entrepreneurship*, 8th ed. (New York: McGraw-Hill/Irwin, 2010); Chuck Williams, *Management*, 7th ed. (Mason, OH: South-Western Cengage Learning, 2013).

Keep in mind that organizational structures evolve over time, depending on the changes in the firm. What will be important as the firm expands is for the culturepreneur to determine exactly who, in terms of function and strategic importance, should report directly to him or her. For example, new research suggests that the human resources executive should be more visible in setting or participating in strategic directions. Finance officers, marketing executives, and technology strategists may also make sense as reporting directly to the firm's leader. However, there comes a point when the culturepreneur's reporting capacity is maximized. According to some researchers, ten direct reports constitute the limit of the *span of control*.[31] Each culturepreneur will decide, and this decision, again, will be pushed through the firm as the corporate culture is crafted in part by emulation and standardizing of the leader's values and behaviors.

People Management

Before hiring any employees or recruiting board members, the culturepreneur should have a clear idea of the intended organizational structure. This early planning will be critical to the success of the cultural arts organization by giving potential employees,

board members, and funders a sense of what can be expected and projecting a professional image to those considering partnering with you. While there will be plenty of opportunity to be flexible with the design, being able to articulate your idea of what the management team and the other teams and departments will consist of will demonstrate clear leadership of the firm.

Bringing human talent to your culturepreneurial enterprise requires, at minimum, recruiting, screening, hiring, developing, and promoting new people. In many cases, careful screening can alleviate future personnel problems. Recruiting, screening, hiring, and developing human talent should be considered an investment, within a matrix of inclusivity and ethical legality related to each area. Since time and resources are committed to this process, each employee who leaves the company represents a cost in terms of investment and the impact on the remaining staff. As has been said, people do not leave companies; they leave managers. Therefore, it is really important to have a process in place that recruits appropriately and at the same time reduces unwanted or costly turnover.

Before beginning the recruiting process, the firm leadership must clearly identify the category of employee needed, such as executives versus staff, and into which area of the firm the new employee will be placed. Each position requires a description of duties, reporting lines, salary, benefits, and expectations used to measure success. Recruiting for the artistic talent pool also needs clear lines of assessment and qualifications criteria.

Some aspects of human resources management can be outsourced, such as using recruiting firms to screen potential members of your staff or management team. Screening can include collecting résumés, testing and evaluating, verifying references and credentials, and so on. Or all of this can be done within the firm. Some company leaders find it helpful to see all the résumés that come in for a particular position, while others will delegate the screening so that the actual number of résumés that the leader sees is smaller than the total pool.

The interview process can consist of telephone screening first, then administering tests to measure abilities and attributes, and finally arranging an on-site visit. During the on-site visit, the candidate may meet multiple members of the organization in different settings or a team of people simultaneously. Gathering feedback from all who participated in the screening and interviewing is critical in order to evaluate that information against the needs of the organization.

The preceding sections have focused on organizational leadership and design, the need for different types of teams or work groups, the importance of establishing boards, and preparing for managing employees. As is clear, the more that can be done to establish these structures and processes, the more likely it will be that the organization will operate effectively. The design and process of organizational structure and leadership dictate the company's culture. The culturepreneurial spirit pushed throughout the organization can go a long distance in growing the firm and taking it to increasing levels of success.

Having a "new arts offering" culture instilled within the organization's DNA is also a key contributor to culturepreneurial success. The discussion, therefore, now shifts to the process of instilling a culture that is open to and generates new ideas.

After that discussion, concepts related to bundling of arts service products are presented with the idea of facilitating exceptional arts offerings.

ESTABLISHING A "NEW" ARTS SERVICE PRODUCT CULTURE

In Chapter 5, the opportunity assessment and business plan were addressed relative to the culturepreneur. The arts service product life cycle (ASPLC) was presented as well. After the initial idea for an arts service product is introduced, how does the culturepreneur or arts manager bring innovation to bear in generating new arts service products and, furthermore, driving this mind-set through the fabric of the organization? A culture that values new ideas and a process for evaluating them will need to be established early on. A few points need to be raised here. First of all, what is meant by the term "new"? And how can the culture of creating and valuing new arts service product ideas come about? What are the processes that can be employed that can increase the viability of new arts services products?

NEW ARTS SERVICE PRODUCTS

"New" can be evaluated from the viewpoint of the cultural arts organization or the cultural arts consumer.[32] From the organization's perspective, new arts service product development (NASPD) as a process of classification can be used to assist with defining a new arts service product. In Chapter 5, the process of assessing the arts offering portfolio was related to the ASPLC and the diffusion of innovations. Here, in a new arts service product classification system, arts offerings are measured by market newness relative to technological newness, based on arts service product objectives; that is, new arts service products are offered in the marketplace because they will provide value to the arts organization, and they are introduced with clear objectives in mind.

As can be seen in Exhibit 9.3, initially the arts organization decides what the objectives are in offering the new arts service product. Is the objective to approach a new target market or offer new arts offerings in an existing market? What are the expected outcomes in doing so? Or is the objective to provide existing arts offerings using technology? In other words, a decision to offer new arts service products is not made without analysis, a point that will be explained in detail in a moment. In regard to the current process of evaluation, the reason for using a matrix is to distinguish newness relative to technological innovation and market segments to quantify the degree of risk and complication involved in bringing a new arts service product to the market. Here we include not only the risks covered in previous chapters, but an additional aspect of artistic risk—new, challenging, or unorthodox arts offerings—which will need to be managed and led within the arts organization.[33] Approaching market segments that have little or no advancement along the arts adoption process, for example, with the use of innovative technologies offers the greatest risk. As such, the opportunity analysis will need to bear in mind the risk/return requirements of introducing the arts service product to the market as well as the artistic risk the

Exhibit 9.3 **New Arts Service Product Classification System**

firm is being subjected to. A high degree of artistic risk translates to the degree of newness the arts organization perceives. However, here one can argue that the risk is mitigated if there is sufficient arts consumer postpurchase evaluation that affirms the purchase decision. As such, the launch of a new, risky arts offering that is technologically innovative will impact the audience's perceived risks and their perceptions of the organization, as discussed in earlier chapters, which in turn impacts the arts organization. Keep in mind too that exposure or success from artistic risk is not expressed only in tickets sold or patrons signed. It also has to do with SMART objectives in subjective quality stated ahead of offering the artistic innovation related to acclaim and critical review. If the belief is, as has been suggested in this textbook, that the arts offerer keep the arts consumer in mind, then this perspective is perfectly aligned. Every new arts offering will be measured against the degree of explicitly stated risk/return/reward, as well as artistic risk, and the impact that highly innovative cultural arts offerings are likely to have on arts consumers.

NEWNESS FOR THE CULTURAL ARTS CONSUMER

Defining "new" arts service products can be challenging. In the consumer goods and services industries, newness is measured by the degree to which new knowledge, behavior, or learning is required of the consumer before using the new product or service. That is, for a product or service to be considered new, it is measured against the disruption that the product or service causes a consumer.[34] As is evident in thinking about "new" this way, it does not consider the organization's viewpoint of risk or return.

Exhibit 9.4 **Continuum Classifying New Arts Service Products**

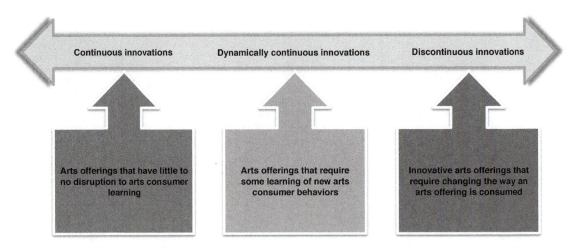

Sources: Roger Kerin, Steven Hartley, and William Rudelius, *Marketing*, 10th ed. (New York: McGraw-Hill/Irwin, 2010); Robert D. Hisrich, Michael P. Peters, and Dean A. Shepherd, *Entrepreneurship*, 8th ed. (New York: McGraw-Hill/Irwin, 2010); Chuck Williams, *Management*, 7th ed. (Mason, OH: South-Western Cengage Learning, 2013).

For our purposes here, the definition of a *new arts service product* will be those arts offerings that are "created in order to provoke and challenge the audience or to satisfy the artist's creative impulses,"[35] thus placing new arts service products on a continuum of provocation. In this analysis, there are three nodes to consider: continuous innovations, dynamically discontinuous innovations, and discontinuous innovations. This continuum is shown in Exhibit 9.4.

Examples of new arts service products include allowing fine arts consumers to borrow artwork and display it in locations of their choosing, developing user-initiated concepts and meaning in art,[36] or turning toward seasonal arts experiences in art auctions (continuous innovation);[37] introducing arts consumers to self-directed art tours using hand-held devices that provide information based on where the arts consumers are in the gallery or museum (dynamically discontinuous innovation);[38] and inviting arts consumers to collaborate in working in an open, tangible cultural fine arts studio (discontinuous innovation).[39]

Though some have carefully argued that a new arts product development process may not apply to the cultural arts because of the model's linearity,[40] successful offerings of new arts service products can be cultivated, even while acknowledging the cultural creative process implied in the definition. The next section explains the process.

DEVELOPING THE NASPD PROGRAM FOR THE CULTUREPRENEURIAL FIRM

To develop an NASPD program, the organization works through the eight steps of the model depicted in Exhibit 9.5. The next paragraphs will touch on each step briefly, and it should be noted that though the new arts service product development

Exhibit 9.5 **New Arts Service Product Model for the Cultural Fine Arts**

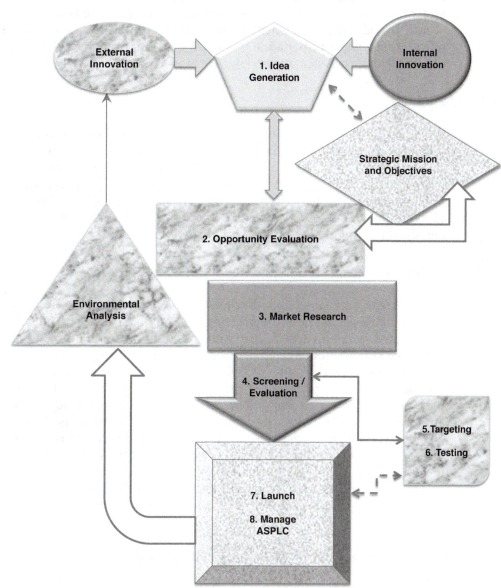

Sources: Maria Crealey, "Applying new product development models to the performing arts: Strategies for managing risk," *International Journal of Arts Management* 5, no. 3 (2003), 24–33; Robert D. Hisrich, Michael P. Peters, and Dean A. Shepherd, *Entrepreneurship*, 8th ed. (New York: McGraw-Hill/Irwin, 2010); Chuck Williams, *Management*, 7th ed. (Mason, OH: South-Western Cengage Learning, 2013); Stephen B. Preece, "Performing arts entrepreneurship: Toward a research agenda," *Journal of Arts Management, Law, and Society* 41, no. 2 (2011), 103–120.

process is presented linearly, there can be circular and indirect pathways leading to each of the steps. Also, it should be pointed out that these steps apply to cultivation of artistic and other supplemental and supporting offerings, such as merchandise, refreshments, and transportation to and from an arts event. No idea should be discounted without a systematic review.

IDEA GENERATION

Where does one get ideas? They can come literally from everywhere, from arts consumers, patrons, employees, board members and advisers, family, friends, television shows, movies, other arts events. In the culturepreneurial firm, new ideas can come from focus groups deliberately set up to suggest ideas; from brainstorming; from filling in the phrase "If we weren't afraid, we would . . ." The way to generate new ideas is almost limitless. It should be encouraged and driven into the firm, and no one should be humiliated or belittled for any idea.

EVALUATING THE IDEA

Once the ideas are generated, they have to be evaluated to see if they stand up to opportunity assessment and marketing research analysis. That means that each idea should be evaluated in line with the organization's mission and strategic goals, the competition, available resources to bring the idea to fruition, what arts consumer need it will fulfill, and what it will take to develop the new arts service product. The culturepreneurial firm should set benchmarks and criteria for each of these categories, and others if necessary, and have them ready to use in evaluating new ideas. Of course, these benchmarks need to be revised when there are changes in the firm or the environment. While the intention is to cultivate new ideas, the evaluation is really meant to determine if the idea is a fit, because each idea that makes it through evaluation moves into the opportunity assessment and research step. As is easily seen, a great deal of effort is expended in this process, and it may be a good idea to have a team that focuses on this aspect of the organization.

OPPORTUNITY AND MARKETING RESEARCH AND ANALYSIS

In this step, if the idea has been evaluated and found to meet the established criteria, the analysis and assessment begins. As was set forth in Chapter 5, the idea, now an opportunity, is subjected to analysis based on the risk and return, and the business model. Here it is critical to decide what the goal of the opportunity is: gaining market share, developing a new market, offering an arts service product in discontinuous innovation, and so on. It would be a good practice, if it is feasible, to gather some members of the potential target market and ask for their involvement in assessing the opportunity.

SCREENING THE OPPORTUNITY

Screening of the opportunity comes next, based on organizational goals and available resources. In other words, here is the critical moment that defines how the opportunity will be financed, especially if the objective of the new opportunity is artistic innovation that may not be subject to a large target market that will provide sufficient earned income. Are there donors or patrons who can be approached? Is there an existing arts offering whose revenue and cost structure will yield a surplus that can be channeled to the new opportunity? Getting this information down on paper and taking a clear look will be beneficial in the long run. This step may be useful in establishing the criteria discussed above.

SEGMENTATION, POSITION, AND ARTS SERVICE MARKETING MIX STRATEGIES

Segmentation, positioning, and arts service marketing mix strategies are next undertaken, as was discussed in Chapter 6. This can serve as a point where the possibility of bundling arts service products is considered. What can be done to package the arts offering in concert with other aspects of new or existing offerings? *Bundling* presents the idea of offering an experience that combines several arts service products in a package for one price, and it is used as a cost saving measure.[41] This process in itself can constitute a "new" arts service product. Examples of bundling packages include pairing gourmet appetizers and wine tastings with arts offerings, packaging two or more arts presentations,[42] or providing exclusive invitations to meet artists at openings and social events, which can be specific to target audiences, based on their values and lifestyles. Importantly, the arts service product offering can be bundled with tourism or cultural heritage packages, as it allows for the creation of events reflecting the local arts, appealing to international and regional arts consumers who have interests in arts.[43] The point is to connect the bundled arts service product with the needs of the target audience and thus to garner the outcome desired, whether it is effectively gathering revenue in a price-skimming mode, increasing audiences, or developing outreach and funding activities. Each of these goals, of course, needs to be stated in SMART terms and be explicit in the bundling process. The culture-preneur or arts manager will need to decide if arts offerings that are bundled can be unbundled or tailored by the arts consumer as part of a customized arts service product package.

MARKET TESTING

Market testing of the new arts service product comes next, by including arts consumers in the process and giving them glimpses of the new works at different points, such as when they attend an arts offering of the business portfolio with stable market share and growth. The point of doing this is to reduce or connect with arts consumers'

perceived risks in a discontinuous innovation. As was discussed in conjunction with subjective quality in the cultural arts experience, some arts consumers seek experiences that are risky. The market testing should therefore be approached as gathering information and answering questions rather than trying to force a determination. If it is found that one or more segments are attracted to risky arts offerings, then they can constitute a target market for discontinuous innovations, for example. The same can be said for other new arts service product offerings that more closely track with continuous and dynamically discontinuous innovations. In other words, the new arts service product model can be used to supplement the culturepreneurial arts offerings portfolio, especially when the process is used to offer new experiences within time frames and within each arts service product class or category.[44]

PRODUCT INTRODUCTION AND LAUNCH

Next come the introduction and launch of the new arts service product, taking into consideration market entry strategies, timing, and the arts as a service product in functional and subjective quality, blueprinting, mapping, and so on.

MANAGEMENT OF THE ARTS SERVICE PRODUCT LIFE CYCLE

Management of the ASPLC is the final step in the process, whereby the new arts offering is evaluated relative to the other offerings in the portfolio.

Engaging in the systematic process of new arts service product development has not only the benefit of driving culturepreneurial aspects into the depths of the organization. It also gives the arts organization a competitive advantage.[45]

Exhibit 9.6 **The Tate Modern**

The Tate Modern is a museum that has both a charitable status and subsidiaries that act in a for-profit manner. The charitable portion of Tate Modern receives some of its funding from the Department for Culture, Media and Sport (DCMS) in the United Kingdom. Tate Modern is governed by its board of trustees. The board is responsible for the operations and outcomes of its subcommittees and councils, as well as its connected charities and subsidiaries. The daily operation of Tate Modern is managed by its director, who reports to the board. The director is appointed by the board with the approval of the prime minister, as set out in the Museums and Galleries Act of 1992. In 1889 Henry Tate, an entrepreneur in the field of sugar refining, owned a substantial collection of art that he wanted to display in the National Gallery of Great Britain. The collection was far too large, and therefore a new gallery was built. When it opened in 1897, Tate could not have envisioned that by 2014 there would be four major sites housing the national collection of British art from 1500 to the present day and international modern and contemporary art, including nearly 70,000 artworks.

Into this expansive effort, Tate Enterprises falls. Tate Enterprises is a wholly owned subsidiary of Tate Modern through which successful business ventures occur. These include publishing, catering, and retail sales of many varieties. Profits from the enterprises are channeled to support the work of Tate Modern. Tate Enterprises' mission is shared with Tate Modern's mission: to promote public knowledge, understanding, and enjoyment of British, modern, and contemporary art. Tate Enterprises' role is to maximize profits and extend the value of the Tate brand in order to support the Tate's work and collection. The company encourages arts consumers to enjoy spending more money in new and different ways. And that is not all; a number of new developments are planned for Tate Modern and Tate Enterprises. Visit the museum's website (www.tate.org.uk) and explore!

CHAPTER SUMMARY

As was explained in the previous pages, the point of this chapter was to examine the ways that a culturepreneurial culture can be modeled within an organization. In this context, organizational structures were discussed, including not-for-profit and for-profit framing for a culturepreneurial organization. Along this continuum, types of organizational structures that can be considered hybrids were also presented, allowing for incorporating the benefits of both not-for-profit and for-profit organizations and mitigating their respective disadvantages. Next, the chapter presented leadership strategies that could be used in a cultural arts organization; strategies for dealing with a dual leadership arrangement were briefly discussed. The chapter then turned to explaining the kinds of teams, work groups, and organizational structures available to the culturepreneur. Specific to this part of the chapter was the executive management team and the way it is employed to aid in the development of the cultural arts organization. Next, the chapter then discussed people management, explaining how to plan for human resources growth and development. Finally, the chapter emphasized establishing mechanisms to systematically bring new arts service products to the attention of the culturepreneur or arts manager in order to keep the firm moving in a culturepreneurial direction.

DISCUSSION QUESTIONS

1. Can a new arts service product development process be systematized in an arts organization? Why?
2. Can an arts organization thrive with two leaders at the helm? Explain.
3. Is there value in establishing a hybrid organizational structure using an L3C corporation, for example? What are some drawbacks?
4. Why would a culturepreneur choose to establish a profit-driven firm?
5. Explain the definition of "new" arts service products from the point of view of the arts consumer.

EXPERIENTIAL EXERCISES

1. What is your leadership style? What types of people should you hire and what complementary skills should they possess to make your leadership style stronger?
2. What arts service products can be bundled?
3. Using the process outlined in the chapter, design a new arts service product that can be used in a cultural fine arts organization. In what way will you determine if the arts offering should be brought to market?
4. Visit the websites of some of the arts organizations mentioned in the chapter and others as well. Design a hybrid cultural fine arts organization that has both a for-profit and a nonprofit component. In your organizational design, include the organizational structures, the executive management team members, the board, and articles of incorporation as needed.

NOTES

1. Frederick G. Crane, "Ethics, entrepreneurs and corporate managers: A Canadian study," *Journal of Small Business and Entrepreneurship* 22, no. 3 (2009), www.freepatentsonline. com/article/Journal-Small-Business-Entrepreneurship/213225828.html.

2. Branko Bucar and Robert Hisrich, "Ethics of business managers vs. entrepreneurs," *Journal of Developmental Entrepreneurship* 1, no. 1 (2001), 59–83.

3. George G. Brenkert, "Entrepreneurship, ethics, and the good society," *Entrepreneurship and Ethics* 3 (2002), 5–43.

4. Terrence E. Brown, Per Davidsson, and Johan Wiklund, "An operationalization of Stevenson's conceptualization of entrepreneurship as opportunity-based firm behavior," *Strategic Management Journal* 22, no. 10 (2001), 955.

5. For a detailed mathematical analysis and economic model of the nonprofit cultural arts organization, please see Henry Hansmann, "Nonprofit enterprise in the performing arts," *Bell Journal of Economics* 12, no. 2 (1981), 341–361; Kevin F. McCarthy, Elizabeth H. Ondaatje, Arthur Brooks, and Andras Szanto, *A Portrait of the Visual Arts: Meeting the Challenges of a New Era* (Santa Monica, CA: RAND Research in the Arts, 2005); James Heilbrun and Charles Gray, *The Economics of Art and Culture*, 2nd ed. (New York: Cambridge University Press, 2001); Paul DiMaggio, "Nonprofit organizations and the intersectoral division of labor in the arts," in *The Nonprofit Sector: A Research Handbook* (2nd ed.), ed. Walter W. Powell and Richard Steinberg (New Haven, CT: Yale University Press, 2006), 432–461.

6. DiMaggio, "Nonprofit organizations and the intersectoral division of labor," around page 422 (online pagination makes it difficult to determine the exact page).

7. Edward Glaeser and Andrei Shleifer, "Not-for-profit entrepreneurs," *Journal of Public Economics* 81, no. 1 (2001), 99–115.

8. James C. Collins and Jerry Porras, *Built to Last: Successful Habits of Visionary Companies* (New York: HarperBusiness, 1994).

9. See the Internal Revenue Service, "Exempt Organizations Annual Reporting Requirements—Annual Electronic Notice (Form 990-N) for Small Organizations: Some Group Subordinates Need Not File," August 15, 2013, www.irs.gov/Charities-&-Non-Profits/Exempt-Organizations-Annual-Reporting-Requirements-Annual-Electronic-Notice-(Form-990-N)-for-Small-Organizations:-Some-Group-Subordinates-Need-Not-File. All nonprofit organizations are required to file tax returns unless earnings and income are reported by a parent organization; which form to file is the question.

10. DiMaggio, "Nonprofit organizations and the intersectoral division of labor."

11. Hansmann, "Nonprofit enterprise in the performing arts."

12. Richard E. Caves, *Creative Industries: Contracts Between Art and Commerce* (Cambridge, MA: Harvard University Press, 2000).

13. DiMaggio, "Nonprofit organizations and the intersectoral division of labor."

14. Internal Revenue Service, "Exempt Purposes—Internal Revenue Code Section 501(c)(3)," October 30, 2013, www.irs.gov/Charities-&-Non-Profits/Charitable-Organizations/Exempt-Purposes-Internal-Revenue-Code-Section-501(c)(3).

15. Internal Revenue Service, "State Links," March 12, 2014, www.irs.gov/Charities-&-Non-Profits/State-Links.

16. Internal Revenue Service, "Apply for an Employer Identification Number (EIN) Online," January 2, 2014, www.irs.gov/Businesses/Small-Businesses-&-Self-Employed/Apply-for-an-Employer-Identification-Number-(EIN)-Online.

17. Benjamin Genocchio, "Auction houses versus private sales: What is the future of buying art?" *Blouin ArtInfo*, April 10, 2012, www.blouinartinfo.com/news/story/830496/auction-houses-versus-private-sales-what-is-the-future-of.

18. Evangeline Gomez, "The rise of the charitable for-profit entity," *Forbes*, January 13, 2012, www.forbes.com/sites/evangelinegomez/2012/01/13/the-rise-of-the-charitable-for-profit-entity/.

19. Kyle Westaway, "New legal structures for 'social entrepreneurs,'" *Wall Street Journal*, December 12, 2011, http://online.wsj.com/news/articles/SB10001424052970203413304577088604063391944.

20. Chuck Williams, *Management*, 7th ed. (Mason, OH: South-Western Cengage Learning, 2013).

21. Ibid.

22. Nancy J. Adler, "The arts and leadership: Now that we can do anything, what will we do?" *Academy of Management Learning & Education* 5, no. 4 (2006), 486–499.

23. Williams, *Management*.

24. David Cray, Loretta Inglis, and Susan Freeman, "Managing the arts: Leadership and decision making under dual rationalities," *Journal of Arts Management, Law, and Society* 36, no. 4 (2007), 295–313.

25. John Chamberlin, "Who put the 'art' in SMART goals?" *Management Services* 55, no. 3 (Autumn 2011), 22–27.

26. Robert D. Hisrich, Michael P. Peters, and Dean A. Shepherd, *Entrepreneurship*, 8th ed. (New York: McGraw-Hill/Irwin, 2010).

27. Rick Cohen, "Sarbanes-Oxley: Ten years later," *Nonprofit Quarterly*, December 30, 2012, http://nonprofitquarterly.org/governancevoice/21563-sarbanes-oxley-ten-years-later.html.

28. Hisrich, Peters, and Shepherd, *Entrepreneurship*; William J. Byrnes, *Management and the Arts*, 4th ed. (New York: Elsevier Focal Press, 2009).

29. Susan G. Cohen and Diane E. Bailey, "What makes teams work: Group effectiveness research from the shop floor to the executive suite," *Journal of Management* 23, no. 3 (1997), 239–290.

30. Ibid.

31. Gary L. Neilson and Julie Wulf, "How many direct reports?" *Harvard Business Review*, April 2012, http://hbr.org/2012/04/how-many-direct-reports/ar/1.

32. Maria Crealey, "Applying new product development models to the performing arts: Strategies for managing risk," *International Journal of Arts Management* 5, no. 3 (2003), 24–33.

33. Ibid; Hisrich, Peters, and Shepherd, *Entrepreneurship*.

34. Thomas Robertson, "The process of innovation and the diffusion of innovation," *Journal of Marketing* 31 (January 1967), 14–19.

35. Crealey, "Applying new product development models," 26.

36. Jennifer Trant, "Exploring the potential for social tagging and folksonomy in art museums: Proof of concept," *New Review of Hypermedia and Multimedia* 12, no. 1 (June 2006), 83–105.

37. Bruno S. Frey and Reiner Eichenberger, "On the rate of return in the art market: Survey and evaluation," *European Economic Review* 39 (1995), 528–537; McCarthy et al., *A Portrait of the Visual Arts*.

38. Nancy Proctor and Jane Burton, "Tate modern multimedia tour pilots 2002–2003," in *Learning with Mobile Devices Research and Development*, ed. Jill Attewell and Carol Savill-Smith (London: Learning and Skills Development Agency, 2004), 127–130.

39. Paula Armstrong, "Open Studios—A growing event," *Arts Professional*, January 14, 2002, www.artsprofessional.co.uk/magazine/article/open-studios-growing-event; Keith Hayman, "Open Studios—Opening up the arts," *Arts Professional*, January 14, 2002, www.artsprofessional.co.uk/magazine/article/open-studios-opening-arts.

40. François Colbert, *Marketing Culture and the Arts*, 4th ed. (Montreal: HEC Montréal, 2012).

41. Joseph P. Guiltinan, "The price bundling of services: A normative framework," *Journal of Marketing* 51, no. 2 (1987), 74–85.

42. McCarthy et al., *A Portrait of the Visual Arts*.

43. Hilary du Cros and Lee Jolliffe, "Bundling the arts for tourism to complement urban heritage tourist experiences in Asia," *Journal of Heritage Tourism* 6, no. 3 (2011), 181–195.

44. Ruth Rentschler, "Museum marketing: Understanding different types of audiences," in *Arts Marketing*, ed. Finola Kerrigan, Peter Fraser, and Mustafs Ozbilgin (Oxford: Elsevier Butterworth-Heinemann, 2004), 139–158.

45. Stephen B. Preece, "Performing arts entrepreneurship: Toward a research agenda," *Journal of Arts Management, Law, and Society* 41, no. 2 (2011), 103–120.

10 Copyrights, Intellectual Property, Cultural Policy, and Legality in Cultural Fine Arts Organizations

CHAPTER OUTLINE

LEARNING OBJECTIVES

After reading this chapter, you will be able to do the following:

1. Understand copyrights and their reach in the United States and abroad.
2. Know what is protected under copyright law and the cultural arts.
3. Discuss fair use and its implications for copyrighted materials.
4. Relate digital rights management with the use of copyrighted materials.
5. Comprehend the scope of the World Intellectual Property Organization.
6. Apply for a patent or a service mark or trademark.
7. Register a copyright.
8. Use trade secrets to the cultural arts organization's advantage.
9. Discuss the advantages and disadvantages of using patents and trade secrets.
10. Relate cultural and arts policy to cultural arts industries.

SPOTLIGHT: THE BAND "MILES"

Miles, a Bangladeshi music group, accused music director Anu Malik of Mumbai of committing theft without giving them the due acknowledgment and royalties accruing to them under the copyright protection of the World Trade Organization. [1]

Members of the music group received information from their followers and fans that their song "Phiriye Dao Amar Prem" had been copied in the soundtrack of the movie *Murder*. After watching the movie, the band members were astonished to find that their song had been copied to the point that it was recognizable to them.

The song had been composed by the music group in 1993 and released in Bangladesh and Pakistan. By 1997 it had become very popular in both Bangladesh and West Bengal, India. Yet now it had been copied for the soundtrack of *Murder* without permission.

The Mumbai movie world known as Bollywood earns millions of dollars by producing and exporting its films, which typically include many art forms, all over the world. Bangladesh carries a trade deficit with India, with imported cultural arts from India contributing to it. Copying and reproducing a song without any payment of royalties is not only unethical but also a violation of the intellectual property rights recognized by the World Trade Organization (WTO). Visit the WTO website (http://www.wto.org/english/res_e/booksp_e/casestudies_e/case3_e.htm) to read the entire article and see what happened with Miles.

DEFINING THE FIELD OF PROTECTION FOR ARTISTIC ENDEAVORS

This chapter provides an overview of the critical nature of cultural policy and legality in cultural arts products and services. The purpose is to impress upon culturepreneurs and arts leaders the need to understand and adhere to relevant laws and how to protect their company's artistic ideas, products, and services from being infringed upon. While it is not within the scope of the textbook to provide legal advice, many culturepreneurs engage the services of appropriate legal counsel in aiding them with issues involving incorporation and intellectual property rights. It may well be that you determine that the services of such experts are warranted. Arrangement can be made with the appropriate firm to work with you in exchange for stock, advertising or sponsorship acknowledgement, a board seat, premium seating at events, or other such incentives.

To begin, it is important to first understand definitional aspects as they relate to the cultural arts-producing organization and how these impact the directions that the culturepreneur will take. What is fair use and what laws are pertinent in presenting

or using artistic works? Next, an overview of cultural policy in the United States and abroad will be presented, noting some aspects of policy issues surrounding arts and the creative industries. It will be important for arts managers and culturepreneurs to understand what policies will affect their enterprise, particularly in light of the choice of a for-profit, not-for-profit, or other corporate arrangement.

According to Ruth Towse,[2] copyright law is an important policy tool affecting the cultural industry and establishing the underlying regulatory environment in which cultural organizations find themselves. A copyright's purpose has historically been to protect the creative assets of artists, to allow them to receive economic benefits, and to protect them from illegal copying or appropriation of their artistic endeavor. Such coverage falls under the general heading of *intellectual property rights* (IPR). IPR have come to include copyrights, patents, trademarks, and trade secrets.[3] With the advent of increased digitalization and electronic cultural and artistic availability, *digital rights management* (DRM) has become an aspect of cultural policy as well. All fall under the purview of the World Intellectual Property Organization (WIPO).

COPYRIGHT

Copyright, as defined and regulated by the 1976 Copyright Act in the United States,[4] is a form of intellectual property law that requires that a work be original, meaning that it was not copied from another work. Copyright protects original works of authorship, including artistic works, such as choreography, plays, and visual arts. Examples of such works that are copyrightable include tangible and intangible arts as they have been defined in this textbook. In order to be technically copyrighted, such works have to be fixed in a given form for the first time. For this reason, it is important to either carefully notate or record choreography and performances.

The Copyright Act of 1976 generally gives the owner of copyright the exclusive right to do and to authorize others to do the following:[5]

- reproduce the work in copies or recordings
- prepare derivative works based upon the work
- distribute copies or recordings of the work to the public by sale or other transfer of ownership, or by rental, lease, or lending
- perform the work publicly, in the case of literary, musical, dramatic, and choreographic works, pantomimes, and motion pictures and other audiovisual works
- display the work publicly, in the case of literary, musical, dramatic, and choreographic works, pantomimes, and pictorial, graphic, or sculptural works, including the individual images of a motion picture or other audiovisual work
- perform the work publicly (in the case of sound recordings) by means of a digital audio transmission

In addition, certain authors of works of visual art have the rights of attribution and integrity as described in section 106A of the 1976 Copyright Act. The visual arts category consists of pictorial, graphic, or sculptural works, including two- and

three-dimensional works of fine, graphic, and applied art. When artwork is transmitted online, the copyrightable authorship may consist of text, artwork, music, audiovisual material (including any sounds), sound recordings, and so on.

Section 106 of the 1976 Copyright Act protects an author's specific expression in literary, artistic, or musical form. Copyright protection does not extend to any usefulness, idea, system, method, device, name, or title. Copyright accrues immediately upon creation of the work, regardless of whether there has been formal application for a copyright. Copyright protection begins from the time the work is fixed in any tangible medium of expression from which it can be perceived, reproduced, or otherwise communicated, either directly or with the aid of a machine or device. A company, such as an arts organization or other enterprise, can own the copyright of works created by employees if the company has designated the work as a work for hire in a written agreement with the employee who is the creator of the work.

Typically copyright runs for seventy years after the creator's death; as long as the work continues to be sold over that period, the author or successors receive royalties and income from copyrighted artistic goods. The copyright act has been extended by corporate leaders to prevent works from going into the public domain; the copyright law is sometimes called the Mickey Mouse Act because the extension benefited the Walt Disney Company.[6] Again, the purpose of copyright is to protect the creator from loss of income and value. However, sometimes copyrighted materials are used without permission, with a defense called fair use, which means that the public can use some of the material without getting explicit permission, depending on several factors.

FAIR USE

What is fair use? The doctrine of fair use has developed from court decisions over the years and was codified in section 107 of the copyright law. Section 107 contains a list of the various purposes for which the reproduction of a particular work may be considered fair, such as criticism, comment, news reporting, teaching, scholarship, and research. Section 107 also sets out four factors, or tests, to be considered in determining whether or not a particular use is fair:[7]

1. The purpose and character of the use, including whether such use is of commercial nature or is for nonprofit educational purposes—is it transformative? In other words, is it simply copied or is the work used to inspire something new and culturally valuable?
2. The nature of the copyrighted work—are you copying facts or are you copying a work of art, for example? If you copy someone's artistic work, this could be problematic.
3. The amount and substantiality of the portion used in relation to the copyrighted work as a whole—you should take as little as possible; do not copy the core of the work and call it yours.

4. The effect of the use upon the potential market for, or value of, the copyrighted work—will your using the material deprive the owner of royalties and other benefits?

The problem is that these guidelines are interpreted on a case-by-case basis when the owner of the material in use disputes someone else's use as copyright infringement. In today's world, there is no actual guide, rule, or specified number of words or behaviors that can be used to determine fair use. Providing references and citations had been understood as a way to make sure that copyrights are not infringed upon. However, that is not the case typically anymore; therefore, it is always wise to get permission to use works or expand upon those that are not yours.

Fair use is a U.S. regulation. The rules of copyright in the United States, as you can imagine, do not necessarily flow to countries. Therefore, you will need to look at international copyrights to understand your coverage and protections.

INTERNATIONAL COPYRIGHT

If you are looking to copyright materials abroad, you will need to work directly with each country's copyright laws. However, there are two principal international copyright conventions: the Berne Convention for the Protection of Literary and Artistic Works (Berne Convention) and the Agreement on Trade Related Aspects of Intellectual Property Rights (TRIPS), one of several agreements that culminated in the creation of the World Trade Organization (WTO).

The Berne Convention[8] covers certain aspects of copyrights relative to three basic principles of national treatment, automatic protection, and independence from the copyright protection granted in the home country:

1. National treatment: Works originating in one of the 167 contracting countries or states (i.e., works whose author is a national of one of the states, or works that were first published in such a contracting state) must be given reciprocal protection
2. Automatic protection: Protection must not be conditional upon compliance with any principle of "automatic" copyright
3. Independent protection: Protection is independent of the existence of protection in the country of origin of the work, except that protection matches the length of time given in the home country

The minimum standards of protection cover all rights in literary, scientific, and artistic works and their duration, regardless of the form of expression; the following are rights recognized as exclusive rights of authorization:

- to translate
- to make adaptations and arrangements of the work
- to perform in public dramatic, dramatico-musical, and musical works

- to recite in public literary works
- to communicate to the public the performance of such works
- to broadcast
- to make reproductions in any manner or form
- to use the work as a basis for an audiovisual work
- to reproduce, distribute, perform in public, or communicate the work to the public

"Moral rights" are also covered by the Berne Convention. The Berne Convention, concluded in 1886, was revised at Paris in 1896 and at Berlin in 1908, completed at Berne in 1914, revised at Rome in 1928, at Brussels in 1948, at Stockholm in 1967, and at Paris in 1971, and was amended in 1979. The Berne Convention resides within the World Intellectual Property Organization Copyright Treaty. The moral rights under the Berne Convention include the right to object to the mutilation, deformation, or modification of the work or other derogatory action relative to the work, which would hurt or subject the author's reputation to question, disrepute, or negative positioning.

The general rule for duration of protection is that it must be granted for fifty years after the author dies. There are exceptions, of course. First, in the case of anonymous or pseudonymous works, the fifty years begins after the work was made available to the public, except if the pseudonym leaves no doubt as to the author's identity or if authors disclose their identity during that period; in the latter case, the general rule applies. For audio films and cinematographic works, the term is fifty years after releasing the work or, if no release is made, fifty years from creating the work. With photography and applied arts, copyright expires twenty-five years after the creation of the work. Keep in mind that some countries that are categorized as developing and are working with the General Assembly of the United Nations may deviate from these protections in regard to translation and the right to reproduce.

Another treaty that is germane to international copyrights is the Agreement on Trade Related Aspects of Intellectual Property Rights, one of several agreements that culminated in the creation of the World Trade Organization on January 1, 1995. As of 2010, numerous countries have established bilateral agreements with the United States. Referring to the U.S. Copyright Office website will aid in determining which countries are cooperating in copyrights bilaterally. Here we need to visit just for a few moments with WIPO and TRIPS.

The WIPO Copyright Treaty was signed in 1996. For purposes of the cultural arts, it recognizes that transmission of cultural products and services over the Internet and similar networks is an exclusive right within the scope of copyright, originally held by the creator. It also claims copyright infringements when technological protection measures are circumvented and when embedded rights management information is removed from a work.

TRIPS enforces protection through the WTO, as a part of the General Treaty on Tariffs and Trade (GATT), covering intellectual property with respect to the following:

- copyright and related rights
- trademarks, including service marks
- geographical indications
- industrial designs
- patents
- layout designs (topographies) of integrated circuits
- undisclosed information, including trade secrets

Importantly, TRIPS specifies that governments have to agree to enforce the rights covered by the treaty. Therefore, WIPO extends copyrights to protect works transmitted online and to protect them from tampering with copyright protection technology; TRIPS provides an enforcement mechanism when there is infringement on intellectual property in general, and signatories to the treaty agree that they will enforce it.

THE DIGITAL MILLENNIUM COPYRIGHT ACT

Now that you have your intellectual property protected, how do you manage the protection? Some organizations use copyright protection software to prevent illegal copying or replication. However, there are individuals who attempt to circumvent the process by using technology to disable the protection software. Particularly difficult is the management of material in digital form, and this aspect is covered by the Digital Millennium Copyright Act (DMCA) of 1998 as part of WIPO.[9] The WIPO Internet Treaties, the 1996 WIPO Copyright Treaty, and the WIPO Performances and Phonograms Treaty address the digital network environment. In general, the treaties require federal governments to create exclusive rights for copyright owners and to allow artists, including cultural artists, to make their works available online and to prohibit the circumvention of copyright protection, such as tampering with rights management information. The scope of DMCA is still being understood, and its reach is unclear: there is no agreed definition of digital rights management; that is, whether it is rights management by digital means or the management of digital rights, such as making them available.

Exhibit 10.1 **So You Think You Can Steal My Dance? Copyright Protection for Choreography**

Explicit copyright protection for choreography is relatively new. Before the enactment of the 1976 Copyright Act, choreography was not mentioned in law, and a dance piece could only be registered, as a type of "dramatic composition." According to the act, like any other protectable creative work, dance pieces are protectable by copyright provided that they qualify as a choreographic work (i.e., are original) and fixed in some tangible medium of expression. Today, choreography can be easily notated or videotaped (i.e., fixed) and copies can be registered with the U.S. Copyright Office. While it is clear that copyright owners retain the exclusive right, among other things, to reproduce and publicly perform their piece, rarely is it the case that another choreographer takes someone else's choreography and re-creates exactly the same piece as if it were the infringer's own. The general test for copyright infringement is whether the infringing work is substantially similar to the copyrighted work.

(continued)

What is choreography? The U.S. Copyright Office developed a formal definition of choreography: "Choreography is the composition and arrangement of dance movements and patterns usually intended to be accompanied by music. . . . To be protected by copyright . . . choreography need not tell a story or be presented before an audience . . . it is a related series of dance movements and patterns organized into a coherent whole."

Several cases have taken choreographic copyright protection to task: *Horgan v. Macmillan* is one of them. In 1986, Horgan, a representative of George Balanchine's interests, accused Macmillan Publishers of copyright infringement because of its use of photographs of Balanchine's production of *The Nutcracker* in a printed book without direct permission from Balanchine's estate for use of the copyrighted work. Horgan's claim was denied by the district court because of questions about the medium and the fact that Macmillan used only snippets of the ballet. However, the claim was won on appeal when the Second Circuit court considered photographs as representative of what was fully copyrighted by Balanchine.

Several authors have written about dance and copyright. One suggested that dance and the choreographic culture of working in a community and a sense of family create barriers to increasing protection from copyright laws. Aside from a historical sense of a dance community and family, two factors, the financial position of choreographers and the lack of choreographers actually pursuing cases of infringement in courts, pose huge limitations that hinder the protection offered in the Copyright Act of 1976 from reaching its objectives.

As can be seen, many are still dancing around choreography and copyrights.

Source: Julia Haye, "So you think you can steal my dance? Copyright protection in choreography," *Law Law Land,* September 13, 2010, www.lawlawlandblog.com/2010/09/so_you_think_you_can_steal_ my.html.

Note: For more information, see U.S. Copyright Office, "Dramatic works: Scripts, pantomimes, and choreography," FL-119 (Washington, DC: U.S. Copyright Office, November 2010), www.copyright.gov/ fls/fl119.html.

PATENTS

As opposed to copyrights, patents are meant to reward inventors through their government by granting them the exclusive right to use the patent for a specific time. In the United States, this is usually twenty years after the granting of the patent. This means others are excluded from making, selling, or reproducing the patented item for that period of time. However, the government discloses the invention to the public when the patent is made in the hopes that it will stimulate more creative works. There are three kinds of patents: utility, design, and plant patents.

In general terms, a *utility patent* protects the way an article is used, manufactured, and works; a *design patent* protects the way a piece of art looks. The two patents may be obtained on a work of art if "the invention" is original in its utility and appearance. However, the original utility and ornamentation are not always easy to see. Plant patents are granted to individuals or corporations who find ways to reproduce plants asexually. Our discussion will naturally not cover the plant patent! The design patent is most closely related to the cultural arts object being created. However, the ability to patent fine arts works is less straightforward; usually the artwork is covered under the process of copyrighting.

Yet there is an example of an ancillary product being patented for a dance. Michael Jackson patented the shoes the dancers used in one of his choreographed pieces:

Granted in 1993 to Jackson and two partners by the U.S. Patent and Trade Office, patent No. 5,255,452 covers a "system for allowing a shoe wearer to

lean forwardly beyond his center of gravity by virtue of wearing a specially designed pair of shoes. A heel slot in the shoes gets hitched to retractable pegs in a stage floor. Wearing the shoes, Jackson (or anyone) could seem to lean past his center of gravity without toppling. The effect would be most striking in live performances, during which harnesses and wires would be too cumbersome or impossible to disguise.[10]

As you can see, then, the patent is given for an object that is useful, nonobvious, and novel. There are many patents for these kinds of inventions;[11] therefore, patents in the culturepreneurial firm should not be dismissed out of hand. Applying for the exclusive right to use an invention is a way to protect earned income.

TRADEMARKS AND SERVICE MARKS

Trademarks, which are used to protect your brand, are federally governed by the Lanham Act of 1946 in the United States.[12] A trademark or service mark covers a word, symbol, design, sounds, or combined aspects of these, including slogans; the term "trademark" is used to cover both goods and services that are trademarked. A trademark or service mark is "used or intended to be used to identify and distinguish the goods/services of one seller or provider from those of others, and to indicate the source of the goods/services. A service mark is a word, phrase, symbol, and/or design that identifies and distinguishes the source of a service rather than goods."[13] Trademarks, which are managed through the U.S. Patent and Trademark Office, can last indefinitely if they are continued in their use and function, and renewed properly. The term initially given is ten years, with renewability of an additional ten-year term; however, you have to actively file for this renewal during the middle portion of the first granting of trademark. Current use and future use of words, symbols, designs, slogans, and so on can be trademarked. The advantage of using trademarks or service marks is that you are the only entity allowed to use them in the territories of the United States, and a registered trademark provides you with the ability to file for trademarks in other countries. If someone infringes on your trademark, you may be able to recover lost profits, damages, or costs. The point is to protect your brand and image as this is directly related to the position you occupy in the marketplace.

There are four basic types of trademarks: *coined or fanciful marks*, which relate the product to a particular good or service in use or planned to be in use in the future, such as logos for Sotheby's or Carnegie Mellon University;[14] *arbitrary trademarks*, which may have another meaning in a different context but are applied to a particular product or service, such as the red cross used by the American Red Cross or the ribbon used by the Susan G. Komen breast cancer organization;[15] *suggestive trademarks*, which cover the ingredients or attributes of a product or service but leave the consumer to make a connection with the product or service underlying it, such as Cirque du Soleil;[16] and *descriptive trademarks*, which have been distinguishable by consumers for a period of time and are representative of a product or service, such as the San Francisco Ballet or Electronic Arts.[17] Your actual trademarks or service marks will vary according to what you want to do. It cannot be overemphasized how

important it is to acquire trademarks for your organization, name, design, and so forth, and to make timely applications for their renewal.

TRADE SECRETS

After filing for copyrights, patents, and trademarks, coming to understand that there is no formal process for trade secrets may come as a relief. However, the protection of your trade secrets is as important to sustaining your competitive advantage as filing for the protections legally available to you. A good place to turn for guidance is the TRIPS agreement introduced earlier in the chapter. According to its standards, a trade secret possesses these characteristics:

1. The information must be secret (i.e., it is not generally known among, or readily accessible to, circles that normally deal with the kind of information in question).
2. It must have commercial value because it is a secret.
3. It must have been subject to reasonable steps by the rightful holder of the information to keep it secret (e.g., through confidentiality agreements).[18]

A *trade secret* is confidential information that gives the culturepreneur a competitive advantage and helps to maintain the organization's position in the industry. Trade secrets can include sales and distribution processes, such as yield management or ticketing; creative cultural processes; advertising strategies; consumer data and profiles; and lists of suppliers, clients, donors, or benefactors. The United States Patent and Trademark Office explains that trade secrets "consist of information and can include a formula, pattern, compilation, program, device, method, technique or process. To meet the most common definition of a trade secret, it must be used in business, and give an opportunity to obtain an economic advantage over competitors who do not know or use it."[19]

While a final determination of what information constitutes a trade secret will depend on the circumstances of each individual case, unfair practices in trade secrets may be individual or collective and may include industrial or commercial espionage or breach of contract and confidence. The unauthorized use of such information is regarded as an unfair practice and a violation of the trade secret. You can cover yourself with trade secret protection by having employees and contractors sign nondisclosure agreements and, where applicable, noncompete agreements. Generally, trade secrets have to be protected by your additional actions, such as knowing whom you can trust, locking files, scheduling meetings in secure places, encrypting computer files, and making sure your secret information is not being leaked or given away by mistake in meetings.

Sometimes there is a blurry line between keeping a trade secret and filing for a patent; or if the line is not blurry, then the advantages of keeping the process secret have to be weighed against the costs and disadvantages of obtaining a patent. The main disadvantage of filing for a patent is that your secret becomes public information at that point; if kept secret, you retain the rights to it indefinitely, assuming

someone else has not patented it, but that right may be more difficult to enforce, particularly if the proper precautions have not been taken. In the United States, trade secrets are covered by the Uniform Trade Secrets Act.[20] Remedies for the violation of trade secrets include actions by the courts. If courts find *misappropriation*, they can order parties that have misappropriated a trade secret to take steps to maintain its secrecy, as well as ordering payment of a royalty to the trade secret owner. Courts can also award damages, court costs, and reasonable attorneys' fees. "This protection is very limited because a trade secret holder is only protected from unauthorized disclosure and use which is referred to as misappropriation. If a trade secret holder fails to maintain secrecy or if the information is independently discovered, becomes released or otherwise becomes generally known, protection as a trade secret is lost. Trade secrets do not expire so protection continues until discovery or loss."[21]

COPYRIGHTING, PATENTING, AND TRADEMARK PROCESSES IN THE UNITED STATES

If you determine that you would benefit from copyrighting, patenting, and trademarking your work or related techniques, much of it can be done on line.

COPYRIGHTING

Online registration through the electronic Copyright Office (eCO) at www.copyright.gov is available to register basic tangible and intangible works. The advantages of using the online system are that it costs less, it is faster, and the fees can be paid electronically. Many different types of files can be uploaded for copyright. Physical filing can also be done; however, the materials require a longer processing time for security purposes. Therefore, depending on your needs, you may choose the course of filing that is best.

PATENTING

This process is somewhat more complicated; however, a flow chart of the process is available online at http://www.uspto.gov/patents/process/index.jsp. At this link, you can click on the different types of patents, such as design, and find a booklet *Trademark Office: A Guide to Filing a Design Patent Application*.[22] This is a lengthy process that requires that you identify your design and explain its uniqueness, provide drawings and specifications, and show that you are the owner of this process. Once the forms are completed, they must be filed with the appropriate fees.[23] The application filing fees have a wide range, depending on the size of the organization and the description of the application, beginning at $35 and ranging upward.

TRADEMARKING

Fees for trademarking are also required after filling out an application.[24] Fees begin at $275, depending on which form you use, and range upward with added requirements

and registrations. Once you have decided that you are going to trademark, you need to follow these steps:

1. Identify your mark format: a standard character mark, a stylized design or mark, or a sound mark.
2. Identify clearly the precise goods and/or services to which the mark will apply. Search the Patent Office website database to determine whether anyone is already claiming trademark rights in a particular mark through a federal registration.
3. Identify the proper "basis" for filing a trademark application: use in commerce (that you have started to use) or intend to use (you plan to use it in the future).
4. File the application online through the Trademark Electronic Application System (www.uspto.gov/trademarks/teas/index.jsp).
5. Pay your fees.

Once you have completed these processes, you will want to visit the World Intellectual Property Organization website and complete the related steps to protect your work in international locations. At the WIPO website (www.wipo.int/services/en/), you will find the necessary information to file for copyrights, patents, and trademarks. Fees for filing for a patent through the Patent Cooperation Treaty begin at about $1,500 and proceed upward.

As you can see, copyrights, patents, trademarks, and trade secrets can be both a benefit to the culturepreneur and a constant source of enforcement. Some culturepreneurs handle this aspect of legality in the arts by hiring attorneys, staff, or consultants who are experts in this area. The main takeaway is that the legal environment cannot be ignored, and when it is possible, your intellectual property should be protected, treated as an asset, and maintained as such once the protections are granted.

CULTURAL POLICY

Cultural policy is concerned with keeping cultural and creative offerings available in a public goods model through public funding, at least in part, whereby all citizens are uplifted and enlightened and arts that fulfill that goal are selected for public funding. Cultural policy is tasked with providing public support for the cultural arts and, in the expansion of the knowledge economy, for creative industries as well. While there is some controversy about the scope of cultural policy and the appropriateness of including creative industries within it,[25] culturepreneurs must be aware of the web of cultural policy that may entangle their organizations. They will need to find ways to tap into resources that may be available for the tangible and intangible fine arts, as they have been defined in this textbook, within cultural arts policy initiatives.

There are at least three strata of cultural arts policy, comprised of many individuals and organizations who are engaged or have a vested interest in creating, producing, presenting, distributing, and preserving the arts and educating people about

their own and other aesthetic heritages, including entertainment activities, products, and artifacts.[26] At the international level, UNESCO develops cultural arts policy; at the federal levels, each country has its own cultural policy; and each state and local government will have its cultural policy as well. In the United States, federal cultural policy falls under the umbrella provided by the National Endowment for the Humanities and the National Endowment for the Arts. In England, there are two entities involved: the Department for Culture, Media, and Sport and the Arts Council of England. Countries around the globe have established similar organizations, listed on the website of the International Federation of Arts Councils and Cultural Agencies (www.ifacca.org). Each of these entities is responsible for implementing the various acts covered by WIPO, as well as guiding cultural policies in their respective nations.

Cultural policy had historically been associated with arts funding policy, but has grown to cover arts and culture, as well as creative and knowledge industries, encompassing issues of diversity, cultural heritage, and accessibility. Importantly, cultural policy considers national identity issues. Yet at the same time, some cultural policy leaders have been criticized for attempting to dictate and cast with a broad net to capture what is a cultural good, with the goal of increasing for-profit democratization of culture and its receipt of public support.[27] For example, the National Endowment for the Arts came under criticism for funding unorthodox projects in the 1980s.[28] As was discussed in Chapter 1, the line between cultural and creative industry has become increasingly blurry, and with the definition of the knowledge economy, the creative industry and its economies quickly overshadow the cultural industries and their economies. Such a fine line can undermine cultural policy for the fine arts. Galloway and Dunlop state it this way: "As arts and culture become subsumed in a creative industries agenda, some important justifications for their support are at risk of being lost."[29] Therefore, it will be prudent to be clear how policy considerations affect the fine arts offering and the eligibility and availability of public funds for the culturepreneurial firm.

Aside from the spread of the domain of cultural policy, the problem with determining which cultural goods receive funding from the government becomes the problem of deciding who determines what is "good." *Cultural democracy* tries to avoid these criticisms by accepting that other forms of culture, such as popular and contemporary arts, need to be considered alongside historical readings of cultural arts. This argument recognizes the existence of a cultural policy issue centered on funding arts services products that are considered aesthetically elite and traditional versus those that are aesthetically popular and contemporary. Simply, this divide is the old high/low arts value argument in a new frame. Current thinking on these two extremes suggests finding a balance in cultural policy that does not favor one over the other.[30] The goal would be to develop policy that supports economic initiatives and honoring culture.

Arts policy has been connected with a concern for production of the cultural values relevant to the arts and culture of human civilization.[31] In simple terms, arts policy historically considered how to fund artists' works in environments that did

not provide adequate revenues or incentives to produce them. Patrons and donors were often the source of stability for artists; indeed, they still perform this important function today, along with philanthropic organizations, granting agencies and foundations, and government tax relief incentive structures. When a government interacts with this economy, it produces and directs arts policy. What has been problematic is the shift of resources and attention of arts policy toward a broader focus on cultural policy and the creative industries, as pointed out above. It is not the intent here to criticize or condone either side of the argument. What is of importance is to be able to identify sources of funds, grants, patrons, donors, and what they require in order to support the cultural arts organization. If the culturepreneur is interested and/or has the opportunity to participate in shaping cultural arts policy, this could be pursued under the umbrella of driving culturepreneurial behaviors throughout the organization in order to develop competitive advantages, as was covered in Chapter 9.

Having a working knowledge of national, international, state, and local arts policies, grants-making institutions, and funding opportunities that impact the culturepreneurial firm will be paramount for thriving and growing. Details of conducting fund-raising efforts—public, private, investor, and otherwise—utilizing these kinds of resources will be covered in Chapter 12.

CHAPTER SUMMARY

This chapter has endeavored to provide an overview of legal and policy issues that may impact the cultural arts organization. The culturepreneur and arts manager will find themselves in a large field of laws, regulations, and policy structures. Culturepreneurs and their associates should be very well versed in copyrights, fair use practices, DRM, and WIPO guidelines. In addition, the practice of applying for patents and registering trademarks should be routine. The organizational leaders should take steps to protect their trade secrets and instill within the culture the need for doing so, which, taken together, can provide extensive barriers to entry for competitors. Not insignificantly, the use of these tools can protect the firm's assets from being diminished or devalued.

Cultural and arts policy discussions can also provide growth and protection for organizations in the cultural arts industry. While there are arguments as to what types of firms will receive public funding, it remains true that there are multiple incentives for funding the cultural arts. Policies exist at the international, federal, state, and local levels. The culturepreneur and arts manager would be well served to have a working knowledge of each of the policies that will impact their organization and, if possible, be able to effect policy changes in their favor.

DISCUSSION QUESTIONS

1. Discuss copyrights and their reach in the United States and abroad. How does this discussion relate to digital rights management?

2. What is protected under copyright law and the cultural arts?
3. Explain the goals of the World Intellectual Property Organization. How do they impact the laws in the United States?
4. Discuss the advantages and disadvantages of using patents and trade secrets in the cultural arts.
5. Conduct an online search of digital rights management processes. How can the digital rights management system be crafted from the artist's viewpoint? How will that differ from a system that is aimed at protecting corporate rights?

EXPERIENTIAL EXERCISES

1. Examine the process of applying for a patent and a trademark at the United States government websites.
2. Develop a document that can be used to give to potential stakeholders regarding protecting trade secrets to the cultural arts organization's advantage.
3. Develop a working database of arts policy organizations that will benefit your cultural arts organization. Include international, federal, state, and local levels.
4. In reference to the work completed in number 3 above, design mechanisms whereby you can serve as an influence on arts and culture policy making at the local level, and then move forward to state and federal levels. Make notes of your findings to prepare you for engaging in a discussion.

FURTHER READING

Americans for the Arts. National Arts Administration and Policy Publications Database. www.americansforthearts.org/by-program/reports-and-data/legislation-policy/national-arts-administration-and-policy-publications-database.

Copyright Clearance Center. International Copyright Basics. *RightsDirect*. 2014. www.rightsdirect.com/content/rd/en/toolbar/copyright_education/International_Copyright_Basics.html.

Taubman, Antony, Hannu Wager, and Jayashree Watal (eds.). *A Handbook on the WTO TRIPS Agreement*. Cambridge: Cambridge University Press, 2012. www.wto.org/english/res_e/publications_e/handbook_wtotripsag12_e.htm.

U.S. Patent and Trademark Office. Trademark basics. www.uspto.gov/trademarks/basics/.

Wikisource. Agreement on Trade-Related Aspects of Intellectual Property Rights. 2013. http://en.wikisource.org/wiki/Agreement_on_Trade-Related_Aspects_of_Intellectual_Property_Rights.

World Intellectual Property Organization. Berne Convention for the Protection of Literary and Artistic Works. www.wipo.int/treaties/en/ip/berne/index.html.

World Trade Organization. TRIPS [trade-related aspects of intellectual property rights] material on the WTO website. www.wto.org/english/tratop_e/trips_e/trips_e.htm.

The following books cover cultural policy in depth:

Throsby, David. *Economics and Culture*. New York: Cambridge University Press, 2001.

———. *The Economics of Cultural Policy*. Cambridge: Cambridge University Press, 2010.

NOTES

1. This is a summary of part of an article written by Abul Kalam Azad, *Rock 'n Roll in Bangladesh: Protecting Intellectual Property Rights in Music*, Managing the Challenges of WTO Participation: Case Study 3, www.wto.org/english/res_e/booksp_e/casestudies_e/case3_e.htm#context.

2. Ruth Towse, "Managing copyrights in the cultural industries," paper presented at the Eighth International Conference on Arts and Culture Management, Montreal, Canada, July 3–6, 2005.

3. Robert D. Hisrich, Michael P. Peters, and Dean A. Shepherd, *Entrepreneurship*, 8th ed. (New York: McGraw-Hill/Irwin, 2010).

4. Please see U.S. Copyright Office, http://copyright.gov/, for more information, forms for registering, and guidelines.

5. There is an online version of the U.S. copyright law at U.S. Copyright Office, *Complete Version of the U.S. Copyright Law* (Washington, DC: U.S. Copyright Office, December 2011), www.copyright.gov/title17/.

6. U.S. Copyright Office, "Chapter 31: Duration of Copyright," in *Circular 92: Copyright Law of the United States of America and Related Laws Contained in Title 17 of the United States Code* (Washington, DC: U.S. Copyright Office, December 2011), www.copyright.gov/title17/92chap3.html.

7. U.S. Copyright Office, "Fair use," FL-102 (Washington, DC: U.S. Copyright Office, June 2012), www.copyright.gov/fls/fl102.html.

8. World Intellectual Property Organization, "Summary of the Berne Convention for the Protection of Literary and Artistic Works (1886)," www.wipo.int/treaties/en/ip/berne/summary_berne.html.

9. U.S. Copyright Office, "Online Service Providers," 2014, www.copyright.gov/onlinesp/ for more information.

10. Dan Vergano, "Jackson's 'smooth' leaning move really was patented," *USA Today*, July 2, 2009, http://usatoday30.usatoday.com/life/people/2009-06-30-jackson-patent_N.htm.

11. Patenting Art and Entertainment, "Patent titles: Dance," http://patenting-art.com/database/dancing.htm.

12. The Lanham Act is found in Title 15 of the U.S. Code. "Lanham (Trademark) Act (15 U.S.C.)," *BitLaw*, www.bitlaw.com/source/15usc/. Please note, though, that the federal act is not the only one covering U.S. trademark law. Common law and state statutes control trademark protection. You should therefore check your state laws as well.

13. U.S. Patent and Trademark Office, "Basic facts about trademarks: What every small business should know now, not later," www.uspto.gov/trademarks/basics/.

14. Sotheby's, "Terms & conditions of use," www.sothebys.com/en/terms-conditions.html; Carnegie Mellon University, "Policy for Use of Carnegie Mellon Trademarks," www.cmu.edu/policies/documents/Trademark.html.

15. Clifford M. Marks, "Charity brawl: Nonprofits aren't so generous when a name's at stake," *Wall Street Journal*, August 5, 2010, http://online.wsj.com/news/articles/SB10001424052748703700904575390950178142586.

16. Liz Benston, "Judge rejects claim for 'cirque' name," *Las Vegas Sun News*, April 23, 2004, www.lasvegassun.com/news/2004/apr/23/judge-rejects-claim-for-cirque-name/.

17. San Francisco Ballet, "Conditions of use," www.sfballet.org/home/conditions_of_use; Zachary Knight, "EA sues EA over the EA trademark," *TechDirt*, October 6, 2011, www.techdirt.com/articles/20111005/11124816224/ea-sues-ea-over-ea-trademark.shtml.

18. World Intellectual Property Organization, "What is a trade secret?" www.wipo.int/sme/en/ip_business/trade_secrets/trade_secrets.htm.

19. U.S. Patent and Trademark Office, Office of Policy and External Affairs: Patent trade secrets, www.uspto.gov/ip/global/patents/ir_pat_tradesecret.jsp.

20. U.S. Patent and Trademark Office, Office of Policy and External Affairs: Patent trade secrets, www.uspto.gov/ip/global/patents/ir_pat_tradesecret.jsp.

21. Ibid.

22. U.S. Patent and Trademark Office, *A Guide to Filing a Design Patent Application* (Washington, DC: U.S. PTO), www.uspto.gov/web/offices/com/iip/pdf/brochure_05.pdf.

23. U.S. Patent and Trademark Office, fee schedule, www.uspto.gov/web/offices/ac/qs/ope/fee010114.htm.

24. Ibid. Scroll down the web page for the schedule of trademark fees.

25. Andy C. Pratt, "Cultural industries and public policy: An oxymoron?" *International Journal of Cultural Policy* 11, no. 1 (2005), 31–44; Nicolas Garnham, "From cultural to creative industries: An analysis of the implications of the 'creative industries' approach to arts and media policy making in the United Kingdom," *International Journal of Cultural Policy* 11, no. 1 (2005), 15–29; Stuart Cunningham, "The creative industries after cultural policy: A genealogy and some possible preferred futures," *International Journal of Cultural Studies* 7, no. 1 (2004), 105–115.

26. Margaret J. Wyszomirski, "Arts and culture," in *The State of Nonprofit America*, ed. Lester M. Salamon (Washington, DC: Brookings University Press, 2002).

27. Pratt, "Cultural industries and public policy."

28. David Throsby, *The Economics of Cultural Policy* (Cambridge: Cambridge University Press, 2010).

29. Susan Galloway and Stewart Dunlop, "A critique of definitions of the cultural and creative industries in public policy," *International Journal of Cultural Policy* 13, no. 1 (2007), 17; see also Cunningham, "The creative industries after cultural policy."

30. David Throsby, *Economics and Culture* (New York: Cambridge University Press, 2001).

31. Throsby, *Economics of Cultural Policy*.

11 Technology and the Culturepreneurial Organization

CHAPTER OUTLINE

LEARNING OBJECTIVES

After working though this chapter, you will be able to do the following:

1. Understand the concepts of the management information system, the business process information system, and the executive information system.
2. Use these three systems in a culturepreneurial organization.
3. Know the difference between outward-facing aspects of the management information system.
4. Comprehend websites relative to Web 2.0 technology.
5. Discern the differences in social media, strategy, and management.
6. Understand dashboards and their importance in visual information.

7. Know the benefit of inward-facing aspects of the business process information system.
8. Realize the value of an arts constituent relationship management system.

WHAT'S ON?

Google Cultural Institute
www.google.com/culturalinstitute/home

SPOTLIGHT: ART IN SECOND LIFE

If life in reality is not giving what you had hoped, there is a solution. Second Life is a virtual world that has an active and growing place for cultural fine art. According to the website, it has a place for everyone with unlimited boundaries and resources, where only your imagination controls what life is like. As an avatar that represents you, you have places to go, things to buy, and unlimited friends to make. In the Second Life community, there are people from all over the world to dance with at dance clubs, groups to join and participate in, and scheduled events to attend. Most importantly, you can choose from a number of lucrative creative careers, including designing, marketing, and fine art.

At a former simulation ("sim") called Artists for Second Life,[1] there was a visual representation of an art world. Exhibits included some of the most seductive, stimulating, and overwhelming cultural fine art produced by individual creators. The galleries displayed art from artists, and Second Life provided residencies for artists who would have liked to produce and display their works in and for virtual worlds. In addition, there was a dedicated installation for fund-raising. Several reality galleries, such as the University of Delaware Art Gallery, the Natural History Museum of Vienna, and the galleries of the Chelsea neighborhood in New York City, had exhibition space at the site. While this sim has since closed, there are plenty of sims you can explore within Second Life if you are interested in art.[2]

While this is in fact a location for different experiences with art, it remains to be seen how effective it becomes. Artists sometimes place work within the virtual reality space that was created for the real-world space, and it may or may not translate well. Some artists create works that are only for the virtual world with no intention of bringing it to reality. At the same time, the virtual art world is a cultural construction itself. Does it represent culture at this point in time relative to creating cultural value? According to Patrick Lichty, author of "The Translation of Art in Virtual Worlds," the use of form, types of audience, cultural contexts, and modalities used with respect to creating cultural fine art raise concerns about the work in these spaces.[3] Importantly, the question looming relatively largely is this: If culturepreneurs utilize this medium, how will they engage arts consumers within it?

USING MANAGEMENT AND BUSINESS PROCESS INFORMATION SYSTEMS IN THE CULTUREPRENEURIAL ORGANIZATION

In the world in which the cultural fine arts organization operates, technology is everywhere apparent. People inside and outside the firm use websites, social media, data systems, and electronic promotions, distribution, and event information, all of which are expected to be handled through seamless electronic interfaces. Therefore, this chapter is presented to provide an overview of management and business information systems that impact the cultural fine arts organization. In so doing, the focus is on establishing both the internal and external technological interfaces that forward the strategic direction of the cultural fine arts organization.

The first part of the chapter concentrates on establishing the internal business processing systems, such as sensitive financial, employee, and stakeholder information; the second part covers the outward-facing aspects of the culturepreneurial firm as it navigates distribution, relationship management, promotions, and mobile applications. Because the technological environment changes daily if not more frequently,[4] culturepreneurs and arts managers have the important responsibility of updating their systems and staying abreast of rapid changes—and balancing technology tools with the needs of the organization. It would be prudent to incorporate into the culturepreneurial arts organization processes that will be followed to remain up-to-date on technological issues in relation to the arts organization's strategic directions and mission. And, like other chapters in this book, this chapter can only provide a tip of the iceberg from the glacier that comprises technology, how it is changing, and the impact it has on businesses strategically and in day-to-day operations. The chapter does not delve into electronic arts or creating artistic service products. Instead, it offers guidance and direction in establishing how to use information systems to the culturepreneur's advantage.

MANAGEMENT INFORMATION SYSTEMS

In this textbook, a *management information system* (MIS) is composed of those aggregate aspects of the organization that interface with people, processes, data, and computer hardware and software. The MIS allows the culturepreneur and the arts manager to evaluate and monitor the activities that lead to the cultural arts organization's ability to fulfill its strategic goals and make decisions. It consists of the computers and their peripherals, such as printers, faxes, scanners, copy machines, and the software and systems relative to those devices. According to *Inc.* magazine's website, "the main purpose of the MIS is to give managers feedback about their own performance; top management can monitor the company as a whole. Information displayed by the MIS typically shows 'actual' data against 'planned' results, and results from a year before; thus it measures progress against goals."[5] Not only does there need to be an MIS; it needs to be integrated so that data can be used to support decisions. Moreover, an MIS should be scaled to benefit the information needs of an organization: it can be based on a platform as small as a smart phone or as large as a supercomputer, and it can range in size between these two extremes. The point is that nearly all culturepreneurial organizations need or will need an integrated MIS and a way to interact with its information.

Key questions that need to be addressed at the outset of launching a culturepreneurial venture or growing one include the following. What is the software and hardware environment that will be used? Is everything going to rest on a Windows, Apple, or Linux operating system? Are the computers going to be desktops, notebooks, or laptops? Who will manage the distribution and servicing of computers and peripherals? Will employees have the option of choosing the type of computer and printer they prefer? Is the cultural arts organization ready to set up extranets and intranets? How much information will be stored "in the cloud" versus on local computer hard drives or networks? Is there a paperless policy in force? How will Internet and mobile device traffic be managed? What are the costs that will be incurred versus the benefits of utilizing an electronically driven MIS? Is the arts organization a *digital firm*, where relationships with stakeholders and core business processes are supported and developed through digital networks?[6] The answers to these questions as they relate to strategic decisions will drive many others relative to the software applications available and how the arts organization operates.

Within an MIS there is an embedded system that is related to the business processes governing how the cultural arts organization produces its services and product. This is the *business processes information system* (BPIS). At the simplest level, it can be conceptualized as follows. Imagine that an arts consumer wants to purchase something from the culturepreneurial organization—attend an arts offering, buy merchandise, or make a donation, for example. When this is done, there will be a *transaction*, which will need to be accounted for. If an arts offering is delivered, people will need to be managed and compensated; facilities, spaces, shipping, and seating need to be managed. If a new work of art is acquired for auction, cataloging and storage will be needed. Each of these transactions and pieces of data comes together and contains information, which can be used for decision support. However, as mentioned with respect to the overall MIS, the BPIS will need integration into what is known as an enterprise system.[7] Drawing from the MIS and the BPIS, arts organization leaders will create an *executive information system* (EIS), developed from data that have been gathered and configured as information intended for decision making.[8] Exhibit 11.1 provides a graphical representation of this.

Therefore, the discussion in the next section will first cover *outward-facing* aspects of the MIS—that is, loosely, those aspects of the MIS that are "facing" the arts consumer, external constituents, and the arts organization's suppliers. Next, the discussion focuses on dashboards and the EIS (Chapter 13 provides an in-depth analysis of financial and investment issues and it is assumed in the current chapter that the accounting system is interactive within the arts organization). After that, the conversation turns to *inward-facing* systems contained by the BPIS. These broadly include the information that will be considered as located within the arts organization. Here consideration is given to arts consumer relationship management systems, documents, distribution and supplier information, intellectual property management, and managing people. As can already be seen, the distinction between inward- and outward-facing systems can be somewhat ambiguous. The dividing line will become clearer as the chapter unfolds and especially as the culturepreneurial decision points relative to establishing the MIS and BPIS

Exhibit 11.1 **The MIS, BPIS, and EIS**

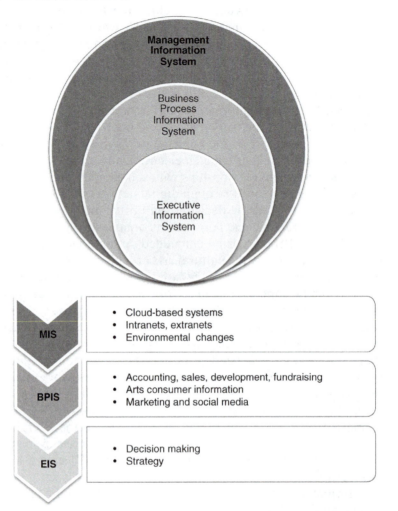

Sources: Kenneth C. Laudon and Jane P. Laudon, *Management Information Systems: Managing the Digital Firm*, 12th ed. (Boston: Prentice Hall, 2012); Chuck Williams, *Management*, 7th ed. (Mason, OH: South-Western Cengage Learning, 2013).

align with costs, system security issues, use of bandwidth, and data storage needs locally and in the cloud.

OUTWARD-FACING ASPECTS OF THE MANAGEMENT INFORMATION SYSTEM

When setting the arts organization in motion, one of the very first areas to address in a digital environment is the website, an outward-facing aspect of the overall digital firm. The term "outward-facing" is taken to encompass aspects of the arts

organization that come into contact with constituents and the information that will be readily available to them and, as such, to competitors.[9] The first face of outward-facing technology that constituents and competitors typically come into contact with is the cultural arts organization's website. Because of this, the idea is to think about the MIS from a strategic viewpoint and understand how it will interact and support the arts service product, as was discussed at length in Chapter 8. Once the website is designed, electronic communications and networks can radiate from there. Websites, configured for browsing from desktop computers, tablets, and mobile devices; mobile applications for smart phones and tablets; and social media should be integrated within this aspect of the MIS. From it, information can be derived to create dashboards that feed into the EIS. This section of the chapter examines each of these aspects in turn.

THE WEBSITE

Having your website designed and architected first will provide logical next steps for the arts organization. First, a *domain name* is needed, such as "www.yourartsorganization.net" (or .com, .org, or .edu, depending on your organization's structure). If you are planning to use email addresses and do not want to show an email provider such as Yahoo! or Gmail, having the website domain selected and registered is vital, and many firms are available that will help you register a domain name by simply conducting an Internet query. Your website domain registration has to be renewed, typically annually, and usually you will receive a notice asking if you want to renew. However, it is a good practice to set an automatic reminder of some sort that will remind the appropriate people in your organization that it is time to renew. The domain name is an asset for your organization and should be treated with seriousness.

Because of this, some culturepreneurs will register several domain names, especially if they believe the domain names they want will be unavailable in the future.

The next step is to decide on the *host* for your website. There are many Internet service providers (ISPs) that will do this for you, assuming that you plan to outsource this function at least in the beginning stages of the organization, until such time as this function is brought in-house. The strategic plan may envision a chief technology officer who manages this aspect of the firm, and whether that person is hired now or later depends on how resources are allocated and the importance of the role within the company. Email addresses will typically match the domain name chosen; deciding how to identify the individuals in the firm will be another matter. Will the naming convention be FirstName@yourartsorganization.net, or FirstName.LastName@mail.yourartsorganization.net? Or will the naming conventions be arranged differently from either of these choices? What email address will you list for people who are looking to contact the arts organization, such as info@yourartsorganization.net. The key is to think about how many email addresses you will need and the likelihood of being able to keep naming conventions consistent. At the same time, finding out who will design and set up the website and having the

web content be available for devices such as notebooks and smart phones are further considerations. Many different options are available, from a full website design to using blogger interfaces. In any event, email use and website hosting, management, and maintenance will impact the ISP costs.

The website will be the outward face of the organization online and may be the only interaction an arts consumer will have with the culturepreneurial firm. In *split seconds* many arts consumers will make judgments about it and decide if they want to continue with your organization or not. What do potential arts consumers, donors, competitors, and employees first experience when they visit your website? Is the information organized and accessible from their point of view? Does it take too long to load? How many clicks into the website are required for arts consumers to find what they need? Will the website be *promotional*, providing information only, or *transactional*—that is, can visitors securely purchase merchandise or tickets, and make a donation? Can they contact the arts organization? Will they be able to engage in live chat on the website? Can arts consumers engage with samples of your arts service product offerings or download a video or audio file? What information about the company leaders and management will be available? Can they learn about the history of the company? Do you require "cookies" or tracking mechanisms such as login protocols to use the site? How are you going to analyze website traffic? How much information about the arts organization is available on the website? What can suppliers gain from interacting with your website? Is there a secure login area where they can get information? Will you have a blog? Can visitors to the website post information? How will you optimize the way arts consumers or other interested parties find your website? Search engine optimization is one such area of website management you will have to consider.

All of these questions, plus others that will be generated as you move through the process, need to be addressed in forming the website and providing for its purpose. The arts consumer experience with the website can be designed using several elements.[10] Keep in mind that information on the website that is not hidden behind a protected login will be accessible to your competitors. However, the contents of the website are copyrighted, and expressly stating this on each website page is quite expected. While these are important questions to answer, keep in mind that the website also portrays your brand, image, and position. Some websites, such as those that are classified as promotional websites, give no product or service information and simply let visitors know how to contact the organization.

Therefore websites nowadays, described here as captured in the phrase "Web 2.0," are produced and deployed within a context of functional and aesthetic aspects whether the website design anticipates ecommerce functionality or not. By determining the contextual aspects of the website design, the types of content used and the amount of it will support the contextual decision. If the website is to enable secure transactions such as purchases or other interaction with suppliers, this decision will come under the aspects of commerce. The website design should provide venues for communication, with login requirements at the site, with the arts organization, such as through email, blog posts, instant messaging, or telephone calls.

Many organizations offer such interactivity in real time for their website visitors. Moreover, Facebook, Twitter, RSS Feeds, and other social media links are expected to be enabled for visitors to the website. These are some of the aspects that need to be considered when designing a website.

However, the website has to be accessible not only by computers such as laptops and desktops; it also has to be interactive through notebooks and smart phones. While many websites work with these two kinds of devices, as standard practice more and more, consumers are able to access website information through applications that configure the website for smart phones and notebooks. If the choice is made to use an outside provider to design the website, the provider will be able to offer configurations using *mobile websites* and/or *mobile applications software (mobile apps)* that will generate the appropriate layout when a notebook or a smart device is accessing website information.[11] If the choice is to use staff in-house or volunteers to craft the outward face of the arts organization, this is something that would need to be discussed and formulated. Mobile website software renders the website readable on a mobile device, displaying content such as video, text, images, and sound and including location and mapping services and call functionality. Mobile applications are designed for specific purposes and are downloadable from an "app store." Mobile websites can be used as mobile apps; however, designing the website and then the mobile website would be first steps before developing a mobile app. Mobile apps are useful when the desire is for personalization of the content, or when, for example, financial or sensitive decision information is developed from data captured from the mobile app. If the decision is to use mobile website development and wait on developing a mobile app, it may still be of value to consider developing social media connectivity within the context of the digital environment. The next subsection will talk briefly about these strategic aspects of employing technology in the cultural arts organization.

THE CLOUD

The "cloud" is a term often used when referring to MIS systems when their operation is virtual—that is, not at the physical location of the organization—and much of the MIS function utilizes this approach rather than having hardware and infrastructure at the business. The cloud comprises a set of MIS and BPIS technologies that enable delivery over the Internet in real time, allowing instant access to data, applications, and information. It is running software through Internet-based applications rather than from desktops or personal computers and laptops. And while many organizations use cloud computing, it is not entirely true that all the computing is done in that fashion. Many employ some level of both methods. For example, they maintain their accounting program on their local PC while their email and management software are in the cloud and accessible by any computer via the Internet. This is what will be discussed in the section on inward-facing aspects of the MIS. However, the cloud can be attractive because systems can be accessed from any location with an Internet connection, and this convenience makes it a flexible option for

Exhibit 11.2 **What's in a Cloud?**

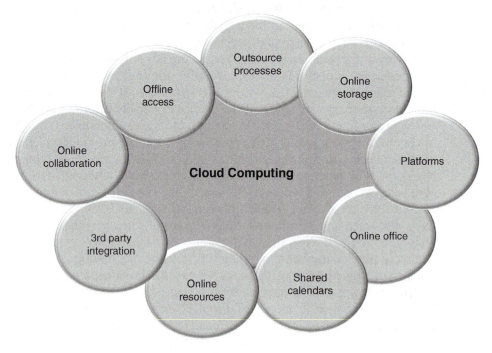

many organizations, rather than having an on-site infrastructure with its costs. The service is subscription-based or pay-per-use service that often extends or functions as the company's information system.

What kinds of pay-per-use services does cloud computing offer? Nearly every aspect of the MIS and the BPIS can be computed this way.

- Software as a Service (SaaS) for web conferencing, enterprise social software, instant messaging, and video conference presence needs.
- Search engine optimization.
- Infrastructure as a Service (IaaS) for on-demand computing, memory, wireless, switching, security, and devices and storage.
- Security as a Service to protect your network infrastructure.
- Disaster Recovery as a Service (DRaaS) for recovery of data and information in a natural disaster such as a hurricane or tornado.
- Desktop as a Service (DaaS) so you do not have to worry about data storage, backup, security, and upgrades.
- Documents and presentations.

Some critics have argued that using the cloud is risky because of the loss of control over data and because systems can be intruded upon and sensitive data stolen.[12] Therefore, prudence will dictate the appropriate use of the cloud for the culturepreneur and arts manager. This decision, whether to keep the processes in

house or outsource with cloud computing, will probably coincide with aspects of social media use. This decision also impacts the way the outward face of the firm is seen, what is communicated, and the use of the data the system captures for decision making.

SOCIAL MEDIA STRATEGY AND MANAGEMENT

What are social media? Are they necessary for an arts organization to use? And if so, in what ways? In today's world, according to Pew Research Center's Internet and American Life Project, using social media is critical to the cultural arts. Using the Internet and social media is necessary and integral for promoting the arts, increasing audience engagement, fund-raising, increasing organizational efficiencies, educating employees and board members, connecting with suppliers and channels, and engaging in cultural and arts policy.[13] Social media are an Internet tool that may be used in an MIS, BPIS, or EIS, and as will be shown in the latter part of this chapter, in arts constituent relationship management situations. Importantly, social media can be accessed on websites, mobile websites, and mobile apps.

While social media can be considered a very expansive area that is in constant flux, for purposes of this textbook, the definition of *social media* will be "a group of Internet-based applications that build on the ideological and technological foundations of Web 2.0, and that allow the creation and exchange of User Generated Content,"[14] that "employ mobile and web-based technologies to create highly interactive platforms via which individuals and communities share, co-create, discuss, and modify user-generated content,"[15] and are used strategically to forward the aims of the culturepreneurial organization. The discussion will focus on using social media to the cultural arts organization's advantage. The culturepreneur and arts manager will decide on how to engage with the tactical aspects of social media, whether to employ someone in-house, to outsource this function, to use the existing social media platforms, or to build one that is exclusive to the cultural arts organization. These decisions will, of course, rest on budgetary and resource allocation initiatives. Yet these decisions are critical to the development of MIS overall and the decision support needs of the organization. As a caveat, again, it has to be stressed that the nature of social media is that they change daily and that the scope of this chapter is not to provide an in-depth analysis of social media. This section covers classifications of social media and what is necessary in using them, as well as a "building block" model that will help make sense of what to do with social media. Lastly, the discussion advocates having a well-developed plan for using social media, with objectives and guidelines so that the resources of the firm are allocated in this area as wisely as possible.

Social media classifications spread across two major theoretical areas that underlie social media. One is *social presence with media richness* and the other is *self-presentation and self-disclosure*. Social presence has to do with intimacy and the time frame involved in developing such intimacy. Intimacy is influenced by asynchronous versus synchronous interpersonal communications and is often related to the medium that is used. When the medium allows for interpersonal communication

that is synchronous, the social presence is higher than when it is asynchronous and mediated. In other words, email provides for a low social presence, but live chat and instant messaging, for examples, provide for higher levels of social presence among the participants. Social presence is further increased if media richness is included in the communication—that is, resolution of ambiguity, risk, or uncertainty produced in the communication by use of information. Here a direct application of this aspect of social media can be used in conjunction with involvement and the arts consumer's desire to mitigate risk, as was discussed in Chapters 5 and 6.

Continuing then with the other piece of social media classification system, self-presentation and self-disclosure are integral to it. Self-presentation, related to how one wants to be seen, is connected to the conversation regarding the anthropology of consumption and the aesthetic object concepts raised in Chapter 4. Self-presentation refers to people's desire to present themselves in a positive light, relative to identity creation. As can be seen, this concept applies to arts consumers, but also to arts organizations that are seeking to position themselves in a particular location within a perceptual map. With self-presentation comes self-disclosure, without which no relationship can actually form—between strangers or otherwise. The amount and type of information presented will influence both. Controlling the kinds of self-disclosure information while presenting a positive face is the goal of this aspect of social media. A graphic presentation of these aspects of social media is given in Exhibit 11.3. In this system, social media are described as high or low in their ability to influence social presentation and self-disclosure while providing social presence with media richness.

Exhibit 11.3 **Types and Classification of Social Media**

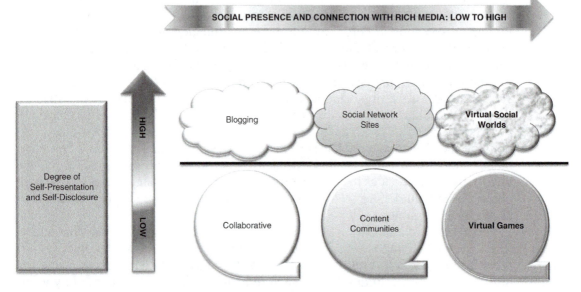

Source: Andreas M. Kaplan and Michael Haenlein, "Users of the world, unite! The challenges and opportunities of social media," *Business Horizons* 53, no. 1 (2010), 59–68.

Blogs offer high self-presentation and disclosure but low social presence and media richness when they are text-based, but can increase social presence when other kinds of media are included. Blogs are personal information, such as a diary, that is written by one person but allows for interaction through comments by site visitors. Comments can be regulated by the blog's author.

Collaborative projects are low in self-presentation and disclosure and low in social presence with media richness. Wikis and user-created content constitute many collaborative projects and the location where many arts consumers get their information—rightly or wrongly, and whether the information is correct or not. However, using collaborative projects can be leveraged for the culturepreneurial firm in the digital environment in new arts service product idea generation, status, and updates to programs and events.

Content communities, such as YouTube, Flickr, and SlideShare, provide for users to share content. More than 100 million videos are accessed daily, and Flickr is a location where many arts firms post information about exhibits, pictures, videos, and so forth. SlideShare is a location dedicated to posting presentation files. Arts organizations can take advantage of low self-presentation and self-disclosure with medium social presence with media richness by utilizing content communities. They can be used in a variety of ways to the arts organization's advantage. As on Google, recruiting videos, speeches, and other newsworthy information can be placed here so that investors, donors, and patrons can see what the culturepreneurial firm has to say!

Social networking sites are what many people think of when the phrase "social media" is bantered about. Social networking sites are Internet websites that let people connect with personal information and communications. On these sites, users can use rich media (video, photos, audio files) and engage in blogging. Social networking sites can be employed by arts organizations as "brand communities" and can be used in marketing research. These sites contain useful data that can be transformed into information to support decisions, and they represent high self-presentation and disclosure and medium social presence with media richness.

The area of social media that contains high self-presentation and self-disclosure along with high social presence with media richness is that of virtual social worlds.[16] In a *virtual world* participants live an imaginary life similar to their real life but without the constraints, and this facilitates multiple self-presentation strategies. Not only can arts organizations create virtual worlds, but communications, virtual world arts service product sales, and marketing research can be conducted within them.

As this brief summary of social media shows, the culturepreneur will require effort and resources to manage social media. Therefore, the types of social media to use should be chosen with the company's goals clearly in mind. Determining whether to create a proprietary platform also has to be considered. Keep in mind that the social media will need to work in an integrated fashion with other promotional elements that are chosen. In deciding on social media, the culturepreneur should remember that being social is, from the arts organization's point of view, part and parcel of making it successful. The idea is to be self-revealing and authentic in real time in order to create a relationship that involves sharing, two-way conversation, and space for people to gather and relate to each other. Culturepreneurs should provide honest

information and avoid coming across as corporate or dictatorial. Also, as MIS and the cloud become more ubiquitous, social media will be mobile.

Given the relationships between different classifications of social media, now the task is to apply social media to your firm's advantage. The first point is to know what social media will be used for, what metrics are to be used for evaluating success, and how the conversations and interactions on social media enhance the arts consumer's experiences. The arts organization will need to monitor what is being said, respond, and add to conversations in as close to real time as possible, as well as drive content on social media sites. Keeping track of competitors will also be necessary. Using the SMART framework, here are some steps to follow to create a social media strategy:

1. Determine your objectives. What do you want to accomplish with social media? Story telling? Conversing? Listening? Building community? Collaborating? Educating? Data collection? Buzz generation? How will you use the information from the process to refine the objectives or work in conjunction with related aspects of the arts organization?
2. Determine your targets. Whom do you want to connect with? Employees? Donors? Patrons? Suppliers? Which target markets?
3. Determine your resources. How will the social media tactics be managed? What people and financial resources will be available?
4. Determine which social media tools will be used for each of the targets based on their behaviors and the objectives sought.
5. Determine a return on engagement—that is, the cost per social interaction.
6. Determine social media monitoring and response processes—how the arts organization will be notified of postings and how to respond to them in real time. Newsfeeds, Google Alerts, keyword searches, wikis, and so on can be monitored using volunteers or personnel; alternatively, given the objectives and resources available, this job can be outsourced to a firm that specializes in this work. Several firms are available and can be found through an online search.
7. Determine metrics to be used in tracking the success of the strategy. For examples:
 - Website activities—visitors to the site, unique visitors, time spent on the website, how visitors arrived at the website, click-through rates from search engine optimization and analytic tools.
 - Comments and content reposted—social network site postings relative to the arts organization, blog comments, social bookmarks.
 - Arts consumer actions relative to positive and challenging posts on social networks, recommendations, and their created content that is posted relative to the arts organization's offerings.
 - Arts consumer actions relative to knowledge, risk, attitude and involvement, and the arts experience index or the impact factor.

The idea behind using social media strategy is to develop a strategic focus and engage in systematic delivery of the arts organization's objectives. It is best to have

these areas well thought out before launching social media. Importantly, the launch should coincide with the company's website activation if possible. Notice that the social media strategy includes metrics, as well as monitoring of activities. As was mentioned, the data gathered within the context of the MIS and the BPIS are converted and used for decision making. Employing dashboards in the EIS is a way to bring pertinent information to the attention of decision makers. Social media statistics will be important in this process. The next section provides a discussion of dashboards and the EIS.

DASHBOARDS AND EXECUTIVE INFORMATION SYSTEMS

The great news about digital organizations using an MIS with integrated BPIS is that data are systematically gathered and used for business processes and management activities that ultimately lead to achieving strategic goals and the business mission. A visual representation of this flow is given in Exhibit 11.4.

Digital dashboards are an important part of the EIS, which provides real-time information on important performance indicators that can be adjusted as needed.[17]

Exhibit 11.4 **The Value of Business Information**

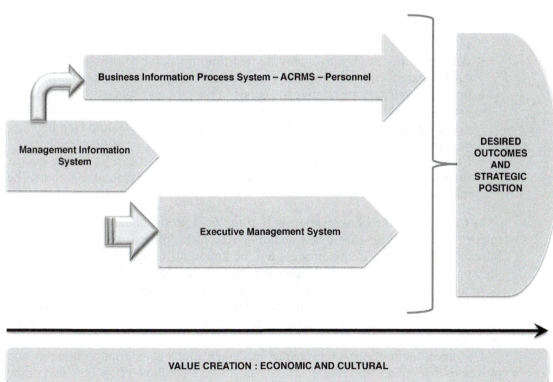

Source: Kenneth C. Laudon and Jane P. Laudon, *Management Information Systems: Managing the Digital Firm,* 12th ed. (Boston: Prentice Hall, 2012), 25.

Displayed graphically with access to detail enabled, the dashboard provides a visual indicator of analysis of variances of metrics. Nearly any aspect of importance to executives and leaders of the cultural arts organization can be installed in a dashboard. Sales information, social media interactions, budgeted and actual expenditures in promotional efforts, supplier information, patron donations, grants funded or denied—nearly any aspect of culturepreneurial management information, business operations, and marketing can be incorporated. The reason that executives use dashboards is that, if necessary, changes can be made more immediately than in the case of receiving information from reading a report of what happened "last month," so to speak. Dashboards are arranged by importance; therefore, key executives will need to provide input into what is necessary to their roles, and not everyone will have the same dashboard metrics. Types of dashboards for cultural arts organizations can be divided into four categories and can be outward-facing or inward-facing (inward-facing business technology systems are covered in the next section):[18]

- *Business intelligence dashboards* display detailed information about a particular area of an organization's operations. Many customer relationship management systems, for example, include dashboards to make it easier for the development staff to track fund-raising activities, ticket sales, donations, and advocacy management. These dashboards can be outward- or inward-facing.
- *Status dashboards* display the critical information everyone in the organization should be able to view all the time. These will most likely be inward-facing.
- *Accountability dashboards* provide real-time financial performance data that can be shared with stakeholders. The dashboard displays the arts organization's financial performance relative to actuals in the past and against future goals.
- *Tracking dashboards*, which can be inward- or outward-facing, typically show visualizations of unfolding data streams in real time. This could be a tracking of ancillary interests and dialogues for the arts consumers or stakeholders.
- *Comparison dashboards* are predictive dashboards that exhibit trends against future scenarios across a range of key metrics, should the current course be maintained.

In Chapter 12, the conversation will come back to dashboards. For now, it is important to consider that when deciding which dashboards to establish, using internal staff to assist in this process will be key in utilizing the EIS. When staffing capabilities are in demand, resources online can be found through a search. Several organizations are available to assist with this aspect of culturepreneurial technology management. The point is to develop methods and processes that will inform decisions and allow for changes and adjustments in as close to real time as possible.

The preceding portion of this chapter has taken a look at external technology and processes that impact the cultural arts organization. That, however, is only part of the technology management story. The next section examines the internal processes that the culturepreneur or arts manager in a culturepreneurial firm will need to consider in the digital environment.

INWARD-FACING ASPECTS OF THE INTERNAL BUSINESS PROCESS INFORMATION SYSTEM

As was seen in the previous section, the line between inward-facing and outward-facing aspects of the cultural arts organization's MIS, BPIS, and EIS can be blurry.[19] To facilitate drawing a distinction, consider *inward-facing systems* as those that allow interactions between employees and stakeholders that the general public does not have access to. While some of the data gathered to provide information may come from an outward-facing aspect of the MIS or BPIS, the point to understand is that these inward-facing systems typically will contain sensitive information. It is also well to note that inward-facing systems are not only restricted from viewing by outsiders, but also can be arranged so that only certain individuals in the organization can access them. Also note that dashboards can be used in conjunction with inward-facing systems. Because of the nature of the information and the data that the BPIS contains, the culturepreneur and arts manager may decide that much of what is contained in the inward-facing BPIS should only be stored locally. Some critics argue that placing sensitive data in the cloud can put organizations at risk from hacking and other types of cyber attacks. Other experts that there is security in using the cloud because documents and other information are backed up and saved. The choice will be made based on the degree of tolerance one has for these issues.

Nevertheless, the kinds of information that would be considered inward-facing include supplier data; arts consumer passwords and credit card information; proprietary information and trade secrets; compensation structures; noncompete agreements; strategic business and marketing plans; financial reports; contracts and supplier agreements; and nearly any other aspect of the cultural arts organization that is not to be shared or distributed or that will violate privacy and laws. These documents and other reports would need to be subject to certain levels of scrutiny, based on an individual's responsibilities in the cultural arts organization. Generally, as responsibility becomes more narrow and specific, so does the access to inward-facing information. In some cases, only certain individuals will have access to sensitive information, such as personnel information. This section provides a brief overview of using inward-facing systems for arts constituent relationship management systems, internal reports and documents, distribution systems and supplier information, collaboration, and people management.

ARTS CONSTITUENT AND RELATIONSHIP MANAGEMENT SYSTEMS

Several different definitions of customer relationship management exist. In addition, arts managers may have had varying experience using such a system. Therefore, disparate understandings of what such a system is make it difficult to grasp the strategic benefits it can accord a cultural arts organization.

The term *relationship management system* may evoke many images in the culturepreneur or arts manager's mind. Some managers consider it a marketing tool, some a sales tool, and some merely a database of information. However, using a relationship management system is a key driver of competitive advantage. These systems can range along a continuum from using a specific technology for a given

project to using integrated plans across marketing and business strategy, or, at the very strategic end, to using a holistic approach to creating value. And like the use of social media, it will be important to define the system and utilize it appropriately for the needs of the organization.

To aid in the development of such a system for the cultural arts organization, we will rely on the following definition of a *customer relationship management* system (CRM):

> a strategic approach that is concerned with creating improved [stakeholder] value through the development of appropriate relationships with key customers and customer segments. CRM unites the potential of relationship . . . strategies and IT to create profitable, long-term relationships with customers and other key stakeholders. CRM provides enhanced opportunities to use data and information to both understand customers and co-create value with them. This requires a cross-functional integration of processes, people, operations, and marketing capabilities that is enabled through information, technology, and applications.[20]

Importantly, such an interaction draws information from all data sources within an organization (and where appropriate, from outside the organization) to give one, holistic view of each constituent in real time. This allows personnel in all areas of the cultural arts organization to make quick, informed decisions.[21] These considerations will be adapted to the cultural arts organization to conceptualize an *arts constituent relationship management system* (ACRMS).

The ACRMS contains records about arts consumers, patrons, donors, and any other entity that the cultural arts organization wants to develop or expand a relationship with. This information can be used strategically to create culturepreneurial value. This system aids in understanding and creating knowledge of the constituents that interact with the cultural arts organization. The system allows *knowing* people on a respectful, consumer-selected naming basis that makes them feel they are known and important, participating in a conversation that is one-on-one with them only, and *all the time*. This kind of communication is referred to as arts consumer knowledge competence, which comes about from internal processes so that arts consumer-specific strategies are developed. That means that not only are there data points for each individual in a household, but the culturepreneur can collect information, for example, on individuals and their organizations or firms, and use it with new arts service product development and aesthetic quality measures, develop secondary marketing research questions, tap into primary research respondent pools, and integrate internal business processes. The internal business processes include those mapping systems of quality presented in Chapter 8. Specifically, within the context of an ACRMS, these include the following:

- A customer information process: the set of behaviors generating arts consumer and constituent knowledge with respect to their current and potential needs.
- Integration with information technology and marketing: the process by which marketing and information technology functions communicate and cooperate with each other.

- Culturepreneur, board, and arts leader involvement: the processes that the executive leaders follow to demonstrate support for the generation and integration of arts constituent knowledge within the firm, in order to ensure the success of the ACRMS; it is estimated that more than 50 percent of the critical knowledge available in the ACRMS is not accessed or correctly applied.
- Not only does the knowledge need to be extracted from the ACRMS, but the evaluation and incentive systems have to be adjusted to include assessing responsible individuals' actions and behaviors as aligned with the arts organization's business and marketing strategies using employee evaluation and incentive systems.[22] In this last aspect, the importance of constituent knowledge creation has to be stressed, education regarding how to do so has to be provided, and consistent metric-based SMART incentives have to be utilized for exceeding expectations in gaps analyses.

These considerations are presented in Exhibit 11.5 as a graphic explanation of the ACRMS framework.

The point of using an ACRMS is not only to store data, but also to use the data for information-driven decision making. It is within this system that answers to

Exhibit 11.5 **Arts Constituent Relationship Management System**

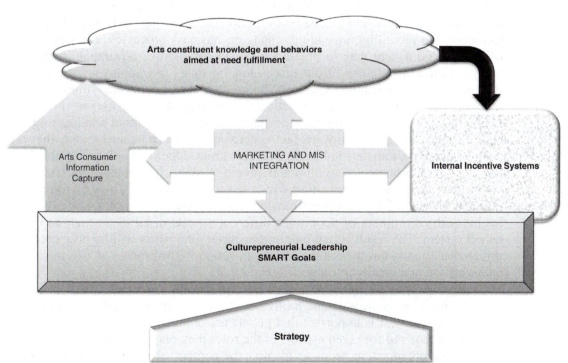

Sources: Adrian Payne and Pennie Frow, "A strategic framework for customer relationship management," *Journal of Marketing* 69 (October 2005), 167–176; Alexandra Campbell, "Creating customer knowledge competence: Managing customer relationship management programs strategically," *Industrial Marketing Management* 32 (2003), 375–383.

questions can be had relative to numbers of people attending arts offerings, prices paid, seats sold, household and arts constituent segmentation information, and so on. The benefits of using an ACRMS, of course, are that data is accessible internally according to the organization's policies; entering data does not become a repetitive chore; and you avoid the slips of paper and Post-it note systems that often get in the way! The downside is that the data has to be entered systematically or captured at the right time. A key issue is that fast decision making is not valuable if the data used to formulate information is inaccurate or untimely. Therefore, accurate and current data capture is critical. Those who are participating in inputting data into the system will need to be aligned with performance goals that are connected to the arts organization's strategic metrics. This point is taken up in the next section.

MANAGING PEOPLE

Perhaps you remember the conversation in Chapter 9 about whether people are self-motivated or need specific direction. In an environment in which a Theory Y point of view is embraced, people are expected to take risks, innovate, learn, and collaborate. In this kind of collaborative, collegial, learning, and innovative culture, moreover, people thrive, are highly committed, and seek to learn and grow.[23] For a culturepreneur or arts manager in the kind of arts organization contemplated within these pages, the attraction and retention of people working with the organization will be strategically driven and guided by the culturepreneurial spirit. Using information technology in recruiting, managing, engaging business processes, and developing people can go a long way to create value and competitive advantage in the arts organization. For purposes of our discussion, "people" are employees at any level with any function, consultants, donors, board members, volunteers—those who are involved with or influence the production and delivery of an arts offering directly or indirectly. Through work processes designed to do so, innovation and learning can be facilitated. Through the inward-facing networks to which people belong, they are enabled to create, transfer, and institutionalize knowledge. The point of establishing this kind of environment is to ultimately avoid or alleviate problems with ACRMS and to provide the arts organization with a strategic advantage. The path to this end includes a cycle of the creation, transfer, and implementation of knowledge, and begins with recruitment of people for different aspects of BPIS through an established system. The result is that culturepreneurial innovation will be promoted and driven consistently throughout the arts organization.[24] The process of arriving at this end is shown graphically in Exhibit 11.6.

Strategic people management as described in Exhibit 11.6 creates the framework whereby individuals are able and motivated to experiment with new ideas. First, to promote creativity, it is important that people are recruited who have the skills and knowledge required for given aspects of the roles they play. To accomplish that, the cultural arts organization needs to identify the competencies that individuals need for succeeding and growing in particular areas using tests, assessments, and work sampling activities that identify personality, values, and performance indicators. Exhibit 11.7 provides a listing of possible indicators.

Exhibit 11.6 **Cultural Arts People Management Cycle**

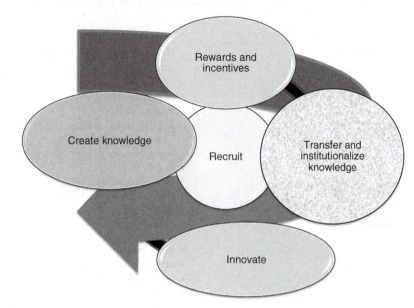

Source: Helen Shipton, Doris Fay, Michael West, Malcolm Patterson, and Kamal Birdi, "Managing people to promote innovation," *Creativity and Innovation Management* 14, no. 2 (2005), 118–128.

Once successfully recruited, people should continue to be developed. This process includes exposing them to new and different experiences and people that value examining and questioning of existing ways of operating. At the same time, providing exposure to the BPIS in many different areas of the arts organization can facilitate new ideas. Establishing these kinds of people development processes increases the likelihood of innovation and happiness in the company and also increases people's desire to remain with the arts organization.

The last aspect of the cycle includes reward systems. Care needs to be exercised here so that the reward actually encourages the behavior being sought, rather than establishing a system that gets people hyper-focused on results that hinder creativity. Therefore, in addition to individual performance, team performance and collective organizational results are relevant as well. The company should establish and adhere to a performance appraisal system in order to increase people development, participation, and empowerment. It needs to include fair pay, promotion, and tangible information but also ways to measure, through work groups and dialogues, employees' learning, knowledge transfer, creativity, and continuous improvement for change as these are related to the arts organization's strategic goals.[25]

Using the ACRMS to monitor outcomes such as project or event management, development events, the cycle time to receive goods or services related to arts offerings, degree of arts consumer gap analysis, levels of responsibility, revenues and income, reports, meeting times, and feedback can be attained through appropriate dashboards. However, while these kinds of performance measures are

Exhibit 11.7 **Individual Performance Competencies for Cultural Arts Organizations**

Competencies Demonstrated	Actions and behaviors
Innovativeness	• Has new ideas and shares them • Is imaginative • Is creative • Is intuitive • Is perceptive
Team and self	• Facilitates and adapts • Enjoys collaborating • Is comfortable in collective or individual environments as needed • Accepts and generates rewards and recognition
Skills	• Has competency in direct skills • Has ability to quickly transfer and recognize patterns
Supportiveness	• Is reliable • Is conscientious • Is courteous • Is honest and genuine
Initiative	• Is a leader, yet knows when to follow • Drives quality, high yet achievable expectations • Is thorough and big-picture oriented

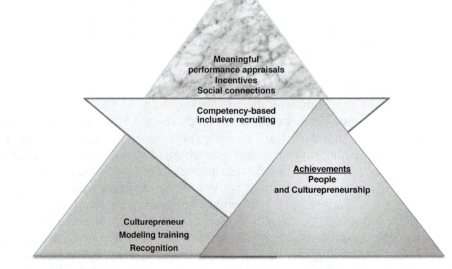

Source: Janice S. Miller and Robert L. Cardy, "Technology and managing people: Keeping the 'human' in human resources," *Journal of Labor Research* 21, no. 3 (2000), 447–461.

needed, the importance of face-to-face interaction with and appraisal by skilled managers and colleagues, in addition to quantitative measures, cannot be overemphasized. This kind of interaction is related positively to performance and citizenship, which infuses innovation and learning in a culturepreneurial firm. Within

Exhibit 11.8　**Square and Other "Cloudy" Issues for Culturepreneurs**

At Square, culturepreneurs and arts managers can do many different things to aid in monetary transactions in the cloud. Several of Square's applications are designed so contributions can be processed and deposited into the appropriate accounts as previously designated. At the same time, Square produces a dashboard page for each individual engaged in a fund-raising and development process, allowing the culturepreneur the visibility to track progress.

Of course, the company provides Square Readers for free, which allow a credit card swipe anywhere there is wireless access to the Internet. If the account is set up with the employer identification number added, sales and donation information can be captured and provided to the Internal Revenue Service. At the same time, both a private and a public dashboard can be created and displayed as the culturepreneurial arts leaders dictate, so that information about the cultural fine arts organization can be seen.

Not only can transactions be processed and captured on the spot, but applications can be developed for different uses. Salesforce.com, through its ArtApp, provides for profit, hybrid, and not-for-profit cultural fine arts organizations with cloud-based business process automation. Fund-raising, collaboration, innovation, and MIS services for cultural fine arts organizations are available.

Visit Square and ArtApp for information and examples of arts organizations taking cloudy issues under control.

Sources: Square Inc., "Square for non-profit organizations," https://squareup.com/help/en-us/article/5101-square-for-non-profit-organizations; Salesforce.com, "Selecting the correct edition: Art studio, gallery, collection or museums management," ArtApp, http://artapp.force.com/index.

this overall face-to-face kind of approach to appraisal, feedback, and learning, the use of mentoring may be a way to supplement the kind of people involvement being sought.

In essence, the culturepreneur creates an environment where exploration is acceptable and people will take risks, experiment with new ideas, and be flexible in their quest for new and different ways of approaching problems. With the establishment of a process that envisions and supports arts organizational learning, mechanisms can be designed to foster and drive creativity, to promote knowledge transfer, and to facilitate collaboration as a cultural organizational goal. Furthermore, by operating in this way, culturepreneurs and arts managers instill within the organization the dynamic capabilities necessary to sustain or create a competitive advantage in the shifting environment.

CHAPTER SUMMARY

This chapter focused on using technology systems in the culturepreneurial organization. It presented outward- and inward-facing aspects of the systems and processes that impact the cultural fine arts leader and manager. The need for establishing an MIS, a BPIS, and an EIS was explained and considerations for ethics in cloud computing were given. Important to this discussion was the application of the technology in building an ACRMS that will foster innovation and link the cultural fine arts organization to its interested parties.

At the same time, such a system can be used to guide and develop people, manage the fund-raising and development system, and assist in developing pricing strategies for arts offerings. As explained in this chapter and further emphasized in Chapter 12,

this kind of system becomes integral to achieving the strategic goals of the culture-preneurial venture.

The chapter examined how to establish the internal business processing systems that would support the organization's strategic directions and mission, anticipating how to use systems to the culturepreneur's advantage. Included was consideration for outward-facing aspects of the culturepreneurial firm relative to distribution, relationship management, promotions, and mobile applications. Importantly, the culturepreneur has to be cognizant of the use of technology and how it impacts the organization.

EXPERIENTIAL EXERCISES

1. Go to this link Artists for Second Life (http://secondlife.com/destination/artists-for-second-life) or type "artists for second life" into your browser. Once there, set up an account and explore different galleries and installations. Consider how this technology can be used to engage arts consumers and to create cultural fine art. Discuss how you feel about this kind of technology and what you see as its impact on the way cultural fine arts are produced and consumed.

2. Visit the IBM website ("IBM Cloud/IaaS," www.ibm.com/cloud-computing/us/en/iaas.html) and set up a free trial for cloud computing. Try it for a month. Not happy with IBM? Then any cloud computing service provider of your choice will suffice.

3. Conduct an online search of firms that will provide dashboards in the five categories listed in the chapter. Establish a relationship between your organization and several of these firms; set up a cost comparison showing what you may gain from using each of them. Is the potential benefit worth the cost?

4. Go to Artful.ly ("Sell Tickets, Take Donations, Track Fans: Intuitive Business Software for Artists," www.artful.ly/about) and explore the development of a dashboard. Then visit Indiana Museum of Art (http://dashboard.imamuseum.org/) and learn about its dashboards.

5. Visit Tessitura Network ("CRM: Constituent relationship management," www.tessituranetwork.com/Products/Software/CRM.aspx) and establish an ACRMS.

6. How would you design an ACRMS? Include in your discussion a process that would incentivize employees to comply with seeing arts constituents as engaging one-on-one conversations that occur in the context of touch points.

FURTHER READING

Inc. N.d. Management Information Systems (MIS). www.inc.com/encyclopedia/management-information-systems-mis.html.

Laudon, Kenneth C., and Jane P. Laudon. *Management Information Systems: Managing the Digital Firm*. 12th ed. Boston: Prentice Hall, 2012.

NOTES

1. Second Life, "Artists for Second Life," http://secondlife.com/destination/artists-for-second-life.

2. Second Life, "Destination guide: Art," https://secondlife.com/destinations/arts.

3. Patrick Lichty, "The translation of art in virtual worlds," *Leonardo Electronic Almanac* 16, no. 4–5 (2009), 1–12.

4. Janice S. Miller and Robert L. Cardy, "Technology and managing people: Keeping the 'human' in human resources," *Journal of Labor Research* 21, no. 3 (2000), 447–461.

5. *Inc.* magazine, "Management information systems (MIS)," www.inc.com/encyclopedia/management-information-systems-mis.html.

6. Kenneth C. Laudon and Jane P. Laudon, *Management Information Systems: Managing the Digital Firm*, 12th ed. (Boston: Prentice Hall, 2012).

7. Ibid.

8. Chuck Williams, *Management*, 7th ed. (Mason, OH: South-Western Cengage Learning, 2013).

9. The distinction between inward- and outward-facing is simplified in this textbook for explaining the different ways to conceptualize the business-related technology. At the present time, there is a need for research in the cultural arts and their successes with inward- and outward-facing systems. See Markham T. Frohlich and Roy Westbrook, "Arc of integration: An international study of supply chain strategies," *Journal of Operations Management* 19, no. 2 (2001), 186–200; Mika Gabrielsson and V.H. Manek Kirpalani, "Born globals: How to reach new business space rapidly," *International Business Review* 13, no. 5 (2004), 555–571.

10. Roger Kerin, Steven Hartley, and William Rudelius, *Marketing*, 10th ed. (New York: McGraw-Hill/Irwin, 2010).

11. Jason Summerfield, "Mobile website vs. mobile app (application): Which is best for your organization?" *Human Service Solutions*, http://hswsolutions.com/services/mobile-web-development/mobile-website-vs-apps/.

12. Keith W. Miller and Jeffrey Voas, "Ethics and the cloud," *IT Pro* (September/October 2010), 4–5; Andreas M. Kaplan and Michael Haenlein, "Users of the world, unite! The challenges and opportunities of social media," *Business Horizons* 53, no. 1 (2010), 59–68.

13. Kristin Thomson, Kristen Purcell, and Lee Rainie, *Arts Organizations and Digital Technologies* (Washington, DC: Pew Research Internet Project, 2013), http://pewinternet.org/Reports/2013/Arts-and-technology.aspx.

14. Kaplan and Haenlein, "Users of the world, unite!"

15. Jan H. Kietzmann, Kristopher Hermkens, Ian P. McCarthy, and Bruno S. Silvestre, "Social media? Get serious! Understanding the functional building blocks of social media," *Business Horizons* 54, no. 3 (2011), 241–251.

16. John D. Sutter, "Artists visit virtual Second Life for real-world cash," CNN, April 7, 2009, www.cnn.com/2009/TECH/04/07/second.life.singer/; Linden Endowment for the Arts (blog), http://lindenarts.blogspot.com. Second Life residents also post many photographs on Flickr; see www.flickr.com/search/?q=second%20life for a sampling.

17. Neal Ungerleider, "Why an arts nonprofit is developing web dashboards," *Fast Company*, October 21, 2013, www.fastcolabs.com/3020230/why-an-arts-non-profit-is-developing-web-dashboards.

18. Beth Kanter and Katie Delahaye Paine, *Measuring the Networked Nonprofit: Using Data to Change the World* (San Francisco: Jossey-Bass, 2012); Alessia Zorloni, "Managing performance indicators in visual art museums," *Museum Management and Curatorship* 25, no. 2 (2010), 167–180.

19. As mentioned above, this is an area that is still evolving for the cultural arts organization. Inward- and outward-facing systems are suggested as ways to conceptualize the way data and information are displayed and handled.

20. Adrian Payne and Pennie Frow, "A strategic framework for customer relationship management," *Journal of Marketing* 69 (October 2005), 167–176.

21. destinationCRM.com, "What is CRM?" February 19, 2010, www.destinationcrm.com/Articles/CRM-News/Daily-News/What-Is-CRM-46033.aspx.

22. Alexandra Campbell, "Creating customer knowledge competence: Managing customer relationship management programs strategically," *Industrial Marketing Management* 32 (2003), 375–383.

23. Helen Shipton, Doris Fay, Michael West, Malcolm Patterson, and Kamal Birdi, "Managing people to promote innovation," *Creativity and Innovation Management* 14, no. 2 (2005), 118–128.

24. Ibid.

25. Wayne F. Cascio, "Managing a virtual workplace," *Academy of Management Executive* 14, no. 3 (August 2000), 81–90.

FROM THE EDITORS

Ethics and the Cloud

Keith W. Miller, *University of Illinois at Springfield*
Jeffrey Voas, *National Institute of Standards and Technology*

The National Institute of Standards and Technology defines cloud computing in the following way:

Cloud computing is a model for enabling convenient, on-demand network access to a shared pool of configurable computing resources (for example, networks, servers, storage, applications, and services) that can be rapidly provisioned and released with minimal management effort or service provider interaction.[1]

Yet the fact that this is the 15th version of this definition reminds us that cloud computing is a rapidly evolving idea.

Regardless, people are devoting a lot of money and attention to this topic, as cloud computing promises to bring significant changes to the world of computing. Whether "the cloud" will be beneficial or detrimental is a current debate.[2,3]

Digital Revolution, Looming Threat, or Gibberish?

Some ethicists see cloud computing as another incremental step in a larger "virtualization" of human civilization. Luciano Floridi—a philosopher well known for his work in information ethics—views cloud computing

as part of the "fourth revolution."[4] According to Floridi, this digital revolution follows the previous Copernican, Darwinian, and Freudian revolutions. These science-based revolutions fundamentally changed our understanding of both the world and ourselves.

Floridi sees cloud computing as the first "graceful step out" of the idea that computers need humans.[4] When compared to locally controlled computers, computing resources in the cloud are remote from their users and more independent. Data in the cloud—both personal and public—could change our fundamental views about ownership, accessibility, and the usefulness of information and knowledge. Floridi embraces what he sees as positive trends in the cloud.

Not everyone is as enthused about cloud computing. Larry Ellison, the founder of Oracle, has been quoted as saying,

The interesting thing about cloud computing is that we've redefined cloud computing to include everything that we already do. The computer industry is the only industry that is more fashion-driven than women's fashion. Maybe I'm an idiot, but I have no idea what anyone is talking about. What is it? It's complete gibberish. It's insane. When is this idiocy going to stop?[5]

Ellison might think cloud computing is "gibberish," but Richard Stallman, long an advocate of Free Software, has a darker view:

One reason you should not use Web applications to do your computing is that you lose control. It's just as bad as using a proprietary program. Do your own computing on your own computer with your copy of a freedom-respecting program. If you use a proprietary program or somebody else's Web server, you're defenseless. You're putty in the hands of whoever developed that software.[5]

Stallman's fears are echoed in many works of fiction. For example, Kurt Vonnegut's first novel, *Player Piano* (Holt, Rinehard, and Winston, 1956), predicts a world where large corporations automate more and more functions, and human beings are increasingly superfluous. (For more on Vonnegut's views, see www.kirjasto.sci.fi/vonnegut.htm.)

Centralized Computing: The Pendulum Swings

Many agree with the idea that cloud computing is becoming ubiquitous. However, some scholars take this a step further by viewing it as a natural progression that's moving computing on

 Published by the IEEE Computer Society 1520-9202/10/$26.00 © 2010 IEEE

the path of acceptance previously taken by utilities such as running water and centrally generated electricity.[6] If computing, like tap water, becomes so commonplace that we rarely think about it consciously, how will that change us?

Ellison might be right that much of what we hear about cloud computing is hype. However, Stallman is also correct in that cloud computing does centralize power. The spread of small computers, led initially by the IBM PC, literally put computing into the hands of individuals. Miniaturization has produced smaller and smaller computers, smart phones, smart cards, and GPS navigators. But the computing done "onboard" these devices is increasingly less important than the connections the devices make to larger sociotechnical systems: the Internet, navigation satellites, and the cloud.

Issues concerning how computing affects power relationships have long interested scholars who study technology and society.[7] The Internet has always connected individuals to other individuals and organizations, but from the start, it has required intricate cooperation and sharing of resources.

When the Internet is used to further centralize computing power and user data, the pendulum seems to be swinging away from individual autonomy and toward more concentrated power in fewer hands. If the holders of this power are beneficent, or at least benign, we can imagine that the centralization can be to our advantage; for example, centralized electrical power is often, though not universally, seen as a societal good.

However, if an individual relies on large corporations to deliver computing power and safeguard data via the cloud, then the individual will be placing a great deal of trust in that corporation—and in their clouds.

Some, like Stallman, see the increasing use of cloud computing as a looming threat, a corporate power grab. Others, like Floridi, see the cloud as another step toward

If computing, like tap water, becomes so commonplace that we rarely think about it consciously, how will that change us?

a more evolved "infosphere," where new efficiencies and creative possibilities will emerge. It's too early to empirically determine if one, or both, of these visions is accurate.

However, IT professionals will be the engineers who will design, develop, and deploy the various technologies that will enable the cloud. So, it behooves us to be aware of both the opportunities and vulnerabilities that the cloud presents. ⊓⊔

Acknowledgments

This paper was not coauthored by Jeffrey Voas as a National Inst. of Standards and Technology (NIST) employee. It reflects Voas's opinion—not the opinions of the US Department of Commerce or NIST.

References

1. P. Mell and T. Grance, "NIST Definition of Cloud Computing v15," National Inst. Standards and Technology, Oct. 2009; http://csrc.nist.gov/groups/SNS/cloud-computing/cloud-def-v15.doc.
2. M. Armbrust et al., *Above the Clouds: A Berkeley View of Cloud Computing*, tech. report UCB/EECS-2009-28, EECS Dept., Univ. of California, Berkeley, 2009.
3. N.M. Mosharaf, K. Chowdhury, and R. Boutaba, "A Survey of Network Virtualization," *Computer Networks*, vol. 54, no. 5, 2010, pp. 862–876.
4. L. Floridi, "The Fourth Revolution," to appear in *Newsweek* (Japanese edition); www.philosophyofinformation.net/publications/pdf/newsweek-article.pdf.
5. B. Johnson, "Cloud Computing Is a Trap, Warns GNU Founder Richard Stallman," *Guardian.co.uk*, 29 Sept. 2008, www.guardian.co.uk/technology/2008/sep/29/cloud.computing.richard.stallman.
6. R. Nichols, "Thomas Edison Would Have Loved Cloud Computing," *CNNmoney.com*, 22 Jan. 2010; http://brainstormtech.blogs.fortune.cnn.com/2010/01/22/thomas-edison-would-have-loved-cloud-computing/.
7. J.F. George and J.L. King, "Examining the Computing and Centralization Debate," *Comm. ACM*, vol. 34, no. 7, 1991, pp. 62–72.

Keith W. Miller *is the Schewe Professor in Liberal Arts and Sciences at the University of Illinois at Springfield. His research areas are computer ethics and software testing. Contact him at miller.keith@uis.edu.*

Jeffrey Voas *is a computer scientist at the National Institute of Standards and Technology (NIST). Contact him at j.voas@ieee.org.*

Part IV
Growth and Succession

12 Fund-Raising and Development for the Culturepreneurial Organization

CHAPTER OUTLINE

LEARNING OBJECTIVES

After reading this chapter, you will be able to do the following:

1. Articulate the difference between fund-raising, sponsorship, and development.
2. Apply the relevant aspects of fund-raising and development to appropriate cultural arts organizational needs.
3. Understand the sources of funds available to the cultural arts organization relative to the organization's legal structure.
4. Discuss the relative advantages and disadvantages of crowd-sourced fund-raising, equity, and debt instruments.
5. Understand the cultural arts organization valuation process.

Exhibit 12.1 **Crowdfunding**

(Courtesy of Carla Stalling Walter)

6. Articulate dashboard measures relative to fund-raising and development.
7. Use a model to engage contributors in expanding their relationship with the cultural arts organization.
8. Produce and evaluate a fund-raising and development management plan and process.
9. Apply metrics that can be used in evaluating and monitoring the fund-raising effort.

SPOTLIGHT: DIVERGENCE VOCAL THEATER

Divergence Vocal Theater is an ensemble of performer-creators, cultivating art adventure-to-adventure. It is an opera company taking a rock band approach. The performance work is made by a small number of professional opera and classical music singers, instrumentalists, theatrical designers, theater and dance artists, composers, writers, and media artists collaborating to bring fresh new

innovation to the cultural intangible fine arts. The company's website (www.divergencevocaltheater.org) boasts that it has had collaborators such as Dominick DiOrio, Elliot Cole, James D. Norman, George Heathco, Kyle Evans, Meredith Harris, Meg Brooker, Natasha Manley, Megan Reilly, Frank Vela, Sarah Mosher, Toni Leago Valle, John Harvey, Michael Walsh, Jon Harvey, Miranda Carol Aston, Kelley Switzer, David A. Brown, Jeremy Choate, and Kris Phelps.

Located in Houston, Texas, Divergent Vocal Theater has garnered support from some of Houston's most noteworthy artists, arts organizations, and business enthusiasts. These supporters include Houston Grand Opera, Eastman School of Music, Rice University's Shepherd School of Music, University of Houston's Moores School of Music, University of Texas at Austin, and Houston's energy sector business entrepreneurs.

Founder Misha Penton believes that "it's time to reconsider the nonprofit model as the only way to do business in the performing arts. When it comes to performance works, smaller really is better: a smaller enterprise lends itself to hybrid business practices that continue to emerge as artists use their creativity to tackle the business side of making art. Embracing a for-profit model or a hybrid for-profit/nonprofit enterprise, are viable business options for artists. Funding organizations really do roll their eyes these days, when yet another nonprofit, pops up with its hands out. Reality: no one is gonna pay your tab."

CROWD-SOURCED FUND-RAISING

In Chapter 5, finding money in the cloud was introduced as a way to receive funding for a cultural fine arts venture. On the surface, it appears to be a way for people to take advantage of the Internet to promote their arts offering. In theory, it is a simple process. Just post an idea online, follow a few protocols, and voilà! Millions of micro investors line up at the culturepreneur's cyber door bearing all sorts of money to take an idea from concept to cash cow. In 2011, more than US$100 million was raised for various projects using crowdfunding. Yet, as with anything that has high upsides, there are always downsides. One downside is the lack of protection against intellectual property theft for those with the ideas and another is the potential for fraud for those investing.

One of the greatest challenges for artists or anyone, for that matter, using crowdfunding sites as a springboard is that there may be little or no intellectual property protection provided by the sites themselves. Once an artist's idea is posted, it can be copied. However, ideas can be protected on crowdfunding sites in three ways: (1) through the early filing of patent applications; (2) through the use of copyright and trademark protection; and (3) through the use of the creative barcode—a new form of idea protection supported by the World Intellectual Property Organization (WIPO).

While the risks for the artists exist, the risks for investors do as well—even though some crowdfunding mechanisms have an all-or-nothing policy, which means that if artists miss their funding goal, they receive nothing and the money is returned to the investors.

However, one problem for investors is that they do not always have the investment savvy to determine whether an investment is real or a fraud, even with seeming adherence to disclosure requirements for participation. The potential for misdirection and theft poses a serious ethical problem. Generally speaking, the individual investment contributions are too small for law enforcement authorities to expend resources to investigate or for attorneys to take on a fraud lawsuit. As a result, investors can find they have given away their money with no hope of seeing a positive return on their investment.

FUND-RAISING AND DEVELOPMENT IN THE CULTURAL ARTS

In Chapter 1, patronage was defined as quantifiable, tangible money or liquid or semi-liquid asset given to not-for-profit or hybrid arts corporations for expenditure or use for an artistic or administrative function. In the United States, what is given can be used to reduce tax liabilities.[1] This definition of patronage focuses on contributed revenues, either from individuals or corporations. Patronage includes sponsorships from companies who contribute money in exchange for publicity and advertising space, companies that contribute money through a foundation subsidiary that they own wholly or in part, and individuals (including artistic directors who donate cash, board members who "pay dues," and all manner of cash donors), families, and/or their family foundations that contribute to cultural organizations either through direct cash donations, granting procedures, or endowment funding.[2] Patronage in the United States as it affects arts organizations can find its origins with the Ford Foundation, founded in 1936.[3] Henry Ford and his son, Edsel Ford, bequeathed stock to the foundation in their wills, and Edsel Ford gave $25,000 to the foundation that could be used while he was alive. At the time of their deaths in 1947 and 1943, family-controlled foundation assets were estimated at $417 million.[4]

The rich legacy of patronage has paved a way for development and fund-raising in the cultural arts, and economic realities have presented the need to find innovative ways to provide the cultural arts. These activities often support or direct changing tastes for them. For-profit and nonprofit cultural arts organization leaders need to understand methods and strategies for development and fund-raising. Guiding such understanding is the overall purpose of this chapter. The chapter covers fund-raising and development for capital projects, operations, and endowments. It covers crowd-sourced funding, equity and debt instruments, and development. Next, the use of funds is discussed in regard to applying funds as directed or promised to patrons, donors, grants makers, or investors. The chapter ends with a discussion of approaches to managing fund-raising and development.

Achieving financial stability, providing capital revenues for projects and endowments, and ensuring longevity are the reasons that some cultural fine arts organizations rely on fund-raising and development. And like everything else in regard

to leading a cultural fine arts organization, the best approach to fund-raising and development is to take a strategic approach, connect it to the organization's goals and objectives, and integrate it into the ACRMS. Fund-raising activities aligned and cultivated in this way can provide for the hierarchy of needs discussed earlier in this volume. Specifically, personal satisfaction through giving is manifested through emotional, social, self-actualizing, and spiritual satisfactions through connections to the arts organization. Indeed, these can be cultivated if the ACRMS is structured correctly. The purpose of approaching fund-raising and development in this way is to enable the organization to carry out its mission more effectively.[5] But what is meant by fund-raising? How is that different from development? To *fund-raise* is to seek donations from various sources to support the cultural arts organization or specific cultural arts projects. *Fund-raising* is the raising of assets and resources from various sources. *Development* comprises the total process by which a cultural arts organization increases constituents' understanding of its mission and acquires financial support for its programs.[6] Therefore, in this textbook the words "fund-raising" and "development" will be used interchangeably. What will be important is to distinguish between the goals and objectives of the components of the process. As such, in this section of the chapter, capital, operations, and endowments will be discussed.

In Chapter 5, the format and contents of a business plan were presented. A business plan contains the elements of the strategic direction in which the arts organization is headed. It includes the mission, vision, objectives, environmental analysis, marketing plans, and pro forma financials for the culturepreneurial venture. It is within the overall strategic objectives of the arts organization that SMART goals are identified for development and fund-raising. These are then translated into the financial projections that cover capital, operations, endowments, and investments plans.

CAPITAL

Cultural arts organization *capital* constitutes nonfinancial assets that are used to produce goods or services. According to the Gates Family Foundation,[7] capital projects are usually defined as projects that have a significant cost and a useful life of at least ten years. While this textbook is not in any way related to accounting or taxation nor does it provide advice in this area, usually a capital project is significant when it is considered as something that can be depreciated over time. Typical capital projects for a cultural arts organization might be tangible assets such as land to place an art gallery, buildings that will comprise an arts cultural center or performance space, building wings, major renovations, additions to expand an existing cultural arts location, infrastructure expansions that may be necessary for the project, and purchases of equipment such as stage lights, museum storage shelving, computers, or any depreciable fixed asset that will be employed for more than a year. In this category, it will be useful to explicitly state how such an investment of resources for each capital expenditure is instrumental to carrying out the aims of the culturepreneurial venture. In doing this, the resulting documentation can be used for targeted development.

OPERATIONS

Cultural arts organization *operations* are concerned with conducting the organization's practices at the highest level of ethical efficiency so that the use of resource inputs to deliver the cultural arts service product output is maximized in fulfilling the organization's mission. The term *operations* in this context covers a broad array of recurring activities and functions, from implementation of the strategic planning initiatives, recruiting and hiring staff, coordinating logistics, and communications to controlling costs and actively managing the development process and the ACRMS. As can be seen from this broad brush of what is included in efficiently operating the cultural arts organization, nearly everything can be included within it. Yet it will be important to identify the nature of the operations that impact the cultural arts organization and the associated expenses as accurately as possible for a given period under consideration. Such expenses include staff salaries related to all areas of the organization, including marketing, volunteer management, office staff, artistic staff, and development staff; rents and interest payments; utility costs; legal costs; printing; supplies; and any other expenditure that is related to the day-to-day running of the cultural arts organization that cannot be depreciated. The culturepreneur should think of operations as the cost to run the cultural arts organization and consider the relationship between operations and the business model. The identified components in this area will constitute the *operations plan*, and aspects of it can be identified for targeted development.

ENDOWMENTS

Cultural arts organization *endowments* are gifts made to the organization under a nonprofit framework as a financial investment that generates dividend or interest income that is used in operations or capital expenditures while leaving the principal untouched. Donors and patrons often specify the use of the endowment related to their personal needs. Cultivating those patrons and donors in establishing endowments is an aspect of operational expense. It is up to the cultural arts organization to manage the cost of establishing the endowments, to deal with structuring them, and to determine a risk/return ratio to maximize the income generated from such a tool. In this sense, the endowment can be designated for more than one type of activity. For example, the income from an endowment can be designated for operations, capital, or other organizational needs. The advantages of endowments are that they supply a sense of financial security and organizational longevity. On the other hand, endowments are typically restricted in their use and as such may be unavailable to meet strategic directions and goals of the culturepreneurial venture over time in areas in which financial support is needed. Grantmakers in the Arts admonishes culturepreneurs and arts managers to ask themselves the following questions in regard to establishing endowments:[8]

1. Does the organization have access to good asset management?
2. Does the organization understand its liquid cash needs?

3. Does the organization understand the costs of raising endowment funds?
4. Does the organization have at least four months' worth of unrestricted cash reserves?
5. Will an endowment contribute to fulfilling the organization's mission? The desire for perpetuity is not a sufficient reason.
6. Will endowment fund-raising interfere with annual giving?

While the details of income statements and investments are covered in Chapter 13, these questions provide a basis for reasoning through the desire for endowments, the expenses related to garnering them, and the use of endowment funds. If the answers are affirmative, then an *endowment plan* will be needed as well.

In concert with the strategic capital, operations, and development plans, it is essential to establish dashboard measures to ensure that goals and metrics are being met and that they are linked to the overall strategic plan. *Dashboard measures* can include these and other measures:

1. Development efficiency—the amount of contributions raised per dollar spent on fund-raising and development.
2. Marketing efficiency—revenue earned per dollar spent on marketing.
3. Program margin—the ratio of earned income to the sum of artistic and production expense.
4. Capacity utilization—in the performing arts, a useful operating measure that analyzes the percentage of total seats available compared to the total that are sold.
5. Financial ratios.[9]

As can be imagined, designing these dashboards will require the culturepreneur and arts manager to have established practices of financial discipline in order to understand the expenses related to carrying out the operations of the firm. With this in mind, the next step is to determine the types of development activity that are useful—and legal—for the culturepreneurial venture. The following section covers different types of fund-raising mechanisms, and, as was mentioned above, Chapter 13 will highlight the details of investing and financial management.

TYPES OF FUND-RAISING

The types of fund-raising activities that are available to the arts organization depend on its structure. By way of a simplifying process, and until there is a change in cultural arts policy, at this writing, only nonprofits can take advantage of grants and charitable contributions, and for-profit structures can take advantage of equity. With that caveat, however, this section covers several aspects of fund-raising, including crowd-sourced approaches; equity and debt instruments; and development of donors and relationships with foundations, governments, and corporate sponsorships. As part of the process of making strategic plans for development, it will be useful to establish categories for each type of development activity and identify exactly what

types of needs can be funded through each. In other words, as was mentioned in the earlier section, knowing the capital needs, the operating and programmatic expenses, and the endowment directions ahead of time will drive the types of fund development that are available, given the cultural arts organizational structure.

Crowd-sourced fund-raising in the cultural arts occurs online through connecting micro donors, patrons, or investors to culturepreneurs seeking funding. Crowd-sourced fund-raising comes from the concept of crowd-sourcing, which is what people and organizations do when they want many parties to engage in a concept of process via an Internet portal.[10] "Crowd funding is a term used to describe an evolving method of raising money through the Internet. For several years, this funding method has been used to generate financial support for such things as artistic endeavors . . . , typically through small individual contributions from a large number of people."[11] Many ideas or projects funded through crowd-sourced fund-raising are driven to this kind of funding source because more traditional sources are not available to the culturepreneur. Crowd-sourced fund-raising can be structured according to the rewards model, the prepayment model, the donation model, the loan model, or the equity model. The first two can be imagined as a fee-based arrangement, in which someone pays for an artistic good or service online and receives it. In the prepayment model, the artist offers to provide a good or service for a fee and then provides it. In the donation model, a person simply provides a donation with no expectation of a reward or receipt of a good; this model is used for nonprofits with a cause generally. In a loan situation, often the loan is made and repayment is of principal only; that is, there are no interest payments. In each of these situations there is no expectation of profit or return on investments.[12]

Many crowd-sourced fund-raising opportunities are available online through directly working with a crowd-sourced fund-raising company or through a portal or intermediary that acts as a broker between buyers and sellers. These kinds of portals and companies can be found around the world, such as on the website culture360. org. The basic arrangement is established by the culturepreneur, the crowd and the crowd's social media relationships with others who care about the cultural offering, and the rules and regulations governing the provision of money. Caring about the cultural arts offering plays a large role in generating the success of the crowdfunded financing. However, accomplishing the ends is not an easy task. Effort must be utilized in arranging these connections and should be in line with ACRMS and social media efforts. Typically, most successful projects receive from 25 to 40 percent of their revenue from their first-, second-, and third-degree connections.[13] Exhibit 12.2 provides a depiction.

In many countries, the issuance of securities to the general public is a regulated activity because governments attempt to protect investors or at least require that securities be purchased with knowledge of risks. In the United States, the Securities and Exchange Commission (SEC)—through Title III of the JOBS Act, or Jumpstart Our Business Start-up Act—is involved with regulating securities in connection with equity instruments in crowd-sourced financing.[14] Title III sets forth certain issues intended to help culturepreneurs raise funds in smaller amounts than in traditional funding, for example with initial public offerings of equities, accessing

Exhibit 12.2 **Crowd Fund-Raising Overview**

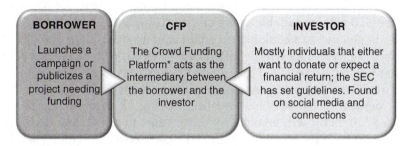

BORROWER	CFP	INVESTOR
Launches a campaign or publicizes a project needing funding	The Crowd Funding Platform* acts as the intermediary between the borrower and the investor	Mostly individuals that either want to donate or expect a financial return; the SEC has set guidelines. Found on social media and connections

*The CFP charges fees for intermediary services, and some specialize in particular areas of funding.

start-up capital, and private placements. The intention here is not to review the JOBS Act, but to note that crowd-sourced fund-raising was included in it as a mechanism for funding in a culturepreneurial context.

The SEC's proposed rules, which were finalized in February 2014, provide guidance about the amount of equity that can be raised of $1 million annually; the types of companies that can use crowd-sourced fund-raising; the role and qualifications of registered broker-dealer funding platform portal providers; and the degree of investment permitted by investors. Investors whose net worth or income is less than $100,000, within a twelve-month window, can invest up to $2,000, or 5 percent of their annual income or net worth, whichever is greater; investors whose net worth or income is greater than $100,000 can invest 10 percent, up to $100,000. The organizations engaging in crowd-sourced fund-raising will have to describe and disclose, for examples, the organization's business, officers, and directors; how the proceeds from the fund-raising efforts are to be used; the price the securities are being offered for; and the targeted total amount and the date for concluding crowd-sourced fund-raising for the project. Financial statements and tax returns are also required to be disclosed. It is important that the arts organization takes precautionary measures to ensure it is in compliance with the rules at the time its crowd-sourced fund-raising efforts are engaged.

Equity and debt instruments are funding vehicles that are available for use in the culturepreneurial organization, again, depending on the organizational structure. *Debt financing* is obtained from borrowed money using interest-bearing instruments. These can come in the form of a bank loan, a line of credit, or credit cards. Loans can be secured—that is, they require collateral, like the support of the value of real property, personal property, or other assets such as accounts receivables and ticket sales—or they can be unsecured. The unsecured loan, line of credit, or credit card does not track with a tangible asset. Interest rates vary based on the kind of loan, the credit rating of the arts organization, the duration of the term of repayment, and whether or not the loan is secured by an asset. Interest rates, which are basically the cost of borrowing the money, can be computed using simple or annual percentage rate interest, with fixed or variable rates. For example, in the simple interest rate calculation, if the secured principal amount of the loan is $10,000, the repayment term

is five years, and the interest rate is 5 percent, then the interest is $10,000 × 0.05, or $500, which is the cost of borrowing. In other words, for $500, the total amount of the $10,000 is available to cover the arts organization's needs.

In contrast to a bank loan, a credit card used to obtain $10,000 today with a repayment in five years will be billed every month, with an annual percentage rate based on the unpaid balance. The annual percentage rates range up to nearly 30 percent. Credit card payments are based on the principal balance, times the interest rate, plus 1 percent of the principal balance. Paying 18 percent interest on $10,000 equates to $250, but it will take nearly thirty years to pay it, and it will cost approximately $14,450. That means the original $10,000 costs $24,450. Therefore, if credit cards are used to finance the organization's needs, care should be exercised to pay them off quickly.

A line of credit is another loan source, which is issued for a certain amount. Suppose the line of credit is for $10,000 but the arts organization needs only $2,500. Then that amount can be accessed and repaid based on the terms of the credit line. In many ways, a credit line operates like a credit card with the benefits of a secured bank loan; that is, it has a lower interest rate and a fixed term such as one to five years to repay it; the borrower accesses only what is needed. That brings the cost of borrowing under control.

Long-term debt, which is repaid over a year or more, is often used in capital expenditures, whereas short-term debt is used for working capital and operations generally. Debt financing does not require any change in ownership in either a for-profit or nonprofit cultural arts organization. Debt can be raised through the Small Business Administration (www.sba.gov). Other loans can be arranged through family and friends, of course. However, care must be taken to understand the relationship between the debt structure and repayment ability. This is another area that can be supported by a dashboard entry, looking at the *debt to asset* ratio, a topic which will be covered in the next chapter.

Strictly speaking, *equity financing* is a type of fund-raising through ownership granted from stock issuance. In purchasing shares of stock, investors not only receive a portion of the ownership of the organization, but expect a dividend or other pro rata income from owning the shares of stock. Equity financing can be executed for a private or public company, as was discussed in Chapter 9. A public company will have its stock traded on an exchange, while a private company's shares will be traded privately through action taken within the firm. However, in a nonprofit there is no ownership, no profits to maximize, and no shareholders. This aspect of the availability of equity investment is directly linked to the business model developed for the cultural arts organization in Chapter 5 and Chapter 9. Therefore, it is imperative that the culturepreneur and the arts manager understand that the choice of structure will have financial ramifications. In today's changing economic environment and technological landscape in which the cultural arts organization functions, it is no longer a given that a particular organizational structure is used. Using a hybrid structure allows the culturepreneur to take advantage of all types of fund-raising mechanisms. Therefore, if the organization has formed under a hybrid structure that includes a for-profit aspect, it could employ equity fund-raising.[15] Business angels and venture capitalists are also investors looking for culturepreneurial opportunities that will

provide some level of ownership.[16] *Business angels* are individuals or groups of individuals who function invisibly in funding a myriad of culturepreneurial ventures, investing between $10,000 and $500,000 into the early stages of a culturepreneurial opportunity while taking an ownership percentage. Business angels expect a return on their investment as the venture succeeds, and they will look for a business model that will allow this. A place to begin looking for business angels is the Angel Capital Association website.[17]

Venture capital typically comes from an equity pool contributed to by partners or institutional investors in an equity capital firm. Investors participating in a venture capital fund seek investments of greater than $500,000, expect a seat on the board of directors, and take a portion of ownership of the organization. It will be expected that there is a functioning management team and that the culturepreneur has the ability to lead and carry out the aims and goals of the organization as well as commit personal resources to it. The arts service product will need to be unique, and a directly demonstrable business model is required. There are many different types of venture capital firms and funds:

- private venture capital firms
- university-sponsored firms
- small business investment companies
- banks and financial institutions
- state- and government-sponsored funds

Culturepreneurs can consult the National Venture Capital Association to get information about the process and the requirements for locating an appropriate venture capital organization to fund their culturepreneurial venture.[18] Exhibit 12.3 illustrates the continuum along which financing occurs.

Raising funds for going public in an *initial public offering* requires that the organization register with the SEC and sell stock that is publicly traded on an exchange. The level of fund-raising using this vehicle will exceed $5 million, and care will need to be exercised to relate ownership percentage relinquished to stock issuance. In particular, culturepreneurs will want to make sure that they retain the ownership level they seek. That said, the new capital raised through this mechanism can be used to fund a variety of projects and operations. Following this path will require ongoing interaction with the SEC. In addition to legal counsel, an underwriter or underwriting team, sometimes called an investment banker, and financial advisers will be needed as well. This type of equity financing is the most extensive, expensive, and involved, requiring a great deal of due diligence.

Valuing the organization will be required for equity or debt financing, whether through angels, venture capitalists, and private or publicly traded stock. *Valuation* is simply the method used for determining how much the cultureprenurial venture is worth. One of the first steps in completing this process is to obtain the correct classification of the business, such as through the North American Industry Classification System (NAICS) codes provided by the U.S. census. The main reason for obtaining this kind of information is to find comparable ventures; it is also necessary

Exhibit 12.3 **For-Profit, Nonprofit, and Hybrid Financing Continuum**

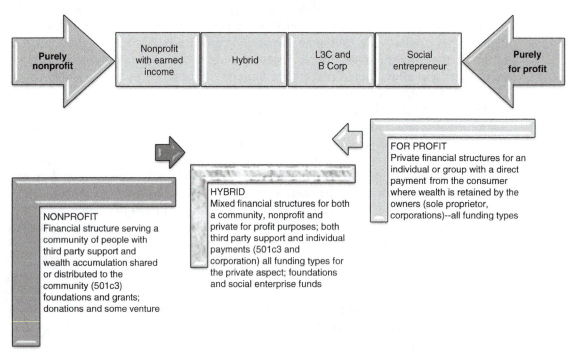

Source: Peter Frumkin, *Changing Environment: New Forms, Actors, and Instruments* (National Arts Strategies and RGK Center for Philanthropy and Community Service, University of Texas at Austin, 2012), www.artstrategies.org/downloads/Changing_Environment.pdf.

in applying for loans, equity financing, and, as will be covered later in the chapter, grants and other kinds of donations. Once this information is obtained, various valuation methods are used:[19]

- *Comparables*: This method examines other firms with similar classifications as the one under consideration to determine the prices for shares of stock, earnings ratios, and other relationships, thus providing a reality check for any culturepreneurial proposal to invest.
- *Earnings and cash flows*: These methods examine revenues and profits using the present value of future cash flows and the present and future value of earnings.
- *Book, replacement, and liquidation values*: These approaches examine the organization's tangible assets. Book value quantifies the asset values on the balance sheet in consideration for depreciation; replacement values estimate what it would cost to replace all the assets; liquidation values quantify what the total accrual would be if every asset were sold today in a "fire sale."
- *Factor approach*: This approach looks at earnings per share, dividend-paying capacity, and book value.
- *Multiples*: This method uses profit or revenues projected into the future multiplied times a factor, such as earnings before interest and tax.

Exhibit 12.4 presents an overview of valuation methods. Some investors will argue that the valuation methods for a service-based culturepreneurial venture will vary from those for a product-based one. This is an argument beyond the scope of this textbook. The main point here is the critical importance of engaging in these kinds of evaluations. In reality, the use of all of these methods is suggested in order to obtain a very broad understanding of the cultural arts organization's value before entering into any market for fund-raising.

Exhibit 12.4 **Valuation Methods**

Valuation method	For-profit	Hybrid	Nonprofit
Comparables: Compare companies' publicly held securities prices in the applicable industry.	✓		
Present value of future cash flow adjusts the value of cash flows for the time value of money, the business, and economic risks. Sales and earnings in the future are projected into today's dollars where the valuation is being made. The time period has to be determined.	✓	✓	
Replacement value is used when a unique asset is involved and the valuation is based on the amount of money it would take to replace or redevelop the asset.	✓	✓	✓
Book value estimates the value of an organization based on its fair market value, or what is called net tangible asset value.	✓	✓	✓
Earnings valuation is based on the potential profits using the current year's profits.	✓	✓	
Liquidation valuation gives the value of an organization if it sold all of its assets at the time of valuation.	✓	✓	✓

General Valuation Method for Determining Venture Capital Investing

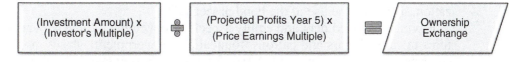

For example, suppose the culturepreneur needs $750,000 of venture capital investment. The company is expecting profits of $1,050,000 in year 5 and the investor is looking for a multiple of 5 times his or her investment. The price earnings multiple of a similar organization has been determined to be 12. The calculation would be

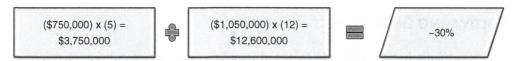

Sources: Robert D. Hisrich, Michael P. Peters, and Dean A. Shepherd, *Entrepreneurship*, 8th ed. (New York: McGraw-Hill/Irwin, 2010); John Warrillow, "The math behind your company valuation: What you need to know to increase the value of your business for a financial buyer," *Inc.*, September 7, 2011, www. inc.com/articles/201109/the-math-behind-your-company-valuation.html.

In using equity fund-raising models, it will be necessary to demonstrate (1) how the cultural arts services and products of the culturepreneurial firm will achieve, sustain, and grow profits through its business model, and (2) excellence in governance through an appropriate board, management team, and organizational structure. The hybrid can be structured under an overarching parent organization, with different subsidiaries under its direction. For example, an art gallery could structure its sales in a for-profit model and raise private equity, yet offer community workshops and classes under the nonprofit model and attract grants. The same kind of structure can be applied to the classical fine arts as well. Setting up such a structure and going into the market for investors will require the use of financial or securities firms, as well as advice from attorneys and tax consultants. Because there is a shifting in the ways in which culturepreneurial organizations relate to the environment surrounding the cultural arts market, its service products, and the cultural arts constituent, these mechanisms should be seriously considered and not dismissed out of hand due to the nature of the cultural arts, given the aims and scope of the culturepreneurial firm.

Strictly speaking, a corporation can also issue securities known as *corporate bonds*, a debt-financing alternative to bank loans that provides funds while providing investors with interest payments. In some instances, the cost of using corporate bonds can be less than the cost of borrowing from a bank. At the same time, corporate bonds do not require relinquishing of any ownership position, but they do require that the tangible assets be offered as collateral. Corporate bonds mature over time, and with time the interest rate associated with a certain principal amount increases. For example, if the cultural arts organization wanted to raise $100,000 that it would pay debt service on for ten years, it could offer a bond that has portions of it maturing over the ten-year period. The first $10,000 would yield an interest rate of 2 percent and mature in one year, while the last $10,000 would yield an interest rate of 5 percent and mature in ten years. Corporate bond issuance requires registration with the SEC, the use of an underwriter or investment banker and legal counsel, a prospectus, and disclosure of particular information about the cultural arts organization, including the use of the bond proceeds.[20]

Having explained debt and equity aspects of development, the conversation now turns towards donors and patrons, foundations, government subsidy, and corporate sponsors. Under the nonprofit, 501(c)3 tax-exempt organizational structures often used in a cultural arts organization, these kinds of fund-raising mechanisms are available. There is an overall process to follow in cultivating donors, patrons, and corporate sponsors, while there is typically a procedure to follow in applying for funding from foundations and government grants.

CULTIVATING BENEVOLENCE

With the use of the ACRMS and social media strategy, cultivation of donors, patrons, and corporate sponsors has evolved. The cultural fine arts organization has to drive cultivation throughout all its parts. It is everyone's job to be cognizant of the need for relationships with donors at every level. Contributors—micro donors, macro patrons, and corporate sponsors—are all equally important to the financial health of

the organization. As can be seen in Appendix 12.1, turning to social media provides a complementary framework within a cultivation strategy. In fact, today the cultural arts organization must include social media in its approach if it hopes to achieve its objectives.

DONORS AND PATRONS

The "traditional" donor and patron engagement model relied upon a progressive image, such as a pyramid or ladder, to categorize the level of giving related to quantified levels of support. At the bottom, there are many donors giving small amounts and receiving small amounts of attention, while at the top there are few patrons giving larger amounts and receiving significant attention. The idea was to move contributors up the pyramid or ladder, so that their contributions would increase in size and the organization's request for a contribution would fit with the contributor's financial level.[21] A more contemporary model of contributor relationship building takes advantage of the contributor's engagement levels in conjunction with social influences, seeking to establish a perceptual map for valuing the contributor's involvement and influence.

At the same time as people seek different levels of influence and involvement in an arts organization, social media have revolutionized the ways in which people can get involved with giving and influence others to get involved also. Continuous communication is required in these endeavors. In Appendix 12.1, Dixon and Keyes describe a new model of contributor cultivation that better serves the needs of nonprofit organizations, including cultural arts organizations:

- The new model allows for contributors to be engaged at different entry points and to move easily between them during the life cycle of their engagement.
- It has no fixed end point for a contributor's engagement.
- It allows for the contributor-engagement footprint to expand or contract in ways that are unique to and driven by the individual contributor.
- It places the contributor's needs—not the cultural arts organization's—at the center of the engagement.
- It accounts for the influence of other people on the strength of the relationship between the contributor and the cultural arts organization.

This model is envisioned as a vortex, where "there are no discrete steps upward or downward or levels to progress, but rather a continuous flow of communication and engagement that begets further communication and engagement. And there is a noteworthy absence of a fixed goal (the equivalent of the pinnacle of the pyramid), recognizing that there is more than one route to maximizing a person's support" of the cultural arts organization's goals and objectives (Appendix 12.1). Dixon and Keyes further suggest that using the vortex model positions the cultural arts organization to present to its contributors a tailored portfolio of involvement that speaks to their desire to have an impact. Concomitantly, doing so maximizes the contributor's commitment, social influence, and lifetime value, while strengthening the core of the

vortex. Employing this model eliminates asking for donations and, instead, initiates a continuous conversation. The importance is that varied engagement opportunities can be presented throughout the life cycle of the contributor and managed with an ACRMS, regardless of their financial size.

CORPORATE SPONSORSHIP

As part of the contributor base, corporate sponsorship is an undeniable aspect of sustaining solvency in a nonprofit cultural arts organization. In reviewing the definition of *corporate sponsorship*, the National Council of Nonprofits states that "a corporate sponsorship is the financial payment by a business to a nonprofit to further the nonprofit's mission, with an acknowledgment that the business has supported the nonprofit's activities, programs, or special event"[22] within the guidelines of a *qualified sponsorship payment*, as defined by the Internal Revenue Service. That guideline states that the sponsor receives no substantial benefit, other than the use of the company's name, product lines, or logo in supporting the cultural arts organization. A qualified sponsorship is different from an agreement by a cultural arts organization to advertise, for a fee, a message for the corporation.[23]

According to Volker Kirchberg, corporate sponsorship of the cultural arts has continuously increased in the United States since the 1960s, complementing the subsidies from foundations and governments.[24] In assessing the income statements of cultural arts organizations, grant funding from governments and foundations can range from 0 to 25 percent of total revenues. Therefore, having corporate sponsors provide direct or matching funds, or other kinds of services, can bolster the financial position quite significantly. Importantly, as was already mentioned in the context of other contributors, cultivation of corporate sponsors will serve a key role in underwriting new arts service product innovation, attracting other contributors, and enlarging the vortex of engagement. As Kirchberg notes,

> The financial security of an arts organization may be ensured by a reputation for being artistically acknowledged and having artistic significance, and corporate support is indeed one factor in fostering this reputation: the business world participation implies that this organization is a worthy recipient for more nonprofit and public funds. The support by a prestigious corporation is an effective catalyst for more funds from other corporations and funding sources outside the business world.[25]

As was discussed in conjunction with patrons, the cultural arts organization must recognize the exchange basis for corporate sponsorship. However, just as there is a need–satisfaction relationship between fine arts consumers and the art they engage with, corporate sponsors have various motivations for participating in the works of cultural arts production. For example, Bank of America states,

> We are one of the leading supporters of the arts in the world because we believe that a thriving arts and culture sector benefits economies and societies. Our

program is designed to engage people in creative ways to build mutual respect and understanding. We do this through grants and sponsorships to arts organizations, and through our own innovative programs.[26]

In general, there are four motives for corporate arts sponsorship.[27]

- *Neoclassical/corporate productivity motives*. This motive is based on the corporate executive's desire to increase the sales, visibility, and reputation of the corporation providing the sponsorship. The sponsorship is grounded in branding and integrated marketing communications for the corporate sponsor, and the cultural arts organization serves as a channel through which the corporation delivers marketing information.
- *Ethical/altruistic motives*. In working from this mind-set, corporate executives contribute to the cultural arts because they perceive it as a socially responsible act, driven throughout the fabric of the firm, while also providing a message of being a good corporate citizen to its stakeholders.
- *Political motives*. Not only do neighbors "keep up with the Joneses" but so do corporations. This model of corporate giving has to do with staying on par with other corporations' giving levels in the surrounding area or neighborhood; in the global world of the cultural arts, "neighborhood" has connotations depending on the scale. Bank of America, for example, can be seen as a neighborhood bank or an international player, motivating the political sponsorship levels of other "neighboring" banks, such as HSBC, which is based in China. The point is that giving is motivated by wanting to do what the competitor is doing. For example, the growth of the Whitney Museum depicts the cascading effect of corporate sponsorship:

> It started eleven years ago, when [the Whitney Museum] . . . installed a satellite museum, the Downtown Branch of Whitney. Then Philip Morris began to plan for a Whitney branch in its new headquarters. . . . When Champion International learned of this plan, they decided to do the same. . . . Now Equitable Life is planning to install a Whitney branch in its new headquarters' building, and . . . another one in a new Philip Johnson building. One branch begets another.[28]

- *Stakeholder motives.* Approaching corporate sponsorship from this direction positions the firm as an indirect recipient of skilled labor and talent, as well as providing for a particular sociocultural base within and around the corporation's sphere of influence. This motivation for sponsorship is given in the light of urban amenities that attract a pool of talent to the geographic areas within which the corporation does business. As a result, other kinds of economic realities come into focus, such as changing values of real estate and the degree of success attributable to public schools.

These models, of course, can overlap. However, what is important to note is that all corporations are led by people, and in discussion with the people at a

corporation one can discover the driving forces behind the company's giving. When this information is placed in the ACRMS, corporate sponsorships can be managed through the vortex model of engagement and perceptual mapping discussed earlier. In doing so, it will be important to understand that corporate sponsorships are based on *corporate* goals. In other words, underwriting the cultural arts will not always be their priority. Sorting through corporations and their sponsorship goals constitutes a very extensive task that is best managed through an ACRMS. This kind of assessment of goals and objectives will also be needed when examining the underlying directions that motivate foundation and government grant support for the cultural arts.

FOUNDATIONS

Although differing from a corporate sponsor, *foundations* also provide financial resources to cultural arts organizations. These are private or grant-making public, nongovernmental, nonprofit or charitable trust organizations whose mission is making grants to unrelated organizations, institutions, or individuals for scientific, educational, cultural, religious, or other charitable purposes. Foundations are often defined as *independent*, *corporate*, or *community*. Because foundations can be structured in different ways, it is advisable to vet any foundation that is being considered relative to the IRS regulations it abides by: not all of them are tax-exempt. For example, often corporations create sponsor programs, as discussed earlier, separate from a corporate foundation. Independent foundations are generally established by private individuals or families. A private foundation derives its money from a family, an individual, or a corporation. An example of a private foundation is the Ford Foundation. A community foundation can be best described as an organization that receives contributions from a variety of sources to benefit a local community and its needs. In contrast, a grant-making public charity (or a "public foundation") derives its support from diverse sources, which may include foundations, individuals, and government agencies.

In garnering foundation and government grant support, it will be necessary to first categorize grant makers into federal, state, and local funder classifications, assess what kinds of projects and initiatives are to be supported, and then further delineate the grant makers so that their priorities match the cultural arts organization's needs. Deadlines and submission requirements must be noted and adhered to. Doing this kind of analysis before beginning the development process is critical. For federal grants, a visit to the website Grants.gov is imperative. Federal grants are listed by category and agency, date opened and closed, and eligibility requirements. State and local grants are best located by contacting the state arts council and the local area arts councils or arts and culture commissions in cities and counties. For foundation support, a search online will turn up several choices, including the Foundation Center (http://foundationcenter.org/), a subscription service that provides information about foundations and what they fund.

FUND-RAISING AND DEVELOPMENT MANAGEMENT

THE PROCESS OF FUND-RAISING

The process of fund-raising and development will demand that the culturepreneur write grants and proposals and in turn arrange for their management. The ACRMS should be used here because there will be details and data to keep track of that provide strategic information. Of course, there are nearly unlimited uses of funds, such as new capital projects, innovative offerings, day-to-day operational expenses, endowments, and events; each cultural arts organization will have its own needs for fund-raising and development. The key is to manage the process and to receive the funding being sought. These ideas are captured in Exhibits 12.5 and 12.6.

Categorize and estimate the relative dollar amounts of the uses of funds being sought for capital projects, innovation, events, and operational expenses. The information will be important when developing the relationship between it and the source of fund-raising. If the cultural arts organization uses a nonprofit framework, to this set of funding uses, add endowments if that is applicable. Next, the uses of funds will be delineated into long-term versus short-term needs. Short-term will cover a time horizon of less than a year.

Once the relative needs and their time horizons are explicit, the next task is linking the needs and time horizons with funding opportunities. What will be the source of funds for each of the needs? Will it be a grant? A contributor? Crowd-sourced fund-raising? A loan? Equity? It is not likely that all the needs will be met by one source; therefore, clearly identifying the approach is necessary. Moreover, identifying more than one source of funding will be useful to yielding additional resources.

Exhibit 12.5 **Cultivating Giving**

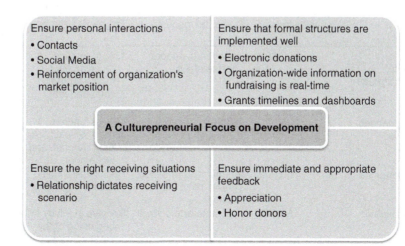

Ensure personal interactions
- Contacts
- Social Media
- Reinforcement of organization's market position

Ensure that formal structures are implemented well
- Electronic donations
- Organization-wide information on fundraising is real-time
- Grants timelines and dashboards

A Culturepreneurial Focus on Development

Ensure the right receiving situations
- Relationship dictates receiving scenario

Ensure immediate and appropriate feedback
- Appreciation
- Honor donors

Exhibit 12.6 **Categorizing Fund-Raising and Development Needs**

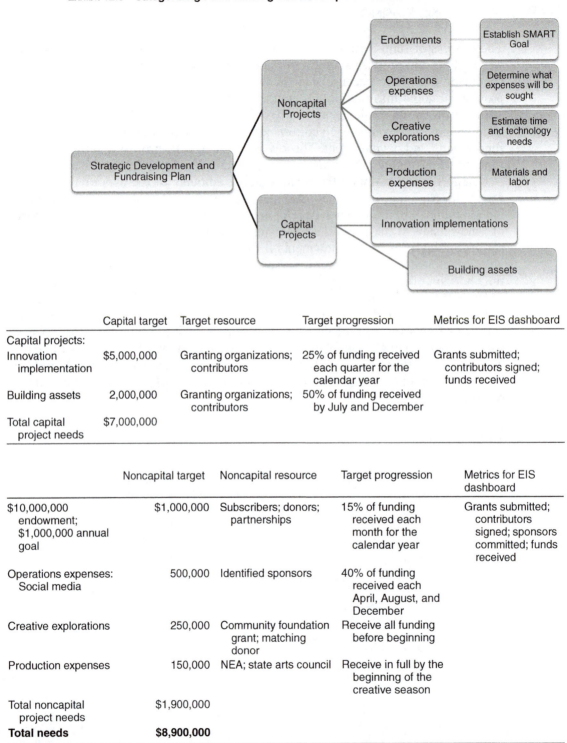

	Capital target	Target resource	Target progression	Metrics for EIS dashboard
Capital projects:				
Innovation implementation	$5,000,000	Granting organizations; contributors	25% of funding received each quarter for the calendar year	Grants submitted; contributors signed; funds received
Building assets	2,000,000	Granting organizations; contributors	50% of funding received by July and December	
Total capital project needs	$7,000,000			

	Noncapital target	Noncapital resource	Target progression	Metrics for EIS dashboard
$10,000,000 endowment; $1,000,000 annual goal	$1,000,000	Subscribers; donors; partnerships	15% of funding received each month for the calendar year	Grants submitted; contributors signed; sponsors committed; funds received
Operations expenses: Social media	500,000	Identified sponsors	40% of funding received each April, August, and December	
Creative explorations	250,000	Community foundation grant; matching donor	Receive all funding before beginning	
Production expenses	150,000	NEA; state arts council	Receive in full by the beginning of the creative season	
Total noncapital project needs	$1,900,000			
Total needs	**$8,900,000**			

Each viable source of funding will be entered into the ACRMS. As can be imagined, the process of identifying sources of funding and linking them to the culturepreneurial organization's needs will involve research. Using the resources explained in the previous section will aid in this process. Because the cultural arts service product will be unique in each culturepreneurial venture, sorting through and accurately identifying the correct resources cannot be avoided. When entering the information, note what is supported, the time periods for requesting funds, and eligibility requirements. This will mitigate problems in fund-raising and development funds and provide clear pathways for the cultural arts organization.

GRANT AND PROPOSAL MANAGEMENT

After identifying the sources of funding and the related uses of potential funds, writing the proposals comes next. As you will have discovered in identifying sources of funds, each provider will have its requirements for proposal contents. It will therefore be efficient to prepare written sections of proposals that can be easily accessed, combined, and updated to match each particular opportunity. Biographical data and information on the expertise of the culturepreneur and the executive management team will always be needed. The background, mission, and vision of the cultural arts organization are likely to be asked for. The source of other funding revenues, the amounts, and the timing are also key information to have available.

Explanations for different projects, the amounts needed, and how they will tie to the cultural arts organization's mission and objectives need to be written. This is why having the categories developed relative to the long-term and/or short-term financial health of the organization is important. Budgets for each of these will need to be created and updated, especially as cycles of funding need to be repeated in the case of unfunded proposals.

With some of the pieces of the grant or application already formed, read the guidelines of the grant or funding requirements and applications carefully. Make note of each of the details, input them into the ACRMS, and establish alerts for submission dates of letters of intent and full proposals. When formulating the documents for submission, having this information already available will greatly maximize efficiency when the time for sending the materials arrives. For that matter, when submitting, it is advisable to send in the full application ahead of the due date to forestall any unforeseen obstacles, such as interrupted Internet service, problems with too much traffic on a particular website, computer glitches, and the like.

DASHBOARDS AND PERFORMANCE METRICS

There is a great deal of pressure on the cultural arts organization to operate efficiently, demonstrate growth, and achieve its mission. As Paul Niven notes, virtually all of the demands to demonstrate success faced by firms are shared by cultural arts organizations.[29] These include both financial and intangible asset measures as they relate to the mission of the cultural arts organization, strategic direction,

resource allocation, and budgets, whether the organization functions under a for-profit, nonprofit, or hybrid structure. Here are several areas that can be slated for measurement:

- financial and fiscal soundness
- cultural arts service quality
- cultural arts consumer experiences
- composition and changes in cultural arts consumer bases
- innovative offerings and ideas implemented
- people management

Many contributors and grant makers *condition* their appropriations by requiring reporting and results information. Each will have its own guidelines. Yet providing information to contributors and grant makers is only a partial requirement for a successful cultural arts organization. Other critical information gathered through the ACRMS assists in detecting achievement of goals or initiating course corrections resulting from deviations. The key is receiving the information in a timely fashion so that decisions can be made. As such, in this section several reporting and dashboard metrics are presented. Note that financial metrics are discussed ahead of Chapter 13, which contains financial management and investment considerations. The culturepreneur and arts manager will select metrics so that they function as a tool in communicating the outcomes of activities that achieve the stated objectives and goals.

The first step in identifying metrics requires linkage of source and uses of funds as they are related to the strategy of the fund-raising objectives, as graphically represented in Exhibit 12.7. *Performance metrics* are measurable indicators that are used in assessing the cultural arts organization in particular areas. The aim of this section of the textbook is to set forth executive and strategic management metrics, which in turn can be used to set the aligning metrics within the arts organization.

In determining performance metrics for the cultural arts organization, four were already pointed out earlier in the chapter:

1. Development efficiency—the *amount* of contributions raised per dollar spent on fund-raising and development.
2. Marketing efficiency—revenue earned per dollar spent on marketing.
3. Program margin—the ratio of earned income to the sum of artistic and production expense.
4. Capacity utilization—the ratio of total seats available compared to those that are sold.[30]

What is critical is that the cultural arts organization is efficient in its development efforts and efficient in allocating the revenues to the mission. Exhibit 12.8 shows this relationship.

Exhibit 12.7 **Strategy and Measurement Map for a Cultural Fine Arts Organization**

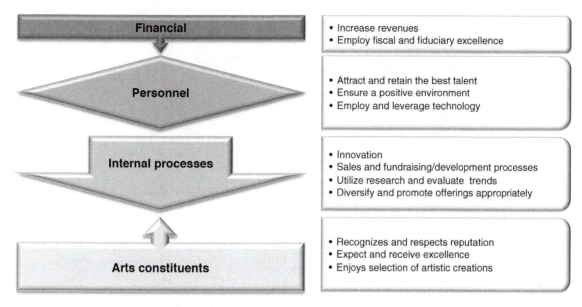

Financial
- Increase revenues
- Employ fiscal and fiduciary excellence

Personnel
- Attract and retain the best talent
- Ensure a positive environment
- Employ and leverage technology

Internal processes
- Innovation
- Sales and fundraising/development processes
- Utilize research and evaluate trends
- Diversify and promote offerings appropriately

Arts constituents
- Recognizes and respects reputation
- Expect and receive excellence
- Enjoys selection of artistic creations

Sample Measures for Metric Development

Arts constituents
- The ease with which arts constituents can avail themselves of the arts service products
- Selection ratings that measure if offerings are meeting the arts consumers' expectations
- Efficiency of purchasing the arts offering
- Quality and satisfaction measures

Internal processes
Innovation: Amount of budget allocated to research and development; number of new product or service development teams; number of focus groups held; number of new arts service products in the pipeline; number of new arts service products developed; revenue generated from new arts service products

Promotion: Distinctiveness of the arts offering differentiation; quality reputation and actual performance; extent to which the cultural arts organization presents the intended perception; loyalty; press coverage

Fund-raising and development: Number of new sponsors and partners; partner and sponsor retention; sponsor and partner satisfaction; number and type of sponsors and partners; number of grant proposals written relative to those won (grant success rate); number of channels utilized in fund-raising; revenue by channel

Personnel measures
Training; recruitment; retention; employee satisfaction; succession planning

Financial measures
Net income; gross revenue; net assets; budget variance; earned income; diversification of income streams and investments; percentage of restricted and unrestricted net assets; budget or forecasting accuracy; income and/or expense per full-time employees

Source: Paul R. Niven, *Balanced Scorecard Step-by-Step for Government and Nonprofit Agencies*, 2nd ed. (New York: John Wiley, 2008).

Exhibit 12.8 **Efficiency in Fund-Raising and Cultural Arts Service Product Offerings**

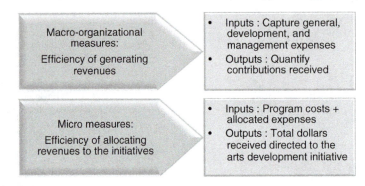

Source: Linda L. Golden, Patrick L. Brockett, John F. Betak, Karen H. Smith, and William W. Cooper, "Efficiency metrics for nonprofit marketing/fundraising and service provision: A DEA analysis," *Journal of Management & Marketing Research* 9 (2012), 1–25.

To these four it is useful to add the following financial performance metrics:

- expendable assets to total liabilities
- ratio of expendable net assets (fund balances) to total expenses
- current ratio of current assets to current liabilities
- accounts receivables to daily sales
- total liabilities to total assets
- debt to equity
- net profit margin
- return on investment
- working-capital of net current assets less current liabilities
- budget deviations of all kinds

Ratios are numerical equations that yield a percentage, giving a quick assessment of the situation. Formulating ratios depends on accurate and timely accounting information. While the scope of the textbook does not delve into accounting methods and practices per se, it does explain where pieces of information are found on financial statements to arrive at the ratio measures. As was mentioned earlier, these performance metrics can be used in providing answers to questions from contributors, grant makers, and corporate sponsors, as well as establishing a benchmark for *valuation* of the cultural arts organization that is situated within a for-profit or hybrid frame.

Each performance metric area can be slated for a particular goal or outcome to establish guidelines. For example, in examining fund-raising efforts, a guideline could be that development efficiency is set so that for every portion of a dollar spent on fund-raising efforts, a certain dollar amount is raised to yield a percentage of 20 percent or less. Ideally, the lower the percentage, the better.[31] The culturepreneur, along with the board and the executive management team, will have to establish the benchmarks for the areas deemed important. With performance metrics clearly identified, dashboards can be created. An example of a dashboard related to performance metrics is presented in Exhibit 12.9.

Exhibit 12.9 **Dashboards and Performance Metrics**

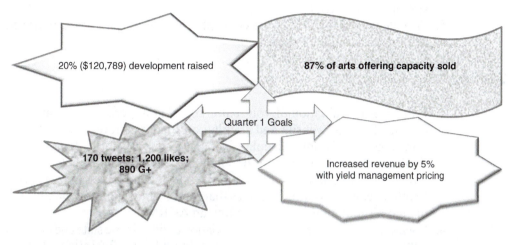

20% ($120,789) development raised

87% of arts offering capacity sold

Quarter 1 Goals

170 tweets; 1,200 likes; 890 G+

Increased revenue by 5% with yield management pricing

Dashboards should always specify a time period.

Note: Dundas Data Visualization's "The Art of Dashboard Design" (www.dundas.com/discover/article/the-art-of-dashboard-design/) provides ideas for designing dashboards. You can also visit the Indianapolis Museum of Art's dashboard (http://dashboard.imamuseum.org) and the Dallas Museum of Art's dashboard (http://dashboard.dma.org/) for ideas, or do your own web search for arts and dashboards.

CHAPTER SUMMARY

This chapter has addressed a broad spectrum of fund-raising and development methods in the cultural fine arts. The topics of capital, operations, and endowments were discussed in terms of explaining how they are used in the culturepreneurial organization and classifying them relative to income statements.

Types of development and fund-raising were presented that covered a spectrum of use in for-profit, hybrid, and nonprofit organizations. These included crowd fund-raising, venture capital, debt, and equity instruments for the for-profit or hybrid structured culturepreneurship. At the same time, the need to cultivate donors, patrons, and corporate sponsorships was emphasized for the nonprofit and that portion of the hybrid form of corporation that can take advantage of such sources.

The ability to garner foundation and government grant support, and grant proposal writing and management, were discussed. Important to this discussion was the use of dashboards and performance metrics that will display real-time development efficiency, ratios, and measures.

DISCUSSION QUESTIONS

1. Explain the differences between crowd-sourced, debt, and equity fund-raising.
2. What kinds of funding are available to the for-profit organization? The nonprofit?
3. Comment on the four motivations for corporate sponsorship in comparison to the definition of corporate sponsorship. Is there any conflict? Why or why not?

4. Note the different kinds of foundations that are available. In what ways are they similar or different?
5. Provide an explanation of the concepts covered in each of the performance metrics presented in the chapter.

EXPERIENTIAL EXERCISES

1. Calculate the valuation of your culturepreneurial venture by visiting the Lincoln Financial Group website and clicking on Planning Tools for the business valuation center at this link: Lincoln Financial Group Business Planning.
2. Utilizing the information in the chapter, develop a contributor model that will guide your cultural arts organization's fund-raising development approach.
3. Identify federal granting agencies that fund the mission of your cultural arts organization. Input their information into an ACRMS.
4. Locate appropriate granting and foundation entities in the state and city in which your cultural arts organization does business. Input their information into the ACRMS.
5. Write biographic and expert information for the culturepreneur and other key executives that will be used in development activities. Write an explanatory document that covers the mission, vision, and objectives of your cultural arts organization.
6. Produce short- and long-term funding projects and initiatives, using a SMART framework.
7. Link each of the projects identified in Exercise 6 to at least two specific viable fund-raising sources found in the research conducted in Exercises 3 and 4.
8. Design and establish a dashboard that will be used in conjunction with managing the fund-raising and development process. Search the Internet for examples to get started. Include as many performance metrics as possible.
9. Establish a procedure for updating the information and meeting reporting requirements for funded projects.

FURTHER READING

Bochner, Steve E., and Jon C. Avina. *IPO Guide*. 7th ed. St. Paul, MN: Merrill Corporation, 2010.
Dundas. The art of dashboard design. www.dundas.com/discover/article/the-art-of-dashboard-design/.
Entrepeneur.com. Going public. December 6, 2005. www.entrepreneur.com/article/81394.
Garecht, Joe. The 5 steps of donor engagement. *The Fundraising Authority*. www.thefundraisingauthority.com/donor-cultivation/donor-engagement/.
Gates Family Foundation. *Facility Expansion & Renovation: Planning for Capital Projects & Campaigns*. Denver, CO: GFF, 2007. www.gatesfamilyfoundation.org/sites/default/files/field_intro_file_1/Facility%20Planning%20Guide.pdf.
Jumpstart Our Business Startups (JOBS) Act of 2012. H.R. 3606. www.gpo.gov/fdsys/pkg/BILLS-112hr3606enr/pdf/BILLS-112hr3606enr.pdf.
Niven, Paul R. *Balanced Scorecard Step-by-Step for Government and Nonprofit Agencies*. 2nd ed. Hoboken, NJ: John Wiley, 2008.

Nonprofit Finance Fund. Loans overview. http://nonprofitfinancefund.org/loans-financing/loans.

Stanford Social Innovation Review. Stanford Center on Philanthropy and Civil Society. www. ssireview.org. ISSN 1542-7099 (Print).

U.S. Securities and Exchange Commission. SEC issues proposal on crowdfunding. Press release 2013–227, October 23, 2013. www.sec.gov/News/PressRelease/Detail/PressRelease/ 1370540017677#.UrNpPRZe_jg.

Warrillow, John. The math behind your company valuation. *Inc.*, September 7, 2011. www.inc. com/articles/201109/the-math-behind-your-company-valuation.html.

NOTES

1. James Heilbrun and Charles Gray, *The Economics of Art and Culture*, 2nd ed. (New York: Cambridge University Press, 2001).

2. Volker Kirchberg, "Corporate arts sponsorship," in *A Handbook of Cultural Economics*, ed. Ruth Towse (Cheltenham: Edward Elgar, 2003), 143–151.

3. Anne Barclay Bennett, *The Management of Philanthropic Funding for Institutional Stabilization: A History of Ford Foundation and New York City Ballet Activities* (New York: Garland, 1993), 84.

4. Ibid.

5. Peter Drucker, *Managing the Non-Profit Organization* (Oxford: Butterworth Heinemann, 1990).

6. Association of Fundraising Professionals (AFP), *The AFP Fundraising Dictionary Online* (2003), www.afpnet.org/files/ContentDocuments/AFP_Dictionary_A-Z_final_6-9-03.pdf.

7. Gates Family Foundation, *Facility Expansion & Renovation: Planning for Capital Projects & Campaigns* (Denver, CO: GFF, 2007), www.gatesfamilyfoundation.org/sites/default/files/field_ intro_file_1/Facility%20Planning%20Guide.pdf.

8. Stan Hutton, "Endowments and arts organizations," *GIA Reader* 19, no. 1 (2008), www. giarts.org/article/endowments-and-arts-organizations.

9. Roland J. Kushner, Thomas H. Pollak, and Performing Arts Research Coalition (PARC), *The Finances and Operations of Nonprofit Performing Arts Organizations in 2001 and 2002: Highlights and Executive Summary* (Washington, DC: PARC, 2003), www.urban.org/ UploadedPDF/311439_Finances_Operations.pdf.

10. Brian J. Rubinton, "Crowdfunding: Disintermediated investment banking," working paper, April 11, 2011, http://ssrn.com/abstract=1807204.

11. This definition is from U.S. Securities and Exchange Commission, "SEC issues proposal on crowdfunding," press release 2013–227, October 23, 2013, www.sec.gov/News/PressRelease/Detail/PressRelease/1370540017677#.UrNpPRZe_jg.

12. Ronald L. Barbara, "Crowdfunding: Trends and developments impacting entertainment entrepreneurs," *Entertainment, Arts, and Sports Law Journal* 23, no. 2 (2012), 38–40.

13. Tanya Prive, "What is crowdfunding and how does it benefit the economy?" *Forbes*, November 27, 2012, www.forbes.com/sites/tanyaprive/2012/11/27/what-is-crowdfunding-and-how-does-it-benefit-the-economy/2/.

14. Dina ElBoghdady and J.D. Harrison, "SEC proposes 'crowdfunding' rules for start-up businesses," *Washington Post*, October 23, 2013.

15. Peter Frumkin, "Changing environment: New forms, actors, and instruments," National Arts Strategies and RGK Center for Philanthropy and Community Service, University of Texas at Austin, 2012, www.artstrategies.org/downloads/Changing_Environment.pdf;

Jeff Hamaoui, "Creating a hybrid for-profit/non-profit social enterprise structure," *Skoll World Forum*, September 25, 2006, http://skollworldforum.org/2006/09/25/creating-a-hybrid-for-profit-non-profit-social-enterprise-structure/.

16. Caroline Williams and Lisa Sharamitaro, "Building a model for culturally responsible investment," *Journal of Arts Management, Law, and Society* 32, no. 2 (Summer 2002), 144–158.

17. Angel Capital Association, "Info for Entrepreneurs," www.angelcapitalassociation.org/entrepreneurs.

18. National Venture Capital Association, www.nvca.org.

19. Martin Zwilling, "How to value a young company," *Forbes*, September 23, 2009, www.forbes.com/2009/09/23/small-business-valuation-entrepreneurs-finance-zwilling.html.

20. U.S. Securities and Exchange Commission, *What Are Corporate Bonds?* Investor Bulletin, SEC Pub. No. 149, 2013, www.sec.gov/investor/alerts/ib_corporatebonds.pdf.

21. Alan R. Andreasen and Philip Kotler, *Strategic Marketing for Nonprofit Organizations*, 7th ed. (Upper Saddle River, NJ: Prentice Hall, 2008).

22. National Council of Nonprofits, "Corporate sponsorship toolkit," www.councilofnonprofits.org/resources/resources-type/toolkits/corporate-sponsorship-toolkit.

23. U.S. Internal Revenue Service, "Qualified sponsorship payment," in *IRS Publication 593: Tax on Unrelated Business Income of Exempt Organizations*, 2012, www.irs.gov/publications/p598/ch03.html#en_US_2011_publink1000267776.

24. Kirchberg, "Corporate arts sponsorship."

25. Ibid., 145.

26. Bank of America, "Global impact: Arts & culture—encouraging those who enrich us all," http://about.bankofamerica.com/en-us/global-impact/arts-and-culture.html#fbid=EzUoa-MMp1X.

27. John O'Hagan and Denice Harvey, "Why do companies sponsor arts events? Some evidence and a proposed classification," *Journal of Cultural Economics* 24, no. 3 (2000), 205–224.

28. Business Committee for the Arts, "Building community—business and the arts: Remarks by Ralph P. Davidson and J. Burton Casey," New York: Business Committee for the Arts, 1984, quoted in Kirchberg, "Corporate arts sponsorship," 147–148.

29. Paul R. Niven, *Balanced Scorecard Step-by-Step for Government and Nonprofit Agencies*, 2nd ed. (Hoboken, NJ: John Wiley, 2008).

30. Kushner, Pollak, and PARC, *Finances and Operations of Nonprofit Performing Arts Organizations*.

31. Charity Navigator, "Financial ratings tables," 2013, www.charitynavigator.org/index.cfm?bay=content.view&cpid=48#.UryJJhZe_jg.

The Permanent Disruption of Social Media
By Julie Dixon & Denise Keyes

Stanford Social Innovation Review
Winter 2013

Social media has chipped away at the foundation of traditional donor-engagement models. A new study highlights the realities of donor behavior and how organizations can redesign their outreach strategies to be more effective.

BY JULIE DIXON & DENISE KEYES | ILLUSTRATION BY ANDREW BANNECKER

THE PERMANENT DISRUPTION OF SOCIAL MEDIA

Spending an entire workday on Facebook isn't part of a typical nonprofit employee's job description. There are programs to run, decisions to make, funds to raise—all higher priorities than the online world of status updates, tweets, pins, and check-ins.

But for one day last fall, all of the people who work at For Love of Children (FLOC) spent all of their time on Facebook. At the end of the day, the organization was nearly $114,000 wealthier. As a participant in Give to the Max Day: Greater Washington, FLOC rallied its supporters to donate $87,000 during the one-day competition, earning it additional prize money from contest organizers for having raised the most donations. For FLOC, Give to the Max Day provided more than just much needed funds. It brought an influx of new donors—many of whom were first introduced to the organization by their friends using social media.

FLOC isn't the only nonprofit taking advantage of social media to raise money, garner new supporters, and increase visibility. One of the most popular—and controversial—nonprofit campaigns of 2012, Invisible Children's KONY 2012 video, was also fueled by social media. The video has been shared more than 2 billion times on Facebook and Twitter since it went live in March. The vast majority of the people watching the video had never heard of Joseph Kony before the campaign, and it's unlikely that they will ever have contact with the organization again. But the impact the campaign had on public awareness of the issue was incalculable.

Until recently the models that nonprofits used to find, engage, and cultivate donors, volunteers, and other supporters were reasonably straightforward. The first step was to use direct mail, phone calls, or other techniques to bring in large numbers of potential supporters at a low level of engagement. These supporters were sorted into neat groups, and the most promising people were continually moved up the pyramid or ladder and cultivated for larger and larger

donations. It was an orderly and linear process. Today, the Internet and social media have permanently disrupted the traditional donor-engagement process. Online competitions, viral video campaigns, mobile giving—with each new way for organizations and donors to interact come increasingly complex entry points into the traditional models of donor engagement, greater variation in movement along the pathway to deeper engagement, and more opportunities for a person to be influenced by forces outside an organization's control.

To better understand the impact that social media is having on donor engagement, we conducted a nationwide research project. We learned that donor behavior and communications preferences have changed because of social media. And as a result, the traditional donor engagement models are no longer sufficient. In their place we need to create a new model of donor engagement, one that is more fluid and continuous, and that better reflects the growing importance that a person's influence (and how she uses it) plays in the process.

THE TRADITIONAL DONOR-ENGAGEMENT MODEL

Pyramids, ladders, funnels—all have long been used as organizing devices and models in the donor-engagement process. Their beauty is in their simplicity; donors exist at a single level at a given point in time and progress predictably up the rungs or levels through carefully calculated outreach and engagement by the organization.

At each level, increasing efforts to engage a person result in increasing commitments (and a drop-off of people who will attain that next level). Those at the bottom are thought to be less engaged than those nearer to the top. People at different levels take different actions and donate in differing amounts; therefore, different communications tools are associated with the levels or rungs. Low-touch or automated tools like direct marketing are at the bottom, and more time- and labor-intensive tools like personal outreach are reserved for only the upper echelon.

The assumption of the traditional donor-engagement models is that the great majority of people enter at the bottom. There is an initial period of time during which the person gets to know the organization and the organization gets to know the person. The organization may ask the person to get involved in some small way, like volunteering for or participating in an event, forwarding an e-mail to friends, or signing a petition. Then—and only then—will they make the "ask" for a small financial gift. This is followed by stewardship and deeper engagement, further research into the person's capacity to give, and eventually, an ask for a larger monetary gift.

In theory, the cycle continues until the person reaches the top of the pyramid or ladder.[1] With each subsequent cycle, forward (or upward) progress is made. A person can neither drop down to a lower level of engagement nor be in more than one level of engagement simultaneously. The culmination of this cultivation? Presenting a person with the perfect ask at the perfect time—with meticulous research informing just how much money to ask for and when.

SOCIAL MEDIA'S IMPACT

The traditional pyramid and ladder models of donor engagement have persisted into the age of social media, as organizations try to make sense of how to use the new tools and what advantages—if any—they hold for fundraising. The consensus among development professionals is that the various types of social media have yet to be proven as effective, stand-alone fundraising tools; few direct asks are being made via these channels today. Yet these social media channels are the very ones that increasing numbers of people use to gather and process information today—young people in particular.

"Social media has created a dilemma around how we reach people," says Shaun Keister, vice chancellor of development and alumni relations at the University of California, Davis. "We can't solicit directly on social media—yet that's where people are doing their business, it's where they're networking, it's where they're getting their information and making a lot of decisions in their lives."

The approach many organizations have taken is to integrate social media into the traditional pyramid and ladder models—occupying the bottom rungs—and use it to build awareness and foster the beginnings of a relationship with the organization. Social media is not used as a way to engender or demonstrate real depth of commitment. "Liking" a cause on Facebook, blogging or tweeting about it, or adding an organization's logo to a social profile are all thought to be gateway actions.

The goal is still to move the casual Twitter user up the ladder to become a legacy donor—but there is little understanding of the pathway this person will take and the best way to navigate the pathway using the new mix of online, offline, mobile, and social media tools. An even bigger question is whether social media is even the best use of a person's or organization's time and resources.

Despite the efforts to meld the old and the new, there is an inherent disconnect between the static pyramid and ladder models—even

JULIE DIXON is deputy director of Georgetown University's Center for Social Impact Communication.

DENISE KEYES is senior associate dean of Georgetown University's Division of Professional Communication, and founder and executive director of the university's Center for Social Impact Communication.

those updated with social media—and the dynamic ways in which people interact with causes today. That is why we need to create a new model of donor engagement. But first, it's important to better understand the changes in how people engage with organizations and causes today.

NEW TYPES OF DONOR BEHAVIOR

To better understand the new world of donor engagement, Georgetown University's Center for Social Impact Communication and Ogilvy Public Relations Worldwide partnered to conduct a quantitative study of Americans to learn how social media has changed the ways people interact with and support the causes and social issues they care about. The survey was conducted in late 2010 with a nationally representative sample of 2,000 people age 18 and older.

Although the results certainly don't imply that organizations should abandon all traditional means of donor outreach and engagement in favor of Facebook, Twitter, and the like, they did reveal important insights into how the traditional models are falling short, both in their discrete categorization of donors and behaviors and in the ways that organizations communicate with their stakeholders.

Survey respondents reported an average of nearly five ways in which they first become involved with supporting causes. The top five ways are donating money (40 percent), talking to others about the cause (40 percent), learning more about the cause and its impact (37 percent), donating clothing or other items (30 percent), and signing a petition (27 percent). Entry points for engagement weren't confined to a particular level or rung on a ladder, but rather reinforced our hypothesis that people enter at various levels—or even multiple levels—of engagement.

Interestingly, when asked in our survey about the ways in which they most often get involved with causes or social issues, the respondents' answers look strikingly similar to how they first get involved. This alignment could be an indicator that people aren't necessarily progressing up a ladder but instead tend to remain at the level(s) at which they are first engaged.

Social media-driven actions are conspicuously absent from the ways in which Americans first get involved with causes. This goes against the updated models that often classify these actions as the gateways at the bottom of the ladder. For example, only 9 percent of Americans first get involved by joining a cause group on an online social networking site like Facebook; other social media actions, like posting a cause's logo on a social profile (6 percent of respondents), and blogging about a cause (4 percent) ranked even lower. These types of activities (and the people who perform them) are commonly lumped together under the heading of "slacktivists," and the assumption is that they replace more traditional (and, from an organizational perspective, more valuable) forms of engagement like volunteering or donating.

Although this might be true if these were the only types of activities these people undertook, we found in our study that these slacktivists actually supplement—not replace—donating and volunteering with promoting the cause on social media. Moreover, they apparently perform these actions after already having been engaged with an organization. So for this group of people, it's very likely that they first donated or volunteered, and then progressed down the

ladder, so to speak, to engage with the organization on social media.

There is very little room in the traditional models for this type of backward motion. In fact, organizations looking to the traditional models may actually think of this downward movement as a bad thing—as if these people are somehow less engaged because they are using social media now.

In practice, it turns out, a person's engagement with an organization is generally more continuous—and messy. It doesn't stop and start with discrete levels, and with the broad range of activities available to potential supporters today, it's actually preferable for people to be engaged on multiple levels.

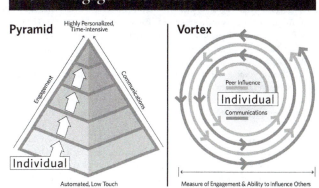

Donor Engagement Models

Pyramid — Highly Personalized, Time-intensive / Engagement / Communications / Individual / Automated, Low Touch

Vortex — Peer Influence / Individual / Communications / Measure of Engagement & Ability to Influence Others

COMMUNICATION CHANGES TOO

In the same way that the traditional models don't fully represent donor behavior today, they also promulgate a somewhat limited and outdated view of how organizations should communicate with donors. The models encourage the segmentation of communications tactics—social media, e-newsletters, and other automated channels at the bottom, and personal outreach, face-to-face meetings, and other labor-intensive, high-touch channels at the top. In practice, segmented communications strategies are quickly losing ground in a world in which the boundaries between offline and online, traditional and nontraditional media are blurring.

Our survey results showed that traditional media (such as television, newspapers, and magazines) are still the way that most Americans learn about causes and social issues (70 percent of respondents agreed that they learn about causes from these sources). But social media and online channels have sizable audiences as well (47 percent of respondents agreed that they learn about causes from these sources).

The most successful organizations are those that embrace communications strategies that integrate online and offline channels. It's about creating what Jennifer Wayman, executive vice president and director of social marketing at Ogilvy Washington, calls a "surround sound" experience—one that uses various channels in people's everyday lives and increases opportunities to both introduce and reinforce messages.

It is also important that organizations use new forms of media to communicate continuously. Direct mail or even e-newsletters can be valuable conduits of information for organizations, but the power of social media is its ability to provide continuous and timely communications.

The traditional models also fall short because they are inherently one way—from the organization to the person. A person's commitment to an organization can depend on many factors that are outside the control of the organization. A donor's peers can greatly influence her actions and deepen her commitment. Likewise, a donor can have great influence on her peers. Our survey results highlighted the role of influence in driving involvement in causes; 39 percent of Americans responded that they're motivated to get involved with causes that have affected someone they know, and 36 percent said they're motivated by it being an important cause to family and friends. Both were among the top five responses, and both outweighed factors

like having the time or money to get involved or feeling an urgency to help those in need.

"Organizations need to recognize that they are not their best messengers anymore," says Katya Andresen, chief strategy officer at Network for Good. "When you rank the potential forces on a donor's decision to give, family, friends, and peers rank higher than anything." Fundraising professionals and organizations accustomed to operating according to one-dimensional models that do not account for the variable nature of peer-to-peer influence are at a significant disadvantage.

CREATING A NEW MODEL

Given what we know about the shortcomings of the traditional donor-engagement models, it is possible to begin to construct the outlines of a new model that takes into account the changes in donor behavior, communications, and influence. The new model should incorporate the following characteristics of donor engagement:

- Allows for a donor to be engaged at different entry points and to move easily between them during the life cycle of his engagement
- Has no fixed end point for a donor's engagement
- Allows for the donor-engagement footprint to expand or contract in ways that are unique to and driven by the individual donor
- Places the donor's needs—not the organization's—at the center of the engagement
- Accounts for the influence of other people on the strength of the donor-organization relationship

The best visual representation of this new model is a vortex, rather than a pyramid, ladder, or funnel, which are used to represent the traditional models. (See "Donor Engagement Models" above.) At the center of the vortex is the individual. Her depth of commitment to the organization (formerly how high up she is on the ladder) is represented by the size of the continuous field around the center. As the person's commitment deepens, the vortex expands outward. The vortex can be strengthened—and expanded—by the influence of others, but as it grows it also becomes a greater source of influence on others.

In a vortex there are no discrete steps upward or downward or levels to progress, but rather a continuous flow of communication and engagement that begets further communication and engagement. And there is a noteworthy absence of a fixed goal (the equivalent of the pinnacle of the pyramid), recognizing that there is more than one route to maximizing a person's support of a cause or issue.

Adopting a model such as this requires organizations to change the way they think about their donors and potential donors, and how they both assign value to and ask for contributions from these groups. It also requires organizations to change the ways in which they train and empower all their employees to engage with their stakeholders.

REDEFINING CONTRIBUTIONS

The first change that an organization needs to make is in how it defines a person's contribution to the organization. Although the pyramid and ladder models tend to emphasize a singular call to action (donate money), a vortex model allows other types of contributions from supporters to be valued.

"I think increasingly philanthropists—whether individual, corporate, or private—are looking at a cause and asking the question: what is the best way to get a result?" says Susan Raymond, executive vice president for research, evaluation, and strategic planning at Changing Our World. "And it may not be writing a check, and it may not be volunteering. It may be other forms of resource mobilization."

Survey respondents were asked what makes them feel like "cause champions"—defined as being very involved in a cause or social issue. Donating was the top response (33 percent), followed by talking to others about the cause (26 percent) and volunteering (22 percent). A majority of respondents (57 percent) chose offline activities, with only a small minority choosing online activities (19 percent) or social networking (10 percent).

Among the 10 percent of Americans who said that a social media activity made them feel like a cause champion, the list of top responses looks quite different from the majority of Americans.' Talking to others about the organization or cause tops the list (49 percent), followed by joining a cause group on Facebook (43 percent), donating (39 percent), asking someone else to add a cause logo to a social profile (37 percent), and signing a petition (35 percent).

As you can see from the survey data, when organizations emphasize financial donations as the primary means of support, they may be doing so at the risk of discouraging other types of supportive activities—many of which have the ability to expand significantly the influence of the person at the center of the vortex, and therefore increase the contributions of others.

There is a parallel shift occurring in the for-profit sector, as more and more consumers turn to social media and online channels to talk about and share their experiences with products and services. As Paul Smith and Ze Zook wrote in their book *Marketing Communications*, "the ideal customer, or most valuable customer, does not have to be someone who buys a lot. The ideal customer could be an influencer who is a small irregular buyer but who posts ratings and reviews, as the reviews could influence another 100 buyers." [2]

For a nonprofit, this valued supporter could be the small donor—with the big network or degree of social platform savvy—who is able to influence others to give well beyond her own capacity. Where the traditional models might write this person off as having a low lifetime value and not worth an organization's time and investment, a model that takes influence into account will value that person more highly.

The whole concept of lifetime value would be reimagined in a vortex model. Where lifetime value has traditionally been a combination of average donations, future capacity to give, and attrition rates, now lifetime value could incorporate factors like the size of the person's network, her propensity to share and influence that network, and her skill in doing so.

DIVERSIFYING CALLS TO ACTION

Once an organization begins to define and value contributions differently, it can begin to diversify the types of calls to action it asks of its supporters. As our research shows, organizations basically get what they ask for. Ask only for financial donations, and that is what people will think is their deepest level of involvement. But ask for more—sharing on social media, forwarding e-mails to friends, advocating for the organization, organizing and leading fundraising events—and a person's contributions, as well as her sense of having an impact, can grow exponentially.

It's no coincidence that the two most successful organizations on Give to the Max Day: Greater Washington, FLOC and Little Lights Urban Ministries (which raised $79,000 in donations and prize money that day) used nearly identical calls to action in their donor communications. In addition to donating, each organization asked supporters to share the e-mail appeals with their personal networks and to post information about the organizations' efforts in the contest on social media. Both are relatively easy tasks that require minimal effort, but can reap tremendous benefits for an organization.

In our research we found that Americans do recognize the value of social media tools in facilitating increased cause engagement; more than half of those surveyed agreed that online social networking sites allow people to support causes more easily. And as we saw in the earlier data, slacktivists who are willing to use digital tools to promote an organization or cause are a desirable group to have. They are just as likely to donate as non-social media promoters, are twice as likely to volunteer or participate in an event or walk, and are more than three times as likely to solicit donations on behalf of a cause. They also participate in, on average, nearly twice as many different kinds of support activities as the average American.

Because there are so many different activities that people can be involved with, organizations need to be strategic about what they ask supporters to participate in. To better understand the relative importance of different types of activities, we categorized them in two dimensions: level of involvement (how much of a personal investment in time, resources, and reputation a person makes), and level of influence (how likely it is that completing that activity alone will sway someone else to get involved).

Donating money, for example, has a relatively high level of involvement (assuming a reasonably substantial contribution), but a low level of influence (if a person donates, but tells no one, it doesn't compel anyone else to take action). Forwarding an e-mail to friends about a cause has the potential to influence other people to get involved, giving it a high influence value, but a lower value for involvement because it's a relatively easy task. (See "Valuing Support Activities" on p. 29.)

There is a noticeable lack of activities that fall into the low involvement, high influence quadrant, because for an activity to be influential, it needs to be grounded in authenticity and personal commitment. A person can be involved but not influential, but can never be influential without being involved.

The goal for an organization using the vortex model is to offer its supporters a tailored portfolio of involvement that speaks to their strengths and ability to have an impact. This in turn will maximize the person's commitment and lifetime value, and strengthen the core of the vortex and its ability to influence others. What was a model designed to prepare each individual donor for the annual ask now becomes a continuous conversation in which varied engagement opportunities can be presented throughout the life cycle of the donor.

SUSTAINING CONTINUOUS COMMUNICATION

Being in continuous communication with donors can seem quite daunting because of the amount of time required. The way to do this is to encourage everyone in the organization to be a communicator. Most organizations equip board members with basic elevator speeches. Some may hold trainings for board and staff to provide guidelines on messaging. But very few embrace the "everyone is a communicator" idea fully—and those that do have a tremendous advantage.

"Give to the Max really highlighted the importance of everyone in-house being an ambassador for your organization," says Andrea Messina, director of development at FLOC. "We have communications trainings for staff—everyone learns what messages are and what our elevator speech is." FLOC provides all staff with guidelines on how to tell the FLOC story to different audiences, in one sentence and in one page. Each staff meeting ends with a specific call to action so that people are aware of what's going on at the entire organization, not just within the confines of their job.

Communications can also be carried on by an organization's supporters. An organization that does this well is charity:water, which has had tremendous success in mobilizing its online supporters to raise funds to provide safe drinking water to people in the developing world. "The reason it comes to them very naturally is that the organization is founded on the very principle of being a network of networks," says Andresen. "It is set up to turn the role of fundraiser from an internal function of the organization to a role that's shared by everyone in their community."

For organizations that don't come by this networked mentality easily, online supporters can be identified, trained, and managed like any group of volunteers. FLOC monitors social media to find potential ambassadors. "I can spend a few minutes on Facebook every day and see people who are posting and liking every time," Messina says. These are the people whom FLOC recruits to be online ambassadors.

What causes most organizations to hesitate in empowering these external ambassadors is the loss of control. "There's a certain amount of the 'they're not going to say it the way we're going to say it' mentality, but the cost-benefit ratio is still going to be positive," says Mark Rovner, founder and principal at Sea Change Strategies. And perhaps with the loss of some control comes an increase in authenticity and transparency, both qualities that can greatly enhance an organization's overall communications.

LOOKING AHEAD

Our hypothesis going into the study was that social media has revolutionized the ways in which people get involved with causes. In short, it hasn't. But it has certainly changed the ways in which people can influence others and increased the range of meaningful calls to action available to nonprofits. Continuous communication is now an expectation—if not a demand.

The full impact of these changes on the traditional donor engagement models is not yet known. It's clear, however, that new ways of thinking about donor behavior should incorporate measures of influence and better account for the fluid and dynamic ways in which people support causes. Even as our understanding of true influence continues to evolve, organizations can begin to respond to these shifts by rethinking their definition of a traditional contribution and diversifying their calls to action.

"People are going to take very different approaches to solving problems as this whole area of social engagement evolves," says Raymond. "There will be people who will never be on anybody's pyramid or ladder ... and they're equally valuable in the sector, equally valuable as leaders—they just come with entirely different sets of optics."

The challenge for organizations is finding ways to maximize the contributions of different groups of people with unique desires and resources. One thing is for certain. The pathway into the digital future is not going to be a linear journey up a ladder or pyramid. ∎

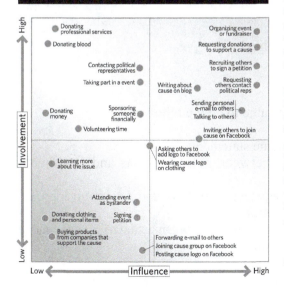

Valuing Support Activities

Involvement (vertical axis: Low → High), *Influence* (horizontal axis: Low → High)

- Donating professional services
- Donating blood
- Contacting political representatives
- Taking part in an event
- Writing about cause on blog
- Donating money
- Sponsoring someone financially
- Volunteering time
- Organizing event or fundraiser
- Requesting donations to support a cause
- Recruiting others to sign a petition
- Requesting others contact political reps
- Sending personal e-mail to others
- Talking to others
- Inviting others to join cause on Facebook
- Asking others to add logo to Facebook
- Wearing cause logo on clothing
- Learning more about the issue
- Attending event as bystander
- Donating clothing and personal items
- Signing petition
- Buying products from companies that support the cause
- Forwarding e-mail to others
- Joining cause group on Facebook
- Posting cause logo on Facebook

Notes

1 Alan Andreasen & Philip Kotler, *Strategic Marketing for Nonprofit Organizations* (Upper Saddle River, NJ: Prentice Hall, 2007); Joe Garecht, "The 5 Steps of Donor Engagement," *The Fundraising Authority,* http://www.thefundraisingauthority.com/donor-cultivation/donor-engagement

2 Paul Smith & Ze Zook, *Marketing Communications: Integrating Offline and Online with Social Media* (Philadelphia: Kogen Page Publishers, 2011): 17.

13 Financial Management and Investing in the Cultural Fine Arts Organization

CHAPTER OUTLINE

LEARNING OBJECTIVES

After reading this chapter, you will be able to do the following:

1. Understand how to read income statements.
2. Recognize the differences between balance sheets and statements of position.
3. Understand the distinction between a top-down and bottom-up approach to budgeting and revenue projections.
4. Assess the financial health of a cultural arts organization using ratio analysis.
5. Choose a set of investment strategies.
6. Set asset maximization objectives.
7. Utilize risk-to-return ratio analysis.
8. Relate investments to the cultural organization's mission.

9. Establish an investment committee and be aware of laws governing it.
10. Comprehend several components of an investment policy.

Exhibit 13.1 **Financial Management**

(Courtesy of Carla Stalling Walter)

INVESTING ETHICALLY

Mission-driven investing (MDI) emanates from the idea of public trust—nonprofit endowments are held in trust. Once a donation has been made, the assets no longer belong to the donor and instead are held in trust for the public good. Society, in the largest sense of the word, is the beneficiary of this trust. In exchange for providing this benefit to society, the donor receives a tax advantage. As all assets donated are generally tax-deductible, along with most of the earnings on those assets, there is a duty to manage all the funds in such a way as to provide the greatest benefit to society—the ultimate beneficiary of the trust. MDI is a way to go about doing this.

One reason that organizations use this kind of investing is to mitigate social and economic problems introduced by the market system. These problems range from homelessness, poverty, and lack of access to clean water to the provision of the

cultural fine arts. Whatever the market issue, culturepreneurial organizations can address it and meet their financial goals as well by making use of their investment program using a MDI approach.

Mission-driven cultural fine arts organizations are situated in a history of processes and thinking ranging back to the 1800s. At that time, though it may be difficult to believe, common stock, real estate, gold, venture capital, hedging, futures, and options were considered too risky for any organization to invest in. In 1830, the Massachusetts Supreme Judicial Court introduced the term "a prudent man" as it ruled that trustees must invest the assets in their care in the manner in which a prudent man would invest his own assets. Of course, we extend the notion to today's evolution and rather use the term "a prudent person"! Nevertheless, key to this decision was the ability of fiduciary responsibility to evolve as times changed: as new investment practices evolved, so too did the prudent person's behavior. Consequently, organizations that invest are now allowed to hold assets such as common stock and real estate.

Increasing numbers of investors believe that sustainability issues, such as social and environmental concerns, impact long-term value. In addition, there is now a fiduciary focus on understanding that investment objectives should match the investment time horizon: there is a movement among institutions toward investing for the long term, not the quarterly return. In recent years, organizations take environmental, social, and governance issues into account when making fiduciary decisions. In 2005, the United Nations Environment Program's Finance Initiative presented a comprehensive report entitled *A Legal Framework for the Integration of Environmental, Social and Governance Issues into Institutional Investment*.[1] The analysis concluded that integrating these considerations into investment processes is clearly permissible and definitely needed.

ACHIEVING AND MAINTAINING FINANCIAL SOUNDNESS

There are nearly unlimited ideas, projects, and expenses that culturepreneurs have to consider. In leading a successful cultural arts organization, culturepreneurs set the tone and importance of fiscal responsibility and drive their beliefs throughout the organization. At the same time, members of the board of directors or advisers function in a capacity that enhances the financial navigation that is critical to long-term stability. In this light, often a culturepreneurial organization needs advances in capital for projects or other expenses, as was discussed in Chapter 12. Moreover, many contributors have become less lenient and require excellence in fiscal management on the part of nonprofit organizations. In fact, the failure to consider the financial operations of the cultural arts organization as critically important and to act appropriately can have considerable negative consequences. At the same time, taking the time to establish and maintain financial management systems benefits all contributors and stakeholders in and around the cultural arts organization. As much attention needs to be paid to this aspect of the firm, if not more, as that given to the production and management of the arts service products themselves.

Financial management and investing strategies constitute two very broad practical and academic subject areas. As such, as in the other chapters presented in this textbook, the material here provides the culturepreneur and arts manager with foundational information for putting a *financial management system* in place. A graphical representation of this system is given in Exhibit 13.2. Importantly, there must be excellence in accounting and financial management software and its data inputs. Data and information used in reports arising from them are key in decision making. At the same time, highly skilled and ethical individuals are needed to drive the systems and processes. These points cannot be overly emphasized. With these caveats clearly expressed, the chapter has two overriding goals. One is to explain financial statements and how to read them; the other is to explain the need for mission-driven investing.

Exhibit 13.2 **A Financial Management Framework**

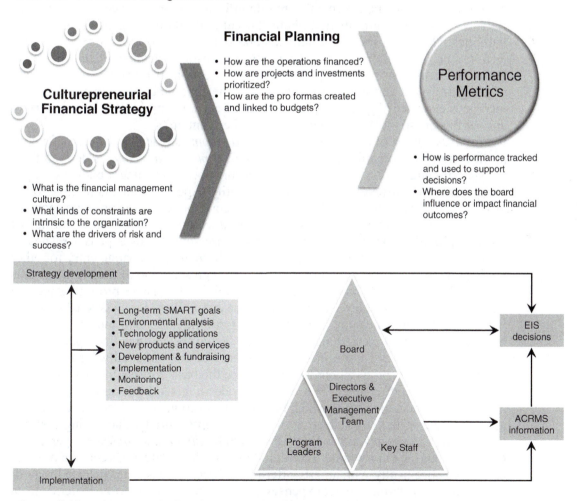

Source: Jim Rosenberg, *Learning from the Community: Effective Financial Management Practices in the Arts; Summary Findings and a Framework for Self-Assessment* (Alexandria, VA: National Arts Strategies, 2003).

Both of these overarching goals are produced in the light of the fiduciary responsibility that rests upon the cultural arts organization in whichever structure it takes on. For the nonprofit, this means managing so that deficits and other cost disease-related issues are avoided, and funds are used to maximize the mission and objectives. For the for-profit organization, it means that funds are managed to the ends of sustainable profit maximization; for the hybrid structure, of course, financial management and investment strategies will reflect each underlying set of objectives. In the latter case, it will mean essentially that financial statements are developed under the parent organization and for each of the different divisions under its umbrella.

FINANCIAL STATEMENTS

In general, financial statements present a picture of the cultural arts organization at a point in time. Income statements provide information on revenues and expenses. Balance sheets give information about the cultural arts organization's assets and liabilities. Generally, income statements and balance sheets are compared to projections. Projections are considered pro forma income statements, and these, in turn, can be used in budgeting. Preparing a projection of revenues and expenses is straightforward and guides the answers to the following questions: How much income is expected? Figuring out the source of each income stream is necessary to answer this question. What will the revenues be spent on?

Revenues consist of *earned* and *contributed income* streams in the case of a nonprofit cultural arts organization. Simply stated, *contributed income* is derived from the sum of contributions and corporate sponsorships. In forming a budget or a pro forma projection of revenues, one has to quantify expected amounts relative to the probability of receiving them. In other words, contributions and corporate sponsorship amounts are delineated. *Earned income* is computed based on quantities of services provided, other income, and merchandise sold, minus expenses related to the cost of selling the services. To this, one would include a separate entry for other kinds of income, such as investment income. A representation of these summations of earned and unearned income is given in Exhibit 13.3. These pro forma income statements should cover three to five years. The cultural arts organizational structure will dictate the nomenclature used in setting forth these kinds of income. It should be evident that the projected incomes will be tied to the cultural arts organization's strategy. Not only will these income statements be used internally for budgeting, planning, metrics, and dashboards; they will be the basis for seeking outside investors should the culturepreneur or arts manager deem this to be necessary.

Expenses reflect the way in which the earned and contributed income streams are allocated, and in fact are reflective of the culturepreneurial values being instilled throughout the organization. Expenses include *direct* and *indirect* operational expenses incurred in providing the cultural arts service product. Direct expenses are associated specifically with an arts offering; indirect expenses are incurred regardless of the arts offering. Direct expenses can comprise a broad array of items, from costumes to copying to choreography. Indirect expenses can include accounting software, rent, utilities, and other expenses. Many organizations attempt to link a

Exhibit 13.3 **Computing Earned, Contributed, and Investment Incomes**

	Year 201X	Percent	Year 201Y	Percent	Year 201Z	Percent
Earned revenues						
Retail/merchandise	403,839	11	415,954	11	432,592	11
Education fees	43,879	1	45,195	1	62,739	2
Tickets	578,997	16	696,873	18	724,748	18
Commissioned works	275,000	7	283,250	7	294,580	7
Lectures	155,000	4	159,650	4	166,036	4
Other income investment	78,346	2	78,346	2	78,346	2
Endowment income, fixed	357,864	10	368,600	10	402,876	10
Total earned revenue	1,892,925	51	2,047,868	53	2,161,917	53
Contributed income						
Federal funding	250,000	7	225,000	6	220,000	5
Arts council funding	35,765	1	36,838	1	38,311	1
Community foundations	72,697	2	74,878	2	77,873	2
Local government	13,879	0	14,295	0	14,867	0
Foundations	365,731	10	376,703	10	391,771	10
Individuals	750,383	20	778,894	20	803,810	20
Memberships	58,823	2	60,588	2	63,011	2
Sponsorships	250,000	7	257,500	7	267,800	7
Total contributed	1,797,278	49	1,818,696	47	1,891,444	46
Total revenues	$3,690,203	100	$3,866,565	100	$4,053,361	100

portion of indirect expenses to each area of arts service product. For example, if the cultural arts organization produces sculptures and paintings and treats these as different business units, indirect expenses as a percentage of use are charged against each of them. The reason for doing this is to be able to see how efficient the allocation of resources is to evaluate business unit costs, and, in the case of new arts service product development, to be able to anticipate where resources can be funneled from to support a new development. As should be evident, all expenses relate to the mission and goals of the cultural arts organization, as reflected in Exhibit 13.4. Many of these items can be targeted for fund-raising and development activities.

INCOME STATEMENTS, ANALYSIS OF VARIANCES, PRO FORMA PROJECTIONS AND BUDGETS

What happens next is a merging of the two sets of projections to come up with the first draft of the income statements, shown in Exhibit 13.5. Ideally, the total amount of income and revenues exceeds the projected expenses. In that case, there is a surplus or profit; in the opposite case, there is a deficit or loss. When there is a deficit or loss, the income statement needs to show how it will be reduced and eliminated over the time period. Basically there are three ways to do that: increase revenues, decrease costs, or do both. As can be seen from Exhibit 13.5, in year 201X there is a deficit, with a surplus, or profit, in years 201Y and 201Z, assuming an escalation of revenues by 3 and 4 percent per year, while expenses increase by 2 percent each year.

Exhibit 13.4 **Estimating Expenses**

	Year 201X	Year 201Y	Year 201Z
Sample expenses			
Salaries	987,392	1,007,143	1,027,286
Employee benefits and expenses	1,086,135	1,107,857	1,130,014
Part-time artists and teachers	59,383	60,571	61,782
Production promotional events	23,876	24,354	24,841
Costumes, sets, and displays	200,389	204,397	208,485
Ticket sale expenses	3,405	3,473	3,543
Costs of merchandise sold	324,073	330,554	337,166
Fund-raising and development	40,389	41,197	42,021
Printing	34,982	35,682	36,395
Accounting and banking fees	7,896	8,054	8,215
Promotional expenses	175,303	178,809	182,385
Legal fees	17,869	18,226	18,591
Equipment repair and rental	6,355	6,482	6,612
Office refreshments	12,000	12,240	12,485
Designers and consultants	534,875	545,573	556,484
Computer and software	4,800	4,896	4,994
Software service fees	2,500	2,550	2,601
Miscellaneous supplies	1,200	1,224	1,248
Travel and touring expenses	50,735	51,750	52,785
Venue expenses	18,675	19,049	19,429
Postage and shipping	46,893	47,831	48,787
Building lease or rental expenses	36,000	36,720	37,454
Electricity	12,000	12,240	12,485
Water and sewer	6,000	6,120	6,242
Gas	3,000	3,060	3,121
Total expenses	**$3,696,128**	**$3,770,050**	**$3,845,451**

	201X	201X	201X	201X
	Arts offering 1	Arts offering 2	Arts offering 3	Unallocated
	50%	40%	10%	
Estimated Expenses				
Salaries	493,698	394,958	98,740	
Employee benefits and expenses	543,067	435,454	108,613	
Part-time artists and teachers	29,692	23,753	5,938	
Production promotional events	11,938	9,550	2,388	
Costumes, sets, and displays	100,195	80,156	20,039	
Ticket sale expenses	1,703	1,362	341	
Costs of merchandise sold	162,037	129,629	32,407	
Fund-raising and development				40,389
Printing	17,491	13,993	3,498	
Accounting and banking fees				7,896
Promotional expenses				75,303

Legal fees				17,869	
Equipment repair and rental				5,355	
Office refreshments				12,000	
Designers and consultants	267,438	213,950	53,488		
Computer and software				4,800	
Software service fees				2,500	
Miscellaneous supplies				1,200	
Travel and touring expenses	25,368	20,294	5,074		
Venue expenses	9,338	7,470	1,868		
Postage and shipping	23,447	18,757	4,689		
Building lease or rental expenses	18,000	14,400	3,600		
Electricity	6,000	4,800	1,200		
Water and sewer	3,000	2,400	600		
Gas	1,500	1,200	300		
Total expenses direct expenses	1,713,908	1,371,126	342,782	268,312	3,696,128
Distribution of unallocated expenses	89,437.33	89,437.33	89,437.33		
Total direct and indirect expenses	1,803,345	1,460,564	432,219		3,696,128

Direct expenses—the bolded and italicized entries—can be allocated directly to an artistic offering.
Indirect expenses are the remaining expenses and should be allocated to an artistic offering by percentage resources allocated to it.
All expenses should be appropriately allocated to show the level of contribution, profit, and/or loss.

Exhibit 13.5 **Pro Forma Income Statement, 201Y–201Z**

	Year 201X	Percent	Year 201Y	Percent	Year 201Z	Percent
Earned revenues						
Retail/merchandise	403,839	11	415,954	11	432,592	11
Education fees	43,879	1	45,195	1	62,739	2
Tickets	578,997	16	696,873	18	724,748	18
Commissioned works	275,000	7	283,250	7	294,580	7
Lectures	155,000	4	159,650	4	166,036	4
Other income investment	78,346	2	78,346	2	78,346	2
Endowment income, fixed	357,864	10	368,600	10	402,876	10
Total earned revenue	1,892,925	51	2,047,868	53	2,161,917	53
Contributed income						
Federal funding	250,000	7	225,000	6	220,000	5
Arts council funding	35,765	1	36,838	1	38,311	1
Community foundations	72,697	2	74,878	2	77,873	2
Local government	13,879	0	14,295	0	14,867	0
Foundations	365,731	10	376,703	10	391,771	10
Individuals	750,383	20	778,894	20	803,810	20
Memberships	58,823	2	60,588	2	63,011	2
Sponsorships	250,000	7	257,500	7	267,800	7
Total contributed	1,797,278	49	1,818,696	47	1,891,444	46
Total revenues	$3,690,203	100	$3,866,565	100	$4,053,361	100

	Year 201X	Percent	Year 201Y	Percent	Year 201Z	Percent
Estimated expenses						
Salaries	987,392	27	1,007,143	27	1,027,286	27
Employee benefits and expenses	1,086,135	29	1,107,857	29	1,130,014	29
Part-time artists and teachers	59,383	2	60,571	2	61,782	2
Production promotional events	23,876	1	24,354	1	24,841	1
Costumes, sets, and displays	200,389	5	204,397	5	208,485	5
Ticket sale expenses	3,405	0	3,473	0	3,543	0
Costs of merchandise sold	324,073	9	330,554	9	337,166	9
Fund-raising and development	40,389	1	41,197	1	42,021	1
Printing	34,982	1	35,682	1	36,395	1
Accounting and banking fees	7,896	0	8,054	0	8,215	0
Promotional expenses	175,303	5	178,809	5	182,385	5
Legal fees	17,869	0	18,226	0	18,591	0
Equipment repair and rental	6,355	0	6,482	0	6,612	0
Office refreshments	12,000	0	12,240	0	12,485	0
Designers and consultants	534,875	14	545,573	14	556,484	14
Computer and software	4,800	0	4,896	0	4,994	0
Software service fees	2,500	0	2,550	0	2,601	0
Miscellaneous supplies	1,200	0	1,224	0	1,248	0
Travel and touring expenses	50,735	1	51,750	1	52,785	1
Venue expenses	18,675	1	19,049	1	19,429	1
Postage and shipping	46,893	1	47,831	1	48,787	1
Building lease or rental expenses	36,000	1	36,720	1	37,454	1
Electricity	12,000	0	12,240	0	12,485	0
Water and sewer	6,000	0	6,120	0	6,242	0
Gas	3,000	0	3,060	0	3,121	0
Total expenses	**$3,696,128**	**100**	**$3,770,050**	**100**	**$3,845,451**	**100**
Net income (loss)	**($5,925)**		**$96,515**		**$207,910**	

Revenues increased by 3 or 4 percent, expenses increased by 2 percent, respectively, per year.

From the pro forma income statements, budgets can be produced. *Budgets* are explanations of how expectations in financial performance match actual events. Budgeting requires understanding of what the revenues and expenses are and when they will be realized. They can be produced for capital asset or current expenditures. It is one thing to expect that at the end of a period of time there will be a surplus; however, the expenses that are incurred may require settling before revenues are available to cover them. Knowing the situation ahead of time will allow for possible funding mechanisms to cover short-term expenses, and information from which to make such decisions.

If an arts organization has a history, its arts managers and executives will look to history to figure out what to plan for. In a culturepreneurial organization that has no history, where does one begin? There is no correct answer to this; however, starting with expenses will guide this discussion.

Research will prove an enormous help in this regard. How much are people paid in given positions? What are rents? How much will office furniture, computerized

systems, supplies, costumes, marketing, legal advice, accounting, insurance, travel, subscriptions to grants databases, and other direct and indirect expenses be? Making a comprehensive list will be beneficial. Expenses can and should be categorized relative to and absorbed directly by the cultural arts programs and offerings, and support or indirect expenses. The projected expenses are compared to the actual expenses for relative time periods. These should be calculated by month and then aggregated for yearly periods. These two figures can then be used as performance metrics quantified visually on respective dashboards to facilitate awareness of variances. *Variances* as considered in this context are simply differences between actual financial performance and what was planned.

Budgets should be based upon and developed with the strategic directions of the cultural arts organization underlying them, with SMART goals in mind. By asking the guiding questions that support SMART goal formation, the budget can be established in line with sources of funds and efficiencies to avoid unfunded deficits. As will probably become immediately apparent, budgets and pro forma financial statements

Exhibit 13.6 **Budgeted Expenses: Actual to Projected for the Period Ended 201X**

Sample expenses	Budgeted for 201X	Budgeted for quarter 1	Actual quarter 1	Variance quarter 1
Salaries	987,395	246,849	259,191	(12,342)
Employee benefits and expenses	1,086,135	271,534	285,110	(13,577)
Part-time artists and teachers	59,383	14,846	15,588	(742)
Production promotional events	23,876	5,969	6,267	(298)
Costumes, sets, and displays	200,389	50,097	52,602	(2,505)
Ticket sale expenses	3,405	851	894	(43)
Costs of merchandise sold	324,073	81,018	85,069	(4,051)
Fund-raising and development	40,389	10,097	10,602	(505)
Printing	34,982	8,746	9,183	(437)
Accounting and banking fees	7,896	1,974	2,073	(99)
Promotional expenses	175,303	43,826	46,017	(2,191)
Legal fees	17,869	4,467	4,691	(223)
Equipment repair and rental	6,355	1,589	1,668	(79)
Office refreshments	12,000	3,000	3,150	(150)
Designers and consultants	534,875	133,719	140,405	(6,686)
Computer and software	4,800	1,200	1,260	(60)
Software service fees	2,500	625	656	(31)
Miscellaneous supplies	1,200	300	315	(15)
Travel and touring expenses	50,735	12,684	13,318	(634)
Venue expenses	18,675	4,669	4,902	(233)
Postage and shipping	46,853	11,723	12,309	(586)
Building lease or rental expenses	36,000	9,000.00	9,000.00	
Electricity	12,000	3,000.00	3,000.00	
Water and sewer	6,000	1,500.00	1,500.00	
Gas	3,000	750.00	750.00	
Total expenses	$3,696,128	$924,032	$969,521	($45,489)

are going to be iterative and will give rise to different alternatives, given a set of assumptions. The assumptions are taken from the macro and micro levels and inform the preparation of the statements. For example, in predicting expenses, what rate of inflation will be used to indicate increases in salaries, rents, and other costs? In forecasting revenues, what macro-level assumptions will provide a basis for projected revenues of each sort? Is the audience growing in absolute numbers or is there a new market opportunity? What kinds of actions are anticipated from contributing sources? Are those sources increasing, decreasing, or remaining level in their contributions? Do they now face increased competition from a growing number of proposals? Are individual contributors giving more or less? In short, the environment needs to be taken into consideration along with internal strengths and weaknesses. It is likely that optimism will influence the ideology of contributed and earned income.

To contextualize these areas, it may be useful to benchmark the cultural arts organization with other existing and similar ones, especially if the culturepreneur is beginning a new venture. However, this advice also rings true for skilled arts managers and executives to be able to point to data that drove the formation and eventual board acceptance of the forecasts. Even so, no amount of data or informational support can be attributed to a source to explain away an arts organization's defaulting on its financial obligations. As such, erring on the side of conservatism in revenues may be wise. At the same time, it seems as if the expenses are always more than anticipated. Detailed research, use of multipliers such as the rate of inflation or the cost of living, and meticulous assessments of likely expenses will help avoid sticker shock relative to expense management. Projected and forecasted expenses, maintenance, emergencies, and higher-than-expected costs should be anticipated. For example, in the days leading up to the financial crisis in 2007 fuel costs skyrocketed and caused other ancillary expenses to increase. It was not in the minds of many financial managers or executives that such a crisis as it played out around the globe was imminent. While the financial crisis was an extreme environmental force beyond the control of the cultural arts organization, and we hope that nothing of that magnitude will manifest again, thinking about different "what-if" iterations in the assumptions applied in budgeting and forecasting is necessary. The environmental assumptions should span other social, cultural, technological, and regulatory issues that press upon the cultural arts concern. Keep in mind that every financial scenario must be tied to mission and strategy, to organizational goals and objectives.

Internal identification of micro-level challenges and strengths is also necessary in formulating forecasts for budgets and pro forma financial statements. Particular program and arts offering capacities, ancillaries, merchandising, prices, access to technology, board composition, effective staff and management teams to cover the internal needs of the culturepreneurial enterprise, access to and effective utilization of fund-raising and development resources, the behavior of competitors—in short, all the assumptions of the internal operations impact the forecast. Limitations, weaknesses, and opportunities should be reflected in the budget and the pro forma financials, demonstrating how they will be met. Meeting them can include reducing the scope of an opportunity or acquiring resources to shore up a weakness.

The nascent cultural arts organization will most likely assign the task of budgeting and forecasting to a few individuals, probably the culturepreneur and the management team

in a *top-down approach*. In larger organizations, this process is more complex, with different divisions and departments often compiling sections of what will become a large, overarching guide. When the annual budget process is anticipated, it is not uncommon to hear many weary groans and murmurs! Yet this need not be the norm. The process should be approached with optimism and with minimal protectionism, in a spirit of collaboration. Division leaders should prepare their budgets and forecasts based on data and make explicit their assumptions. Providing a template will be useful. The culturepreneur and the executive management team will evaluate the information provided and perhaps need to send feedback to each leader. Once an agreeable budget is derived from each area of the cultural arts organization using this *bottom-up approach*, then a total budget can be assembled. The figures submitted and later approved by the board will comprise performance metrics for the organization, the division or department, and importantly, each leader and respective employees. In this way, the budget and forecasts are "aligned": everyone is moving in the same direction and has some aspect of ownership and responsibility in the process. See Exhibit 13.7 for a graphical depiction of the process.

Exhibit 13.7 **Budgeting and Forecasting Approaches**

Top-down Approach

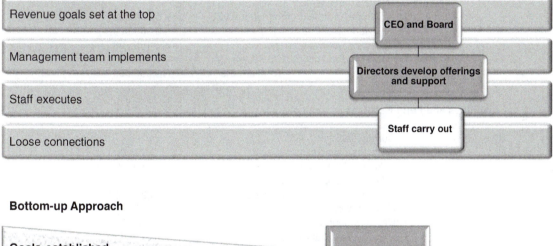

	CEO and Board
Revenue goals set at the top	
Management team implements	Directors develop offerings and support
Staff executes	
Loose connections	Staff carry out

Bottom-up Approach

Goals established	Arts constituents involvement
Management team implements	Organization-wide development offerings and support
Evaluation	
Projections gathered	CEO and Board support

BALANCE SHEETS AND STATEMENTS OF POSITION

Pro forma balance sheets and *statements of position* consist of a subset of financial projections that provide a snapshot of the *assets, liabilities,* and *equities* of the culturepreneurial enterprise. A representation of this is given in Exhibit 13.8. *Current assets* are valuable liquid assets that the arts organization owns, such as cash, investments, and accounts receivables that will be used in the next one-year period to operate the firm. Long-term, tangible, or *fixed assets* include vehicles, land, and buildings with an adjustment for depreciation; investments in long-term instruments; art works; and other assets such as computer equipment, furniture, and fixtures. To determine

Exhibit 13.8 **Pro Forma Balance Sheet and/or Statement of Position, 201Y**

Assets

Current assets	
Cash	$125,000
Future receivables	1,120,000
Prepaid expenses	15,000
Other current assets	110,000
Total current assets	1,356,500
Noncurrent assets	
Grants or other contracted funds	5,000,000
Fixed assets (less depreciation)	6,000,000
Notes receivable	150,000
Total noncurrent assets	11,150,000
Total assets	**12,506,500**

Liabilities and Fund Balances

Current liabilities	
Wages payable	2,000,000
Accrued liabilities	500,000
Deferred support, current	1,200,000
Total current liabilities	3,250,000
Notes payable	800,000
Deferred support	5,000,000
Total liabilities	9,050,000
Fund balances (equity)	
Fund balance, unrestricted	100,000
Fund balance, restricted	3,356,500
Total liabilities and fund balances	**$12,506,500**

if something is a fixed asset, ask these three questions: Does the cultural arts organization (1) own it? (2) use it in producing the arts service product? (3) expect to liquidate and spend the proceeds from the liquidation in the next year? Opposite to assets, the cultural arts organization incurs *liabilities* or obligations it has to meet in terms of repayment. Liabilities generally consist of accounts payable, debts such as

loans or bonds, and taxes due based on assets. *Equity* consists of the amounts that the culturepreneur and partners have invested, and issues of equity if any. A not-for-profit cultural arts organization needs to evaluate *fund balances*—that is, the value of funds invested and/or set aside for particular purposes under a not-for-profit fund accounting structure. As can be seen from Exhibit 13.8, assets, liabilities, and equities or fund balances consist of short- and long-term measures that are in balance and are derived from the equation of assets equaling liabilities and equity, or assets equaling liabilities and fund balances, as shown.

ANALYSIS OF FINANCIAL STATEMENTS

In Chapter 12, several ratios were presented that could be used in evaluating the financial health of the cultural arts organization. In this section of the chapter, a wide selection of ratios is presented and discussed. In keeping with the aims outlined at the beginning of the chapter—that is, that the culturepreneur and arts manager are able to develop forecasts and budgets relative to the strategic direction and mission, as well as read and assess financial statements—the conversation turns to taking information from the financial statements and placing it in context. Deriving particular financial performance metrics to use in dashboards and to implement incentives for their outcomes will aid in moving the cultural arts concern towards its stated strategic goals. Once again, it must be stressed that ethical excellence in accounting, including data input integrity and accuracy, is crucial in the ability of the arts organization's leadership to make intelligent use of financial information in decisions.

In order to understand financial analyses and ratios, it will be necessary to refer to Exhibit 13.9.

Exhibit 13.9 **Ratios and Financial Statement Analysis**

The use of ratios is a way to get a feel for the overall health of the cultural arts organization at a moment in time, allowing a comparative understanding of what has been happening. Ratios do not necessarily give reasons for what they measure; rather, they reflect the decisions made by the leaders of the organization and sometimes the outcomes that have arisen as a result of changes in the environment. The point is to be able to understand the documents you get from an accountant or evaluate the documents you prepare before you distribute them to interested parties, such as banks or other investors and funders.

Ratio A: Current Assets to Current Liabilities

Current assets to current liabilities are a measure of liquidity, relatively speaking. The equation is

current assets ÷ current liabilities

(not including restricted and deferred amounts because generally these are not available immediately). A healthy ratio is greater than 1, which means there is enough cash to cover your expenses. Always compare the last year to the current year, and the relative corresponding periods within them to get a feel for the situation.

(continued)

Ratio B: Number of Months Expendable Fund Balance

This ratio shows the organization's ability to cover programs and expenses from accessible unrestricted fund balances. Look for a measure that shows at least a value of 30 percent. The equation is

expendable fund balances ÷ total program expenses.

Ratio C: Total Liabilities to Total Assets

This ratio shows the organization's

total liabilities ÷ total assets.

Total liabilities to total assets, sometimes referred to as the total debt to total asset ratio, measures the solvency, or the percentage of the financial position of the company that is liability; this number should be less than 20 percent.

Ratio D: Debt to Equity

Total debt or liabilities ÷ shareholder equity.

In the for-profit firm, this ratio measures the company's debt versus the equity that is financing the company. For a measure of health, it would be wise to look at this as a service firm, with a value ranging below 0.30. The higher the number goes, the more leveraged the company is, and that means it will have difficulty paying its way or using existing resources for new innovations.

Ratio E: Net Profit Margin

Net income after taxes ÷ revenue.

This ratio tells you how much after-tax profit you make for every dollar in revenues. The higher this number is, the better.

Measures of Efficiency and Capacity

Areas where goals will be needed to determine metrics and measures of success:

- Development efficiency—the amount of contributions raised per dollar spent on fund-raising and development. Here setting guidelines will be helpful, such as for every $100 raised in fund-raising and development, related expenses will remain under 20 percent or $20. Be wary of development expenditures that equal the amount of contributions.
- Marketing efficiency—revenue earned per dollar spent on marketing; the same kind of goal setting is required here as in the development efficiency.
- Program margin—the ratio of earned income divided by the sum of artistic and production expense.
- In the performing arts, capacity utilization is a useful operating measure that analyzes the percentage of total available seats available to those that are sold and are part of a yield management process.

Sources: R.J. Kushner, T.H. Pollak, and Performing Arts Research Coalition (PARC), *The Finances and Operations of Nonprofit Performing Arts Organizations in 2001 and 2002: Highlights and Executive Summary* (Washington, DC: PARC, 2003), www.urban.org/UploadedPDF/311439_Finances_Operations. pdf; Johanne Turbide and Claude Laurin, "Measurement in the arts sector: The case of the performing arts," *International Journal of Arts Management* 11, no. 2 (Winter 2009), 56–70; Frederick J. Turk and Robert P. Gallo, *Financial Management Strategies for Arts Organizations* (New York: ACA Books, 1984); Jim Rosenberg, *Learning from the Community: Effective Financial Management Practices in the Arts; Summary Findings and a Framework for Self-Assessment* (Alexandria, VA: National Arts Strategies, 2003).

OVERVIEW OF INVESTING AND INVESTMENT STRATEGIES

The previous section of the chapter walked through some of the issues relevant to the culturepreneur in terms of financial savvy and the culturepreneurial firm. The culturepreneur needs to be articulate in the areas of financial management and have an understanding of investing and investment strategies. As part of the financial responsibilities of the culturepreneurial venture, it will be necessary to have in place objectives and guidelines for investing. The income from the investments is used for operations, typically. As was mentioned earlier in the textbook, organizations might periodically initiate capital campaigns to attract new contributions to their endowments.

When the endowment is funded or when the revenues come in from the development efforts, into what kinds of investment vehicles will the revenues go? Who will determine the types of funds and their rates of return? Who will monitor their performance? It will behoove the organizational leaders to invest their revenue carefully, even when the urge to leave it under the mattress is strong! There are firms, consultants, and, of course, employees who can be given the responsibility of oversight. However, the ultimate responsibility will be the culturepreneur's, and the outcomes will also accrue to the culturepreneur. Therefore, this section addresses the topic of setting objectives, particularly with establishing risk, and appropriate instruments. Then, of course, determining where the involvement with these issues lies will be necessary as well. In a nonprofit, the board will necessarily be involved, though it may be a subcommittee of the board that is directly responsible. In a private for-profit firm, the responsibility will rest with the owners.

SETTING OBJECTIVES

There are different objectives for different types of firms, and the objectives are, in turn, vetted by the board. The culturepreneur acting as a sole proprietor will be able to set objectives freely; the culturepreneur in nonprofit organizations has to adhere to guidelines or have them established. Long-term investment funds in nonprofit organizations are often called endowments, which typically have investment terms of longer than one year; there are penalties for using the principal before maturity. At the same time, directions are explicit about the disposition of earnings. Short-term accounts, like checking and working capital accounts, are held in vehicles that are designed to be accessible for business operations. The terms *endowments* and *long-term investment funds* are used interchangeably; they are defined as a portfolio of assets donated to a nonprofit cultural fine arts organization to aid in its support. Often the investment funds are restricted for a length of years. These funds are held in a variety of investments. From the investments "income" accrues from capital appreciation as well as interest, dividends, rents, and royalties. In the United States, investment of endowment funds is generally governed by the 2006 Uniform Prudent Management of Institutional Funds Act (UPMIFA) and is followed in most states. Investments are typically the responsibility of an investment committee in a nonprofit cultural arts organization. The term "investment committee" is used broadly to

include any committee (such as a finance or audit committee) with responsibility for the management of the financial assets of a cultural fine arts organization.

The UPMIFA sets forth a number of factors that managers should consider in acting in accordance with the standards the law supports:

- General economic conditions.
- The possible effect of inflation or deflation.
- The expected tax consequences, if any, of investment decisions or strategies.
- The role that each investment or course of action plays within the overall investment portfolio of the institution.
- The expected total return from income and the appreciation of investments.
- Other resources of the institution.
- The needs of the institution to make distributions and to preserve capital.
- An asset's relationship or special value, if any, to the mission of the culturepreneurship.[2]

The UPMIFA also incorporates a duty to diversify investments if there is not a statement that special circumstances make a decision not to diversify reasonable.

Cultural fine arts organizations will often seek individuals with special financial capabilities to serve on their investment committees. The UPMIFA states that a person who has special skills or expertise, or is selected in reliance upon the person's representation that the person has special skills or expertise, has a duty to use those skills or that expertise in managing and investing institutional funds.

Investment committees and the portfolios they are responsible for can vary widely. Some committees include sophisticated investors as members overseeing complex portfolios managed by experienced investment staff of the organization. Other investment committees consist of volunteer board members who lack investment expertise and are supported with few if any staff.

Funds are invested based on the answers to following questions, established by the organization's investment committee and the fund trustees. What is the objective of our endowment? How should it relate to the institution's mission? How much should it contribute to the operating budget? Should any of it be dedicated in perpetuity? How should it be invested for maximum return? What are our limits of risk? Who should make the decisions? Who should assume which responsibilities in overseeing the investments? The answers to these questions are part of the strategic direction of the firm. Investing long-term funds is completed in line with the culturepreneurial mission.

These are issues that guide a strategic discussion of the investment strategy:[3]

- Determine how the fund is to support the mission and contribute to a healthy financial state.
- Explicitly state the real return goal needed from investments, given the nature of the environment and the performance of investments of the size and caliber anticipated.
- Determine how the income will be distributed, and when, so that it meets the obligations and needs of the cultural fine arts organization's objectives.

- Make plans for handling additions to the fund, such that the cultural fine arts organization can take advantage of critical mass.
- Know the legal requirements that govern investing.
- Explicitly state how much of the endowment's income will be spent and how much reinvested, and how this should be calculated; what will be the exception for using principal?
- Come to consensus as to the risk the board members will tolerate and delineate which investments are acceptable.
- Adopt formal procedures and document them. Explicitly state who will have responsibility and accountability, including for which investment decisions, over the investment process. Clear and specific information about using professionals outside the organization should be included in this step.
- Document special characteristics of press programs, distributions, and other financial decisions that can affect spending or tax exposure.

If you feel a bit challenged by these issues that is to be expected! However, it is necessary to outline these and other areas that are germane to the situation before problems arise. After that is done, then the investment committee, under the direction of the board and the culturepreneur, moves forward in selecting investment instruments within the broad guidelines established by the investment strategy.

INVESTMENT STRATEGIES AND RISK

Given the financial crisis of the early twenty-first century, many individuals and organizational leaders have experienced losses on investments. As you probably know, any investment will have a risk associated with it. The risk is usually calculated or at least reflected by the interest rate the investment pays and the time it takes for the investment to mature, or the degree of liquidity it represents.

The question is how volatile the investment is, and what the organization's tolerance for the volatility is. Some have the ability to navigate and accept volatility; others do not. For example, cash is ultimately liquid, nonvolatile, and safe given a stable economic environment and government, but it does not earn income when it sits in non-interest-bearing accounts, such as certificates of deposit. However, holding currencies of other economies is not without risk. Land is an example of a rather illiquid investment (depending on the location), but investing in a real estate fund may offer a more liquid approach. A "safe" investment will typically have a lower yield. Treasury bills are considered safe. Early maturity of any asset will reflect a cost, such as forfeiture of the interest or a devaluing or erosion of principal invested.

The solution is to seek diversity in investments in order to manage volatility.

Therefore, if the aim is to get the most out the investments over the long term, it will be necessary to invest in some instruments that have a higher degree of risk. However, also holding investments whose performance has a low degree of volatility can balance this risk/return equation. As such, diversification of the portfolio will be critical to achieving objectives. At the same time, it is important to verify the tax regulations governing the operations of the culturepreneurial organization at federal

and state levels before investing in any instrument. Nevertheless, in today's world, organizations are being called upon to invest not only wisely, but with attention to their mission grounded in social responsibility. While the chapter is not intended to give advice on what to invest in, the culturepreneur would be wise to be aware of the impact that particular investments will have and the way in which investment choice reflects the aims of the organization to all of its stakeholders.

INVESTMENT IDEOLOGY AND INSTRUMENTS

Over time, there has been change in the rules that govern investment risk. The concept of a prudent person goes back to the early 1800s in reference to the expectations and responsibilities of anyone managing investments. That is, there is a requirement for prudence, discretion, and intelligence in managing one's financial affairs, but the prudent investor has to keep in mind that there are financial risks and hazards inherent in the process, as was mentioned in the opening dialogue on ethics. A bit of history may be helpful at this point to bring us up to date.

In the early 1970s, the National Conference of Commissioners on Uniform State Laws adopted the UMIFA, which evolved in 2006 to the UPMIFA as mentioned above. Included here was the idea that looking at risk "one investment at a time," so to speak, was not necessarily the right approach. Investments, rather, need to be evaluated with a more macro view of the entire portfolio in order to manage risk. Between these two events, the Uniform Prudent Investor Act (UPIA) was approved in 1994. This act, which forwarded the aims of prudent investing and supported greater portfolio diversification, required that risk and return objectives be set by organizations and be reasonably suited for them. In any event, at this writing, a range of strategies is available for organizational investment committees and culturepreneurial financial managers in light of balancing risk and return. These strategies will reflect the organizational culture set by the leaders, the stakeholder values, donor restrictions, and overall directions of the culturepreneurial organization. What is most important is what is known as mission-driven investment in a socially responsible frame.

Mission-driven investment (MDI) is an investment process that considers social and environmental returns in addition to financial ones, employing various methods to achieve these returns. This kind of investing is undertaken for two primary reasons. The first reason is strategic so that investments are in line with the organization's objectives, avoiding choices that do not reflect the culturepreneur's core values. And the second reason is to use investing as a means to further the cultureprenurial organization's mission. MDI requires that a nonprofit institution articulate its core values and seek ways of investing that are consistent with these values. That means that given the decision to invest in a portfolio that contains stock or other investment choices for companies that support the kinds of sustainable values held by the culturepreneurial organization, they would be selected. Of course, that means portfolios have to be reviewed, screened, and vetted.

Culturally conscious investing is a strategy for the culturepreneur which combines elements of socially responsible investing and community investing. This particular approach to financing has often targeted the communities in the United

States and abroad that are underserved by traditional financial institutions through a venture capitalist framing. Interest is growing in the potential of venture capitalism combined with social investing. Most socially responsible venture capital funds, which are relatively new, incorporate some form of sponsorship or subsidized funding. They include community development financial institutions, small business investment companies, and, most recently, funds sponsored by nonprofit organizations or international governmental agencies. Existing community investing business models range from a "pure" venture capital model to mixed revenue models that combine private investment with philanthropic or public funding. In the abstract, transferring the concept of community investing to the cultural sector means finding investors interested in financing cultural enterprises that show rapid growth potential but are also stable, self-supporting sources of jobs, entrepreneurial activity, and infrastructure.

Portfolio screening requires that the investment manager is willing and able to do the additional work required to ensure these core values are not abandoned in the process of meeting the organization's financial objectives. An MDI program works to achieve the financial objectives of the institution—and is assessed using the same established performance measurements. The difference is that MDI techniques seek to directly connect an institution's core values with its financial activities. Socially responsible investing incorporates screening strategies that work together to promote socially and environmentally responsible business practices, which in turn contribute to improvements in the quality of life throughout society. Screening employs criteria to evaluate stocks of companies whose employee relations, environmental, human rights, or other policies align with the investor's preferences. The most widely used screening factors include tobacco, environment, human rights, employment/equality, gambling, alcohol, and weapons. Screening can also consist of examining portfolios for a company's relations regarding labor, animal cruelty, community investing, and community relations. In addition, specialty screening extends to include fair executive compensation policies, abortion and birth control policies, and international labor standards.[4]

CHAPTER SUMMARY

During the course of this chapter, the focus has been presenting approaches that allow the cultural fine arts organization to achieve and maintain financial soundness. This process entails reading and understanding financial statements and analyzing what is happening financially. Because of that need, income statements and their analyses of variances were discussed. At the same time, when starting a new venture or introducing a new arts service product, the culturepreneur will need to formulate projections for financial analysis and budgeting. To this end, pro forma projections and budgets, along with balance sheets and statements of positions, were introduced. Importantly, ratio measures that could be utilized in establishing dashboards were given.

After that, the chapter turned to investing and investment strategies, seeking to give a broad overview of what is entailed. MDI was presented, as was the need for setting strategic investment objectives and adopting investment policies. In the

policy statement, the investment committee, the level of risk, and portfolio management would be addressed and clearly articulated, as would the investment ideology and the investment vehicles or instruments that are permissible to achieve the culturepreneurial organization's financial goals (see Appendix 13.1).

DISCUSSION QUESTIONS

1. Refer to Exhibit 13.3. What has changed? What is the trend in total revenues? How have those changes been compensated for in the overall trend of earned revenues?
2. Link each of these revenue sources to the culturepreneurial organization's financial strategy, and categorize each in terms of a strategic planning goal, as explained in Chapter 12. Then, using a SMART framework, assign particular fund-raising and development initiatives to the appropriate entries, and the probability of realizing fruition of the funding. Prepare a pro forma projection, and assign metrics to be used in dashboards at the appropriate levels within the organization.
3. What are the main issues that a culturepreneurial organization has to consider when adapting an investment policy? Do you think it is wise to outsource this task? Explain.

EXPERIENTIAL EXERCISES

1. Using the data given in the various tables in the chapter, calculate Ratios A, B, and C.
2. Establish dashboards that can give you a quick read on the ratios you calculated in Exercise 1.
3. How would you establish revenue projections for the next three years given the data in Exhibit 13.3? Use a bottom-up approach.
4. Develop measures of efficiency and capacity that you can use in either your organization or one that you will lead. Go online and find other arts organizations that have utilized these and related measures to calculate their financial health. What did you find? Explain.
5. Search the web for four or five cultural fine arts organizations that have adopted an investment policy. In light of what you find, critique those policies against the information given in Appendix 13.1.

FURTHER READING

Gibson, Charles H. *Financial Reporting & Analysis: Using Financial Accounting Information.* 13th ed. Mason, OH: Cengage Learning, 2012.

Mintz, Joshua J. The roles and responsibilities of investment committees of not-for-profit organizations. The John D. and Catherine T. MacArthur Foundation, July, 2009. www.macfound.org/media/article_pdfs/ARTICLEONINVESTMENTCOMMITTEESREV4.PDF.

Williams, Caroline, and Lisa Sharamitaro. Building a model for culturally responsible investment. *Journal of Arts Management, Law, and Society* 32, no. 2 (2002), 144–158.

NOTES

1. United Nations Environment Programme (UNEP) Finance Initiative, *A Legal Framework for the Integration of Environmental, Social and Governance Issues into Institutional Investment*, produced for the Asset Management Working Group (London: Freshfields Bruckhaus Deringer/Switzerland: UNEP Finance Initiative, October 2005).
2. National Conference of Commissioners on Uniform State Laws, *Uniform Prudent Management of Institutional Funds Act*, passed July 7–14, 2006 (Chicago: NCCUSL), www.uniformlaws.org/shared/docs/prudent%20mgt%20of%20institutional%20funds/upmifa_final_06.pdf, 12.
3. Russell Olson, *The Handbook for Investment Committee Members* (Hoboken, NJ: Wiley, 2005).
4. U.S. Social Investment Forum, *2001 Report on Socially Responsible Investing Trends in the United States*, SIF Industry Research Program (Washington, DC: USSIF, November 28, 2001), www.ussif.org/files/Publications/01_Trends_Report.pdf (accessed February 1, 2014).

APPENDIX 13.1. SAMPLE INVESTMENT POLICY

The "Organization Name" Endowment Fund (the Endowment Fund) is created by resolution of the Board of Directors (the Board) of the "Organization Name" (the Organization). Contributions directed to the Endowment Fund shall comprise a (permanently) restricted fund of the Organization. The original principal amount of any contribution shall be committed to the Endowment Fund irrevocably and the original principal balance of contributions to the Endowment Fund shall not be invaded for any reason. The aggregate of contributions to the Endowment Fund shall be referred to in this document as the "original contributions." The Board shall be responsible for holding and managing the original contributions according to the Investment Policies (the Policies) set out in this document. The Board shall also be responsible for distributing any income and gain produced by the Endowment Fund in accordance with the Policies, with the purpose of benefitting the Organization and furthering the Organization's mission and purposes.

DELEGATION

The Board delegates supervisory authority over the Endowment Fund to the Finance Committee of the Board. The Finance Committee is responsible for regularly reporting on the Endowment Fund's investments to the Board. In carrying out its responsibilities, the Finance Committee and its agents will act in accordance with the Policies and all applicable laws and regulations. The Board reserves to itself the exclusive right to revise the Policies.

The Board and its Finance Committee are authorized to retain one or more Investment Managers (the Manager) to assume the management of funds and assets comprising the Endowment Fund. In discharging this authority, the Finance Committee can act in the place and stead of the Board and may receive reports from, pay compensation to, and enter into and terminate agreements with the Manager. The Board

and its Finance Committee shall designate an employee of the Organization as liaison to the Manager.

INVESTMENT OBJECTIVE

The primary investment objective of the Endowment Fund is to produce a rate of total return which will permit maximum support for the General Operating Fund of the Organization to the extent that is consistent with the following: prudent management of investments, preservation of principal, potential for long-term asset growth, and socially responsible investment practices.

INVESTMENT GUIDELINES

Permissible Investments

Endowment Fund assets may be invested in publicly-traded common and preferred stocks, convertible bonds and preferred stocks, bank common funds, mutual funds and fixed income securities (including corporate bonds and money market instruments), whether interest-bearing or discount instruments, subject to any restrictions hereinafter specified. No other securities are permissible investments without the specific approval of the Board.

Investments and Transactions That Are Not Permitted

Equity Investments—The following are not permissible investments: common stock in non-public corporations, letter or restricted stock, derivative instruments, initial public offerings, buying or selling on margin.

Fixed-Income Investments—The following are not permissible investments: tax-exempt bonds; bonds, notes or other indebtedness for which there is no public market (private placements); direct placement of mortgages on real property.

Options and Futures—Transactions are not permitted in futures contracts nor in options contracts of any kind.

Socially Responsible Investing

In keeping with the mission and goals of the Organization, the assets of the Endowment Fund shall be invested in a socially responsible manner. The portion of Endowment Fund assets invested in publicly-traded common and preferred stocks, convertible bonds and preferred stocks, and corporate bonds shall be invested in companies listed in at least one of the Domini Social Index 400, the Calvert Social Index, the Citizens Index 300 or among the holdings of a mutual fund generally recognized as screening for socially responsible investments including, but not limited to, those offered by Calvert Group, Domini Social Investments, Citizens Funds, Green Century Funds, New Alternatives Fund, Parnassus Fund, and Pax World Fund

Family. Any portion of the Endowment Fund assets invested in mutual funds shall be invested in mutual funds which are generally recognized for socially responsible investing including, but not limited to, those listed above.

Asset Mix

The investment objective of the Endowment Fund implies a balanced approach. The Investment Manager is authorized to utilize portfolios of equity securities (common stocks, preferred stocks, and convertible securities), fixed-income securities (debt instruments), and short-term investments (cash equivalents), or mutual funds comprised of these security types, according to the following asset allocation guidelines. These asset allocation guidelines may be modified from time to time by the Finance Committee.

	Long-term target	Allowable range
Equity	60%	30 to 70%
Fixed income	40%	30 to 70%
Short-term	0%	0 to 20%

Start-Up Thresholds

The Manager may deviate from the above guidelines concerning Asset Mix until such time as the total market value of the Endowment Fund reaches a point where this level of asset mix is reasonable.

Asset Diversification and Quality

The asset quality standards outlined below apply at the time of initial purchase. The Manager and Finance Committee shall review the status of any holding whose quality drops below these standards and determine at that time whether the security should be retained.

Equity Securities—No more than 10 percent of the market value of any equity portfolio may be invested in the securities of any one issuer. The Manager shall also maintain reasonable sector allocations such that no more than 20 percent of any equity portfolio may be invested in the securities of any one market sector. A level of diversification by market capitalization appropriate to prevailing market conditions is also required. In developing the equity portfolio, the Manager may use mutual funds, pooled funds, convertible preferred stocks and bonds as equity investments.

Fixed-income securities—The fixed-income securities of a single issue or issuer are limited to no more than 20 percent of the market value of the fixed-income portfolio. These diversification requirements shall not apply to U.S. Treasury

obligations, which may be held in unlimited amounts within the fixed-income portfolio. The quality rating of bonds and notes must be A or better, as rated by Standard & Poor's or Moody's. The portfolio may consist of only traditional principal and interest obligations (no derivatives) with maturities of no greater than ten years. Average maturity of the portfolio should not exceed seven years.

Short-term investments—The quality rating of commercial paper must be at least A-1 as rated by Standard & Poor's, or P-1 as rated by Moody's. Any money market funds utilized must comply with the quality provisions for fixed-income securities or short-term investments.

Foreign Securities—The total value of investments in securities whose issuers are foreign corporations and investments in mutual funds comprised primarily of foreign securities shall be limited to 10 percent of the assets of the Endowment Fund.

DISTRIBUTION OF UNRESTRICTED INCOME AND GAIN

The income and/or gain earned by the Endowment Fund is considered unrestricted revenue and may be distributed to the Organization as general support revenue for its programs. On at least an annual basis the Finance Committee of the Board shall recommend to the Board an amount to be transferred from the unrestricted income and/or gain of the Endowment Fund to the General Operating Fund of the Organization. At no time shall the permanently-restricted original contributions to the Endowment Fund be invaded. As a matter of prudence, no distribution of income and/or gain shall decrease the total market value of the Endowment Fund below 110 percent of the permanently-restricted original contributions balance. At the same time, an amount no greater than 10 percent of the total market value of the Endowment Fund may be distributed in a given calendar year.

REVIEW PROCEDURES

Review and Modification of the Investment Policies

The Finance Committee of the Board shall review these Investment Policies at least once a year to determine if modifications are necessary or desirable. Any proposed modifications must be approved by the Board and if adopted must be communicated promptly to the Investment Manager and other interested persons.

Meetings with the Investment Manager

The Investment Manager is expected to consult with the Finance Committee of the Board at least annually to review the Endowment Fund portfolio and investment results in the context of these Investment Policies. If cost or schedule prohibits a meeting, a telephone conference is an acceptable substitute for an in-person meeting.

Reporting Requirements

The Investment Manager is expected to provide the Finance Committee of the Board with the following reports.

Monthly—A written statement of all pertinent transaction details for each separately managed portfolio for the preceding month, including (1) the name and quantity of each security purchased or sold, with price and transaction date; (2) an analysis for each security of its description, percentage of total portfolio, purchase date, quantity, average cost basis, current market value, unrealized gain or loss, and indicated income and yield (percent) at market; and (3) an analysis for the entire portfolio of the current asset allocation by investment category (equity, fixed-income, short-term investments).

Semi-Annually—A semi-annual summary of all transactions to date in the fiscal year, together with a report of investment performance for the portfolio to date.

Performance Measurement

The Finance Committee of the Board shall review at least annually the performance of the Endowment Fund portfolio relative to the objectives and guidelines described in the Investment Policies. The Finance Committee shall present its review to the Board at least annually as well.

Performance Benchmarks

The Investment Manager is expected to achieve total returns competitive with performance benchmarks appropriate to each asset class, as measured over a fair market cycle of three to five years. The specific indices used as benchmarks must be agreed upon by the Finance Committee and the Investment Manager. In the equity asset class, indices specific to the socially-responsible investment field should be considered.

Note: From Minnesota Council of Nonprofits, "Sample organization: Endowment fund investment policies," www.minnesotanonprofits.org/events-training/finance-conference/finance-conference-handouts/ Investment_Manager_2.pdf. Reprinted with permission.

14 Succession Planning for the Cultural Fine Arts Organization

CHAPTER OUTLINE

LEARNING OBJECTIVES

After reading this chapter, you will be able to do the following:

1. Understand the concept of succession planning.
2. Include a succession plan component in the strategic and culturepreneurial fabric of the organization.
3. Have the knowledge and resources to establish a succession plan.
4. Undertake the process of identifying successors.
5. Have the capability to operate in the event of an unexpected transition.
6. Understand the impact that leaving succession planning to chance can have on continuing the organization's mission and carrying out the culturepreneurial vision.
7. Be knowledgeable with regard to the options available for managing reevaluations of the culturepreneurship.

WHAT'S ON?

ArtsStrategies
How should arts and culture organizations approach succession planning?
YouTube, April 27, 2010
www.youtube.com/watch?v=r7iPnyI4MSw#t=26

DEFINING SUCCESSION PLANNING

After establishing and setting the vision and mission, and engaging in strategies to realize them, the firm has grown and is successful. This book has walked through relative ways of positioning, growing, improving, offering innovative arts service products, and connecting to thriving and growing numbers of arts constituents. Pricing is working to the culturepreneurial organization's advantage. Dashboards are in place to measure what is happening and to provide information to the appropriate people in the organization. Development and fund-raising are successful, investment continues without overspending, while copyrighting and patenting are occurring. In short, all systems are working and processes are in place.

There comes a moment in time when the culturepreneur will begin thinking about what will come next. That moment is best observed at the outset, at the beginning of establishing the organization. That is when the culturepreneur needs to consider answers to questions such as "How will this organization change hands or transition? Will it be sold? Will the partners take over my share? Will it simply sell its assets and close the doors? Will the family take it? Or will the board replace me?" The answers to these questions depend on the structure of the culturepreneurial organization; however, the asking of them is critical regardless of the structure, and answering them early on is imperative.

The most successful firms have plans to transfer them to other individuals in some form or fashion. For-profit organizations, if they are privately held, can be transitioned to family members, spouses, or other individuals as directed by the culturepreneur. The privately held firm can also be sold to buyers interested in the company. Publicly held firms can have stock purchases and search for and plan for leadership transitions. In the nonprofit, the transitions can also be planned. In any event, sometimes the transition is unexpected, earlier than anticipated, or a result of a change in the environment. This can happen to any culturepreneurial organization regardless of its structure. At all times, insurance should be in place at levels that are appropriate for the individuals and the organization.

This chapter gives readers a map to follow so that their firms may continue in their absence. Succession planning is sometimes approached with reluctance, but it should not be. Perhaps this is due to a shuddering feeling one gets when thinking of handing over control. Or the thought is too daunting as the organization is in its nascent stages. Yet unless this kind of thinking is attended to, there will come a moment when either the culturepreneur will want to spend time differently or an unplanned event will cause a change in leadership.

THREE WAYS OF THINKING

When beginning a culturepreneurial venture, strategic understanding and planning for transitions in leadership should be incorporated into the vision. Some transitions are planned even if they are not wanted; others are unexpected. Therefore, in light of these considerations, this brief, concluding chapter of the textbook will provide information about this important but often overlooked and sometimes even dreaded process known as succession planning. *Succession planning*, or *executive transition management*, as it is sometimes referred to (for purposes of this volume), is defined as the identification and careful, systematic development of people to take over strategic roles in the culturepreneurial firm in a way that is least disruptive to the organization's operations, value, and position in the marketplace. Simply stated, it is a process of "finding suitable people and preparing them to replace important" players in an organization when they leave or retire.[1]

As depicted in Exhibit 14.1, there are three ways to think about succession planning regardless of the structure of the culturepreneurial firms.

THE CULTUREPRENEUR'S TENACITY: LEVERAGING THE PASSION

As Jim Collins would say, get "the right people on the bus" from the beginning.[2] This is an ongoing practice based on the culturepreneurial strategic vision: it entails identifying the leadership and managerial skills necessary to carry out that vision, and recruiting and maintaining talented individuals who have or who can develop those skills. In following the processes that were explained in Chapter 11, systems to recruit, retain, and incentivize innovative people need to be in place. First, the core competencies required of each position should be clarified. Then, once hired, each individual needs to be developed and regularly appraised.

Exhibit 14.1 **Three Ways to Think About Succession Planning**

Culturepreneur's Tenacity
Leverage passion and strategic vision

Culturepreneur's Dream
Leverage process in passing the baton

Culturepreneur's Unexpected Departure
Leverage planning during uncertainty

By ingraining the idea that there will be a transition, it becomes possible to consider how it will take place. Establishing employee ownership levels in a for-profit structure, such as in employee stock option plans, is one such idea. Similarly, the structure can be arranged so that the executive management team has the first right of refusal in a purchase, and for a partnership or limited liability arrangement, the change may entail redistributing percentages of ownership. For the nonprofit, the options are relative to directions included in the articles of incorporation and to the board's composition, leadership capacity, oversight, and reach.

RESPECTING THE CULTUREPRENEUR'S DREAM

When a culturepreneur notifies the management team and board that his or her departure is being planned, then the aspects of strategic vision included in succession planning can be implemented. Doing this is a way to pass the baton in a smooth transition, and if the strategic thinking has carried through from the beginning, this should be relatively straightforward. Acting on this exit strategy will bring to light what the culturepreneurship's direction might be as it goes forward. Then the board and management team will together determine what they seek in the successor and what competencies and skills will be needed to achieve those goals. The leadership must also devote significant attention to building the capacity of the board and managers; making sure that the systems in place are capable of sustaining financial solvency and growth; and delivering arts product services as they stand and as they are envisioned beyond but including the current culturepreneur's legacy.

THE CULTUREPRENEUR'S UNEXPECTED DEPARTURE

Emergency succession planning ensures that strategic leadership, direction, operations, and arts service product offerings will continue without disruption in the unpleasant case of an unplanned exit not only of the culturepreneur but of all important leaders of the organization. This is not to imply that anyone is unimportant. However, the loss of the leaders can significantly hurt the organization if it is not dealt with properly. Crisis management is one of those events that no one looks forward to, but having a plan in place will be tremendously valuable, not only for the culturepreneur, but for all arts constituents affected by the change.

For this kind of unexpected transition, whether temporary or the beginning of the search for new leadership, there will need to be an analysis of the most critical leadership and management functions that are embodied in the culturepreneur. Using these as a basis for planning, each area should be delegated to an appropriate *position* within the organization. There also needs to be direction as to which individuals in the culturepreneurial organization have the authority to make such delegations. People in these key positions will need to be educated and developed for such purposes, even though such a need may never arise. At the same time, if there is an unexpected change in leadership, it will need to be communicated to the arts

constituents. Therefore, a plan for what will be said, when, to whom, and in what media is also important to have in place.

Of course, although the discussion regarding unexpected transitions has focused on the culturepreneur, this kind of thinking and planning should be applied to every critical leader in the organization.

REEVALUATIONS

Any culturepreneurial venture faces the risk that the organization will face bankruptcy, reorganization, or a complete closure before starting up again. As discussed in earlier chapters of the textbook, a culturepreneur has to have the ability to deal with these kinds of realities, especially in light of the fact that the success rate of culturepreneurial ventures is very low. There are some rules of thumb that can be followed to keep the organization moving in the direction sought, such as trying to maintain a balanced outlook when the venture is successful, using marketing strategies that offer new arts experiences, making use of financial resources and investments, and being aware of the general business cycles that the organization faces. These kinds of processes were discussed in previous chapters.

Sometimes financial problems seem to appear unexpectedly. Yet closure or bankruptcy generally occurs gradually. The culturepreneur should be on the watch when questions about spending are difficult to answer or when major financial expenditures or contracts elude acceptable documentation. Always watch financial ratios and forecasts, and make sure that payroll tax payments and other required state and federal requirements are adhered to. Check for excessive discounting of arts offerings in order to increase cash flows, and beware when creditors ask for cash payments from the cultural fine arts organization. Arts consumers' dissatisfaction and complaints are also important to gauge and adjust to, and the culturepreneur should monitor turnover of key people. These are all indicators that can lead to instability and, if not monitored, can appear to impact the organization "overnight," so to speak.

If these kinds of processes have been established, but there is still a lack of economic support to maintain the organization, it still remains in the control of the culturepreneur to determine what direction will be taken. This is inherent in the culturepreneurial process itself. Will the culturepreneur close the existing organization? Start over? Is a reorganization or turnaround of the culturepreneurial venture possible? Do any of these directions include bankruptcy? Aside from thinking about succession planning in the three ways outlined above, it is necessary to understand what actions are available in the event of sustained negative economic indicators that lead to bankruptcy or closure of the organization—or the beginning of a new cultural fine arts venture.

BEGINNING AGAIN

To begin again, options include corporate turnarounds, reorganizations, and closure. All three of these may or may not include bankruptcy, which can take on the forms known as Chapter 7 or Chapter 11. The discussion begins with *corporate*

turnarounds, which is a process of instilling a change in management to bring about sustained and positive culturepreneurial organization performance with the expectation of doing it relatively quickly.

For a corporate turnaround to be effective, the first step is recognizing that there are problems with the culturepreneurial organization's finances or that substantial changes in the environment, such as technology and economic indicators, are negatively impacting the organization. To effect a successful corporate turnaround, aggressive and strong leadership aimed at success is required, as is making sure that the people in the organization are clearly informed and, at the same time, well directed. This kind of leadership has to be situated within a corporate turnaround plan. Such a plan answers four questions and takes on the form of a strategic plan. What are the causes of the threat of instability and can they be mitigated? Where are we now and what are our strengths and weaknesses? Where are we going and what goals and objectives do we have to get us there? How will we get there quickly enough to ward off failure?

Corporate turnarounds can help to avoid bankruptcy or to show that the culturepreneurial organization can be put back on track. Another option is to restructure or reorganize the organization, which again may or may not be a part of a bankruptcy direction. For purposes of this textbook, the terms *reorganization* and *restructuring* are used interchangeably. They mean a "significant modification made to the debt, operations or structure of an organization," a type of action "usually made when there are significant problems which are causing some form of financial harm and putting the overall organization in jeopardy"; "a change in the strategy of an organization resulting in diversification," which can involve eliminating aspects of the cultural fine arts venture, to increase its long-term viability.[3] Restructuring can entail transferring a major portion of ownership or merging with another organization; it can be directed by a bankruptcy court or achieved by downsizing or rightsizing.

All of these can include changes in debt and ownership structures, and they often call on valuation methods covered in Chapter 13 to understand the impact that such changes will have. And as with any process, there needs to be a plan in place that will guide the restructuring efforts. Importantly, a restructuring or reorganization will need to occur quickly. Ask: What types of restructuring or reorganization are needed and how will these be implemented? In what way will these decisions be conveyed to arts constituents? After these questions are answered, then the leadership can move into action. In some cases, for a corporate turnaround or reorganization, an outside consultant is sought for guidance and impartial assessment of the situation, as well as to lead the culturepreneur through the processes.

As was mentioned, each of these reevaluation directions can be accompanied by bankruptcy. The type of bankruptcy available to the culturepreneur depends heavily on the way the company is organized—sole proprietor, partnership, or corporation. Bankruptcy is a legal process that is governed by the courts and detailed bankruptcy codes and laws that are designed to relieve debts and make creditors whole. Non-profits can benefit from the corporate turnaround, restructuring, and bankruptcy processes, without a doubt. However, restrictions on property and donor-provided

assets or other complexities may have to be considered. Understanding these kinds of bankruptcy remedies at the outset of the venture can help with determining the structure the organization chooses. And this is yet another reason that succession planning should be a part of the culturepreneurial strategy process.

In any event, the decision or the evaluation of the decision to go in a direction that includes bankruptcy needs to be taken with consideration and advice of legal counsel, *which this textbook does not offer*. Therefore, what follows is a brief description of three bankruptcy types: Chapter 7, Chapter 11, and Chapter 13.

Chapter 7 is an option for businesses and individuals that do not have resources to cover their liabilities. In this form of bankruptcy, all assets, with some exceptions for core assets that prevent one from earning a living, have to be sold to generate cash to repay creditors, and the culturepreneur has to demonstrate that he or she has insufficient funds to continue to operate the organization.

Chapter 13 differs from Chapter 7 in that there is no fire sale of assets, and a repayment plan that covers three to five years is established to make creditors whole. Business and personal debts will be included in a repayment plan, and the creditors must approve it before it is enacted. The plan could involve culturepreneurs repaying much of their debt solely over three to five years. But they have to demonstrate that they have a sufficient income that will allow them to repay according to the plan. Usually this will mean that tax returns and other documentation to prove earning capacity have to be supplied to the court.

Chapter 11 is the option for large culturepreneurships that are corporations with significant debt and assets. Chapter 11 can occur with a corporate turnaround and a reorganization or restructuring. This form of bankruptcy allows for debts to be repaid without affecting the business's assets or operations. The culturepreneurial venture under Chapter 11 can continue to run.

After changing the corporate structure or emergence from a bankruptcy, there can be opportunities to begin again. As noted in Chapter 5, learning from experience is part of the culturepreneurial process, and while there will be a period of self-evaluation, it should only serve to strengthen and guide the next steps. What comes from that is knowledge, understanding, and wisdom in regard to analyzing opportunities, developing business plans, articulating the business model, and establishing metrics. Careful consideration of internal processes, offering new arts service product experiences, and understanding markets, fund-raising, and development are all necessary ingredients for the culturepreneurial venture. These aspects of leading and growing a culturepreneurial firm are invaluable and can be carried into the next opportunity as it arises or as the culturepreneur envisions it anew.

CHAPTER SUMMARY

In some ways, this chapter pushes a review of the beginning ideas leading to developing a culturepreneurial venture. The thought of what will happen at the end of the venture is often left unexamined. Yet taking that approach can lead to problems. In order to avoid them and to plan for how the cultural fine arts organization will transfer leadership, succession planning is essential.

To position the organization to pass on the founder's dream and honor the culture-preneur's vision and tenacity, it is necessary to think about planned succession and what to do in case of an emergency loss of the leader. Processes put in place when organizing will go a long way in aiding both planned and unplanned transitions.

Outside of a transition that is caused by the culturepreneur's decisions, external pressures can lead to reevaluations of the venture. These include engaging in corporate restructuring, turnarounds, or complete divestitures of the cultural fine arts organization. The options available depend in part on the structure of the culture-preneurial organization. Within the reevaluation process, particular forms of bankruptcy can be or may be included. The main point is to see these kinds of transitions as opportunities to self-evaluate, examine lessons learned, and begin anew, with more wisdom and knowledge about establishing a successful culturepreneurship.

DISCUSSION QUESTIONS

1. What is the benefit of having a succession plan in place at the founding of the culturepreneurial organization?
2. Why is it difficult to include this aspect in the strategic planning of the organization?
3. Compare and contrast corporate turnarounds and restructuring.

EXPERIENTIAL EXERCISES

1. Search the Internet for succession planning. Design a succession plan for a non-profit organization and for a for-profit organization using the three ways to think about succession planning as your guide. Include aspects that will allow for a hybrid form of ownership as well.
2. Establish a corporate turnaround tool kit. By conducting an Internet search, locate consultants or others who will be available to assist in this aspect should it materialize.
3. Based on what was accomplished in the previous question, what kinds of bankruptcy are accessible for each scenario? Conduct an Internet search to reveal resources that can be used in the event that such a direction is taken.
4. Place the information gathered in the previous questions in the context of the vision for a culturepreneurial organization. What new awarenesses emerge in planning to move forward?

FURTHER READING

Adams, Tom. *Founder Transitions: Creating Good Endings and New Beginnings: A Guide for Executive Directors and Boards*. Baltimore, MD: Annie E. Casey Foundation; Evelyn and Walter Haas Jr. Fund, 2005.

Collins, James C. *Good to Great: Why Some Companies Make the Leap . . . And Others Don't*. New York: HarperBusiness, 2001.

Collins, James C., and Jerry I. Porras. *Built to Last: Successful Habits of Visionary Companies*. New York: HarperBusiness, 1994.

NOTES

1. Cambridge Dictionaries Online, "Succession planning," http://dictionary.cambridge.org/us/dictionary/business-english/succession-planning.
2. James C. Collins, *Good to Great: Why Some Companies Make the Leap . . . And Others Don't* (New York: HarperBusiness, 2001).
3. Investopedia.com, "Restructuring," www.investopedia.com/terms/r/restructuring.asp; Dictionary.com, "Corporate restructuring," http://dictionary.reference.com/browse/corporate+restructuring; Robert D. Hisrich, Michael P. Peters, and Dean A. Shepherd, *Entrepreneurship*, 8th ed. (New York: McGraw-Hill/Irwin, 2010).

Part V
Cases

Case 1. Sex, Lies, and Museum Governance
When Two Worlds Collide

Ruth Rentschler

> Nowadays recruiting a board is a delicate and serious business. You need people who are leaders in their own fields, dedicated networkers with good political and corporate connections. They have to be prepared to make substantial financial contributions, spend a lot of time at subcommittee meetings, rehearsals and performances, be on tap to offer pro bono advice, be held responsible in the case of economic downturn, and to do all this for nothing.
> —John Bell[1]

As leading arts board member and CEO of Bell Shakespeare John Bell illustrates, the world of organizational governance is complicated. However, limited theoretical foundation exists regarding how trustee dynamics are forced to adjust in nonprofit museums. In museums, creativity represents the highest ideals of human endeavor, none more praised than that of the artist as represented by the curators who present the work in exhibitions, catalogues, and public presentation. Boards of museums bask in the glory of success of these endeavors, reflecting in the glory of artists as heroes and art as the creative expression of genius. The art market has always been a world of intrigue, power, prestige, commercial transactions, and images of privilege.[2] It provides glimpses into the world of museum governance where the organization meets art in new, unexplored ways in the world of research. This study presents two case studies from "down under" to show that the art market is indeed global, that governance scandals are universal, and that lessons to be learned for governance at the intersection of art and organization debunk the romantic, highbrow, elite perception of the arts held by some.

The study unravels the notion of conflict of interest in governance and links it in a new way to creativity. Conflict of interest is the use of codependent but legitimate interests for personal gain. Conflict of interest is one part of governance that has the potential to damage the organization and the individuals in it or associated with it. This study is for people who are worried about the focus in governance research on

Case used with permission from Ruth Rentschler.

simplified templates of conformance and performance that do not look to the difficult and challenging matters that underlie governance. In using the case study for analysis— rarely used in this way in arts research—the study takes a step forward in governance research and analysis, drawing on accounts that have been missing previously.

Governance is complex in museum organizations not only due to the diverse range of people whose decisions it affects but also for what it tells us about the double jeopardy of conflict of interest. The diverse range of people includes sponsors, philanthropists, staff, volunteers, the community, business, the media, and artists who influence how governance in museums operates. Trustees in museums need to heed these groups, as well as recognize the effect of their decisions on the museum's reputation and creative mission, on staff and volunteer morale, and on the legal and financial aspects of museum operations. These people are associated with power and influence and are usually people of some standing in the community, with a high media profile. Double jeopardy of conflict of interest tells stories of sex and seduction in institutions by people perceived to hold power, so that the creative processes usually associated with museum work go awry.

Two leading art museums in Melbourne, Australia, serve as case studies. The National Gallery of Victoria (NGV) is one of the largest and oldest state galleries in the country. It provides a scintillating example of conflict of interest where creativity and curatorship collide in a double jeopardy. Heide Museum of Modern Art is a smaller gallery that was founded by philanthropists thirty-two years ago in order to collect and exhibit haunting paintings by gifted, emerging early modern artists who later achieved worldwide fame. Heide provides a curious example of conflict of interest at board level where a trustee was also an artist as author of numerous books on some of the notorious artists from Heide. While this gallery is not as well known, it constitutes a second important example of creativity gone awry. Both these case studies are from the "other side of the world," but the lessons they teach us are no different from those of Enron in the United States, where spirals of social and business connections became entrenched in scandal, media frenzies, and loss of reputation. The study concludes by providing key implications for governance in museums in order to avoid conflict of interest.

GOVERNANCE, MUSEUM TRUSTEES, AND CONFLICT OF INTEREST

Museum governance as a field of study is relatively new, although the study of governance in the nonprofit sector continues to grow, with organization studies aplenty.[3] Governance changes in the 1990s to overcome irregularities in some museums included establishing due process in accounting and accountability, organizational restructuring, new and orderly procedures, a more significant place in the community, and cultural change. As an Australian museum director told me, "museums have gone beyond the powerful aesthetic of an individual to drive them toward a personal vision."[4] The continuing evolution of governance in museums has been of interest to a number of researchers, as it has been to other arts professionals. Governance in the nonprofit arts has been defined as "how boards reconcile their value adding responsibilities (strategic direction and business building) with responsibility for financial stewardship

(disclosure, internal controls and fiscal rectitude)."[5] There is little in this definition to alert us to the celebrity of governance problems that would beset the NGV and Heide.

Governance is often described as pertaining to performance and conformance, which is relevant to museum governance.[6] *Performance* covers the strategic contribution of the board to performance, as well as stakeholder liaison and analysis of the external environment to determine its influence on organizational success. *Conformance* covers accountability, executive officer supervision, legal affairs, monitoring, and access to resources. Grounded in sociology and organizational theory, conformance is important as a boundary-spanner that makes timely information available to executives, monitors executive money management, and extracts resources from the community, government, and sponsors. These activities enhance the organization's legitimacy and help it achieve goals and improve performance. Hence, the interrelationship between performance and conformance is integral to museum governance through the strategic oversight provided by the governing trustees.

Conflict of interest for trustees of museums has been discussed little in the scholarly literature. Organization studies on museum governance focus on work by Bieber, Griffin and Abraham on effectiveness of boards, Radbourne on arts board recruitment and reputation, Rentschler on organizational leadership, and Wood and Rentschler on ethics.[7] These studies used mixed methodologies, including reflection, case studies, surveys, and interviews. Some studied boards as part of a larger study on museum leadership or the museum as organization; others studied performing arts governance. These few studies on museum governance complement the growing field of broader organization studies on boards in fields as diverse as hospitals, sport organizations, and charities.[8]

However, in 2002, an article in *Museums Journal* cited the shortage of good trustees in museums as a "situation that was only likely to get worse," with "very little literature on best practice governance" in the museum sector.[9] So researchers are aware of the need for good governance in museums and are searching for ways to find trustees who can provide it. In an increasingly complex regulatory environment, where accountability is demanded, conflict of interest in governance needs to be carefully considered. However, the fact that it is rarely considered in the museums' literature is perhaps not so surprising, given that only 5.7 percent of articles in significant museums journals cover "administration" issues, with governance not identified separately as a topic of interest. Of the thirty-nine titles most cited in these museum publications as "influential works," not one of them is on governance.[10] My argument is that this leaves the field wide open for a historical analysis that identifies and understands the ways in which conflict of interest lies at the heart of museum governance and explores the ways in which it festered at the NGV and Heide as well as the consequences for the development of governance research.

METHODOLOGY

Publicly available documents are the basis for conclusions drawn, from a case study of two art museums. Documents selected were media and annual reports, artist biographies and interviews with arts board members over a number of years. Media

reports, biographies, and interviews are appropriate and valid research data and suited to theory building. Given the paucity of data on museum governance and specifically conflict of interest, this approach is appropriate to the purpose. The purpose of case study analysis is to interpret change through practical examples. The selection of two cases follows arguments by Eisenhardt that theory development and the understanding of phenomena can best be achieved by case study methods.[11] The case studies draw upon Fillis's argument that new theory generation can benefit from embracing nontraditional modes of enquiry.[12] As many governance studies are large-scale surveys, the historical case study approach is nontraditional for governance research. Themes on conflict of interest were identified judgmentally from documents, consistent with case study methods, from which conclusions are drawn.

CASE STUDY 1: NATIONAL GALLERY OF VICTORIA AND THE SEDUCTION OF DOUBLE JEOPARDY

The National Gallery of Victoria (NGV) in central-city Melbourne, Australia, may seem far away on the other side of the world from many who study governance. But it provides a telling example of governance through conflict of interest. The conflict of interest dispute was a public brawl between the NGV's young and charismatic Australian art curator, Geoffrey Smith, and his former partner Robert Gould, owner of the commercial contemporary Australian art gallery, Gould Galleries, also in Melbourne. Smith was feted by the gallery-going public as a highly successful curator of Australian art. Young, good-looking, and articulate, he perfectly represented the professional image that the NGV set out to present. He had also managed to accumulate a sizable collection of valuable Australian art during his partnership with Gould, using his formidable knowledge of the networks and trends in collecting and his personal links to the commercial gallery. Smith was well respected for his art curatorship, his personal style, and his ability to tell stories of Australian art through personal presentation, exhibition, and publication.

Yet during 2006 Smith became embroiled in a personal battle with Gould about ownership of their vast art collection. The drama became public through a court case and received extensive media attention. Telling stories took an unusual turn with the curator finding that he was justifying his own story rather than telling stories about the museum collection. The case escalated beyond the control of the two people initially involved in a private property dispute and became a conflict of interest case between Smith and the NGV, which reached a dramatic climax involving the board of trustees.

The nub of the public brawl was that Smith claimed in court that he was instrumental in raising the profile of Gould Galleries and amassing its $7 million art collection during the fourteen-year relationship.[13] In an affidavit, Smith stated that, while employed as a curator with the NGV, he "worked diligently in building the reputation of Gould Galleries."[14]

The public governance interest argument states that it was wrong for Smith to be spending work time building Gould's commercial business while employed as a public servant in a publicly funded institution. The governance issues were *first*

serious misconduct and *second* conflict of interest. Smith's work for Gould Galleries included advising on art purchases, helping with exhibitions, introducing Gould to collectors, while holding long hours at the NGV to make up for time spent working and supporting Gould's gallery.[15] Deep concern remained in the art world over the need for specific policies relating to personal relationships with artists and dealers and preferential commercial links.[16] The case finished with Smith resigning his post. The case dragged on in the courts for six years before being settled.

Smith's lawyers' strategy highlighted the network of art world interrelationships between NGV staff, the executive, and the board of trustees. They presented Smith's actions as the norm, no different from those of others in an art world that is rife with cozy relationships and powerful cliques of favoritism and curatorial bias. Smith sought to give public focus to others associated with the NGV through such relationships and networks.

One of the things that emerged from the case is that people of influence, from curators to trustees, had been given leeway and the benefit of the doubt over years of professional practice. While there had been some tittering from the sidelines, scrutiny of the behavior of public officials had been delayed until the crisis occurred. The lessons for governance are less about Smith's culpability and more about seduction at a number of levels. These seductions are how trustees, employees, and influential people are beguiled by image and reputation to the extent that they fail to notice flaws in the glass and so fail to follow up on regular checks until pressed to do so by a media scandal. Networks of influence protected Smith and the NGV from scrutiny in earlier stages, scrutiny that might have been in both parties' interests. The case proved to some that art gallery curators, who often liaise with dealers, artists, and wealthy collectors who might donate or provide art pieces to the gallery, may overstep what is acceptable. Is this behavior a part of general business practices or is it unethical? Information on future exhibitions or collections' policies is known by staff and board members before it is known by the public. Is it a conflict of interest for gallery board members to buy art pieces when they know in advance what the gallery is collecting? Is this not similar to insider trading?[17] This washing of dirty linen in public began as a personal spat but became a public humiliation for the NGV, including its trustees, and a searching examination of double jeopardy. Ultimately, all museums in Australia reviewed and rewrote their ethics policies as a result of this case.

CASE STUDY 2: HEIDE MUSEUM OF MODERN ART AND THE AESTHETICS OF PERFORMANCE

The Heide Museum of Modern Art, also in Melbourne, Australia, may not be known to many outside these dominions. But the persuasive performances of people played out in the media extensively at this small but iconic art museum in the middle suburbs of Melbourne. Some background on the art museum sets the scene. In the early 1930s, Sunday and John Reed, a wealthy establishment couple, bought a run-down farmhouse then on Melbourne's northeastern, semirural fringe. The Reeds were both passionate and wealthy art collectors, mentors to emerging artists, and

philanthropists. Heide developed a reputation for supporting important local and international artists from Barry Humphries to Mike Brown, Charles Blackman, and Albert Tucker. It provided accommodation and stipends to the artists, promoting them and their work, keeping the wolf from the door. From 1980, Heide has been in public hands, a gift from the Reeds to the people. This case is about the legacy of the Albert Tucker paintings, the role of a trustee as biographer of Tucker, and Tucker's widow, Barbara Tucker, as guardian of his estate, and perceived conflict of interest on the board.

Heide's influence on Australian modern art cannot be overestimated. But public controversy has sometimes surrounded Heide's famous artists. In this case, public controversy also surrounded the board's governance practices. In 2001, the publication of a book by art historian, author, and board member of Heide, Janine Burke, caused division on the Heide board. The book was called *Australian Gothic: A Life of Albert Tucker*, named after one of Tucker's paintings called *Australian Gothic*. The controversy stemmed from Burke's interpretation in the book that Tucker had "lost" his artistic prowess in the second half of his artistic career when married to his second wife, Barbara Tucker. Burke argued that the talent that made Tucker one of Australia's foremost modern artists was mainly evident while he was married to his first wife, Joy Hester (1920–1960)—also an artist. Barbara Tucker took exception to the argument and threatened to withdraw her offer of donating a $15 million gift of Albert Tucker's paintings to the art museum while Burke remained on the board. Barbara Tucker also withdrew support for the use of Tucker's images in Burke's book. The book had to be pulped and reprinted without the images. Unfortunately for Burke, Albert Tucker, who had provided unstinting support to Burke over the book, died while she was writing it.

The aesthetic and governance principles in this case are not as clear-cut as in the case of the NGV. However, similarities emerge in the belief that governance is primarily about rational and cerebral relationships rather than the visceral, less rational appetites of some of the players. The board was aware that Burke was a seasoned author on Heide artists: that was a key reason for her appointment to the board. Nonetheless, the board became divided in its support of Burke as pressure grew from the artist's widow, Barbara Tucker, for Burke's resignation. One board member was reported as saying, "I am concerned about freedom of expression which was so fundamental to the spirit of Heide . . . to do something against that spirit would be tragic."[18] However, another stated a contrary view: "The will of the board is that . . . we maintain goodwill with the people involved with Heide."[19]

Tensions on the Heide board came to a head in December 2001, when chair Ken Fletcher called for Burke to step down, therefore avoiding the potential loss of the Tucker bequest. Ironically, Burke did offer her resignation to the board before the December board meeting, ensuring the Tucker gift. However, she subsequently withdrew her resignation, saying, "I am sticking by my principles, like John and Sunday Reed." She added, "Heide is a public gallery funded by taxpayers' money. Surely in such an environment, dissent and scholarship should be able to flourish."[20]

The basis for Burke's change of mind not to stand down from the Heide board was legal advice that her biography did not constitute a conflict of interest with her board responsibilities.[21] Burke held her ground during the December 2001 board meeting attended by her eleven board colleagues, who voted for Burke to resign from the board. A statement released by the Heide board stated, "The board was disappointed with her decisions and would seek to find a solution that is in the best interest of all concerned."[22]

Burke remained on the board. Two months later, in February 2002, Janine Burke's biography of Albert Tucker was released. Ultimately, its publication did not affect Barbara Tucker's $15 million gift to Heide. Heide board members and Barbara Tucker agreed that the bequest was *independent* of Burke's biography of Albert Tucker. The aesthetic and performance dimensions of governance were separated, to enable a sensible outcome for Heide. But emotion remains a central plank in the Heide board case and it is something that cannot and should not be banished from governance research. We need to open up the black box of governance processes and their consequences for a functioning board. In this case, it was not a staff member's sense of entitlement that was at stake, as in the NGV case, but an aggrieved widow whose influence on the creative expression of a great Australian artist, Albert Tucker, was perceived to have been neglected. Barbara Tucker sought to protect the reputation of her artist-husband and of herself, while the author sought the aesthetic freedom to interpret creativity as she saw it exemplified.

The division over Burke's book also raised questions about censorship, which was at odds with Heide's philosophy of free speech and the right to be critical. The governance issue facing the Heide board was a matter of conflict of interest between Burke's right as member of the board to publish a book that potentially denigrated a significant benefactor of Heide. Heide's governance responsibility was to keep the museum out of conflict and effectively manage risk. Heide's artistic heritage embraced risk and confronted it head on. Here, creativity conflicted with conformance in governance and created a media feeding frenzy demanding critical scrutiny and challenging the status quo.

LESSONS LEARNED FROM THE COLLIDING OF TWO WORLDS

These two case studies on museum governance provide exemplars on how two worlds can collide, presenting a cautionary tale for those seeking to apply idealized notions of governance to management studies. The issues highlighted show that the rational side of governance focusing on performance and conformance is not enough. The emotional side of governance focusing on creativity can sideline an organization, leading to dire reputation damage. Many board members are high-profile individuals with significant business, political, and art world connections. These connections are useful in the world of negotiating and dealing for art works. But they come unstuck when museum boards rely on romantic notions of art as good for the community.

The threefold lessons that emerge from these case studies are trustee experience, personal benefit, and professional judgment.

TRUSTEE EXPERIENCE

Conflict of interest occurs in a number of ways in museum governance, as illustrated by these cases. First, it is appropriate that people on museum boards become symbols of museum accountability and integrity. By probing behavior that permeates these two cases, we make an important move toward understanding the psychodynamics of museum governance that is beyond conformance and performance, although each influences the other. It is these often invisible dynamics that form the basis of issues in the two cases. Second, museums are rightly concerned with their reputation, known by the quality of their people both at trustee level and in the curatorial ranks. Perhaps in no other market is the relationship between an organization's name, value, and reputation so clear.[23] This point was made by Schroeder in relation to the artist and the brand.[24] It is no less imperative in relation to museum boards, their reputation, the decisions they make, and their strategies. At times, this reputation derives from the trustees, while at other times it derives from the curators and their public role spruiking [promoting] exhibitions. In the case of the NGV, the interaction between trustee and curator for reputation development was sullied by the implications that the curator had compromised his position by his private art dealings with a commercial gallery during NGV work time. The logic of governance—through perceived conflict of interest—informed curatorial practice as the logic of curatorial practice informed museum governance. In the case of the Heide Museum of Modern Art, conflict of interest was perceived to compromise a trustee's position, hence potentially compromising philanthropic giving. In the latter case, the potential donor sought to influence the board by withholding her gift while a particular board member remained on the board. Both these museums' reputations relied on trustees' experience to articulate cultural meaning and association in order to bring the museum back on track. As these cases show, within the museum world of increasing governance complexity, creative people can get into trouble and affect a museum's reputation and their own careers and reputations. Exploring these challenges enables us to move from ignoring them or being seduced by them to a freer space where we can become more thoughtful leaders of museum governance.

People who are trustees need to recognize the passion in others, when it is appropriate to use it and when it is appropriate to rein it in. This is called trustee experience. Trustees with wide horizons of interests and competencies rather than narrow specializations provide solid foundations for decision making in these complex dynamics. It is often the case that new ideas emerge at the interface of domains. If horizons are too narrow, they can blinker views of possibilities.

PERSONAL BENEFIT

The blurring of the personal and the professional, touching on the legal realm, illustrates how governance matters function on the boundaries of organization. When partnership problems were reduced to publicly available transcripts, the link between

loose words stated in a personal dispute affected not only job security but also public accountability that had governance implications. For many in the art world, Smith's case brought to the fore conflict of interest in the art world in general, where deals and insider knowledge for people who wear more than one hat provide opportunities to people in the know. This matter has not been resolved and will continue to be discussed in the small, incestuous world of art dealing, buying, and collecting, where people may hold multiple positions, serving as trustees of one organization, dealers in another, and having philanthropic interests in a third.

As has been argued in the world of sport governance—where similar organizational conditions apply of nonprofits with volunteer boards and a small, incestuous world of intersecting interests—one individual can hold multiple roles. The question posed is this: when are these roles interests in conflict and when are they conflict of interest? Such matters are yet to be disentangled.

From a trustee perspective, it is essential to look inward and outward and reflect on the reasons for becoming a trustee. Even the word itself suggests "stewardship" of the organization, a key term implying that more than personal benefit is at stake in governing a museum. Becoming a trustee for personal benefit suggests that danger and devastation are likely either for the museum or for the trustee or both. Both the case studies illustrated found that the trustees did not have a conflict of interest. What the cases do show is that conflict of interest often runs counter to what is expected or intended by curators or trustees. It is in this matter that there is capacity for insight by trustees and curators alike in order to limit reputational damage.

PROFESSIONAL JUDGMENT

While museum governance has been little portrayed in academic journals, due to the focus on other matters of organizational and artistic interest, people in museums have exhibited professional judgment for centuries since museums were developed as professional bureaucracies. The trustee's professional judgment role emerged later, as museums themselves developed from small organizations run by one paid director and a few volunteer trustees. Certainly the twentieth century revealed the interconnections between performance and conformance of trustees. Museum links with fame, fortune, and philanthropy mean that their governance is entrenched with elites in contemporary society. Thus, notions of the high-minded purity of art clash with people, politics, and power. Trustees need to be ever-mindful of these links so that their professional judgment remains sound.

Recognizing the best people to contribute to the museum also requires professional judgment. The trustee plays a vital role in the process of creating an entrepreneurial organization. The trustee is a crucial gatekeeper, in a leadership position, who holds the keys for turning bold ideas into practical action.[25] To call such people *volunteers* is to misunderstand their purpose. They are an essential part of innovation fostered in the museum, creating an environment where entrepreneurship flourishes through broad decision making as a mark of professional judgment.

CONCLUSIONS

These two cases illustrate that governance is complex, contested, and reputationally based and that lack of oversight can impact governance in surprising and unexpected ways. Adverse publicity, reputation damage, and public brawling make unpleasant bedfellows. The cases show a clear connection between the need for rethinking entrepreneurship to guide governance in organization studies.

Higher standards of accountability are expected due to public requirements for transparency of behavior in cultural institutions. This expectation is extended to standards requiring not only efficient and effective decision making but also ethical behavior.[26]

The two cases provide a siren song to trustees who rely too heavily on conformance and performance in museum governance without examining critically the passionate side of governance. The continual changes and increasing professionalism in museum governance attest to ongoing evolution of structural frameworks, policies, and procedures. These two cases suggest that changes have not been systematic but may have evolved in response to scandals or public disquiet about how governance matters focus on performance and conformance. Here are two organizations whose governance was called into question by reputational slurs from linkages with the colliding of two worlds. While questions occurred at the individual museum organization level, they are also received attention at the cultural industry level, changing policy and practice.

NOTES

1. John Bell, "Strut and fret," *Australian Financial Review*, July 13, 2006, 44.
2. Samuel N. Behrman, *Duveen: The Story of the Most Spectacular Art Dealer of All Time* (New York: Little Bookroom, 2002); Jonathan E. Schroeder, "Aesthetics awry: The painter of light and the commodification of artistic values," *Consumption, Markets and Culture* 9, no. 2 (2006), 87–99.
3. Russell Hoye and Graham Cuskelly, "Board-executive relations within voluntary sport organisations," *Sport Management Review* 6, no. 1 (2003), 53–74; F. Warren McFarlan, "Working on non-profit boards: Don't assume the shoe fits," *Harvard Business Review* 77, no. 6 (November–December 1999), 65–80.
4. Ruth Rentschler, *The Entrepreneurial Arts Leader: Cultural Policy, Change and Reinvention* (Queensland: University of Queensland Press, 2002), xx.
5. Helen O'Neil, *Making Board Performance Better in the Arts* (Sydney: Australian Major Performing Arts Group, 2002), 46.
6. Henry Bosch, *The Director at Risk: Accountability in the Boardroom* (Melbourne: Pitman, 1995); F.G. Hilmer, *Strictly Boardroom: Improving Governance to Enhance Company Performance* (Melbourne: Business Library, 1993).
7. Martin Bieber, "Governing independent museums: How trustees and directors exercise their power," in *The Governance of Public and Non-Profit Organizations*, ed. Chris Cornforth (London: Routledge, 2003); Des Griffin and Morrie Abraham, "The effective management of museums: Cohesive leadership and visitor-focused public programming," *Museum Management and Curatorship* 18, no. 4 (2000), 335–368; Jennifer Radbourne, "The Queensland

Arts Council: The case for governance in volunteer arts boards," paper presented at the 7th International Conference on Arts and Cultural Management, Milan, Italy, June 29–July 2, 2003; Ruth Rentschler, "Directors' roles and creativity in art museums in Australia and New Zealand," (PhD diss., Monash University, Melbourne, 1999); Greg Wood and Ruth Rentschler, "Ethical behaviour: The foundation stone for entrepreneurial activity in arts organizations," The New Wave: Entrepreneurship and the Arts, April 5–6, 2002, Melbourne Museum (CD-ROM).

8. Hoye and Cuskelly, "Board-executive relations."
9. John Pybus, "The board game," *Museums Journal* 102 (February 2002), 30.
10. Jay Rounds, "Is there a core literature in museology?" *Curator: The Museum Journal* 44, no. 2 (2001), 194–206.
11. Kathleen. M. Eisenhardt, "Building theories from case study research," *Academy of Management Review* 14, no. 4 (1989), 532–550.
12. Ian Fillis, "Being creative at the marketing/entrepreneurship interface: Lessons from the art industry," *Journal of Research in Marketing and Entrepreneurship* 2, no. 2 (2000), 125–137.
13. Kate Collier, "Art feud costs blow out $280,000 legal bill," *Herald-Sun* [Australia], December 18, 2006; C. Perkin, "Gallery defends scandal conduct," *The Weekend Australian*, February 24–25, 2007; K. Strickland, "When art of the deal is a hanging offence," *Australian Financial Review*, September 9, 2006.
14. Strickland, "When art of the deal is a hanging offence," 27.
15. Strickland, "When art of the deal is a hanging offence."
16. Perkin, "Gallery defends scandal conduct."
17. Strickland, "When art of the deal is a hanging offence."
18. Gabriela Coslovich, "Art gift in doubt as author stays put," *The Age* [Australia], December 13, 2001, 3.
19. Georgina Safe, "Penguins angry widow rocks gallery," *The Australian*, December 11, 2001, 1.
20. Georgina Safe, "Tucker furor divides board," *The Australian*, December 12, 2001, 5.
21. Safe, "Penguins angry widow."
22. Coslovich, "Art gift in doubt as author stays put," 3.
23. Radbourne, "The Queensland Arts Council."
24. Jonathan E. Schroeder, "The artist and the brand," *European Journal of Marketing* 39, no. 11/12 (2005), 1291–1305.
25. Martin Csikszentmihalyi, "The context of creativity," in *The Future of Leadership*, ed. W. Bennis, G.M. Spreitzer, and T.G. Cummings (San Francisco: Jossey-Bass, 2001).
26. Wood and Rentschler, "Ethical behaviour."

Ruth Rentschler is a professor in arts management at Deakin University, Melbourne, Australia. She has managed a range of governance projects, such as writing topical briefing papers for the board of a major visual arts organization; identifying best practice in sports, arts, and charities boards, and analyzing arts governance conformance and performance. Dr. Rentschler has held various board positions, including with Multicultural Arts Victoria, VicHealth, Art Gallery of Ballarat, and the Duldig Gallery. She is an honors graduate in fine arts (First Class Honors, First Place) and German from the University of Melbourne, with a PhD from Monash University. She maintains a strong interest in the visual arts and museums in her work and private life.

Case 2. More Than a Circus!
Insights from the Chair of a Major Arts Board

Ruth Rentschler

What is it like being the chair of a nonprofit arts board? This inquiry attempts to uncover strategic insights from the everyday lived existence of the chair of the board of Circus Oz, a major performing arts company in Melbourne, Australia, using the experiences of the researcher as much as those of the interviewee as part of the study. The board chair investigated sits on "a most unusual board": a constituency board that arose from a collective organization, containing both staff members on the board as a developmental tool and outsiders who bring specific skills to the board. Using multiple interviews of one person, board observation, attendance at performances, informal conversations, and autobiographical material, this study examines phenomena in depth.

It is unusual to be given access to board members and especially access to board meetings. However, Wendy McCarthy, the arts board chair who participated in this study, is unusual. She writes about the "craft of autobiography" that details "the meaning of our experience."[1] Her openness about her experiences and her work as a board chair tell us something important about the person studied and her attitude to board strategy. With nearly thirty years of experience on boards, in various roles, such as chair, deputy chair, CEO, and ex officio board member, McCarthy has been exposed to the circus of boards beyond Circus Oz. In other words, examining the lived experience of one informant enables exploration of phenomena that are often taken for granted, thus uncovering new meanings and providing rich new stories of a particular set of board strategy. A teacher by profession, McCarthy has witnessed the change in nonprofit boards from amateur to professional, in arts, entertainment, social justice, and mental health. She has served as deputy chair of the Australian Broadcasting Corporation (ABC), chair of Headspace (for youth mental health), chair of the National Heritage Commission, chair of Circus Oz, and CEO of nonprofits. In this examination of the governance experience of Wendy McCarthy, with a focus on the arts and Circus Oz, her strategic approach emerged as a key theme, including feminist insights, volunteer insights, and strategic insights.

Case used with permission from Ruth Rentschler.

BACKGROUND

Board members use governance to steer the organization, making decisions that are strategic in their oversight, insight, and foresight. In the arts, governance is still emerging as a discipline of study, with its intricacies yet to be examined in depth. As an emerging domain, theory has been drawn largely from mainstream disciplines such as corporate and nonprofit governance and other areas of management. Yet there are calls to conduct research in domains outside the norm. Researchers such as Forbes and Milliken and the Australian Institute of Company Directors have emphasized the need for studies of boards of different types of organizations so that we can better understand governance.[2] This case study of an arts board chair addresses this call. Here, governance is seen as a process of dynamics that steers an organization, a network of organizations, or a society itself by allocating resources and exercising control and coordination.[3]

Governance scholars call on theory to address the needs of governance. Theories used to investigate arts governance include agency, stakeholder, stewardship, resource dependency, and managerial hegemony theories. There has been relative silence in feminist theory on arts board research of relevance to this case study. This is curious, given the predominance of women in the arts and their contribution to the social sector in general, leading some researchers to suggest that women have a greater interest in social justice than men.[4] Studies have shown that educated women play an important role in charitable provision and political advocacy.[5]

A further paradox is evident in the studies of women on corporate boards. While women directors on corporate boards are covered extensively in the literature,[6] there has been little gain for women on corporate boards. However, empowered by education and reduction of barriers in the commercial world, women are taking up opportunities for paid work in professional roles, which could decrease their contribution to the nonprofit sector. Conversely, while women have obtained up to 50 percent of the positions on some nonprofit arts boards over the past twenty years, there has been little academic study of the field. We know little of the demographic characteristics and roles of women on nonprofit arts boards. More than this, we know little about the motivators for women to join arts boards, the role that they play on those boards, and how they may or may not affect performance. Yet this information is essential for stakeholders, such as elected government ministers and the bureaucrats who implement the vision of the elected members of parliament, who appoint board members to some types of nonprofit arts boards. It is also essential information for arts board members themselves as they seek to navigate uncertain economic times and reduced funding. It is also important for the communities that the boards of arts organizations serve.

There have been several high-profile controversies concerning nonprofit arts boards. For example, boardroom tensions between the chair and CEO at the prestigious Australian Museum in Sydney were the focus of the television current affairs program *Four Corners* on September 29, 2003.[7] Conflict of interest, called "curatorgate," in one national gallery in Australia, where the curator divided his time between

his gallery duties and buying for a separate, commercial gallery, saw all galleries and museums in Australia rewrite their ethics policies to ensure that commercial dealings would not sully nonprofit gallery work. Governance concerns emanating from such cases have resulted in reviews of governance of public sector authorities (e.g., the *Uhrig Report* in 2003) with a raft of regulatory reform impacting the industry (e.g., the Victorian Public Administration Act of 2004).[8]

Findings not only inform theory but also are relevant to industry stakeholders such as government policy makers, boards, volunteers, industry management, and funders in their quest to enhance performance and sustainability, at a time when the nonprofit sector is undergoing significant change in Australia.[9] Researching nonprofit arts boards, where profit is not the only performance yardstick, but where financial crises are imminent,[10] provides a wealth of data to understand this important part of society. The nonprofit sector had about 600,000 organizations in Australia in 2010. The sector generated $43 billion in 2006–2007. The estimated growth rate of the nonprofit sector in the last decade has been 8 percent, outstripping the performance of other sectors of the Australian economy. The sector mobilizes 4.6 million volunteers, who contributed $15 billion in unpaid work in 2010. About 89 percent of nonprofit directors perform their role on a voluntary basis.[11] Given the significant social and economic impact of the nonprofit sector, this study on an arts board leadership advances knowledge during a tumultuous period of change. The case study builds upon previous research and inquiries[12] to provide the first Australian, in-depth analysis of what an arts board chair does, taking shape around McCarthy's board history over three decades.

METHODOLOGY

Phenomenology includes the study of the lived experience of an individual, understood from describing firsthand experiences. Quantitative or empirical methods, emphasizing the observable and accessible, have often been used for research on boards. Phenomenological work provides rich data from the interviewee's perspective. Hence, this research article emphasizes discovery, description, and meaning rather than prediction, control, and measurement.[13] It uses phenomenology and is embellished by the experience of the researcher. It takes a different approach from the many statistical surveys of CEOs, mostly in the commercial sector. The CEO surveys are used as proxies for board studies.

This study straddles nonprofit-arts-board literature and women-on-boards literature from the perspective of the participant. However, rather than investigate the imbalance of women to men on boards, or the influence of gender on board dynamics, or the contribution of women on boards to effectiveness,[14] this case study focuses on one individual and her lived experience as nonprofit arts board leader.

This study was designed in order to provide information of interest to a particular audience: those in nonprofit arts organizations interested in boards. Concern for the audience is central to hermeneutics,[15] which seeks to be authentic and credible to that audience. It is common in phenomenological studies to recruit small numbers of participants to enable depth analysis and exploration of the lived experience. The

interviews with McCarthy were semi-structured, of one hour duration, allowing the participant to relate her lived experience as a board member. The researcher also listened to podcasts of prior interviews, read the interviewee's autobiography, attended a board meeting as an observer, attended circus performances and other events, and analyzed organizational documents.

INSIGHTS

PARTICIPANT PROFILE

Wendy McCarthy grew up in rural New South Wales, in the 1940s, where a "university degree was as unusual as a refrigerator."[16] From this beginning, she moved into community politics, public debate, and scrutiny, as society changed over the decades. McCarthy discovered the "power of narrative and shared experience" pressing for reform (98).

McCarthy now lives in Sydney and works in Sydney and Melbourne, both large Australian cities on the eastern seaboard. She is chair of the board of one of the major performing arts organizations in Australia, Circus Oz. She is also the chair of Headspace, a prominent mental health organization. For eight years (1983–1991), she was deputy chair of the Australian Broadcasting Corporation, the noted government-owned television agency, akin to the BBC. She has also been executive director of the National Trust, chair of the Australian Heritage Commission, and chair and board member of various education institutions. McCarthy is a high-profile chair who seeks to make a difference to the boards on which she works. She also runs her own mentoring company, through which she provides support to managers, executives, and board members.

CASE STUDY ORGANIZATION PROFILE

Circus Oz combines theater with satire, acrobatics, and performance art. The company was founded in 1977 but its origins are older than that, dating back to the late 1960s and the Australian theater, which developed an Australian voice, heightened physicality, and an interest in contemporaneity, comedy, politics, and breaking down the barriers between performer and audience.[17] Circus Oz was originally a collective, born of idealism in an age of collaboration and cooperation in decision making and organizational structure. One of the company's goals is to use its resources to facilitate community involvement and participation. Jon Hawkes states that Circus Oz has "demonstrated that thinking performers, technicians and administrators can collectively create exciting and enduring work. It has created a new context for accessible artistic experimentation."[18] The circus has from eleven to thirteen performers (with two specialist musicians) who present its pastiche of spectacle, subversive humor, knockabout physicality, and social satire. Additionally, it has a staff of about twenty-five and a board of nine people. Circus Oz seeks to create a performance mode that is accessible to all ages and cultural and class divisions and an effective tool for the development of an indigenous Australian culture.

Circus Oz is located in inner Melbourne, Australia. Melbourne is a city with 4.5 million people, growing rapidly, a multicultural mix of immigrants and longer-term residents with a history of settlement over generations in Australia, originally linked to our British heritage. Roughly 25 percent of residents are immigrants, changing the mix of people in the city. As I was told by a male board member on another Australian arts board, mature in outlook, experienced, and successful, "Look around the streets. What do you see? The faces are from all over the world. This is our country's future." Inner Melbourne is funky and cool, with street art decorating the iconic laneways, making Melbourne a city of world renown, attracting tourists from far and wide to see the paintings on the walls of buildings, alleyways, and fences, to sip coffee in street cafés, and to see the theater and art presented both inside and outside galleries, at festivals, and, of course, at the circus.

Besides performing in Melbourne, Circus Oz has toured Australia, as well as twenty-five countries on five continents, performed in festivals, and broken box office records. However, it was noted in the Circus Oz annual report that the "global economic crisis and an exceptionally strong Australian dollar" made operating "very difficult in 2010," with the company touring less internationally.[19] The company has a turnover of close to A$6 million ($1 USD equals $1.08 A).

All board members are volunteers: five are external to the company and high-profile; four are internal company members. This is an unusual board composition, arising out of the community background of the circus. The board seeks to engage "different points of view, grounded in the circus schedule. It is a completely unique experience. You don't sit at a distance like you do with other boards," says McCarthy. Board members rotate constantly.

Australian boards follow the English and Canadian models for boards, rather than the model that predominates in the United States of America. Men and women on Australian arts boards do fund-raise but have broader governance responsibilities than simply "give, get, or get off." Fund-raising is becoming an increasingly important part of the role, due to reduced income sources from other domains. In summary, then, Australian arts organizations have one board, usually with eight to ten directors on it, who undertake a range of responsibilities and accountabilities, with the chair leading a small, tight-knit team. Circus Oz fits this model.

The next section describes the lived experience of our interviewee through her board work. Although this article focuses on Circus Oz, McCarthy's collective experience is interwoven into the analysis to enrich the discussion.

THEME 1: FEMINIST INSIGHTS

Feminist insights describe McCarthy's experiences with women in leadership positions over the length of her career and from a governance perspective. She describes how behavior is shaped according to expectations, which change over time and according to opportunities presented. She also illustrates how she acted as a change agent, testing the waters for pushing boundaries, using the women's movement and then her high profile as a means of engendering change.

According to Hawkes, Circus Oz has "encouraged women to work in areas long perceived as exclusively male domains." This is consistent with Circus Oz's founding in the radical 1970s, years of change, reform, and renewal, especially for women. The role of women at Circus Oz is not limited to the circus arts but also includes the chairmanship of the board, which McCarthy occupies, like the circus she serves, with "bite and pizzazz."[20] It is not by chance that McCarthy alludes to the role of women on boards and the theme of diversity in her interview, although they are not the only topics of importance to this case study. McCarthy is a feminist, with significant media experience in print, on radio, and on television and diverse board experience.

When she first served as a board member, there were few road maps showing how a director should operate, corporate plans were unheard of in many nonprofit organizations, and women on boards were few and far between. McCarthy has developed her own experience and skill sets as governance in the sector itself developed but also shaped by key members. She saw a sector transition from hostility toward management from board members, infighting, and uncertain paths to formalized, developed systems and structures in a reformed, strategic governance world. Her entry onto boards came about due to her community activism, not an unusual pathway for the few women who broke through the glass ceiling in the 1980s. She saw the 1980s as "a difficult changeover time," where directors had a "passion" for the organizations with which they worked but few of the governance skills that subsequent generations developed.[21]

McCarthy has a long-standing reputation and interest in diversity and the role of women in leadership positions.[22] She describes herself as someone whose "public and community life" began "in the Women's Movement."[23] In one of McCarthy's many publications, she writes,

> I grew up in Australia of the 1950s, when words like "career" and "leadership" were not part of a polite girl's vocabulary. A leader was a male hero directing from the front, military-style, the antithesis of a well-raised girl, who learned to wait to be asked to dance and not to be bold or pushy. This remains a powerful cultural imprint for women today.[24]

McCarthy started her professional life as a teacher. Her discussions, books, lectures, interviews, and her mentoring business reflect her interest in developing people by teaching them from her experience. In her autobiography, she describes her experience as deputy chair of the ABC and how she doubted her ability to perform the role when asked (although she said yes to the offer). She has an open attitude, sharing her fears, self-doubt, and joy at the opportunity to make a difference. She states that she could "barely breathe," alternating between "fantastic excitement stimulated by the chance to do something with an organization" and "abject terror" that she would be "out of her depth."[25] Her characteristic openness with her readers is motivating, reassuring, and consoling as we can relate to her circumstances. She describes herself in her autobiography as a "professional human relationship educator."[26]

She has wide-ranging board experience over many years. But McCarthy now sees diversity as extending beyond having women on the board to having a board with diverse skill sets that meet the changing needs of the organization. This interest played itself out in her comments on board diversity:

> I want to say one other thing that benefits not-for-profits: having a diverse board. People make a very big mistake if they get monochrome boards. Diversity means gender, age, contribution, cultural background, expertise, and interests. The board will be a much happier place, with so much better chemistry and so much more interesting to work on if you have diversity.

McCarthy holds the view that boards should mirror the community they serve. As the circus is for families,

> the board should constantly say: do we look like the community we serve? The board should have old and young people on it, different cultures and expertise. It's not just about gender. The gender lens is one. It has become an article of faith and it needs to go further.

Nonprofit arts boards in Australia have risen to the challenge to develop more diverse boards. Cultural change has occurred over the last twenty years. Nonprofit arts boards often comprise 30 to 60 percent women, with some nonprofit boards having directors from diverse cultural backgrounds. McCarthy sees nonprofit boards as providing a "combination of circumstance," sharing leadership as they have overcome the "model of the warrior" that was unpalatable to feminists in the 1970s.[27] Feminists of the 1970s did not aspire to organizational leadership as board members, McCarthy reflects. Cultural change has occurred since then on leadership in nonprofit boards. Given the importance of diversity to the nonprofit board, McCarthy comments that security in one's role and knowing the business can lead to straight talking in some instances, with protocols backing up comments made:

> You have to be fairly secure in your role as a non-executive director about what is your role and your business. . . . I can remember being rung by an extremely senior executive in another private television business [when McCarthy was on the ABC board as deputy chair], threatening me to get a program off the air. You have to understand your role and take it seriously.

THEME 2: VOLUNTEER INSIGHTS

Volunteer insights describe the arts as organizations, as they moved from those run by amateurs without professional governance and managerial structures around them, to professional organizations with skill-based boards. This transition occurred during McCarthy's career on nonprofit boards, where she was both a CEO and a board member in major organizations. When McCarthy was executive director of

the National Trust, many "members and volunteers resented what they called profes-
sional management."[28] As a change agent, McCarthy was having fun bringing struc-
ture to unstructured spaces. As she was often working in organizations that relied on
volunteer labor, both at board and operational levels, the systemic changes occurring
were painful to some but exciting and challenging to others.

In the interviews, McCarthy talked about the role of the chair of the board from
her perspective as a volunteer board member on a professional board, but within
the framework of having seen nonprofit boards develop from "amateur" to "profes-
sional." She emphasized leadership, being a role model, taking a direct leadership
role in fund-raising, the chair–CEO relationship, and the limits of the role of the
board in relation to the core business of the organization. For Circus Oz, the core
business is circus performance.

> The role of the chair is the most important in any company. The chair is the team
> leader who sets the standards; the relationship between the chair and the CEO
> is the crucial one. When it becomes dysfunctional, one has to go and sometimes
> it has to be the chair. It takes a self-knowing chair to do that, but sometimes it
> happens. The chair takes the responsibility of working out whether the board
> leadership is going to be loose-tight or tight-loose. All organizations and non-
> profits particularly have to assume that in order to get the job done there has to
> be shared vision and clear understanding of roles and responsibilities. You can
> use all sorts of strategies and tactics to do it.

The role of the chair is to motivate people on the board and provide a role model,
whether it be by cultivating fund-raisers or making meetings enjoyable so that
board members want to attend them. On potential fund-raisers, McCarthy proffers
this view:

> Directors should welcome funders. The chair should do that. I facilitate that. If
> I meet someone who may be a donor, I share the vision and enable the task to
> be done by others. I may introduce them to someone on the board or in manage-
> ment. I may go or I may not go to meet them.

McCarthy holds the view that the chair of the board should facilitate opportuni-
ties for other board members and for other staff members. Hers is a professional
approach, learned from her years on the ABC board as deputy chair. One important
way of facilitating opportunities is by working with executives:

> Let's take fund-raising; non-executive directors in a not-for-profit should want
> to open doors for executives. . . . The non-executive directors share their con-
> tacts in the way the executives share their experiences and their inspirations
> with the board. If I have members of the management team, who want to meet
> someone significant who may be a donor, I share that with them. Another one
> of my roles on the board is to increase the learning by the nonexecutives and
> executives.

After more than thirty years of engagement with boards and nonprofits, McCarthy had been both responsible to boards and on boards overseeing management. She had seen the landscape change from one of benign government funding most operations to a need for diversity of funding from many sources outside government. Change was a theme that was consistently mentioned in the interviews and in McCarthy's books and media podcasts. A shift to a more North American model of fund-raising was part of that change. These were all governance issues of importance. McCarthy uses the example of fund-raising to make her point about the importance of the chair acting as a role model and mentor for the CEO. For example, in relation to fund-raising, she says,

> There have to be opportunities for management to do things on their own and to get credit for it. If you know that someone is likely to give you money, it's a nice thing to be able to send someone else to get it, so the other person can come back and say "Wow, I got $200,000 or $20,000 or $10,000 from someone. Wendy introduced me, but I did the pitch." I don't think not-for-profits can achieve their goals unless they've got a board that knows how to work with management, constantly reevaluate, to keep that tension between vision and action.

An important aspect of arts governance is the art form and the interaction with the events around it that engage artists, audiences, managers, and board members. Traditionally, board members are expected to attend some events. From a governance perspective, the event is a means of blurring the boundaries between the passion of the art and the opportunities for networking and mentoring through meeting people. McCarthy understands the difference between the role of the chair and the role of management, referred to metaphorically as steering, not rowing:

> I want the board to role model, to set good standards. I don't want the board micro-managing. I want them to share their contacts. I want them to learn what the business is about. I expect them to turn up to the shows, if it's an arts organization.

However, McCarthy is not averse to stepping in to "start a private fund-raising program" if necessary, "with the consent of management" and when management is stretched beyond capacity. She reminds us how ubiquitous fund-raising is for the not-for-profit arts board. However, since Circus Oz is a small, flat organization with few specialist staff outside the artistic focus, starting a major fund-raising campaign is a more hands-on responsibility of the board, led by direct action by the chair, than might be the case in a larger nonprofit arts organization. The major fund-raising program seeks to raise money for the new premises of Circus Oz:

> The next thing now for me is to start the private fund-raising program. I want to do the private fund-raising, not because it's going to raise a vast amount of money, but because I want to demonstrate to the government that there is community support for what we're doing.

The steep learning curve for McCarthy and the imperfections of governance were evident in comments she made. For example, when she served with the National Trust, an organization undergoing significant cultural change,

> The status of volunteers was at the heart of the trust's management dilemma and, surprisingly, individual philanthropy was not part of the trust culture.[29]

THEME 3: STRATEGIC INSIGHTS

Strategic insights refer to the need for high-level oversight and foresight in governance, making the most of opportunities to move the organization forward by strategic decision making. McCarthy has a reputation for "getting things done," networking widely and developing people. She uses her experience and profile to move the agenda forward, bringing the people and organizations she serves with her on her journey. Not all her strategies have been successful. McCarthy is open about the tensions in a system of governance that relies increasingly on commercial successes to underpin social experiences and the role of stakeholders in those successes. Such tensions were evident in decisions about finances and funding, policy development, organizational growth, and appointment of key people to leadership roles. McCarthy's insights reflect the spirit of the times, their importance, and the increasingly strategic nature of decision making.

McCarthy's education and work as a teacher helped her in her developmental roles on boards. The role of the arts and the business of the arts clash on occasions, with people and positions and governance cultures not always aligned to the new realities of stakeholder engagement. Clashes between old and new cultures, between amateur and professional approaches to the business of the arts, and the adversarial nature of strategic encounters were evident in McCarthy's autobiography *Don't Fence Me In*, published in 2000.

Due to the diversity of people on a not-for-profit arts board, it is vital to be clear about the mission of the organization and to invest in people on the board who can provide the required skill sets for the large projects that the board undertakes. McCarthy says,

> Yes, we focus on the mission. At Circus Oz we have been given A\$15 million (\$1 USD equals \$1.08 A) from the government for our new home. We now have to focus on our new premises. We have to move into new premises over the next eighteen months.

McCarthy explains a paradox of the nonprofit arts board: while steering, not rowing, is the perceived board role, when a large project is to be undertaken in a domain that is not part of the core mission of the circus, a more hands-on approach to governance is adopted. Circus Oz does not have people with experience in a major construction project. Rather than employ a construction manager (which the circus cannot afford), a new board member with specific skills in construction project

management takes on that role. However, McCarthy makes the point that the more hands-on role of the board is undertaken "with the consent of management":

> We will start a major fund-raising campaign, because we need facilities and an extra $5 million from the community campaign. I brought skilled people on the board, as I'm asking the board to lead some of the management work with the consent of management. I invited onto the board the CEO of Transfield Services, a major infrastructure engineering company. My rationale was that we need relevant expertise on the board. We need someone with engineering, big building experience and we need someone who's really smart with money.

Government has provided Circus Oz with significant funds to enable the company to move to new premises in Collingwood, in inner urban Melbourne. The new premises will be tailor-designed to the needs of the circus, requiring a new skill set for managing a large construction project. The new skill set is not part of the core business of a circus. McCarthy made it clear that the board is going to take responsibility for it, leaving the management team free to fulfill the organizational mission, a creative mission. This is an important point, as McCarthy explains:

> I invited a major investment banker onto the board and together with our infrastructure specialist, they have been keen advocates on the new project, working in partnership with government.

Having business people on the board of a not-for-profit arts organization is a vexed issue. McCarthy discussed their role and the key role of the chair in steering discussions to areas of importance for the board, such as the topic of mission and investing in people.

> Circus Oz needs to bring people onto the board, embed them in a Circus Oz culture, which is a really flat structure. Coming from a hierarchal work place, this is challenging.
>
> The biggest problem on arts boards is business people asked for their business expertise who think they've been asked for artistic merit. They immediately start telling management how to program: "My wife wouldn't like that." That's a good line . . . or "I've got a daughter who plays piano and she'd never come to anything like that." It's a trivialization and the chair must not allow it. If it happens, the chair has to be mature enough to manage it. The chair is first among equals, in terms of setting the tone of what's acceptable.

McCarthy is clear about the role of the chair of the board. She sees the role as enabling the management team to do its job while she does her job. She explains that protocols need to be in place to clarify the roles. Her language is sometimes colorful, forceful, as is her personality, while not overstepping the mark as regards ethical precepts:

> It demonstrates the importance of the chair, of conducting a conversation and creating the rule book. People know when they've gone too far. When we go

onto these boards, they're mostly things of the heart. We're flattered if someone asks us to an area that is really not our expertise. We forget that governance is our expertise, but the content matter of this particular issue may not be our expertise. I was taught at the ABC that the director's role is not to discuss programs. If management invites us to offer our comments as citizens, we may or may not do it, but we don't want to get down there, because that's what we hired them to do.

If you're a good board with good directors, you have protocols in place. You have protocols about whistle-blowing, about handling complaints, about diversity. For example, the board might decide, in discussion with management, to have at least one woman director, or one woman playwright, or three Australian plays or two comedies or two dramas, because that's what the demographic information and the audience research have told us is expected of this particular theater. It reflects the community in which the theater is located. That's why people come here. They like that sort of variety. If they want to go to musicals, they go to another theater.

If that's the policy and protocol for the season, the board can get the hell out of the way. It's up to management to choose what it is. They can come back to the board for advice, but its advice, not a resolution. It's not a firm agreement; they don't have to stick with it. I have nothing whatsoever to do with the Circus Oz programming, in terms of content or hire. I listen to what they say.

McCarthy combines her perceived role as leader of the board with her other perceived roles of coach and mentor, developing both board members and the executive:

If executives are able to meet, for example, the CEO or the chair of another organization where I've obtained an entrée, they go with my blessing. The days of the chair or directors doing a handshake with a slush fund are over. I may prefer them to talk to the management team.

McCarthy's comments on making board meetings enjoyable demonstrate her leadership credentials by challenging board members to take their engagement to another level in order to make her chairmanship worthwhile. However, she also wants to make the time that volunteer board members spend on the board seem a worthwhile experience:

It is the role of the chair to make board meetings enjoyable. I remember on one board people said, "We've never . . . enjoyed a board meeting in our life." I replied, "Well, if you don't enjoy board meetings after I've been here a year, I'm leaving." Why would you go otherwise?

Supporting and developing your people is another key role of the chair of the board. This is a strategic issue, especially in a small, cash-strapped, nonprofit arts organization. Good people are scarce; they need to be nurtured so that growth can

occur and they can give their best to the organization. McCarthy's view is at odds with the view of some who see people as disposable:

> People say, "We'll go and get another one." I say, "Where? Where do you get one?" You have to invest in people and support them. If you do, it brings rewards, or you find clarity. If you don't, you'll never know whether that person could have made it. You'll probably come across them six months later and find that they are flourishing somewhere else. You could have saved yourself the pain and expense of changing them.

DISCUSSION

The key outcomes from this case study—a description of the lived experience of the chair of a nonprofit arts board over time—are both similar to and different from those in other nonprofit studies of boards. First, this study is similar to other studies in that the role of the chair is that of a broker, a change agent (here using skills honed in the women's movement), whose highest attribute is common sense and the ability to make strategic decisions in the best interests of the organization. Decisions are made based partly on strategy, with research provided by management, but also on the more extensive and bird's-eye experience that board members and especially the chair bring to the board from the world of business and their experience of other nonprofit organizations.

This leads to the second point. The chair of the board is a role model. She understands the role of management and the need to support it. However, she is prepared to take charge when the organization needs direction, such as when a project is beyond the ken of the professional management team. In some instances, this may lead to a more hands-on role for directors on the nonprofit arts board than is the case on commercial boards. Given the small, flat nature of many nonprofit arts organizations, with few specialist skills outside the creative domain, it falls on the board to take direct action when a major new project is undertaken. This is done with management consent. This outcome differs from results obtained in other studies, such as Forbes and Milliken,[30] which show that boards do not undertake operational matters, even with management approval. The contribution to theory of this case reinforces the holistic nature of the experience of leading a nonprofit arts board in a feminist, strategic, and volunteer board environment in organizations that are professionalizing their governance. Furthermore, the motivating nature of the chair in leading the board and the organization in key strategic decision making and activity, such as constructing new premises, is confirmed as a central plank in success.

In the commercial and wider nonprofit literature, there has been a reluctance to engage with issues such as this. The current study emphasizes the importance of board direct action to enable small, nimble nonprofit arts organizations to undertake major projects.

One of the main contributions of this case study is to validate the power of individuals by giving them a voice. Its benefits are motivating as well as strategic in the

investigative process. This topic requires additional investigation. The intention is to follow up this study with additional interviews of women on nonprofit boards.

LIMITATIONS OF THIS STUDY

As in other qualitative studies in which one person is central to the data gathered and analyzed, generalization here is not possible, nor is it desirable. The purpose of this study is not to seek to generalize but to dig deep into the lived experience of the person interviewed.[31] This study values the experience of the interviewee but may be open to criticism as not providing a wide enough scope in addressing the issues.

Most board research has been conducted in the for-profit sphere, with a growing literature in the nonprofit realm as well as in the area of diversity.[32] This study adds to that literature. In the nonprofit arts domain, scant attention has been paid to the role of women on boards.

CONCLUSIONS

This paper has described and explained the lived experience of the chair of the board of Circus Oz, a major performing arts company in Melbourne, Australia. She has explained the role of the chair from her perspective. The concept of steering, not rowing, has been called into question for the nonprofit arts board under certain conditions, due to the small, flat structure of many arts organizations and the need for the board to provide expertise that is not found in management nor affordable for the company. Understanding a feminist viewpoint provides a difference to this nonprofit arts board research. These findings diverge from the widely held view about the role of the board and especially the chair of the board. The second key perspective offered by the study is the role of a woman as chair of the board, a rare occurrence in some domains at that level of the organization. The voice of the female chair, whose role may not differ from that of her male compatriots, is nonetheless a role model in a male world at the top echelons of the organization. In this way, hermeneutic phenomenology may be an empowering research strategy, giving voice where one is rarely heard.

NOTES

1. Wendy McCarthy, "Daughters of the revolution: In a documentary without a script," *Griffith Review* 32 (Winter 2011), 48–57.
2. Daniel P. Forbes and Frances J. Milliken, "Cognition and corporate governance: Understanding boards of directors as strategic decision-making groups," *Academy of Management Review* 24, no. 3 (1999), 500; Australian Institute of Company Directors, *Directors Social Impact Study 2011* (Sydney: AICD and Centre for Social Impact, September 2011).
3. David Shilbury, Lesley Ferkins, and Liz Smythe, "Sport governance encounters: Insights from lived experiences," *Sport Management Review* 16, no. 3 (2013), 349–363.
4. Nuno S. Themudo, "Gender and the non-profit sector," *Nonprofit and Voluntary Sector Quarterly* 38, no. 4 (2009), 663–683.

5. Elayne Clift (ed.), *Women, Philanthropy and Social Change: Visions for a Just Society* (Medford, MA: Tufts University Press, 2005); Wendy McCarthy, *Don't Fence Me In* (Sydney: Random House Australia, 2000).

6. Siri Terjesen, Ruth Sealy, and Val Singh, "Women directors on corporate boards: A review and research agenda," *Corporate Governance* 17, no. 3 (2009), 320–337.

7. Peter George, "Skin and bones," *Four Corners*, Australian Broadcasting Corporation, September 29, 2003.

8. John Uhrig, *Review of Corporate Governance of Statutory Authorities and Office Holders; or, The Uhrig Report* (Canberra: Commonwealth of Australia, 2003), www.finance.gov. au/financial-framework/governance/review_corporate_governance.html; Victorian Public Administration Act, Australasian Legal Information Institute, 2004, www.austlii.edu.au/au/ legis/vic/consol_act/paa2004230/.

9. Zilla Efrat, "Not-for-profit governance," *Company Director* 27, no. 9 (October 2011), 40–42.

10. Johanne Turbide, Claude Laurin, Laurent Lapierre, and Raymond Morrissette, "Financial crises in the arts sector: Is governance the illness or the cure?" *International Journal of Arts Management* 10, no. 2 (2008), 4–13.

11. Australian Institute of Company Directors, *Directors Social Impact Study.*

12. Andrew Pettigrew, "On studying managerial elites," *Strategic Management Journal* 13, no. S2 (1992), 163–182; Turbide et al., "Financial crises in the arts sector"; Susan Woodward and Shelley Marshall, *A Better Framework: Reforming Not-for-Profit Regulation* (Victoria: Centre for Corporate Law and Securities Regulation, University of Melbourne, August 2004); Helen Nugent, *Securing the Future: Final Report (Nugent Inquiry)* (Canberra: Commonwealth of Australia, 1999).

13. Susann Laverty, "Hermeneutic phenomenology and phenomenology: A comparison of historical and methodological considerations," *International Journal of Qualitative Methods* 2, no. 3 (2003), 21–35.

14. Berit Skirstad, "Gender policy and organizational change: A contextual approach," *Sport Management Review* 12, no. 4 (2009), 202–216; Nicholas van der Walt and Coral Ingley, "Board dynamics and the influence of professional background, gender and ethnic diversity of directors," *Corporate Governance* 11, no. 3 (2003), 218–234; Sabina Nielsen and Morten Huse, "The contribution of women on boards of directors: Going beyond the surface," *Corporate Governance* 18, no. 2 (2010), 136–148.

15. Jim McKenna and Michael Whatling, "Qualitative accounts of urban commuter cycling," *Health Education* 107, no. 5 (2007), 448–462.

16. McCarthy, *Don't Fence Me In*, 1.

17. Jon Hawkes, "The history of Circus Oz," www.circopedia.org/Circus_Oz.

18. Ibid.

19. Circus Oz, *Annual Report 2010* (Melbourne: Circus Australia Limited, 2010), 3.

20. Hawkes, "History of Circus Oz."

21. McCarthy, *Don't Fence Me In*, 168.

22. Richard Aedy, "Mentoring: Wendy McCarthy," *Life Matters*, ABC Radio National (Australia), August 13, 2008; McCarthy, *Don't Fence Me In.*

23. McCarthy, *Don't Fence Me In*, 181.

24. McCarthy, "Daughters of the revolution," 50.

25. McCarthy, *Don't Fence Me In*, 167.

26. Ibid., 180.

27. Richard Aedy, "Leading by example: Wendy McCarthy," *Life Matters*, ABC Radio National (Australia), April 21, 2011.
28. McCarthy, *Don't Fence Me In*, 229.
29. Ibid.
30. Forbes and Milliken, "Cognition and corporate governance."
31. McKenna and Whatling, "Qualitative accounts of urban commuter cycling."
32. Terjesen, Sealy, and Singh, "Women directors on corporate boards."

References

Adler, Nancy J. 2006. The arts and leadership: Now that we can do anything, what will we do? *Academy of Management Learning & Education* 5, no. 4, 486–499.

Ajzen, Icek. 1991. The theory of planned behavior. *Organizational Behavior and Human Decision Processes* 50, 179–211.

Ajzen, Icek, and Thomas J. Madden. 1986. Prediction of goal-directed behavior: Attitudes, intentions, and perceived behavioral control. *Journal of Experimental Social Psychology* 22, no. 5 (September), 453–474.

Allison, Henry E. 2001. *Kant's Theory of Taste: A Reading of the Critique of Aesthetic Judgment*. Cambridge: Cambridge University Press.

American Marketing Association (AMA). 2004. About AMA: Marketing research. October. www.ama.org/AboutAMA/Pages/Definition-of-Marketing.aspx.

———. 2013. About AMA: Marketing. July. www.ama.org/AboutAMA/Pages/Definition-of-Marketing.aspx.

Americans for the Arts. 2007. *Arts & Economic Prosperity III: The Economic Impact of Nonprofit Arts and Culture Organizations and Their Audiences*. Washington, DC: Americans for the Arts.

———. N.d. Creative industries. www.americansforthearts.org/by-program/reports-and-data/research-studies-publications/creative-industries.

Andreasen, Alan R. 1992. *Expanding the Audience for the Performing Arts*. Santa Ana, CA: Seven Locks Press.

Andreasen, Alan R., and Philip Kotler. 2008. *Strategic Marketing for Nonprofit Organizations*. 7th ed. Upper Saddle River, NJ: Prentice Hall.

Armstrong, Paula. 2002. Open Studios—a growing event. *Arts Professional*, January 14. www.artsprofessional.co.uk/magazine/article/open-studios-growing-event.

Ashenfelter, Orley, and Katheryn Graddy. 2006. Art auctions. In *Handbook of the Economics of Art and Culture*, ed. Victor A. Ginsburgh and David Throsby, 909–945. Amsterdam: Elsevier North-Holland.

Association of Fundraising Professionals (AFP). 2003. *The AFP Fundraising Dictionary Online*. www.afpnet.org/files/ContentDocuments/AFP_Dictionary_A-Z_final_6-9-03.pdf.

Azad, Abul Kalam. N.d. *Rock 'n Roll in Bangladesh: Protecting Intellectual Property Rights in Music*. Managing the Challenges of WTO Participation: Case Study 3. www.wto.org/english/res_e/booksp_e/casestudies_e/case3_e.htm#context.

Bank of America. N.d. Global impact: Arts & culture—encouraging those who enrich us all. http://about.bankofamerica.com/en-us/global-impact/arts-and-culture.html#fbid=EzUoa-MMp1X.

Bannerman, Sara. 2013. Crowdfunding culture. *Journal of Mobile Media* 7, no. 1, 1–30.

Barbara, Ronald L. 2012. Crowdfunding: trends and developments impacting entertainment entrepreneurs. *Entertainment, Arts, and Sports Law Journal* 23, no. 2, 38–40.

Barber, Robin. 1990. The Greeks and their sculpture. In *Owls to Athens: Essays on Classical Subjects Presented to Sir Kenneth Dover*, ed. E.M. Craik. Oxford: Clarendon Press.

Barclays. 2012. *Profit or Pleasure? Exploring the Motivations Behind Treasure Trends*. Wealth Insights, vol. 15. London: Barclays. www.ledburyresearch.com/media/document/barclays-wealth-insight-volume-15.pdf.

Barrere, Alain (ed.). 1988. *The Foundation of Keynesian Analysis*. New York: Macmillan Press.

Basel, S.T. 2012. The art market: Why buy art? *The Economist*, June 22. www.economist.com/blogs/prospero/2012/06/art-market.

Bateman, Bradley W., and John B. Davis (eds.). 1991. *Keynes and Philosophy: Essays on the Origin of Keynes's Thought*. Aldershot, UK: Edward Elgar.

Batra, Rajeev, and Olli T. Ahtola. 1990. Measuring the hedonic and utilitarian sources of consumer attitudes. *Marketing Letters* 2 (April), 159–170.

Baudrillard, Jean. 1981. *For a Critique of the Political Economy of the Sign*, trans. Charles Levin. St. Louis, MO: Telos Press.

Baumol, William J. 2006. The arts in the 'new economy.' In *Handbook of the Economics of Art and Culture*, ed. Victor A. Ginsburgh and David Throsby, 339–358. Amsterdam: Elsevier North-Holland.

Baumol, William J., and William G. Bowen. 1966. *Performing Arts: The Economic Dilemma*. Cambridge, MA: MIT Press.

Beardsley, Monroe C. 1966. *Aesthetics from Classical Greece to the Present: A Short History*. New York: Palgrave Macmillan.

———. 1982. *The Aesthetic Point of View*. Ithaca, NY: Cornell University Press.

Beaven, Zuleika, and Chantal Laws. 2007. Service quality in arts events: Operations management strategies for effective delivery. *Event Management* 10, no. 4, 209–219.

Becker, Gary S. 1996. *Accounting for Tastes*. Cambridge, MA: Harvard University Press.

Becker, Gary S., and Kevin M. Murphy. 1988. A theory of rational addiction. *Journal of Political Economy* 96, no. 4 (August), 675–700.

Belch, George E., and Michael A. Belch. 2012. *Advertising and Promotion: An Integrated Marketing Communications Perspective*. 8th ed. New York: McGraw-Hill/Irwin.

Belk, Russell V. 2012. The sacred in consumer culture. In *Consumption and Spirituality*, ed. D. Rinallo, L. Scott, and P. Maclaran, 69–80. New York: Routledge.

Belk, Russell W., Melanie Wallendorf, and John F. Sherry Jr. 1989. The sacred and the profane in consumer behavior: Theodicy on the odyssey. *Journal of Consumer Research* 16 (June), 1–38.

Bennett, Anne Barclay. 1993. *The Management of Philanthropic Funding for Institutional Stabilization: A History of Ford Foundation and New York City Ballet Activities*. New York: Garland.

Benston, Liz. 2004. Judge rejects claim for 'cirque' name. *Las Vegas Sun News*, April 23. www.lasvegassun.com/news/2004/apr/23/judge-rejects-claim-for-cirque-name/.

Berry, Leonard L., and John H. Kunkel. 2002. In pursuit of consumer theory. In *Consumer Behaviour Analysis: Critical Perspectives on Business and Management*, Vol. 1: *The Behavioural Basis of Consumer Choice*, ed. G.R. Foxall, 35–49. New York: Routledge.

Bettman, James R. 1979. *An Information Processing Theory of Consumer Choice*. Reading, MA: Addison-Wesley.

Boardman, John. 1996. *Greek Art*. 4th ed. New York: Thames & Hudson.

Boerner, Sabine, and Sabine Renz. 2008. Performance measurement in opera companies: Comparing the subjective quality judgments of experts and non-experts. *International Journal of Arts Management* 10, no. 3, 21–37.

Bothwell, Robert. 1999. *Canada and Québec: One Country Two Histories*. Vancouver: University of British Columbia Press.

Bothwell, Robert, Ian Drummond, and John English. 1981. *Canada since 1945: Power, Politics, and Provincialism*. Toronto: University of Toronto Press.

Botti, Simona. 2000. What role for marketing in the arts? An analysis of art consumption and artistic value. *International Journal of Arts Management* 2, no. 3, 14–27.

Bourdieu, Pierre. 1984. *Distinction: A Social Critique of the Judgment of Taste*, trans. Richard Nice. Cambridge, MA: Harvard University Press.

———. 1993. *The Field of Cultural Production*, ed. R. Johnson. New York: Columbia University Press.

———. 1996. *The Rules of Art, Genesis and Structure of the Literary Field*, trans. Susan Emanuel. Cambridge: Polity Press.

Brenkert, George G. 2002. Entrepreneurship, ethics, and the good society. *Entrepreneurship and Ethics* 3, 5–43.

Brooks, Arthur C. 2006. Nonprofit firms in the performing arts. In *Handbook of the Economics of Art and Culture*, ed. V.A. Ginsburgh and D. Throsby, 473–506. Amsterdam: Elsevier North-Holland.

Brooks, Arthur C., and Jan I. Ondrich. 2007. Quality, service level, or empire: Which is the objective of the nonprofit cultural arts firm? *Journal of Cultural Economics* 31, no. 2, 129–142.

Brown, Alan S., and Rebecca Ratzkin. 2011. *Making Sense of Audience Engagement*, Vol. 1: *A critical assessment of efforts by nonprofit arts organizations to engage audiences and visitors in deeper and more impactful arts experiences*. San Francisco: San Francisco Foundation.

Brown, Terrence E., Per Davidsson, and Johan Wiklund. 2001. An operationalization of Stevenson's conceptualization of entrepreneurship as opportunity-based firm behavior. *Strategic Management Journal* 22, no. 10, 953–968.

Bucar, Branko, and Robert Hisrich. 2001. Ethics of business managers vs. entrepreneurs. *Journal of Developmental Entrepreneurship* 1, no. 1, 59–83.

Budd, Malcolm. 1998. Aesthetics. In *Routledge Encyclopedia of Philosophy*, ed. E. Craig. London: Routledge. www.rep.routledge.com/article/M046.

Business Committee for the Arts. 1984. Building community—business and the arts: Remarks by Ralph P. Davidson and J. Burton Casey. New York: Business Committee for the Arts.

Byrnes, William J. 2009. *Management and the Arts*. 4th ed. New York: Elsevier Focal Press.

Cambridge Dictionaries Online. Succession planning. http://dictionary.cambridge.org/us/dictionary/business-english/succession-planning.

Campbell, Alexandra. 2003. Creating customer knowledge competence: Managing customer relationship management programs strategically. *Industrial Marketing Management* 32, 375–383.

Carnegie Mellon University. N.d. Policy for use of Carnegie Mellon trademarks. www.cmu.edu/policies/documents/Trademark.html.

Cascio, Wayne F. 2000. Managing a virtual workplace. *Academy of Management Executive* 14, no. 3 (August), 81–90.

Caves, Richard E. 2000. *Creative Industries: Contracts Between Art and Commerce*. Cambridge, MA: Harvard University Press.

Cellini, Roberto, and Tiziana Cuccia. 2003. Incomplete information and experimentation in the arts: A game theory approach. *Economia Politica* 20, no. 1, 21–34.

Centre for Economics and Business Research (CEBR). 2013. *The Contribution of the Arts and Culture to the National Economy*. Report for Arts Council England and the National Museum Directors' Council, May. London: CEBR.

Chamberlin, John. 2011. Who put the 'art' in SMART goals? *Management Services* 55, no. 3 (Autumn), 22–27.

Charity Navigator. 2013. Financial ratings tables. www.charitynavigator.org/index.cfm?bay= content.view&cpid=48#.UryJJhZe_jg.

Chen, Yu. 2009. Possession and access: Consumer desires and value perceptions regarding contemporary art collection and exhibit visits. *Journal of Consumer Research* 35, no. 6, 925–940.

Chomsky, Noam. 1972. *Language and Mind*. New York: Harcourt Brace Jovanovich.

Christie's. 2013. Christie's attracts new collectors as global appeal for art continues to grow in 2012. Press release, January 17. www.christies.com/about/press-center/releases/pressrelease. aspx?pressreleaseid=6125.

Clarke, Mary. 1956. *The Sadler's Wells Ballet: A History and an Appreciation*. London: A. and C. Black.

Clifford, James. 1988. *The Predicament of Culture: Twentieth-Century Ethnography, Literature, and Art*. Cambridge, MA: Harvard University Press.

Cohen, Rick. 2012. Sarbanes-Oxley: Ten years later. *Nonprofit Quarterly*, December 30. http:// nonprofitquarterly.org/governancevoice/21563-sarbanes-oxley-ten-years-later.html.

Cohen, Susan G., and Diane E. Bailey. 1997. What makes teams work: Group effectiveness research from the shop floor to the executive suite. *Journal of Management* 23, no. 3, 239–290.

Colbert, François. 2012. *Marketing Culture and the Arts*. 4th ed. Montreal: HEC Montréal.

Collins, James C. 2001. *Good to Great: Why Some Companies Make the Leap . . . and Others Don't*. New York: HarperBusiness.

Collins, James C., and Jerry Porras. 1994. *Built to Last: Successful Habits of Visionary Companies*. New York: HarperBusiness.

Crane, Frederick G. 2009. Ethics, entrepreneurs and corporate managers: A Canadian study. *Journal of Small Business and Entrepreneurship* 22, no. 3. www.freepatentsonline.com/article/ Journal-Small-Business-Entrepreneurship/213225828.html.

Crawford, Donald W. 1974. *Kant's Aesthetic Theory*. Madison: University of Wisconsin Press.

Cray, David, Loretta Inglis, and Susan Freeman. 2007. Managing the arts: Leadership and decision making under dual rationalities. *Journal of Arts Management, Law, and Society* 36, no. 4, 295–313.

Crealey, Maria. 2003. Applying new product development models to the performing arts: Strategies for managing risk. *International Journal of Arts Management* 5, no. 3, 24–33.

Cronin, J.J., M.K. Brady, and G.T.M. Hult. 2000. Assessing the effects of quality, value, and customer satisfaction on consumer behavioral intentions in service environments. *Journal of Retailing* 76, no. 2, 193–218.

Crow, Kelly. 2013. In Miami, crowds and confidence. *Wall Street Journal*, December 5. http:// online.wsj.com/news/articles/SB10001424052702303997604579240493758072908.

Csikszentmihalyi, Mihaly. 1975. *Beyond Boredom and Anxiety*. San Francisco: Jossey-Bass.

Cunningham, Stuart. 2004. The creative industries after cultural policy: A genealogy and some possible preferred futures. *International Journal of Cultural Studies* 7, no. 1, 105–115.

Dallas Museum of Art. 2014. Dashboard. http://dashboard.dma.org/.

Davis, J. Charlene, and Scott R. Swanson. 2009. The importance of being earnest or committed: Attribute importance and consumer evaluations of the live arts experience. *Journal of Nonprofit & Public Sector Marketing* 21, no. 1, 56–79.

Delgado, Mercedes, Michael E. Porter, and Scott Stern. 2010. Clusters and entrepreneurship. *Journal of Economic Geography* 10, no. 4, 1–24.

destinationCRM.com. 2010. What is CRM? February 19. www.destinationcrm.com/Articles/CRM-News/Daily-News/What-Is-CRM-46033.aspx.

de Valois, Ninette. 1977. *Step by Step*. London: W.H. Allen.

Dickie, George. The Myth of the Aesthetic Attitude, *American Philosophical Quarterly*, 1, 1, 1964, 56–65.

Dictionary.com. N.d. Aesthetics. http://dictionary.reference.com/browse/aesthetics.

———. N.d. Fine art. http://dictionary.reference.com/browse/fine+art.

———. N.d. Corporate restructuring. http://dictionary.reference.com/browse/corporate+restructuring.

———. N.d. Lifestyle. http://dictionary.reference.com/browse/lifestyle.

Dijksterhuis, Ap, and Teun Meurs. 2005. Where creativity resides: The generative power of unconscious thought. *Consciousness and Cognition* 15, no. 1, 135–146.

DiMaggio, Paul. 1987. Classification in art. *American Sociological Review* 52, no. 4, 440–455.

———. 2006. Nonprofit organizations and the intersectoral division of labor in the arts. In *The Nonprofit Sector: A Research Handbook* (2nd ed.), ed. Walter W. Powell and Richard Steinberg, 432–461. New Haven, CT: Yale University Press.

Dimand, Robert W. 1988. The development of Keynes's theory of unemployment. In *Keynes and Public Policy After Fifty Years*, Vol. 1: *Economics and Policy*, ed. O.F. Hamouda and J.N. Smithin. New York: New York University Press.

Dixon, Julie, and Denise Keyes. 2013. The permanent disruption of social media. *Stanford Social Innovation Review* (Winter).

Dobrzynski, Judith H. 2013. The art of the hunt. *New York Times*, April 28.

Douglas, Mary, and Baron Isherwood. 1996. *The World of Goods: Towards an Anthropology of Consumption*. Rev. ed. New York: Routledge.

Drucker, Peter. 1990. *Managing the Non-Profit Organization*. Oxford: Butterworth Heinemann.

du Cros, Hilary, and Lee Jolliffe. 2011. Bundling the arts for tourism to complement urban heritage tourist experiences in Asia. *Journal of Heritage Tourism* 6, no. 3, 181–195.

Dundas Data Visualization. N.d. The art of dashboard design. www.dundas.com/discover/article/the-art-of-dashboard-design/.

The Economist. 2003. Just the two of us: The duopology in fine-art auctions is weakened but very much alive. February 27. www.economist.com/node/1612774.

Eggen, Dan. 1999. In Williamsburg, the painful reality of slavery. *Washington Post*, July 7.

ElBoghdady, Dina, and J.D. Harrison. 2013. SEC proposes 'crowdfunding' rules for start-up businesses. *Washington Post*, October 23.

Elkins, James (ed.). 2006. *Art History versus Aesthetics*. New York: Routledge.

Emmons, William R. 2012. Don't expect consumer spending to be the engine of economic growth it once was. *Regional Economist* (January). www.stlouisfed.org/publications/re/articles/?id=2201.

Entrepreneur Media. N.d. Market research. *Entrepreneur.com*. www.entrepreneur.com/encyclopedia/market-research.

Fayena-Tawil, Frieda, Aaron Kozbelt, and Lemonia Sitaras. 2011. Think global, act local: A protocol analysis comparison of artists' and nonartists' cognitions, metacognitions, and evaluations while drawing. *Psychology of Aesthetics, Creativity, and the Arts* 5, no. 2, 135–145.

Förster, Eckart. 2000. *Kant's Final Synthesis: An Essay on the Opus Postumum*. Cambridge, MA: Harvard University Press.

Frey, Bruno S. 2000. *Arts & Economics: Analysis & Cultural Policy*. Berlin: Springer-Verlag.

Frey, Bruno S., and Reiner Eichenberger. 1995. On the rate of return in the art market: Survey and evaluation. *European Economic Review* 39, 528–537.

Frohlich, Markham T., and Roy Westbrook. 2001. Arc of integration: An international study of supply chain strategies. *Journal of Operations Management* 19, no. 2, 186–200.

Frumkin, Peter. 2012. Changing environment: New forms, actors, and instruments. National Arts Strategies and RGK Center for Philanthropy and Community Service, University of Texas at Austin. www.artstrategies.org/downloads/Changing_Environment.pdf.

Gabrielsson, Mika, and V.H. Manek Kirpalani. 2004. Born globals: How to reach new business space rapidly. *International Business Review* 13, no. 5, 555–571.

Galbraith, John Kenneth. 1960. *The Liberal Hour*. London: Hamish Hamilton.

———. 1998. *The Affluent Society*. Boston: Houghton Mifflin.

Galloway, Susan, and Stewart Dunlop. 2007. A critique of definitions of the cultural and creative industries in public policy. *International Journal of Cultural Policy* 13, no. 1, 17–31.

Gardner, Howard. 1993. Seven creators of the modern era. In *Creativity*, ed. J. Brockman. New York: Simon & Schuster.

Garnham, Nicolas. 2005. From cultural to creative industries: An analysis of the implications of the "creative industries" approach to arts and media policy making in the United Kingdom. *International Journal of Cultural Policy* 11, no. 1, 15–29.

Gates Family Foundation. 2007. *Facility Expansion & Renovation: Planning for Capital Projects & Campaigns*. Denver, CO: GFF. www.gatesfamilyfoundation.org/sites/default/files/field_intro_file_1/Facility%20Planning%20Guide.pdf.

Gay, Peter. 1995. *The Bourgeois Experience: Victoria to Freud*, Vol. 4: *The Naked Heart*. New York: Oxford University Press.

Genocchio, Benjamin. 2012. Auction houses versus private sales: What is the future of buying art? *Blouin ArtInfo*, April 10. www.blouinartinfo.com/news/story/830496/auction-houses-versus-private-sales-what-is-the-future-of.

Ghisi, Marc Luyckx. 2010. Towards a transmodern transformation of our global society: European challenges and opportunities. *Journal of Futures Studies* 15, no. 1, 39–48.

Ginsburgh, Victor A., and David Throsby (eds.). 2006. *Handbook of the Economics of Art and Culture*. Amsterdam: Elsevier North-Holland.

Glaeser, Edward, and Andrei Shleifer. 2001. Not-for-profit entrepreneurs. *Journal of Public Economics* 81, no. 1, 99–115.

Golden, Linda L., Patrick L. Brockett, John F. Betak, Karen H. Smith, and William W. Cooper. 2012. Efficiency metrics for nonprofit marketing/fundraising and service provision: A DEA analysis. *Journal of Management & Marketing Research* 9, 1–25.

Gomez, Evangeline. 2012. The rise of the charitable for-profit entity. *Forbes*, January 13. www.forbes.com/sites/evangelinegomez/2012/01/13/the-rise-of-the-charitable-for-profit-entity/.

Gopnik, Blake. 2011. Why is art so damned expensive? *Newsweek*, December 5. http://mag.newsweek.com/2011/12/04/why-is-art-so-damned-expensive.html.

Gordon-Reed, Annette. 2013. Critics of the liberal arts are wrong: Yes, science and tech are important, but a new report shows that employers prize a more broadly-based education. *Time*, June 19. http://ideas.time.com/2013/06/19/our-economy-can-still-support-liberal-arts-majors/.

Graeber, David. 2001. *Toward an Anthropological Theory of Value: The False Coin of Our Own Dreams*. New York: Palgrave.

Green, Peter, 1993. *Alexander to Actium: The Historical Evolution of the Hellenistic Age*. Berkeley: University of California Press.

Grove, Stephen J., and Raymond P. Fisk. 1992. The service experience as theater. In *NA—Advances in Consumer Research* 19, 455–461.

Grubb, Edward L., and Harrison L. Grathwohl. 1967. Consumer self-concept, symbolism and marketing behavior: A theoretical approach. *Journal of Marketing* 31, 22–27.

Guiltinan, Joseph P. 1987. The price bundling of services: A normative framework. *Journal of Marketing* 51, no. 2, 74–85.

Hagedorn, Katherine. 2006. From this one song alone, I consider him to be a holy man: Ecstatic religion, musical affect, and the global consumer. *Journal for the Scientific Study of Religion* 45, no. 4, 489–496.

Hamaoui, Jeff. 2006. Creating a hybrid for-profit/non-profit social enterprise structure. *Skoll World Forum*, September 25. http://skollworldforum.org/2006/09/25/creating-a-hybrid-for-profit-non-profit-social-enterprise-structure/.

Hamouda, Omar F., and John N. Smithin (eds.). 1988. *Keynes and Public Policy After Fifty Years*, Vol. I: *Economics and Policy*. New York: New York University Press.

Hansmann, Henry. 1981. Nonprofit enterprise in the performing arts. *Bell Journal of Economics* 12, no. 2, 341–361.

Hart, Jim. N.d. What if . . . artists were trained as entrepreneurs? *TCG Circle*. www.tcgcircle.org/2011/05/what-if-artists-were-trained-as-entrepreneurs/.

Hausmann, Andrea. 2010. German artists between bohemian idealism and entrepreneurial dynamics: Reflections on cultural entrepreneurship and the need for start-up management. *International Journal of Arts Management* 12, no. 2 (Winter), 17–29.

Haye, Julia. 2010. So you think you can steal my dance? Copyright protection in choreography. *Law Law Land*, September 13. www.lawlawlandblog.com/2010/09/so_you_think_you_can_steal_my.html.

Hayman, Keith. 2002. Open Studios—Opening up the arts. *Arts Professional*, January 14. www.artsprofessional.co.uk/magazine/article/open-studios-opening-arts.

Haynie, Michael, and Dean Shepherd. 2009. A measure of adaptive cognition for entrepreneurship research. *Entrepreneurship Theory and Practice* 33, no. 3, 695–714.

Hayter, Chris, and Stephanie Casey Pierce. 2009. *Arts & the Economy: Using Arts and Culture to Stimulate State Economic Development*. Washington, DC: NGA Center for Best Practices, January 14. www.nga.org/files/live/sites/NGA/files/pdf/0901ARTSANDECONOMY.PDF.

Heilbrun, James, and Charles Gray. 2001. *The Economics of Art and Culture*. 2nd ed. New York: Cambridge University Press.

Hendon, William S. 1980. Introduction. In *Economic Policy for the Arts*, ed. William S. Hendon, James L. Shanahan, and Alice J. MacDonald. Cambridge: ABT Books.

Henry, Colette (ed.). 2007. *Entrepreneurship in the Creative Industries: An International Perspective*. Northampton: Edward Elgar.

Hill, Elizabeth, Catherine O'Sullivan, and Terry O'Sullivan. 2003. *Creative Arts Marketing*. 2nd ed. New York: Butterworth Heinemann.

Hirschman, Elizabeth C. 1983. Aesthetics, ideologies and the limits of the marketing concept. *Journal of Marketing* 47, no. 3 (Summer), 45–55.

Hirschman, Elizabeth C., and Morris B. Holbrook. 1982. Hedonic consumption: Emerging concepts, methods, and propositions. *Journal of Marketing* 46, no. 3, 92–101.

Hisrich, Robert D., Michael P. Peters, and Dean A. Shepherd. 2010. *Entrepreneurship*. 8th ed. New York: McGraw-Hill/Irwin.

Hogarth, William. 1753/1997. *The Analysis of Beauty*, ed. Ronald Paulson. New Haven, CT: Yale University Press.

Holbrook, Morris B., and Elizabeth C. Hirschman. 1982. The experiential aspects of consumption: Consumer fantasies, feelings, and fun. *Journal of Consumer Research* 9, no. 2 (September), 132–40.

Holt, Douglas B. 1995. How consumers consume: A typology of consumption practices. *Journal of Consumer Research* 22, no. 1, 1–16.

———. 2004. *How Brands Become Icons*. Boston: Harvard Business School Press.

Howlett, Michael, Alex Netherton, and M. Ramesh. 1999. *The Political Economy of Canada: An Introduction*. 2nd ed. Don Mill: Oxford University Press.

Hoyer, Wayne D., and Deborah J. MacInnis. 2010. *Consumer Behavior*. 5th ed. Mason, OH: Cengage Learning.

Hume, Margee. 2008. Understanding core and peripheral service quality in customer repurchase of the performing cultural arts. *Managing Service Quality* 18, no. 4, 349–369.

Hume, Margee, and Gillian Sullivan Mort. 2008. Satisfaction in performing cultural arts: The role of value? *European Journal of Marketing* 42, nos. 3/4, 311–326.

———. 2010. The consequence of appraisal emotion, service quality, perceived value and customer satisfaction on repurchase intent in the performing cultural arts. *Journal of Services Marketing* 24, no. 2, 170–182.

Hume, Margee, Gillian Sullivan Mort, Peter W. Liesch, and Hume Winzar. 2006. Understanding service experience in non-profit performing cultural arts: Implications for operations and service management. *Journal of Operations Management* 24, 304–324.

Huntington, Carla Stalling. 2003. Ninette de Valois, Lydia Lopokova and John Maynard Keynes, III; Economics and Ballet in London 1932–1942, Society of Dance History Scholars: *Proceedings of the Society of Dance History Scholars*, (Summer), 55–59.

———. 2004. Moving beyond the Baumol and Bowen cost disease in professional ballet: A 21st century pas de deux (dance) of new economic assumptions and dance history perspectives. PhD dissertation, University of California, Riverside.

———. 2007. Reevaluating segmentation practices and public policy in classical performing arts marketing: A macro approach. *Journal of Arts Management, Law, and Society* 37, no. 2, 127–141.

———. 2011. *Black Social Dance in Television Advertising: An Analytical History*. Jefferson, NC: McFarland.

Hutton, Stan. 2008. Endowments and arts organizations. *GIA Reader* 19, no. 1. www.giarts.org/article/endowments-and-arts-organizations.

Inc. N.d. Management Information Systems (MIS). www.inc.com/encyclopedia/management-information-systems-mis.html.

Indianapolis Museum of Art. N.d. Dashboard. http://dashboard.imamuseum.org/.

Investopedia.com. N.d. Restructuring. www.investopedia.com/terms/r/restructuring.asp.

James Irvine Foundation. 2011. Overview. http://irvine.org/grantmaking/our-programs/arts-program.

Juxtaposition Arts. 2013. Genius loci: part 1 (video). *YouTube*, December 23. www.youtube.com/watch?v=cgnN8X6RRQ4.

———. N.d. Our vision. Minneapolis, MN. http://juxtapositionarts.org/about/our-vision/.

Kant, Immanuel. 1790/1951. *Critique of Judgment*, trans. John Henry Bernard. New York: Hafner Press.

Kanter, Beth, and Katie Delahaye Paine. 2012. *Measuring the Networked Nonprofit: Using Data to Change the World*. San Francisco: Jossey-Bass.

Kaplan, Andreas M., and Michael Haenlein. 2010. Users of the world, unite! The challenges and opportunities of social media. *Business Horizons* 53, no. 1, 59–68.

Kapuscinski, Afton N., and Kevin S. Masters. 2010. The current status of measures of spirituality: A critical review of scale development. *Psychology of Religion and Spirituality* 2, no. 4, 191–205.

Katz, David. 1950. *Gestalt Psychology*, trans. R. Tyson. New York: Ronald Press.

Kemp, Gary. 1999. The aesthetic attitude. *British Journal of Aesthetics* 39, 392–399.

Kennedy, Duncan. 2013. Titanic violin could fetch record price at auction. *BBC News*, October 16. www.bbc.co.uk/news/uk-24560046.

Kerin, Roger, Steven Hartley, and William Rudelius. 2010. *Marketing*. 10th ed. New York: McGraw-Hill/Irwin.

Keynes, John Maynard. 1936. *The General Theory of Employment, Interest, and Money*. New York: Harcourt, Brace.

Kietzmann, Jan H., Kristopher Hermkens, Ian P. McCarthy, and Bruno S. Silvestre. 2011. Social media? Get serious! Understanding the functional building blocks of social media. *Business Horizons* 54, no. 3, 241–251.

Kimbell, Lucy. 2011. Designing for service as one way of designing services. *International Journal of Design* 5, no. 2, 41–52.

King, Alexandra. N.d. The aesthetic attitude. In *Internet Encyclopedia of Philosophy*, ed. J. Fieser and B. Dowden. www.iep.utm.edu/aesth-at/.

Kirchberg, Volker. 2003. Corporate arts sponsorship. In *A Handbook of Cultural Economics*, ed. Ruth Towse, 143–151. Cheltenham, UK: Edward Elgar.

Knight, Zachary. 2011. EA sues EA over the EA trademark. *TechDirt*, October 6. www.techdirt.com/articles/20111005/11124816224/ea-sues-ea-over-ea-trademark.shtml.

Koffka, Kurt. 1935. *Principles of Gestalt Psychology*. New York: Harcourt, Brace.

Köhler, Wolfgang. 1929. *Gestalt Psychology: An Introduction to New Concepts in Modern Psychology*. New York: Liveright.

Kushner, Roland J., Thomas H. Pollak, and Performing Arts Research Coalition (PARC). 2003. *The Finances and Operations of Nonprofit Performing Arts Organizations in 2001 and 2002: Highlights and Executive Summary*. Washington, DC: PARC. www.urban.org/UploadedPDF/311439_Finances_Operations.pdf.

Lanham (Trademark) Act (15 U.S.C.). BitLaw. www.bitlaw.com/source/15usc/.

Larson, Kara. N.d. *Can You Use Dynamic Pricing?* Portland, ME: Arts Knowledge.

Laudon, Kenneth C., and Jane P. Laudon. 2012. *Management Information Systems: Managing the Digital Firm*. 12th ed. Boston: Prentice Hall.

Levine, Lawrence. 1988. *Highbrow/Lowbrow: The Emergence of Cultural Hierarchy in America*. Cambridge, MA: Harvard University Press.

Levy, Sidney J. 1959. Symbols for sale. *Harvard Business Review* 37 (July–August), 163–176.

Levy-Garboua, Louis, and Claude Montmarquette. 2003. Demand. In *A Handbook of Cultural Economics*, ed. Ruth Towse, 201–213. Cheltenham, UK: Edward Elgar.

Lichty, Patrick. 2009. The translation of art in virtual worlds. *Leonardo Electronic Almanac* 16, no. 4–5, 1–12.

Linden Endowment for the Arts. N.d. Blog. http://lindenarts.blogspot.com.

Lopes, Dominic McIver. 1998. Aesthetics in the Academy: Survey results in brief. *Aesthetics online*. www.aesthetics-online.org/academy/survey-results.php.

Lovelock, Christopher H. (comp.). 1992. *Managing Services: Marketing, Operations, and Human Resources*. 2nd ed. Englewood Cliffs, NJ: Prentice Hall.

Lovelock, Christopher H., and Jochen Wirtz. 2010. *Services Marketing: People, Technology, Strategy*. 7th ed. Upper Saddle River, NJ: Prentice Hall.

Lowry, W. McNeil (ed.). 1984. *The Arts and Public Policy in the United States*. Englewood Cliffs, NJ: Prentice-Hall.

Mankiw, Gregory N. 2000. *Macroeconomics*. 4th ed. New York: Worth.

Mano, Haim, and Richard L. Oliver. 1993. Assessing the dimensionality and structure of the consumption experience: Evaluation, feeling, and satisfaction. *Journal of Consumer Research* 20, no. 3 (December), 451–466.

Mantoux, Étienne. 1946. *The Carthaginian Peace, or The Economic Consequences of Mr. Keynes*. London: Oxford University Press.

Marks, Clifford M. 2010. Charity brawl: Nonprofits aren't so generous when a name's at stake. *Wall Street Journal*, August 5. http://online.wsj.com/news/articles/SB1000142405274870370 09045753909501781 42586.

Martin, F. David. 1972. *Art and the Religious Experience: The "Language" of the Sacred*. Lewisburg, PA: Bucknell University Press.

Martin, Thomas R. 1996. *Ancient Greece: From Prehistoric to Hellenistic Times*. New Haven, CT: Yale University Press.

Mathews, Rick. 2012. US GDP is 70 percent of personal consumption: Inside the numbers. *PolicyMic*, September 21. www.policymic.com/articles/15097/us-gdp-is-70-percent-personal-consumption-inside-the-numbers.

McCain, Roger. 2006. Defining cultural and artistic goods. In *Handbook of the Economics of Art and Culture*, ed. Victor A. Ginsburgh and David Throsby, 147–167. Amsterdam: Elsevier North-Holland.

McCarthy, Kevin F., Elizabeth H. Ondaatje, Arthur Brooks, and Andras Szanto. 2005. *A Portrait of the Visual Arts: Meeting the Challenges of a New Era*. Santa Monica, CA: RAND Research in the Arts.

McCracken, Grant David. 1986. Culture and consumption: A theoretical account of the structure and movement of the cultural meaning of consumer goods. *Journal of Consumer Research* 13, no. 1 (June), 71–84.

———. 1988. *The Long Interview*. Thousand Oaks, CA: Sage.

———. 1990. *Culture and Consumption: New Approaches to the Symbolic Character of Consumer Goods and Activities*. Bloomington: Indiana University Press.

———. 2005. *Culture and Consumption II: Markets, Meaning, and Brand Management*. Bloomington: Indiana University Press.

———. 2008. *Transformations: Identity Construction in Contemporary Culture*. Bloomington: Indiana University Press.

McKendrick, Neil. 1982. The consumer revolution of eighteenth-century England. In *The Birth of a Consumer Society: The Commercialization of Eighteenth-Century England*, ed. Neil McKendrick, John Brewer, and J.H. Plumb, 9–33. Bloomington: Indiana University Press.

Merriam-Webster Online. N.d. Aesthetic. www.merriam-webster.com/dictionary/aesthetic.

Miller, Janice S., and Robert L. Cardy. 2000. Technology and managing people: Keeping the "human" in human resources. *Journal of Labor Research* 21, no. 3, 447–461.

Miller, Keith W., and Jeffrey Voas. 2010. Ethics and the cloud. *IT Pro* (September/October), 4–5.

Minnesota Council of Nonprofits. N.d. Sample organization: Endowment fund investment policies. www.minnesotanonprofits.org/events-training/finance-conference/finance-conference-handouts/Investment_Manager_2.pdf.

Moggridge, D.E. 1992. *John Maynard Keynes: An Economist's Biography*. London: Routledge.

National Conference of Commissioners on Uniform State Laws. 2006. *Uniform Prudent Management of Institutional Funds Act.* Passed July 7–14. Chicago: NCCUSL. www.uniformlaws.org/shared/docs/prudent%20mgt%20of%20institutional%20funds/upmifa_final_06.pdf.

National Council of Nonprofits. N.d. Corporate sponsorship toolkit. www.councilofnonprofits.org/resources/resources-type/toolkits/corporate-sponsorship-toolkit.

National Endowment for the Arts (NEA). 2009. *2008 Survey of Public Participation in the Arts.* Research Report #49, November. Washington, DC: NEA.

———. 2010. *Audience 2.0: How Technology Influences Arts Participation.* Washington, DC: NEA, June.

———. 2011. *Time and Money: Using Federal Data to Measure the Value of Performing Arts Activities.* NEA Research Note #102, April.

———. 2012. *How Art Works: The National Endowment for the Arts' Five-Year Research Agenda, with a System Map and Measurement Model.* Washington, DC: NEA, September.

Neilson, Gary L., and Julie Wulf. 2012. How many direct reports? *Harvard Business Review* (April). http://hbr.org/2012/04/how-many-direct-reports/ar/1.

Nietzsche, Friedrich. 1968. *The Will to Power,* trans. W. Kaufmann and R.J. Hollingdale; ed. W. Kaufmann. New York: Random House.

Niven, Paul R. 2008. *Balanced Scorecard Step-by-Step for Government and Nonprofit Agencies.* 2nd ed. New York: John Wiley.

O'Hagan, John, and Denice Harvey. 2000. Why do companies sponsor arts events? Some evidence and a proposed classification. *Journal of Cultural Economics* 24, no. 3, 205–224.

Okada, Erica Mina. 2005. Justification effects on consumer choice of hedonic and utilitarian goods. *Journal of Marketing Research* 42, no. 1, 43–53.

Olson, Russell. 2005. *The Handbook for Investment Committee Members.* Hoboken, NJ: Wiley.

Parasuraman, A., Valarie A. Zeithaml, and Leonard L. Berry. 1985. A conceptual model of service quality and its implications for future research. *Journal of Marketing* 49, no. 4, 41–50.

Patenting Art and Entertainment. N.d. Patent titles: Dance. http://patenting-art.com/database/dancing.htm.

Paumgarten, Nick. 2013. Dealer's hand: Why are so many people paying so much money for art? Ask David Zwirner. *The New Yorker,* December 2. www.newyorker.com/reporting/2013/12/02/131202fa_fact_paumgarten?currentPage=all.

Payne, Adrian, and Pennie Frow. 2005. A strategic framework for customer relationship management. *Journal of Marketing* 69 (October), 167–176.

Peirce, Charles S. 1932. *The Collected Papers of Charles Sanders Peirce* (8 vols.). Cambridge, MA: Harvard University Press.

Pirsig, Robert. 1999. *Zen and the Art of Motorcycle Maintenance: An Inquiry into Values.* 25th anniv. ed. New York: Quill.

Porter, Michael E. 1990. *The Competitive Advantage of Nations.* New York: Free Press.

Pratt, Andy C. 2005. Cultural industries and public policy: An oxymoron? *International Journal of Cultural Policy* 11, no. 1, 31–44.

Preece, Stephen B. 2011. Performing arts entrepreneurship: Toward a research agenda. *Journal of Arts Management, Law, and Society* 41, no. 2, 103–120.

Prive, Tanya. 2012. What is crowdfunding and how does it benefit the economy? *Forbes,* November 27. www.forbes.com/sites/tanyaprive/2012/11/27/what-is-crowdfunding-and-how-does-it-benefit-the-economy/2/.

Proctor, Nancy, and Jane Burton. 2004. Tate modern multimedia tour pilots 2002–2003. In *Learning with Mobile Devices Research and Development,* ed. Jill Attewell and Carol Savill-Smith, 127–130. London: Learning and Skills Development Agency.

Radbourne, Jennifer, Katya Johanson, and Hilary Glow. 2010a. Empowering audiences to measure quality. *Participations: Journal of Audience & Reception Studies* 7, no. 2, 360–379.

———. 2010b. Measuring the intrinsic benefits of arts attendance. *Cultural Trends* 19, no. 4, 307–324.

Radbourne, Jennifer, Katya Johanson, Hilary Glow, and Tabitha White. 2009. The audience experience: Measuring quality in the performing arts. *International Journal of Arts Management* 11, no. 3, 16–29.

Ratchford, Brian T. 1975. The new economic theory of consumer behavior: An interpretative essay. *Journal of Consumer Research* 2, no. 2 (September), 65–75.

Ravanas, Philippe, and Paula Colletti. 2010. What price is right for looking glass? *International Journal of Arts Management* 12, no. 3 (Spring), 3.

Rentschler, Ruth. 2004. Museum marketing: Understanding different types of audiences. In *Arts Marketing*, ed. Finola Kerrigan, Peter Fraser, and Mustafs Ozbilgin, 139–158. Oxford: Elsevier Butterworth-Heinemann.

Rinallo, Diego, Linda Scott, and Pauline Maclaran (eds.). 2012. *Consumption and Spirituality*. New York: Routledge.

Robertson, Thomas. 1967. The process of innovation and the diffusion of innovation. *Journal of Marketing* 31 (January), 14–19.

Rogers, Everett M. 2003. *Diffusion of Innovations*. 5th ed. New York: Free Press.

Roodhouse, Simon. 2008. Creative industries: The business of definition and cultural management practice. *International Journal of Arts Management* 11, no. 1 (Fall), 16–27.

Rose, Stuart. 2001. Is the term "spirituality" a word that everyone uses, but nobody knows what anyone means by it? *Journal of Contemporary Religion* 16, no. 2, 193–207.

Rosenberg, Jim. 2003. *Learning from the Community: Effective Financial Management Practices in the Arts; Summary Findings and a Framework for Self-Assessment*. Alexandria, VA: National Arts Strategies.

Roth, Steven. N.d. Pricing the arts. Unpublished article.

Rousseau, Jean-Jacques. 1761/1997. *The Social Contract and Other Later Political Writings*, ed. and trans. V. Gourevitch. New York: Cambridge University Press.

Rubinton, Brian J. 2011. Crowdfunding: Disintermediated investment banking. Working paper, April 11. http://ssrn.com/abstract=1807204.

Salesforce.com. N.d. Selecting the correct edition: Art Studio, Gallery, Collection or Museums Management. ArtApp. http://artapp.force.com/index.

San Francisco Ballet. 2014. Conditions of use. www.sfballet.org/home/conditions_of_use.

Saucier, Gerard and Katarzyna Skrzypinska. 2006. Spiritual But Not Religious? Evidence for Two Independent Dispositions. *Journal of Personality* 74, no. 5 (October), 1257–1292.

Saussure, Ferdinand de. 1916/1966. *Course in General Linguistics*, trans. W. Baskin. New York: McGraw-Hill.

Schindler, Robert M., and Morris B. Holbrook. 2003. Nostalgia for early experience as a determinant of consumer preferences. *Psychology & Marketing* 20, no. 4, 275–302.

Schopenhauer, Arthur. 1969. *The World as Will and Representation* (Vol. 1), trans. E.F.J. Payne. New York: Dover.

Scitovsky, Tibor. 1976. What's wrong with the arts is what's wrong with society. In *The Economics of the Arts*, ed. M. Blaug. London: M. Robertson.

Seaman, Bruce A. 2006. Empirical studies of demand for the performing arts. In *Handbook of the Economics of Art and Culture*, ed. Victor A. Ginsburgh and David Throsby, 415–474. Amsterdam: Elsevier North-Holland.

Second Life. N.d. Artists for Second Life. http://secondlife.com/destination/artists-for-second-life.

————. N.d. Destination guide: Art. https://secondlife.com/destinations/arts.

Sheppard, Blair H., Jon Hartwick, and Paul R. Warshaw. 1988. The theory of reasoned action: A meta-analysis of past research with recommendations for modifications and future research. *Journal of Consumer Research* 15, no. 3 (December), 325–343.

Shiner, Larry. 2001. *The Invention of Art: A Cultural History*. Chicago: University of Chicago Press.

Shipton, Helen, Doris Fay, Michael West, Malcolm Patterson, and Kamal Birdi. 2005. Managing people to promote innovation. *Creativity and Innovation Management* 14, no. 2, 118–128.

Shostack, G. Lynn. 1982. How to design a service. *European Journal of Marketing* 16, no. 1, 49–63.

————. 1984. Designing services that deliver. *Harvard Business Review* 62, no. 1, 133–139.

Simmel, Georg. 1904/2004. *The Philosophy of Money* (3rd ed.), ed. David Frisby; trans. Tom Bottomore and David Frisby. New York: Routledge.

Singh, R.P. 2001. A comment on developing the field of entrepreneurship through the study of opportunity recognition and exploitation. *Academy of Management Review* 26, no. 1, 10–12.

Sirgy, M. Joseph. 1982. Self-concept in consumer behavior: A critical review. *Journal of Consumer Research* 9, no. 3 (December), 287–300.

Skousgaard, Heather. 2005. A taxonomy of spiritual motivations for consumption. *Advances in Consumer Research* 33, 294–296.

Slater, Barry Hartley. N.d. Aesthetics. In *Internet Encyclopedia of Philosophy*, ed. J. Fieser and B. Dowden. www.iep.utm.edu/aestheti/.

Solman, Paul. 2013. Performing artists compete, move, adapt in tough economy. *PBS Newshour*, June 27. www.pbs.org/newshour/bb/business-jan-june13-artists_06-27/.

Sonsev, Veronika. 2012. The artist entrepreneur: How technology is transforming the art world. *Forbes*, October 22.

Sotheby's. 2011. Terms & conditions of use. www.sothebys.com/en/terms-conditions.html.

Sparks, Erin, and Mary Jo Waits. 2012. *New Engines of Growth: Five Roles for Arts, Culture, and Design*. Washington, DC: NGA Center for Best Practices. www.nga.org/files/live/sites/NGA/files/pdf/1204NEWENGINESOFGROWTH.PDF.

Spivy, Nigel. 1996. *Understanding Greek Sculpture: Ancient Meanings, Modern Readings*. London: Thames & Hudson.

Square, Inc. N.d. Square for non-profit organizations. https://squareup.com/help/en-us/article/5101-square-for-non-profit-organizations.

Staniszewski, Mary Anne. 1995. *Believing Is Seeing: Creating the Culture of Art*. New York: Penguin Books.

Stiglitz, Joseph E. 2000. *Economics of the Public Sector*. 3rd ed. New York: W.W. Norton.

Stole, Inger L. 2001. Advertising. In *Culture Works: The Political Economy of Culture*, ed. R. Maxwell, 83–106. Minneapolis: University of Minnesota Press.

Strategic Business Insights. N.d. US Framework and VALS™ Types. www.strategicbusinessinsights.com/vals/ustypes.shtml.

Stuart, F.I., and S. Tax. 2004. Toward an integrative approach to designing service experiences: Lessons learned from the theatre. *Journal of Operations Management* 22, no. 6, 609–627.

Summerfield, Jason. N.d. Mobile website vs. mobile app (application): Which is best for your organization? *Human Service Solutions*. http://hswsolutions.com/services/mobile-web-development/mobile-website-vs-apps/.

Sutter, John D. 2009. Artists visit virtual Second Life for real-world cash. *CNN*, April 7. www.cnn.com/2009/TECH/04/07/second.life.singer/.

Thompson, Craig J., and Diana L. Hayko. 1997. Speaking of fashion: Consumers' uses of fashion discourses and the appropriation of countervailing cultural meanings. *Journal of Consumer Research* 24, no. 1 (June), 15–42.

Thompson, William Irwin. 1996. *The Time Falling Bodies Take to Light: Mythology, Sexuality and the Origins of Culture.* 2nd ed. New York: St. Martin's Griffin.

Thomson, Kristin, Kristen Purcell, and Lee Rainie. 2013. *Arts Organizations and Digital Technologies.* Washington, DC: Pew Research Internet Project. http://pewinternet.org/Reports/2013/Arts-and-technology.aspx.

Thorpe, Vanessa. 2014. Royal Ballet vs English National Ballet: Who will win battle of ballet superstars? *The Observer (The Guardian)*, February 1.

Throsby, David. 1994. The production and consumption of the arts: A view of cultural economics. *Journal of Economic Literature* 32, no. 1 (March), 1–29.

———. 2001. *Economics and Culture.* New York: Cambridge University Press.

———. 2010. *The Economics of Cultural Policy.* Cambridge: Cambridge University Press.

Throsby, C. David and Glenn A. Withers. 1979. *The Economics of the Performing Arts.* New York: St. Martin's Press.

Towse, Ruth. 2005. Managing copyrights in the cultural industries. Paper presented at the Eighth International Conference on Arts and Culture Management, Montreal, Canada, July 3–6.

Trant, Jennifer. 2006. Exploring the potential for social tagging and folksonomy in art museums: Proof of concept. *New Review of Hypermedia and Multimedia* 12, no. 1 (June), 83–105.

Turbide, Johanne, and Claude Laurin. 2009. Measurement in the arts sector: The case of the performing arts. *International Journal of Arts Management* 11, no. 2 (Winter), 56–70.

Turk, Frederick J., and Robert P. Gallo. 1984. *Financial Management Strategies for Arts Organizations.* New York: ACA Books.

Ungerleider, Neal. 2013. Why an arts nonprofit is developing web dashboards. *Fast Company*, October 21. www.fastcolabs.com/3020230/why-an-arts-non-profit-is-developing-web-dashboards.

United Nations Environment Programme (UNEP) Finance Initiative. 2005. *A Legal Framework for the Integration of Environmental, Social and Governance Issues into Institutional Investment.* Produced for the Asset Management Working Group. London: Freshfields Bruckhaus Deringer/Switzerland: UNEP Finance Initiative, October.

U.S. Bureau of Economic Analysis. 2014. Widespread growth across industries in 2012; revised statistics of gross domestic product by industry for 1997–2012. News release BEA 14-02, January 23. www.bea.gov/newsreleases/industry/gdpindustry/2014/gdpind12_rev.htm.

U.S. Bureau of Labor Statistics. 2010. *Occupational Outlook Handbook*, 2010–11 ed. Washington, DC: U.S. Bureau of Labor Statistics.

———. 2013. Occupational employment and wages, May 2013: 27–1013 Fine artists, including painters, sculptors, and illustrators. www.bls.gov/oes/current/oes271013.htm.

U.S. Copyright Office. 2010. Dramatic works: Scripts, pantomimes, and choreography. FL-119. Washington, DC: U.S. Copyright Office, November. www.copyright.gov/fls/fl119.html.

———. 2011a. Chapter 31: Duration of copyright. In *Circular 92: Copyright Law of the United States of America and Related Laws Contained in Title 17 of the United States Code.* Washington, DC: U.S. Copyright Office, December. www.copyright.gov/title17/92chap3.html.

———. 2011b. *Complete Version of the U.S. Copyright Law.* Washington, DC: U.S. Copyright Office, December. www.copyright.gov/title17/.

———. 2012. Fair use. FL-102. Washington, DC: U.S. Copyright Office, June. www.copyright.gov/fls/fl102.html.

———. 2014. Online Service Providers. www.copyright.gov/onlinesp/.

U.S. Internal Revenue Service. 2012. Qualified sponsorship payment. In *IRS Publication 593: Tax on Unrelated Business Income of Exempt Organizations*. www.irs.gov/publications/p598/ch03.html#en_US_2011_publink1000267776.

———. 2013a. Exempt Organizations Annual Reporting Requirements—Annual Electronic Notice (Form 990-N) for Small Organizations: Some Group Subordinates Need Not File. August 15. www.irs.gov/Charities-&-Non-Profits/Exempt-Organizations-Annual-Reporting-Requirements-Annual-Electronic-Notice-(Form-990-N)-for-Small-Organizations:-Some-Group-Subordinates-Need-Not-File.

———. 2013b. Exempt Purposes—Internal Revenue Code Section 501(c)(3). October 30. www.irs.gov/Charities-&-Non-Profits/Charitable-Organizations/Exempt-Purposes-Internal-Revenue-Code-Section-501(c)(3).

———. 2013c. 14. Sale of property. In *Publication 17 (2013), Your Federal Income Tax*. Washington, DC: IRS. www.irs.gov/publications/p17/ch14.html#en_US_2012_publink1000172315.

———. 2014a. Apply for an Employer Identification Number (EIN) online. January 2. www.irs.gov/Businesses/Small-Businesses-&-Self-Employed/Apply-for-an-Employer-Identification-Number-(EIN)-Online.

———. 2014b. State links. March 12. www.irs.gov/Charities-&-Non-Profits/State-Links.

U.S. Patent and Trademark Office. 2013a. Basic facts about trademarks: What every small business should know now, not later. www.uspto.gov/trademarks/basics/.

———. 2013b. Office of Policy and External Affairs: Patent Trade Secrets. www.uspto.gov/ip/global/patents/ir_pat_tradesecret.jsp.

———. 2014. Fee schedule. www.uspto.gov/web/offices/ac/qs/ope/fee010114.htm.

———. N.d. *A Guide to Filing a Design Patent Application*. Washington, DC: U.S. PTO. www.uspto.gov/web/offices/com/iip/pdf/brochure_05.pdf.

U.S. Securities and Exchange Commission. 2013a. SEC issues proposal on crowdfunding. Press release 2013–227, October 23. www.sec.gov/News/PressRelease/Detail/PressRelease/1370540017677#.UrNpPRZe_jg.

———. 2013b. *What Are Corporate Bonds?* Investor Bulletin, SEC Pub. No. 149. www.sec.gov/investor/alerts/ib_corporatebonds.pdf.

U.S. Social Investment Forum. 2001. *2001 Report on Socially Responsible Investing Trends in the United States*. SIF Industry Research Program. Washington, DC: USSIF, November 28. www.ussif.org/files/Publications/01_Trends_Report.pdf.

Veblen, Thorstein. 1912. *The Theory of the Leisure Class: An Economic Study of Institutions*. New York: Macmillan.

Vergano, Dan. 2009. Jackson's 'smooth' leaning move really was patented. *USA Today*, July 2. http://usatoday30.usatoday.com/life/people/2009-06-30-jackson-patent_N.htm.

Verma, Rohit, Gary M. Thompson, William Moore, and Jordan J. Louviere. 2001. Effective design of products/services: An approach based on integration of marketing and operations decisions. *Decision Sciences* 32, no. 1, 165–194.

Vogel, Harold. 2007. *Entertainment Industry Economics: A Guide for Financial Analysis*. 7th ed. New York: Cambridge University Press.

Walker, Kathrine Sorley. 1995. The Camargo society. *Dance Chronicle* 18, no. 1, 1–114.

Walker, Orville C., Jr., and John W. Mullins. 2008. *Marketing Strategy: A Decision-Focused Approach*. 6th ed. New York: McGraw-Hill/Irwin.

Walter, Carla. 2013. A womanist transmodern theodancecologic approach to reframing markets and consumption. Paper presented at the Consumer Culture Theory Conference, Tucson, Arizona, June 13–16.

Wang, Ning. 1999. Rethinking authenticity in tourism research. *Annals of Tourism Research* 26, no. 2, 349–370.

Warrillow, John. 2011. The math behind your company valuation: What you need to know to increase the value of your business for a financial buyer. *Inc.*, September 7. www.inc.com/articles/201109/the-math-behind-your-company-valuation.html.

Weinrich, Nedra Kline. 2011. *Hands-on Social Marketing: A Step-by-Step Guide to Designing Change for Good.* 2nd ed. Thousand Oaks, CA: Sage.

Wertheimer, Max. 1938. Gestalt theory. In *A Source Book of Gestalt Psychology*, ed. W.D. Ellis. London: Kegan Paul.

Westaway, Kyle. 2011. New legal structures for "social entrepreneurs." *Wall Street Journal*, December 12. http://online.wsj.com/news/articles/SB10001424052970203413304577708860406339194.

Williams, Caroline, and Lisa Sharamitaro. 2002. Building a model for culturally responsible investment. *Journal of Arts Management, Law, and Society* 32, no. 2 (Summer), 144–158.

Williams, Chuck. 2013. *Management.* 7th ed. Mason, OH: South-Western Cengage Learning.

Williams, Raymond. 1983. *Culture and Society: 1780–1950.* New York: Columbia University Press.

Wilson, Steven G., David A. Plane, Paul J. Mackun, Thomas R. Fischetti, and Justyna Goworowska. 2012. *Patterns of Metropolitan and Micropolitan Population Change: 2000 to 2010.* 2010 Census Special Report, C2010SR-01, September. Washington, DC: U.S. Census Bureau. www.census.gov/prod/cen2010/reports/c2010sr-01.pdf.

Wollstonecraft, Mary. 1792/1989. *A Vindication of the Rights of Woman*, ed. C.H. Poston. New York: W.W. Norton.

World Intellectual Property Organization. N.d.a. Summary of the Berne Convention for the Protection of Literary and Artistic Works (1886). www.wipo.int/treaties/en/ip/berne/summary_berne.html.

———. N.d.b. What is a trade secret? www.wipo.int/sme/en/ip_business/trade_secrets/trade_secrets.htm.

Wyszomirski, Margaret J. 2002. Arts and culture. In *The State of Nonprofit America*, ed. L.M. Salamon. Washington, DC: Brookings University Press.

YourDictionary.com. 2014. Contemporary art. LoveToKnow Corp. www.yourdictionary.com/contemporary-art.

Zeithaml, Valarie A., Leonard L. Berry, and A. Parasuraman. 1993. The nature and determinants of customer expectations of service. *Journal of the Academy of Marketing Science* 21, no. 1, 1–12.

Zeithaml, Valarie A., Mary Jo Bitner, and Dwayne D. Gremler. 2006. *Services Marketing: Integrating Customer Focus Across the Firm.* 4th ed. New York: McGraw-Hill/Irwin.

———. 2013. *Services Marketing: Integrating Customer Focus Across the Firm.* 6th ed. New York: McGraw-Hill/Irwin.

Zikmund, William G., and Barry J. Babin. 2012. *Essentials of Marketing Research.* 4th ed. Independence, KY: South-Western Cengage Learning.

Zorloni, Alessia. 2010. Managing performance indicators in visual art museums. *Museum Management and Curatorship* 25, no. 2, 167–180.

Zwilling, Martin. 2009. How to value a young company. *Forbes*, September 23. www.forbes.com/2009/09/23/small-business-valuation-entrepreneurs-finance-zwilling.html.

Index

Page numbers in *italics* denotes an illustration/table/figure

About the Author

Carla Stalling Walter currently serves as Dean, Division of the Arts, Humanities and Social Sciences at Chabot College. Prior to this she held tenured positions in schools of business and management in the United States, and business in France and Germany. She has published several books, journal articles, and book chapters and has presented papers at numerous conferences on the classical performing arts and related topics. In addition, Dr. Walter has extensive experience leading and directing entrepreneurial fine arts organizations, including successfully founding and directing a professional performing ballet company. Her track record includes having established university graduate-level arts management programs, as well as having led and served on fine arts, music, and dance company boards.

Dr. Walter earned her doctorate in Critical Dance Studies/Dance History and Theory from the University of California, Riverside. Her master's work resulted in an MBA in Marketing and Management from California State University, San Bernardino, and her undergraduate work in economics culminated in a bachelor's degree from the University of California, Riverside.